DRAWING

Structure and Vision

Fritz Drury

Joanne Stryker

Rhode Island School of Design

PEARSON

Prentice
Hall

Upper Saddle River, New Jersey 07458

Library of Congress Cataloging-in-Publication Data
Drury, Fritz.
 Drawing : Structure and Vision / Fritz Drury, Joanne Stryker.
 p. cm.
 ISBN-13: 978-0-13-089602-5
 ISBN-10: 0-13-089602-0
 1. Drawing—Technique. I. Stryker, Joanne. II. Title.
 NC730.D78 2009

 2007028408

Editor in Chief: Sarah Touborg
Senior Editor: Amber Mackey
Editorial Assistant: Carla Worner
Director of Marketing: Tim Stookesberry
Executive Marketing Manager: Marissa Feliberty
Marketing Assistant: Irene Fraga
Senior Managing Editor: Mary Rottino
Production Liaison: Barbara Taylor-Laino
Senior Operations Specialist: Brian Mackey
Creative Director: Jayne Conte
Cover designer: Bruce Kenselaar
Director, Image Resource Center: Melinda Patelli
Manager, Rights and Permissions: Zina Arabia
Manager, Visual Research: Beth Brenzel
Manager, Cover Visual Research & Permissions: Karen Sanatar
Image Permission Coordinator: Vicki Menanteaux
Photo Researcher: Francelle Carapetyan/Image Research Editorial Services
Composition/Full-Service Project Management: Pine Tree Composition Inc.
Cover Illustration/Photo: Julie Mehretu, Transcending: The New International (2003), ink
and acrylic on canvas, 107 × 237 in. (271.8 × 602 cm), Collection Walker Art Center Min-
neapolis; T.B. Walker Acquisition Fund, 2003. (Photo: Cameron Wittig)

Printer/Binder: Courier Kendallville

Credits and acknowledgments borrowed from other sources and reproduced, with permis-
sion, in this textbook appear on appropriate page within text (or on pages 441–450).

Pearson Education LTD. London
Pearson Education Singapore, Pte. Ltd
Pearson Education, Canada, Ltd
Pearson Education–Japan
Pearson Education Australia PTY, Limited

Pearson Education North Asia Ltd
Pearson Educación de Mexico, S.A. de C.V.
Pearson Education Malaysia, Pte. Ltd
Pearson Education, Upper Saddle River,
 New Jersey

10 9 8 7 6 5 4 3
ISBN (10): 0-13-089602-0
ISBN (13): 978-0-13-089602-5

"One must always tell what one sees. Above all . . . one must always see what one sees."
—*Charles Péguy*

To my father, Felix Drury, who made me an artist and a teacher.

Fritz Drury

To Ted and Teddy Weller and Louise Stryker for their patience and support.

Joanne Stryker

Contents

PART TWO ELEMENTS OF FORM 47

Chapter Three Organic Mark and Form 48

Chapter Four Geometric Mark and Form 78

Chapter Five The Experience of Space 108

Chapter Six Value: Light and Form 137

Chapter Ten Composition and Expression 266

PART FOUR APPROACHING A SERIES 301

Chapter Eleven Investigations with Media and Sketchbook Studies 302

Chapter Twelve Contemporary Process and Series 332

Chapter Thirteen Individual Series Development 363

Appendix A Materials and Processes 383

Appendix B Linear Perspective 398

Appendix C Basic Human Anatomy 412

Preface

Drawing: Structure and Vision introduces students of drawing to a full range of skills and concepts, wedding the most exciting trends in contemporary practice to structures and methods inherited from the greatest drawing traditions of art history. Drawing has truly been rejuvenated in the past decade as a rich and complex art form availing the practitioner of an enormous variety of approaches and concepts. Our book is precisely focused on introducing the reader to the expressive possibilities in drawing, and the manual, conceptual and visual skills necessary to access these opportunities. Our goal is to establish a real understanding of both method and meaning, and to connect current art-world concepts with actual classroom investigation. Every issue we raise is tied specifically to something the students can do, and might want to do, in their own drawings.

APPROACH

It is our belief that drawing has its own particular language rooted in direct tactile experience of media and the personal investigation of visual form. Our text is designed to clarify the presentation of this language in a manner that encourages beginning students to develop a direct familiarity with essential drawing elements and confidence about making personal expressive choices. It has been our goal in the preparation of this text to reveal drawing's full range of possibilities, while maintaining ease of access.

Our text is accompanied by examples of drawings that show the connection between elemental form and expressive statement, and between historical precedent and contemporary possibility. Every image has been selected for the clarity of connection with the formal topic under discussion, and older and newer works are often shown side-by side to highlight similarities and distinctions. It is our belief that the truly exciting aspect of the current era in drawing is the re-discovered relevance for a vast array of approaches from all areas of world culture and history. We attempt to cast a wide net for sources of inspiration, while keeping a tight focus on the particular aspects of the art form of drawing.

Drawing takes it strength from the direct connection between eye, mind and hand. Our book emphasizes intimate personal response, and we tie the study of the components of drawing—line, form, value, texture and broader structures—with sights, feelings and associations of daily life. *Drawing: Structure and Vision* emphasizes direct visual experience as a basis for making marks, forming judgments and adjusting artistic statements. Our belief is that nature and the visual habits of daily life represent a common grounding of experience for all people, and are the best starting point for gaining an understanding of the link between visual form and associative meaning. In drawing, the simplest mark can lead directly to a conceptual statement of great subtlety and complexity. This is the unique power of the art form.

ORGANIZATION

Often it is the classroom critique, as much as actual practice in drawing, that acquaints students with drawing's conceptual possibilities. *Part One: Orientation* includes a chapter on *Class and Critique* that clarifies the procedures and goals of verbal discussion of art. In addition, each chapter ends with a list of

Critique Tips—questions that might be pertinent to discussion of work done within the focus of that chapter, giving students clear direction for thinking and verbalizing about their own work. Italicized terms throughout the text are defined in the *Glossary* at the end of the book. We emphasize the need for students to think and express visually, but also to understand and express verbally.

Part One: Orientation continues with a review of some hands-on practicalities for beginning drawing students, including coverage of materials, the use of the personal sketchbook, basic approaches to gesture, proportion, composition and other initial strategies for defining the underpinnings of a drawing.

Part Two presents an overview of the *Elements of Form* in an organized and lucid manner: organic mark and form; geometric mark and form; 2D and 3D space; value, light and color. The abstract forms and structures of drawing are related to natural form and forces such as gravity, growth, erosion and the action of light.

Parts Three and Four elaborate on the discussion of form and content in *Part Two*. *Part Three: Expressive Directions* explores particular application of drawing to two general themes: the human figure and compositional structure. In each case, the discussion blends historical precedent and contemporary applications, using the study of specific methodologies as a springboard for discussion of relevant philosophical and social issues.

Part Four: Approaching a Series guides students through the development of extended personal drawing projects. Beginning with a deeper understanding of sketchbook use, media experimentation, and varied approaches to process, students further their understanding of the expressive possibilities of drawing and connect this knowledge to personally determined imagery. Students are encouraged to ask questions, and push beyond assignment-based drawing. All stages of the creative process, from the search for ideas to choices of material and format to the development and realization of the drawings, are covered in depth. Bodies of related works by both contemporary artists and students are used as examples, clarifying decision-making and the development of visual ideas.

The four-part organization of the text allows for flexible multi-semester use. *Parts One and Two* might form the foundation of a first semester course. *Parts Three and Four* are geared to more advanced students, but linkages with *Part Two* are easily established: organic form and the human figure; value studies with expressive composition, and so on. *Part Four: Approaching a Series* can function as the complete instruction for an extended full-semester project, or in combination with earlier sections.

SPECIAL FEATURES

Our years of experience as teachers have convinced us of the need for a practical book that will offer students the full range of skills necessary to truly investigate the art form of drawing. Our text offers a broad menu of technical resources, including detailed appendices on *Materials and Processes, Linear Perspective, and Human Anatomy*. These resources exist apart from the main body of the text as optional extensions of issues raised in the chapters. They can be included in the course of study in part or in full, depending on the focus of the individual instructor's syllabus, or the interest of the individual student. *Issues and Ideas* boxes are interspersed throughout the chapters and highlight the most important points in each section for review and discussion. *Sketchbook Links* direct students to specific sketchbook activities and are found in *Chapters 2-13. Suggested Exercises* are grouped at the end of each chapter. Both *Sketchbook Link* assignments and indexed reference for *Suggested Exercises* are included in the *Issues and Ideas* boxes, tied to specific ideas raised in the text. Particular assignments can be included or easily skipped at the instructor's discretion as the course proceeds. *Contemporary Artist Profiles* are embedded in many chapters, tying the issues under discussion to a well-known contemporary practitioner.

It has been our goal to provide a thorough but easily navigable resource for teacher and student, adaptable to the needs of individual instructors and courses of study. We hope to convey the enormous potential of drawing as an art form in a manner that will be accessible and meaningful to today's students.

ACKNOWLEDGMENTS

We'd like to thank the many people that helped bring this book to fruition including Amber Mackey, Bud Therien, Barbara Taylor-Laino, John Shannon, and Francelle Carapetyan with special thanks to Henry Horenstein for planting the seed. We'd like to express our appreciation for the many helpful suggestions offered by reviewers of the manuscript, including:

Adrienne LaValle, Saint Anselm College

Andrew Murad, McLennan Community College

Anita Giddings, Indiana University Purdue University - Indianapolis

Anne Beidler, Agnes Scott College

Camille Rendal, Roger Williams University

Carolyn Cárdenas, Ohio University

Drake R. Gomez, Keystone College

Elizabeth Frey-Davis, Huntington University

Janette K. Hopper, University of North Carolina, Pembroke

Janice M. Pittsley, Arizona State University

Julia Morrisroe, University of Florida

Ken Burchett, University of Central Arkansas

Kent Rush, University of Texas, San Antonio

Paul Rutkovsky, Florida State University

René J. Marquez, University of Delaware

Robert Brawley, University of Kansas, Lawrence

Roger T. Dunn, Bridgewater State University

Ruth Trotter, University of LaVerne

Sal Torres, San Antonio College

Stephen F. Smalley, Bridgewater State University

This project would not have been possible without the support of our friends, colleagues and families. Nor would it have been possible without the inspiration of our own teachers from many years ago, and more recently the inspiration of our incredibly talented students of the Rhode Island School of Design, represented by the wonderful works included in the following pages.

Fritz Drury

Joanne Stryker

PART one

Orientation

INTRODUCTION

Part One provides an introduction to the study of drawing, describing basic methods, concepts and materials, and outlining important aspects of the individual and interpersonal working environment in the studio.

Drawing is about vision and communication, and an important first step is learning to understand what you see and how to express your ideas about it. The study of drawing has two important aspects. The first concerns artistic expression. Drawing has its roots in the very beginnings of human consciousness and has an unbroken relevance to human experience through history. In studying drawing you can expect to gain insight into past cultures and the consciousness of individuals from distant eras. You can also find connection with artists working today, a common bond of identity based on shared experience expressed through drawing. Most importantly, you learn to connect with your own thoughts, feelings and ideas, and to express them in your drawings.

A second dimension of the study of drawing, in many ways just as important as the first, is the model of personal organization of thought and action that drawing suggests and the interpersonal

working dynamic of the class. Through drawing, you can gain insight into processes of assessment and decisive action that have broad application in life and work in other fields. Classroom discussion (*critique*) can help to develop vital workplace skills of communication and formulation of shared goals.

Chapter One: Class and Critique, begins with an overview of drawing as an art form, historically and in terms of contemporary practice. The chapter continues with an introduction to special methods for understanding and discussing drawings in the context of class review, and extending insights gained in class to self-assessment of your work in progress. The chapter ends with a look at the important role your personal sketchbook will play in your artistic development.

Chapter Two: Materials, Procedures and Concepts, reviews the basic tools and methods of drawing. The chapter begins with a discussion of essential equipment and its proper use to ensure your effective connection with the medium and to minimize frustration. The discussion continues with an in-depth study of various methods for "breaking the ice" in drawing, procedures that can help establish your understanding of the opportunities and roadblocks inherent in the art form, and bring you closer to a personal vision informed by, and in service of, your work in drawing.

Class and Critique

1

THE EDUCATION OF AN ARTIST

What Is the Art of Drawing, and Who Is an Artist?

Drawing is about personal ideas and expression; creativity tied to human experience. Becoming an artist is about freeing your hand to follow your heart and mind and freeing your eye to respond to the world around you. Each of us, in the midst of life, is bombarded by daily stimuli: visual, emotional, social, and cultural. This accumulated experience and the very excitement of being alive are valid as material for art. Learning how to translate your perceptions into an art form, like drawing, is the essence of becoming an artist. An important aspect of this process is learning to respond sensitively and knowledgeably to artworks—those made by others and your own work during the act of creation.

Thousands of students of all ages continue to take studio classes in drawing and other art forms, emerging with substantial growth in their understanding of the methods and concepts of art making. What exactly are they learning? What aspects of art are beyond the scope of the classroom?

As a student, what can you expect to take away from drawing class? How can you make the best use of your time and opportunities here? What will you have to provide from your own resources to make this the most satisfying, dynamic, and useful experience possible? This introductory chapter addresses these important questions.

Perhaps you are taking this class because you constantly feel compelled to draw, paint, or make

things. Maybe you are just curious about art, artworks, or the lives of artists based on knowledge that you have gained in other classes, through trips to galleries or museums, or from reproductions of art in books or magazines. Awareness of art history and contemporary art has never been more broadly based than at the present time, and there is an ever-growing roster of well-known individual artists and art movements.

You may have decided that you would like to explore the idea of pursuing a career as a professional artist. Art plays a burgeoning role in our society and culture as exemplified by Keith Haring's public murals on important social issues **(Figure 1.1)**, but the business aspects of art can seem mysterious from the outside. One segment of the art world is comprised of galleries that display and sell artwork to the public. It is quite possible to be a part of this world. There are many different kinds of galleries geared toward specific markets, and the public appetite for purchasing art continues to grow.

However, many people think of themselves as serious, committed artists even if they pursue other means of support besides making and selling their own work. Art is not so much a job as it is a response to a vocation (or "calling"). That is, it is an activity and area of study principally engaged in for its own sake: for the enjoyment of the process, for the fulfillment of personal vision, for the advocacy of a personal or social point of view, or as a philosophical inquiry into life and culture.

Many people who have pursued an education in studio art, whether as a major field of study or as a secondary interest, work in related fields as art educators, museum and gallery curators, art writers, critics, or cultural organizers; or a variety of

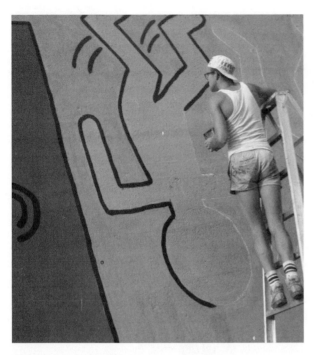

Figure 1.1 KEITH HARING, at work on *Crack Is Wack* mural, New York City, 1990 (Keith Haring painting Houston Street mural, New York, 1982." Photograph by Tseng Kwong Chi © 1982 Muna Tseng Dance Projects, Inc. New York. Subway Drawing by Keith Haring. © 1982 Estate of Keith Haring, New York)

applied fields as discussed in the next section. For others, experience with art serves principally to enrich their lives, giving them a sophisticated approach to the experience of looking at art and at the world around them.

Applied Art and Fine Art

The image of the artist that might be most familiar to us from the recent history of art is of a self-directed individual following his or her own instinct in the creation of objects of beauty, expressive intensity or intellectual interest. The most important function of these objects is the fulfillment of the artist's vision, and they find their proper home in a public gallery such as a museum or in the collection of an art lover where they serve as objects of contemplation or as connections to a broader school of cultural thought. Ultimately, such objects might take their place in the history of art, helping later generations understand the character of the time in which they were created

and setting the stage for the creation of future works. Although simplified, this image of the independent creative work of a self-directed individual artist defines the concept of **fine art.** Fine art is work that is created for its own sake as intellectual or aesthetic expression.

Applied art is a term for creative work that fulfills a utilitarian function. Illustration is a good example of an applied art form that is closely connected to drawing. An illustration needs to tell a specific story, often generated by someone other than the artist. To be successful, the details and general expressive feeling of the image must conform to the given subject for the illustration. It might be beautiful or fascinating on its own in some way, but if it does not successfully evoke the content or mood of the assigned narrative, it can be said to have failed in its applied purpose. Someone other than the artist often determines this success or failure: an art director or editor, a business client, or the author of a written piece. Illustrations can certainly be fine art if they are inherently beautiful or intellectually stimulating and express a strong view of the world that derives from the artist's vision. The line between these two aspects of art is flexible, but good to understand nonetheless, especially as it helps us to define concepts and criteria for evaluating drawings.

Drawing as Fine Art

This book will approach drawing as a fine art form, as defined above. The exact character of fine art drawing is constantly being redefined, however, and this is one of its most intriguing aspects. Though many aspects of drawing are universal, drawing can fulfill a very different role in art today than it once did, and this can be important to bear in mind when looking at older art, or when contemplating your own work or the work of other contemporary artists.

Drawing has changed in form and purpose over many centuries in close relation to the role art and artists have played in various societies. One of the most notable periods for drawing was during the Renaissance in Europe in the Fifteenth and Sixteenth Centuries. Drawing was vital to the

spirit of empirical investigation and cultural re-birth of this era, manifest in the semidiagram-matic studies of Leonardo DaVinci (Figures 4.5, 9.16a, 11.9, and 10), and the classically inspired figure drawings of Michelangelo and many others (Figures 9.24a, 9.38). All these works, on one level, were studies; they were done as part of an investigation or in the planning of larger works of art. The principal art media of the time were carved marble for sculpture, and fresco or egg tempera for painting, all very time-consuming and precise processes. In addition, most art was done on public commission, for a church altar or other important venue. Drawings fulfilled an important role in artistic process, making sure that the actual execution of the final work went smoothly, and giving the patron of the artwork an idea of what the finished product might look like. Ironically, some of these "studies" came to be seen in later centuries as expressively superior to the finished frescoes or sculptures, conveying the artist's vision with unmatched vitality.

In seventeenth-century Europe, with the ascendancy of oil painting and the rise of the commercial market for already completed artwork, drawing became less important as a preparatory medium. Oil paint allows easy reworking and a loose approach, permitting the artist to work out ideas on the final canvas. There are very few surviving drawings by such painters as Velazquez, Caravaggio, or Vermeer. However, certain artists like Rembrandt, found a special role in their creative investigation for drawing, not as preparation for painting, but as a more immediate, informal art medium, perfectly suited for spontaneous response to the artist's imagination or to the sights and events of daily life. Rembrandt's drawings are often unlike his paintings in execution and ambition and constitute a linked, but unique, body of work **(Figure 1.2)**.

Beginning in the late Nineteenth Century, drawing was given new life by the spirit of innovation at the center of modern art. Edgar Degas, who also practiced drawing-as-study in a way very similar to the artists of the Renaissance, forged a new role for drawing media through his extensive experimentation with layered work in pastel and **monotype** (Figures 9.43, 10.20). The Cubists in the early Twentieth Century added the art of **collage**—cut and pasted paper—to the vocabu-

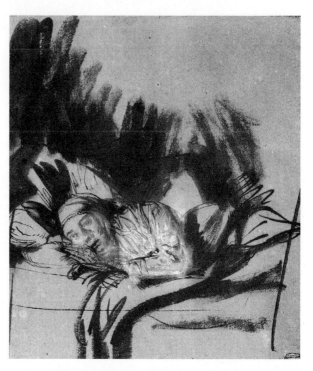

Figure 1.2 REMBRANDT, *Saskia Ill in Bed (1635),* pen and ink wash, 16.3 × 14.5 in.

lary of drawing, and broke down divisions between drawing, painting, and sculpture (Figure 10.26). For the first time, drawing was created and displayed as a fully-fledged **final art medium.**

The art of today has brought this independent status of drawing to the forefront of the art world on a new level of ambition and innovation. Drawings can be enormous and richly textured, intended as complete artistic statements. The format and vocabulary of drawing have been extended into room-filling environments, with the addition of found objects and printed materials, or reconstituted as film or computer animations.

With all these changes, drawing as an art form is principally understood to have an essential quality of directness and transparency: Its great strength is the clarity and simplicity through which the viewer can grasp the artist's actions, ideas, or emotions. Art today centers on the importance of individual expression and originality, and drawing, by means of its flexibility of form and directness of execution, is ideally suited to convey an artist's touch and thought to the viewer.

Expression, Technique, and "Genius"

Returning to the subject of the education of an artist, you might ask how the character of fine art drawing just described would determine what you can expect to learn in drawing class. For the applied artist, the accumulation of skills has an obvious benefit. A given job might call for subject matter of a specific nature to be drawn effectively, requiring certain techniques or conceptual principles. In the case of the fine artist, however, it could seem at first that a set of principles, rules, or techniques or even the classroom environment itself could compromise free personal expression.

With its stated belief in freedom, the importance of individual experience, and diversity of viewpoint, our society holds in high regard the unique voice of the innovator and the independent thinker. Leon Golub is a fiercely independent contemporary artist, using drawing as direct political commentary to expose injustice, hypocrisy, and corruption in harrowing, often violent, images **(Figure 1.3)**. Individuals from the history of art who are most highly esteemed are those who broke new ground but were often misunderstood or underappreciated during their own lifetimes. We think of them as solitary, courageous geniuses, possibly listening to a "muse" the rest of us cannot hear.

Actually, we all have a muse somewhere within. One of the most important functions of art education is to strengthen your own access to your innate creative instincts—your muse. Learning how to trust and respect your own ideas, to interpret your reactions to your work and the work of others, to be aware of the range of creative options available to you and how they might fit in with your personality, the experience of your life, and other factors that might determine your artistic interest represent the most important goals of the study of art.

On the other hand, most art, including that made by "geniuses," is based on a series of cultural precedents and an edifice of understanding built over time. Drawing is unique among art forms in its simplicity and directness, but it too has traditions of method and concept that have

Figure 1.3 LEON GOLUB

increased the range of its expressive possibilities. These traditions and techniques constitute the core of drawing instruction not as requirements, but as opportunities for subtler, more complex, and more specific artistic statements. Gaining an understanding of the principles of drawing is more likely to clarify and give force to your personal expressive statements than to inhibit them.

Art and Communication

In addition to opening new worlds for the artist, the study of drawing can clarify the function of art as a communicative vehicle. An excerpt from the studio notes of Marlene Dumas suggests the depth of her consideration of the meaning and purpose of her actions as an artist **(Figure 1.4)**. While we value art as an outlet or exploration of personal feeling and thought, drawing can also record our experience and ideas for appreciation by our contemporaries or those who follow us in time. Connection with the art of others and the anticipation of the contact that other people might have with the works we produce can be enormously satisfying,

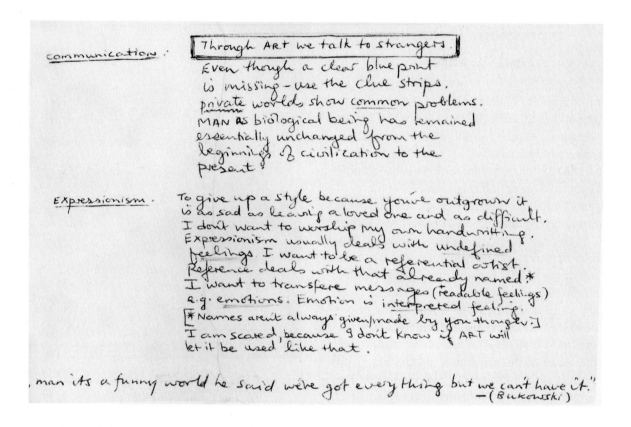

communication :

┌─────────────────────────────────┐
│ Through ART we talk to strangers.│
└─────────────────────────────────┘
Even though a clear blueprint
is missing - use the clue strips.
private worlds show common problems.
MAN as biological being has remained
essentially unchanged from the
beginnings of civilization to the
present.

Expressionism.

To give up a style because you've outgrown it
is as sad as leaving a loved one and as difficult.
I don't want to worship my own handwriting.
Expressionism usually deals with undefined
feelings. I want to be a referential artist.
Reference deals with that already named *
I want to transfere messages (readable feelings)
e.g. emotions. Emotion is interpreted feeling.
[* Names aren't always given/made by you though.]
I am scared, because I don't know if ART will
let it be used like that.

, man its a funny world he said we've got every thing but we can't have it."
— (Bukowski)

Figure 1.4 MARLENE DUMAS, journal entry

breaking down the isolation of the individual in the world. Applied art such as illustration or graphic design has a requirement to communicate effectively, but all art is really about communication—first with ourselves as we listen to our instincts, thoughts, and memories in the act of creation, and later with others as they experience the artistic record we have produced.

The study of drawing is an opportunity to refine our understanding of the agents of visual communication and the reactions we might expect from other people to various aspects of our work. The public forum might be painful at first; it can be difficult to accept others' misinterpretation of something that we have worked hard on or that has a sensitive personal dimension. Furthermore, the idea of adjusting our work in relation to the opinions of others might seem to violate the ethic of individuality of expression.

Few of us, however, begin to draw knowing exactly what we want to do or how to do it. Participating in a drawing class and trying to be as open as possible to what others are doing and thinking can in fact be a very effective part of a person's drawing process. We are always free to reject the opinions of others if they clash with something we truly believe in, but it is wise to fully understand what they are saying before we decide. The seed of a new approach or idea may be contained in a seemingly negative comment that will ultimately allow us to come closer to what we really want to say in our work.

Just as some artists work more instinctively and some more deductively, teachers structure their drawing classes with many different approaches. One may be intuitive and expressive and give open-ended assignments, while others are more structured, focusing on specific goals and intentions. You might feel more comfortable with a certain approach but could actually learn more—or "stretch" more—from teachers to whom you are not immediately attuned. Anything you try that seems new and different will benefit and make stronger what you already know and are comfortable with.

ISSUES AND IDEAS

❏ The essence of art is expression—transforming ideas, experience, and thoughts into an art form.

❏ Fine art is artwork created for its own sake. Applied art is artwork created for an outside, often commercial, purpose.

❏ Through artistic expression, we can communicate thoughts and feelings to others.

❏ Part of the learning process in art involves openness to the ideas and insights others have about our work and practice in forming ideas about the work of other artists.

THE GROUP CRITIQUE

Forming an Opinion

One of the most important opportunities for the exchange of ideas in drawing class is the group critique. The term "critique" might suggest an emphasis on negative criticism, but the point is to identify positive qualities and possibilities in a drawing as much as aspects that need improvement. Group critiques can take many forms, from short, informal discussion of classroom work in progress **(Figure 1.5)** to extended reviews of finished projects conducted in an exhibition-like setting. Their common feature is that *everyone* is expected to look hard at the work presented and

Figure 1.5 Critique in progress

verbalize their feelings and thoughts about it. This is distinct from a review in which the instructor does all the talking. Certainly, your teacher can be expected to take the lead in proposing specific lines of discussion for the critique or in making sure the talk stays on track. The most important necessity for this particular exercise however, is for you, the student, to be involved as completely as possible.

A common misconception is that the chief point of a critique is to pass judgment on the work presented. There could be some value or fairness in acknowledging that someone put in a great deal of effort on an assignment or accomplished something very skillfully. The real point, however, is to dig deeper, to gain an understanding of *why* a drawing is powerful or moving in some way, or to suggest stronger emphasis of a given quality.

Instead of simply saying, "I like (or don't like) this drawing," try to ask yourself why. The critique process should be one of analyzing your ideas, thoughts, and feelings, clarifying and giving depth to your response.

One of the wonderful things about drawing as an art form is the way in which many different interpretations of a given piece can coexist as appropriate responses to the work. Personal associations of shape, varying response to mark or texture, diverse connections with outside cultural precedents or individual experience can all affect the way a work is perceived by a viewer. It is impossible for any artist to understand all these factors at once while focusing on his or her own conceptual and expressive goals. Still, if you accept that art is at least partially about communication, you must

broaden your understanding about the varied experiences that others will bring to a work of art that you create. Critique is an excellent time to hear about the effect that your work is having on other people.

The first thing you may notice before the critique even begins is that your drawing looks different on the wall in front of the class than it did in your workspace. The classroom studio is most likely larger and brighter, and your drawing will probably seem much smaller and could lose the intensity of contrast it seemed to have when you were working on it. You can anticipate or counteract this effect while you work by looking at your drawing-in-progress under different light: in the hallway or even outside.

The most important change in your sense of the drawing in the classroom, however, will probably be due to the sudden comparison with the work of other students in the class and the awareness that other people are looking at your creation. This is a fascinating, if daunting, effect and could allow you to see your work in a new way even before the talking begins. Make a few notes on your first reaction, both weaknesses and strengths. It will be interesting to compare these notes with the comments of others as the critique progresses and to have these quick insights at your disposal when you get back to your own studio.

Responding to the Work of Others

As the critique begins, it is just as important to concentrate on understanding and expressing your reaction to the works of others as it is to hear their response to your work. This goes beyond simple fairness or giving everyone in the class his or her time in the "spotlight." Being vocal in critiques in a thoughtful way is actually something that you are doing *for your own good;* one of the best ways to develop a firmer understanding of drawing as an art form is to analyze other people's work.

It is difficult for anyone to be objective about his or her own drawings. Often you have spent so much time wrestling with one aspect of a given work that the overall effect has drifted from your thoughts. Perhaps you have personal knowledge of some aspect of the subject matter that is affecting the way you think about the piece, but it is not apparent to others.

In any case, it is much easier to *objectively* respond to someone else's drawing and so come to understand how certain structures or marks could be perceived if you were to use them in your own work. Critiquing the work of others is a way to assemble a vocabulary of visual possibilities for your own use and to practice visual analysis so that you can more effectively make decisions while you are at work.

Practicing Directed Looking

The first step in a critical analysis of a drawing is, of course, to look. Sometimes the artist mentions some things about the conditions of creation of the piece such as aspects of the subject matter or the reasoning behind the choice of media or format. Other times during a critique, the class will simply confront the work on the wall, letting the drawing "speak" for itself. In any case, when the time comes to actually respond to the work, you should practice **directed looking.** This simply means concentrating on absorbing the visual impact of the piece. Everyone in the class will have a slightly different approach or angle of entry into the work, and this difference is entirely positive. Varying points of view are in fact the point of the critique, and no one should be nervous about seeing the piece "wrongly." There is not really a wrong way to see.

Instead, the goal is for you to open yourself to your own feelings and reactions as you look at the work. You may have to force yourself a bit. Perhaps you find the work initially uninteresting. This, in itself, is an important aspect of your reaction because one of the principal functions of artwork is to interest a potential viewer. Still, addressing a work in critique is different than looking at art in the outside world; you are all there to help one another. You should give the work a while to sink in. Try to gauge what the artist's intentions were. If the artist gives an introduction to the piece, factor those remarks against what you see going on in the work.

The most difficult part of directed looking is understanding your own reactions. The best way is to start simply: What do you see in the drawing, or more particularly, what do you notice? Visual emphasis is one of the most important aspects of drawing and art in general. Because multiple qualities often coexist within a work of art, emphasizing a certain aspect of the drawing is usually important in clarifying the point of the image. In the end, the most noticeable quality of the artwork should have a strong relationship to the point of the piece.

Ultimately you should compare the stated intentions of the artist with your first impressions to gauge the effectiveness of the work. The process of directed looking could be divided into three steps. You can go through these steps when you first sit down in front of the work, before discussion begins.

1. Immediate impact: How does the work strike you visually? What seem to be the artist's priorities based on the choices of mark, medium, subject, and composition?
2. Evidence of stated purpose: Based on your knowledge of the assignment, or the stated priorities of the artist, can you begin to follow a line of thought or find a sense of purpose in the piece?
3. Analysis of particulars: If you have found a clear expressive direction in the work, how do the various choices made by the artist support or detract from this direction.

Some visual qualities that could dominate your first reaction include these:

Shape character or arrangement
Movement of your eye through the composition
Graphic pattern
Depth or spatial illusion
Illusion of solid form and surface
Light situation or atmosphere
Color or tonal usage
Texture of the surface, use of materials
Compositional balance or imbalance
Overall mood: quiet or aggressive
Point of view

In addition, you might have an immediate reaction to the subject matter or imagery. Aspects of your reaction might include the following:

Associations of personal memory or familiarity
Associations of culture: references or echoes from art history or popular culture
Reactions to the meaning of gestures or facial expressions
Psychological implications of point of view or compositional placement
Narrative implied by figures, spaces, or abstract relationships of form
Free associations or unexplainable reactions
Connection with previous work by the artist or someone else in the class
A sense of the artist's process, spontaneous or planned

We will explore all these factors for drawing in greater depth in later chapters of this book.

ISSUES AND IDEAS

❏ Critique is a discussion in which participants compare their reactions to the artwork presented in order to clarify its meaning or expressive impact.

❏ Forming a thoughtful opinion about the work of others can give you excellent insight into issues in your own work.

❏ Directed looking means analyzing your reactions to a drawing in relation to the artist's intentions and specific qualities that are present in the work.

Verbalizing

Once the class has "taken in" the work for a while, someone, often the instructor, starts the discussion. Perhaps the instructor would like the critique to center on a particular theme or issue in relation to the drawing at hand. You can compare your first reactions to the work with this theme or with the remarks made by others as they come up. At this point, you should begin to practice verbalizing your thoughts.

Verbal thought is a particular characteristic of human beings. Certainly everyone also has nonverbal thoughts, but the particular advantage of verbal thought is that it is a bit more definite, recordable, and communicable. You could find that trying to clearly verbalize the thoughts you have about a drawing helps you to understand the actual nature of your initial, visually based reactions. This should be a multistep process. First, try to think of some terms that might help you characterize an aspect of your reaction to the work (see the following section Using Specialized Vocabulary) and weave them into sentence form. Repeat the sentence to yourself silently and "listen" to it; try to assess the effectiveness with which it conveys your feelings. It is usually most productive to frame your ideas in a positive manner. Even if your reaction to the drawing has to do with a certain weakness, try to address it in terms of a potential quality that could be improved.

When you are ready, raise your hand and speak. The first few times you do this can be embarrassing, but it will get easier. Remember that no one is so convinced of the rightness of his or her own opinions to feel completely sure that yours are wrong.

It is important to track the reactions to your comment from the other participants. If you are contradicted, try to understand the point the other person is making and compare it with your own thinking. If other members of the class pick up your idea and elaborate on it or confirm it, this can add to your confidence in analyzing future works. The point is to build a web of communication between the drawing on the wall, your comments, and the comments of others that will ultimately solidify your own ability to understand the way in which works of art can function.

Extending the Thread of Discussion

You should feel comfortable with the idea of expressing almost any opinion or feeling during the critique. Your class discussions can have a particular character based on the teacher's approach, but it could also be interesting for you to raise issues or ideas you are learning in other courses: history, literature; three-dimensional design, science, or math. However, because the critique usually has a time limit and some dominant theme in relation to the assignment or topic of the day, you should remember that everyone else is following a particular line of thought in relation to the work on the wall. Your comments should extend that line of thinking or adjust it rather than coming from a completely irrelevant angle. If you feel strongly that the discussion is ignoring something important about the piece, then by all means say so.

Do not worry or be intimidated by students with more experience in drawing or verbalization than you have; learn from them. You can advance your own knowledge and abilities most quickly by absorbing and analyzing the ideas and approaches of your peers.

Using Specialized Vocabulary

The most important qualities your remarks in critique can have are clarity and sincerity. If you are honest about what you are seeing in the work and organize your words simply, they will be of greater help to the student who did the drawing.

Often, however, aspects of your reaction to a given piece will be difficult to explain in everyday language. Art criticism has a specialized vocabulary that has developed and changed over the years to facilitate discussion and understanding. Knowledge of these phrases and the concepts behind them can expand your understanding of the components of art and make your comments more comprehensible to others.

Of course, it is important to truly grasp the meaning of a phrase before you use it rather than just repeating something you have heard. Do not hesitate to question a word used by another stu-

dent or your instructor. A definition understood in common by all members of the class will help the effectiveness of the critique.

This book includes a glossary consisting of words, phrases, and concepts that are particularly relevant to different components of drawing. Bold words in each chapter are listed in this glossary. As you read, study these terms in relation to the illustrations in the text, the concept presented, and the exercises and assignments. Art vocabulary has varying levels of complexity, including words borrowed from other languages. It is not really important to use words for their own sake, but for the simplicity and clarity of reference they provide. It is best to rely on words you feel comfortable with rather than adopting a particular jargon to attain an air of sophistication. Remember that the guiding principle should be honesty and clear expression of your feelings and observations.

A brief list of general terms with some synonymous variations follows. You can also make your own list in your sketchbook from new words you encounter in discussions or in readings.

Abstract: Removed from incidental reality. Abstract thought involves general concepts; abstract form is simplified or distilled from real-world objects; abstraction can also be based on specific principles such as geometry.

Aesthetic: Having to do with appreciation of beauty or other sensual visual qualities.

Arbitrary: Based on free choice, unconnected with any restrictions; capricious.

Composition: The arrangement of shapes and lines on the page (two-dimensional composition) or, in drawing, of implied three-dimensional of forms in space (in drawing, implied three-dimensional composition); also a drawing or image as in "a narrative composition."

Conceptual: Having to do with a governing idea or philosophy.

Drawing: The art form primarily concerned with marks on paper; also the organization of mark, edge, and form as they might occur in painting or other art forms, as in "this painting has drawing problems."

Dynamism: Energy; a sense of directed compositional movement; emotional or creative excitement (adjective: dynamic).

Element: A unit of form, such as a mark, shape, line; a basic aspect of approach, as in a narrative element.

Focus: Emphasis; the quality of being organized around a goal or sense of purpose; also a quality of sharpness of definition (or blurriness in "soft" focus).

Form: An element, graphic or with implied physicality, as in "solid form"; the quality inherent in a form, as in "the sense of form."

Formal: Having to do with the character or relationships of form as a chief priority, as in "this composition has a formal clarity."

Formalism: A school of aesthetic theory placing the highest priority on relationships of basic form.

Format: The dimensions of the picture plane or another overall aspect of an artwork; the means of presentation or basic medium of an artwork.

Gesture: A mark made with energy and direction; the quality of movement or direction in a whole composition or in a figure; also an artistic statement, usually bold, forceful, or especially public.

Graphic: Pertaining to flat shape, line, and two-dimensional composition; also means vivid or hyperclear.

Loose: Open, unresolved; can be positive (free, dynamic) or negative (sloppy, unclear).

Medium: The specific materials of an artwork or art form such as graphite, ink, or charcoal.

Objective reaction: Emotionally distanced reaction; matter-of-fact or reasoned analysis.

Open up: To stretch out, aerate, or free up; back away from resolution; move toward implication rather than definition; extend outward as in "the looseness of mark opens up the composition on the left."

Picture plane: The flat or two-dimensional surface of a drawing; the conceptual two-dimensional field; the imaginary "glass"

through which we perceive space in an illusionistic drawing.

Realism: A quality or expressive priority pertaining to the everyday world; in drawing, often used to refer to illusionistic qualities of solid form, textural surface, space, and light.

Relationship: The interconnection of elements within a picture or on the picture plane.

Resolve: To define, finish, balance, or clarify as in "the composition is resolved by this adjustment of relationships"; focused, as in "highly resolved detail" (noun: resolution).

Stasis: Lack of movement, deadness, heaviness (adjective: static).

Subjective reaction: Intuitive or emotional response based on personal knowledge or associations.

Tension: Dynamic opposition or balance between unlike or separate elements; a principle of dynamic composition.

Tight: Highly resolved: can be positive (clear) or negative (static).

Trompe l'oeil: French for "fool the eye," refers to a complete realistic illusion.

Unity (of an artwork): Expressive coherence or clarity; wholeness; a unified artwork "works well as a whole"; Gestalt (a German word referring to a whole greater than the sum of its parts).

Weight: Significance or emphasis as in "a composition weighted to the left"; also the quality or implication of heaviness in form or of thickness in line as in "line weight."

ISSUES AND IDEAS

❏ Verbalizing your thoughts, in your own mind or aloud to others, can clarify your immediate reactions to the work in a critique.

❏ A good critique often features a thread of discussion or line of thought about the work on the wall, but diverse comments are also important. Honesty and sincerity are of greatest importance.

❏ A working knowledge of terms specific to the discussion of art can greatly aid your ability to communicate your feelings to others in critique.

Responding to Criticism of Your Work

Although the larger part of a critique will most likely consist of discussing the work of other people, you will certainly be most concerned when your turn comes around. It is natural to be wary of criticism directed at your work. If you have truly devoted yourself to the task of creative expression, the resulting drawing will have more than a little bit of yourself in it. A public discussion of its deficiencies or even of its merits can be embarrassing or even annoying. Remember that it is the drawing that is being discussed, not you. Try to create a lit-

tle distance between yourself and the work, difficult though it may be.

Looking at your own work in a critique is a vital step in moving it toward full realization as art. The best spirit in which to accept criticism is as a practical acknowledgement of the link between appreciation of an artwork by others and its full existence as a communicative work.

Talking and Listening

Oddly enough, the least important time to talk during critique could be when your own drawing is

the subject of discussion. You might be asked to give a brief overview of your goals or process, but it is best to keep your remarks fairly brief; the class should be responding as directly as possible to the experience of looking at the work. If you feel, after a few minutes, that something is missing from the group's understanding of your intentions, it could be appropriate to explain what you were trying to do, especially if you did not introduce the piece in the beginning. Do not make excuses or be overly defensive. You want the rest of the students to concentrate on what they are seeing on the paper rather than on what you are saying.

The way to make the best use of this process is often just to listen. After all, you have already put a great deal into the discussion—the drawing itself. Pay attention to all comments; sometimes the most interesting or relevant remarks come from quiet members of the class. In some ways, it is best for you to fade into the background a bit. Do not cut people off with an immediate, unconsidered, or defensive response. It is in your best interest to encourage everyone to be open and honest in his or her remarks. You should not interpret anything as a personal judgment, but as a potentially useful insight. Defensiveness is counterproductive and suggests immaturity.

Try not to make any disclaimers, such as "I was bored doing this drawing." A comment like this—however much it might seem to lessen your responsibility for anything wrong with the work—will make the rest of the class feel foolish for taking the work seriously and immediately derail the discussion. The drawing could be more effective than you think it is, and you can gain new insight from the unexpected appreciation of the class. Remember that there will be aspects of drawing that will be new to you throughout your time in the class. You could very well find new, completely legitimate ways to look at your own drawings and entirely new criteria for defining a successful image. The best outcome of a critique of your work is to help you step beyond what you already know and are comfortable with. This is how you will truly learn and grow.

Taking Notes

Taking notes throughout a critique is an excellent idea and not only when your own work is the subject of discussion. It is easy to forget what was said in a critique, and jotting down a few brief keywords can help you recall an important point later. If you note the speaker of each comment, you can even continue the discussion with them after class. Similarly, the names of relevant artists, art movements, or other cultural references could come up in the critique, particularly in the instructor's remarks. It can be enormously helpful to do follow-up research later in the library, or online, to connect with professional work that could ease your access to qualities you are seeking in your work, or ideas that will expand or deepen your understanding.

ISSUES AND IDEAS

❐ You should not take discussion of your drawing in a critique as personal criticism.

❐ When your drawing is under discussion, your goal should be to gain new insights about it.

❐ Limit your own comments to those that could help the class understand what you were trying to achieve. Do not make excuses or negative assessments of your own efforts.

❐ Keep track of the comments offered by others, and review them later while reassessing your work.

SELF-CRITIQUE AND THE WORKING PROCESS

Judgment of Your Work in Progress

The ultimate goal of the critique is to teach you to be able to make judgments about your own work in the midst of working. Some basic habits and procedures can help. Whenever you are drawing, you should step back every few minutes to look at the image on your paper from a distance. As you look back at the drawing from a few feet away (or farther for larger drawings), try to take in the effect of the whole piece. Let your eye wander around the page directed by the visual effects of line, tone, and shape, comparing form and space. Be especially aware of marks that seem out of place or assertive in a way that you had not intended. It can be helpful to have a simple verbal characterization of the overall interest of your composition that you can repeat to yourself at this point (for example, "confrontational power" or "delicate rhythm"). Is the drawing meeting this goal? Is there something interfering with the effect that you want?

Perhaps a part of the drawing seems just right. This is the most important thing of all! Remember the effectiveness of this area and try to preserve it. You might also use it as an inspiration for the improvement or development of the other areas.

It could seem that this process of analysis would disrupt your workflow or interfere with the inspired transmission of energy from your mind to the page. Certainly, as long as things are going well, you should "surf" the wave of your inspiration stay connected with your drawing **(Figure 1.6)**. Simply do a mental check every minute or two to make sure that you are clear about what you are doing and why. If you suddenly feel unsure or stuck, you should *stop drawing*, take a step back, and look for a minute. Try to reconnect with the energy of the drawing as evidenced on the page. Run through your thinking on the focus or goals you have for the work.

Figure 1.6 Work in progress

If you feel confused, it could be that you have not done anything wrong, but it is time to make a decision about how you want the drawing to proceed from this point forward. This could take a bit of consideration. It is not a bad idea to take a short break for a drink of water or to take the drawing off the easel and look at it from a longer distance or in a different light. Trying to assess various options that are open to you, and deciding to push in one direction or another are where the skills of analysis that you hone during the group critique process will do you the most good.

You do not need to decide everything at once; trial and error always has a place in the working process. If you clarify your ideas enough to get a new spark started, that is usually good enough reason to get back to work and see where the new thread leads you. If you still have nagging uncertainty, try doing some small sketches of the subject on a new piece of paper to work out different possibilities.

All artists develop their working habits and analytical abilities throughout their career **(Figure 1.7)**. Your understanding of visual qualities and expressive possibilities will continue to increase every time you encounter new work by others. Your view of your own priorities in drawing and your methods for reaching them will also change and mature. Ultimately, you can come to a clear sense of your work in relation to the spectrum of artistic expression: an artistic identity. The work you do now is an important step toward that goal.

ISSUES AND IDEAS

❏ The most important goal of both drawing class and critique is to teach you to judge your own work as you create it.

❏ It is important to step back and try to see your drawing-in-progress objectively.

❏ All artists develop personal work habits that allow them to enhance their progress toward their own goals. These techniques can include adjustments to the pace or scale of work, and cultivating new thoughts or insights based on outside stimulus or distance.

❏ As you increase your understanding of your work and your own goals for it, you will be taking steps toward establishing an identity for yourself as an artist.

Figure 1.7 MARLENE DUMAS, in her studio

BEGINNING BY SKETCHING: DEVELOPING A HABIT

The drawing experience begins with the development of a habit—that of drawing in a sketchbook. Many artists use sketchbooks, and it is not too soon for you to develop this habit and discover just how a sketchbook might be most useful to you.

Think of a sketchbook as a way for you to have your art with you and to be engaged with the visual world around you at all times. It is important for you to take your sketchbook with you wherever you go. You must take it seriously and devote time and attention to its use, from quick sketching to fully developed studies. You need not plan or wait for an extended period of free time to draw; two minutes is enough to develop a meaningful image or page of notations in your book. This can be done while riding on a bus, sitting in a coffee shop, waiting for class to begin, or before you get out of bed in the morning.

Pop artist Wayne Thiebaud lives and works in California. His work is about the everyday scene—rows of bakery goods, landscape, portraits—and ideas for his work are all around him **(Figure 1.8)**. Thiebaud, who has kept sketchbooks since he was 18, said, "I actually can't think of any place I haven't taken a sketchbook: to hospitals, churches, on steam-ships, airlines, even to the tennis court. Sometimes they're sketches in different countries, sometimes in museums, sometimes at athletic events, in the car, at concerts, from television, or during lectures, so I have a kind of all-inclusive journal and notational diary."

You can fill your sketchbook with drawings of objects, interiors, people, self-portraits, quick sketches accompanied by written descriptions, imagined situations, copies of artworks in galleries or museums, experimentation with media, compositional ideas, conceptual brainstorming, notes from class critiques, notes on slide images from

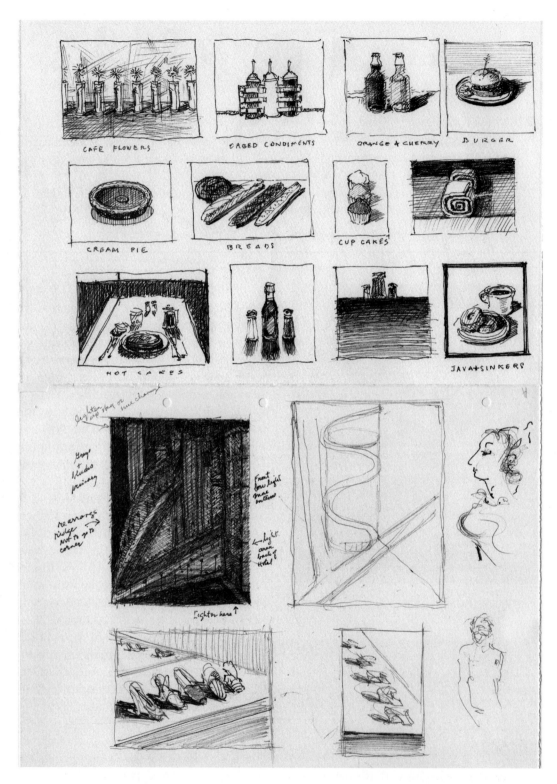

Figure 1.8 WAYNE THIEBAUD, sketchbook drawings (Wayne Thiebaud, Café Flowers, Caged Condiments, Cupcakes Java and Sinkers, and Other Food, ca. 1995 / Wayne Thiebaud, artist, sketch: 1 p.; 28 × 38 cm. Courtesy of the Wayne Thiebaud papers, 1944 © 2001, Archives of American Art, Smithsonian Institution. © 2009 Wayne Thiebaud/Licensed by Vaga, NY

class, doodling, playing—and on and on. Your sketchbook is your personal journal of visual ideas, images, and thoughts. You do the work in your sketchbook for yourself. You do not need to concern yourself with presenting it to the class. Your teacher may want to review it but will let you know if that is the plan. As you begin to take a sketchbook with you wherever you go, you will come to record your visual and verbal thoughts, interpretations and observations on a routine basis.

Finnish architect Aalvar Aalto drew constantly in sketchbooks as he traveled. He felt that the drawings he did from architecture around the world and from nature played a critical role in his work as an architect. These drawings became personal, inward moments for him beyond mere notations. Goran Schildt wrote of Aalto's sketches **(Figure 1.9)** that they "filter clearly per-

ceived separate entities through the unconscious so that a viable synthesis arises. . . . Aalto trains his eye for the complicated interaction of visual forms. The goal is not to create artistic sketches . . . but to train the sensibilities." Training your sensibilities is important; just as a musician practices scales, artists must look, observe, and record their responses to their world on a consistent basis.

To begin, just draw: record, sketch, doodle, play and jot down ideas. Juxtapose images that come into your mind whether they seem to make sense or not. Soon your book will become very important and precious to you; it will develop a worn patina, and you will come to depend on it. Just be sure not to lose it. Wayne Thiebaud relates that artist Georges Braque lost his sketchbook and said, "It's like I've lost my brains."

Beginning with the following extended sketchbook assignments, each of the chapters in this book has suggestions for specific sketchbook exercises, but you should add your own drawings and observations. Never feel limited when working in your sketchbook; the goal is for you to work out the best way for you as an individual artist to use it as a resource. Trying different approaches will help you find your way. We will return to the subject of sketchbooks in Chapter 11 where we look at various artists' sketchbook work in more depth. By then you will be well along the way toward a sketchbook approach that works for you.

Figure 1.9 AALVAR AALTO, sketchbook drawing

ISSUES AND IDEAS

❒ Take your sketchbook everywhere to develop the habit of using it everyday.

❒ Develop a range of drawings from quick sketches to more developed drawings.

❒ Use your sketchbook as a personal journal of verbal and visual ideas and observations.

Sketchbook Exercise 1.1: An Overall Visual Chronicle of Your Week

For one full week, record with drawings and words your experience every half hour of your awake time. Fill at least one page of your book each half hour. If you are in geometry class for one hour and the teacher would consider it rude of you to draw during class, go to class early, draw before class, and stay late to draw again. In other words, if there is a half hour you cannot record, you need to make up that time slot. At the end of each day, you will have a minimum of 30 pages filled. Your goal is to be visually engaged with your world at all times. You can draw what you observe, what you are thinking, what you are imagining, your dreams, and so on. Be certain to carry your book with you everywhere you go: to class, meals, the library, on the phone, the store, the bathroom, a car, church, bed—wherever you go, it goes too. The drawings can be quick or developed. The important thing is to be aware of where you are and what you are thinking and respond to what you are doing and what you see. Get it down visually. Do not worry what the drawings look like or fuss over them. You are beginning to develop a habit, and your skill will develop as you go.

Sketchbook Exercise 1.2: An In-Depth Visual Chronicle of a Daily Walk

Now that you have chronicled a week of your life, you need to hone in on something more specific and find more nuances within it. Choose a route that you walk every day. It can be walking from your dorm room to the library, from your apartment to your coffee shop or newspaper store or with your dog. Choose some route that you are familiar with and that takes you from five to ten minutes to accomplish. On three different days this week, walk this route, but take one hour instead of five to ten minutes. You will be pausing along the way a number of times to record something about the route that is of interest to you. Continue walking and pause again to draw, and again and again. Force yourself to take one hour even if it means that at the end of the walk you have drawn every

inch. Some drawings could be of something you have never seen before, that you have passed unnoticed numerous times. Some drawings can be indoors, some outdoors. Note landmarks along the way as well as small details. Some drawings can be panoramic, others tiny details blown up in scale. Note the weather; draw in the rain if that is what is happening. Try to increase your awareness of the visual reality of your everyday world to access it for your artwork. You will be pausing to draw every few yards, spending time in places you normally pass very quickly. By drawing them, you will come to know them more intimately and see things you have never noticed, getting beyond the virtual world and accessing the real world. This real world may be bucolic and beautiful or gritty and grimy, but it is important in any case to be aware and to get yourself beyond the obvious and superficial. Heighten your senses as though you are looking for clues. Scrutinize your route. You will do drawings on the same walk three different days; it is fine to vary the spots where you pause or to revisit the same ones each day.

Sketchbook Exercise 1.3: A Visual Chronicle of One Interior Space

Stay in one room for three hours and develop numerous sketches of the space. You will be drawing nonstop the entire three hours. Do not leave the room, do not stop drawing, do not answer the phone, do not have the TV on. You will want to do some drawings of large areas of the room and others of details of objects in the room. As in the previous assignment, the goal is to become visually aware of your surroundings by really looking and exploring with drawing. You can work in your own room, a kitchen, a room in the library, a store, and so on. Change the pace of the drawings from quick sketch to more developed compositional study. Look for relationships of furniture, architectural details—anything that gives character, feeling, or atmosphere to the space. Again, try to notice things you have never seen and heighten your experience of the space and place by drawing them over and over. Change medium and experiment. You should try to fill a minimum of 30 pages.

Contemporary Artist Profile
JULIAN HATTON

Julian Hatton **(Figure 1.10)** works in tiny sketchbooks (3.5 by 5 inches) with colored pencil, sitting in the fields that surround his home in the countryside of New York. During a day spent on-site in nature, he will produce perhaps 75 small drawings in intimate visual communion with the woods, meadows, ponds, and clouds **(Figure 1.11)**. His response is a mixture of observation and invention; the images shift between naturalistic form and a private vocabulary of associative abstraction. Hatton often remakes the landscape space into imaginative constructions of line and shape, and his colored pencils allow the immediate integration of color into the simplest line drawing. The medium's somewhat limited range of darker values suits the artist's style; the paintings that grow out of these sketches feature a luminous middle-toned palette, with a sense of playful, joyous

Figure 1.10 JULIAN HATTON, at work

engagement. The perfect portability of pencils and minisketchbooks means that Hatton can go anywhere to draw, leaving no trace on the environment. He has adapted his approach to suit the medium: immediate response with no erasure and a light touch that takes advantage of pencils' thin, variable mark, delicate textures, and color.

Figure 1.11 JULIAN HATTON, sketchbook pages (2005), various sizes

Materials, Procedures, and Concepts 2

MATERIALS AND TOOLS

Part of learning about drawing is becoming familiar with drawing materials. Some materials have become standard for drawing, especially for introductory drawing classes, because of their characteristics in relation to specific desirable qualities in drawing. Charcoal, for example, is probably the most common drawing material in classroom application because of its breadth, workability, and response to touch. As a **final medium** for drawing, however it can be troublesome because of these same qualities: It tends to rub away too easily.

The most important rule of thumb for choosing a material in drawing is to get the right tool for the job. First, you must become familiar with the basic features of as many different materials as possible, considering how they erase, the range of tone they can produce, and how they interact with the paper or other materials. It is a good idea to experiment with any instrument that you become aware of. You may find that the "feel" of one very specific tool is just right for you. Ideally, you can come to understand the natural actions of a given material so that you will be able to use its particular qualities letting the material "speak" or work for you.

This is certainly true of the brush study of an owl by Josef Albers in **Figure 2.1**. The soft, complex strokes evoke the texture of the feathers at the same time the dynamic lines suggest the animal's life and character. Maximum expression is accomplished with a minimum of effort.

Emphasis and *sensitivity* are two qualities to keep in mind when you are experimenting with a given tool. Emphasis in a composition can be created with a strong note or powerful mark, and some materials are more suitable than others for bold effects. Conversely, other materials have a greater sensitivity of response in creating subtle lines or tones. In **dry media**, pressure is the principal means of modulating intensity of mark. Strong pressure will create emphasis and light pressure will permit greater sensitivity. **Wet media** are usually softened by dilution and strengthened by purity or

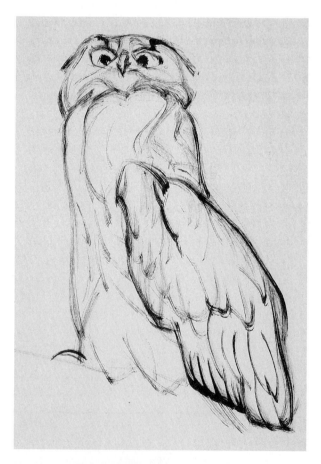

Figure 2.1 JOSEF ALBERS, detail from *Two Owls* (ca. 1917), ink in paper, 19 7/8 × 28 1/2 in. © 2009 The Josef and Anni Albers Foundation/Artist Rights Society (ARS) NY.

layering. Thickness or thinness of stroke is also a decisive characteristic of different drawing media.

Always have a good range of drawing tools with you when you come to class; you never know what you will need, and being prepared will save you time. A basic list of drawing materials includes, but is not necessarily limited to, **conte crayons** (in a range of browns, reds, white, and black), compressed charcoal, vine charcoal (thin and thick sticks), charcoal pencils, graphite pencils, and woodless pencils. You should have each of these in a range of medium hard to very soft. Also include sumi ink, ink brushes and pens, small water containers, kneaded erasers and hard erasers such as white Staedtler Mars, or Pink Pearl. Appendix A discusses these and other materials in more detail.

Paper

Paper is a vital component in the visual effect of media. The **tooth** or roughness of a paper's surface is something you will become particular about in relation to your needs for a given drawing or drawing medium. In the case of wet media, absorbency is also crucial; with dry media, the paper's ability to stand up to erasure and reworking is very important to consider. You must test many of these qualities through experience, and if you find the perfect paper for a given purpose, stick with it. You can determine a great deal about a particular type of paper through touch, and it is no sin to use your fingers in the art store to determine the tooth and tactile character of a paper. Many art supply stores have sample books of their papers for this purpose.

Sketchbook Link: Media Experiments

Fill 15 pages of your sketchbook with media experiments. Try different wet and dry media alone or in combination. Paste swatches of other paper types into your book and work on them. The subject matter is irrelevant; you are simply trying to get a feel for different options in drawing materials. Ultimately, these pages can function as a materials reference.

An extensive list of various papers and their qualities appears in Appendix A.

Not all drawings are done on paper; the very earliest ones were done on rocks and the walls of caves. Today almost anything can serve as a surface for drawing, but paper continues to be the one most artists use and a practical choice for students.

Paper Size and Support

When working in a sketchbook or drawing pad under 11 by 17 inches, most artists are comfortable sitting down to work with the pad in their lap. If you are working on paper larger than around 40 by 60 inches, you will need to work on a wall. A good support wall should be smooth unless you intend to incorporate the texture of the wall into your drawing (see **frottage** in Chapter 10). As you try a range of sizes, you will find that the experience of a small, intimate 2-by-2-inch drawing can be rewarding and that an invigorating 9-by-9-foot

ISSUES AND IDEAS

❑ Drawing materials are responsive to touch. Their tactile qualities can help describe aspects of your subject.

❑ You can create emphasis by pressure (dry media) and layering or using wet media at full strength.

❑ A paper's tooth (texture) and absorbency dramatically affect the action of the drawing media on its surface.

drawing will give an entirely different experience. You should find the opportunity to work very large and very small. The choice of scale in drawing is tied to intention and idea as we discuss in several of the following chapters.

Most often in class, however, you will be working in a midrange from 18 by 24 inches to 40 by 60 inches. The best way to approach drawing at this scale, particularly when you are working from direct observation, is to stand at an easel.

The Easel

Most schools provide easels for drawing classes and it is important that you use yours appropriately. Many classrooms are used by more than one group, so you must check your easel each time you draw to make sure it will work well for you.

Your easel must be sturdy and have two adjustment points. The first adjustment is the angle of the vertical beam of the easel. This angle should be comfortable for you to work on; you do not want to lean in too far to reach your paper, so keep it fairly vertical, but not so vertical that your drawing board tips out toward you. Some easels have top pieces that clamp down on the drawing board, allowing greater forward tilt. The second adjustment point is the height of the horizontal tray that holds your drawing board. This tray should be adjusted up or down so that your eye level falls at about the midpoint of your paper and you can reach the top and bottom of your paper without having to bend over or stretch beyond your reach.

The Drawing Board

You must have an appropriate drawing board as support for your paper. The support must be of a size in scale to your paper: If your paper is 24 by 36 inches, then a board 28 by 40 inches would be fine. You must secure your paper firmly to the drawing board. If your paper is in a pad, several large clips will work to keep it in place on the board. A single sheet should be taped directly to the board on all sides. Masonite a quarter of an

inch thick is a good material for the board; it is not too bulky and is rigid enough up to a size of about 48 by 48 inches. A lighter but excellent alternative is half-inch thick foam core board. It is easier to carry around than masonite or wood, though not as durable. Rigidity is important because you will be applying pressure to the surface and do not want any "give" or floppiness. A drawing pad with a cardboard backing is definitely not sturdy enough to substitute for a board. A top crossbar that can secure the board from above adds to the board's stability. If your easel does not come with a tray with grooves or pegs to hold the drawing board in place, and the tray is wooden, use two pushpins at the lower corners to hold the drawing board firmly against the vertical beam **(see Figure 2.2)**. An unsteady or toppling drawing board will seriously interfere with your concentration. You should be

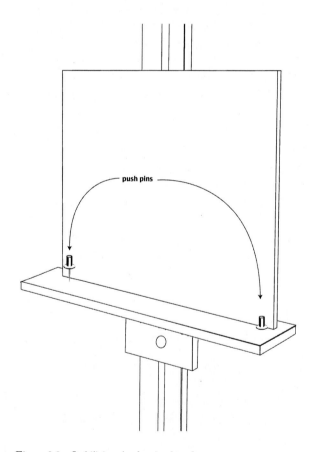

push pins

Figure 2.2 Stabilizing the drawing board

able to push hard on any part of your drawing with a minimum of shifting of the drawing board and easel.

Positioning Your Easel

When positioning the easel in class, be certain that you can see your paper and your subject without having to twist around. On the other hand, don't let your drawing board block your view. Your body needs to be at an angle to the subject so that you are looking either over your drawing arm and shoulder **(Figure 2.3a)** or over your non-drawing shoulder **(Figure 2.3b)**, whichever feels more comfortable. You will have to move your eyes and perhaps your head from subject to paper, but if you find yourself moving your whole body back in space or rotating around, you are not in a good position for drawing. Some people have their backs to their subject without even realizing it and if you look at the subject and then have to turn around to draw, you might actually forget some of what you have seen. You should be able to look and draw with as little shifting as possible.

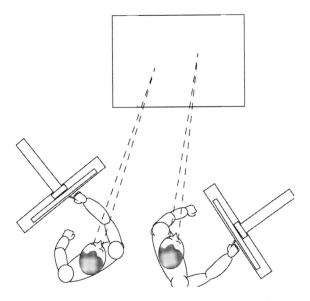

Figure 2.3 Easel position and line of sight

BASIC PROCEDURES

Physical Connection

A number of important principles help ensure vigorous drawing. Some of these principles are connected to the idea that drawing is a physical activity, one that involves the whole body. It can be important, for example, to stand while you draw. This keeps you "on your toes" and more physically engaged with the process. It is not unusual to see an artist at work on a drawing slightly crouching, stretching, bobbing, or leaning from side to side. Often this movement has something to do with visual pressures or angles in the composition or the subject. The artist is feeling or experiencing these forces with her or his whole body as a real physical gesture. The goal of this approach is to facilitate understanding of the interplay of forces in the composition.

Having a comfortable physical relationship to your whole page while drawing is important. Even when there are large empty areas in the drawing, you should be able to reach all edges with your hand and eye, taking in the entire area, and weighing the empty space against the marks and forms you are making. Draw broad lines from your shoulder rather than your wrist. Writing comes from the wrist, with the hand resting on the page, but drawing at an easel should involve the whole arm, holding the charcoal or pencil like a conductor's baton **(see Figure 2.4)**. When you are working in a sketchbook, holding the instrument like a writing pen can be more appropriate because of the work's smaller scale.

Overview

Standing up also allows you to move back quickly from your image to assess the overall composition. It is crucial to step back frequently, at least six feet from your drawing, so you can see what you are doing in the context of the entire page, especially with large compositions. Be sure your easel is situated so you can do this; clear a little

"runway" back from the easel. As you begin a drawing, every 30 seconds is not too often to step back allowing you to see things that you want to change early on. This is one of the most important drawing habits to develop. Just stop drawing and stand back to see what you have done. Only then can you proceed in a meaningful way; details should always be developed with awareness of the entire drawing.

Concentration

Concentration is absolutely essential to working successfully as an artist, but conducive conditions

Figure 2.4 Holding the tool like a conductor's baton

vary. Some artists believe that music gives them energy and helps them to focus. Others like total silence or "white noise" such as a fan. In any case, you should monitor your concentration level. If you find that you are thinking about something unrelated to the drawing you are working on, stop and try to refocus your attention. Otherwise, you can destroy 20 minutes' worth of good work in 15 seconds. Again, full attention to your work is crucial!

It is possible, however, to get so wrapped up in one aspect of your work that you lose track of what you are doing overall. This happens frequently with detailed work, when the particularities of some small part of the image cause you to forget your goals for the piece as a whole. Frustration can also have this effect; it is possible to become obsessed with a troublesome detail, allowing your annoyance to paralyze your ability to make sensible choices.

In both of these instances, the solution is the same: Back off! Look at the work as a whole and try to assess the areas that are working well and those that need immediate attention. Try to see detail as part of the larger whole, and give it only the amount of time it really needs. If you still cannot figure out an appropriate direction for developing the image, go get a drink of water. When you come back, try to look at the work as though you have never seen it before. How does it look? What does it need? Can you remember what you had in mind as a visual focus or statement when you started? Try to pick up the thread again.

ISSUES AND IDEAS

❏ Drawing is a physical activity, and you should take care to orient yourself and your work surface in a manner most conducive to concentration and easy connection with both drawing and subject.

❏ Drawing with your whole body while working from the shoulder will facilitate full freedom of movement and a dynamic connection with the drawing.

❏ Moving back from your work to gauge its overall effect and controlling obsessive frustration with stubborn details are essential working habits.

THROUGH THE LOOKING GLASS

Starting to Draw

In Lewis Carroll's book *Through the Looking Glass* (Figure 2.5), Alice steps through the mirror over the mantel and enters a new world of imaginative adventure and unusual insight. The process of drawing involves exactly such a transition. As an artist, you will step out of the everyday way of looking at things and into a world where previously unnoticed phenomena become significant, and things that once seemed to be most important in the visual world recede from your focus. Drawing will encourage you to explore visual reality as a series of sensations or associations filtered through your own focused consciousness. You will make new connections instead of looking at the world as a set of nameable facts or routine landscapes to be navigated by habit.

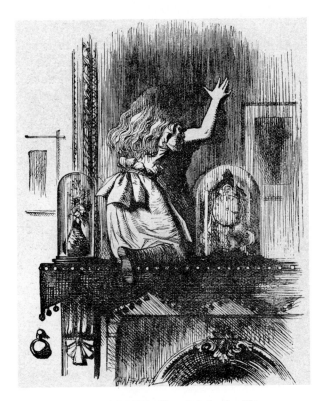

Figure 2.5 JOHN TENNIEL, *Through the Looking Glass*

The Perceptual Screen and the Page

The gateway to this new approach to the world is similar to the looking glass, or mirror, in Carroll's story: flat, but with mysterious depth. Actually, there are two such gateways. The first is the screen of your own vision—what your eyes see. We certainly understand that this spectacle that forms the tissue of our visual experience has three dimensions, including depth. On another level, however, it is simply a parade of pictures, a shifting pattern of light that our eyes perceive and our brains interpret. Learning to draw has something to do with understanding this, with being able to see the world as a picture, concentrating on how things look and the associations they bring to mind rather than on what they are to you as objects of familiar use.

The second point of entry to drawing is the sheet of paper on which you draw. It is definitely flat, yet much of drawing concerns opening the paper up to depth or other sensations that are part of your visual world. Opening it will prove to be surprisingly easy on a simple level, but controlling the effects of depth and flatness in your work is more difficult, requiring insight and practice.

First Steps

In some ways, the first steps are the most difficult to take. One of the most exciting things about the experience of looking at drawings is the sense of the sudden appearance of form on the page created from almost nothing. Approaching this act of creation oneself can be nerve-racking, however: The first mark seems to be such a commitment! How can it possibly be the right mark in the right place?

This is a universally acknowledged problem, even for experienced artists. It is, in fact, very difficult to be accurate, precise or perfect immediately, and there is a simple solution that all experienced artists know: *Don't worry about it.* It is fine to use exploratory marks to get a feel for your subject gradually.

Henri Matisse, a master draftsman who certainly appreciated linear perfection, took a long

time to get there as the erasures apparent in **Figure 2.6** testify. It is not so much that these erased lines represent mistakes, but that he used them to build toward the final form of the drawing. In many ways, erasure or lines drawn over other lines can legitimately suggest your **process** as an artist and the character of your **search.**

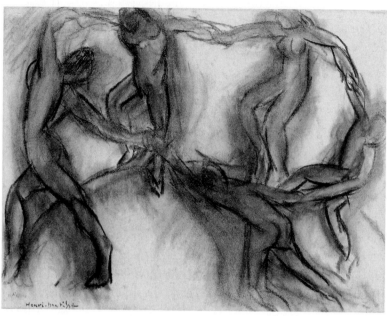

Figure 2.6 HENRI MATISSE (1869-1954), *Study,* charcoal on Ingres paper, 48 × 63.5 cm (S.B.G.: Henri Matisse. Legs Agutte-Sembat en 1923. Musée de Grenoble, Inv.: MG 2213 © 2009 Succession H. Matisse/Artists Rights Society (ARS), NY)

Perfection and Correction

There will always be a balance in a given drawing between **freshness of mark** and **perfection of mark.** Working a line over might bring it closer to the description of form that you are after, but it could lose some of the freshness that comes from the first interaction of the material and the paper or the excitement of your first assessment of the subject. "Imperfections" can often be valuable as evidence of fresh reaction. Acceptance of the idiosyncrasies of your drawing can be an important step toward understanding your own vision as an artist rather than thinking that you must polish and fine-tune every line that you make to be

"correct" according to a rigid photographic or stylistic standard.

The following exercises describe four approaches that suggest ways to "break the ice" as you begin to draw. Some involve erasure; others do not. They all support the idea that drawing is an exploration rather than a perfectly mechanical process of reproduction. The marks that you make on the way to finding the form that you want need not be hidden, especially if they contribute in some way to expressing your involvement with the drawing.

Exercise 2.1 Scribbled Armature

Materials: thin medium pencil or ballpoint pen, medium sketch pad

Scribbled **armature** is more tactile than visual. It works well with a ballpoint pen, which never needs to be sharpened, makes a mark easily, and has a constant line. The idea is to create simple forms in your drawing out of overlaid lines and to get used to moving your arm, feeling the instrument on the paper, and building up density. A posing figure is a perfect

subject, but still life objects or trees can also be effective Let your arm swing around and around as your mark spans the breadth of the form you are drawing **(Figure 2.7)**. Perhaps your lines are the imagined pathways of the electrons that spin constantly in all solid matter. You can vary the direction of your scribble, even to include one that follows the **outside contour** of the form, but try to keep a regular rhythm and pressure. The point is to build up the **sense of volume** slowly.

Figure 2.7 MARLENE DUMAS, *Love Hasn't Got Anything To Do with It* (1977), color pencil collage on paper, 152 × 144 cm

Exercise 2.2 Mass Gesture

Materials: ink wash and/or charcoal, watercolor paper or manila

Mass gesture is related to scribbled armature but relies on a broader tool to lay in areas. Use the side of your charcoal or a broad brush with diluted ink or watercolor. In either case, the density of your tone should be fairly light; building up with overlay will allow you to alter the shape. Your first strokes should lay out the basic configuration of your subject as simple blocks as Francisco Goya has done in **Figure 2.8**. Try to grasp the "thingness" of each segment of an object and just lay it down with as few strokes as possible. Do not worry about the accuracy of the outside contour until you have "chunked in" all the forms in your drawing. At that point, you can go back and build the outside contour with charcoal around the massed forms. Finally, use your thumb to smudge the outer lines and link them with the gray shapes in the interior.

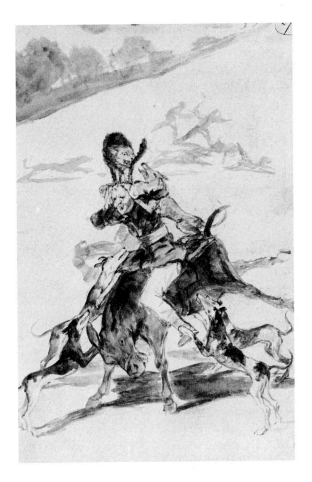

Figure 2.8 FRANCISCO GOYA
Man on Donkey Attacked by Dogs
Brush and wash, 7 7/8 × 5 1/2 in.

Exercise 2.3 Repetitive Contour

Materials: charcoal or soft pencil, eraser, medium sketch pad

This approach focuses on outline as a path to **interior form.** Analyze your subject with your eyes, breaking it down into simple shapes. Draw these as outlined shapes with a thick black pencil (ebony is best), but use a variation of the scribble technique, going around and around with fairly light pressure until you feel that you have solidly defined part of the form. If you are drawing a figure, you might start with very simple forms: torso, head, two joints each for arms and legs. Then work smaller forms on top of the initial group, dividing the torso into separate components of rib cage and belly, breast, shoulders, and so on. Work into the drawing now with an eraser, breaking down the borders between segments where the form is continuous (e.g., the knee) and leaving a crease where you see one in the figure **(Figure 2.9).** You can also shape the outline with your eraser, moving away from simple shapes into the more nuanced edges in your subject. Smudging with your finger will help bring the drawing together and give a sense of surface continuity to the interior form.

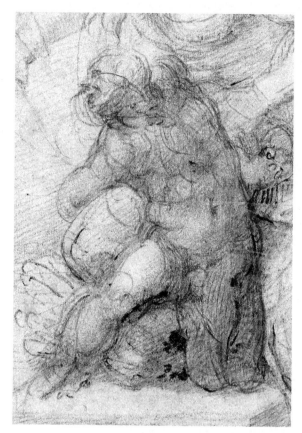

Figure 2.9 MICHELANGELO BUONARROTI (1475-1564), *Sacrifice of Isaac,* detail, black chalk, pen and ink, 408 × 289 mm. Inv. n. F., Location: Casa Buonarroti, Florence, Italy, Scala/Art Resource, NY

Exercise 2.4 Blind Contour

Materials: Ebony pencil, medium sketch pad

The point of this exercise is not so much to make a realistic drawing as it is to practice connecting the movements of your drawing hand to the movements of your eye. Arrange to have someone sit for a portrait, or do a self-portrait in a large mirror. Concentrate only on contour: the outside edge of the form and any important ridges or edges within the form, such as the bridge of the nose, a cheekbone, and so on **(Figure 2.10).** Follow the contour you are trying to draw with your eyes, carefully noting any details of shape and overlap. Keep your eyes on the contour, and *do not look at your drawing.*

It is best to keep your pencil in contact with the paper so that you do not lose your place, but you can lighten your touch if you are retracing or cutting over to an isolated contour.

Do not look at the drawing until you are pretty sure you have mapped all of the contours in the pose. Then you can check it out—probably to your astonished horror! In all likelihood, the various body parts are all over the place, but there are probably also some moments of good observation and some very interesting marks. Try it again with the same subject, and remember that honesty and concentration are what count. Try to feel the connection between the movement of the eye around the

contours of your subject and the movement of your hand and drawing instrument across the surface of the page. This **eye/hand connection** is the essence of drawing and well worth practicing regardless of the resulting image. Try to sustain this feeling of connection when you are drawing in a more regular way.

Figure 2.10 Jean Arp (Hans) (1888-1966) *Danger of Death* (Danger de mort). 1954. Pencil on paper, 322 x 257 mm. Presented by Mr. and Mrs. Robert Lewin through the Friends of the Tate Gallery 1987.Tate, Photo, Tate, London / Art Resource, NY, (c) 2009 Artists Rights Society (ARS), New York, VG Bild-Kunst, Bonn

Exercise 2.4a Variation: Worked Blind Contour

Materials: Same as for Blind Contour

Begin by using the blind contour method to map the basic forms of your subject, but when you have come to the end, you may look at the drawing and edit or shape it in relation to the subject matter.

ISSUES AND IDEAS

❐ Exploratory marks or techniques of simplified description can be used to "break the ice" in drawing. Freshness and honesty of reaction are often more important to a drawing's life than "accuracy."

❐ Simplifying form and detail into lines, shapes or textures allows for quick notation of overall perceptions and integration of the medium with the subject.

❐ The energy of mark-making can contribute to the life of the drawing

Sketchbook Link: Visual Notes

Practice any or all of Exercises 2.1 to 2.4 in your sketchbook, quickly taking "visual notes" of passing scenes and objects. Use the simplification techniques described in the exercises to reduce your subject to a simple set of marks. Do not worry about legibility for other viewers, but try to get the essence of the form in simplified terms

FROM REAL SPACE TO PICTORIAL SPACE

A common goal for beginning artists is "to be able to draw what I see." Drawing is not always based on observation, and some drawings do not have recognizable subject matter. Still, the ability to transpose a scene or object in front of you onto the page is a powerful skill and an important way to establish a sense of confidence and control over the art form. Accuracy or "realism" is not by any means the ultimate quality to be sought in drawing. In the beginning, however, working closely from observation can help you train your eye to important issues such as proportion, shape, and arrangement of form.

The first marks you make on the page will begin to set up relationships on both two-dimensional (2-D) and three-dimensional (3-D) levels. Taking control of these relationships is the essence of learning to draw, but the first step in this direction is one of understanding. You must learn to see your own drawing, to appreciate the interactions of mark and page, form and space. This can be more difficult than it sounds. Learning to appreciate the possibilities of drawing can be just as difficult as the actual creation of form and may be the key to successful work.

A number of techniques that are a bit mechanical in nature can guide you in coming to understand the nature of fundamental relationships within the pictorial space of drawing. The goal of these methods is to lay down structural approaches that you will ultimately internalize or do automatically. The most effective way to learn anything, from riding a bicycle to speaking a foreign language, is to *do it*, maybe with artificial help, and then gradually on your own. The real point of any drawing exercise is not to teach you a specific technique for its own sake, but to build your awareness of possibilities inherent in the medium.

As stated earlier, effective drawing is based on an awareness of the "screen" of your visual perception of the world and the related screen of the surface of your paper. The goal of Exercises 2.5 to 2.10 is to help you connect these two screens, bridging the gap between 3-D perceptual reality and the 2-D surface of the page. The previous exercises also concerned this problem, but the next group concentrates on *relationships* between elements rather than on the simple translation of observed form into line or shape. (See definitions of **form**, **line**, and **shape** in the Glossary.)

Proportion

The first type of relationship you will study is that of **2-D proportion,** which involves comparisons of size within a given shape or between shapes. In irregular shapes, these measurements can be quite complex, so you will start with simple rectangles that have only two measurements: height and width.

You will need ten four-by-six-inch notecards and a small-diameter dowel about nine inches in length (a long pencil is good) for these exercises. You will use the dowel to measure lengths and angles from the real world and transfer them to your drawing. Conceptually, this technique imposes a 2-D measurement on the 3-D scene in front of you so you can transfer it to your 2-D page.

When you hold the dowel up to look at the objects in 3-D space, you have to keep it **perpendicular** to your line of vision or **parallel** to your face **(see Figure 2.11).** If you tip it into depth, you will not be making an accurate 2-D measurement. Practice rotating the dowel by turning your wrist from **vertical** to **horizontal,** but never into depth. Imagine your line of vision as a thread coming from between your eyes (the bridge of your nose). If the thread is pulled taut and straight out so that it is parallel to the floor, when it meets the dowel, it will meet it at a right angle. Accurate orientation of the dowel is very important.

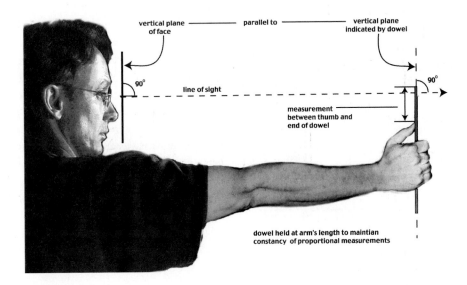

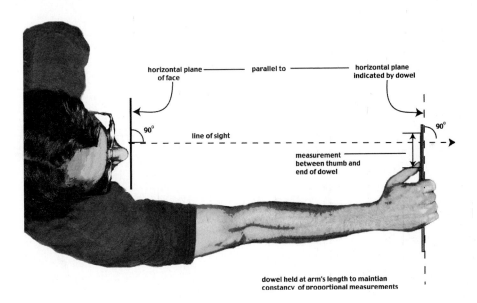

Figure 2.11 Measuring basic proportion

Exercise 2.5 Basic Proportion

Draw X's with a ruler from corner to corner on the cards as shown in **Figure 2.12.** Pin one card to the wall and practice drawing it from straight on, developing a good sense of the height to the width. Use the following procedure **(refer to Figure 2.11 and Figure 2.13).**

1. Stretch your arm out so your elbow is not bent.
2. Holding the dowel so that it is perpendicular to your line of vision (parallel to your face), measure the width by putting one end of the dowel at the bottom of the plane at point *d* and moving your thumb to point *a*. Keeping your thumb in place, transfer this length onto your page as a perfectly horizontal line.
3. Rotate your wrist so the dowel lines up along the side from points *a* to *b* with the end at *b*. Be absolutely certain to keep the dowel perpendicular to your line of vision (parallel to your face) as you move it, keeping your thumb in place.

Figure 2.12 Prepared notecard

4. You will see that line *ab* is shorter than line *ad*. Move your thumb to point *a* to make the new measurement, and transfer it to your drawing as before.

Another, perhaps easier, method is to simultaneously measure both the angle and length of the diagonal line *ac* and transfer it to your paper **(see Figure 2.14).** Then measure line *cd* and extend verticals of that length on your paper up from *a* and down from *c*. Finally, connect the corners with horizontal lines.

This may sound complicated, but it is actually straightforward and very useful in drawing buildings, interiors, and anything with planes.

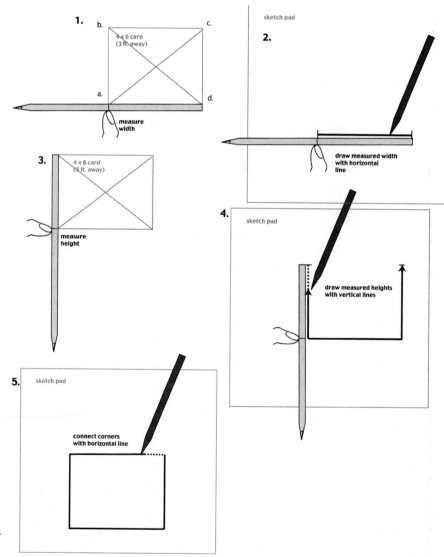

Figure 2.13 Transferring measured proportions

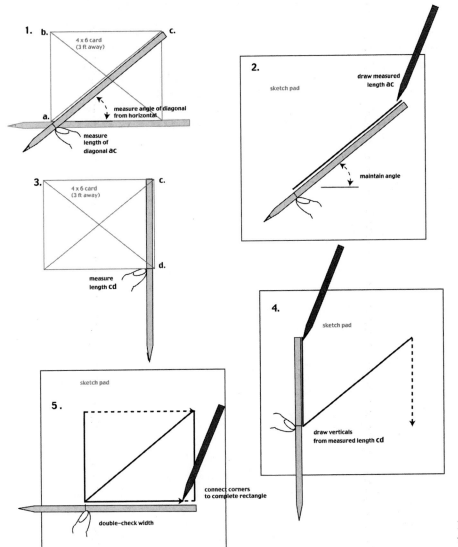

Figure 2.14 Measuring proportion with the x-method

Exercise 2.6 Proportion in 3-D Space, Part I

In **Figure 2.15**, a number of four-by-six-inch cards have been fastened to small boxes to stabilize them and then arranged so that all cards face directly forward but at different distances from the front edge of the **ground plane.** Some are horizontal, some vertical.

Your **eye level** should be even with the tabletop: You do not see its surface and therefore do not see where in space the planes are set. The only clues to relative placement are from **overlap**

and size. Because all the planes are the same size, we know that the ones appearing to be smaller are further back in space.

Keeping your eye level right at the tabletop so you see none of the top plane of the table, draw the setup. Measure with your dowel to establish the proportion of the height to the width of each plane, or use the X method as described in Figure 2.14 to develop strong proportions. If you can see only part of a card due to overlap, just measure what you can see. Also using the

dowel, establish the angle and distance of the corner of one plane to the corner of another plane. Angle measurement can be difficult because there is no sure way to keep the dowel at the same angle as you rotate from setup to paper. Practice this technique anyway, but double-check by measuring the height and width of the triangle that the measured angle forms between the cards.

Check proportions of the spaces between the cards. Build a web of vertical, horizontal, and diagonal relationships before drawing in the actual objects. As you develop the drawing, use a varied line weight to communicate the space from one plane to the next. You may draw those closer more crisply and with more contrast to the page so they stand out. The sharpness and value of the line can diminish as the objects move back in space. Be sure to look, draw, look again and again, erase, reassess, draw, and

Figure 2.15 Cards set up on an eye-level ground plane

change until you have a real sense of the setup on your page, constantly using guidelines and angle relationships. Move your arm from your shoulder, keeping the lines loose and fluid. Stand back frequently to look at the drawing.

Exercise 2.7 *Proportion in 3-D Space, Part II*

The spatial arrangement of planes in **Figure 2.16** is much clearer because you are now looking at the setup from above and the ground plane is giving you information about the relative placement of the planes to one another. Those planes closer to you are lower in your field of vision and those farther away are higher. This will always be the case, as long as the objects in a group are set on the same flat ground plane. The second view gives you more information and therefore is less **ambiguous.**

Using the same arrangement of mounted planes as in Exercise 2.6, change your eye level so you see the tabletop. In drawing this setup, you need to be very specific about the relative distance between each plane and the space from the bottom of the page to the bottom of the plane. It is important to pay as much attention to the space between the planes as to the planes themselves.

Proceed as in Exercise 2.6, measuring for proportions and drawing a web of relationships

before drawing objects. Pay attention to the entire drawing; do not draw one object and then another, but move from one to the next so you consider all at the same time. Erase, change,

Figure 2.16 Cards on a ground plane below eye-level

reassess, erase, and change, keeping the drawings light and fluid until you have worked out the placement of the objects. Attention to line quality is essential; ghost lines, or pentimenti, will show your process and reconsideration. As always, keep the line loose and move your arm from your shoulder.

Sketchbook Link: Proportion

Practice proportional measurement in relation to buildings, windows, and other rectangular objects. You might first try to "eyeball" or estimate the proportions without measuring and then check your results with the dowel technique.

ISSUES AND IDEAS

❏ Drawing involves an awareness of the paper as a two-dimensional picture plane.

❏ Working from life, you must be able to translate forms from three to two dimensions.

❏ A long tool held parallel to the plane of your face can help "map" the 3-D scene in front of you in terms of two dimensions.

❏ Two-dimensional proportional measurements can aid in translating a 3-D scene or form to the page.

Proportion and Depth Recession

Receding planes, edges, or forms present a special challenge in drawing. Three-dimensional recession changes the appearance of the proportions and shape of a form, but it is a natural tendency to draw the form undistorted, as it would look from a frontal or 2-D view. Purposeful application of our dowel measuring technique will confirm the visual distortions of receding form, allowing you to objectively record in your drawing what your eye is seeing.

Two things happen when vertical cards are angled back in space: Opposite edges, formerly parallel and equal, now vary in length and/or angle, and their shapes shrink horizontally. In **Figure 2.17**, you will see immediately that the edge closest to us (*cd*) is longer than the edge farther back in space (*ab*). This is due to the simple fact that objects become smaller to our eyes as they retreat into distance. The top and bottom edge of the card appear to **converge** as they move away from us into space, reading as diagonals and bridging the change in apparent

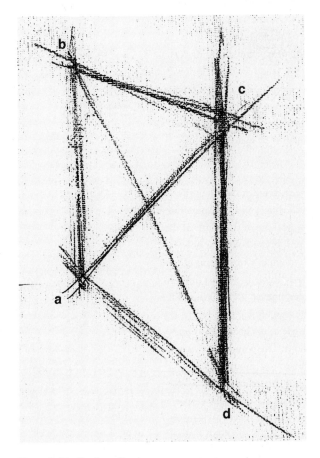

Figure 2.17 Card receding in space

dimension between the closer (longer) edge and the further (shorter) edge.

The receding dimension, the horizontal width of the card, appears substantially shorter than in frontal views. The more the card is angled in depth, the shorter this dimension will appear from a given point of view. This effect is called **fore-shortening,** and it has many important applications in drawing including the projection and compositional arrangement of geometric form as discussed in Chapter 4, the evocation of spatial depth as discussed in Chapter 5, and the convincing depiction of the human figure as discussed in Chapter 9. Comparing the distorted receding dimension with the unforeshortened vertical (*cd*) can be helpful in revealing the shrinkage caused by foreshortening.

Exercise 2.8 Measuring a Receding Plane

Practice drawing one card at a time from a variety of angles. Use the *X* marking on the card, as described in **Figure 2.18,** step 1, to read the angle and length of *bd*. Then extend *ab* and *cd* vertically, taking proportional readings of their lengths with your dowel (Figure 2.18, step 2). Connect lines *b* to *c* and *a* to *d*, double-checking the new angles and lengths by measuring (Figure 2.18, steps 3 and 4). The comparison of the length of *bd* with the vertical lengths will show you an accurate foreshortening of the width of the card. If you hold your dowel horizontally from point *a*, you will be able to see just how angled line *ad,* is. The same will be true for *bc*. Analyze the angle *ac* to check the proportions: The point where *ac* intersects *ab* should be the same point where *ad* should intersect *ab*. As always, be certain to hold the dowel perpendicular to your line of vision as you find and analyze the angles.

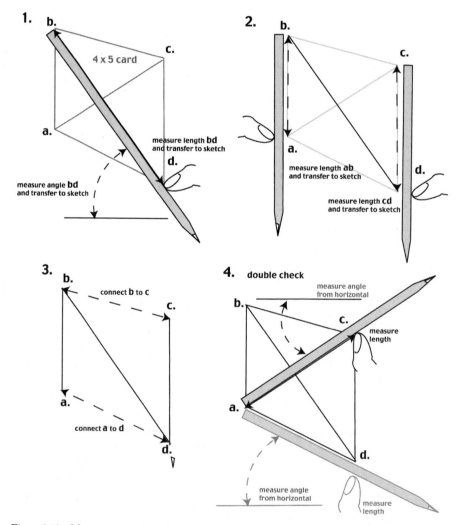

Figure 2.18 Measuring a receding plane

Exercise 2.9 Reclining Planes

Create a setup of four or five planes reclining on the tabletop. Before you even begin to draw, get in the habit of looking at the setup for vertical and horizontal relationships. Using your dowel, find vertical lineups **(see Figure 2.19)**. Understanding the relationships before you draw is helpful. Pay particular attention to the distances and angles between the planes on the tabletop. Use the *X* method to find proportions. Build the web by finding any vertical points that line up, horizontal points that line up, and diagonals that line up. In a plane that is at an angle, both sets of parallel edges will converge slightly as they recede. Again, build a web of vertical, horizontal, and diagonal relationships, changing and adjusting as you go. Move quickly from one object to the next so they are all developed simultaneously.

Figure 2.19 Cards reclining on a ground plane

Exercise 2.10 Standing Receding Planes

You will do a drawing of a setup of standing planes as in **Figure 2.20.** As you did before, map out a web of light guide lines to locate planes in relationship to each other and with attention to proportions, using basic measuring and *X* methods. Pay particular attention to the placement of objects on the tabletop plane, looking carefully at the spaces between planes. Develop the line weight to give an even clearer sense of the space. Keep your line light and fluid, draw, erase, redraw, and remeasure until everything falls into place.

Figure 2.20 Receding cards on a ground plane

ISSUES AND IDEAS

❒ The receding dimension of planes tipped into depth will shrink or compress due to foreshortening.

❒ Measuring can bring this foreshortened dimension into your drawing accurately, but only if the measuring tool is kept parallel to the plane of your face. Do not tip it into depth in imitation of the plane you are drawing.

❒ Equal vertical edges will shrink the farther away they are even if they are not tipped into depth. The corner angles of tipped rectangles will change to allow linkage of closer (bigger) and further (smaller) edges.

❒ All proportional and angular changes due to depth recession can be accurately measured for a drawing as long as the measuring tool is kept in a two-dimensional (parallel) relationship to the plane of your face.

Sketchbook Link: Eyeballing

Practice "eyeballing" angles and proportions of receding rectangles, checking your measurements with the dowel technique. Remember that the farther of two equal edges will seem smaller. See if you can construct believable receding planes in your sketchbook based on the principles you have studied in this chapter.

Further Study

Exercises 2.5 through 2.10 have been designed to acquaint you with the interplay between 3-D forms viewed in depth and 2-D forms on the surface of your page. You have been working with simple rectangular planes, but the principle of measuring 3-D reality with a 2-D system has much broader applications. We raise these issues again in Chapter 4, a broader examination of geometric form in drawing, and in Chapter 5 where we discuss overall systems of depth projection such as linear perspective.

Ultimately, measuring could prove to be a useful, even essential, process in your work. For other artists, a looser approach is more appropriate. Let us now look at some other ways to explore the territory shared by two- and three-dimensional form. These methods can be used separately or in conjunction with measuring.

Shape Composition and the Picture Plane

Shape in the real world is a quality that objects have in our perception: A tree has a round shape; a mountain, a triangular shape. In drawing, a shape is a definite **graphic** form, an object of a two-dimensional nature. When you measure the proportions and angles of rectangular planes, as in the previous exercise, you are gauging them as shapes, ignoring their relationship to depth, in order to bring them into the two-dimensional world of our drawings.

An awareness of shape can be helpful in other ways to analyze visual reality in terms of drawing. Developing your ability to see the world in front of you as graphic form—shape, pattern, and line—will obviously facilitate your ability to translate what you see into graphic form on the page. Even though drawings can have very convincing illusion of depth, they remain flat with many relationships that can be best understood on a graphic level.

The composition of angled planes on a tabletop from Exercise 2.10 (**Figure 2.21a**) has been shown as three flat black shapes on a white ground in **Figure 2.21b**. Although the spatial character of the original planes is largely lost, the outside contours of the groups of planes as

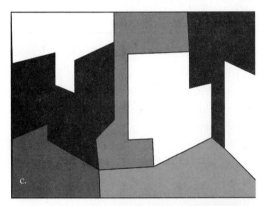

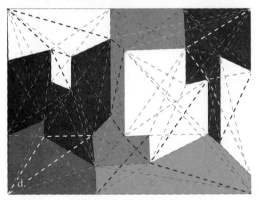

Figure 2.21a–d Shapes made by negative space

shapes are much easier to see. Your eyes are sensitive to the dimensions of these graphic shapes in a different way; you notice the segments that make up the borders of the groups and their angles and lengths with a simple clarity. Another outgrowth of this graphic transformation is that you are more aware of the shape character of the spaces *between* the groups of planes. This is so because the **hierarchy** of solid object and empty background that you are accustomed to seeing in everyday reality has been neutralized. Now both object and background are flat, graphic elements. If you break up the background into pieces, the shape character is even clearer **(Figure 2.21c)**. You might imagine using your measuring dowel to investigate the individual shapes in this composition. There are more measurements to take because the shapes are more complex and irregular than simple rectangles, but the process still works **(Figure 2.21d)**.

The shapes made in the background are referred to as **negative shapes** because they are formed in the spaces between the contours of objects. If you are thinking graphically, however, and simply trying to gauge proportion and placement, the distinction is somewhat irrelevant. It is when an *object* is depicted in a drawing—whether an illusionistic figure in depth or a graphic shape against a background—that the term negative shape becomes meaningful.

The point is that you can work with negative shape just as effectively as with the positive shapes or objects in your drawings to develop accurate placement and proportion in translating imagery from 3-D reality to the 2-D page.

Matisse was obviously very aware of negative shape as he composed his *Violinist at the Window* in **Figure 2.22.** The interlocking **armature** of strong shapes links the figure to the rectangular forms of the room and gives the picture a clarity and force of composition.

Although the drawing features soft edges, the shape structure is still very strong, sometimes cutting across divisions of clothing, hair, and so on to make larger compositional elements. You have the sense that nothing is left to "flap in the breeze." All is brought into the graphic structure of the whole.

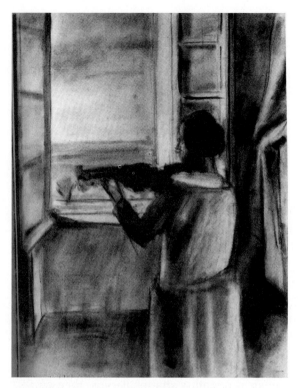
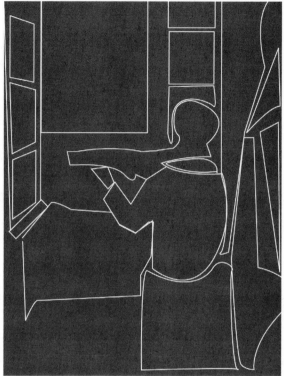

Figure 2.22 HENRI MATISSE (1869-1954), *Violinist at the Window, Nice,* 1924 (with diagram of shape structure), charcoal, 24 3/4 × 18 3/4 in. (© 2007 Succession H. Matisse, Paris/Artists Rights Society [ARS], New York)

Exercise 2.11 Analyzing Negative Shape, Part I

Materials: tracing paper, Ebony pencil, medium sketch pad

In an art book, find a good-sized reproduction of a painting or drawing that has a composition actively engaging the edges of the frame. As you search for the right image, practice looking at compositions graphically, concentrating on the 2-D shapes made by the figures or objects and the shapes of the spaces between. When you have found a reproduction that seems to have a particularly interesting shape structure, do a compositional study, simplifying the positive and negative shapes and using simple tonal characterization to differentiate

them from each other. As you assemble the shapes next to each other, erase and revise to obtain accurate contours, fitting the whole together like a jigsaw puzzle. Try to duplicate the "balance" of the composition.

Using a second reproduction, begin by drawing only negative shapes, defining the "objects" in the image by the leftover spaces. Start with the largest areas and work toward laying in the small space between objects close to each other. See if you can find groups of small shapes that define larger shapes or large shapes that can be divided into smaller components.

Exercise 2.12 Analyzing Negative Shape, Part II

Materials: charcoal, medium sketch pad

Working from a still life of household objects, set up a still life against a simple background as Juan Gris has in **Figure 2.23.**

The objects should be close enough together so that the spaces between them form easily identifiable shapes. Overlapping and varying spatial position on the tabletop are also desirable. Begin your drawing by doing three quick

compositional studies in which you try different framing possibilities, looking at how different parts of the still life form interesting shapes, experimenting with close and far views and with **cropping.** Every object should be represented in your drawing, but some may extend off the edge of the frame. Choose the most interesting of your sketches and make a larger (18 by 24 inches) drawing from it, beginning by defining the negative shapes. Use simple tonal coloring to differentiate shape in the composition.

Sketchbook Link: Shape Composition

Make a series of studies of interiors (three by four inches in size) with or without figures. Begin each sketch with a rectangle representing the edges of your composition. Reduce the composition to its most basic shapes and lay these in before proceeding further, adjusting their forms until they make a strong design. Add smaller shapes, fitting them into those already there. Add tone or detail, retaining a strong role for shape.

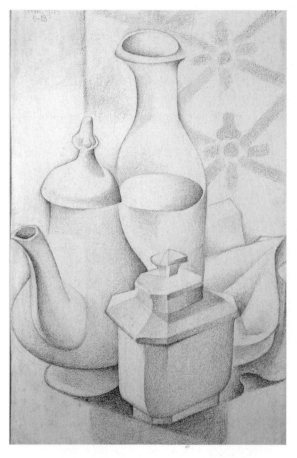

Figure 2.23 JUAN GRIS, *Still Life* (1918), pencil, 19 1/8 × 11 5/8 in. (Collection of Kroller-Muller Museum, Otterlo, The Netherlands)

ISSUES AND IDEAS

❏ A shape is a 2-D graphic form. The graphic quality of shape can be applied to or found in 3-D forms.

❏ In many drawing compositions, the picture plane can be analyzed in terms of interlocking shapes, positive and negative.

❏ Positive shapes are those made by objects; negative shapes are those made by the spaces between objects out to the edges of the page.

❏ Strong positive/negative shape structure can give a force and coherence to a composition.

Viewfinders

Some students and even professional artists find it useful to look through a rectangular viewfinder when they study a setup or scene for compositional structure. This tool is very easy to make and can be helpful with both initially laying out or framing your overall composition and later reexamining proportional and shape relationships within the composition. Like the measuring technique

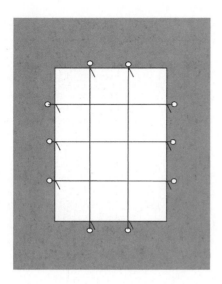

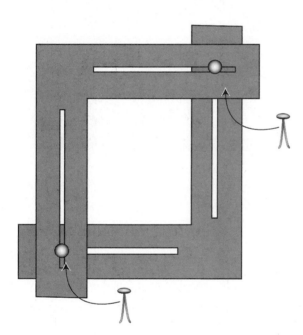

Figure 2.24 Viewfinder construction

described earlier in this chapter, the viewfinder asserts a 2-D framework over the 3-D scene, clarifying its graphic nature.

A simple piece of cardboard with a rectangular hole in the proportions of your composition will work well for this purpose. If you use two right angles of cardboard, you can make a proportionally adjustable viewfinder as shown in **Figure 2.24.** More precision-minded artists sometimes make a rectangular network of threads over the hole to break the shape structure of the scene down into smaller pieces. On the other end of the technical scale, it is possible to get some effect simply by making a frame out of the forefingers and thumbs of your two hands. In all cases, the viewfinder can be moved closer to or farther from your face to take larger or smaller chunks of the scene into the composition.

It is important to look through a viewfinder using only one eye. Otherwise, you will see a confusing double image of either the scene you are drawing or the viewfinder. **Monocular** vision is also flatter than **binocular,** and you will be better able to see objects in diverse spatial locations at once.

Paul Cezanne is one of the great masters of translating the 3-D visual world into 2-D compositions of strength and **graphic integrity (Figure 2.25).** His work is not "realistic" per se; instead he sees the possibilities for the design of a drawing in a given natural scene. As you look through your viewfinder, think in these terms: How would these forms translate as shapes, lines, and textures on the page?

Exercise 2.13 Composing with a Viewfinder

Working from a preexisting situation, such as a landscape or interior, use your viewfinder to identify three compositions with strong shape structure, both positive and negative, as defined in the previous exercises in this section. Make small (four-by-five-inch) studies of each one, breaking the rectangle into tonal shapes with strong contours that divide the composition in an interesting way. You can move the viewfinder closer to your eyes to enlarge the section of the scene you are taking or farther to shrink it.

You can try vertical or horizontal compositions. If you are using an adjustable viewfinder, you can experiment with the rectangular proportions as well. In any case, your sketches must be the same orientation and proportional dimensions as the viewfinder.

Look for **proportional balance,** or interesting imbalance, in the division of the frame. Focus on active negative shapes and clearly defined shape structure in the objects in the

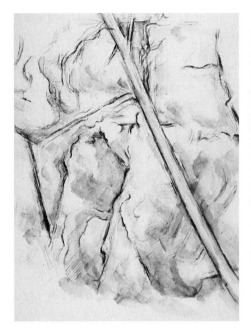

Figure 2.25 PAUL CEZANNE, *Pines and Rocks near the Caves of the Chateau Noir* (c. 1900), (with a photograph of the motif by John Rewald), pencil/watercolor on paper, 18 1/8 × 14 in. (John Rewald Archive, Department of Image Collections, National Gallery of Art Library, Washington, D.C. © Sabine Rewald)

composition. The first step is to work with your eyes, moving the viewfinder around, looking at different aspects of the scene around you. If you can identify a good composition before you start drawing, you will be much closer to a good final result.

Choose the best of your compositions and base a larger drawing on it, using your sketch to lay in the basic forms before re-turning to direct observation for added detail and texture. Make sure that your larger drawing corresponds proportionally to the dimensions of your viewfinder and sketch; all the rectangles should have the same relationship of height to width, although they can vary in actual size.

Unity of the Composition

In an earlier part of this chapter we discussed the importance of regularly moving back from the easel as you draw in order to see the whole composition. But what exactly is it that you are looking for when you move away? Composition is a complex topic and will be explored more fully in relation to issues of shape, form, light, and space in later chapters. Still, the concept of working your entire drawing as a whole is an important basic principle in learning to draw, so we touch on it here.

In one sense, the discussion of negative shape has already broached the subject; by considering the spaces between (and around) objects as graphically equal in a composition to the shapes made by objects, you are already concerned with the whole page. Some helpful habits can ensure that your drawings make effective use of the graphic space of the page, and we review those now.

You may have heard drawing or painting teachers say that you should do the whole drawing at once. This is probably the best advice you can ever hear, but it might seem impossible to actually implement. How can you draw on every square inch of paper at the same time? Technically, you cannot, but two methods will let you approximate simultaneous overall development of the drawing. The first is to keep moving around the composition as you work: from the top to the bottom to the left to the right, developing areas equally, not letting one section get ahead of another. This is especially true in the first stages of a drawing.

In the end, you may actually want to have some areas that are more resolved than others, but you will make this decision much later. It is important to avoid drawing one object and then another one next to it, and then another, and so on. As you work on the contour of an object, be aware of the negative shape it is creating with its outer boundary in relation to the contours of other objects or to the edges of the page, thinking of each line as part of a larger whole encompassing every mark you have already made. You must consider all these elements together and develop them as one entity or the drawing will look pieced together.

The second thing to practice (and here we return to the concept of getting back from your drawing) is seeing the relationships within your drawing *all at once.* This takes some adjustment. People generally focus their vision to look at one thing or a part of a thing, but in this instance you are looking for a web of interconnection: **visual weights** and balances. In fact, for this method to be effective, it is very helpful to avoid focusing your vision on any one part of the drawing. After you have stepped back from your work, you can try to take your eyes slightly out of focus. Concentrate on the overall pattern of shape on the paper. Be aware of concentrations of mark, areas where the mark trails off or seems weak, and imbalances of proportion.

One theory is that some kind of mark should touch every edge of the page, but this is not really necessary. What is necessary is for you to consider your composition all the way to the edges of the paper (and including the paper's edges as "lines" or shape contours in the composition). If your page has any empty areas, they should be there on purpose to add something to the overall image, and they should have strong character as negative shape.

Looking from one part of the setup to another and seeing how each relates to the others is a way to keep the whole drawing going at once. You can build a web of vertical, horizontal, and diagonal lines on your page or consider the scene in terms of positive and negative shape. Let your eyes move around the situation as though you are looking at flat shapes. Practice "drawing with your eyes" or seeing the world in terms of graphic form.

If you believe that you are having trouble truly seeing the relationships within your drawing, you can try looking at it from a really long distance (perhaps from out in the hall), upside down (the drawing, not you), or in a mirror. Many artists carry small pocket mirrors with them for this purpose. The idea is (1) to flip the picture around so you are seeing it in an unfamiliar way, (2) to reduce it to small, simple shapes, or (3) to undo the hierarchy of gravity by turning it upside down. Each of these techniques can be helpful, and you may find one that is particularly effective for you.

Elmer Bischoff works from a posing model in his sketchbook **(Figure 2.26)** finding a role for the furniture, walls and empty space of the room in his spontaneous, informal compositions. The arrange-

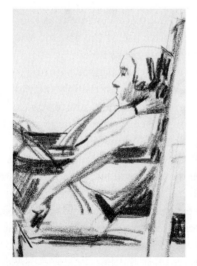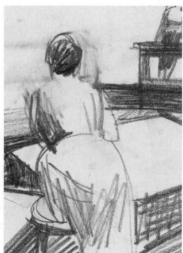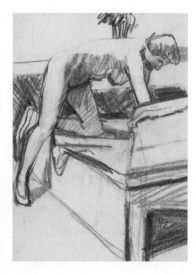

Figure 2.26 ELMER BISCHOFF (1916-1991), 3 sketches from a sketchbook, ca. 1950 (Elmer Bischoff, artist, 1 v.: graphite and ink, 30 × 22 cm, courtesy of the Elmer Bischoff papers, 1931-1990, Archives of American Art, Smithsonian Institution)

ment of forms on the page reflects the artist's simultaneous concern for 2-D design and his interest in the three-dimensional aspects of his figurative subject. The spirit of the work is informal: an observed incident. Notice the different emphasis given to various parts of the composition by the varying density of line and carefully place blocks of tone. In the end, a **pattern of looking** is set up that suggests the actual, intimate perception of the artist at a given moment. (See Sketchbook Link: Compositional Notes box on page 46.)

Exercise 2.14 *Perceiving Overall Compositional Structure*

Working from a still life setup as in Exercise 2.12, prepare to compose a large drawing by using a viewfinder to identify an interesting area in the setup that has a good interplay of positive and negative shapes, and an engagement of the edges of the frame. Do at least one small compositional sketch using simple tonal areas with strong outside contours to clarify and organize the composition in your mind.

Make sure that the edges of your paper correspond proportionally to your sketch and/or viewfinder. If they do not, draw a rectangle within the paper's edges in the correct proportions.

As you begin the drawing, return to the setup, keeping your sketch in a place where you can refer to it easily. Begin with negative shapes, but move around the composition as you lay it in. Skip from a shape in the lower left to one in the upper right, then over to the upper left, and so on. Use light lines that you can revise later if necessary, but try to accurately approximate the distances and placement of each new shape in relation to the ones you have already put down. Move away from the easel frequently, taking the sketch with you, and practice perceiving the whole image based on the marks you have made. It should be possible to get more and more precise in your placement of new shapes as the composition gets blocked in and the large areas of empty paper diminish. Take the time to refine and accurately place each negative and positive shape, letting your eye move quickly around the whole composition. As you become more certain about a given line, you can revisit it, firming up the shape character and thickening your contours. When you are satisfied with basic placement, develop the drawing in terms of tonal areas and textural details, but maintain an emphasis on the interlocking structure of shape and the play of the composition off the edges of the paper.

ISSUES AND IDEAS

❒ "Finding a composition" means seeing the interconnected relationships within the page as a whole.

❒ Artificial tools, such as viewfinders, can help you identify compositions in nature.

❒ When drawing, you must practice seeing the various pieces of your composition together as a whole, a functioning composition.

Conclusion: Observation, Insight, and Imagination

The exercises included in this chapter are intended to introduce important principles and procedural approaches to drawing. Although they are presented here on a simple level, these issues are the foundation for aspects of drawing at all levels. You can refer to them at any time in your own development. We revisit similar concepts and methods throughout this book.

We urge you to do the exercises in this section early in your studies. Whether you are drawing from the human figure, buildings, still life, or landscape, a clear understanding of measuring and mapping proportions, seeing graphic shape and overall compositional structure, and representing basic planes and geometric solids in space can get you past many very basic drawing problems and provide insight into ex-

pressive structures. It is certainly worth taking the time to build a strong understanding of these visual systems. This background will enable you to bring strength and assurance into both the **representational** and **abstract** structures of your drawings.

Much of the drawing you do in the first year will be **observational** drawing; you will be looking at a subject and drawing it. It is important to understand that every time you draw, you are *interpreting* the subject; your drawing, no matter how realistic, never actually becomes the subject you are drawing. The lines, marks, and tones that you use to represent your observations do not exist in the world you are observing. They are your interpretation of that world. The more you draw and the fuller your understanding of the structures in the world becomes, the more interpretive your drawings may become. Ultimately, insights gained in this way will allow you to work effectively from your own visual imagination, gradually breaking down the barrier between the world you see with your eyes and the world of form on paper that is your own as an artist.

Sketchbook Link: Compositional Notes

Make a series of ten small (four-by-five-inch) compositional studies of scenes from life. As you begin each study, use only quick indicational lines or simple shapes, piecing the "web" of the composition together. Do not worry whether the drawing would be legible to anyone else; think of it as "note taking" for yourself. Try to convey the reality of the arrangement of forms you are looking at as a whole rather than concentrating on details.

—— Critique Tips Chapter 2: Materials, Procedures, —— and Concepts

During critiques for the assignments in this chapter, look at your own and your classmates' drawings for qualities based on the following questions. Words in bold are defined in the Glossary at the end of the book. You might also want to review the vocabulary in the Using Specialized Vocabulary section in Chapter 1.

Is the material used in the drawing working well? *Does it have qualities that complement the drawing's subject or feeling, and is the artist taking the best advantage of these qualities?*

Does the drawing seem to have been worked on as a whole? *All forms need not be worked on in the same way, but each part, even empty areas, should have a role to play.*

In drawings using mass gesture, scribbled armature, or repetitive contour, has the basic form been identified strongly? *Is there a character to the form that seems to be the artist's unique observation?*

Is there a freshness or honesty of mark? *Does the artist effectively convey the act of looking or of direct visual experience?*

In compositions made using measuring techniques, is an integrity or solidity of connection established between the forms? *Do you feel the "rightness" of their placement in relation to each other?*

In compositions made using measuring of receding planes, is an effective sense of depth established? *Do the planes, seen together, suggest a coherent spatial environment?*

In compositions involving positive/negative shape, is a solid role established for all shapes in relation to the edges of the page?

In compositions made with a viewfinder or by considering the whole page, is there an interesting balance or relation of one part to another in the composition? *Do you feel that a piece of reality has been selected for the drawing that is interesting or sets up an engaging scene?*

PARTtwo

Elements of Form

INTRODUCTION

The next section of this book builds on the basic procedures described in Part 1 by exploring in depth forms and methods available to the art of drawing. This study begins with an introduction to the simplest elements—drawing, line, and shape— examining the way these basic units can be organized and inflected to suggest solidity, emptiness, energy, movement, emotion, atmosphere, light, shadow, and spatial position.

The great strength of drawing as an art form comes from the connection between the simplest mark and the most far-reaching vision. To truly know drawing you must learn how to access the expressive potential of simple forms, tools, and procedures to make artistic statements with depth, power, and interest. This art form thrives on the knowledgeable use of the most basic elements, and even the most complex approaches are based on a thorough understanding of the essential aspects of form.

The subject of Chapter 3 is organic mark and form. It approaches line and shape with a priority for the fluid forms of nature and the building blocks of curvalinear solids. Chapter 4 concerns the principles of geometry as they structure the world and provide order for form in drawings. Chapter 5 explores the experience of space, working with organizational principles for line and form that will bring control and power to the illusion of depth in drawings.

Chapters 6 and 7 investigate the use of value, light, and shadow to create volume and space and give visual and emotional force to compositions. Chapter 8 extends the discussion of light to a consideration of full color.

As you continue, it will be of great benefit to continue to refer back to the procedures covered in Part 1, adapting them to the specific subjects and exercises that follow.

Organic Mark and Form

3

MARK, LINE, AND SHAPE

The Field and the Mark

At its simplest, drawing is an art form of marks. Drawings can suggest many things in the real world: trees, waterfalls, light, solidity, emotion and idea. At its root, however, a drawing is made up of marks on paper (or another surface), and it is important in learning to draw to be aware of this basic truth.

In the drawing of a young man by the California artist David Park in **Figure 3.1**, a number of factors contribute to a feeling of gentle humanity and vulnerability in the subject. Park uses a thick simple mark, almost clumsy in its bluntness, yet without any sense of harshness or violence. The curves and angles that describe the contours of the body and face have a decisive elegance. Repeated arcs shape the chin and nose, and a delicately irregular echo passes between the lines forming the arms and shoulders and the rectangular edges of the frame of the drawing.

Park has expanded the body to fill and move beyond the frame so that the outer contours are **cropped.** This has the effect of bringing the viewer nearer to the young man but also causes a metaphorical identification of the surface of the chest with the surface of the paper. Indeed, it is difficult to take your eyes off this chest and easy to imagine inscribing the marks of the nipples and navel within this open space. Paper is skin, Park seems to be saying, and will feel each mark made on it.

Park's drawing works from an acute awareness of the two principal physical elements of drawing,

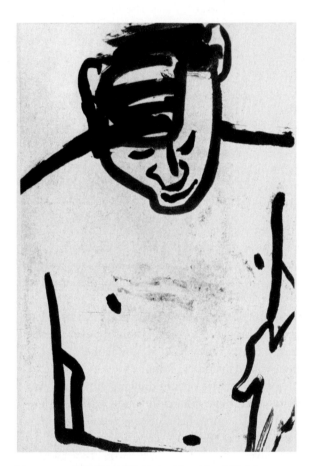

Figure 3.1 DAVID PARK, *Untitled (man)* (c. 1958), ink on newsprint, 19 × 13 in.

the **field** and the **mark.** The field in this case is a rectangular piece of drawing paper, and the mark is a thick ink stroke. It is clear from the purposeful clarity and simplicity of the drawing that the artist anticipated the interaction of mark and field, particularly in the framing and the play of line against the corners and broad interior.

Other fields can be more complex or varied than a simple rectangle of paper. In prehistoric drawing such as the curled-up bull on the ceiling of the Altamira cave in Spain **(Figure 3.2)**, rich natural textures have strongly influenced the artist's decisions. There is a fluid patterning of the bull along the rock surface, reminiscent of the flowing water that shaped the cave. The outside edges of the animal, which apparently were suggested by pre-existing cracks and ridges, blend easily with the natural patterns and forms of the cave wall.

Figure 3.2 Bull from the Altamira Cave (c. 13,000 B.C.), pigment on rock wall, about 50 in. long

This sense of a natural wholeness, of the perfect continuity of the created object with its environment, is surely one of the highest aspirations for a work of art. Looking at these images you can feel a sense of the profound connection of early humans with the force and grace of nature.

In fact, line is such an important and exciting type of mark precisely because of its power to suggest movement. As an artist moves his or her hand across the page, a mark is made that perfectly reflects the movement and pressure of the hand. Afterward, as the eye of a viewer moves along this line, that movement is re-created. In this way, a line can be said to express movement, both in the

Line

The most familiar category of mark—in many ways the most important—is **line.** Lines result naturally from the movement of the hand across the page; given a drawing instrument like a pencil or crayon, any adult or child will most likely react by making a line. It might be said that making a line on a page is the essence of drawing, as you *draw* the pencil across the paper. There is a joy in this simplest of art-making activities, a freedom and a sense of possibility that feel a little like skating out into the middle of a frozen lake on fresh ice where no one has been before. **(Figure 3.3)**.

Figure 3.3 Beginning with line

making of the line by hand and in the way the eye perceives it once it is made.

As a line proceeds from its beginning to its end, it draws the eye along in a manner specific to the character of the movement used to make the line in the first place. That movement can be smooth or jerky, fast or slow, simple or complicated. There can be lines with very clear real-world associations like the flight of a butterfly or a rocket, like crumpled wire or a silky ribbon. A line can embody or evoke an **abstract quality** through this kind of association. When that line is used in the depiction of a subject, some of that association is transferred to the subject.

The drawing in **Figure 3.4**, done from a posing model, uses a great boldness of line in broad arcing strokes to suggest the taut energy of muscular exertion in the arch-backed pose. The drawing has a strength based on the simplicity of the curves and the thick force of the line, which makes the Altamira bull in Figure 3.2 seem delicate by comparison. You cannot see the face of the model or many details of the body, but the sense of life and movement is unmistakable.

Gesture

Figure 3.4 is an example of **gesture drawing,** focused on the depiction of a simplified movement in the subject. Line is the primary element of ges-

Figure 3.5 *Bones,* charcoal, 24 × 18 in.

ture drawings, used in a **felt connection** with an idea about movement or energy. You can imagine the movement of the artist's arm in making this line, a confident swing from the shoulder. Through this line, the artist moves himself—and the viewer—into the experience of animal motion: figure, eye, arm, and line all moving in one charged curve. This idea of feeling a line as you make it is extremely important in drawing. The magic of the art form is the direct transfer of the artist's touch to the mark made. If you "live the mark," the mark will live.

The most appropriate subject for this type of drawing could be a living creature capable of movement, but it is also possible to use gestural marks to evoke energy in a broad range of subjects. **Figure 3.5** shows a group of bones drawn with a wonderful sense of sculptural dynamism conveyed through powerful gesture lines that make up the contours of the object. The bones were not actually in motion, but the thrusting lines convey the vitality common to all living things. The form seems to explode into physical presence, and the smooth lines used suggest the tactile character of the surfaces. Notice how the line thickens in places and almost disappears in others. This technique brings a kind of flexible tapering to the sense of the object as though the form were being

Figure 3.4 MARK BOOTH, student work (1985), ink and brush, 14 × 12 in.

stretched like rubber. The disappearing line allows the enclosed object to visually connect with the background in certain places, suggesting a rounded surface moving back in space. Where the line is thick and bold, it pulls the form strongly forward. The form seems to change and shift as the eye moves along each edge, reinforcing the feeling of organic flexibility.

Quality of Line

Different qualities or visual characteristics of line are to be found everywhere in nature, and human psychological reaction to various types of line in drawing surely derives in part from daily visual experience. The pumpkin tendrils in the photograph by Karl Blossfeldt in **Figure 3.6** suggest the smooth, joyful flow of organic growth while the jagged fork of lightning in **Figure 3.7** has a nerv-

Figure 3.7 Lightning, photo

ous fragility that belies its power but accurately suggests its volatile ephemerality. The sweeping marks of the Islamic calligraphy pictured in **Figure 3.8** have a special importance that is tied to their function as linguistic symbols, but they also have a strong abstract character as marks, which can suggest meaning even to the viewers who do not actually read the language. Here poetry and

Figure 3.6 KARL BLOSSFELDT (1865-1932), *Pumpkin Tendrils*, photograph, German Cucurbita (c) 2009 Karl Blossfeldt Archiv / Ann u. Jurgen Wilde, Koln / Artists Rights Society (ARS), New York

Figure 3.8 AL MU'TAMID, *Al Mu'tamid* (2002), pen and ink

strength are combined in a complex state-ment made within an energetic and subtle tradition. The "speed" of the mark—the pace at which the eye follows it—gives an urgency to the message even as it suggests balletic elegance.

The marks chosen by the English artist Frank Auerbach to describe a man's head (see **Figure 3.9**) also have a somewhat **tangential** relationship to the **nominal subject matter** of the drawing. The face seems static, if a bit tense, but the form is shattered into jagged, overlapping shapes, suggesting an emotional frenzy. You might imagine that you are being shown the inner turmoil behind the public facade of the individual portrayed, but it is more likely that the emotion in the portrait is of the drawing's creator. You re-experience the spastic movements of his pencil scratch-ing across the paper and come to understand the artist's agitated vision of humanity.

The Jackson Pollock drawing in **Figure 3.10** has a nervous vibration similar to the one by Auerbach. The lines (actually drip-pings and spatters of ink) stretch to the edge of the field as though the drawing seeks to describe a whole cosmos. Pollock's drip mark is agitated, but extremely fluid, bringing to mind exploding stars or the movements of whirling dancers.

The character of Sam Messer's line, on the other hand, has a straightforward con-nection to his interest in portraying the com-plexity of the human spirit. Wit, soul, and a rumpled tactility combine in the convoluted, fluctuating lines that make up his *Dreaming of That Damn Dog* (**Figure 3.11**). The line seems extremely casual or even careless, but in fact the forms of the figure occupy the field and divide its space with an assuredness that brings us directly into the presence of the sitter. The raw character of the mark sug-gests that no "prettifying" has taken place in the transcription of the human moment. In this case, the line also perfectly describes the subject's character: crumpled and bony, but as full of life and surprises as a well-told story.

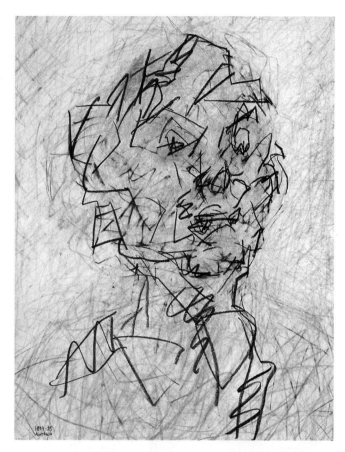

Figure 3.9 FRANK AUERBACH, *Head of JYM*, pencil, 30 × 22.5 in.

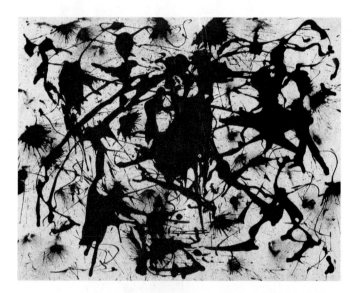

Figure 3.10 JACKSON POLLOCK (1912-1956), *Untitled* (ca. 1950), ink on paper, 17 3/8 × 22 1/4 in. (Gift of Mr. and Mrs. Ronald Lauder in honor of Eliza Parkinson Cobb. [448.1982] Digital Image, The Museum of Modern Art/Licensed by SCALA/Art Resource, NY. © The Pollock-Krasner Foun-dation/ARS, NY)

ISSUES AND IDEAS

❐ The essential elements of drawing are the field (or surface) and the mark.

❐ Line, an especially important form of mark, is capable of expressing movement through the movement of the artist's arm and hand.

❐ Line quality is enormously variable and can suggest emotional or narrative overtones in a drawing.

Suggested Exercises

3.1 Expressive Line, p. 69.
3.2 Responding to Outside Stimulus p. 69.
3.3 Gesture Studies of the Figure p. 70.
3.3a Gesture Study (Variation) p. 71.

Sketchbook Link: Line Quality

In your sketchbook, use a flexible tool such as a soft pencil or brush-pen (see Appendix A) to explore the contours of organic forms you see around you: trees, plants, rumpled cloth, clouds, or perhaps a passing dog. Try to emulate the surfaces or textures of the form by the quality of lines you make to describe the outlines or edges within the form. Strive for a distinctive character of line rather than descriptive accuracy.

Line Defining Shape

When a line or a number of lines connect to form a closed circuit, the resulting entity is called a **shape.** Shapes are strongly influenced by the nature of the line that forms their border, but they also have certain characteristics all their own. Most notably, shapes suggest objects. If line's primary nature is one of movement, shape has a basic tendency to convey physical presence.

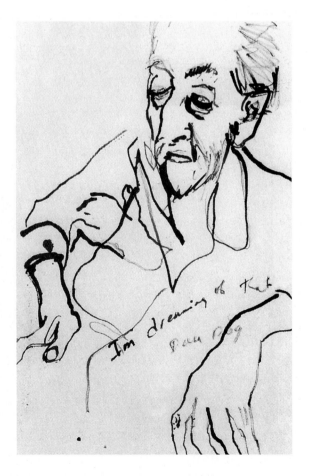

Figure 3.11 SAM MESSER, *John Serl,* (1990), ink on paper

Figure 3.12 Wolf Jaw

Figure 3.13 Dandelion

Figure 3.14 *SONIA NOSKOWIAK, White Radish*

Figure 3.15 Sand dunes

Figure 3.16 River

Associations of shape, like those of line, are at least in part based on everyday life experience. People naturally associate curving shapes with softness and jagged ones with pain. Nature is a particularly rich source of interesting shapes **(Figure 3.12 to Figure 3.16).**

Joan Miro has mixed all sorts of shapes into *The Family* **(Figure 3.17)**, creating a complex

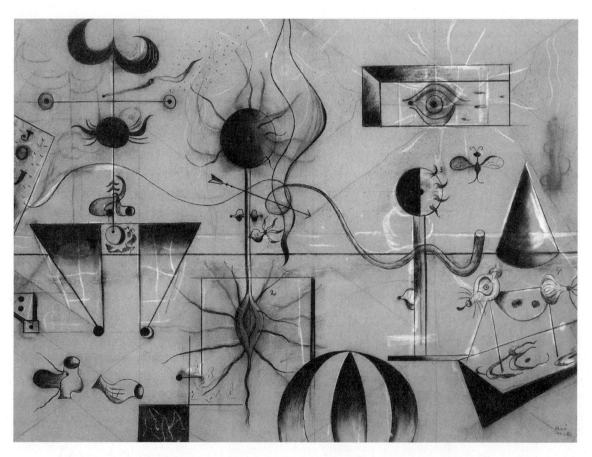

Figure 3.17 JOAN MIRO, *The Family* (1924), charcoal, chalk and conté crayon scored on sandpaper, 29 1/4 × 41 in. (Gift of Mr. and Mrs. Jan Mitchell. [395.1961] Digital Image ©The Museum of Modern Art/Licensed by SCALA/Art Resource, NY. © ARS, NY). © Successión Miró/Artists Rights (ARS), NY/ADAGP, Paris

Figure 3.18 JEAN (HANS) ARP (1888–1966), *Automatic Drawing* (1917–18 [inscribed 1916]), ink and pencil on paper, 16 3/4 × 21 1/4 in. (Given anonymously. [109.1936]. © Digital Image © The Museum of Modern Art/Licensed by SCALA/Art Resource, NY, Jean Hans Arp © 2009 ARS, New York)/VG Bild-Kunst, Bonn

through shape association: Father has a pompous curlicue mustache and immobile block-like legs, while mother is a mysterious hydra with soft tentacles.

Hans Arp's *Automatic Drawing* of 1916 **(Figure 3.18)** has less narrative attached. In fact, the artist consciously avoided a predetermined concept for the drawing by letting his hand wander over the page, producing random marks. He later selected a number of the lines to ink in, turning them into shape-based "objects." Although resolutely abstract, the drawing defines a specific **experience of form** with many possible real-world associations. The linear nature of the original marks is still a strong influence on the drawing, imparting a gentle undulating movement.

mayhem of differing personalities. Even though the figures are not specifically human in their outward appearance, we might recognize certain social and emotional characteristics, conveyed

Shape and Composition

Qualities of movement, emotion, or narrative can be transferred from line to shape and finally to any composition in which shapes and lines interact with each other. In the case of organic forms, visual qualities often derive from patterns of growth or natural structure. Discerning these patterns and bringing them into drawing through line and shape can express a strong link between subject and form. There is a dramatic comparison in **Figure 3.19** between the thin, wiry line that describes a beleaguered tree

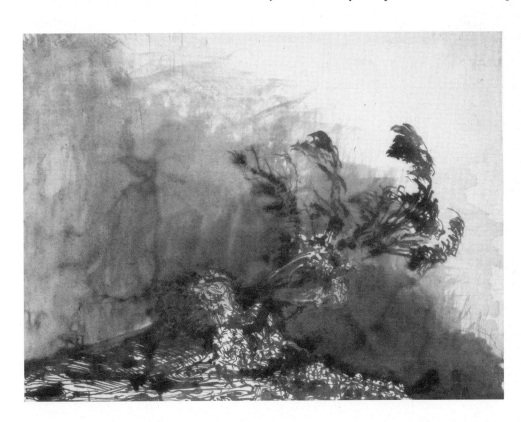

Figure 3.19 VICTOR HUGO, *Tree Flattened by Wind*, pen and brown ink wash, 8 9/16 × 11 7/16 in.

and the great dark shape of turbulent atmosphere behind, rising like a wave.

The marks describing the plant forms in the drawing by Bada Shanren in **Figure 3.20** extend into the field of the page with a beautifully soft curvilinear rhythm, making great use of the leftover blocks of white paper. These **negative shapes** in the composition are important visual elements in themselves, bringing an enveloping void into the rectangle and emphasizing the slender fragility of the plant stems. They act graphically to stabilize and strengthen the composition as discussed previously in Chapter 2, p.39.

Georgia O'Keeffe on the other hand, plunges us into the midst of the flower forms in **Figure 3.21** by taking the image off the edges of the page in all four directions, filling our field of vision. The swimming lines seem to fold us into the center of this image while the rich dark ruffles caress the eye. Dynamic organic form is overwhelming in this composition—powerful yet soft and comforting.

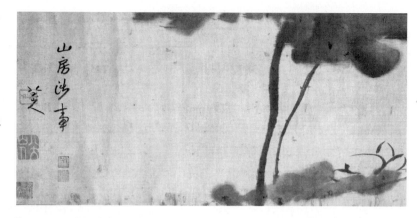

Figure 3.20 BADA SHANREN (ZHU DA), *Bird in a Lotus Pond*, ca 1690 (The Metropolitan Museum of Art, New York, NY, U.S.A.

Sketchbook Link: Natural Shape

Practice simplifying the forms of natural objects (including people) into soft shapes or interlocking groups of shapes. You can define shape with expressive edges (see previous Sketchbook Link) or use a brush or brush-pen to make solid shape strokes (see "Mass Gesture" Exercise 2.2). Strive for immediacy of impression rather than descriptive legibility.

ISSUES AND IDEAS

❏ Shapes are formed by a closed line or group of lines.

❏ Shapes inherently suggest physical presence or the existence of an object.

❏ The character of a shape is strongly influenced by the quality of the line that defines it.

❏ Lines and positive and negative shapes can influence the character of a composition by their innate character, and by their interaction with each other.

Suggested Exercise

3.4 Shapes from Nature, p. 71.

acter of mark, giving the drawing a physical richness and tumultuous vivacity. The figures seem to be literally pulling themselves out of a swamp of drawing material with odd squiggles and smirches adding to the mayhem. The artist's skill at suggesting physical form with simple contour is such that the drawing easily merges illusionary depth and a bold assertion of marks on the paper.

The short repetitive marks, or **hatching**, with which Vincent van Gogh draws the rocks, trees, and grass in **Figure 3.23** give a wonderful sense of the complexity of natural surfaces. Directional changes of mark suggest faceted rock or the bunches of leaves. At the same time, the vibrating rhythmic stroke suggests the bursting life force of a summer day in the country and the artist's own excitement at being immersed in work. Art, nature, and van Gogh's passionate connection with the moment are all conveyed at once by the frenetic pace of his mark making.

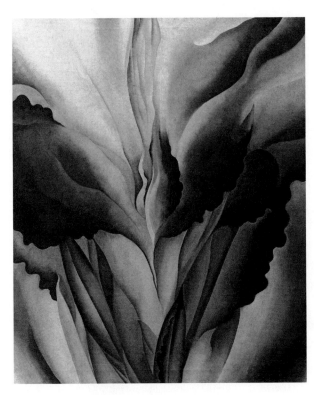

Figure 3.21 GEORGIA O'KEEFFE, *Red Canna*, oil/canvas, mounted on masonite

Complex Mark

Different types of mark can be layered and mixed in a drawing, creating a complex interplay between different physical qualities, types of movement, variations in density, and sense of distance. Anthony Van Dyck's page of studies **(Figure 3.22)** is a miasma of shifting **line weight** and diverse char-

> ## Sketchbook Link: Texture Marking
>
> Try sketching an extremely complex and irregular subject: a bush, a pile of junk, the stuff on your plate during lunch. Use a loose material such as a brush with ink or a mixture of charcoal and felt tip pen and try to evoke the colliding textures and interweaving forms. Do not try to detail every piece, although you might pick out one or two clearer areas within the whole for more careful description. Mainly try to vary your mark and use of material to create a sense of energy and tactile density.

ISSUES AND IDEAS

❏ Lines and marks of various qualities can be mixed and layered in one drawing.

❏ Different experiences of movement, atmosphere, illusory form, and graphic mark can coexist and complement each other.

❏ Complex mark can suggest chaotic movement or the density of nature.

Suggested Exercise

3.5 The Garden p. 73.

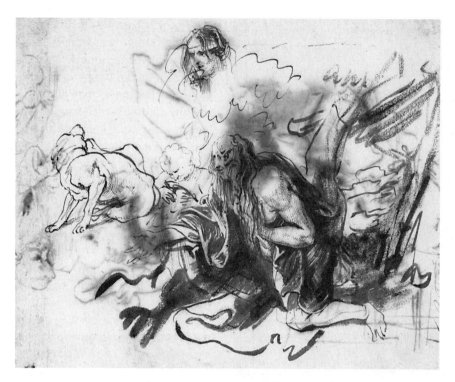

Figure 3.22 ANTHONY VAN DYCK, *The Penitent Magdalen* (c. 1618–1622), pen and brown ink, brown wash, 7 1/4 × 9 in.

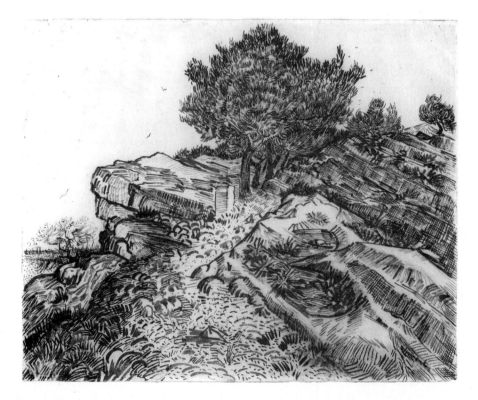

Figure 3.23 VINCENT VAN GOGH, *Rocks and Trees, Montmajour*, reed pen and ink over graphite, 19 3/8 × 24 in.

CONTOUR AND ORGANIC FORM

Outside Contour

The connection between a drawn shape on the page and a sense of solid presence is very strong. Historically, one of the most important functions of line in the art of drawing has been to describe the edges of solid objects in the imaginary "space" of the field or page. Line can be referred to in this role as **contour** or **outside contour.** There are a number of different types of contour with one thing in common: They describe the outer surfaces of forms or volumes. If asked to draw a simple object, like an apple, almost everyone will begin with a contour line to describe the outside edge. The line in the drawing of the bull in Figure 3.2 is an outside contour, as are many of the lines used in gesture studies of the figure in action (Exercise 3.3). A line used as an outside contour can suggest movement as a gesture, simultaneously the paper field into two entities, object and space. The area enclosed by the contour line becomes the focus of attention, and the area outside "drops back" as a background. This effect is so automatic that it is taken for granted, but it is important for you as an artist to understand what is happening to gain a clearer control over the phenomenon.

Essentially, when looking at an empty page, a viewer will subconsciously try to "see" something in it. This phenomenon derives from the day-to-day experience of using the eyes to navigate and interpret the visual aspects of the world. The brain is in the habit of looking for spatial relationships and significant visual information and is primed to respond in this way. A piece of paper in its white emptiness bears so much resemblance to an empty place, or a field of depth, that viewers will usually be quite accepting of the idea that marks or shapes are not "on" the paper, but "in" the depth that exists there. It is remarkably easy for an artist, even a child, to open up this conceptual reference to objects in depth with just a few lines. The viewer is not really fooled into thinking he or she is looking at a spatial re-

ality but understands and participates in the image on this level nonetheless.

Despite the simplicity of the child's method in **Figure 3.24**, there is no question that viewers will read the triangles of white paper between the legs as empty space and the circular contour lines in the figure as objects—heads or bodies. However, to decisively engage the possibilities of this technique as an artist, it is important to sensitize yourself to the particular behavior of contour lines in describing solid objects or forms.

An outside contour can be thought of as the edge of a solid form, but a better term might be the **profile** of the form because it implies a point of view rather than an absolute edge (see **Figure 3.25**). By definition, solid form continues behind the view that is presented at any given time. As the form turns or as viewers move their point of view in relation to the form, they perceive different "profiles" or views of the edge of the form. The sculptor Rodin was said to have modeled his sculptures by constantly rotating them, always looking at the changing profile of the form against the background to see accurately how the surface was articulated. Even

Figure 3.24 ROBERT BOHM, children's drawing, pencil, 7 7/8 × 8 3/4 in. (Gabriele Munter and Johannes Eichner-Stiftung, Munich)

a slight turn in a complicated form like a leg or an arm noticeably changes the profile, and is a good idea to bear in mind that the profile of an organic form really represents a changeable horizon beyond which the form continues.

Josef Albers used simple contour to maximum advantage in **Figure 3.26**. His subtly varying contour beautifully evokes the soft curves of a grouping of geese. Little else is needed to convey the form of each bird, which we imagine to be rounded and flexible like their outside contours.

Sketchbook Link: Contour Profiles

Sketch an object on a table in front of you, concentrating on a simple description of outside contour. Turn the object slightly and draw it again next to the first sketch, noting how the outside contour has changed. Repeat this process until you have a series of simple sketches that together suggest a sequence of rotation of the object in space.

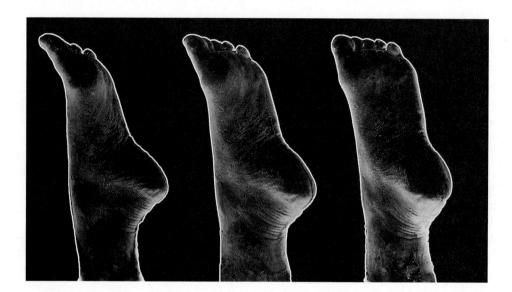

Figure 3.25 Profiles of a rotating foot

ISSUES AND IDEAS

❑ Outside contours are lines that define the profile or outside edge of a three-dimensional (3-D) form.

❑ Drawing can, simply through contour line, readily suggest the presence of a solid object in the illusory "space" of the page.

❑ An object's contour is closely connected to the artist's point of view, changing as the object is rotated and the 3-D character of the surface is revealed.

Suggested Exercise

3.6 Observing Natural Contours, p. 74.

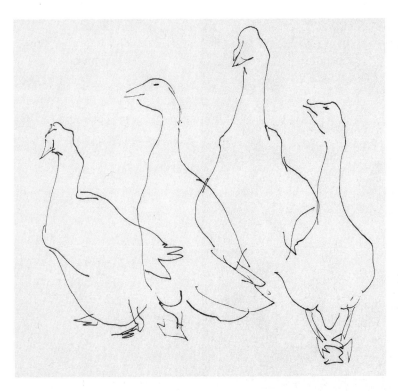

Figure 3.26 JOSEF ALBERS, *Four Geese* (1917), pen and ink, 10 1/8 × 12 5/8 in.
© 2009 The Josef and Anni Albers Foundation/Artists Rights Society (ARS), NY

Elliptical Contour

A special category of contour line is the **elliptical contour,** a type of line that describes the edge of part of a circle or ellipse with a degree of geometric clarity and regularity. The diagram in **Figure 3.27** shows a number of circles and ellipses with thicker lines showing contours derived from them.

As Rodin understood, looking at the visible profile or edge of a form is the easiest way to see the 3-D character of its surface. Within the contours, however, the 3-D character of the form can be difficult to describe without the use of directional light or descriptive interior details. The classic example of this problem is the sphere, which appears as a flat circle unless there is some descriptive modulation of the facing surface. Still, every curve has the potential to describe the profile of a spherical surface and with very minor intervention, you can access a greater sense of 3-D possibility using only outside contours.

Amadeo Modigliani's *Caryatid* **(Figure 3.28)** is made up almost entirely of elliptical contour lines.

Through this limited vocabulary, the artist is able to suggest the organic roundness of the human body with very little shading or articulation of the surface. Each curve works with a neighboring curve

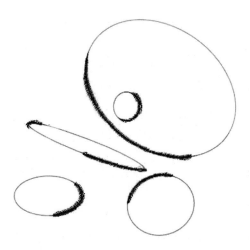

Figure 3.27 Elliptical edges

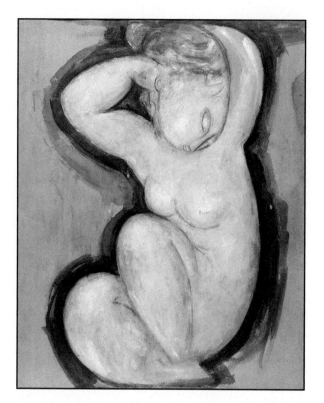

Figure 3.28 AMADEO MODIGLIANI, *Caryatid,* Watercolor and gouache, 25 1/2 × 19 5/8 in.

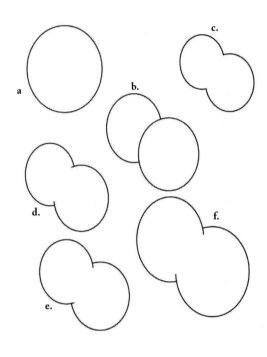

Figure 3.29 Elliptical contour overlap

on the opposite side of the form to create an elliptical shape and a balloonlike sense of volume. The result is a thoroughly convincing sense of rounded three dimensionality, although the broad, perfectly circular character of the ellipses suggests a stylized or abstracted sculpture rather than a real person. The actual human body is much more complex but can still be described well by elliptical contours in more irregular configurations (see Chapter 9).

Modigliani also uses a technique for activating the 3-D reading of a form described with simple contour by moving edges in front of or behind each other. This technique is called **contour overlap,** previously discussed in Exercise 2.6 and also shown in Figure 3.50. Overlap is probably the simplest means of suggesting three dimensionality in drawing. By covering part of one form with another, as the torso in Figure 3.28 is covered by one of the knees, an artist can suggest that the second form is in front of the first and therefore that they both exist in space, or three dimensions. Diagram **a** in **Figure 3.29** shows an ellipse defined by a sim-

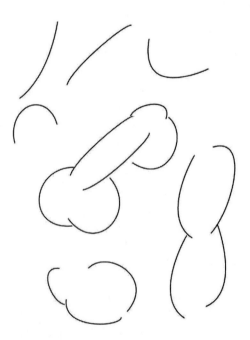

Figure 3.30 Free elliptical contours

ple outside contour. While it could be possible to imagine that this ellipse encloses a rounded 3-D form, say an egg, it might also be just a flat disk. Diagram **b** shows the circle overlapped by another just like it, and something has changed. Now, although it is possible to imagine that these are two overlapping disks, there seems to be a greater possibility that they are spherical forms. Merely by introducing the idea of three dimensionality through overlap, a 3-D reading of the interior form has become a stronger possibility for the viewer. Diagram **c** removes the dividing line that clarifies the overlap, but the complex bulbous shape still reads more like a volumetric form than the simple circle. Diagrams **d** and **e** show another strategy: using slightly overlapping lines to suggest interconnection between the elliptical forms with one in front. These configurations could be said to suggest rounded 3-D form even more strongly than the simple overlap. Diagram **f** takes the technique one step further with each ellipse overlapping the other, creating a kind of figure eight. The sense of rounded volume is still strong even if it is a little more complicated to imagine what is going on inside the volume.

Although this demonstration might seem trivial, it actually leads to a method that is one of the most powerful and universally employed approaches to drawing rounded 3-D forms, particularly the human figure. **Figure 3.30** shows a number of elliptical contours or sections of circular curves. As with the circle in Figure 3.29, the curves tend to appear as 2-D arcs when drawn in isolation, but when paired or put in more complicated groupings, they have a noticeable tendency to describe volumetric form, particularly when overlap is employed. Perhaps because they are incomplete as geometric figures, the curved contours are both more three-dimensionally

suggestive and more flexible than the overlapping circles in Figure 3.29. Ultimately, even small references to an elliptical edge can suggest that a form bounded by such a contour is a rounded volume.

In **Figure 3.31**, a working sketch by the renaissance artist Raphael, elliptical contour is used to build variations of a compositional grouping of the Madonna and child. Every line in the drawing is an elliptical contour, describing legs, shoulders, toes, and facial features. Broad elliptical arcs indicate lines of force uniting the configuration of forms and giving a sense of movement and energy to the whole. Despite the simplicity and apparent speed of the linear treatment, there is an

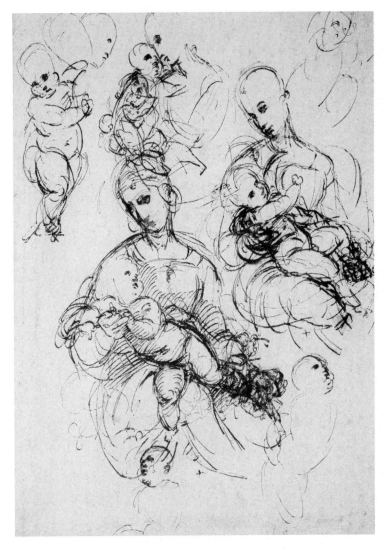

Figure 3.31 RAPHAEL, *Studies for a Virgin and Child* (c. 1505), pen and brown ink, 10 × 7 1/4 in.

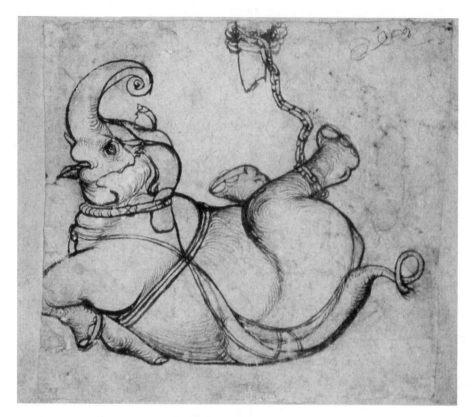

Figure 3.32 RAJPUT KOTA, *A Fallen Elephant* (c.1700), brush drawing on paper, 8 5/8 × 9 7/8 in.

immediate and convincing sense of rounded volume.

A great deal of art throughout history has relied on elliptical contour structure as its basic tool. Interwoven elliptical contours give a combined sense of bulbous form and complex writhing movement to the drawing from India of a chained elephant from India shown in **Figure 3.32**. The contours function simultaneously as serpentine gesture lines and as indicators of rounded physical form. As in much Indian art, there is a high priority for sinuous, decorative elegance in the graphic character of the work. All these factors coexist easily through the masterful, directed use of elliptical contour.

Some new types of art also use this kind of contour. One is cartooning, such as the drawing of Bugs Bunny in **Figure 3.33**. The simplified linear definition of Bugs is important in terms of efficiency; it allows the animator to make the thousands of drawings necessary for film production.

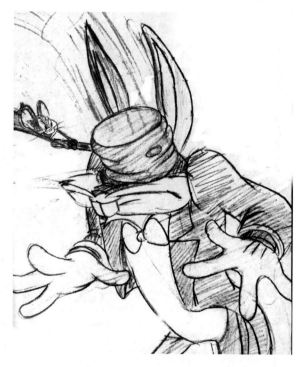

Figure 3.33 Bugs Bunny, colored pencil (BUGS BUNNY and all LOONEY TUNE characters, names and all related indicia are TM & © Warner Bros. Entertainment Inc. All Rights Reserved.)

At the same time, there is a humorous sense of bulbous extrusion in the form, which reinforces the expression of the character depicted.

Another common use of curved contour is in the renegade art form of graffiti, where letters, often the writer's name or nickname, are given cartoonlike character and bold 3-D form **(Figure 3.34)**. As with the animated cartoon character, the speed with which this type of line is capable of indicating solidity is important, for the work is often done under extreme physical or societal pressure.

Sketchbook Link: Elliptical Head Sketches

Do a series of drawings of the back of the heads of people in a cafeteria, assembly hall, or other public space. Use elliptical contours to define the forms of the skull, ears, hair, shoulders, and so on.

Try to link your contours to the rounded volume of the forms, exaggerating it if necessary.

ISSUES AND IDEAS

❏ Elliptical contours are lines based on the curved edge of a circle or ellipse.

❏ Elliptical outside contours efficiently suggest rounded form within, especially when used in pairs as opposite edges.

❏ Overlapping the ends of adjacent contours increases the 3-D reading of rounded form in space.

❏ Elliptical contours can suggest curvalinear gesture while also defining rounded form.

Suggested Exercises

3.7 Drawing the Figure with Elliptical Contour, p. 75.
3.8 Caricature and "Tag" p. 75.

Figure 3.34 ANONYMOUS, *NY Grafitti* (2006)

Contemporary Artist Profile
ELIZABETH MURRAY

Contemporary New York painter Elizabeth Murray **(Figure 3.35),** the subject of a major retrospective at the Museum of Modern Art in New York in October 2005, has been an important figure in

Figure 3.35 ELIZABETH MURRAY, working on Whazzat project in Gemini artist studio, April 1996 (Photograph © Sidney B. Felsen 1996)

defining the new territory for expression open to artists today. Murray's roots lie in the severe tradition of **formalist abstraction,** but there is a playfulness in her imagery and approach foreign to that twentieth-century dogma. Her layering of rectangular picture planes in *Popeye* **(Figure 3.36)** reinterprets **Cubism** by way of **minimalist** Frank Stella's shaped canvases of the 1960s, but in a loose and funky way. Her borrowing of the elliptical contour style used in cartoon imagery differs from similar references by **pop artists** such as Roy Lichtenstein because of her insistence on a sense of the handmade surface and personalized form and content. The comical character of the balloonlike form is retained, but with a mute mystery in its new application to the personal abstract expressive priorities of the artist.

Figure 3.36 ELIZABETH MURRAY (1940–), *Popeye* (1982), pastel and charcoal on cut-and-pasted paper, 76 1/4 × 37 5/8 in. (193.8 × 95.8 cm) (Gift of Abby Aldrich Rockefeller [by exchange]. [389.1984] Digital Image The Museum of Modern Art/Licensed by SCALA/Art Resource, NY) © 2009 Elizabeth Murray, courtsey Pace Wildenstein, NY

Cross Contour

Another type of contour, related in many ways to outside elliptical contour, is **cross contour.** In a similar way, cross contour uses line to map the curved surface of depicted forms in a drawing, but instead of dealing with the profile of the form, it moves within the outer boundaries and maps the surface facing the viewer. In a sense, you could think of cross contour as the multiple profiles of

the form actually drawn onto its skin. Although cross contour on rectangular surfaces can be useful, the most prevalent form of this technique involves curved contours to describe rounded organic form. There are many strategies for applying cross contour to the surface of forms (see **Figure 3.37**). It can be useful to mix and overlap cross contours, to let them fade in and out of application, or to use them in a "broken" manner. Layering cross-contour strokes in different directions is sometimes called **cross hatching.**

Figure 3.37 Approaches to cross-contour

Cross contour is one of the most frequently employed techniques for suggesting the roundness of form. As you can see from the drawing in **Figure 3.38** by contemporary artist Cheol Yu Kim, fine cross contour looks almost like smooth tonal gradation, building up toward the edges of the form. It has the added power, however, of "following" the form with its directional marks, giving a sense of planar specificity to the surface. Drawings created with careful cross contour read almost like carved sculpture in their exactitude of undulating or bending surface.

Even though Kim's forms resemble organic creatures, they have a mechanical regularity that suggests machine-made parts. Cross contour frequently imparts this mapped, diagrammatic feeling, especially when the cross-contour lines are regular and even. Varying their weight and density or combining hatching in different directions can soften the effect.

Albrecht Durer's *Arm with a Sword* (**Figure 3.39**) has a powerfully tactile surface created with a mixture of cross contour and cross hatching. He has varied his application of mark in relation to a strong directional light source and woven together many different directions of stroke. The slinky surface created is still somewhat otherworldly in intensity of the hatchmarked detail, but it is certainly flexible and soft. The precision of mark guides the eye across the surface of the form, creating a dramatically 3-D twisting and turning in the gesture.

Underground cartoonist Robert Crumb uses a slightly less regular elliptical hatching style to de-

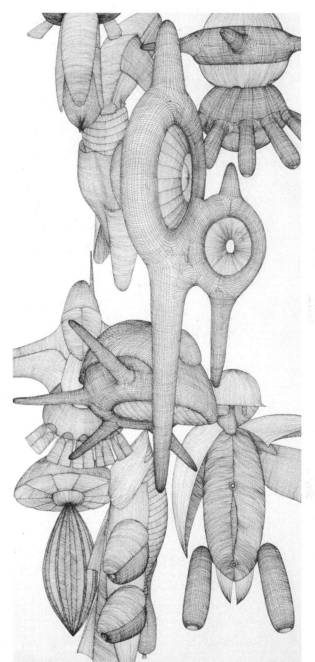

Figure 3.38 CHEOL YO KIM, drawing for Sculpture (2002), pencil on paper, 31 × 15 in.

scribe his own hand in **Figure 3.40**, but the exaggerated knobbiness of the surface is perfectly suited to the use of cross-contour technique. The interruption of the cross-contour lines in the back of the hand allows for the description of a directional light effect, rooting the drawing in observed reality.

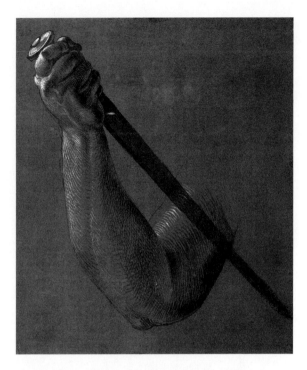

Figure 3.39 ALBRECHT DURER, *Arm of Lucretia* (c. 1508), brush, heightened with white, on grey paper, 9 × 7 7/8 in.

Figure 3.40 ROBERT CRUMB, *Drawing of A Hand* (Courtesy of Agence Litteraire Lora Fountain & Associates)

Sketchbook Link: Cross-Contour Hands

Try sketching your hand using cross contour. After laying out the hand position with a few simple lines, start by defining each joint of the fingers as a form bounded by elliptical edges. Then work into the fingers using cross contour spanning the width of the form. In the palm or back of hand, use short strokes laying on the surface of the bumps and depressions of the "skin" of the form in your drawing. Then try to connect them into longer bands. Experiment with different levels of looseness or tightly connected cross contour.

ISSUES AND IDEAS

❏ Cross contour brings elliptical curves within the boundaries of form to map the surface.

❏ Cross contour can be applied in one direction or in any mix of directions as long as the mark follows the surface of the form.

❏ Cross-hatching refers to a softer, woven application often used to build up tonal areas of shadow.

Suggested Exercise

3.9 Cross-Contour Tree Trunk, p. 76.

Exercise 3.1 Expressive Line

As you have seen, line quality can bring meaning or mood to a drawing through association. The most direct way for an artist to access this power is to feel the character of movement of the arm and hand as the mark is made, connecting it with a physical quality of emotion. This can take some practice and experimentation to fully grasp. In this exercise you will simply make lines, but they should be as full of feeling as possible **(Figure 3.41)**. On a large drawing pad (30 by 40 inches), practice making lines with a stick of soft charcoal. Each line should span the length of the pad. Use your whole arm in the motion that creates the line, drawing from the shoulder. Think of the passage of the charcoal across the page as a short drama. It begins, perhaps slowly and delicately. It picks up force and speed and ends with an abrupt reversal of direction. Vary the passage of your line across the page in as many ways as you can think of, but each time try to experience the character of the motion as fully as possible, as though you were moving in a dance. You can also vary pressure, producing bold swaths of tone or fading into a wiry thinness. Try using the side of the charcoal, turning it slightly as you draw to make ribbonlike strokes. Fill ten pages with line in this way. When you have finished, pin the sheets to the wall and compare the

Figure 3.41 Varieties of line

marks. Where you have been particularly successful, the mark should allow your eye to re-create the movement and associated feeling just by looking.

Exercise 3.2 Responding to Outside Stimulus

As a variation on Exercise 3.1, work with varying line qualities, but tie your associative movement in making the marks to a piece of recorded music. The rhythmic qualities of some music might result in a certain speed and energy of line while the emotional qualities in certain musical passages or the rising and falling textures of sound might inspire a gentler mark **(Figure 3.42)**. There is no "right" interpretation except to genuinely experience the music and transfer its power down your arm and onto the page.

Dynamic movement. The point seen in dynamic terms, as an agent.

Simple linear motion, self-contained. Free line.

Free line , companion line (The melody above: accompanied)

Two secondary lines, moving around an imaginary main line.

Dividual-individual connected by rhythmic articulation

Figure 3.42 Movement of line, diagram adapted from *The Thinking Eye* by Paul Klee

Exercise 3.3 Gesture Studies of the Figure

You must have access to a posing model for this exercise. A professional model knows how to coordinate his or her frozen pose to seem like a moment of action. When you have some practice in this area, you can move out into the world, drawing passing people on the street with this same approach.

In the studio, work on a large pad (30 by 40 inches) placed vertically on an easel with the center of the pad at roughly the level of your eyes. The easel should be angled to the model stand so that you can easily see both the model and your drawing without turning your head too much or having to peer around the pad (see Chapter 2, p. 23). It is important that you stand squarely in front of the pad at a distance of the length of your arm from the paper. The model should be instructed to take a series of quick poses, about 60 seconds apiece, and you should be aware of this time frame as you approach your drawings.

As the model takes a pose, let yourself twist or bend in a similar manner, thinking about the nature of the movement the model is making. As you look up and down the figure, try to imagine a line in the pose that summarizes the main force of the gesture. It might be the arc of the bending back, or a strong diagonal line running through the torso and down one leg **(Figure 3.43).**

Ideally, the line that you find will have a strong role to play in the model's movement: turning, twisting, thrusting, bending, and so on. Using your whole arm, lay this line down on the paper, trying to give it the same energy and freedom of your best lines from Exercise 3.1. Do not worry about detail; consider only energy and an accurate depiction of the character of the movement. As soon as you have made your mark, step back and compare it with the posing model. If an important aspect of the model's pose differs from your drawing, redraw the line right over the first one. A frequent mistake is to underestimate a bend in the pose or the sharpness of a change of direction. Be especially careful about drawing the gesture overly straight, calm, or static. The goal is to get the energy of a living human being into your drawing through the power of line. When you are satisfied with your first line, search the model's pose for a secondary or complimentary linear movement. Lay this into the drawing with the same priority for energy with which you made the first line. Keep adding parts of the pose to your drawing, but not as arms, legs, hair, and so forth. Rather, each new mark should enter the drawing as a line of energy that works in tandem with those already on the page. Your lines may be closely based on the contours of the model's body, but they should enter the drawing as lines with the same priority for energy and emotion as in Exercises 3.1 and 3.2.

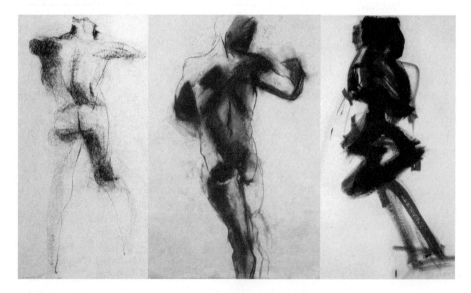

Figure 3.43 CYNTHIA LAHTI, student work (1986) charcoal, 24 × 18 in. each

Exercise 3.3a Gesture Study (variation)

It is also possible to work from any object with linear form, such as a tree or a draped sheet. Try to find a few major linear components in your subject. These could be outside contours, but they could also be lines of shadow, large fragments of form, abstract linear connections across the form, or even just a simple thrust to the general formation that you can feel even if you can not exactly see it. Get these few lines down with broad marks that suggest movement as Ingres has done with the folds of fabric in **Figure 3.44.** Do not worry about small details; the real goal here is energy.

Linear gesture drawing should be a warm-up exercise every time you draw. Do ten drawings, each lasting about three minutes, to reacquaint yourself with the importance of focusing on overall energy.

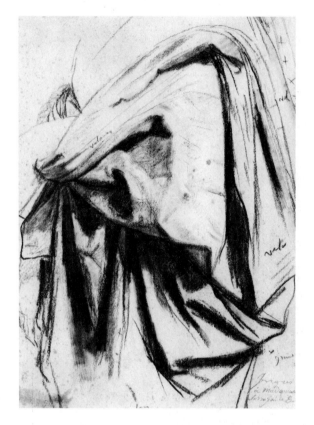

Figure 3.44 JEAN AUGUSTE D`OMINIQUE INGRES (French, 1780–1867), *Study for Drapery* (The Metropolitan Museum of Art, Roger Fund, 1937 [37.165.100] Image © 2008 The Metropolitan Museum of Art)

Exercise 3.4 Shapes from Nature

Materials: vine charcoal, soft compressed charcoal or India ink and large brush, sketchbook (18 by 24 inches), and large sheet of heavy drawing paper at least 40 by 30 inches.

In this exercise, you move from the consideration of line to the exploration of shape. As you have seen, the essence of line in drawing is the expression of movement while shape is more concerned with expressing a presence or form. Still, lines have an important role in a shape-based drawing, usually as the outside contours that are the boundaries of shapes.

The photograph of a monkshood shoot by Karl Blossfeldt in **Figure 3.45** has a sense of upward lift and not just because you might know that the plant is growing in that direction. Rather,

the outside edges of the white stalk form linear contours that lift the eye up to the handlike leaves about to spread. Still, it is a wonderful fact that the character of this contour so perfectly expresses the growth pattern or "action" of this organism and that this connection is to be found throughout the world of natural forms.

For your drawing, try to find a natural object—plant form, shell, or bone—in which you feel a strong character of movement or memorable presence. Make several small sketches (18 by 24 inches) to determine the view of the object that seems the most expressive and interesting. As you sketch, pay special attention to your line quality and let the object fill the page. Use your material broadly to block in the shape, as in **Figure 3.46,** being sensitive to the character of the contours that are formed at the edges.

Figure 3.45 KARL BLOSSFELDT, *Monkshood,* photograph
(c) 2009 Karl Blossfeldt Archive, Ann U. Jurgen Wilde, Koln /Artists
Rights Society (ARS), New York

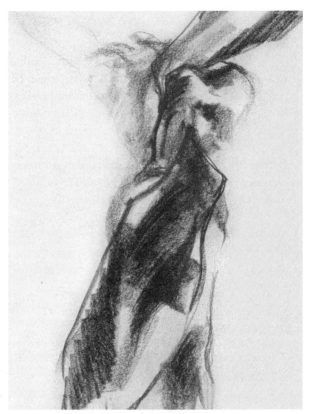

Figure 3.46 CYNTHIA LAHTI, student work (1986)
charcoal, 24 × 18 in.

A good approach is to turn your charcoal sideways so that you have a wider stroke and are dealing immediately with the interior of the shape, not just making a line to be colored in later. If you are using a brush with ink, the instrument will guide you in this direction anyway. Rather than spending a great deal of time on complex details, try to work quickly, grasping the basic configuration of the form. You can also experiment with cropping and careful placement within the rectangle. If your object is white, like the radish in Figure 3.14, you could begin by darkening the background around the form or concentrate on shadows as in the drawing of bones in Figure 3.5.

Choose the best of your sketches and transfer it to a larger sheet of paper, making sure that you retain the linear energy and the relationship of the basic shape to the edges of the rectangle. The best way to do this is to put the sketch on the wall and draw directly from it. You will probably be more conscious of the basic character of shape and line working from your own drawing than you would be working directly from the object itself. This is fine; emphasize

the energy and character you see in your own sketch, and try to give it new force by moving with your whole body, as in Exercise 3.3. Drawing on a large scale can be a very physical experience and requires real commitment to match the strength of lines in a smaller drawing. Remember that the scale of thickness of your marks will diminish in relation to the whole in a large drawing, so you will probably want to make larger marks, using the side of the charcoal or a big brush.

When you have the basic shape down, go back to the object itself and develop the drawing based on direct experience of the form. Do not overemphasize the details, but add enough information about the interior so that the 3-D character of the form comes through. Your new lines should complement the existing ones, similar in line quality and gestural force. Keep the drawing simple and forceful in impact. Compare it with the sketch from time to time to make sure you are not losing the energy of the original marks.

Exercise 3.5 The Garden

Assemble a selection of natural forms: twigs, branches, leaves, seed pods, dried or cut flowers, and weeds. Try to find a variety of forms: broad or thin; floppy or stiff, and so on. On a large sheet of paper, start layering linear strokes inspired by your objects. (You can arrange the actual objects ahead of time in an interesting array or just put them together on the paper as you go, finding a pattern in the marks that begin to build up on your page.) Each plant form should be treated with a distinctive mark, emphasizing the diversity within the group. Do not be afraid to overlap the edges or lay forms on top of each other; this will add depth to the composition. Try to vary the placement of different forms so that as the eye moves across your composition, there is a dynamic succession of visual qualities: up/down, thin/dense, or angular/serpentine. You

can use the edge of your eraser to bring out particular forms in overlap. Just "draw" with it as you would the charcoal, creating a white mark instead of a black one. You can work over the drawing repeatedly, layering new forms on top or erasing in, but try to keep the freshness and textural variety of your original marks.

Finally, you should have a panorama that suggests some of the complexity found in nature along with the rhythm and energy of growing forms through a variety of shapes and marks as in the flower drawings by Egon Schiele and Jan Van Huysum **(Figure 3.47 and Figure 3.48).**

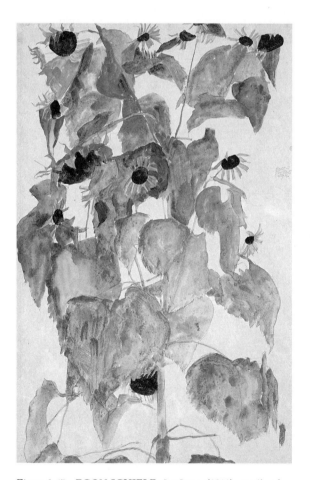

Figure 3.47 EGON SCHIELE, *Sunflowers* (1911), pencil and watercolor, 17 1/8 × 12 in.

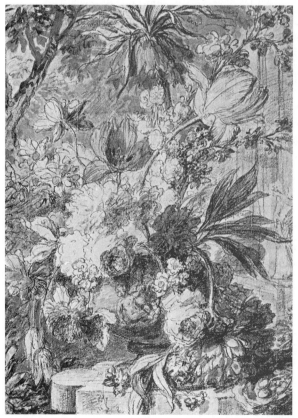

Figure 3.48 JAN VAN HUYSUM, *Vase of Flowers*, black chalk, watercolor, 18 5/8 × 14 in.

Exercise 3.6 Observing Natural Contours

After experimenting in your sketchbook (see *Sketchbook Link: Contour Profiles* on page 60), find an object that you think will be interesting to draw using line. As you are choosing your object, look carefully at its outside edge (its profile). Rotate the object to see how the profile changes as different sides of the object's surface come around into view or disappear. If your object's form is very simple, like a pear or an apple, its profile could change little as the object rotates. If the object is more complex, like a shoe, the profile will have a great deal of change. Make your final object choice one that will have an interesting diversity in the outside contours of its profile.

Now make a drawing of the object, larger than lifesize. Your drawing should fill the page of your drawing pad.

Concentrate on the outside contour using a simple line to carefully describe the profile of the form. Your viewer should be able to get a clear sense of the character of the 3-D surface of the whole object from the way you draw your outside contour. If the interior of the object has major divisons, as in the drawings of the pinecone in **Figure 3.49,** show them with strong simple lines but do not get excessively involved with interior detail. Try to deal as much as possible with line only. Do three more drawings of the same object, rotating it slightly to get a new view each time. Pin all four drawings on the wall and observe the way the group serves to define the object's physical character.

On a new sheet of paper, redraw the object from a different point of view. This time, be aware of places where the outside contour seems to cut into the form, leaving the outer edge.

Notice the many instances of overlap in the Albers drawing in **Figure 3.50.** At these points, another line takes over as the outside edge, coming out from behind. Show this in your drawing as an overlap or crossover of lines.

Keep your emphasis close to the edge of the object, but allow the crossover contours to give an added sense of 3-D structure and depth to the drawing.

Continue to study the object (or select another that seems more interesting based on your experience so far in this exercise) and do 20 drawings in any one of the following media: charcoal, pencil, crayon-compressed charcoal, ballpoint pen, ink and brush, or marker. Experiment with different speeds and qualities of line. Try to invest the object with as much energy and feeling as you can while being clear about its character as a 3-D entity. Vary the line weight as described in relation to the bone drawing in Figure 3.5 to stretch, compress, bring forward, or fade back the contour.

Figure 3.50 JOSEF ALBERS, *Duck, Brush & Ink* (1917), brush and ink, 10 1/4 × 14 13/16 in. © The Josef and Anni Albers Foundation/Artists Rights Society, NY

Figure 3.49 Pinecones: profiles of a rotating form

Exercise 3.7 Drawing the Figure with Elliptical Contour

Working with a posing model, use elliptical contour to define the basic forms of the body. Look for the largest division of form in the figure: ribcage, hips, belly, thighs, and so on as the artist has done in **Figure 3.51.** Define each of these basic forms with a pair of convex elliptical contours, one on each side of the form like parentheses. Even if some of the outside contours of the figure do not seem curved, give them a gentle outward curvature similar to that in Figure 3.30. Define inward curves as the intersection of two convex curves. The goal is to build the figure entirely from rounded solids implied with contour similar to that in Figure 3.51. A remarkable sense of physical form is possible with nothing more than line.

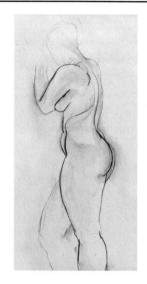

Figure 3.51 CHRISTINA LIVESEY, student work (1996), charcoal, 24 × 18 in.

Exercise 3.8 Caricature and "Tag"

Use curved contours to draw your first name or a nickname that you devise for the project, as a bulbous 3-D graffiti "tag" similar to the one for "Jill" in **Figure 3.52.** Try to be as inventive as you can with the basic letterforms, utilizing as many opportunities for rounded knobs and complications as you can. The final tag should be legible to a knowing viewer but may be merely abstract forms at first glance. Its 3-D character as form should be immediately powerful, however, with overlapping and spatial relationships between the letters made clear.

When you have finished the tag, compose a caricature of yourself using the same linear vocabulary. Again, make the most of the various features of your face as opportunities for 3-D form. Do not let vanity interfere! Your drawing should look like a wacky inflatable cartoon character with a genuine, if exaggerated, sense of volume, and should be immediately identifiable stylistically as the same artist who did the tag, as in **Figure 3.53.**

Figure 3.53 *Caricature: Jill*

Figure 3.52 *Tag: Jill*

Exercise 3.9 Cross-Contour Tree Trunk

Using elliptical contours to describe the outside of the form and cross contours to describe the interior surface, make an oversize drawing (40 by 60 inches) of a tree trunk or section of branches. Try to find a tree that has an unusually interesting set of curves and undulations in its form. Pay particular attention to places where a branch meets the trunk or splits into two smaller branches. Try to accurately describe the twisting and turning of the form while giving it a sense of energetic movement through the curves of the outside contour and variation of your mark. You may use any combination of materials, but the mode should be primarily linear. The cross contours need not be perfectly continuous or evenly spaced, but they should work effectively together to give a tactile sense of the surface of the tree and its movement through space as the artists have done in **Figure 3.54** and **Figure 3.55**.

It could help you to think of the tree as a creature capable of movement and to look for the same kind of linear force in the overall form that you found in doing gesture drawings from the figure.

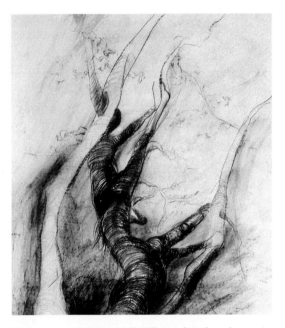

Figure 3.54 APARNA MEPANI, *Tree* (2002), student work, charcoal, 24 × 18 in.

Figure 3.55 NICK JAQUITH, *Tree* (2002), student work, charcoal, 24 × 18 in.

Critique Tips Chapter 3: Organic Mark and Form

During critiques for the exercises in this chapter, look at your own and your classmates' drawings for qualities based on the following questions. You might also want to review the vocabulary in the Using Specialized Vocabulary section in Chapter 1.

What are the uses of line? *Does the drawing have a strong linear movement or gesture? Is line used in other ways unconnected with the principal gesture?*

How does the use of the medium influence the way you experience the drawing? *Is the line quality connected with the particular medium chosen? Was this medium the right choice?*

Is the page or field used effectively? *Do the lines that define gesture or shape divide the space of the page in an interesting way? Is there a compositional role for empty areas?*

How does the expression of the drawing through mark or form compare with the subject matter?

What is the role for solid volume or three dimensionality in the drawing? *Is the primary reading of the image a graphic one (2-D shape and line), or is there an important role for depth and solidity?*

How is line showing volume? *If the drawing suggests three dimensionality of form, how is this quality being shown by the use of outside contour, overlap, or cross contour?*

Is the sense of solid form integrated with the sense of gesture?

What is the range of mark? *Is the drawing composed of homogenous marks or of a complex variety? If complex, what is the effect of the differences of mark?*

Geometric Mark and Form

4

PRINCIPLES OF VISUAL GEOMETRY

Natural Force and Form

A special category of visual form in drawing is connected to the branch of mathematics known as **geometry**. Pure geometry is a man-made field based on numerical relationships, but many wonderful instances of geometry occur in nature. This is so because both geometric form and the building blocks of natural form are generated by clear, simple connections and principles. Nature creates forms through the exertion of basic

forces. Gravity is one of these forces, and it is responsible for many aspects of the visual world. The perfect flatness of the horizon (which is actually gently rounded) and the perfect disk of the moon, seen in **Figure 4.1,** are geometric forms that result from the evenly distributed pull of gravity. **Figure 4.2** shows this principle in the top diagram: circular form resulting from an even force pulling toward a central point. On the bottom is a similar force in the opposite direction resulting in a **radial** form, essentially a pattern of

Figure 4.2 Radial forces: gravity and expansion

Figure 4.1 *Gravity: Moon and Sea*

growth or expansion from a central point. It is easy to see how this basic principle results in some familiar and wonderful natural forms like the snowflake in **Figure 4.3** and the holly leaf in **Figure 4.4.**

Leonardo da Vinci spent much of his career exploring physical principles in relation to the forms of nature. His study of the radial structure of a plant in **Figure 4.5** not only documents the regularity of the arrangement of leaves but also invests the whole with an almost mechanical sense of whirling energy, connecting visual pattern with the forces of growth.

Geometric Principles: The Straight Line

Perhaps the simplest geometric form and one with special implication for drawing is the straight line. A truly straight line can be difficult to draw, and it is not bad to practice this seemingly simple act. It is, of course, possible to use a ruler, but attempting perfect straightness "freehand" is a good way to increase your appreciation for its special qualities.

The straight line has a sense of absolute perfection, although it can seem a bit stark and hard when compared to the more playful curves discussed in Chapter 3. In fact, this sense of absolute clarity and unchangeableness has attracted many artists to the straight line. Among the best known of these is the Dutch/American twentieth-century painter Piet Mondrian. Mondrian believed in strong philosophical principles with religious overtones and sought to imbue his art with a serious sense of **transcendental** purity. He used only primary colors and straight black lines, carefully arranging the resulting rectangles to form inventively balanced compositions such as the one in **Figure 4.6.**

Figure 4.3 KARL BLOSSFELDT (1865–1932), *Sea Holly*, photograph

Figure 4.4 ROBERT BENTLEY, Snowflake

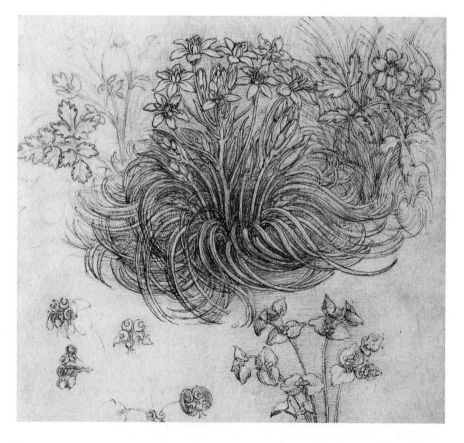

Figure 4.5 LEONARDO DA VINCI, *Star of Bethlehem and Anemones* (detail), pen and ink over red chalk, 6 1/4 × 7 3/4 in.

ISSUES AND IDEAS

❑ Geometric form has simplicity and regularity. Straight lines or circles are examples.

❑ Geometry is often evident in natural forms due to patterns generated by physical forces such as growth.

❑ Geometry in drawing can lend a sense of order or concerted force.

Suggested Exercise

4.1 Finding Geometry in Natural Objects, p. 100.

Sketchbook Link: Patterns of Growth

Make 20 quick sketches of trees using only short straight lines. Follow the path of growth of the tree from the ground up. Emphasize any pattern you see in the branching of forms or in the overall configuration.

mospheric effect than are those used by Mondrian. The soft-edged forms in rich hues disappear as shapes (although their proportions are very important) and the viewer is invited to look into them, to experience the emotional qualities evoked by the color. Balance can be taken for granted in the stable stack of vertically organized rectangles, echoing the division of earth and sky.

Vertical and Horizontal Balance

The straight lines in Mondrian's work have another characteristic that was important to the artist: They are either exactly vertical or exactly horizontal. In this, they echo the edges of the picture's frame, which function as pre-existing lines in the composition. Just as important, however, the lines call to mind the components of balance based on gravity: vertical lines representing its directional pull; horizontal lines evoking the balanced ground plane created by gravitational force.

Mark Rothko, another twentieth-century artist, used rectangles almost exclusively in his mature work, such as the drawing in **Figure 4.7,** but they are more closely tied to landscape and at-

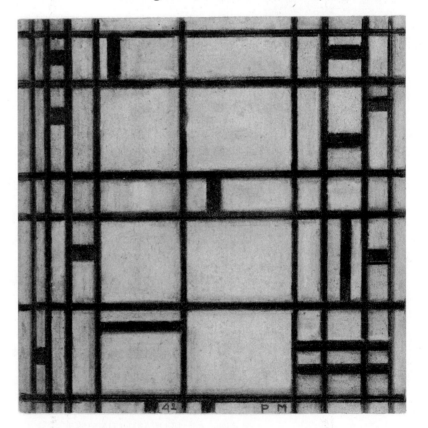

Figure 4.6 PIET MONDRIAN 1872–1944, *Study II for Broadway Boogie Woogie,* 1942, Charcoal on paper, 9 × 9 1/2 in.

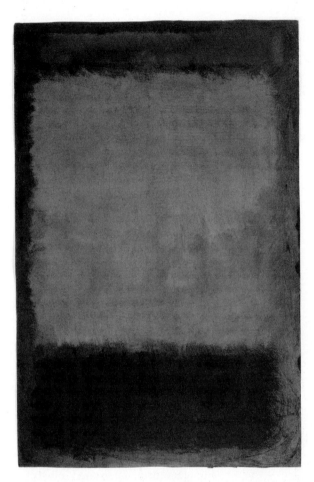

Figure 4.7 MARK ROTHKO, *Untitled 1959*, tempura on paper, 38 × 25 in.

Geometry and Architecture: The Rectangle

Most drawings are rectangular, a fact that people tend to take for granted, but one that has an important source in their experience of the world. People live their lives within the force of gravity, and they are profoundly sensitive to changes of balance in relation to it. We are surrounded by rectangular forms (doorways, windows) and are used to looking through or past them. In this way, the rectangle becomes the most neutral of forms, not calling attention to itself, but framing and stabilizing visual experience.

Richard Diebenkorn often worked from observation of architectural space, emphasizing the interconnected geometric shape created by doors, walls, and cast shadows, as in **Figure 4.8.** This world is familiar territory, but he brought decisive clarity to the interwoven pattern that the rectangles (and one triangle) create in the interior,

Sketchbook Link: Vertical/Horizontal

Spend an hour sketching outdoors or looking through a window at a scene with a mix of buildings and natural forms. Try to use only straight lines as in the previous link. Keep an eye out for verticals and horizontals in the architecture and in the natural forms, and emphasize both. Use a light wash (ink and brush) to build atmosphere and pattern into your sketch.

ISSUES AND IDEAS

❏ Straight lines, both vertical and horizontal, evoke balance in relation to the force of gravity.

❏ The architectural environment is composed of vertical and horizontal forms because of their stability.

❏ Balanced compositions of verticals and horizontals often project a sense of calm stillness or resolved order.

Suggested Exercise

4.2 Windows and Walls, p. 100.

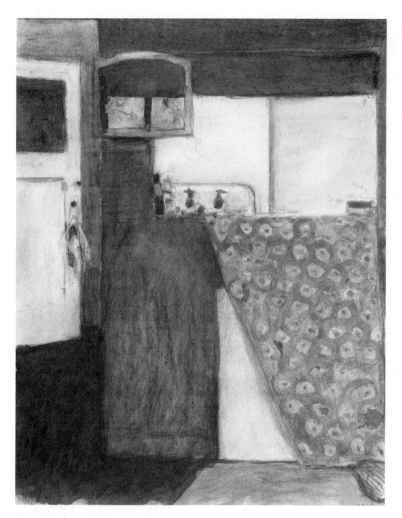

Figure 4.8 RICHARD DIEBENKORN, *Interior with Mirror* (1967), charcoal and gouache, 24 1/2 × 19 in.

emphasizing an independent abstract character to the arrangement.

Diagonal Lines

Lines and shapes with diagonal orientation have a very different character than vertical and horizontal ones, but their nature also comes from a relationship to gravity: they suggest instability, as though they are on their way to tipping over. Diagonals often suggest movement, and the efficient way they move from beginning to end as straight lines makes that movement rapid. A classic example can be found in the work of Franz Kline, a member of the **Abstract Expressionist** movement of the Mid-Twentieth Century. Kline's

drawing in **Figure 4.9** suggests a frantic pace, evocative of life in New York. Slashing gestures and angled paper overlays divide the rectangle into fragments like broken glass. The eye richochets like a pinball around the image.

Contemporary artist Joel Shapiro utilizes a more rigorous geometry of constructed rectangles but softens the effect with powdered charcoal edges in **Figure 4.10.** A keen sense of teetering balance is achieved in relation to gravity, which is established by the rectangular edges of the page.

The instability of the diagonal also underlies the fundamental compositional principle of *Cubism,* the dominant abstract art movement of the first decades of the Twentieth Century. Cubist composition sought to subvert traditional gravity-based pictorial structure by "floating" geometric shapes on the surface of the picture plane (often literally, as collage elements). Then the Cubists "pulled the rug out" by utilizing strong diagonals in the lower half of the image, undercutting vertical or horizontal structure that could suggest the balanced support of weight. The resulting destabilized composition moves the eye around the image in a circular manner, skipping from one planar shape to another based on graphic visual emphasis rather than on a continuous progression into depth. **Figure 4.11** by the Spanish painter Juan Gris shows the free-form pictorial space that results. Instead of a potentially static image of bottles firmly planted on a horizontal table, the forms are left to float free in a diagonal matrix, creating a far more dynamic visual experience for the viewer. Dramatic jumps in value and shifting planar surfaces that seem to penetrate each other "transparently" heighten the sense of energy and instability. Diagonals can also be combined in a composition with vertical or horizontal forms to emphasize a contrast between dynamism and stability.

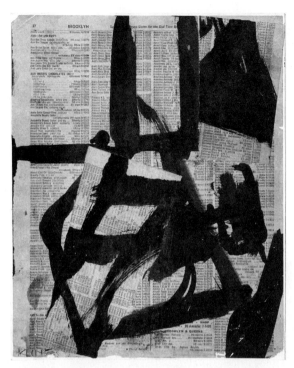

Figure 4.9 FRANZ KLINE (1910–1962), *Untitled II,* (ca. 1952), ink, and oil on cut-and-pasted telephone book pages on paper on board, 11 × 9 in. (Purchase. [309.1983] Location: The Museum of Modern Art, New York, NY, U.S.A. Photo Credit: Digital Image © The Museum of Modern Art/Licensed by SCALA/Art Resource, NY/ © 2009 The Franz Klune Estate/Artists Rights Society (ARS), NY

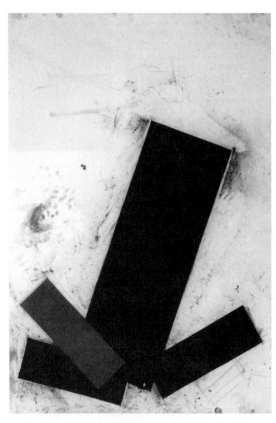

Figure 4.10 JOEL SHAPIRO (1941–), *Untitled* (1988), charcoal and chalk on paper, 88 × 60 in. (223.5 × 152.4 cm). (Purchased with funds from Mrs. Nicholas Millhouse and the Drawing Comittee, # 88.21, Collection of the Whitney Museum of American Art, New York, © 2009 Artists Rights Society (ARS), NY

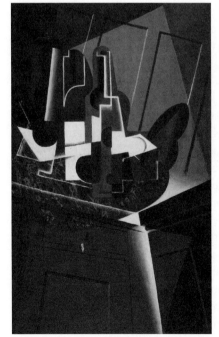

Figure 4.11 JUAN GRIS (1887–1927), *The Sideboard* (1917), oil on plywood, 45 7/8 × 28 3/4 in. (Nelson A. Rockefeller Bequest (957.1979). Location: The Museum of Modern Art, New York. U.S.A. Digital Image © The Museum of Modern Art/Licensed by SCALA/Art Resource, NY/Juan Gris © 2009 Artists Rights Society, (ARS), NY

Sketchbook Link: Diagonals in Action

Position yourself in a public space where you can watch people coming and going. In your sketchbook, get their movements down quickly using short, straight diagonal lines. Try drawing without looking at your sketch, letting your eye skip across the moving forms, recording them with quick diagonal "notes."

ISSUES AND IDEAS

❐ Diagonal lines evoke movement as the eye follows their path.

❐ Diagonals suggest instability in relation to gravity.

❐ Compositions based on diagonals move the eye around the page, suggesting flux and energy.

Suggested Exercise

4.3 Finding Diagonal Energy, p. 101.

GEOMETRIC SYSTEMS

Grids and Meshes

As discussed in Chapters 2 and 3, one of the most important concepts for anyone seeking a full awareness of drawing as an art form is the **picture plane.** In simple terms, the picture plane in a drawing is the piece of paper you are working on, but more importantly, it is a conceptual field that comprises the stage or two-dimensional (2D) space in which a drawing takes place. Approaching the act of drawing, an artist should be keenly aware of the surface and dimension of the page: corners and edges, length versus width, and overall size.

One way to connect in a direct way with the picture plane is by use of a **grid,** a network of lines that extends fully over the 2D surface. Grids can be rectangular, echoing the edges of a standard piece of paper in a regular pattern, or can include diagonals or nonrectangular units. In **Figure 4.12,** Sol Lewitt fills a black field with delicate white diagonals, threading the corners and midpoints of a square. The intervals between lines open toward the center of the drawing, giving the soft sense of a trampoline or a spider web. The picture plane is asserted as a flexible membrane and a network of tiny connections for the eyes to explore.

An actual spider web such as the one in **Figure 4.13** represents an elegant natural model for this approach to drawing. Through touch, the spider is intimately aware of every strand in its web, responding to small vibrations or pressures across the field. This same sensitivity to surface and mark, rhythm

Figure 4.12 SOL LEWITT (1928–2007), *Lines from Corners, Sides & the Center, to Points on a Grid,* (1977), etching and aquatint, printed in color, plate: 34 5/8 × 34 13/16 in., sheet: 34 5/8 × 34 13/16 in. (Gift of Barbara Pine [through the Associates of the Department of Prints and Illustrated Books]. [446.1977] Location : The Museum of Modern Art, New York, NY, U.S.A./ Digital Image © The Museum of Modern Art/Licensed by SCALA/Art Resource, NY/© 2009 ARS, NY)

and interval, balance and tension within the picture plane is vitally important to the understanding of the expressive potential of drawing. Every inch of the page surface is interconnected, tied together by visual relationships you construct in your drawing.

Expressive Grids

The extreme simplicity of the grid as a visual structure might not seem to present an adequate subject

for drawing. Why not just buy a piece of graph paper? The reason is that a handmade grid offers a possibility for expression in the individual artist's decisions of touch and rhythm. Geometric forms are inherently familiar because of the clarity and simplicity of their construction. This means that the viewer is aware of any deviation or change in structure of geometric form: A slight wobbliness in a circle is immediately apparent and distortion of a regular grid has an almost physical effect on the sense of balance and pacing in the work. These qualities can be seen as "defects" in the context of mathematics or engineering, but for drawing, they represent expressive potential.

Eva Hesse was an artist famed for her emotional sensitivity, but her visual statements were often framed in a language of geometric mark. In her hands, change and irregularity were brought to the geometry, imparting a distinctly handmade feeling and creating a theater of emotional transformation. Subtle alterations of the forms that make up the grid in **Figure 4.14** evoke human emotional flux and subjectivity within mass-produced regularity.

Figure 4.14 EVA HESSE, *Untitled 1968*, brown ink with wash, 13 1/4 × 13 1/4 in.

The eloquence of this message can also be felt in the African Kuba cloth weaving in **Figure 4.15.** A gently changing diamond-shaped pattern pushes and pulls at the regularity of its own grid with elements overlapping each other like fish

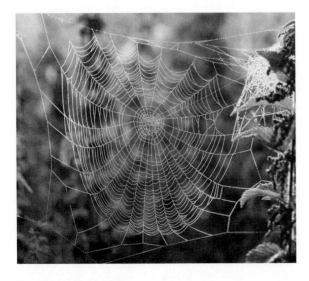

Figure 4.13 Spider's Web

Figure 4.15 Kuba cloth, Republic of Congo, woven fabric, 24 × 24 in.

ISSUES AND IDEAS

❏ The picture plane, including its edges, is the field on which drawings exist.

❏ Grids map the picture plane's surface as an interconnected, tactile network.

❏ The regularity of grids can evoke time and repetition. Slight distortions are immediately perceptible.

Suggested Exercise

4.4 Exploring the Picture Plane, p. 101.

Sketchbook Link: Exploring Grid

Open your sketchbook to a new page and draw a rectangle that more or less fills the whole page. Begin on one edge with a short line segment, vertical or horizontal, that moves into the rectangle. From the end of this segment, draw another segment of the same length, but diagonal. From the end of this segment, draw another segment, but horizontal or vertical, and then another diagonal (roughly similar or opposite in angle to the first). Repeat this alternating process until you reach one of the edges of your rectangle. Then begin again on a different edge. Repeat this process until you have engaged all four edges. Notice the resulting divisions and shapes. Repeat the exercise on new pages, trying to vary your decisions as much as possible within this limited format.

scales. Based in part on the homemade nature of the looms involved in the manufacture of the cloth and in part on the sensitivity and invention of the artist at work on this one-of-a-kind creation, the irregularity of the pattern suggests natural growth and evolution through time from one corner to another.

Grids and Three-Dimensional Illusion

A grid, like all other elements in drawing, resides on the picture plane. More than most marks and forms, however, a 2D grid **refers to** or **maps** the

Figure 4.16 GEGO (GERTRUDE GOLDSCHMIDT) (b. 1912), *Untitled* (1970), colored ink on paper, 25 3/4 × 19 3/4 in. (Gift of Patricia Phelps de Cisneros in memory of Warren Lowry. [2418.2001] Location: The Museum of Modern Art, New York, NY, U.S.A./Digital Image © The Museum of Modern Art/ Licensed by SCALA/Art Resource, NY) © Gego (Gertrude Goldschmith/Fundacion Gego, Caracas, Venezuela

picture plane, suggesting its surface and dimension. In fact, this character of grids can be used as a point of departure for an investigation of depth, extending a grid-based drawing's territory into the illusion of three dimensions.

The Venezuelan artist Gego, a sculptor who used wire, thread, and other tenuous materials, created a fragile mesh of drawn line in **Figure 4.16.** A triangular grid, which we can imagine as a regularly spaced structure, shrinks and expands across the surface of her drawing, suggesting undulations and shifts in the structure.

A more carefully controlled and visually dazzling effect occurs in the work of British artist Bridget Riley, whose images of fine-tuned geometric patterns defined the 1960s movement of **Op Art.** In the **gouache** on paper study in **Figure 4.17,** Riley worked with tightly organized rows of tiny pale ellipses. Their regularly varying orientation and subtly changing tonal contrast with the

background creates an ambiguously 3D rolling effect. The rigidity of the grid-based composition has a mysteriously charged tension with the undeniable sense of movement created through the smoothly graduated change in geometry and tone.

Figure 4.17 BRIDGET RILEY, *Untitled (Study for 19 Greys)*, 1966, gouache and pencil on paper, 13 1/2 × 10 in.

Sketchbook Link: Layered/Irregular Grid

Use your sketchbook to experiment with materials and layering in a grid format. Layer thick pale marks over thin dark ones, wash over ballpoint pen or pencil, and so on. Practice retaining areas of white paper, or work with an eraser to create grid layers of pale lines. Vary the spacing or density within the grid, allowing areas to open up or condense.

ISSUES AND IDEAS

❏ There is a natural connection between a two-dimensional (2D) grid and the surface of the picture plane.

❏ Distortion or layering of grids can suggest a tactile surface or atmospheric 3D space.

❏ Awareness of the picture plane is an important starting point for 3D effect in drawing.

Suggested Exercise

4.5 Three-Dimensional Grid, p. 102.

Figure 4.18 BRICE MARDEN (1938), *Card Drawing #11 (Counting)* (1982), ink, gouache, and watercolor on cardstock, 6 1/8 × 6 in. (gift of Mrs. June Noble Larkin. [317.1983] Digital Image The Museum of Modern Art/Licensed by SCALA/Art Resource, NY © 2009 ARS, New York)

struction as well as its nature as the graphic embodiment of basic structural principles. The circle, the star, the crescent, the cross, to name only the most obvious examples, are forms that are imbued with content and power based on their innate geometric character, as well as associations that have accrued to them over human history. Geometric patterns can evoke a sense of magic or private symbolic language. The elegant face and body painting tradition of the Nuba tribe of Sudan shows the transformation of regular geometric patterning into specialized forms that suggest abstract representations of energy, spirit, and growth through graphic rhythm, shape association, dynamic asymmetry, and bold color as shown in **Figure 4.19.** The tribesmen replace these designs daily, melding group traditions with personal intuitive choice.

Swiss artist Paul Klee developed an approach to art somewhere between the spiritual focus

A direct way of accessing 3D effect in a grid-based image can be achieved by layering or transparently overlapping one pattern over another. In effect, multiple picture planes can be organized spatially, proceeding back from the viewer in space. Brice Marden layered rectangular grids to suggest an airy architectural lattice in **Figure 4.18.** By a skillful use of tonal contrast, he evokes a dark space with bright light visible through "windows" beyond. The extreme simplicity of his approach with all lines parallel to the edges of the picture plane is remarkable given the poetic, compelling effect of space and light he achieves. (See Sketchbook Link: Layered/Irregular Grid and Issues and Ideas boxes on page 87.)

SYMBOL AND MARK

Geometric form has often been used as the basis of symbolic language in human culture. This is due to its recognizability, regularity, and simplicity of con-

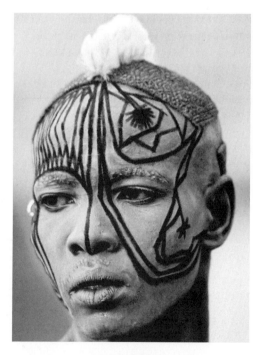

Figure 4.19 LENI RIEFENSTAHL, Nuba face painting (1974), photograph

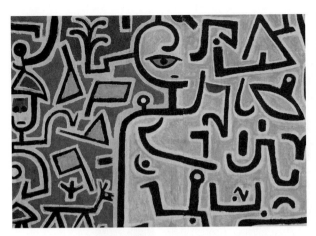

Figure 4.20 PAUL KLEE (1879-1940), *Intentions (1938)*, colored pastel and newsprint, 29 1/2 × 44 1/8 in. Kunstmuseum, Bern. Switzerland © 2009 Artists Rights Society (ARS), New York, VG Bild-Kunst, Bonn

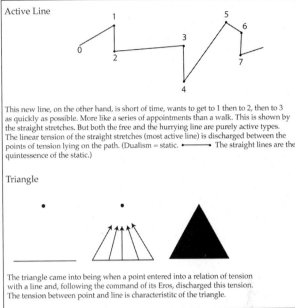

Active Line

This new line, on the other hand, is short of time, wants to get to 1 then to 2, then to 3 as quickly as possible. More like a series of appointments than a walk. This is shown by the straight stretches. But both the free and the hurrying line are purely active types. The linear tension of the straight stretches (most active line) is discharged between the points of tension lying on the path. (Dualism = static. ●——→ The straight lines are the quintessence of the static.)

Triangle

The triangle came into being when a point entered into a relation of tension with a line and, following the command of its Eros, discharged this tension. The tension between point and line is characteristitc of the triangle.

Figure 4.21 Diagram adapted from *The Thinking Eye, The Notebooks of Paul Klee, Vol. I*

of a tribal shaman and the intuitive invention of a child at play. The sense of symbolic meaning in Klee's work is entirely rooted in his perception of the inherent qualities of mark, shape, and color. The geometric forms in **Figure 4.20** come alive as an interactive graphic community, based on his ideas of the significance of form as documentd in his writings and journals **(see Figure 4.21).**

One of the greatest artistic traditions incorporating geometric form and symbol was the art of the Maya, active in Mexico and Guatemala from 900 to 1200 A.D. Within a religious tradition of complex mythology and ritual, the Maya developed a rounded geometric style to tell the stories of their gods and the origins of their culture and the natural world. One of these narratives, *The*

Birth of the Jaguar Baby, is shown in **Figure 4.24 (page 91),** as an "unrolled" or flattened drawing from a vase. It can be difficult to distinguish the figures and other pictorial elements from the letter-like **glyphs** in this image, but it has a unity of character to the form that links the narrative action with the **iconic signs,** visually re-creating the symbolic significance of the acts portrayed. Decoration, figurative image, symbol, and sign are fused into a sacred visual language defined by geometric repetition and variation.

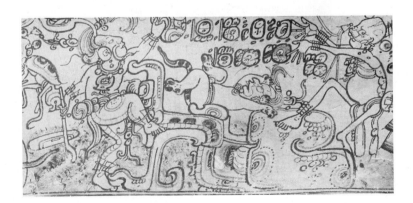

Figure 4.24 Maya vase painting, *The Jaguar Baby with Chak and God A*, detail, unrolled (Photo by Justin Kerr)

Contemporary Artist Profile
KEITH HARING

Keith Haring **(Figure 4.22)** began his career drawing symbol-based narratives on the walls of New York City's subway in the 1980s and developed a simplified cartoonlike language of figures and symbols based in part on the precedent of the Mayan and other early cultures. The specific references of the symbols, however, are much more familiar: TV sets, money symbols, and robots as well as figurative references, two figures with heads as interconnected rings, that are decipherable in terms of modern life. Haring's message is the struggle for life and love in the modern city. His messages, glimpsed in passing in the subway station, communicate on many levels. In addition to the specific symbolic references, the visual density and geometric rhythms suggest the energy of the city in **Figure 4.23.** Haring later undertook many public works projects, murals in which his playful imagery contrasted with somber warnings about the dangers of AIDS and crack cocaine. Haring himself succumbed to AIDs in 1989.

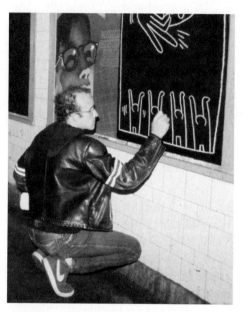

Figure 4.22 Keith Haring in the NYC subway, 1981. Photograph by Tsng Kwong Ci © 1981 Muna Tseng Dance Projects, Inc. © 1981 Estate of Keith Haring, NY

Figure 4.23 KEITH HARING (WITH KEITH OSWALD), *Untitled 1983,* Enamel on wood, 72 × 72.3 in.

ISSUES AND IDEAS

❏ Symbolic form in drawing functions at a meeting point of image, writing, and abstract sign.

❏ Geometric forms function effectively as the basis for symbols because they are easily recognizable and based on strong, simple principles.

❏ Personal reaction to symbols can involve response to the abstract character of form, learned narrative, or both.

Suggested Exercise

4.6 Geometric Symbol and Sign, p. 102.

Sketchbook Link: Natural Symbol

Use your sketchbook to document signs and symbols that you encounter daily. Look carefully at the form of the symbol without thinking too much about its meaning. Some symbols, such as those on traffic signs, are obvious. Others, such as symbol-based graffiti, are purposely obscure. Now try to find markings in nature that resemble symbols: plant configurations, scars or textures, patterns in snow or on rock. Draw these carefully, being true to their natural character while trying to emphasize what you think special or "symbolic" about the shape or configuration. You do not need to specify an exact meaning unless you find it helpful.

Figure 4.25 HENRI MATISSE, *Self Portrait (1837)*, charcoal and stump on paper, 18 11/16 × 15 7/8 in.

FINDING GEOMETRIC ORDER

Geometric Interpretation of Form and Scene

So far you have been looking at the character of geometric form as a self-contained vocabulary, an important category of form to be appreciated for its unique qualities. Geometry can play an important role in drawings of diverse motifs, however, adding a clarity of organization, a strong connection to the picture plane, and a sense of perfection or resolution to what could otherwise be an irregular or complex subject. Henri Matisse's famous self-portrait in **Figure 4.25** gives ample evidence of the precise nature of his character as an artist through the imposition of a geometric vocabulary of arcs and angles onto the forms of the face. Though clearly aware of the three dimensionality of the head, Matisse

forcefully flattened the nose into a triangle and "ironed out" the forehead and chin. In so doing he strengthened the drawing's relationship to the picture plane and to the abstract structure of geometry. The result is a remarkable fusion of flat and volumetric form that conveys the reality of the head while strongly asserting the artist's governing role in interpreting, organizing, and idealizing his image.

Richard Diebenkorn, strongly influenced by Matisse, follows a similar approach in his study of a seated woman in **Figure 4.26.** Although quite believable as a sketch taken from life, the horizontal, vertical, and diagonal forms created by the woman's body and the architectural background elements connect to the edges of the picture plane, locking the scene into a carefully balanced geometric **asymmetry.** Using mixed drawing media, the

Figure 4.26 RICHARD DIEBENKORN, *Seated Woman (1965),* conte, 17 × 14 in.

Sketchbook Link: Geometric Composition Sketches

Make a series of sketches from life: scenes around your house with or without people. Each sketch should be completed in a few minutes and should begin with a drawn rectangular frame of about five inches: horizontal, vertical, or square. Break your subject into a few large shapes of geometric simplicity. Pay special attention to diagonals and arcs as well as horizontals and verticals. Do not concern yourself with detail, but try to give force to the interlocking composition of shapes. Add tonal distinctions with hatching, scribbling, or rubbing to emphasize elements within the design. Proceed from the largest shapes to smaller shapes that could be contained within, but keep the geometric character strong. Be inventive in tying forms such as arcs and angles together to enable you to describe the contours in your subject.

IDEAS AND ISSUES

❏ Geometric relationships provide a simple vocabulary for unifying form.
❏ Geometric structure can work within a drawing of an organic or irregular subject, giving strength, directional force, and a sense of determined organization.
❏ Two-dimensional geometry found in a drawing with a 3D subject helps to assert the picture plane and to ease the transformation of the scene into the language of drawing.

Suggested Exercise

4.7 Imposing Geometric Structure, p. 104.

artist adds blocks of tonal color which fill this pattern and add a graphic energy of contrast and shape rhythm. Notice the perfect vertical column created by the nose, forearm, and knee, playing off the powerful diagonal of the extended leg, which stretches toward the lower-left corner of the page.

Three-Dimensional Geometry

Circles, rectangles, triangles, and more complex geometric shapes can also contribute to the organization of illusionistic 3-D form in drawing. Henri Matisse's forehead (Figure 4.25) is a technically a flat semicircle, but viewers understand that this circle refers to a 3D solid, a sphere. Geometry is one of the best methods to incorporate a 3D reference in drawing, because of its simplicity and visual comprehensibility.

Of course, certain subjects, particularly man-made ones, lend themselves to geometric description or **projection** in drawing. One of these is architecture, which, because of its necessary relationship to gravity, utilizes many vertical and horizontal members creating rectangular and

Figure 4.28 ARMIN LANDECK (1905–1984), *Manhattan Canyon* (1934), drypoint, sheet: 17 3/4 × 10 3/8 in. (Purchase, with funds from Mr. and Mrs. William A. Marsteller, in memory or Erini Meyer [77.11] Collection of the Whitney Museum of American Art, New York)

prismatic solids. Edward Hopper's *Jenness House* in **Figure 4.27** is a seemingly straightforward view of a farmhouse, but the artist has particularly emphasized the geometric character of his subject, on both 2D and 3D levels. The hard-edged starkness for which he is famous can also be interpreted as geometric clarity, and the tough precision of his composition adds to the weight and sense of realism in the scene as well as a disturbing sense of vacancy. Because of its abstract perfection, geometric form can seem impersonal or cold, and Hopper used this to great expressive advantage.

Armin Landeck, Hopper's contemporary, modifies this vision with reference to urban modernity in **Figure 4.28**. A dramatic vertical format

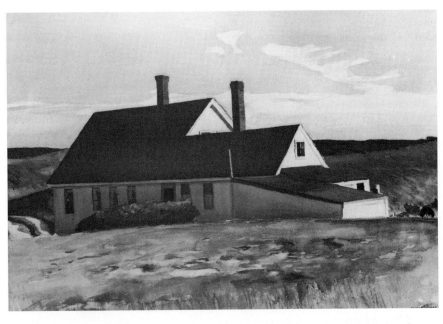

Figure 4.27 EDWARD HOPPER (American, 1882–1967), *Jennes House Looking North* (1934), watercolor, 19 × 27 1/2 in. (SN949, Museum purchase, collection of The John and Mable Ringling Museum of Art, the State Art Museum of Florida)

IDEAS AND ISSUES

❏ Geometric form in drawing can work on both 2D and 3D levels, separately or simultaneously.

❏ Three-dimensional geometry involves the definition of planar, cylindrical, or spherical solids (see p. 105).

❏ Solid geometry in drawings helps to convey weight and volume as well as an assertive simplicity or strength.

Suggested Exercise

4.8 Analyzing Rectangular Solids p. 104.

Sketchbook Link: Analyzing Solid Geometry

Practice analyzing forms around you as geometric solids, especially cubes, cylinders, and rectangular or triangular prisms (see Figure 4.48, p. 105). Anything that you see that you think could have a geometric 3D structure is a good candidate for this analysis. In the case of a car, for example, see whether you can build the basic structure with simple rectangular forms, and then add angled and curved planes to get closer to the real shape. Buildings and furniture are easier, but pay special attention to proportion; the unique character of a specific form is often due to the relation of height to width to depth.

emphasizes both abstract geometric design and a dizzying aerial point of view. Here the dominant three-dimensional sensation is one of unknowable depth in this angular, shadowy chasm.

The Geometric Figure

Some subject matter, like the human figure, does not show geometric structure as obviously as architecture. Still, as mentioned in the discussion of ellipses in Chapter 3, geometry can play an important part in the depiction of organic form such as the human body and has definite advantages of clarity and ease of construction. One of the greatest exponents of this approach was Pablo Picasso, whose lifelong obsession with the figure and geometric structure in painting and sculpture led to countless experiments in this area. Picasso's interest in the simplicity and power of "primitive" sculpture such as the piece in **Figure 4.29,** led him to construct figures with **planar solids** resembling carved wood and was part of the larger investigation of geometric form known as Cubism exemplified by the drawing in **Figure 4.30.** Later in his career, he worked more with a modeled geometry of cylinders and spheres, as in **Figure 4.31,** creating monstrous pseudosculptural entities, which seem to have a larger-than-life sense of scale. His

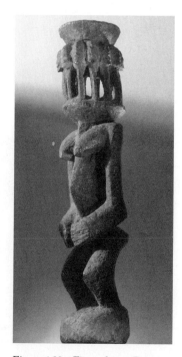

Figure 4.29 Figure from a Dogon shrine, Mali, carved wood

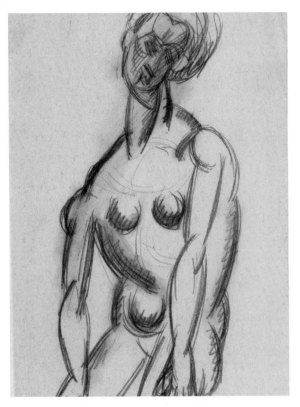

Figure 4.30 PABLO PICASSO, *Seated Nude (1909),* charcoal on paper, 12 3/4 × 8 3/8 in.

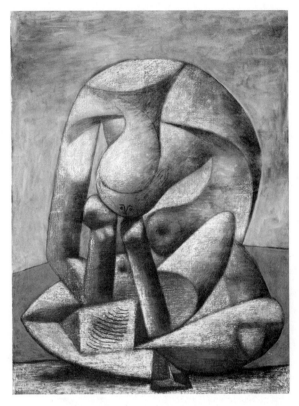

Figure 4.31 PABLO PICASSO, *Bather with Book (1937),* oil, pastel, and charcoal on canvas, 51 1/4 × 38 3/8 in.

Sketchbook Link: Geometric Figures

Experiment with the basic structure of the figure (head, nose, jaw, segmented arms and legs, etc.) to make configurations of cylinders, spheres, and angled prisms. Do not worry too much about the humanity of your creations, but do try to make them seem solid, both in a sculptural sense of implied 3D form and in a 2D design sense of geometric shape. Observe people sitting around you for inspiration. Clothing often simplifies the form of the figure to make this kind of exercise easier, but you will have to experiment with simplifying hair and facial features.

activities in drawing and painting were accompanied by investigation of actual sculptural process in both clay modeling and the use of industrial materials such as steel rods and sheets. (See Issues and Ideas box page 96.)

The Geometry of Spatial Arrangement

By definition, 3D forms exist in depth. In drawing compositions based on two or more of these objects, relationships between the objects can also be conceived in three dimensions playing off the 2D arrangement on the picture plane. One approach is to make drawings of 3D forms that float free on the page as Al Held did in **Figure 4.32.** His is an abstract world of pure geometry, rendered as armatures of 3D **polyhedrons,** in which

ISSUES AND IDEAS

❏ Solid geometry can be imposed on nongeometric subjects like the human figure.

❏ Drawings built with solid geometry can suggest or refer to sculptural form or schools of sculpture such as Pacific Islander or African art.

❏ Solid geometry in the figure can suggest a monumental architectural or industrial overtone.

Suggested Exercise

4.9 Build Your Own Robot, p. 106.

Figure 4.32 AL HELD, *Inversion XI (1977)*, acrylic on canvas

the eye moves over, under, and through form in an oddly ambiguous space. Held's world is so clean and sharp that it is unreal, possibly illustrating the philosopher Plato's call for art to be concerned with the ideal and to reject trivialities of the everyday appearances. Held was principally involved with rhythm and graphic arrangement rendered in "quasi" three-dimensionality, creating an ambiguous, shifting sense of depth.

Giorgio Morandi, a twentieth-century Italian painter who worked almost exclusively with still life and simple landscape, presented a world that has more reference to reality than Held's in his depiction of domestic objects placed on a table in **Figure 4.33.** However, Morandi's vision still has a primary role for geometric simplification and extreme clarity in the placement of the objects. The artist's assertion of strong directional light, a defined point of view, and the unifying force of gravity—rooting all the objects to the table top—gives a sense of decisive factuality to the scene, devoid of the ambiguity of Held's space.

Morandi's later work is famous for the sensitivity of his touch and for the **idiosyncratic** arrangements of objects and point of view, as in **Figure 4.34.** The look of this work is less starkly geometric, but the artist's conscious arrangement of form and space is perhaps even more vivid than in the previous image. The solidity of the objects is still defined by their geometric nature; the viewer understands their forms despite a minimum of descriptive detail. Their soft "skin" and huddled grouping, however, suggest sentient beings with memory and emotion.

The **diminishment of scale with distance** is an important rule of thumb for depiction of solid geometric form and is discussed fully in Chapter 5 but should be touched on here. It is an obvious fact of daily visual experience that objects shrink

to the eye as they move away in depth. This fact is the foundation of the drawing system called **perspective,** but its application in drawing is flexible; it is possible to use it or not, or to use it partially, depending of the desired effect.

Patrick Henry Bruce, an early twentieth-century modernist, chose not to utilize any space-based scale change in his composition in **Figure 4.35.** The front and back edges of his forms are depicted as being exactly the same length (unless, like the two "pie slices" in the center, they actually have unequal sides). Like many other early twentieth-century artists associated with Cubism, Bruce was interested in the play between two and three dimensions in his work and delighted in the strangeness of ambiguously flattened solid shapes. His work has a contemporary echo in that of Al Held, discussed earlier.

Wayne Thiebaud, on the other hand, made full use of the space-based scale change in his *Various Pastels* **Figure 4.36.** The closer sticks are larger than the farther ones, but each stick also shows definite scale change between its close end and its far end. The result is a convincing sense of movement into depth despite the odd lack of any reference to the table surface beyond the cast shadows of each object. Tension between 2D and 3D is a larger factor in the arrangement of foreshortened

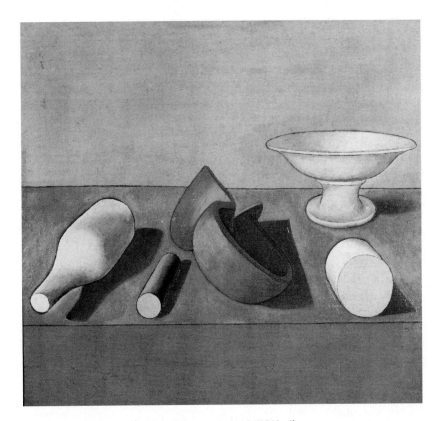

Figure 4.33 GIORGIO MORANDI, *Metaphysical Still Life,* oil on canvas

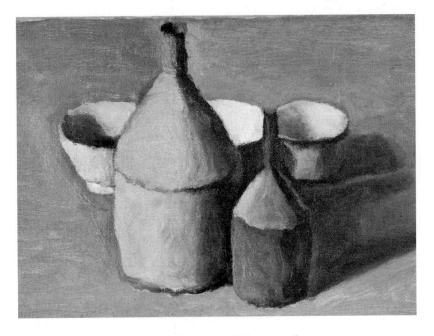

Figure 4.34 GIORGIO MORANDI, *Flagon and White Bowls,* oil on canvas

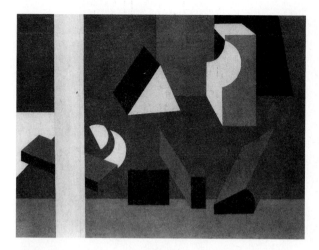

Figure 4.35 PATRICK HENRY BRUCE, *Peinture/Nature Morte (c. 1925–1926),* oil/pencil/canvas, 35 1/8 × 45 3/4 in.

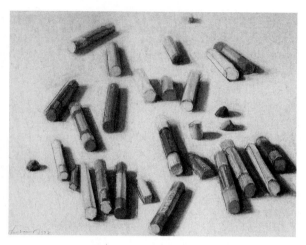

Figure 4.36 WAYNE THIEBAUD, *Various Pastels (1972),* pastel on paper, 10 1/2 × 14 in.

geometry in *Desk Set* **(Figure 4.37).** The composition sets up a twisting tension in the implied ground plane due to the different levels of scale change in the objects and their shadows. The writing pad shrinks decisively as it recedes while the shadow of the stamp pad widens due to the spreading effect of directional light (see Chapter 5). A surprising drama of shape, negative shape, depth, and flatness give tension and energy to the grouping, half way between Patrick Henry Bruce's **ambiguous** flatness and the unified spatial recession of Thiebaud's pastels. Again, the ground plane remains unspecified by texture or edge, allowing this spatial ambiguity to exist in an open field.

William Bailey's still life in **Figure 4.38** has a full sense of solid geometric volume but uses no perspectival scale change at all. Because his forms are all cylindrical and set close to eye level, the ellipses that form their tops and bottoms are so extremely **foreshortened,** they seem to be simple straight lines. If it were not for the delicate shading, the objects could appear as flat rectangular shapes. Overlap and varying position on the table's surface increase the effect of depth, but the lack of recessive edges give the image a stillness and stability. Bailey's compositional concept, like the other artists mentioned in this chapter, is based on a visual simplicity derived from a keen understanding of geometry, both two- and three-dimensional.

ISSUES AND IDEAS

❏ Compositions of geometric solids can be considered in terms of both 2D and 3D arrangement.

❏ The 3-D issues of arrangement include placement in depth, scale change in depth, tipping the forms into depth, and relationship to the viewer's eye level.

❏ Objects arranged on a plane, like a tabletop, will show unified effects of foreshortening and clearly mapped placement in depth, connected to the recession of the supporting plane.

Suggested Exercise

4.10 Perceiving Geometric Spatial Arrangement, p. 106.

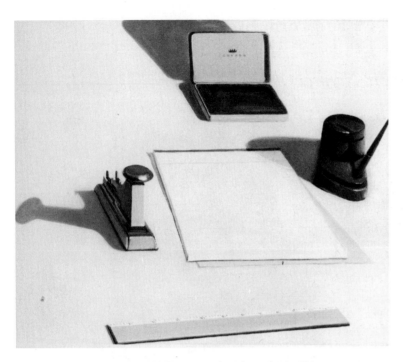

Figure 4.37 WAYNE THIEBAUD, *Desk Set (1971)*, pastel, 16 × 20 in.

Sketchbook Link: Still Life in Two and Three Dimensions

An arrangement of 3D objects on a table is closer in effect to 2D arrangement of shape on the picture plane the higher your point of view. Explore this by making three sketches of the clutter on your desk or kitchen table, the first from a standing point of view next to the table, the second from a seated position close to the table, and the third seated a few feet away. In the first composition, notice how the tabletop functions as the background for the objects as well as the negative shapes between them. Draw all objects and negative shapes strongly with attention to their 2D geometric character. From the close seated position, there is still a strong graphic role for the negative shapes on the tabletop, but with a greater sense of 3D depth between the front objects and the back objects. As you pull away from the table in the third position, this sense of depth increases, and it becomes more difficult to treat object and negative shape equally. Still try to maintain an awareness of the 2D geometry of shape even as you work on projecting the three dimensionality of the solid forms in your still life.

Figure 4.38 WILLIAM BAILEY, *Still Life (1977)*, pencil on paper, 13 × 21 in.

Chapter Four: Geometric Mark and Form Exercises

Exercise 4.1 Finding Geometry in Natural Objects

Find six natural forms or pictures of natural forms which have different types of radial structure. Make a drawing of each one in which you try to convey the power or force that its form suggests: extension, compression, expansion, growth, and so on. Section your page into six rectangular frames and center each drawing in a separate frame. Draw freehand (without ruler or compass), but try to give your drawing a sense of "geometric authority"; that is, the line should appear straight or evenly curved as if formed by the pulling or exploding force you are seeking to describe in the image. Evenness of proportion, smoothness of line, and precision of centering will contribute to this feeling. Your drawing may involve some description of the surface but should clearly express the structural forces as in **Figure 4.39**. Diagrammatic lines that express the basic configuration of the object can be left in or even emphasized.

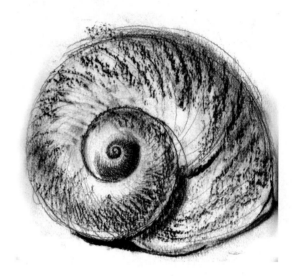

Figure 4.39 *Snail Shell/Spiral Growth*, charcoal, 14 × 14 in.

Exercise 4.2 Windows and Walls

Make three compositions in charcoal on 18-by-24-inch paper based on your bedroom. All elements of the architecture and furniture should be drawn exclusively with horizontal and vertical lines; the placement of the forms in relation to each other should be drawn from the actual scene. Overlap may be used to suggest the 3D order of the objects, but minimize any diagonals. Make sure to note carefully the intervals between edges, and experiment in each composition with different relationships of the forms in the drawings to the edges of the page. Vary the proportion and orientation (horizontal or vertical) as much as possible, experimenting with placement and balance from one composition to the next. You could add tonal coloring to the shapes to increase variety and distinction as in **Figure 4.40**.

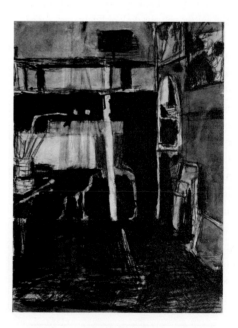

Figure 4.40 RICHARD DIEBENKORN, *Untitled 1963*, wash and conte crayon, 12 1/2 × 17 in.

Exercise 4.3 Finding Diagonal Energy

Make a setup of furniture and other rectangular geometric objects in your room. Lean the elements on each other in a chaotic pile rather than neatly stacking them. Try to create an interesting series of interlocked forms, with busy areas and hollow zones. Now make three drawings of the pile from different angles, emphasizing diagonal lines generated by the edges of the objects. Pay special attention to the negative shapes that result between the objects and the placement of lines in relation to the rectangular edge of the paper as in **Figure 4.41.** Try to find a chain of diagonals that will move your eye around the composition, exploring different areas. Avoid any reference to a balanced supporting surface like the floor or walls, although you can include vertical and horizontal elements to contrast with the diagonals. You may use pure line or areas of tonal color to help define shapes that result from the arrangement.

Figure 4.41 *Still Life with Diagonals,* graphite 24 × 18 in.

Exercise 4.4 Exploring the Picture Plane

The goal of this exercise is to explore the picture plane by filling it with geometric form, partially to get in touch with the qualities of drawing media and partially to practice control over vertical and horizontal alignment. On a large sheet of drawing paper (about 18 by 24 inches) make a solid rectangular shape near the center of the paper using any one of the following media: charcoal, compressed charcoal, pencil, ink wash, pen, or ink hatching. Consult Appendix A for the specifications of these media. Your rectangle can be any proportion but should be oriented with the edges of the paper and should be no more than three inches in any dimension. Now draw another rectangle using a different medium from the list, leaving about one-quarter of an inch of space between it and the last one. The new rectangle should be lined up with one edge of the first one but can move off from it in any direction and can have different proportions. One dimension should be the same as one of the dimensions in the first rectangle, but the other can be entirely different. Continue attaching new rectangles to the group, alternating the six media listed with each new rectangle sharing one dimension with its predecessor until you fill in the space of the paper.

Looking at the finished drawing, find the medium that you feel has the most interesting or variable interaction with the paper and the rectangular shape. Make a new drawing, similarly sized, but using only this one medium. In this drawing, you should start at the upper left and construct regular rows and columns of duplicate rectangles separated by the thinnest margin possible. This time try to vary the use of the medium in each rectangle as much as you can. You can change the stroke with which you are putting down the material, change the density of the material, and explore patterning and both the subtlety and breadth of value range. Continue until the paper is evenly covered. As you work, be aware of the interaction of the rectangles with each other and see if you can create an interesting overall pattern and sense of tactile variety.

Exercise 4.5 Three-Dimensional Grid

The goal of this exercise is to explore the capacity for 3D effect with geometric mark on the picture plane. The ideal medium for this exercise is charcoal in a number of varieties for malleability and capacity for layering. You will also need to use a fixative. Take care in relation to this potentially hazardous material: *Always spray your drawing outdoors!*

Begin your drawing with a short piece of vine charcoal, perhaps one inch in length. Use it sideways to make one-inch stripes or lengthwise, against the paper, to

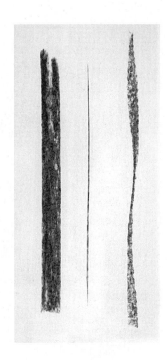

Figure 4.42 Grid strokes

make thinner stripes. You can also twist the stick as you draw, achieving a ribbonlike effect as in **Figure 4.42.** Fill your page with stripes, but vary the interval slightly if you like to create a sense of "breathing" in the pattern. Now, using an eraser or your fingers, make another pattern perpendicular or diagonal across the first one. The new pattern should be open enough so that areas of the first layer are visible and unchanged. You do not have to completely erase the first marks with your new strokes; a smudgy "ghost" can remain. Next, take your drawing outside and spray it. When the fixative has dried, work back into the drawing with thin-stick compressed charcoal (see Appendix A), making a new pattern over the old. Again,

Figure 4.43 ELEANORE MIKUS (American, b. 1927), *Tablet Litho 3, 1968 Lithograph (stone),* in black on German etching paper, sheet: 51.8 × 35.5 cm (20 1/2 × 14 in.) (Image © 2007 Board of Trustees, National Gallery of Art, Washington, D.C./Gift of Dorothy J. and Benjamin B. Smith, 1984.34.301)

make the new pattern open enough so that it does not completely obscure the underlayers. Continue layering in this way until you have a satisfying sense of depth and interaction of pattern as in **Figure 4.43.** Do three more drawings in this same manner, varying the character of the layers.

Exercise 4.6 Geometric Symbol and Sign

For this assignment, you are to create a page that combines symbolic images with text drawn in a common geometric **vernacular.** You can use easily decipherable **pictograms** as in Keith Haring's work in Figure 4.24, or coded geometric patterning as shown in **Figure 4.44.** Consider the list of geomet-

ric forms and their meanings in **Figure 4.45.** Try to convey a simple story or idea, but its meaning does not have to be fully comprehensible to the viewer. You should, however, be able to explain your decisions to the class during critique. The most important thing is to use the regularity and associative charac-

ter of geometric mark to make your meaning whether in the marks and shape used to construct the figures or in the symbolic nature of the "text." The text should interact with the figures in an interesting way in terms of placement and should be clearly coherent visually and in terms of mark and shape character. In some senses, this assignment is a more elaborate version of the graffiti/caricature exercise in Chapter 3.

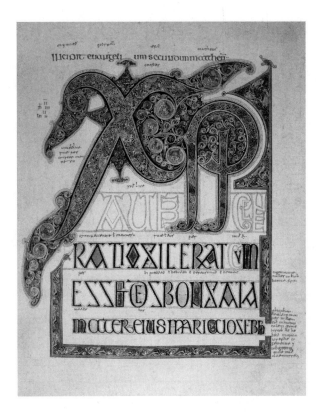

Figure 4.44 Beginning of St. Matthew's Gospel. Lindisfarne Gospels (c. 698 AD) (MS. Cott Nero D IV, fol. 29. British Library, London, Great Britain/Bridgeman Art Library)

Square	Stability, self-sufficiency, enclosure.
Tall Rectangle	The body, a door or window.
Long Rectangle	Reclining figure; altar or coffin.
Triangle	Directional radiation, the trinity, resolution.
Circle	Movement in place; the sky; the sun; wholeness or totality.
Cross	Balance; righteousness.
Diagonal	Instability; movement; descent/ascent.
Vertical	Gravity; transcendence.
Horizontal	The earth; sea; repose.
Star	Omnidirectional radiation; energy; light; spirit.
Arrow	Male principle, direction.
Mandorla (Almond Shape)	Female principle, gate.
"S" Curve	Growth, water, life, smooth movement.
Zig Zag	Harsh energy.

Figure 4.45 List of geometric forms and their symbolic meanings

Exercise 4.7 Imposing Geometric Structure

Plan a large-scale self-portrait drawing (about 24 by 30 inches) in charcoal in a familiar environment such as your studio or bedroom. The background does not need to be elaborate but must provide a context of shape surrounding the figure. You could include a part of the chair you are sitting on or other simple furniture.

The goal is to interpret the forms of the figure as strong geometric shapes—arcs, angles, and combination forms—without compromising too much of their character as parts of the body, furniture, or architecture. Look at the edges of complex forms and see how you can simplify or break them down into geometric compo-

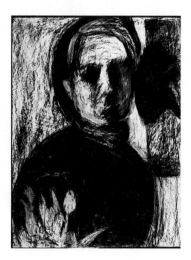

Figure 4.46 SARAH WOLF, student work, (1985), compressed charcoal, 36 × 30 in.

nents. In particular, make sure that your composition extends all the way to the edges of the page and that the shapes which your compositional elements make with the paper's edges are strongly geometric. Pay attention to negative shapes made by space between forms, and give these a geometric identity. You can make distinctions of space with tonal color applied to certain shapes, but try also to consider these color areas as part of a designed pattern across the surface of the composition. The overall point is to give the image a strong *graphic integrity* in relation to the picture plane and a forceful geometric simplicity as in **Figure 4.46.**

Exercise 4.8 Analyzing Rectangular Solids

For this exercise, you will need to find a simple view of a building or group of buildings to draw. The goal is not so much to realistically portray the scene as a whole but to clearly interpret the parts of the building(s) as simple geometric solids, most likely rectangular. You can work from photographs or from life; in either case, the point is to emphasize the geometric solidity of the architecture as in **Figure 4.47.** Do not just copy what seems to be in front of you, but interpret each aspect of the building as a clearly understood geometric solid. If you have to eliminate detail or complete a part of the building that you cannot see, do it. When you have finished, there should be no doubt about the definition of the rectan-

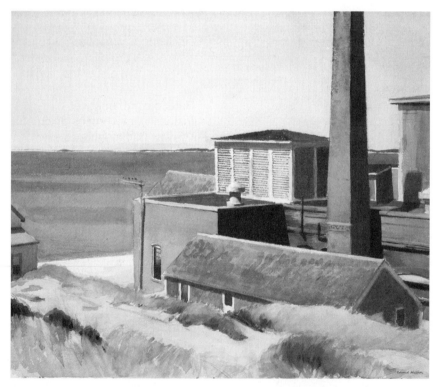

Figure 4.47 EDWARD HOPPER, *Cold Storage Plant*, (1933), watercolor, 21 3/4 × 27 in.

gular, triangular, or cylindrical forms. Study the charts in **Figure 4.48, Figure 4.49,** and **Figure 4.50** for a categorization of geometric solids and methods of orienting them in space. It may help you to shade the various faces of your buildings to differentiate the planes, but you can also leave them as outlined forms.

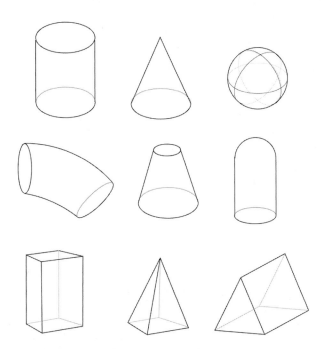

Figure 4.48 Categories of geometric solids

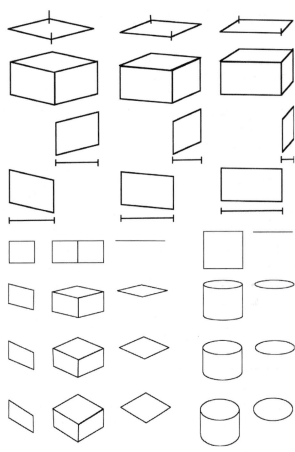

Figure 4.49 Rotation of geometric solids

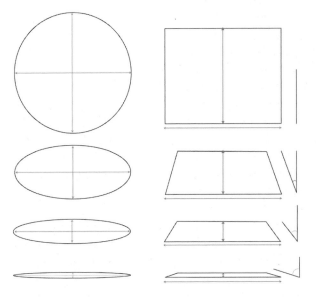

Figure 4.50 Foreshortening of planes

Exercise 4.9 Build Your Own Robot

Man-made objects tend to be geometric because of the nature of mechanical manufacture and the efficiency of making connections. The goal of this project is to use simple geometric elements to put together a drawing of a sculpturally solid figure or contraption (robot). Your creation can have a close connection with the reality of the human body, or be a wild fantasy, but it should be structurally connected and solid. Any type of geometric form or combination of forms can be used, but try to keep a handle on the basic regularity of the components in relation to rectangular, cylindrical, or faceted triangular solids as they appear in Figure 4.47. Projecting the illusion of solidity can be tricky. One strategy involves the use of cross contour that you studied in Chapter 3 (pages 48–77 and Exercise 3.9). Another strategy is to identify the surface with modeled shading as Picasso used in Figure 4.31. Clearly identifying the "seams" where solids connect or merge will also help clarify the form in your drawing. You can also think about establishing a floor, or ground plane, for your figure, which is a concept we will review in Exercise 4.10 and in Chapter 5. Feel free to add any details such as rivets, stitching, or bolts that will help make your robot a vivid creation, but concentrate primarily on clearly defining the solidity of the structure through geometry.

Exercise 4.10 Perceiving Geometric Spatial Arrangement

Compose a grouping of geometric objects on a tabletop; select some rectangular and some cylindrical objects. Vary the intervals within the arrangement to achieve an interesting rhythm of object and space, both from left to right and front to back. Position yourself looking down on the scene, but not too steeply, as in **Figure 4.51.** On a large piece of paper, approximately 18 by 24 inches, begin to place the objects carefully, describing them by means of their simplified geometric forms. Consider the angle of the ground plane relative to your point of view. Try to suggest this angle in the positioning of the object. Study the techniques described in Figures 4.49 and 4.50 for principles for constructing ellipses and rectangular planes in three dimensions. Use your pencil held at arm's length in the manner described in Chapter 2 (pages 20–46) as a measuring device. Try to accurately gauge the different angles of the sides of boxes, and the vertical dimension of receding circular and rectangular planes. Measure also the distance between objects and their distance back from the front of the edge of the table.

After you have achieved the basic placement of the objects, work on their individual forms in relation to your knowledge of basic geometric form, regularizing them and adjusting their angles and sides to seem parallel. Finally, you may add texture or tonal color to the surfaces to help solidify the objects or place them in relation to a light source.

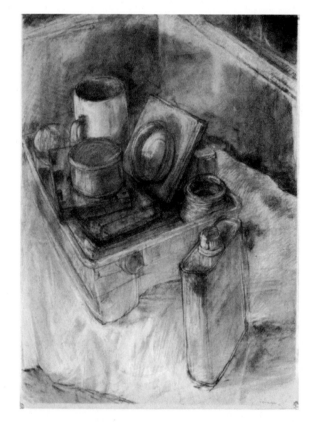

Figure 4.51 DANNY RUIZ, geometric object still life, student work (2001), charcoal, 24 × 18 in.

—— **Critique Tips** Chapter 4: Geometric Mark and Form ——

During critiques for the assignments in this chapter, look at your own and your classmates' drawings for qualities based on the following questions. You might also want to review the vocabulary section on pages 11–12.

How is geometric form being used in the drawing under discussion? *Is there a meaningful fusion between geometric structure and the forms inherent in the subject?*

Is the page or field used effectively? *Do the forms that make up the object(s) have a considered relationship to the edges of the page? Have the edges been considered as part of the composition? Is there a compositional role for empty areas?*

What is the role that balance plays in the composition? *Is there a role for gravity or a sense of stability? How is it expressed by the forms in the drawing? In a composition with strong diagonals, is there a clear role for movement or imbalance?*

In a grid-based composition, what is the relationship between the surface of the paper, the grid, and any sense of space behind or in front of the grid? *How is the grid activating the perception of the picture plane?*

How do geometric shapes convey symbolic meaning? *How can the innate character of geometric shapes be channeled and combined to suggest new meanings?*

If the drawing suggests a three dimensionality of form, how is this quality being shown by the use of geometric form?

In drawings involving 3D geometry, what is the role for solid volume or three dimensionality in the drawing? *Is the primary reading of the image a graphic one (2D shape and line), or is there an important role for depth and solidity? Has the composition been considered in three dimensions?*

Do the objects involved in a geometric still life convincingly convey a unity of spatial arrangement in relation to the viewer's position? *How is depth shown? Do the objects conform to the planar angle of the table?*

The Experience of Space

5

THE UNIVERSE OF SPACE

Objects, Surfaces, and Space

As you have seen in Chapters 3 and 4, drawing can easily suggest many things seemingly beyond the basic two-dimensional (2-D) world of the page: solid objects, movement, even emotions. Marks on the paper's surface can evoke these physical or ephemeral qualities with surprising ease through simplified reference to everyday visual experience.

Drawing can describe another aspect of the world that in some ways is the most mysterious of all: empty space. The world is full of space. In fact, it has more empty space than anything else; the proportion of mass to emptiness in the universe is hugely tipped toward the latter.

The experience of space can take many forms: great distance in landscape, a small interval between two objects, an interior volume enlivened by light, a dizzying plunge downward, or towering height. In all instances, however, the experience of space presents a unique challenge for the visual artist because space, by definition, is invisible. To bring the sensation of space into your work, you must access it indirectly, enclosing emptiness with a net of lines, a border of tactile or measured surfaces or an atmospheric envelope made visible. First, however, you must acquaint yourself with the various manifestations of space in the world and learn to appreciate them as exciting visual phenomena.

In many ways it may seem more logical for you as an artist to focus on *objects*. You can touch them, they have clear names or uses, and some of them are even alive. Perhaps you can more easily identify

with objects because your body is an object. Space cannot be touched, and its dimensions can be difficult to understand just by looking. Maybe this is one key to the interest of space in drawing: Space is fluid, expanding and contracting to suggest the continuously flexible relationship that you have with your surroundings.

Because objects are easier to comprehend visually, approaching the study of space through objects can be the most practical method. Objects occupy and divide the space in which they reside, and it is sometimes easier to see an interval of space by noticing how it lies between things. The drawing in **Figure 5.1** is based on careful observa-

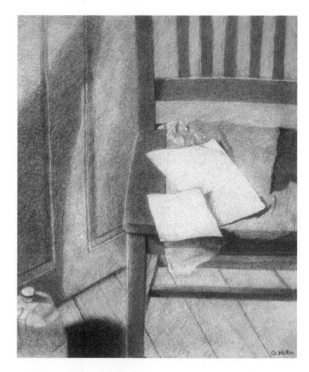

Figure 5.1 GEOFFREY MULLEN, student work (1987), pencil, 24 × 18 in.

tion of a chair and some other objects in a room, but as the artist studied their surfaces, their relationship to each other and the distances between them emerged. The objects themselves are less important than the overall situation; the viewer feels a strong sense of place and a stillness of air hovering around, through and between the various surfaces. It could be that the most interesting relationship in the composition is between the left edge of the chair and the wall. This is the biggest gap, the area least occupied, and the viewer is literally drawn into the void. Through the careful evocation of the surfaces of bordering objects, an interval of space is defined, yet remains intriguingly mysterious—a presence of emptiness.

Sketchbook Link: Looking for Space

Use your sketchbook to focus your awareness of space as a visual entity. Set a goal to make ten sketches that define or evoke a passage of space. Some places to look are pathways, corridors, and spaces between trees and buildings. Try filling the "space" in your drawing with light tone in pencil or charcoal and then erasing it just to make contact with the air or volume there.

Observing Intervals and Angles

One way to sensitize yourself to the experience of space is simply to use your eyes in a directed way as you go about your daily life. Because space can be defined in one sense as the distance between things, an awareness of space can be cultivated by noticing how objects, large and small, are separated from each other in the world. Some relationships are dramatic such as the extreme distance between the top edge of a high building and a spot on the sidewalk below. Some are delicate, such as the small space between someone's fingers resting on a desk. Intervals of space share the same basic quality of emptiness and visual transparency but can differ radically in scale.

A given scene in the world or in a drawing composition is composed of an infinite number of these **spatial intervals,** or distances between points on the objects in the scene. If your goal in a composition is to suggest the experience of space in a certain area, one way to do it is to build a web of observed distances between specific points. This approach is fully described in Chapter 2 in Exercises 2.5 to 2.10.

When you hold your pencil out at arm's length [it must also be perfectly perpendicular to your line of sight (see Figure 2.11)], you can "read" or measure the 2-D configuration of the 3-D situation, according to your point of view. For example, the distance in **Figure 5.2a** between the edge of the

ISSUES AND IDEAS

❐ Drawing, although a 2-D art form, can suggest many three-dimensional (3-D) qualities of the world.

❐ Space can be defined as the absence of form or the area between forms.

❐ Space is often most clearly visible or quantifiable in relation to the surfaces of solid forms: between forms, contained by forms, surrounding forms.

Suggested Exercise

5.1 Exploring Space through Surface. p. 130

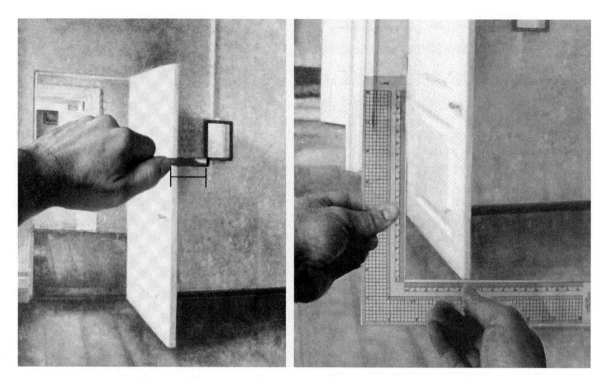

Figure 5.2 a. Measuring 2-D interval with a pencil; b. Measuring 2-D angle with an L ruler

door and the picture frame, which in reality is a complex 3-D relationship, has been reduced to about 1 1/2 inches of pencil length, which can be directly transcribed into a drawing of the room. If a series of similar measurements are taken, the proportional and spatial relationships of the room from this particular distance and point of view can be transferred accurately into a drawing.

In addition to intervals, angles play a large role in the configuration of a spatial situation. There are **angles of 2-D arrangement:** the direction from one point in the scene to another measured in two dimensions. There are **angles of recession:** edges of objects moving away from the viewer into depth, like the door in **Figure 5.2b**. There are systems

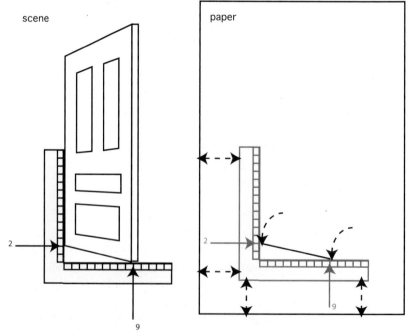

scene

paper

L ruler must be held straight, vertical/horizontal and perpendicular to your line of sight. You can measure the full angled edge, or any segment. In ths case the bottom of the door is a 2H x 9W angle (approx.14°).

L ruler must be vertical/horizontal on paper (aligned with paper's edges). Transfer points 2H and 9W to paper at a deisred position, and connect with line.

Figure 5.3 2-D measurement of a receding angle

for specifying angles of recession as you will see later in this chapter, but both types of angles can initially be measured using a device such as an *L* ruler (shown in **Figure 5.3**). In addition to imposing a 2-D plane over the spatial situation, the *L* ruler measures the angle's proportion of height to width by means of the number scale on each side of the *L*. An angle two units wide and nine units high, for example, is very steep or vertical. A nine-unit width by two-unit height proportion is very shallow or horizontal. Laying the *L* ruler directly in place on your paper and drawing a line connecting the height to the width, you can get a very accurate reading of a particular angle in the scene. As with regular proportional measurement, the ruler must be kept perfectly perpendicular to your line of sight but also vertically oriented in relation to the scene and when you are transferring the measurement to your paper as shown in the diagram in **Figure 5.3**.

With practice, using tools and measurements can lead you to a more intuitive approach to exploring space through points. Simply looking and estimating the position of key points in a scene, adjusting and readjusting the relationships as the web of interconnection develops on your paper, you can achieve an almost organic connection with the space. Ultimately, you should feel as you work that the drawn web actually exists in depth and your marks are really pushing in and out of space.

Alberto Giacometti's drawing in **Figure 5.4** gives an idea of the vivid, but fluid, sense of space that can be achieved by variations of point-to-point measurement. By "feeling" his way through the space of this small room, touching various key points with his pencil and building an almost tactile web of connections, he was able to create a very genuine experience of the space of the room. As you explore the position of the table and chairs in relation to each other and follow the artist's connections, the sense of a complete spatial situation becomes more and more focused. Finally, even the upper half of the room, which contains very few marks, seems to be convincingly "empty" or "filled with depth." In some ways, the various points the artist defined can be thought of as spatial markers, identifying specific positions and interrelationships within the void of the room. The experience is a little like the meditative, reflective way your eyes might explore an intimate environment when you are alone, looking around quietly.

Sketchbook Link: Finding Space in a Painting

Find a painting in a museum or a book involving architectural space (interior or exterior) that is more than just a single building or room. There should be plenty of corners, intervals, and dimensions to explore. Step back from the image and make a drawing from the painting using the technique described in this section. The goal is not to reproduce the detail but to accurately assess and re-create the relationships between forms that are functioning to make the space in the picture. Repeat this exercise with other paintings.

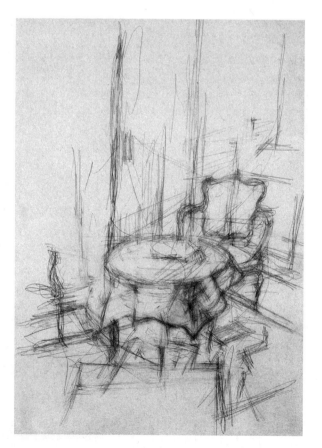

Figure 5.4 ALBERTO GIACOMETTI (1901–1966), *Hotel Room I* (1963), pencil on BFK Rives 50.4 × 33.5 cm (© Alberto Giacometti Foundation/ Kunsthaus Zürich)

ISSUES AND IDEAS

❏ Observing spatial interval, or the distance between objects, is a good way to "map" space in a scene.

❏ A given scene is composed of an infinite number of spatial intervals between objects, which can be measured and mapped as an interconnected, space-defining web.

❏ Measuring imposes a 2-D grid over 3-D reality, easing its translation onto the page.

❏ When measuring and mapping, you are charting a 2-D configuration of the objects before you, not their actual positions in depth. However, the illusion or representation of depth will emerge from an accurately perceived 2-D configuration.

Suggested Exercise

5.2 Mapping Space, p. 131

The Horizon: Scale and Viewpoint

So far you have been approaching the experience of space in drawing as an open exploration, finding a pathway for your eyes by using objects as stepping stones. An alternate way to think about space in drawing concerns an overall condition of 3-D depth and a simplified idea of the viewer's relationship to the world in front of her or him. You can see an example of this approach in **Figure 5.5,** an ink wash drawing by the nineteenth-century German Romantic painter Caspar David Friedrich.

Friedrich was a deeply religious person, and he used the experience of landscape to embody his belief in the overarching presence of God in the world. His vision was also tinged by an awareness of death or of human fragility in the vastness of the universe. This emotional condition of awe in the face of existence has come to be known as **the sublime.** For Friedrich, the sublime ultimately resides in the experience of space: the mystery of endless void. His work features a spectacular evocation of space achieved through scale relationships, atmospheric effects, and an assertion of the **horizon.**

The horizon in this drawing is the line where the sky and the sea meet; on a more conceptual

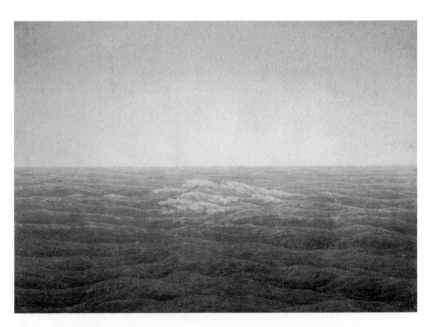

Figure 5.5 CASPAR DAVID FRIEDRICH, *Sunrise over the Sea* (1826), sepia, 7 3/8 × 10 1/2 in.

level, however, it represents an approximation of infinite depth, where the scale of object and interval diminishes to be imperceptibly miniscule. Friedrich's waves become smaller and smaller, and the implication is that they will continue forever into the distance.

Even more than representing the infinite extension of the plane of the earth, the horizon represents the viewer's **eye level** projected straight forward as a boundary. Nothing below the viewer's eye level can ever rise above this boundary, and nothing above eye level can ever fall below it. Because the viewer is looking down on the sea in this picture (otherwise he or she would be under water), its surface rises into the distance toward the horizon line but never crosses it, no matter how far into the distance the viewer can see. Instead, the sea and the shapes of the waves on its surface become smaller and smaller as the surface recedes into the distance, finally moving beyond perception at the horizon. This scale change happens at a perfectly regular pace with a steadily diminishing proportion. By clarifying the horizon line in a picture, and adjusting scale change in relation to it, you can evoke an amazingly effective sense of deep space.

Understanding the relationship of your eye level to the horizon can be difficult. You must try to visualize a horizontal plane, like a sheet of glass, extending straight forward from your eyes into infinite depth. This plane is perfectly parallel to the ground, and it does not tip with your eyes when you turn your head up or down. It will, however, be higher or lower in relation to surrounding objects depending on the height of your eyes. If you are sitting on the floor, your eye level is closer to floor level. If you stand on a table, your eye level will be closer to the ceiling. In either case the "sheet of glass" of your eye level extends straight out into space, perfectly parallel to the ground, into infinite depth where it defines the horizon.

Jason Brockert organized his image around a clearly defined horizon line to project a great sense of distance in **Figure 5.6**. The dark shape in the foreground—a shadowy street—points like an

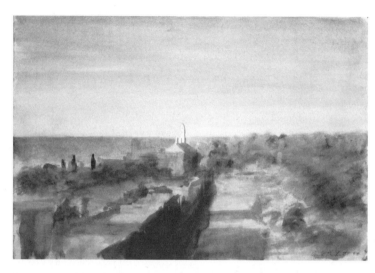

Figure 5.6 JASON BROCKERT, *View of Providence* (1990), student work, watercolor, 16 × 22 in.

arrowhead to the horizon. Its two sides would seem to meet at a point there if the street extended farther into depth. The shape pinches as it moves toward the horizon because the width of the street **diminishes in scale with distance,** and the two sides **converge.** Brockert also picked out some tiny details for special emphasis in the far distance, increasing the awareness of the shrinkage of these forms (actually big buildings) because of the great interval of space. The horizon intersects the steeple of one building, indicating that your eye level is precisely at that height. You are standing on a hill or rooftop at the same height as the line where the steeple is cut by the horizon, and the top of the steeple is above your eye level. Notice that most of this composition is empty sky or roughly defined landscape, but the picture nonetheless has a precise realism and a convincing sense of depth. This is the great power of a clearly defined horizon line.

Sketchbook Link: Scale and Horizon

Make ten sketches from life that use comparison of scale relationships leading to the horizon to establish a sense of great space. Remember that the most effective scale comparisons often involve objects of similar size: trees, phone poles, houses, and sometimes even clouds. Try to find situations in which the trail of objects leads toward the horizon, which should be perfectly horizontal.

ISSUES AND IDEAS

❏ The sensation of space in a drawing can be organized and unified in relation to a particular point of view.

❏ The imagined height of the eyes of a drawing's viewer, projected into infinity at the horizon line, divides the scene into areas above and below eye level.

❏ The scale of objects becomes smaller and smaller in the drawing as they recede into space toward the horizon line.

❏ Objects above the horizon move down on the page as they recede while objects below move up on the page toward the horizon.

Suggested Exercise

5.3 Horizon and Scale, p. 132.

LINEAR PERSPECTIVE

Vanishing Points: The Ordering of Spatial Experience

One side effect of the visual scale change caused by distance is the phenomenon of **vanishing points.** The Renaissance architect Filippo Brunelleschi is credited with discovering this system and expanding it into a means of artificially constructing convincing spatial effects in drawing.

The idea is that a given two-dimensional measurement, a height or width, diminishes visually in scale in a perfectly gradual way as it moves father from the viewer. In fact, as any 2-D measurement moves away toward the horizon line, its end points run along two "tracks" that smoothly converge toward a single point. This point is

called the vanishing point for that 2-D measurement. **Figure 5.7** illustrates this principle applied to a group of columns and the wall of a building. As you can imagine, vanishing points make it easy to place duplicate objects deep into an imaginary space or to order a drawing so that it has a clear and accurate feeling of depth. The concept of vanishing points attached to the horizon line is the basis of **linear perspective,** one of the most commonly used drawing systems and the basis for much post-Renaissance art in Europe.

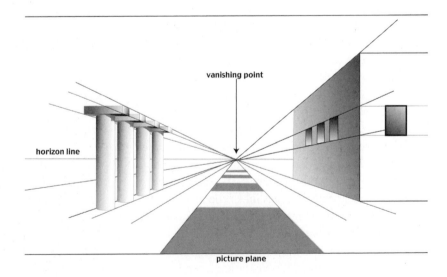

Figure 5.7 One-point perspective: a central vanishing point

You will see two important expressive results of this system in this chapter. The first is the sense of order that perspective provides. The second is the sense of movement into depth. These effects can be especially involving for someone looking at a drawing because they both spring from a strong relationship to a precise **point of view,** the location of the eyes of a person looking at the drawing. In a sense, the viewer is brought into the drawing along his or her own line of sight. Standing in front of a unified perspective drawing, the viewer is engaged with an extremely compelling illusion of space and gravitational balance, and his or her own implied presence.

In **Figure 5.8**, Toba Khedoori defined architectural elements—walls and floors—with careful relation to a high horizon line and a single vanishing point. The result is a beautiful sense of stillness, complemented by soft generalized light entering from the front. Centrality and perfect balance in relation to gravity dominate this drawing and the artist adds to the feeling of stability by placing the vanishing point in the center of the horizon line. Many Renaissance paintings adopted this technique to give a sense of calm to their subject, *The Brera Altarpiece* by Piero Della Francesca **(Figure 5.9)** being among the most emotionally affecting. Khedoori gave this vision new power working on a huge scale (12 feet square) with a luminous beeswax drawing medium.

Figure 5.10, by Caspar David Friedrich, also shows a quiet, empty room, but the architecture has shifted; the window now frames the deepest space at an angle to the viewer's gaze. The natural urge to look out at the harbor in the distance is balanced against the pull of a second vanishing point, leading the eye to the left along the wall. Most of the vanishing lines in the image—the horizontal elements in the window frame and sill—lead to this second point, and a **dynamic tension** develops in the picture as the viewer's eye is pulled along competing tracks. Even though the atmosphere is calm, a restlessness of indecision is injected into the viewer's consciousness.

Friedrich's picture actually has more than two vanishing points. The diagram in **Figure 5.11** shows the basic configuration. Notice that while most of the edges vanish to the left, the top and

Figure 5.8
TOBA KHEDOORI, *Untitled (Rooms)* (2001), oil and wax on paper, 144 × 144 in. (365.76 cm × 365.76 cm) (San Francisco Museum of Modern Art 2002.46.A-B. Accessions Committee Fund: gift of Shawn and Brook Byers, the Modern Art Council, Elaine McKeon, Christine and Michael Murry, Lenore Pereira-Niles, and Robin Wright. © Toba Khedoori)

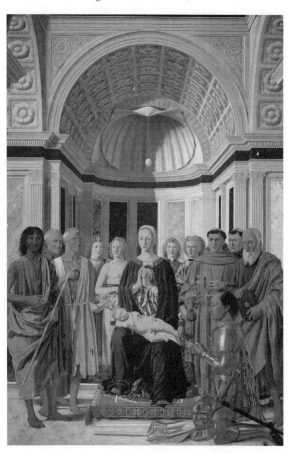

Figure 5.9 PIERO DELLA FRANCESCA, *Madonna & Child with Saints* (1472–1474), 97 1/2 × 67 in.

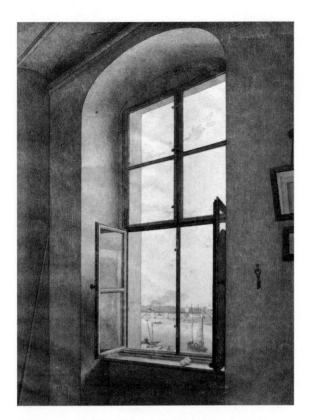

Figure 5.10 CASPAR DAVID FRIEDRICH, *View from the Artist's Studio* (1805–1806), pencil and sepia, 12 1/4 × 9 3/8 in.

zon line because the top and bottom edges remain horizontal, but each window goes to a different point because they are open at slightly different angles. You can imagine that the vanishing point configuration could get quite complex if many different windows or other planes were shown at different angles to each other.

In fact, it is possible to have many vanishing points in a single composition, and also to have them recede to points not on the horizon line. In this case, the eye can be shifted around the space of the picture; it can even seem as though the viewer's gaze is being forcefully pulled around the composition. **Figure 5.12** is a contemporary drawing by Los Carpinteros with many vanishing points and planes configured at a variety of angles to each other, giving a jumbled feeling to the drawing. It is possible to discern a unified planar relationship among most of the blocks, as though they are sitting together on the same floor plane. Several blocks are tipped in relation to this plane, and they have different vanishing points from the other blocks; those points will lie above or below the horizon line. Only horizontal edges, parallel to the earth's surface, recede to vanishing points on the horizon. As vanishing points multiply and move off the horizon line, the visual effect in a drawing is one of increasingly chaotic movement.

Analyzing the vanishing points for objects in a composition or in a real scene can take some practice. It is sometimes easier to begin with the vanishing point and project the object or group of objects out from them. **Figure 5.13** shows three house-shaped objects in different orientations to the viewer and different relationships to eye level. **Figure 5.14** shows a group of houses in different orientations, but all lying on the ground plane. Note the different way your eye moves through the two groups, bobbing up and down, over and back in Figure 5.13, but following a horizontal curve from overhead in Figure 5.14. As an object or plane is projected in a certain orientation

bottom edges of the two small frames in the lower window vanish off to the right side of the horizon line. Because the little windows have been opened—their orientation is almost perpendicular to the plane of the wall—so they recede into space in the opposite direction. They vanish to the hori-

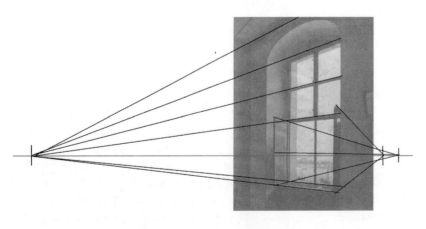

Figure 5.11 Vanishing points for Figure 5.10

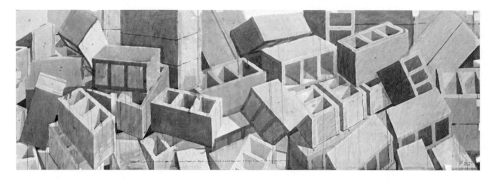

Figure 5.12 *Los Carpinteros (20th century)* (1999), watercolor and pencil on paper, 46 1/4 × 138 1/8 in. (Copyright © Proyecto de Acumulacion de Materiales [Project of Accumulation of Materials]. Purchased with funds provided by Sylvia de Cuevas, Leila and Melville Straus, and The Contemporary Arts Council. [1608.2000] Location: The Museum of Modern Art, New York, NY/Digital Image © The Museum of Modern Art/Licensed by SCALA/Art Resource, NY)

in perspective, a simultaneous indication is made to the viewer's position in relation to the object. Effective use of perspective will always involve keeping both these factors in mind, acknowledging the expressive primacy of the viewer's spatial experience. For a further discussion of vanishing points and their relation to point of view, see Appendix B, Figures AB.2 to AB.13.

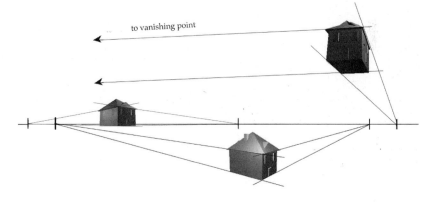

to vanishing point

Figure 5.13

Practical Problems

The practical use of perspective for artists involves a number of difficulties, one of which is clear in both Figures 5.13 and 5.14. Notice that for the houses whose front side faces the viewer the most directly, the vanishing points are too far off to one side or the other to fall within the edges of the paper. In Figure 5.13, the left vanishing point of the highest house is so far off to the left that the receding lines going to it seem to be barely converging at all; this vanishing point could be 50 feet to the side of paper! Technical problems like this make mechanical perspective very difficult to teach in the classroom and lead to much frus-

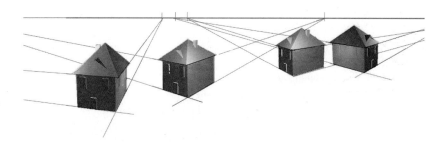

Figure 5.14 Houses constructed from vanishing points

tration for students. It helps to realize that this system has its limits, especially when approached informally as part of a larger drawing curriculum.

Early Renaissance artists, using only a single, central vanishing point, showed a nearly frontal plane as a nonperspectival rectangle, flat to the picture plane. This is a perfectly fine place to start even in a drawing using multiple vanishing points.

Draw the frontal plane square, and then diminish the far vertical edge slightly, bringing the lower corner toward the horizon line as in **Figure 5.15**. In effect, you are approximating the recession of the lower edge of the plane to an extremely distant vanishing point on the far left of the horizon line.

This method yields good results, even if it is not mathematically precise. In fact, most profes-

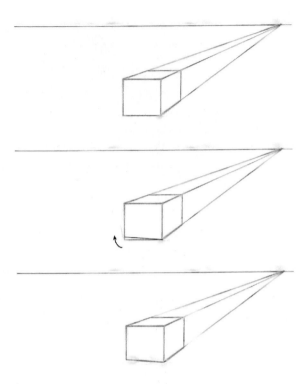

Figure 5.15 Approximating a distant vanishing point

> ### Sketchbook Link: Finding Vanishing Points
>
> Although vanishing lines are abstract entities within perspective drawing, sometimes it is possible to find them or something that looks like them in the real world. See if you can find ten examples of vanishing-point structures in your environment. They will most likely occur where two parallel linear objects—street curbs, railings, edges of a building, tracks, or floor-boards—are receding sharply into the distance. You will not always see the vanishing point at which the lines come together; they could stop short. Follow the lines out anyway, and place the point on the horizon. Add some other elements of the scene to enhance the experience of space.

ISSUES AND IDEAS

❏ Two **vanishing lines** converging to a vanishing point in a perspective drawing trace the recession into depth of a *2-D measurement* of height or width, coming together at a perfectly regular rate, and define a plane receding to the vanishing point.

❏ All edges in the drawing parallel to the receding edges of the first plane will vanish to this same point.

❏ Only planes whose receding edges are parallel to the ground (horizontal planes) recede to vanishing points on the horizon line.

❏ Planes that nearly face the viewer can be shown as flat rectangles (one point perspective) or with a subtle angling of the edges toward the horizon line.

Suggested Exercises

5.4 Vanishing Point Still Life, p. 132

5.5 Vanishing Point, Interiors, p. 133

sional artists who use perspective in drawing feel free, after years of practice, to dispense with horizon line and vanishing points completely; they have learned to draw "toward" them without actually defining them. Perspective is ultimately not so much a mechanical system as it is a way to look at an aspect of the world and bring it into drawing. For other solutions to practical problems in working with vanishing points, see Appendix B, Figures AB.14 to AB.18.

Comparison of Perspective Systems

Like Friedrich's window in Figure 5.10, **Figure 5.16** uses a secondary vanishing point off to the left of the image as shown in the diagram in **Figure 5.17**. This allows the frontal plane of the column's capitals to recede away from the center of the picture. This second receding plane is actually parallel to the wall in the back, which is frontal to the viewer. It can be said to be receding only as it moves off to the side, requiring the viewer to look to the left to follow it into space. There is a contradiction here that is important to understand: A wide plane that faces you in space, parallel to the picture plane, does not recede as you look straight at it. It does recede, however, as you look on it from an oblique angle, off to the left or the right. At that point, it begins to recede toward a second vanishing point.

Artists have chosen to show this secondary vanishing point or not, depending on their creative priorities. Renaissance artists interested in stability and order, such as Piero Della Francesca, use only one vanishing point in the center of the picture. Later in art history, as powerful pictorial movement

becomes a priority in art, two-point perspective is more common.

There is even three-point perspective that stretches the recessive plane strongly down or up. **Figure 5.18** shows all three systems: One-point (a), two-point (b), and three-point (c). Three-point

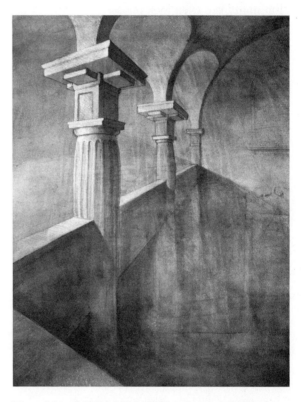

Figure 5.16 LAURA MCCARTY, student work (2002), charcoal and conte, 32 × 26 in.

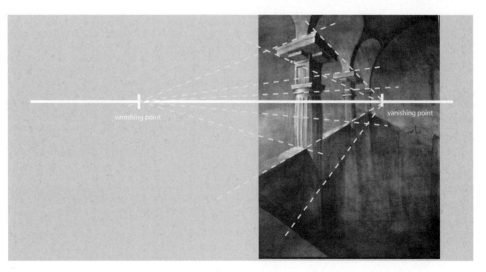

Figure 5.17 Vanishing points for Figure 5.16

perspective suggests either the viewer's extreme closeness to the scene or the subject's huge size. This technique is shown in **Figure 5.19**, giving the effect of dizzying height to an everyday interior. This depiction might not even look real, but it has a powerful physical effect on the viewer's sense of balance and position in the room. This effect is further evidence of the important connection between linear perspective and the viewer's implied location.

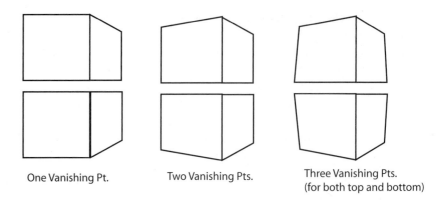

One Vanishing Pt. Two Vanishing Pts. Three Vanishing Pts. (for both top and bottom)

Figure 5.18 Vanishing Points

All linear perspective systems are simplified approximations of actual vision, with artificially imposed limitations. As you study the expressive character of the various images in this chapter—serene, dynamic, or even frightening—think how the artist's choice of one-, two-, or three-point perspective affects your spatial experience as the viewer.

Perspective and the Expression of Space

Perspective is sometimes thought of as a utilitarian system in drawing because of its mechanical basis, but its effects are strong and provide an easily accessible force for artistic expression. Huma Bhabha combined a tunnel-like recession created by one-point perspective with a powerful massing of inky darkness to transform this view of her apartment into a gloomy meditation on the sublime in **Figure 5.20**. The two-point treatment of the dresser on the left makes this a hybrid or combination of one- and two-point systems and subtly enhances the horizontal scale of the spatial effect. Compare this drawing with Figure 5.16, which has a virtually identical one-point/two-point hybrid

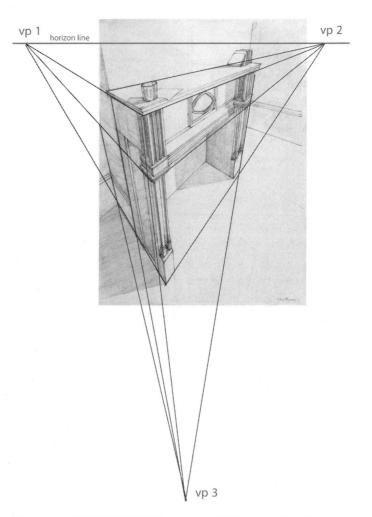

Figure 5.19 CHRIS MURRAY, student work (2001), pencil, 24 × 18 in., with three-point perspective

structure, but with a very different spatial emphasis. Tonal development determines which part of each space our eye is drawn to.

German artist Anselm Kiefer used a simple one-point structure and a low horizon line to evoke a feeling of antiheroic desolation in his *Int-erior* (**Figure 5.21**). Like much of Kiefer's work, the ruined grandeur of this space seems to refer to the disastrous patriarchal trajectory and ensuing destruction of the German nation in the twentieth century. The ceiling extends boldly over your head, guiding your gaze upward and emphasizing the room's mammoth emptiness.

In both of these works, the simplicity of the drawing contributes strength while the centrality

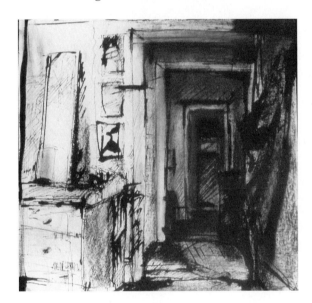

Figure 5.20 HUMA BHABHA, student work (1984), mixed media, 14 × 14 in.

> *Sketchbook Link: Changing Viewpoint*
>
> Position yourself in relation to a corner of a building. You can be outside looking at the building from a short distance or inside looking at the corner of a large room. Do three sketches of the corner. Include the top (ceiling or roof line) and bottom (floor line or foundation). Each time take a different position in relation to the corner: over to one side, in the middle, and toward the other. Use the measuring techniques described in Chapter 2 to estimate the angles that form the corner in each drawing. When you have finished, compare the drawings. There should be a sense of rotating viewpoint around the "hub" of the corner.

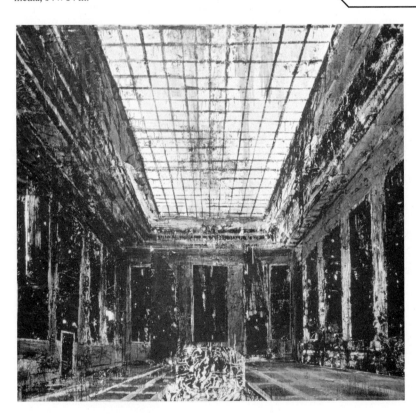

Figure 5.21 ANSELM KIEFER, *Interior* (1981), oil, straw, and paper on canvas, 113 × 122 in.

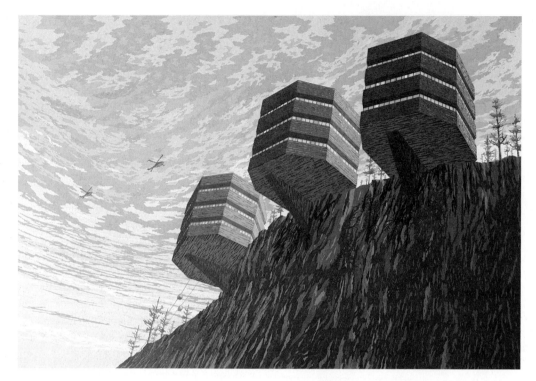

Figure 5.22 DAVID THORPE, *Pilgrims* (1999), paper collage, 46 1/4 × 68 in.

of focus pulls the viewer in a powerful way toward the point of infinity at the horizon line. This strong movement contrasts with a sense of stillness and immobility in the space as a whole.

The huge cut paper collages of David Thorpe, a contemporary artist from Scotland, also have a sense of gigantic space as seen in **Figure 5.22**. The man-made structures project a

ISSUES AND IDEAS

❏ Vanishing points can be applied to a subject in one-, two- or three-point perspective systems depending on the artist's choice. Each system is an artificial simplification of the actual perception of space.

❏ The spatial effect created by perspective systems can have a profound effect on the viewer's sense of position—near or far, high or low, balanced or imbalanced.

❏ A perspective system can be used to draw the viewer strongly into space, to project form strongly toward the viewer, or to create complex combinations of movement into depth in a composition.

Suggested Exercise

5.6 Exaggerated Perspective, p. 133

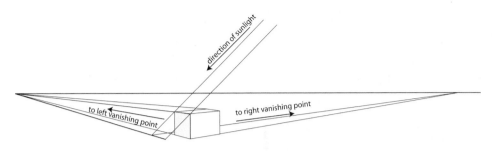

Figure 5.23 Directional light

weird exuberance of ambition, complemented here by the presence of helicopters floating in the distance. Thorpe used a low point of view and three-point perspective with vertical vanishing point high in the sky to suggest that these odd octagonal buildings are perched on a huge cliff. The elliptical cloud patterns in the sky diminish toward a tilted horizon line on the left, well below the lower edge of the page.

Perspective and Light

Perspective structures make ideal channels for **directional light** in drawing. They are so simple and clearly organized that the action of light within them can be fully anticipated and realized by the artist, and clearly read by a viewer. As the rays of light move through the space surrounding 3-D surfaces, they help to show the configuration of the surfaces in depth, grouping parts of the scene in pools of darkness, causing dramatic cast shadows and emphasizing surface texture. Linear perspective can project compelling directional planes in illusionistic space, but light brings them to life.

The shadow of a box cast on the ground recedes to the same vanishing points as the planes of the box. The angle of the light perfectly projects the edges of the box onto the ground along the angle of its path as in **Figure 5.23**. For rules governing various light situations, see Appendix B, Figures AB.27 to AB.29.

You can determine the angle of light in Edward Hopper's watercolor in **Figure 5.24** by following the shadow created by the telephone pole to its point of contact with the white fence. Note how the shadows cast by the house's eaves and porch roof conform to this same angle. The scene is clearly divided into planes facing the light and those in shadow down to the smallest details. Interestingly, the effect makes the viewer less aware of these details, but more conscious of the unity and atmosphere of the overall situation.

The topic of light in drawing is

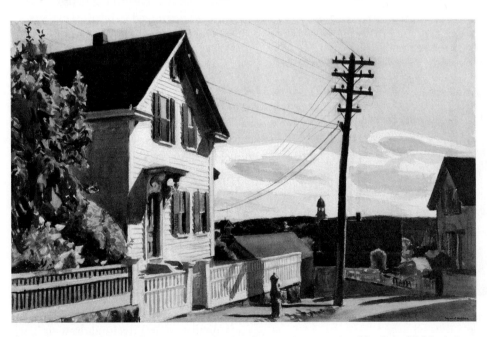

Figure 5.24 EDWARD HOPPER, *Adam's House* (1928), watercolor, 16 × 25 in. (The Roland P. Murdock Collection, Wichita Art Museum, Wichita, Kansas)

ISSUES AND IDEAS

❐ Light, which moves in straight lines, can help to reveal the orientation of planes in depth.

❐ Planar shadows have vanishing points like regular planes.

❐ Cast shadows clarify the position of objects and edges in relation to each other in a light situation.

Suggested Exercise

5.7 Lighted Structure, p. 134

Sketchbook Link: Shadow World

Find a strongly lighted situation, whether an interior with a bright directional light source or an exterior on a sunny day. Position yourself so that the light is coming toward you or is off to one side. Draw all the shadows you see cast on the ground; pay special attention to the edges of shadows cast by rectangular objects. Link these shadows with the dark sides and shadow shapes on the objects themselves, shading the shapes with tone. Try to describe the scene only with shadow.

explored more fully in Chapter 6, but it is such a universal visual condition that it is important to discuss here as a full realization of the space created by perspective.

Scale and Complexity

Perspective systems make possible the illusionistic projection of large empty areas, as you have seen, but they can also allow the easy creation of dense thickets of detail organized in relation to a vanishing point, but layered or accumulated on a level that can suggest awesome enormity. Max Klink's one- and two-point perspective projections, based on derelict factory spaces near his native Pittsburgh and realized on discarded architectural blueprints, have a depressing air of structural collapse and clogged passages, even as they evoke the airy grandeur of gothic cathedrals, as shown in **Figure 5.25**. Although constructing so many perspective rectangles seems to be a daunting task, once a vanishing point has been set, the work can go very quickly as long as all planes in the subject are parallel.

Silke Schatz's work in **Figure 5.26** partakes of the precision and diagrammatic quality of architectural drawing

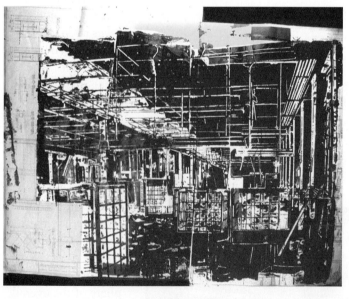

Figure 5.25 MAX KLINK, *Untitled,* from the Pittsburgh Series (1997), mixed media on blueprint paper, 30 × 36 in.

ISSUES AND IDEAS

❐ Repeated details or regular repeating textures can add a sense of large scale to an image.

❐ Architectural details such as window cross-bars or bricks usually line up with the same vanishing points as the walls in which they are contained.

❐ Mechanical techniques such as a snap line (Appendix B and Exercise 5.8) can accurately and quickly bring this type of detail to your drawing.

Suggested Exercise

5.8 Perspective Textures. p. 134

more exactly. She forms lacy layers of colored pencil planes, adhering to a two-point perspective structure to achieve an integrated feeling of assem-

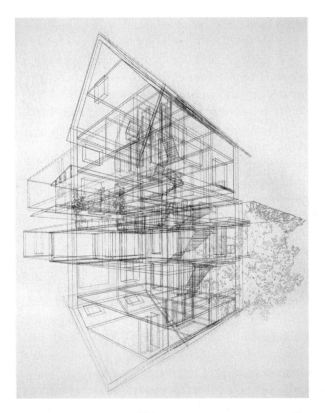

Figure 5.26 SILKE SCHATZ, *Kristall II, MarriagePicture*, pencil and colored pencil on paper, 55 1/8 × 43 3/8 in.

Sketchbook Link: Scaled Texture

Find a field or plaza surrounded by buildings. Sketch in the basic outline of a building, being clear about the angles' edges in relation to vanishing points; give the field or plaza the same attention. Now work into the surfaces of both building and field, using a textural mark that changes scale as it moves back into the distance. You might base your texture on the surfaces you see: bricks, stones, blades of grass, and so on. The point does not necessarily have to be "realistic," but have the changing texture add sense of depth and visual complexity. Be sure to make the patterns of mark (rows, columns, etc.) parallel to the edges of the walls. Absolute accuracy is not necessary; just get as close as you can.

bled space. Despite their abstract transparency, the spaces of these drawings are ultimately quite navigable due in large part to the overall order that perspective provides. As usual, the viewer's location is clearly determined by the horizon (where the horizontal planes appear as flat lines), offering a starting point for visual exploration of the structure. The large actual scale of the drawing is complemented by the implied scale created by the dramatic angles top and bottom, as well as the delicate complexity of interpenetrating lines.

Nonperspective Structures

Linear perspective is efficient in creating the effect of large continuous volumes of space as you have seen, but other spatial systems have different pictorial purposes and fascinating spatial effects. Artists in India have often used a changeable viewpoint to bring special attention to aspects of a narrative scene.

Viewpoint shifts dramatically throughout a **Rajput** drawing depicting a romantic narrative in **Figure 5.27**. The central image of a woman being groomed by servants is framed by architecture that seems to be in one-point perspective. Closer inspection reveals disconnected vanishing points without reference to a single horizontal line, and a lack of diminishment of scale with distance. As a result, the scene floats in an ambiguous space on the picture plane. In a separate building on the left, the woman's lover tries to coax her into a bed that is angled up in an overhead view, while the figures and architecture are shown at eye level. On the right, the lover leaves the palace by a distant gate. A unifying wall in the background provides horizontal continuity to the three-part narrative, while the shifting spatial structure suggests that the depicted scenes are distinct from each other in time. Narrative sequence takes precedence in this drawing over unified spatial sensation.

The **Mughal** artist Miskina suggests a floating point of view through **paraline** perspective structure in **Figure 5.28** . All receding edges are portrayed at approximately the same angle (about 45 degrees) in the context of a generalized overhead viewpoint with no diminishment of scale with distance. The eye is not pulled so strongly into depth as in vanishing-point perspective but moves more freely across the graphic surface of the image. This allows the artist to combine various aspects of the hectic narrative in "stacked" spaces. The real action here is shown in the figures, all drawn at eye level, who seem to have tumbled down the stairs to pile up against the lower edge of the picture. When the viewer learns from the title that the man in the lower center has actually been thrown to his death, the narrative point of the vertically organized space is suddenly clear.

In contrast, two contemporary artists use nonperspectival structure to enhance eerie qualities of isolation in their drawings, disconnecting the viewer from the depicted spaces. Cheryl Goldsleger's *Plateau* **(Figure 5.29)** suggests a deserted city seen from a great distance overhead, perhaps by a surveillance satellite. The structure is not necessarily paraline because diminishing perspectival scale change will not be apparent from a distant overhead view even in a perspective system. With such a high horizon line, the vanishing points are simply too far away for parallel edges to have a noticeable convergence.

Paul Noble's obsessive views of the imaginary city Nobson are purely paraline in structure, allowing the viewer to visually skip around the ruined city without actually inhabiting any of the spaces **(Figure 5.30 and Figure 5.31)**. A dehumanizing sense of repetitive anti-individuality pervades the overwhelming scene. In addition to being incredibly complex and detailed, the drawing itself is over 13 feet long.

Goldsleger and Noble use nonperspectival approaches to create chilly distance, but this approach can also impart a fascinating sense of unreality or mystery on a more positive level. The great Siennese painter Duccio knew how to invest a biblical scene with a sense of magic and power conveyed by unusual spatial structures, as in **Figure 5.32**. Although Duccio's architecture has a superficial resemblance to Noble's, the narrative effect is very different. Duccio's doorway is otherworldly, but compelling. We will enter this door, like Christ and his companions in the depicted biblical narrative, and at that moment reality will change. Since the time of Duccio, the system of perspective has provided drawing with a convincing approximation of natural vision. Photography has since confirmed the visual truth of many aspects of this approach, and once you are used to images organized by a horizon line and vanishing points, deviation can seem odd. However, as the artists in this section demonstrate, this sense of oddness can have a positive expressive or narrative outcome. Ultimately, perspective space is just one option among many available to drawing.

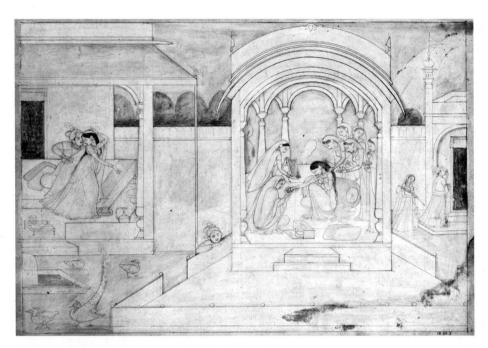

Figure 5.27 *The Marital Bliss of Nala and Damayanti*, page from a dispersed Nala-Damayanti Series (Romance of Nala and Damayanti), India, ca. 1790-1800, ink and opaque watercolor on paper, 11 1/2 × 15 1/2 in. (29.2 × 39.4 cm) (The Metropolitan Museum of Art, Rogers Fund, 1918 [18.85.3]. Digital image © 2008 The Metropolitan Museum of Art)

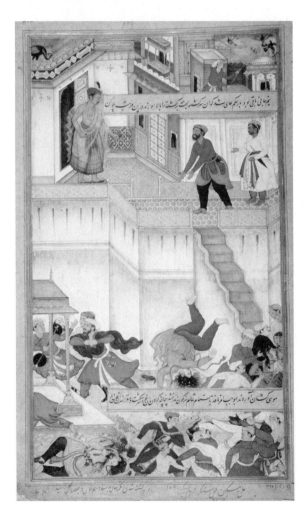

Figure 5.28 MISKINA (with Shankar), *Adam Khan is flung to his death from the palace walls at Agra in 1562* (c. 1590–1595), 11 3/4 × 7 5/8 in.

Figure 5.29 CHERYL GOLDSLEGER, *Plateau* (1994), charcoal, 50 × 85 in.

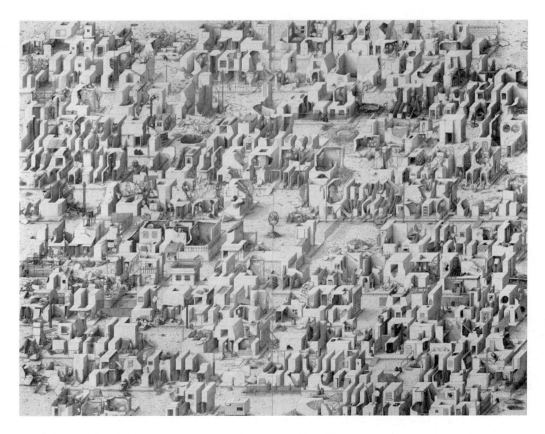

Figure 5.30 PAUL NOBLE, *Nobson Central*, pencil on paper, 82 1/2 × 59 in.

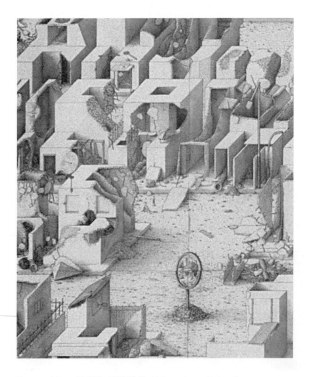

Figure 5.31 PAUL NOBLE, *Nobson Central*, detail

Sketchbook Link: Spatial Diary

Choose a part of your daily routine to document in your sketchbook, perhaps a journey to school or a layered task like waking up and getting dressed. Make quick sketches of four important stages of this process, basing each around the depiction of the space in which it occurs. Rather than drawing each scene from your own point of view, however, pretend you are looking at the action from overhead, through a window, or from some other detached or distanced viewpoint. You can show a figure representing yourself, but this is not necessary. Concentrate on the spaces, especially those aspects that are important to the story: a doorway, a tabletop, interior or exterior of a bus, and so on. Choose three of these scenes and experiment with ways of stringing the scenes together into a composite image. This composite does not need to make spatial sense as a unified scene from one point of view but can have twists and turns of perspective that allow the viewer's eye to move around the image.

this exercise that you not use line to define the outside contour of the objects in the scene you are drawing; you must distinguish one surface from another as light reveals them as in **Figure 5.35**. Begin by choosing an interesting, small incident of space to draw. This can be a narrow place between two objects on the corner of your desk; it could be a part of a plant or a shell. Ideally, the light source in the room should play on the surfaces in an interesting way, revealing textures or creating shadows that add to the complexity of the space. Begin in the center of a large piece of paper, about 18 by 24 inches in a square zone of about 5 by 5 inches. With a semisoft pencil (B or 2B), try to approximate the tonal variations and colors in your subject. You can use very faint lines to place the edges of objects in your composition, but as you work into the drawing, avoid using lines to define the edges more strongly. Instead, describe each edge as the meeting place of two areas of tone, one for the object you are drawing and another for the background tone next to it (this can be a wall surface, a tabletop, or another object). Be as precise as you can about the tonal relationship between the two colors. The first decision to make is which one is lighter and which one is darker. If they are exactly the same, you should let the two tones merge without a border. Otherwise, define the edge by carefully showing light against dark or vice versa approximating the tonal "colors" as accurately as you can. Continue to define the remaining edges of all the objects in this way, carrying the background tones along until they meet another object

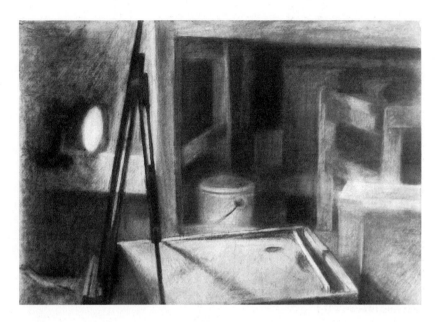

Figure 5.35 STEPHANIE ANDERSON, student work (1996), charcoal, 18 × 24 in.

or edge. Pay close attention to the variation of tones within the surfaces, not just cast shadows but also small changes in intensity of light.

When you have fully realized the tonal qualities of your central mini-composition, move to the adjacent areas of the paper, continuing to describe the light falling on the surfaces in your subject. It can be that, beyond the small area you chose for your initial subject, the composition is less obviously interesting, perhaps just wall or floor. Continue anyway; be sensitive to changes of the light and the description of all surfaces and edges. The point is to objectively explore the reality of the scene as you find it. Take your drawing to the edges of the paper, including anything that happens to enter the composition as you go and defining all by tonal edge without lines.

Exercise 5.2 *Mapping Space*

Using a pencil or an L-square, carefully build a web of anchor points in the depiction of a simple interior space; your bedroom or studio is a good subject. Begin with the points that seem to be landmarks of space in the room: the closest corner of the bed, the place where the door meets the floor, the edge of a rug that divides the room. Let your eye move around the place, trying to encompass the "flow" of the space from near to far, left to right, up and down. You might be able to forget

that this is just an ordinary room, stretching the intervals of space into a more monumental architecture of emptiness in the drawing, pushing the ceiling up into a great vault, stretching the bed far into the distance. The goal here is not exaggeration, however, but honest exploration. By measuring, you should be able to convey your own presence as observer with the space opening up around you.

Exercise 5.3 Horizon and Scale

For this exercise, you must find a window with a broad view or draw outside where you can see into the distance, as in **Figure 5.36**. The first step is to establish the horizon in your drawing. If you can actually see the horizon, this is easy, but be careful; the meeting place of land and sky or building and sky is not necessarily the horizon. If you are looking at a large hill or ridge or at a city skyline that is much higher than your vantage point, it is not the real horizon. Remember that the horizon is *your eye level,* projected horizontally into space. It cuts through buildings and hills that rise above your eye level.

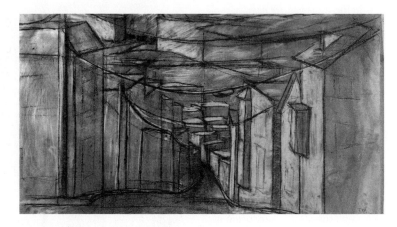

Figure 5.36 TIM LILES, student work (2001), conte, 14 × 28 in.

Once you have determined the horizon line, draw it lightly on your paper, perfectly straight across. Turn back to the view and see if you can find a series of objects or shapes in the area below the horizon. These can be houses, trees, cars, or the rectangular shapes of yards, streets, or roofs. Begin to draw these on your paper, carefully noting of their sizes relative to each other. You can use the measuring technique from Exercise 5.2 to compare sizes or just estimate them. In general, similar size elements become smaller the closer they get to the horizon (the farther away from you they are). Try to find objects that are close to compare with objects that are far away. Ultimately, the goal is not so much to document this particular view as it is to establish a sense of deep space in the drawing. You can try placing invented objects into the composition to complete the sense of scale change, artificially linking closer, larger objects with tiny duplicates in the distance.

Exercise 5.4 Vanishing Point, Still Life

Gather a number of objects with geometric form, particularly those with rectangular forms such as boxes and cubes. Arrange them on a tabletop in a spatially dynamic way—some objects close, some far—oriented in different directions. Draw close to the group at a particular eye level. If your eye level is low, the effect will be very different than if you lean over and look down on the arrangement.

Begin by identifying the horizon (your eye level). If you are looking down on the scene, the horizon could actually be off the top of the page. In this case, you need to tape your drawing to a large board so you can include the horizon relative to your composition. Sketch the objects into your composition lightly, noting the different angles of orientation. Most of your objects should be resting on their end or side, flat to the table, but if you like, you can prop a few of them up on edge.

When you have sketched in most of the edges, use a straight-edge to find a vanishing point for each one by laying it against one edge of the object and following it up (or down, if the edge is above your eye level) to the horizon line. You can then use the vanishing point to draw all the parallel edges of this object and any other object lined up with it. For each object, try to find an edge that recedes to the horizon at a point within or near your page. More distant points require larger drawing boards, possibly huge! If one of the planes of a given object is nearly frontal, use the technique described in Figure 5.15 to approximate its angle without a vanishing point.

When you are satisfied with the configuration of angles, work into the still life to show light and shadow and the tonal character of the surfaces of the objects.

Exercise 5.5 Vanishing Point, Interior

Find an interior space that features strong movement back into space, perhaps a hallway or a view through a door or series of doors, as in **Figure 5.37**. Move around until you find a point of view that gives you a powerful or compelling angle on the architectural forms that define the space. This could involve sitting on the floor or looking past a large foreground element into the distance. Included in the composition should be at least one receding plane or 2-D measurement of height or width. This could be a wall or floor surface, the side plane of a large piece of furniture, or a line of clearly equal objects, like the columns in Figure 5.16. As you begin to draw, locate your eye level in the scene—the height of your eyes from the floor projected forward into the space at an even height. Using the measuring system described in Exercise 5.2, compare the proportions of the front part of the space with the elements in

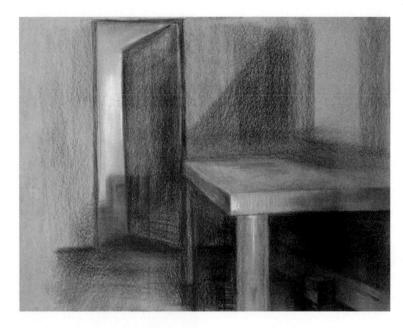

Figure 5.37 GAVIN SCHMITT, student work (2002), charcoal/conte, 16 × 20 in.

the distance. It will be more practical to begin up front to make sure that the closer, and therefore larger, elements will fit onto the page.

Measure to find the change in proportion between the closest and farthest sides of rectangular objects. You can then draw a straight line between their end points to find a vanishing point on the horizon line. Anything in the room that is **parallel,** or lined up squarely with your original object, will recede to this same point. In many rooms, the furniture will be parallel to the walls simply because this arrangement makes the best use of the space. In this case, one vanishing point is sufficient to draw almost anything in the room. If there are objects or architectural elements that are not parallel, you will have to repeat the process of measuring the farthest and closest edges and tracing back to the horizon.

Exercise 5.6 Exaggerated Perspective

Set up to draw a scene in your home from an unusual vantage point. The most accessible and dramatic view could be from floor level **(Figure 5.38a, c)**, but you can also look down in **Figure 5.38b**. In any case, begin by defining your eye level and establish it in relation to the view of the scene you want to draw. The horizon most likely will occur in the picture, but some, such as the one in Figure 5.22 could be off the bottom or top of the page. All receding edges which are horizontal will go to the horizon. In fact, after making a few notations of

the placement of the edges and details of your subject, you can move the drawing process to a more convenient surface such as a wall or a desk and use a ruler to complete the composition. All parallel edges will go to the same vanishing point, and this can make it very easy to quickly lay out all surfaces in perspective. Once you have done this, you should return to your original spot to observe the light and shadow that plays across the scene, bringing a greater vividness to the surfaces and to the sense of space.

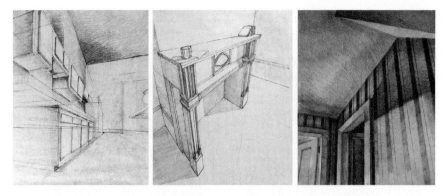

Figure 5.38 a. CHARMAINE O'SAERANG, student work (2002), pencil, 16 × 14 in.; b. CHRIS MURRAY, student work (2001), pencil, 24 × 18 in., c. MICHAEL DEAGRO, student work (1983), pencil/conte on paper, 9 × 6 in.

Exercise 5.7 Lighted Structure

Choose a simple architectural area as the subject for a perspective drawing. **Figure 5.39** shows a corner of a loft bed. Set up your drawing with a clear point of view and eye level, and organize the recession of the surfaces using vanishing points or use a measuring technique with a pencil or L-ruler.

Now position an artificial light source so that the subject's structure is set off by an interesting arrangement of shadows. You could try to organize the space with the light, creating a pool of shadow in the foreground or overhead as in Figure 5.39 or deep in the space as in Figure 5.20. You can also use natural light or an existing light situation, but in any case, it will be helpful to fully understand where the light is coming from and the boundaries of shadow areas in relation to the surfaces of the architecture.

As you work tone into the drawing, allow the light and shadow to accentuate certain parts of the architecture (especially those that are spatially the most interesting) and obscure others.

Figure 5.39 JUAN VERA, student work (2002), charcoal, 24 × 18 in.

Exercise 5.8 Perspective Textures

Take a photograph of an architectural space, interior or exterior, that has complex detail, but whose overall structure is relatively simple as in **Figure 5.40**. The average cityscape, for example, is really just a series of parallel boxes, but each is covered with hundreds of windows. An auditorium can have many rows of seats, but each is parallel to the others and recedes to the same vanishing point.

Pin a large piece of paper (30 by 40 inches) to the wall of your work space with enough room on either side to project the vanishing points of your buildings. This can be difficult if you are working with two-point perspective and a semifrontal plane as described in Practical Problems on page 117, so you might want to work with a one-point perspective space (Figure 5.40) or a "corner view" as in Figure 5.26. Appendix B in Figures AB.16, AB.17, and AB.18 describes a special method to work with exceedingly distant vanishing points using measured scales. Although it is somewhat time consuming, it could give you insight into the desired effect for your drawing.

Determine an eye level for your drawing. (It does not actually need to be the same viewpoint as in the photo. You can raise or lower it for a different spatial effect.) Sketch the basic outlines of the buildings or walls in your subject onto the drawing, and project estimated vanishing points to the horizon (see Figures AB.14 and AB.15 in Appendix B). In two-point perspective, less distance between the vanishing points make the viewer seem to be closer to the scene. The farther apart they are, the more distant the scene will seem.

When you have projected the vanishing points to the horizon line, mark each with a pushpin and tie a thick thread to each one. Pull one thread over the area in the drawing where a line of windows or other detail will be receding toward that vanishing point.

Using compressed charcoal, chalk the thread along the length where you will want a line in the drawing. Now hold the thread tightly against the drawing. With your other hand, pinch the thread and snap it against the paper, transferring a thin, but noticeable, line to the drawing. Continue this process to define the grid of windows receding to the vanishing point, or work with two threads to define perspective floor tiles or other floor elements. You can stay faithful to the buildings in your photograph, or, if you are comfortable with the system, invent objects or surfaces in the space. The goal is to define enough complexity on a small scale but with a definite clarity of organization so that a sense of largeness emerges from the whole.

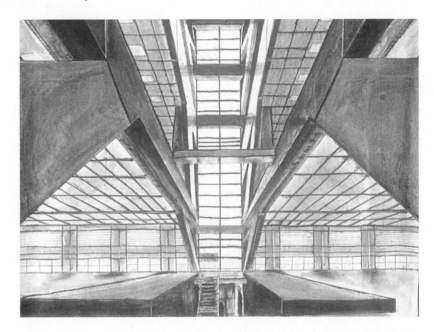

Figure 5.40 MELISSA RIVERA, student work (1999), pencil and charcoal, 24 × 36 in.

Exercise 5.9 *Narrative Space Composition*

Using vanishing-point perspective, paraline projection, or any combination of these or other forms of spatial projection, create a space that suggests a narrative journey. Use figures or leave the space empty, but in either case the goal is to evoke a series of movements through the space: passages from one part of the space to another, comparison of spaces with different characters, or a sense of impossibility of entering certain spaces. You should be aware of the viewer's physical relationship to the spaces you create: specific eye level (perspective) or nonspecific (paraline); balance or imbalance in relation to gravity, or deep recession or flat pattern. Your composition can seem to be a connected maze, or it can move back and forth between inhabitable spaces and perplexing "fun house" illusions. For example, it is possible to include pictures of spaces on the walls within the space of your picture (see Figure 5.34), but you will have to carefully adjust the illusions created to suggest to your viewer the "reality" or flatness of a given space. Directional light can add a richness of dimension to your

image. Note the ambiguity that the great Italian **Surrealist** Giorgio DiChircio created by suggesting the strong shadows of the afternoon sun as lines that alter and warp the sense of perspective in **Figure 5.41**

The experience of space in your finished picture should be visceral, that is, emotionally physical. It can suggest elation, anxiety, claustrophobia, or a sense of mystery. Draw on your own memory of spaces that you have experienced in your life or dreams.

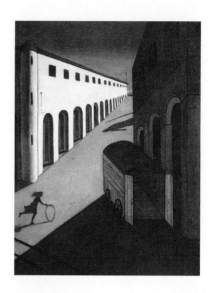

Figure 5.41 GIORGIO DE CHIRICO, *Melancholy and Mystery of a Street* (1914), oil on canvas, 24 1/4 × 28 1/2 in. (Private Collection. Acquavella Galleries, Inc., NY. © 2008 Artists Rights Society [ARS], New York/SIAE, Rome)

—— Critique Tips Chapter 5: The Experience of Space ——

During critiques for the exercises in this chapter, look at your own and your classmates' drawings for qualities based on the following questions.

How can space be defined in a drawing? *What are some of the difficulties in describing sensations of space in drawing? How do you understand space in the real world?*

What role can space play in the expression of a drawing? *What important aspects of human experience or other topics for drawing can be strengthened or defined by projecting spatial qualities?*

What is the significance of eye level? *How do you know where eye level will be in a composition? What is the effect of placing eye level high or low on the page?*

Why is it important to have a unified relationship between the horizon line and vanishing points? *How can you know when this relationship is solid? How do you know when it is not?*

What is the effect of the vanishing point structure in a given drawing? *Beyond being "right" or "wrong," what does a one- or two-point vanishing system do to the composition?*

How can perspective define movement?

How can perspective structure define emotion or psychology?

If light or textures are used in a perspective drawing, how are they integrated with the surfaces?

If a drawing has a story or implied narrative, how does it relate to the structure of space in the composition? *Is there an emotional aspect of the space that complements the story? Is there a progress or movement of space in the composition that is connected to the story's narrative progress?*

Value: Light and Form

6

VALUE

Chapter 6 introduces the element of **value** in drawing. As you know, value has several different meanings in the English language: In financial terms value measures the monetary worth of anything from stocks to works of art; On a personal level if something is of great value it is a measure of its importance to you. Societies have values or ethical beliefs that guide the behavior of citizens. Value is also a mathematical term and it has specific meaning in the law. Similar to its other uses in our language, value in drawing refers to a measurement; it is used to measure the lightness or darkness of **tone,** from white, through gradations of gray to black.

Value is a versatile drawing element because it holds numerous possibilities of expression, abstraction, and description. This chapter focuses on the use of value and contrast relationships to create the illusion of light and shadow, volume, texture, and space in drawing. Value as a compositional, conceptual, and psychological element will be considered further in the next chapter.

The value or gray scale (**Figure 6.1**) shows the range of possible values; every value-based drawing will have tones that fall within this range. Although there could be many more, this scale has eight gradations between white and black, the lightest and the darkest of all values. Any given value is perceived relatively, through relationships with other values. In other words, it is through contrast and comparison that a value's lightness or darkness is gauged. Contrast or difference between values is greater the further they are from each other on the scale; therefore, black and white have the highest degree of contrast of any possible value combination. Conversely, the lowest contrasts on this gray scale are between values next to each other.

To give significance or character to the light value on a piece of white paper, contrasting values of marks, lines, or tones must be drawn on the paper. The remaining whiteness of the paper then becomes light, illumination, or abstract shapes. Contemporary artist Judith Murray transformed the white of her paper (**Figure 6.2**) into a glowing illusion of light, accomplished by enclosing areas of the white paper with large, rich, tonal values. If you compare the value scale in Figure 6.1 with Murray's drawing, you will see that she used an exceptionally wide range of tones within her drawing. Looking further, you will see that the cloudlike **atmospheric** composition allows the viewer to delve into the space of unknown territory, while the crisp gray bar on the right of Murray's drawing makes a jarring contrast to the softer edges of the core of the drawing.

Compared to Murray's enclosed light values, Antonio López Garcia's light values seem limitless, extending in the viewer's imagination far beyond the edges of the page (**Figure 6.3**). Here, small areas of contrasting values pierce the stark white paper. These tonal values not only define the lighting and details of the plates and food but also structure the space and give a sense of vastness to the tabletop. Like Murray, López Garcia used a wide range of values, although in different proportions to the whole. The white areas of the papers function differently in these two drawings though they both depend on the addition of contrasting values between white and black to engage the light within the paper.

Figure 6.1 Value scale

Figure 6.2 JUDITH MURRAY, *Untitled #4* (1996), 17 × 18 in., graphite on paper

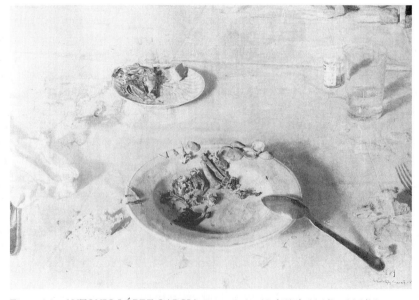

Figure 6.3 ANTONIO LÓPEZ GARCIA, *Restos de Comida* (1971), 16 1/2 × 21 1/3 in., pencil on paper

THE NATURE OF LIGHT, TEXTURE, AND COLOR

Vision and Light

In a world without light—a world of absolute darkness—people would not see anything. They would understand the world through touch, sound, taste, and smell. But there is light that makes visual the world's richness of colors, shapes, spaces and textures. Within a drawing tonal values can modulate this light evoking aspects of its behavior in daily vision. Therefore, an awareness of the physical properties of light and its interactions with the atmosphere, **local colors,** surfaces and material attributes of objects can help you understand many of the uses of value in drawing. This is evident in both Murray's abstract drawing from imagination (Figure 6.2) and López Garcia's drawing from observation (Figure 6.3) in which the convincing tonal values convey the artists' understanding of human perception and light and shadow in the world.

While artists have worked to interpret what they see and experience visually, scientists, philosophers, and cognitive psychologists have worked for centuries to comprehend how humans see. The complex process of seeing involves light's interaction with the world and the response of the brain to light waves or **electromagnetic radiation** reflected from surfaces to our eyes. People are able to see only part of the range of possible light waves called the **visible spectrum,** and within this spectrum the brain distinguishes colors by seeing different wavelengths as different colors. When light hits an object, some light waves are absorbed and others are reflected; for example, an object that appears to be red absorbs all visible light waves except for the red waves that are reflected to our eyes. Light-color objects reflect the most waves, and dark ones absorb the most waves. Many animals and insects perceive the world differently than humans do because they see a different range of light rays and therefore a different range of colors. People see the human version of the world, not the world in all of its visual possibilities. It is interesting to think about how different humanity's creations could be if human eyes were sensitive to another range of light waves.

Sources of Light

Sources of light can be **natural** or **artificial.** Clearly, the sun is the principal natural source of light. Many people believe that the moon is a source of light because it illuminates the night sky and can cause **cast shadows.** But in fact, the moon does not emit light; it only reflects light from the sun; the shadows it casts are the result of this **reflected light.** Fire, lightning, and even fireflies and bioluminescent jellyfish are examples of other natural sources of light. The major artificial sources of light are electric light bulbs, most commonly incandescent and fluorescent. Even though we can see and identify light sources, light is not visible as it passes through space.

Many observations about light can be seen in natural light effects, or re-created through experimentation with an artificial light source. One observation is that as a light source moves closer to a subject, the subject's cast shadow grows larger. Also, as a light source changes position from low to high, the cast shadows are modified from long to short. This is easy to observe on a sunny day; early in the morning when the sun is low, the shadow your body casts on the ground is long, and closer to midday the shadow will be very short. Another observation to make is the difference between **ambient light** (also called indirect light), that produces soft shadows with little definition and harsh direct light that creates sharp, focused shadows. Yet another aspect to observe is that light striking a surface can become diffused by reflection, bouncing from object to object in the immediate environment. Reflected light can be further diffused if it reaches your eyes through a hazy atmosphere. Try to find examples of these, or create them yourself for a better understanding of the behavior of light and shadow in the world.

Intensity of Reflectance

As mentioned earlier, an object is visible when light rays hit its surface and reflect to our eyes. **Intensity of reflectance** is the term used to describe the strength and quality of light being reflected from an object. The strength of the light source, the proximity and angle of illumination, the surface characteristics of the object, and the character of the atmosphere all affect the intensity of reflectance that we see. Planes or surfaces of objects that directly face a close light source catch and reflect a high level of light rays and are brightly illuminated. The luminosity of surfaces diminishes as the planes begin to angle away and/or move further from the light source simply because fewer light rays are caught and reflected by the surfaces.

The plaster horse sculpture and skull (**Figure 6.4**) and the blocks (**Figure 6.5**), are lit with a strong, directional, light source; therefore, you can clearly see which planes face the light, catch the light rays, and reflect them to your eyes and which planes turn away and are in shadow. The areas you see as lighter values have a higher intensity of reflectance; those in shadow seen as darker values have a lower intensity of reflectance. It is important to notice that all of these objects are similar in local color, therefore, all changes in value are a result of light and shadow. (Color, value and light are discussed shortly.)

Notice the complexity of shadow and light shapes on the organic forms of the horse and skull in comparison to the simple shapes on the geometric blocks. This difference reveals that the change in planar direction on the blocks is sudden, and therefore, the jump from light to shadow or from high to low intensity of reflectance occurs without transitional planes. Many of the shifts from light to shadow or from high to low intensity of reflectance on the horse head have gradual transitions providing information about the subtle changes in plane. Note that in both Figures 6.4 and 6.5, the illuminated planes and the shadow planes grow darker and darker, forming their own value scale as they move further away from the light source and the light's intensity of reflectance diminishes.

Material Reflectance

Another factor influencing the reflectance of light rays is that a range of object or material types from absolutely **opaque** to fully **transparent** exists in the visible world. Opaque materials reflect many light rays and transparent materials reflect very few because most of the light rays pass through them. **Translucent** surfaces reflect some light rays and can vary from almost opaque to nearly transparent. In the group of objects of transparent, translucent, and opaque materials varying degrees of **reflectance** are evident (**Figure 6.6**). As seen on the far right object,

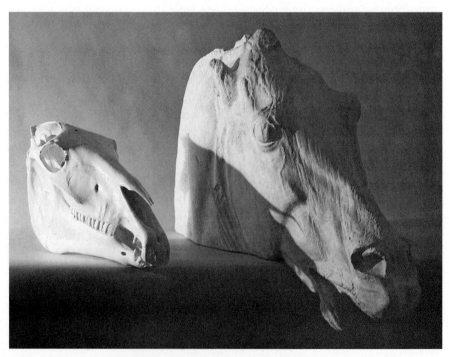

Figure 6.4 Intensity of reflectance on horse skull and plaster cast of head of a horse from the east pediment of the Parthenon, Acropolis, Athens

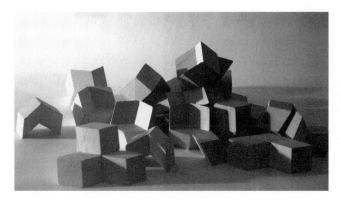

Figure 6.5 Intensity of reflectance from blocks

Figure 6.6 Reflectance from opaque, translucent, and transparent objects

a transparent surface can seem opaque if the light strikes from a particular angle and causes a glare.

In drawing, value can reveal the degree of reflectance and glare off of opaque, transparent, or translucent surfaces. For instance, British artist

David Tress used value contrast in *Light Across (Loch Kishorn)* to show that one body of water can have many qualities depending on the effects of the environment. In **Figure 6.7** his responsive, loose representation of the dark opacity of the deep water is

Figure 6.7 DAVID TRESS, *Light Across (Loch Kishorn)*

ISSUES AND IDEAS

❏ Without light the world would not be visible.

❏ The pattern of value on an object can reveal its structure by describing the intensity of reflectance of its planes.

❏ An object's opacity, translucency, or transparency is revealed by light; an opaque surface reflects more light than a transparent one does. In drawing these characteristics can be described with value.

Sketch Book Link: Changing Natural Light

Do several quick value studies of the same large object (such as an automobile, a tree, a boulder.) outside at different times of the day. Choose a clear sunny day and find an object that will be in place throughout the day. Determine whether your object is transparent, translucent, or opaque and how that quality affects the light and shadows. In your sketchbook, draw the object and the changing natural light as seen from the north, east, south, and west of the object, every two hours from 7 A.M. until 7 P.M. Notice any change in intensity of reflectance as the light changes. As you move from north to east to south to west, note the dramatic changes in light, for instance, the silhouetting of the object if the sun is shining in your eyes in contrast to what you see when the sun is behind you. Record the changing cast shadow from long to short to nonexistent throughout the day. Write down the direction you are facing and the time of day for each drawing and make notes about your observations. You can do several of these drawings on a page, filling several pages of your book.

interrupted by slashes of translucencies caused by reflections and shadows. Moving beyond the enveloping shadows, viewers experience the brilliant sunlight as it glares off the water's surface and calls attention to the horizon.

The behavior of natural and artificial light is fascinating to observe, and it always has an explanation. As you walk outdoors, or through a building, observe the changing light and determine just what is causing it to act the way it does. Observing and drawing different lighting situations will increase your sensitivity to light and shadow; this will enhance your drawings even when drawing from imagination.

Texture as Value

Another important aspect of the visual world is surface texture. Since light and shadow reveal variations of textures to our eyes, value can be used to describe them in drawing. In very subtle textures, minute planes or facets reflect light in a complex variety of directions. The size, form, and arrangement of the facets determine the subtle differences of intensity of reflectance and visual impact of, for instance, a glossy paint versus the matte surface of an eggshell. In more obvious textures, our eye can discern the planes that create the textures such as the spines on a sea urchin or the nubs of a textile. Compare the range of textures on the sea life forms in (**Figure 6.8**). Light reveals that the surface of the horseshoe crab is smooth and somewhat shiny, contrasting with the matte, stubbly surfaces of the varied coral specimens.

Diverse textures have an important role in the surreal still life drawing by Ramon Alejandro (**Figure 6.9**). The artist slows down the viewer's gaze and demands close scrutiny of every part of the composition because each object is endowed with its own specifically evoked surface that holds interest over a long period of time. Varying pat-

Figure 6.8 Variety of textures on natural objects

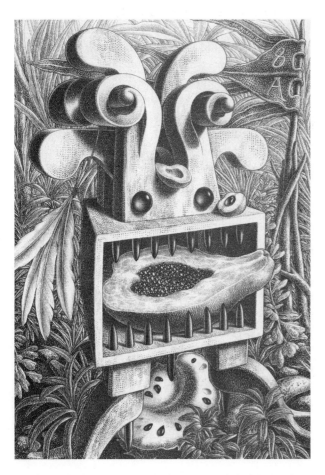

Figure 6.9 RAMON ALEJANDRO, *Destiny* (1990), chalk

terns of light and dark values reveal the smooth façade of the mechanical contraption with its glistening eyes and slick bullet-shaped teeth that contrast sharply to the more complex textures of the fleshy fruits, slimy seeds, and delicate leaves. The veracity of textural representation in this drawing suggests that Alejandro worked closely from actual objects, even while inventing the overall composition. This **allegory** of texture elicits a scene of a writhing tropical jungle, with a suggestion of the tumultuous political history of the artist's home country of Cuba.

Texture represented by value can also be invented and developed by making marks that refer to the process of drawing rather than to an observed, or known texture. Martin Kline worked in this way in many of his drawings (**Figure 6.10**). The vigorous spiral of changing value is built with individual marks: Some areas have high contrast with very dark marks against the white page; others are more densely developed with groups of marks merging into dark masses. Lighter marks have low contrast on the white paper and function

Figure 6.10 MARTIN KLINE, small untitled oilstick drawing (2001), 19 1/4 × 26 3/8 in.

Color as Value

An important issue in value-based drawing done from observation, but without the use of color media, is whether the tonal values refer to light and shadow or to the **local colors** in the subject. Every color has a value, or a degree of lightness or darkness that can be matched to a value scale. When creating a value-based drawing you will need to understand the inherent value of the local colors of objects and translate the colors to their value equivalent. In the everyday world you see objects with many different values. For instance, if there were an evenly lit white bowl filled with deep red cherries, you would notice that the bowl has a very light value and the cherries a much darker value. In a tonal drawing of this still life, the value range would show the difference in value of the white and deep red. But, imagine a dramatically lit charcoal portrait in which the hair is represented as the darkest value of the drawing. The darkest value could tell you one of three things: The first possibility is that the hair is in the deepest shadow of the drawing, the second is that the local color of the hair, say brown or black, is a very dark value even in full light, or third, the dark value could be the result of a combination of shadow and local color. You will want to be able

as areas of light. Kline gave careful consideration to the value contrast of mark on page and mark against mark to achieve the swirling energy of texture evident on the page.

Sketchbook Link: Texture Swatches

Develop several pages of texture swatches. Closely examine surfaces with varied textures, such as shiny, smooth, rough, and spiny. Draw the textures independently of the objects. Think of this as making an inventory or bank of textures.

ISSUES AND IDEAS

❐ Light reveals subtle textures of a surface by interacting with minute planar changes.
❐ Textures drawn with tonal values can be an element in a drawing that makes viewers slow down to look more carefully.
❐ Mark making can be used to develop invented textures through contrast in value.

Suggested Exercise

6.1 Textures in Natural Objects, page 162

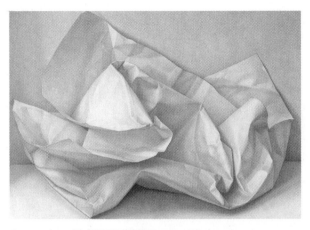

Figure 6.11 CLAUDIO BRAVO, *White Paper*

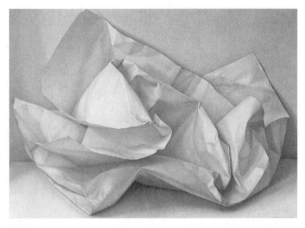

Figure 6.12 CLAUDIO BRAVO, *White Paper*

to determine which is the reason for the dark value of the hair.

Color and black and white reproductions of two drawings by Claudio Bravo (**Figure 6.11**, **Figure 6.12**, **Figure 6.13**, and **Figure 6.14**) demonstrate the translation of color to value. The subject of the first image is simply a piece of white rumpled paper in an environment of the same white color. Therefore, each variation of value is due to the shadows and cast shadows caused by the light striking the planes. The black and white reproduction loses the warm colors, but the value relationships in both reproductions are equivalent.

The drawing of the gently illuminated shoes with widely varying local colors is much more complex to translate to value because each differently colored shoe could have a different value. It is

easy to see that the orange and blue shoes are naturally darker values than the white stripes on the multicolored shoes. However, until you look at the black and white reproduction, it may be more difficult to see that even though the local color of the orange shoes compared to the blue shoes is very different, their values, or their relative lightness or darkness are very similar. In the color reproduction, because of color contrast the orange shoes stand out much more than the blue shoes do from the blue floor. In the black and white reproduction, however, the orange and blue shoes all merge with the rug, because there is little contrast of value between these shoes and the rug. But the white stripes on the multicolored shoes have a strong value contrast to the rug. All of the value variations in Bravo's paper drawing refer to light and shadow,

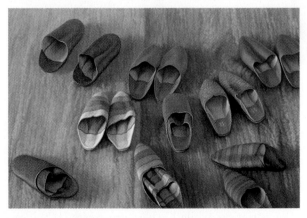

Figure 6.13 CLAUDIO BRAVO, *Babouches* (2005), pastel on paper, 29 1/8 × 42 7/8 in.

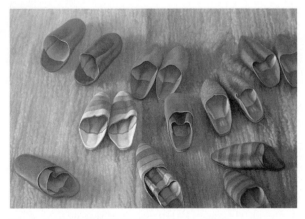

Figure 6.14 CLAUDIO BRAVO, *Babouches* (2005), pastel on paper, 29 1/8 × 42 7/8 in.

but in the shoe drawing, the value variations refer primarily to the local color of the objects.

In contrast to Bravo, Richard Diebenkorn drew without color (**Figure 6.15**) and he gave a general representation of the values of the objects. In this boldly graphic and angular composition, the lightest value shapes represent paper, scissors, and other objects against the dark desktop. Dark-framed glasses were layered on top of the light paper to break up its shape. Unlike Bravo's drawing of paper, the value range in Diebenkorn's drawing does not result from a particular lighting situation, but from the light and dark values of the local colors of the objects, which are placed in relationship to each other to activate the page. While the juxtaposition of light and dark values seems haphazard or hurried, Diebenkorn succeeded in building a composition that teeters on chaos but ultimately pulls together, involving the viewer in a protracted and stimulating experience.

Contemporary artist James Valerio also drew without color (**Figure 6.16**), but unlike Diebenkorn he refered to light, shadow and to local color simultaneously, and in a very specific way. As you can see from the direction of the shadows cast by the doughnuts, the light source is from the left and slightly behind the setup. A combination of our familiarity with the subject and Valerio's careful representation of values and textures makes it evident that some of the doughnuts are chocolate iced and some are covered with coconut or powdered sugar; the viewer can "see" the colors even in this value drawing. Further care with surface reveals that the small white covered dish on the right

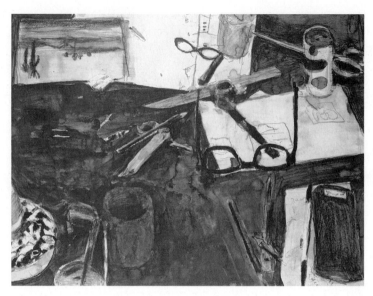

Figure 6.15 RICHARD DIEBENKORN (American, 1922–1993), *Still Life/ Cigarette Butts and Glasses,* (1967), ink, conte crayon, charcoal and ball-point pen on wove paper, 13 15/16 × 16 3/4 in. (35.6 × 43.2 cm) (Photograph © 2005 Board of Trustees, National Gallery of Art, Washington, D.C. © the Estate of Richard Diebenkorn)

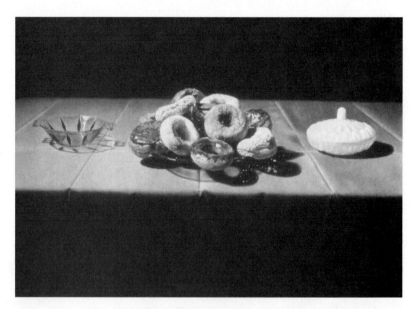

Figure 6.16 JAMES VALERIO, *Donuts* (1999), pencil on paper, 28.7 × 40 in., George Adams Gallery

is opaque and much lighter in value than the table cover, while we see through the transparent glass bowl on the left. Valerio combined qualities of local color, texture, opacity, transparency, and light and shadow with clear description and delicate value variation, while Diebenkorn created a bolder, more graphic depiction of his still life. All the

value changes in these drawings are there as a result of deliberate decisions by the artists but give very different results.

Once you begin to see and understand the role of value in revealing light, shadow, form, texture, reflectance, and color of objects, you should observe it everywhere. For instance while riding in a car on an open highway on a sunny day, notice the location of the sun and how it illuminates the cars in front of you. How are the value ranges different on white cars, red cars, and black cars? What is the different reflectivity of shiny, new cars versus older cars whose paint has dulled? As the day goes on and the earth changes position in relationship to the sun, watch how the light and shadows change, especially the shadows the cars cast onto the road. As mentioned, similar observations can

be made as you walk outside with your own cast shadow, which can be in front of you, behind you, or directly under you, depending on your changing relationship to the sun, streetlight, or other source of light. Observe the houses or buildings around you. Which planes are illuminated or in shadow at different times of day? How do the color and material of the building affect the value range and character of the lights and shadows? How are values, textures, and surfaces different when they are lighted by streetlights or moonlight as opposed to sunlight? In every instance, notice how the light and shadows reveal or give information about the structures you are seeing.

APPROACHES TO LIGHT AND FORM

Light and shadow are not stable, rather they are the result of momentary interactions of light sources and forms. It has been noted in the everyday world how light changes minute by minute as the earth rotates around the sun. In a studio situation with artificial light, the lighting is more controllable, but even then one movement of the model can change the shadow pattern significantly. Similarly lowering or raising the light source causes a definite change in light and shadow. These fugitive qualities of light and shadow add to the mystery they bring to a work of art: the sense of a moment caught. Shadows are visible, but they cannot be touched. Yet they have a

Sketchbook Link: Translating Color to Value

Spend the day observing and translating colors into values in your sketchbook. Keep in mind a gray scale (**Figure 6.1**) from white to black and determine how light or dark the colors of the surfaces are. Juxtapose some white objects with some red and blue ones and so on. Try not to become involved in the detail of the objects, but seek a general sense of relative values of the objects you are observing. Squinting at the colors and holding a gray scale next to them can help you to determine which is lighter or darker in value.

ISSUES AND IDEAS

❑ Change of value in a drawing can refer to light and shadow or to local color of the objects, or to both.

❑ Every color has a value, or degree of lightness or darkness that will fall within the value scale.

Suggested Exercise

6.2 Value Change, Color, or Light? Page 162

powerful significance in Western art both as symbol and visual phenomenon: Artists paint and draw them, and treatises and books have been written on the use of shadows in art.[1]

It is interesting to speculate why an intangible part of the world has come to play such a central role in Western paintings and drawings. Ironically, one reason is the priority in this tradition for representing the world in its three-dimensional (3-D) form as solid objects in space. Systems of drawing such as chiaroscuro and modeling have proven invaluable in the endeavor to use ephemeral effects of light and shadow to emphasize solidity and physicality. Often, observed light and shadow conditions are edited or changed slightly to meet the artist's intentions; copying the light does not work in many instances. Editing may be necessary if **ambient light** creates a light situation that is unclear or confusing. Conversely, in strong light, edges of harsh cast shadows may need to be softened so they do not camouflage or pull apart the form of objects. Many artists edit to find clarity of form by simplifying and/or exaggerating actual lighting situations. We will consider some of the most prevalent approaches to the use and editing of light, shadow, and value in drawing form and structure.

Chiaroscuro

The early fourteenth-century artist Giotto is credited with taking a great leap in painting toward the representation of three-dimensionality on a two-dimensional surface. His work broke from the flatter Byzantine painting to show form through **modeling.** With shadows based on a sense of soft directional light, he was able to translate the three-dimensionality of the visible world to his two-dimensional (2-D) surface (see Figure 9.7). Renaissance artists such as Leonardo da Vinci and Michelangelo

furthered these investigations, solidifying the system of **chiaroscuro** that became a process of using light (**chiaro**) and dark (**scuro**) to create the illusion of solid form in believable space. Later Baroque artists such as Caravaggio and Rembrandt used chiaroscuro with increasing emotional intensity and the technique found new interpretations by nineteenth- and twentieth-century artists including Georges Seurat and Edward Hopper. Today chiaroscuro is used in representational drawing and painting, and as you will see, it is often adapted for contemporary purposes.

Based on the observation of light and shadow in the world, chiaroscuro employs a purposeful grouping of value shapes that change gradually from light to dark. This pattern of value shapes, gives the illusion of volume. The Leonardo drapery study (**Figure 6.17**) and the Roger de Piles diagram of spheres (**Figure 6.18**) demonstrate the principles of chiaroscuro. Notice the subtle transitions from light to dark tones; sudden or harsh lighting is softened, or edited to give continuity to the surface and make the illusion of the form solid.

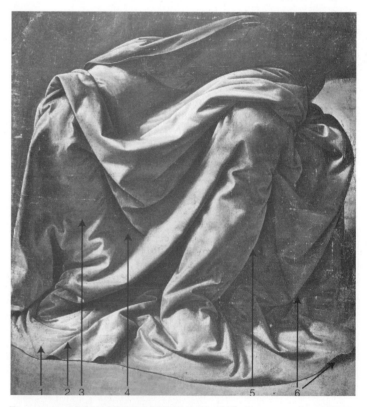

Figure 6.17 LEONARDO DA VINCI (1452–1519), *Drapery on a Seated Figure,* 10.4 × 10 cm. (INV2255. Photo: J. G. Berizzi. Louvre, Paris, France. Photo Credit: Réunion des Museés Nationaux/Art Resource, NY)

[1]Suggested books on light and shadow: Michael Boxandall "Shadows and Enlightenment," Yale University Press, London and New Haven, 1995. "The Notebooks of Leonardo da Vinci," Oxford World's Classics, Oxford University Press, Oxford, 1998.

As you read about the elements of chiaroscuro, find the corresponding numbers on the objects in Figures 6.17 and 6.18.

Elements of Chiaroscuro

1. *Light* falls on those planes or surfaces that face the light source directly.
2. *Highlights* are found within the areas of light where the light is reflected most strongly.
3. *Shadow* is found on those planes that face away from the light. Because there is a deficiency of light striking them, only a small amount of light is reflected from the surface to the eye.
4. *Core of shadow* is the darkest value within the shadow.
5. *Reflected light* occurs when light is redirected from an illuminated surface onto a shadow area and subtly or slightly lightens part of the shadow area.
6. *Cast shadow* occurs when one form prevents light from reaching another form. The cast shadow can give information about the surface it is cast onto but is not caused by that form.

In his studies of the seated model (**Figure 6.19**) Peter Paul Rubens employed the principles

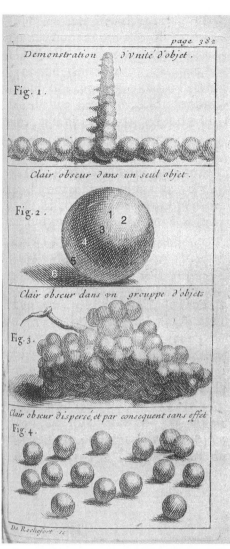

Figure 6.18 ROGER DE PILES, *Cours de Peinture par Principes, Paris, Esteve* (1708), plate 2

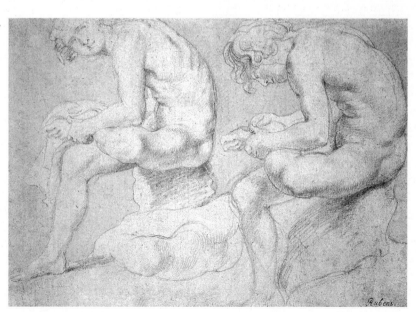

Figure 6.19 PETER PAUL RUBENS (1577–1640), *Youths, after 'Lo Spinario',* red chalk on paper.

of chiaroscuro to show the volumes and structures of the figure and its relationship to the rock he sits on. Careful observation of the lights and shadows on the two studies reveals that they are lit from different angles. The light source for the drawing on the left is above and slightly to the left of the figure. Therefore, the arm has a shadow on its right side, blocks the light from the torso, and casts a shadow onto it. The light source for the drawing on the right comes from the above right of the model, therefore the shadow on the arm is on its left side. This time the shadow on the torso front is not cast by the arm, but is present because the front of the torso faces away from the light. Looking again at the drawing on the left, note the strong light reflected from the rock onto the thigh and buttocks. Indeed, every nuance of light and shadow shape gives information about the model's form and relative position to the light source.

Over the centuries the system of chiaroscuro has been adapted by artists to meet their needs. An example of a drawing in which the artist used the basic elements of chiaroscuro while simplifying and exaggerating the shapes of light and shadow is the twentieth century anonymous portrait of Wassily Kandinsky (**Figure 6.20**). Quick broad strokes of the brush follow the form of the skull most notably on the forehead and chin. In a broad, generalized drawing such as this, the direction of the stroke is critical and the artist was

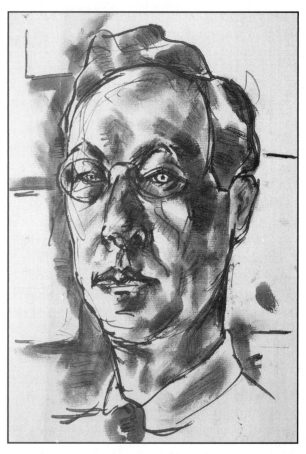

Figure 6.20 ANONYMOUS (20th century), *portrait of Wassily Kandinsky,* black china ink, wash, 9 1/2 × 7 in. (Inv. AM81-65-1038. Musee National d'Art Moderne. © Centre National d'Art et de Culture. Georges Pompidou, Paris, France/CNAC/MNAN/Dist. Réunion des Musées Nationaux/Art Resource, NY)

ISSUES AND IDEAS

- ❏ A range of values referring to light, shadow, and cast shadow can be used to clarify the structure and volumes of forms.
- ❏ Contemporary artists continue to use chiaroscuro to describe forms and place them in space in imaginary and representational drawings.
- ❏ Simplifying or exaggeration of light and shadow may be necessary to achieve the artist's desired effects in a drawing.
- ❏ Line and tone can be used together to describe form and volume and to clarify light and shadow.

Suggested Exercise

6.3 Light and Shadow, with Media Experimentation, page 162

Sketchbook Link: Observing and Recording Artificial Light

Sketchbook Link: Observing and Recording Artificial Light

Keeping in mind the elements of chiaroscuro, do a series of quick drawings in your sketchbook of a single object illuminated by a strong artificial light. Move the light from near to far, high to low, and rotate it 360 degrees around the object. Draw from 10 to 15 different lighting situations. Make notations to go with the drawings on your observations. When is the cast shadow long? short? or not present? Is there reflected light? How do the light and shadow shapes reveal the structure of your object?

careful to make the light and shadow hold the forms together. As this drawing also shows, line can be effectively incorporated with tonal value. The lines and tonal values mutually support and inform one another so that where there is a change in direction of a line, there is a corresponding change in plane and tone. Interaction of line and tone should be consciously planned and adjusted so that each plays off and enhances the other. The exaggeration of tonal values and line that define form also contribute significantly to the sensation of flickering light in this drawing.

Imagined Light and Shadow

To strengthen work done from their imaginations many artists, designers, and scientists use value to draw invented light and shadow situations. For instance, architects and sculptors often need to visualize a space or sculpture that is not yet built, a scientist may need to describe something that will not be preserved for viewing, and of course many artists prefer to work from their imaginations, inventing all sorts of situations that they want to give form. Whether a drawing is done employing observed or invented light, similar elements and handling of value can be at work.

With an imagined, but traditional lighting situation coming from above and the left,

nineteenth-century German zoologist Ernst Haeckel described a jellyfish (**Figure 6.21**). Notice his dramatic, but clear use of value change in the top part of the jellyfish: an abrupt move from the very light rim to the darkest interior and then a gradual change out of the dark interior to the medium value of the far edge. This invented light gives straightforward information about the structure of the animal. Haeckel no doubt had the opportunity to draw from actual jellyfish, but we can imagine the challenges he faced; the lighting on them would be transitory and ever shifting while they are in water, and specimens out of water would simply collapse. Therefore, Haeckel made up the value changes based on his knowledge of light, shadow, and structure. Although this drawing was done primarily to inform students and the public about the structural aspects of the jellyfish, it conveys much more than that, including the

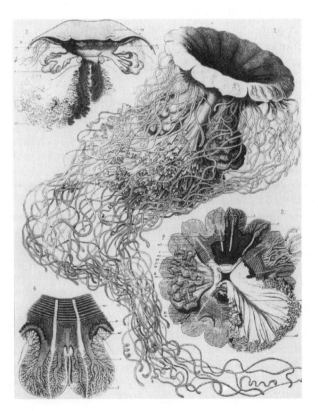

Figure 6.21 ERNST HAECKEL, Desmona annasethe (a jellyfish) (1879), pencil

absolute pleasure and relish Haeckel felt in the way he put down the lines and tones with pencil on paper. The drawing's specificity of information communicated through beautiful lines and tones proves his love of observing, imagining, and drawing the natural world.

Another example of the role of value in invented light and shadow can be seen in the drawing by Shuvinai Ashoona (**Figure 6.22**), an Inuit artist who did most of her work in the 1990s. Ashoona drew indoors from her memory; the light and shadows were invented based on her intimate knowledge of the landscape in which she lives: Cape Dorset, Canada. Using value to create solid rocks, and describing the planes in a clearly structured and weighty manner she gave proof of a strong personal vision and attachment to the land. Without reference to a particular time of day, the light seems timeless, neither transitory, nor flickering, nor about to disappear under a cloud. In addition, a system of complex mark-making suggests the artist's intense concentration and a suspension of time.

Architect Hans Poelzig's expressive use of value in this imaginary interior (**Figure 6.23**) is cranked up to an emotionally charged, dizzying

glow. Often grouped with the German Expressionist movement, his work also drew strongly on earlier traditions to develop new designs. In this concept study for the interior of the Salzburg Festival Theater Opera House, he looked back to Baroque architecture for inspiration. Based on his understanding of the mechanics of light in interior spaces, Poelzig envisioned a source from above. Even though his use of light and shadow reveals structure, viewers are not encouraged to interpret it literally, but to experience it expressively. The drawing shimmers as light and form dissolve together through the invigorating, passionate marks causing the vibrating surface to refer to the music that would fill his opera house.

Modeling

A variation of imagined light and shadow is **modeling** which uses value to create an illusion of three-dimensionality in objects without reference to a clear light source. Instead a generalized system of shading is applied equally to all forms in a drawing, often using the dark values to push the edges of forms back into space.

Twentieth-century artist Fernand Leger used this method of modeling to give volume to his cylindrical forms (**Figure 6.24**). He intentionally **stylized** people and objects as a comment on the modernity of the quickly developing twentieth-century machine age that emerged during his lifetime. Believing that the mechanical world was taking over the natural world which had traditionally been the inspiration for artists, Leger's figures become anonymous and removed from emotion. Arms, legs, and faces become interchangeable as the polished, cold quality of Leger's invented modeling creates volume with an even use of value on the edges of forms and fits his vision of world issues.

Figure 6.22 SHUVINAI ASHOONA (1961), *Cape Dorset, Rock Landscape with Stairs,* (1997/98), felt-tip pen on paper, 11 3/4 × 13 1/4 in.

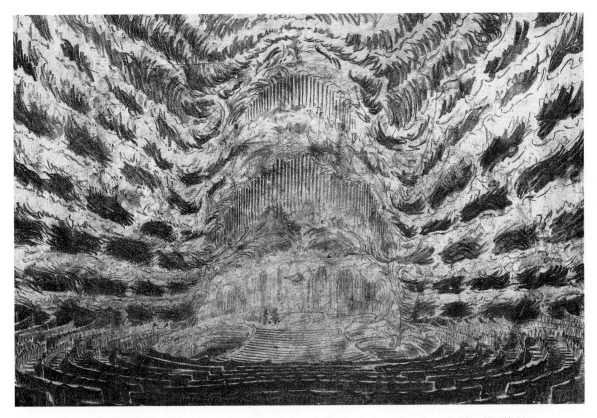

Figure 6.23 HANS POELZIG, *Salzburg Festival Hall* (first version: Auditorium), charcoal on tissue, 21 7/8 × 27 15/16 in.

Diagrammatic Light

In creating diagrams, illustrators try to elicit actual light and shadow, but they often stray far enough from reality to catch our eye. Ted Weller's wood burning (**Figure 6.25**) is done from a found image: a typical diagram from a scout manual. Maintaining the illustrator's reference to a general light source from above that is used in many diagrams, Weller captured the strangeness of this imagined scene. The light, shadows, and cast shadows are consistent on each log as though the illustrator imagined the drawing one log at a time. Astute viewers recognize the discrepancies in the drawing and understand the implausility of the image. Weller furthered the irony embodied

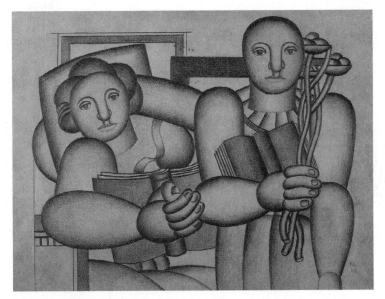

Figure 6.24 FERNAND LEGER, *Etude pour la lecture* (1923), crayon sur paper, 10 2/3 × 14 2/3 in.

Figure 6.25 TED WELLER, *Stacked Logs* (1984), burnt plywood, 48 × 77 in.

trigger associations of light and form gained from experience of daily life. Still to viewers aware of their departures, these drawings remain removed from reality.

VALUE AND SPACE

Value can have a significant impact on the creation of deep or shallow space within a drawing. Whether an artist wants to indicate an inch or two between objects in a still life, convince viewers of miles of deep space in a landscape, or even artificially flatten the space, the role of value contrast is essential to understand.

in the image by replicating the stacked logs on plywood with a burning process.

The value changes in the Haeckel, Ashoona, Poelzig, Leger and Weller drawings were not drawn from actual lighting situations, but they do

Objects in Space

One important use of value to clarify space is in the representation of cast shadows that can show where objects are in relationship to their immediate surroundings. If you look back, you will see that the cast shadows in the de Piles diagram (Figure 6.18) firmly place the spheres on the ground plane because they touch both and connect them to each other. The cast shadows also help to place one sphere in a clear relationship to the others. Similarly, in the Valerio drawing (Figure 6.16) the doughnuts sit on the dishes and the dishes sit firmly on the tabletop because of the information the cast shadows give about their spatial relationships. In

Sketchbook Link: Invented Shading

Do several tonal drawings of the same object in your sketchbook. Place the object in a lighting situation that has multiple sources so there are not strong shadows to copy. Based on your knowledge of light, shadow, and chiaroscuro, invent shading to describe the structure of the object. For some of the drawings, imagine the light source from a definite direction and for others, experiment with invented modeling similar to Leger (**Figure 6.24**).

ISSUES AND IDEAS

❏ A clear understanding of light and shadow in a natural or artificial situation can help you to develop imagined or invented light.

❏ Invented light and modeling are often used to create a sense of volume in imagined drawings.

❏ A confusing natural lighting situation can be clarified with some invention of light and shadow.

contrast, contemporary British sculptor Edward Allington's drawing of classical objects creates varying spaces (**Figure 6.26**). Cast shadows cause the small foreground sphere and the object to its right to hover in space above the ground plane, because these cast shadows do not connect the objects to the ground. The drawing is a riddle of light, shadow, space and proportion. Why are the cast shadows on the floor so dark compared to the others? Why don't the partitions cast shadows? In this drawing Allington, like many other contemporary artists, has used his knowledge of light and shadow to create imagined situations that flop between physical reality and fantasy. Viewers interpret the arrangement of values in the observed Valerio drawing as well as the imagined Allington drawing based on their experience of actual cast shadows in their environment.

A very different use of value conveying a flattened space is seen in Gwen Strahle's still life drawing (**Figure 6.27**). Since the same light value is used to describe the cup in the background and the shell in the foreground, these objects tend to collapse into the same spatial plane. At the same time, similar dark values link the tall, narrow vase in the background and the flower stem in the foreground. These two objects also link due to their echoing shapes to form a vertical that is anchored at the top and bottom of the composition further flattening the space. Seemingly simple in design, Strahle's drawing is a complex layering of discreet objects that bond through like value, shape, and orientation. Viewers consider and reconsider the relationships among and between objects again and again.

Figure 6.26 EDWARD ALLINGTON (1951–), *Seated in Darkness* (1987), pencil, pen and ink, and acrylic emulsion on paper canvas, 1830 × 2440 mm (Inspired by works of Piranesi. © Tate Gallery, London, Great Britain/Art Resource, NY)

Tonal Atmospheric Perspective

Another important use of value in creating space in drawing is through **atmospheric** or **aerial perspective.** This is shown

Figure 6.27 GWEN STRAHLE, *Untitled (2005)*, ink wash on paper, 11 × 15 in.

through the progressive lessening of contrast between values and diminishing sharpness of detail from foreground to background. Observed most dramatically over long distances even in clear conditions artists commonly use atmospheric perspective to emphasize deep space in landscape. But it can also be used for spatial effect on a smaller still life scale, or even in an abstract composition.

Sensitivity to the quality of light is crucial for effective use of atmospheric perspective. Time of day, weather conditions, and geographic location all affect the air: A landscape in the morning has a different atmosphere than it does later in the day, and the air in different parts of the world varies. For instance, in southwest United States the air is generally dry and clear and this explains the sharpness of shadows and the clarity of light that are present day after day. In New England, it is a special day when the shadows are crisp and clear because the atmosphere often has abundant moisture, dust, fog, and smog, all of which scatter or diffuse the sun's rays. Regardless of how clear the atmosphere is, as objects move away from your eye farther and farther into space, they eventually become less distinct because there is more of the atmosphere between you and them.

Atmospheric perspective had already been well developed in Chinese painting and drawing by the Eleventh Century. Great Chinese landscape art and its timeless, mysterious qualities evoke the natural atmosphere that exists in China and often the source of light is less specified than in Western art. Working in this tradition, Kuo Hsi was interested in creating a world that felt eternal (**Figure 6.28**), rather than one that caught a single moment of time with light striking the forms just so. The mountainous forms disappear into the fog and mist and even merge with the drawing's background because they are similar in value. The strongest contrast in value is reserved for the foreground where the lines, tones of the trees and rocks move forward in space. The overall misty, cloudy atmospheric perspective is used as a structural device but also conveys a sense of the artist's contemplation and unity with the natural world. Kuo Hsi transmitted his deep feelings and personal familiarity with the landscape to the viewer without question and in a way not seen in Western art.

In contrast to Kuo Hsi's timelessness, contemporary artist Sangram Majumdar's drawing of rooftops in Brittany, France (**Figure 6.29**) captures a particular time of day. Viewers understand that

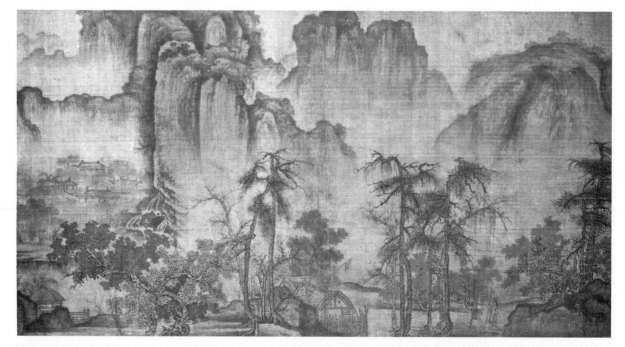

Figure 6.28 KUO HSI SUNG (attributed), *Clearing Autumn Skies over Mountains and Valleys,* Chinese, 11th century; ink and tint, silk *makimono*: 2.060 × .260 (8 1/8 × 10 1/4 in.). (Courtesy of the Freer Gallery of Art, Smithsonian Institution, Washington, D.C.)

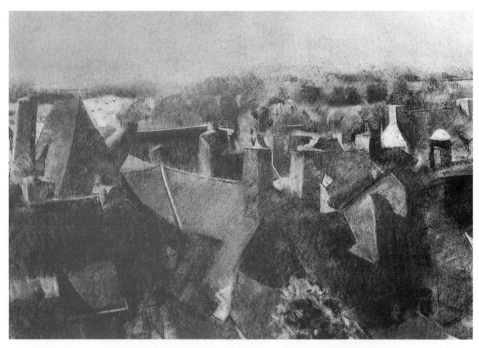

Figure 6.29 SANGRAM MAJUMDAR, *Southern Hills* 2005, graphite on paper, 22 × 30 in.

the light and shadows are fleeting and an hour from now they will create very different value patterns. Showing the atmosphere and aerial perspective present in the region's warm June sun, the planes of rooftops and chimneys work together in a crowded geometric configuration of shadow, cast shadow, and reflected light. Clarity, contrast and hard-edged shadows in the foreground and middle-ground soften as they move far into space where the atmosphere takes over and diminishes the contrast and detail to a blurry, gray vagueness. This change from sharp to hazy shapes also gave Majumdar the opportunity to develop a drawing richly varied in tonality.

Although Roger Brown's landscape (**Figure 6.30**) does not at first appear to have much in common with Majumdar's, both artists created space by using a similar lessening of value contrast to soften the edges of the distant shapes. Unlike Majumdar, Brown's *Misty Morning* is a stylized composition made up of uniformly repeating 2-D patterns that convey flatness of space. In contradicting this collapsed space with the change in value contrast, Brown has joined traditional atmospheric perspective with a late-twentieth-century priority for flatness to create a tension between the 2-D surface of the piece and the 3-D landscape.

Figure 6.30 ROGER BROWN, *Misty Morning* (1975), oil on canvas 72 × 72 in.

Linear Atmospheric Perspective

Just as tonal drawings can represent atmospheric perspective, so can linear drawings with a change in value of the line. Simply by adjusting the

Contemporary Artist Profile.
THOMAS SANCHEZ

Tomas Sanchez was born in Cuba but now lives in Florida. His Florida landscape drawing (**Figure 6.31**) emphasizes the space from the middle-ground island to the background landmass through diminishing scale and atmospheric perspective in the form of lessening value contrast and fading textural detail. Strong middle-ground darks dissipate into pale hazy tones as the viewer floats more deeply into the expansive, peaceful space. The exaggerated shift in contrast and detail from the island to the background stretches the sense of depth even as the low viewpoint juxtaposes the island with the ground of the distant land. Given the artist's history, does he perhaps see this island as Cuba in isolation from the rest of the world or as himself separated from his homeland now that he lives in the United States?

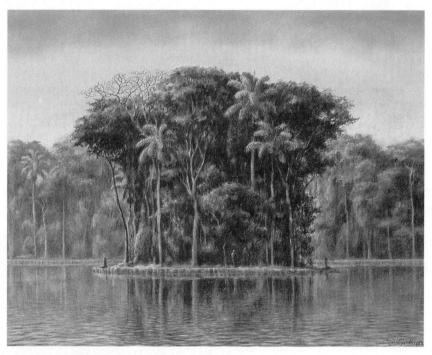

Figure 6.31 TOMÁS SÁNCHEZ, *El Norte y El Sur* (2003), charcoal and pastel on paper, 19 × 25 in. (50.17 × 64.77 cm)

pressure used in applying the medium or through erasing, the line's weight and contrast relationship with the background can be controlled. Dutch artist Jan Van de Velde II developed a clear sense of deep space by using this method (**Figure 6.32**). The spatial placement of each aspect of the landscape is established by the value of the line describing it. Those elements closest to the viewer have high contrast with very dark lines against the white of the paper. This high contrast gradually fades and the background buildings are faint with light lines merging into the white of the page.

Edges: Merging and Emerging Shapes

Still another aspect of value shapes that artists use to create or collapse space is careful articulation of their edges. Boundaries of value shapes represent-

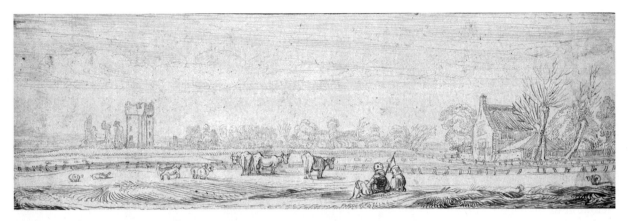

Figure 6.32 JAN VAN DE VELDE II, *Landschaft mit Herden und zwei rastenden Wanderern, im Hentergrund Ruine eines Schlosses*, 4 × 12 1/4 in.

ing light and shadow do not necessarily correspond to the limit or border of an object. When you are developing a tonal drawing, look for light tones on figures or objects that merge with the light background. Alternately, look for areas where dark shadows on a figure or object merge with dark tones in the areas around them. As connected areas of tone cross the boundary between objects and background, a legitimate spatial connection can result. We saw this occur dramatically in the Majumdar drawing (Figure 6.29) where rooftops, chimneys, and cast shadows were part of the same light or dark value shapes. In other parts of the drawing, strong contrast and sharp edges create a separation between objects.

Subtle attention to edges in Kathe Kollwitz's *Whetting the Scythe* (Figure 6.33) established a clear sense of space with merging and emerging value shapes. The German artist contrasted the sharp-edged light on an old woman's hands with the dark value of her dress and surrounding shadows. This contrast separates the hands from their environment so that they emerge into a forward space, where viewers focus on her work of sharpening the blade of the scythe. Conversely, the dark values of the woman's hair and left arm merge and connect with the dark value of the background, even to the point of completely losing their edges and becoming part of the

same value shape. The harsh edge of the cast shadow on her face calls attention to her head as she wearily leans against the scythe for support. This is a good example of using light and dark value relationships to define a specific space and at the same time unfolding the meaning and emotions of the work.

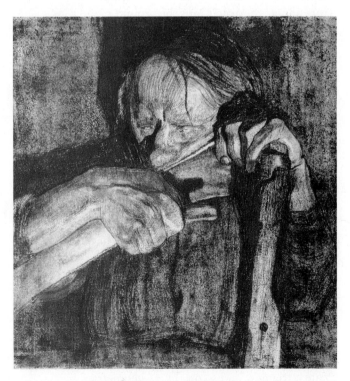

Figure 6.33 KATHE SCHMIDT KOLLWITZ, (1867–1945), *Whetting the Scythe*

As in Kollwitz's drawing, value, edges, merging and emerging forms are the basis for the spatial relationships in Georges Seurat's drawing of a boy (**Figure 6.34**). Characteristic of Seurat, softly nuanced, slowly changing values create an atmosphere that surrounds the boy in a peaceful, casual scene of summer relaxation. Seurat built his values with a conte crayon on a rough paper, preserving some of the whiteness of the page for his brightest lights while gradually making the other areas denser and denser. His process is entirely **additive** or built up; he did not erase or take away.

As he drew, Seurat created a dramatic merging of different forms, most notably where the dark-colored pants and the ground plane become part of the same value shape; it is impossible to determine where the pants end as they melt into the ground plane. On the other hand, he caused the lower leg to emerge in a bold relief by making the background light against the legs dark shadow and dark against its illuminated edge. Similarly, the boy's shadowed face was emphasized with a slight lightening of the background value and on the left side, against the light area of background are the dark tones of the hat and the boy's back that throw them into relief. If this were an actual observed background, it is unlikely that its value would vary this dramatically from dark to light to dark again. Instead, Seurat manipulated the background to make some of the boy's forms merge with it and others emerge from it.

In addition to the considered value adjustments, Seurat imposed a geometric structure on this drawing of triangular shapes. The overall figure creates a triangle; the background shape to the right is a triangle; the space between the calf and the thigh is a triangle; the arm, thigh, and torso create a triangle; and so on. These geometric shapes gain strength and dominate the image be-

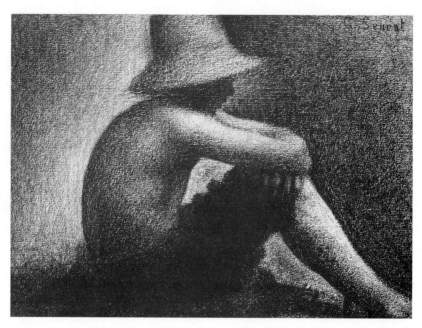

Figure 6.34 GEORGES SEURAT (1859–1891), *Seated Boy With Straw Hat* (study for Bathers at Asnières. 1883–84), black conte crayon on Michallet paper. Sheet: 24.1 × 31.1 cm (9 1/2 × 12 1/4 in.)

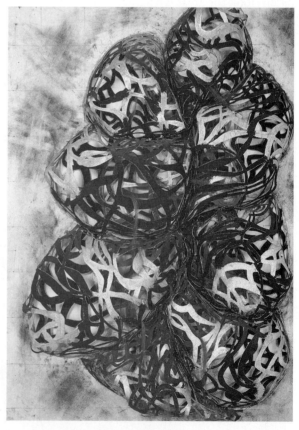

Figure 6.35 BARRY LEDOUX, *Drawing of Self-Doubt* (no. 3, 1989–90) cut paper, hair, glass beads, oilstick, pigment, 40 × 29 × 12 in.

cause the figure fills and even moves off the page. The merging and emerging spatial shifts carry on a lively dialogue with the geometric structure and their abstract relationships coexist subtly with the figurative subject of the drawing.

In his 12-inch-deep abstract drawing of cut paper inspired by natural forms (**Figure 6.35**), Barry Ledoux used some of the same ideas of merging and emerging forms as Seurat. This drawing has a convoluted 3-D maze-like structure with light values (the white of the paper) that work as illuminated areas of the organic segments. While each bulbous section maintains its own identity, the darkest values within them merge in the central spine of the structure. LeDoux also incorporated smudges on the flat background that occurred as a result of the drawing process to help relate the 3-D part of the drawing to its surface; a clean white surface would have emphasized sepa-

ration. Using a changing value contrast along the edges to play the illusion of space against the three-dimensionality of the form also enhances a sense of fluid movement and organic life.

> ### Sketchbook Link: Merging and Emerging Objects
>
> In your sketchbook, do several quick tonal studies of a still life with a controllable light source. Darken the room and set the light so that the lights and shadows on the objects merge with the ground, the background, and each other. Edit and manipulate the tones in your studies as in the Kollwitz and Seurat drawings so that some areas merge and others separate to create the space you want.

ISSUES AND IDEAS

- ❒ Cast shadows can be used to relate an object or figure to the space it occupies.
- ❒ Change in value contrast can be used to create the illusion of deep space through atmospheric or aerial perspective.
- ❒ Objects or parts of objects with a value similar to their surroundings will merge with the surroundings and in some cases completely lose their edges. Conversely, objects with values that contrast with their surroundings separate from the surroundings and occupy a different spatial plane.

Suggested Exercises

6.4 Atmospheric Perspective to Create Space, page 164
6.5 Abstract Shapes in Merging Lights and Shadows, page 164

Exercise 6.1 Textures in Natural Objects

Study the surfaces and textures of several natural objects such as bones, gnarled wood, pine cones, coral, rocks, insects, and so on. Choose one to three of the objects that have clear overall structure as well as interesting textures. Place the objects in a directional natural or artificial light and do a large blow-up study of the textures of the objects. You may want to draw parts of objects juxtaposed next to other parts to make a composition that has interesting but different textures next to each other. Look for structure within the texture. Be inventive with the use of tone, erasing, and mark making, and emphasize the use of light and shadow to reveal structure and texture. Notice how the light behaves on different surfaces such as opaque versus translucent ones. **Figure 6.36** is an example of this exercise by Tessa Ferreyros who chose to study the diverse textures of a dragonfly. The translucent, veined wing contrasts well to the opaque segmented thorax and the frontal view of the insect's head. Ferreyros was intensely inventive with her

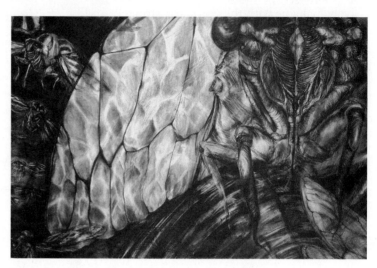

Figure 6.36 TESSA FERREYROS, student work (2002), charcoal on paper, 38 × 50 in.

use of charcoal, and spent considerable time erasing, drawing, and working the medium to develop the textural aspects of the drawing while maintaining a sense of structure.

Exercise 6.2 Value Change, Color, or Light?

Create a color collage from 2-D found objects such as leaves, magazine pictures, and so forth on a piece of illustration board 9 by 12 inches. Include images and objects of varying colors: some light in value, some medium, and others dark. Also include some images with clear light and shadow. The space need not be representational. Once you have established the composition of the collage, do a graphite drawing of the values on 9-by-12-inch paper. Be careful to assess whether the value changes are from change in lighting or local color. The values can be blocked in quickly and then developed to address issues of texture.

Exercise 6.3 Light and Shadow with Media Experimentation

The focus for this exercise is to use the elements of light and shadow to describe the structure of objects while experimenting with different media and various ways of using them. It will be helpful to read through the entire assignment before you begin.

First, choose two objects, one an organic object with gently curving, gradually changing planes such as a green or red pep-
per, a ceramic vase with organic form, or a shell. The other object should be clearly angular and geometric in nature: a simple box, block, or book. It is important to understand the structure of the object that you will be drawing, so run your hands over the two objects to get a sense of them; once you have felt the objects, look at them from every angle; turn them so you can see every view of them as you study the differences in planar structure.

The next step is to direct one clear light source at the objects. Turn off general lighting and use a photo clip-on lamp that you can control and move freely. As you move the light source, study the change in the cast shadow on the tabletop. Place the objects against a wall and again observe the change in their cast shadows on the wall as you move the light source higher and lower. Within the objects, notice how the sudden change in planes on the geometric object leads to hard-edged, abrupt changes from light to shade while change on the organic object is much more gradual. Move the light so the objects are illuminated from as many different angles as possible.

Now do up to 10 drawings of each object from different angles and with the light in different positions. Have a range of lighting from almost completely illuminated to almost completely in shadow.

The light and shadows of the objects you are drawing can be represented in many different ways. Study the sample details (**Figure 6.37**) and try to do your drawings in a range at least as broad. Try different media and use the eraser as a drawing tool. Some samples are worked in layers of value, eraser, value, and line; others are built up and never erased; still others are worked by rubbing charcoal with a cloth. Experiment with the way you draw: put the charcoal, graphite, conte, or ink onto the paper and play with it once it is down while maintaining the structure of the objects.

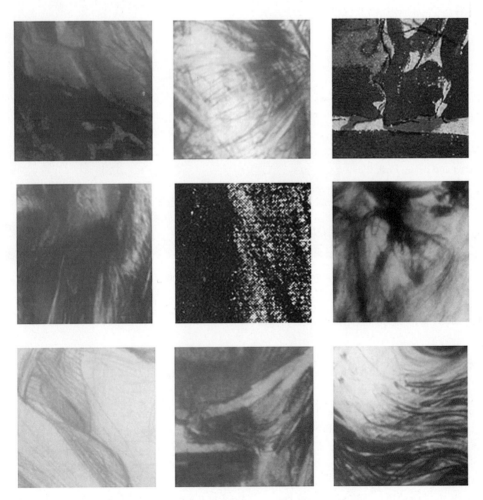

Figure 6.37 Details of light and shadow drawings

Exercise 6.4 *Atmospheric Perspective to Create Space*

The drawing in this exercise should show how light can reveal the structure of forms and establish a sense of space. You want to bring together your knowledge of creating volume through light and shadow with the ideas of atmospheric perspective.

Find a cityscape or a landscape with clear light, shadows, and cast shadows. Alternatively, set up a still life of objects with a foreground, middle ground, and background. Crowd the space with the objects and direct a single light source at the setup, moving it until you have clear lights, shadows, and cast shadows. Whether you choose landscape or still life, look for an interesting composition of values.

Tone your page with vine charcoal, covering the surface evenly in a middle-gray tone. Begin to erase out the light shapes and draw in the darker values. Do not consider individual objects, buildings, or landscape elements until you have developed all large value areas. As you progress, pay more attention to individual objects, pulling the closest ones forward in space and letting the ones farther away fade out and lose both contrast and detail. Push the idea of atmospheric perspective to deepen the space.

To make the form more solid or to increase the depth of space, edit or change the light and shadows wherever you need

to. Address the negative shapes around the objects as convincingly as you draw the objects themselves. Pull objects closer to you with high contrast and sharp detail. Exaggerate the space by losing contrast and fading details for objects farther from you. An example of the assignment is **Figure 6.38** by Erica Kim. Notice how Kim created a deep space by pulling some objects forward and pushing some back into space. Because the light source comes from the left, but behind the cylindrical object, the strongest contrasts are in the middle ground, and they fade and soften as they move away. The large shapes of dark shadows and light areas give the composition a strong value structure.

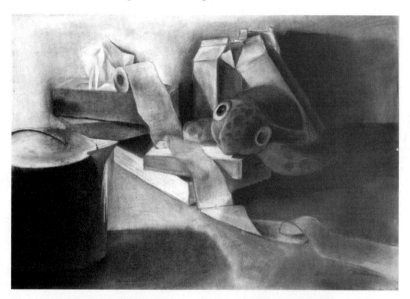

Figure 6.38 ERICA KIM, student work (2005), charcoal on paper, 30 × 40 in.

Exercise 6.5 *Abstract Shapes in Merging Lights and Shadows*

Every part of the page in this exercise needs to be considered from the very beginning of the drawing process. Backgrounds should be developed at the same time as the objects. First, set up a still life of objects against a wall and light it with an artificial light. Move the light around until you have a strong pattern of lights, shadows, and cast shadows including some cast shadows on the wall behind the setup. Tone your paper with a mid-tone of vine charcoal. You want the lights and shadows to

fill the page and go off the edges. Erase out the light shapes and darken the darker values; draw only value shapes of light and shadow, not objects. Let the drawing remain somewhat abstract; do not describe the detail of objects.

Look at the example by Eleanor Sibley Denker for ideas on building your still life (**Figure 6.39**). She was successful in unifying many disparate objects by using light and shadow.

Similar to the Strahle drawing (Figure 6.27) Denker's drawing is pared to a few basic values. The value of the paper represents illumination and the others represent shadow or dark local color. Objects merge with other objects, or with background and shadows. Because the boundaries of the objects are often broken by tonal merging, the space is difficult to read. Strahle and Denker present a purposely ambiguous situation that moves close to abstraction; the viewer is more aware of the light and dark of value shapes than objects. Try to keep your drawing as abstract as these.

Figure 6.39 ELEANOR SIBLEY DENKER, student work (2005), charcoal on paper, 36 × 24 in.

Critique Tips Chapter 6: Value, Light and Form

During critiques for the exercises in this chapter on value, look at your own and your classmate's drawings for qualities based on these suggested topics below.

What is the light source? Is it natural or artificial light? *Is it coming from above, below, behind, or in front of the objects? Is there one direct source or several indirect sources? Or, is the drawing done with invented light?*

How does the use of the medium influence the way you experience the drawing? *Look for clues about how the drawing was done. Was the paper toned with vine charcoal and then erased into to achieve light areas and darkened to achieve dark values? Or, were the tonal values gradually built up from the white page? Was the medium worked vigorously: pushed around and erased and built up and erased and pushed around? Do the marks have an overall quiet mood or an active and noisy one?*

Are there instances where the light reveals the structure of objects *and where it may camouflage the structure?*

How do the characteristics of the shadows reveal the character of the objects? *Are the changes in plane sharp and sudden or organic and gradual? Why do some tonal areas turn gently and others abruptly?*

Are values used to show the textures *or materials of the objects?*

Are changes in value *due to the actual color of the objects, the lighting situation, or invention?*

Does the drawing include atmospheric perspective? *Is it convincing? Is it exaggerated?*

How is the space defined by the use of value? *Are there areas that merge together and areas that separate? How and why is this happening?*

If you squint at the drawing to edit out detail, are you aware of a strong basic composition? *Are different areas of the drawing held together by value?*

What type of mood or attitude does the light give to the drawing? *Does this work with the composition and the subject?*

Value: Idea and Response

<div style="text-align: right">7</div>

Chapter 6 focused on value in describing volume, light, shadow, and space; this chapter considers the link between design elements and ideas in value-based compositions. Aspects of design such as the proportion of light to dark values, range of values, quality of value shapes, and value tempos and rhythms can have a significant bearing on ideas in abstract or representational drawing. Responses to value-based compositions can be physical, metaphorical, emotional, or visual when an artist sensitively handles value to evoke the presence or absence of qualities as disparate as stress, sound, light, pathways, or a sense of life. In addition, the specific placement of a light source can have cultural and conceptual references that elicit distinct reactions.

IMMEDIATE RESPONSE TO LIGHT AND SHADOW

Artists understand that an important use of value in drawing is the development of compositions based on light and shadow. Furthermore, they are aware that viewers can make immediate personal connections to these drawings if they evoke physical correlations. This is in part because people associate light and shadow with physical comfort, and feel even subtle changes such as moving from an area of warm welcoming sunlight into a cool shadow. Depending on the season and the geographical location, people attempt to control the temperature most simply by letting sunlight into the environment or keeping it out. Similar to the control and balance of temperature for physical comfort, artists control their use of light and

shadow for expressive purposes most often through exaggeration or minimization. In literature as well as art, the use of excess darkness or brightness can evoke emotion through associations with viewers' natural responses.

Richard Diebenkorn triggers receptive viewers' memories of rooms with lighting similar to the one he composed in **Figure 7.1**. Confining viewers to the coolness of the dark interior space while

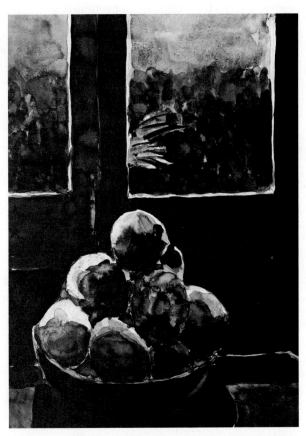

Figure 7.1 RICHARD DIEBENKORN, *Fruit and Windows* (1966), gouache and ballpoint ink on paper, 17 × 14 in.

they look out to the warmth of the daylight certainly creates different physical responses; some may feel immediately protected and comforted by the dark inner world while others may feel chilly and isolated and long to be out in the warm light. Whether Diebenkorn's room seems refreshing or unpleasant depends on personal and culturally influenced responses to light and shadow.

Diebenkorn allows only a small amount of sunlight to illuminate the window edge and the back planes of the fruit while the backlit trees and shrubs outside assume a dark value shape that frames the brightness and warmth of the sunlight. The large scale of these bold shapes quietly surrounds the viewer with a tranquil space. Because Diebenkorn exaggerated value contrast, the dark shadows are darker and the light areas lighter than they would be in reality. Value shapes and shadow edges are not softened, as they might be in a chiaroscuro drawing, but sharpened to emphasize the graphic arrangement of mark and shape. Ultimately it is the viewer's immediate response to the feeling of enveloping space, exaggerated value contrast, and sharpened shadow edges that give this enigmatic, still environment its expression.

In contrast to Diebenkorn's cool interior, Todd Moore exposed rocks on the beach to a scorching, blinding light **(Figure 7.2)**. He stressed the glaring sun by minimizing shadows and maximizing the pure white value of the paper. The extreme light forces viewers to feel that the powerful summer sun will burn their skin and blast their retinas, compelling them to protect themselves one way or another from this harsh situation. Oddly, the subject here could be thought of as pleasant: the beach on a sunny day. By purposefully exaggerating value relationships, the artist focused this experience so that the physical reaction to the extreme light instead of the rocky beach is the subject of the drawing.

A similar physical intensity of the sun and heat in his novel, *The Stranger*, drove Albert Camus' emotionless main character to commit murder. With the searing presence of sunlight, Moore and Camus expressed the simple fact that extremes of

Figure 7.2 TODD MOORE, *111005* (2005), ink on paper, 31 × 21 in.

light and shadow in real life can bring physically inhospitable conditions that can threaten existence.

In another drawing, Moore presents an analogous scene later in the afternoon, again creating a physical response **(Figure 7.3)**. Here he calls attention to the looming shadows on the rocks as tangible barriers to easy travel through the drawing, forcing viewers to contemplate the physical problems of entering and traversing this space. The use of value in this drawing emphasizes the solid, imposing presence of the rocks just as it eroded their form in his other drawing. By pushing viewers away with intense light in one drawing and blocking them out with imposing shadows in the other, Moore used extreme light and shadow as

Figure 7.3 TODD MOORE, *120705* (2005), ink on paper, 31 × 21 in.

a metaphor to state that, one way or the other, life's journey has unnerving impediments.

As you know, it is important for works of art to express a point of view or an idea. Linking ideas about physical reactions to light and shadow with the composition gives viewers something to respond to. Diebenkorn, Moore, and Camus all accomplished this linkage in a deliberate and immediate way.

VALUE RANGE LINKED TO IDEA

Another aspect of value-based compositions to consider is the range and proportion of values. Many artists work with these qualities of value

in their drawings to amplify or clarify their ideas.

Proportion of Light to Dark Values

The proportion of light values to dark values is an important compositional factor to consider when you develop a drawing. The presence of light values makes dark tones seem richer; conversely, dark values help make light tones appear brighter or more luminous. An imbalance of tones in the dark range or the light range can emphasize this effect and attract more attention to the lesser represented value. Although the proportion of light to dark values is not the only compositional issue at work in a drawing, pushing the proportions in one direction or the other can be a convincing way to make a clear statement.

Two very different light and dark value balances are present in drawings by portrait artist Don Bachardy **(Figure 7.4)** and Hugh Ferriss, an early twentieth century visionary architect **(Figure 7.5)**. Although both drawings have a full tonal range from the white of the page to the darkest value of the medium, each composition is dominated by one end of the value range. Ferriss unified his drawing with dark values; Bachardy used the light values to do the same.

In *Truman Capote,* Bachardy created subtle tonal shapes, most of which represent light or shadow. Large areas of intense light on the shirt and head merge with the light background, but the small dark details of the face attract the most attention through contrast. The portrait's drama comes from the starkness of the light, imbalance of tonal proportion, and direct gaze of the sitter, all working together to create a sense of youthful innocence.

Ferriss' drawing is a dark night view with just enough illumination for viewers to make out the presence of a skyscraper. Initially, the light draws the eye to the base of the building, then the thin light shaft runs it up the building's edge emphasizing the verticality of the composition. The large proportion of dark values causes the light values to

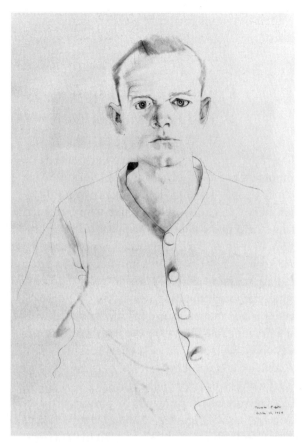

Figure 7.4 DON BACHARDY, *Truman Capote (1924–1984)*, (1964), pencil on paper, 26 2/5 × 19 in.

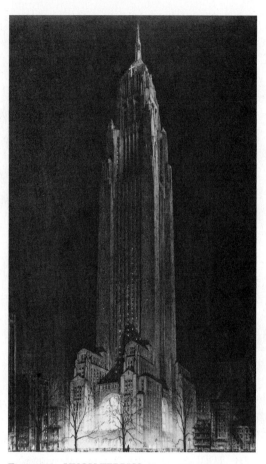

Figure 7.5 HUGH FERRISS, *Proposed Convocation Tower, Madison Square (Northeast Corner of Madison Avenue and East 26th Street, New York City)*, (1921), photostat mounted on illustration board 25 1/8 × 14 5/8 in. (638 × 371 mm)

glow and attract attention. This dark night simultaneously draws viewers in and repels them from the enigmatic, intimidating composition in which they are the lonely human presence.

Although these two value-based drawings have some commonalities such as the uncluttered simplicity of the centered figure or building, their expression is completely different. One is honestly certain with nuanced shadows and uncomplicated appeal, and the other is menacing and unsettling in its drama. This is not to say that all dark drawings are menacing and all light ones are straightforward; however, the combination of value proportion, composition, and subject matter gives each drawing its particular qualities. Observing the drawings together, the viewer becomes acutely aware of the cyclical passage of time: day/night/day/night as the buoyancy of light and the mystery of darkness bring expressive meaning to these drawings.

Limited Value Range

The value range—or the part of the scale from white to black—included in a composition may also determine conceptual and emotional effects. A limited value range can create a calm feeling invoking a sense of muffled sound or even the complete absence of sound. This may happen because the drawing has no harsh, active value contrast or **visual noise.** Jasper Johns, (**Figure 7.6**), Frida Kahlo, (**Figure 7.7**), and Troy Brauntuch (**Figure 7.8**) have limited the range of value in their drawings to one end of the scale. In the *Diver*, Johns began with the brown of the paper and worked toward the dark range of the value scale. Using his hand and footprints, he incorporated a

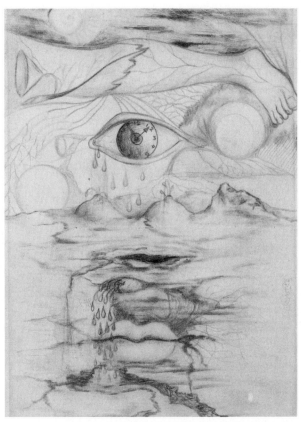

Figure 7.6 JASPER JOHNS, *Diver*, (1962–63), charcoal, pastel, and watercolor on paper mounted on canvas, two panels, 72 1/2 × 71 3/4 in. (Partial gift of Kate Ganz and Tony Ganz in memory of their parents, Victor and Sally Ganz, and in memory of Kirk Varnedoe; Mrs. John Hay Whitney Bequest Fund; gift of Edgar Kaufmann, Jr. [by exchange] and purchase. Acquired by the Trustees of The Museum of Modern Art in memory of Kirk Varnedoe. [377.2003.a-b]
Location: The Museum of Modern Art, New York, NY, U.S.A. Photo Credit: Digital Image © The Museum of Modern Art/ Licensed by SCALA/Art Resource, NY/ © 2008 Judy Pfaff/Licensed by VAGA, NY)

Figure 7.7 FRIDA KAHLO, *Fantasia Nol* (1944), drawing. (Location: Fundacion Dolores Olmedo, Mexico City, D.F., Mexico, © 2008 Banco de Mexico Diego Rivera and Frida Kahlo Museums Trust. Av. Cinco de Mayo No. 2, Col. Centro, Del. Cuauhtemoc 06059, Mexico, D.F. Reproduction authorized by the Instituto Nacional de Bellas Artes y Literatura. Photo Credit: Schalkwijk/Art Resource, NY)

diagrammatic dive within a shower of mysterious, expressive marks. The prints and directional marks eerily suggest a person's presence in the mute depth of the black and infinite water; the dive has been completed. Many writers have said Johns made this drawing in memory of his friend, the poet Hart Crane, who committed suicide by drowning. The metaphorical darkness created with limited value range expresses the absence and quietness of a person who is no longer present.

Like the *Diver*, Mexican artist, Frida Kahlo's drawing, *Fantasia Nol*, was drawn in a narrow value range. Since it hovers at the light end of the scale the contrast with the value of the paper is very low.

Despite the precision of the rendering, the drawing's most notable characteristic is atmosphere: ephemeral, personal, and mysterious. The combination of delicate tones and marks isolates viewers from their surroundings and involves them with a disconnected world emptied of sound. The dreamy silence and sorrow in this drawing come from the implied remoteness and absence of reality as we move through a surreal landscape of body parts and facial features. The design of horizontal lips and leg keep us from moving into deep space, but we float from object to object creating our own narrative on the emotional and lonely journey.

The third drawing with limited value range, Troy Brauntuch's *Untitled (Shirts 1)* seems to refer to an observed situation but is actually from his imagination. Drawn within the dark end of the

Figure 7.8 TROY BRAUNTUCH, *Untitled (Shirts 1)*, (2005), conte on cotton, 63 × 51 in. (Courtesy Friedrich Petzel Gallery, New York, Photo: Lamay Photo)

is so strange that only the fact that a person drew it assures the viewer that humans exist in this world.

The Johns, Kahlo, and Brauntuch drawings present variations on silence as an atmospheric quality tied to limited value range. Whether human presence is expected, never existed, or was there and disappeared, the role of value to evoke these auditory sensations and emotional ideas is powerful.

Extended Value Range

Extended value range—inclusion of strong light and emphatic dark values—often brings a bold and brash character to a drawing. Jack Beal's still life (**Figure 7.9**) has a graphic, noisy energy from the sharpness of the contrasting values. As the dark cast shadows make striking shapes against the high-contrast pattern of the tabletop, the midrange values are minimized in visual importance. The shallow space of the overhead, angled viewpoint emphasizes the composition's skewed flatness, causing the feeling that the precariously set oysters are poised to fall off the table's edge. The high tonal contrast of the extended value range, the exaggerated space and the odd viewpoint all work together to bring a staged, nervy, and harshly disturbing expression to the drawing.

Robert Zakanitch also used an extended value range with extreme light and dark values in his drawing of lace (**Figure 7.10**). The result is striking, but quieter than Beal's still life. Unlike

value scale, the low contrast view of shirts stacked on a shelf, as in a clothes store, is dominated by a sense of human absence or anticipated arrival. In the low, dusky light, the viewer contemplates silence and stillness. Eyes must strain to see what this quiet, paradoxical drawing is presenting. The view

ISSUES AND IDEAS

❐ The proportion of light and dark values supports or sets the mood of a drawing.

❐ Limiting the range of values contributes to a drawing's specific psychological impact.

❐ A drawing with a wide range of values often has a bolder feeling than one with a limited range of values.

Suggested Exercise

7.1 Experimenting with Value Proportions, page 188.

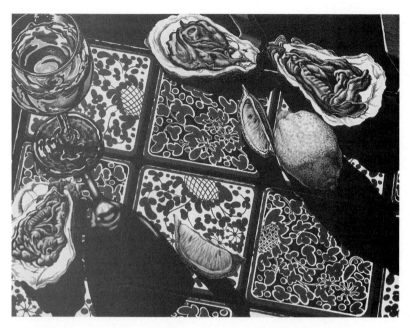

Figure 7.9 JACK BEAL, *Oysters with White Wine* (1974), lithograph, 13 × 17 in.

Beal's sharp-edged shapes, Zakanitch allowed a purposely clumsy smudging of the medium on a black ground to soften the impact of the contrast. Therefore, instead of sharp white against pure black, the lightest value merges with a blurred midvalue mass of intertwined lines of lace. The decorative character of the lace also suggests a playful, delicate energy that exists within a curving design moving vertically and horizontally rather than the harsh angular composition of Beal's drawing. Comparison of these two very different extended value drawings demonstrates that value range in and of itself is one aspect of a drawing that contributes to a work's expression. All formal elements and aspects of media handling combine to determine the drawing's meaning and expression.

VALUE SHAPES LINKED TO RESPONSE

Another consideration in value-based drawing is the character of the value shapes. Most value shapes can be read abstractly even if they refer to a representational image. That is, they can be seen as detached from the image for their qualities as shapes. Depending on all factors of the drawing, sometimes the abstract quality of the shape prevails; at other times, the image unfolds first and foremost. Even if the image stands out, the character of the abstract shapes is crucial to the expression of ideas and will elicit specific responses from viewers.

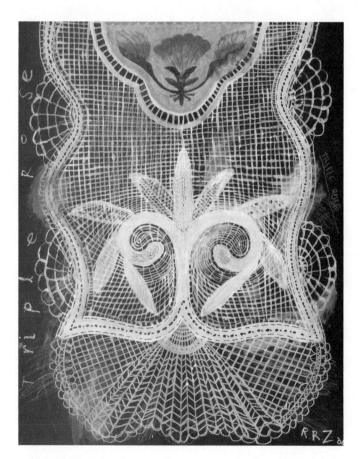

Figure 7.10 ROBERT ZAKANITCH, *Triple Rose* (2006), mixed media on paper, 29 × 23 in.

Image and Abstraction

British artist Alexander Cozens drew two versions of the same landscape. The value study (**Figure 7.11a**) moves toward abstraction and is distinguished from the more literal line drawing (**Figure 7.11b**) that gives specific details of the subject. In the value study, trees, hills, and buildings appear not as individual elements but as one large dark value shape that moves horizontally across the entire page. In fact, this study has only three major shapes: the band of light value across the top of the page, the band of dark value across the middle, and the band of light value across the bottom of the page. Cozens designed the value study with an expressive commitment to abstraction not present in the line drawing. The value study has a feeling of mystery due to the particular lighting situation, the time of day depicted, and, most of all, the presence of the large value shapes while the line drawing remains more diagrammatic.

Like Cozens contemporary artist Jake Berthot saw his landscape (**Figure 7.12**) in terms of only a few abstract light and dark value shapes. He composed the page with three atmospheric areas: one looming dark shape moves viewers from the foreground to the background, encompassing both the closest part of the space and trees much farther away. The other two shapes are light values, one in the near middle ground shows the light on the ground and the other in the upper right represents the sky. They are far from one another spatially, but relate to each other abstractly in terms of similarity of shape and lightness of value. Viewers traveling the luminous path into the billowing dark shape are enveloped by it because the hushed tonalities and rich graphite surfaces ease them through with soft transitions. The feeling of a quiet journey to an unknown destination is

a.

b.

Figure 7.11a–b ALEXANDER COZENS, *Italian Landscape with Domed Building*, pencil and wash on paper

Figure 7.12 JAKE BERTHOT, *Untitled*, (2005), graphite and gesso on paper, 22 × 28 in. (55.88 × 71.12 cm)

conveyed. This drawing is as much or more about the expressive feeling of the abstract value shapes and the lush use of the medium as it is about the specific landscape.

Sharp Shapes and Atmospheric Shapes

In contrast to the large but quiet shapes that give a peaceful feeling to the Berthot landscape, Otto Dix's drawing **(Figure 7.13)** has a more complex and edgy set of lights and darks. A German artist, Dix had the traumatic experience of fighting in World War I, and the brutality of war became the focus of his work. In *Grave (Dead Soldier),* Dix broke the page into shardlike value shapes, creating an active, jittery composition that is subdued by the presence of the dead soldier. Dramatic, expressively distorted shapes present a grotesque narrative about the horror of war and its effect on people. Viewers cannot help but understand the message Dix expressed by the angular fleshless skeleton still dressed in its military uniform. This powerful image peels away the comforting, cosmetic surface of society to a raw reality, yet his exposé is ultimately hopeful. Dix presents the

precarious nature of a world gone mad, but a world that is worth saving.

The clear but soft-edged shapes of the many light and dark values in *The Forest,* a group of drawings by Enrique Martinez Celaya **(Figure 7.14),** express completely different ideas than the harsh shapes used by Dix. Consequently, Celaya's thoughts in contrast to Dix's brutally urgent ones, are personal and meditative to be considered quietly. The anonymous solitary figure in a forest is sometimes shrouded by shifting values and in other instances contrasted with them, but the relationship between figure, light, and shape always remains the subject of the drawing. Celaya's imagined, softly glowing light emits emotion, and his mystical content expresses introspection in a

a. b. c. d. e.

Figure 7.14 ENRIQUE MARTINEZ CELAYA, **a.** *The Forest I, Light* (1999), watercolor on paper, 11.5 × 11.5 in.; **b.** *The Forest II, Bird* (1999), watercolor on paper, 11.5 × 11.5 in.; **c.** *The Forest III, Lily* (1999), watercolor on paper, 11.5 × 11.5 in.; **d.** *The Forest IV, Tulip* (1999), watercolor on paper 11.5 × 11.5 in.; **e.** *The Forest V, Clearing* (1999), watercolor on paper, 15 × 32 in.

Figure 7.13 OTTO DIX, *Grave (Dead Soldier),* (1917), drawing

ISSUES AND IDEAS

❏ Value shapes can be abstract as they structure the composition even if they also refer to an image.

❏ The character of light and shadow shapes in a drawing can evoke a range of strong emotional responses and ideas.

❏ The shapes of the light and shadows in invented or observed light can be used to compose the page and simultaneously give meaning to a drawing.

Sketchbook Link: Value Shapes

In your sketchbook, make quick visual notations of different shapes of light and shadow that you observe indoors and outdoors. The shapes should be abstract ones that you extract from what you see rather than referring to specific objects. Then invent some of your own shapes. Exaggerate the characteristics of the shapes to express an emotion. Refer to drawings by Dix (**Figure 7.13**) and Celaya (**Figure 7.14**) for ideas.

strong but never harsh manner. Viewers might speculate that these drawings have implications about the natural cycle of life, death, time, light, or darkness, but nothing refers to untimely or violent death as we saw in the angular composition of Dix.

LIGHT SOURCES: IDEA AND RESPONSE

The distance, angle, and intensity of a light source can strongly influence the ideas expressed in value compositions. Knowing how you want to design your drawing with value shapes is helpful in deciding where to place the light source. If you use an artificial light on a subject, consider the value shapes with great care; take the time to position the source so that the light and shadow areas support the ideas you are expressing. When you work with natural or existing light that you cannot control, position yourself so that your view of the action of light inspires your interest. If you are inventing the light and shadow, think about the feeling you are trying to create in your choice of imagined placement of the light source. Careful decisions about the placement and intensity of your light source affect the composition psychologically, expressively, and conceptually.

Lighting From Above

Traditionally, most drawings and paintings with light as an important element are lit from above. This is probably because people are accustomed to seeing sunlight shining down from the sky, casting shadows onto the ground.

Lighting from above is depicted in the sunlit drawing by Michèle Fenniak (**Figure 7.15**). Her delicate application of the media and subtle value range combined with the distant and diffused light source gives the drawing a soft, flowing, atmospheric character. This results in light with a dreamlike quality—bright but ephemeral. Gradually, the sunlight quietly changes from ordinary to mysterious in relation to the narrative. More sense of mystery comes from that part of the narrative that Fenniak did not show as viewers realize the woman is surprised by something beyond the frame of the page.

Although also lighted from above, Joseph Stella's *At the Base of the Blast Furnace* (**Figure 7.16**) expresses very different ideas from Fenniaks'

work. In this drawing, the proximity and intensity of the light source create a strong contrast that leads to clear value shapes representing dramatic lights and shadows. Actually, this drawing connects the light source with narrative in a direct way: The source is the furnace that looms over the laborers who are in the midst of hard physical work in a Pittsburgh steel mill. While the viewers' eyes float through Fenniak's drawing, they plod along in Stella's composition from one illuminated shape to the next as viewers are compelled to feel the strain of labor in the men's gestures and exhaustion. The work's physical stress and the intensity of the light cannot be separated as they reveal Stella's ideas and determine viewers' responses.

Both Fenniak and Stella used a light source from above their subjects. But a comparison of Fenniak's ethereal light to Stella's brutal light clearly indicates that the intensity and proximity of the source strongly determine the character of the value shapes' that each artist emphasized to develop their composition, idea, and expression.

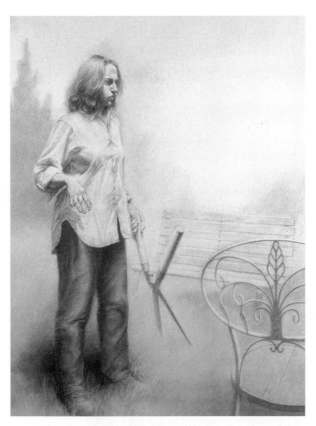

Figure 7.15 MICHÈLE FENNIAK, *Garden* (2002), graphite and conte crayon on paper, 50 × 38 in.

Lighting From Below

Lighting from below usually catches a viewer's attention because it often imparts an odd psychological effect. As discussed, people are accustomed to sunlight from above, so the opposite can seem unnatural. For this reason, artists, architects, and filmmakers use under light when they want to develop striking works of a particular type. An example is film noir, a cinema

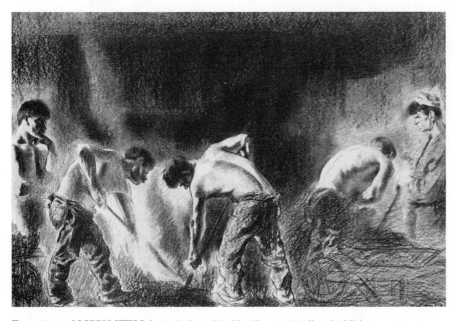

Figure 7.16 JOSEPH STELLA, *At the Base of the Blast Furnace*, 14 1/3 × 21 2/3 in.

Contemporary Artist Profile
UGO RONDINONE

Swiss artist Ugo Rondinone, who now lives and works in New York City, created large-scale ink copies **(Figure 7.17)** of his own small on site nature studies. Rondinone borrowed a romantic, 19th century approach to image and style, but gave them a contemporary context by using ink on paper in a huge size. The lighting from below is another signal that this is not the work of a 19th century artist or even a purely natu-ralistic vision. No longer a simple bucolic scene, the menacing image is an unsettling collision of nature and culture. The value shapes are groups of marks that give the drawing the look of a photographic negative or a flash of blinding, artificial light. How long will the light endure? Why does it come from below? These drawings combine unconventional choices with traditional approaches to landscape space, including softening focus between foreground and background, in an archetypal **postmodern** stylistic blend of **appropriation** and innovation.

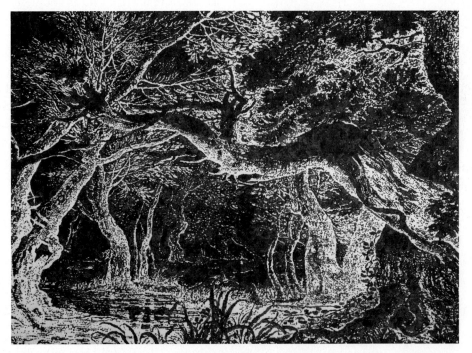

Figure 7.17 UGO RONDINONE, *No. 135 Fourthofjunenineteenninetynine* (1999), ink on paper, 79 × 118 in. (© Ugo Rondinone, courtesy Matthew Marks Gallery, New York)

genre concerned with sinister psychological drama in which under lighting and cast shadows are used to give viewers a sense of impending crime, betrayal, and murder.

Hans Otto Wendt, the designer of a German poster for a film noir **(Figure 7.18)**, pushed the use of artificial under lighting to an extreme. The gesture, facial expression, costume, props, and es-pecially the lighting give the male actor an evil criminal aspect. Close to the subject and carefully angled, the light source creates strong narrative value shapes in the form of deep, dark cast shadows. The shadow cast by the actor and his gun onto the woman's face creates interest about her fate in the film. Will there be a confrontation between these two characters, and will the weapon

Figure 7.18 HANS OTTO WENDT, *Highway 301*, movie poster, 1950

ing someone who is sitting in front of a window with the sunlight coming in from behind him or her, you see a silhouetted figure with little or no definition, but he or she can see your face clearly because the same light illuminates you. As with other placements of light sources, lighting from behind can be the basis for the composition, expression, and concept of a drawing.

Lighting from within the drawing is a tradition that has existed in Japanese art for centuries. In Ando Hiroshige's sketchbook image, *The Silhouette* (**Figure 7.19**) the source of light, a candle, is included within the drawing, and its placement high on the page adds to the feeling of space. The candle seems far from the figure that it silhouettes. Details of the subject's profile are clear, but her shadow gradually fades, almost obscured below the window frame where the material of the screen shifts from translucent to nearly opaque. Hiroshige's subtle, nuanced approach and softly varying value impart a sense of atmospheric mystery. The artist furthered the mystery in subtle detail: a tiny bit of the figure's carefully hidden robe is in view giving just a hint of her as more than a distant ghostly silhouette. As you think about Hiroshige's careful handling of shadow and detail consider this quote from

be used against her? This same cast shadow convincingly unites the two figures as it cuts across their cinematic scale change. Throughout this image, the placement of the light source creates the dramatic power of the value shapes of light and shadow that in turn communicate the threatening feeling of the situation portrayed in the narrative of the film.

Lighting From Within the Composition

Lighting from behind a subject or from within the space of a drawing usually creates strong two-dimensional value shapes with details only at the contours. For instance, if you are draw-

Figure 7.19 ANDO HIROSHIGE, *The Silhouette*

Japanese writer Jun'ichiro Tanizaki from *In Praise of Shadows:*

> And so it has come to be that the beauty of a Japanese room depends on a variation of shadows, heavy shadows against light shadows, it has nothing else. . . . We delight in the mere sight of the delicate glow of fading rays clinging to the surface of a dusky wall, there to live out what little life remains to them. . . . Such is our way of thinking, we find beauty not in the thing itself, but in the patterns of shadows, the light and the darkness, that one thing against another creates.[1]

This cultural focus on and sensitivity to shadows certainly comes through in the Hiroshige sketchbook drawing.

Virgil Grotfeldt's drawing (**Figure 7.20**) has a bolder layering of value shapes than the Hiroshige. Although *Growing Pains* does not have an identifiable subject, it does seem to have a specific light source that emanates from in between the silhouetted foreground shapes and the more volumetric background shapes. This veiled, invented world feels alien and mysterious, but also vaguely familiar. Suspended as though under water, the organic forms are not grounded and viewers float with them in and out of space

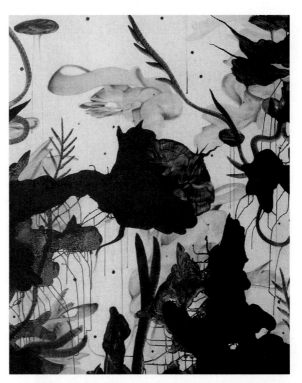

Figure 7.20 VIRGIL GROTFELDT, *Growing Pains*, (2004), coal dust and acrylic on linen, 60 × 54 in. (152.4 × 137.16 cm)

from one value layer to the next. Grotfeldt used coal dust and acrylic powder in an emulsion to build his world of decay, mutation, and regeneration.

ISSUES AND IDEAS

❑ We are accustomed to seeing sunlight come from above us, so lighting from above seems natural in drawing compositions.

❑ Because lighting from below does not exist in the natural world, it can be effectively used for dramatic, out-of-the-ordinary situations.

❑ A three-dimensional object that is backlit can appear to be a two-dimensional shape as in a silhouette.

❑ Backlighting can create a sense of mystery or distance by veiling detail.

Suggested Exercise

7.2: Silhouetting a Three-Dimensional Object, page 188.

Ultimately, strong value-based compositions developed with light sources from above, below, or within the image directly link with the ideas expressed as well as viewers' responses. Artists learn to see and appreciate these effects in their own way, using the potential in light and shadow to express individual interpretations.

VALUE PATHS AND HIERARCHY

Drawings with value compositions offer many different types of visual journeys. Some have definite rhythms, fast or slow in tempo; others take viewers to precise destinations; still others let viewers meander through them. As the eye travels around a composition made up of value shapes, the brain tends to look for groupings and patterns to organize similar values and shapes. Depending on the design the composition a drawing can have areas that claim more visual and conceptual attention than others. In other words, a hierarchy of importance among value shapes may be

established. The journey becomes more complex if a drawing contains recognizable subject matter that may cause the viewer to scan the image differently than if it is an abstract design with only light and dark value shapes. The goal is to integrate the abstract value patterns or structures with the subject matter or narrative to create meaning.

Tempo of Light and Dark Values

Patterns of value can create rhythms or tempos, as in the battle scene by Courtois (**Figure 7.21**). The relatively small shapes of light and dark move the eye in a snappy light/dark/light/dark repetition around and through the drawing while calmer, steadier areas of lower contrast allow the eye to slow down and glide through the sky and ground plane. It makes sense that very high value contrast defines the central figure on horseback so that he catches much of the attention; this is an example of the value structure reflecting the **hierarchy** of the narrative. The important supporting role of the army to this central figure is also acknowledged as the quick rhythm pulls the eye into the crowd even if only temporarily.

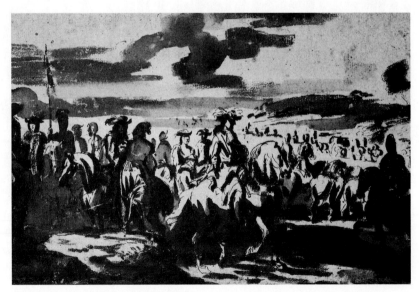

Figure 7.21 JACQUES COURTOIS, *Horsemen in a Landscape*, pen and wash, 8 3/4 × 13 11/16 in.

Unlike the Courtois drawing, the value-based double drawing, *O O* by D-L Alvarez (**Figure 7.22**) initially prevents the rhythm of the value structure from asserting itself. Given two almost identical states of the same smouldering campfire, a viewer's gaze shifts continuously from left to right and right to left. Even attention is given to both sides of the diptych. Only secondarily after the comparison of both campfires is concluded, does the rhythm of light and dark values of the logs and glow-

Figure 7.22 D. L. ALVAREZ(b 1965), *0 0, 2003*, graphite on paper, 20 5/8 × 16 3/4 in. (Fund for the Twenty-First Century. [70.2004.b] Digital Image © The Museum of Modern Art/Licensed by SCALA/Art Resource, NY. © 2008 D. L. Alvarez, Dereck Eller Gallery, NY)

Figure 7.23 SANDY WALKER, *Cathedral* (1981), ink on paper, 84 × 120 in.
Water

ing embers take hold. Alvarez used the ebbing campfire as a symbol for a specific tragedy of the late 1960s: the Manson family murders, but he extended the reference to include a general loss of innocence and hope in society and modern art.

Still another tempo of values is seen in a drawing by Sandy Walker who limited his large scale drawing to pure black strokes of ink on a white ground, making the value contrast as strong as possible (**Figure 7.23**). The vertical repetition of the dark/light at the top half of the page creates a choppier rhythm than the horizontal marks on the bottom half. The horizontal marks are easier to move across and the eye quickly passes over them. Throughout the drawing, Walker creates shifts in visual movement by taking viewers from black as positive to white as positive and by having his horizontal and vertical marks move left/right or up/down in complementary rhythms. In spite of all of the visual activity, Walker leads viewers to maintain an even attention on the entire drawing. Unlike the hierarchical value composition and narrative ideas of the Courtois drawing (Figure 7.21), all parts of Walker's drawing are equal in visual, narrative, and psychological importance, making the subject, abstract value pattern, and idea inseparable.

Paths to a Defined Destination

While eyes naturally explore a composition, an artist can forcefully indicate the route. Many drawings have paths created by

combinations of subject, idea, and abstract value relationships to defined destinations. This is the case for the drawings by Edgar Degas (**Figure 7.24**) and John Robert Cozens (**Figure 7.25**). Despite different subjects, the Degas and Cozens compositions have similar abstract value structures with defined visual destinations in the middlegrounds. These

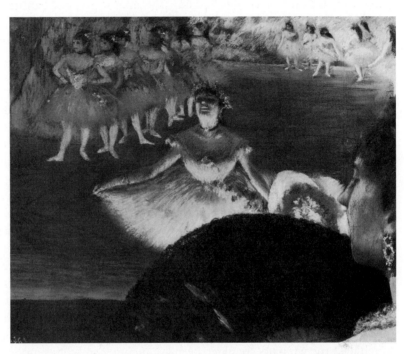

Figure 7.24 EDGAR DEGAS, *Danseuse au Bouquet*, pastel over monotype, 15 7/8 × 19 7/8 in.

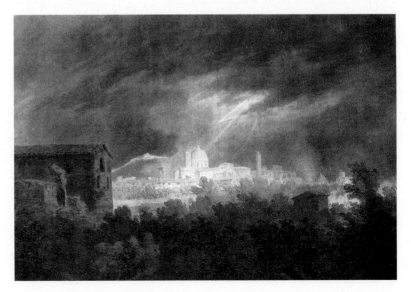

Figure 7.25 JOHN ROBERT COZENS, *Padua*, (after 1782), watercolour on paper, 10 1/5 × 14 1/4 in.

abstract value structures begin with dark foreground value shapes. Cozens made his value shape with merged buildings, trees, shrubs, and vegetation; Degas united the balcony edge and fan. In both cases, the dark foreground value shapes emphasize the narrative importance of the illuminated middle grounds. The illumination on Cozens' buildings emanates from a flash of lightning, fulfilling the same role as the stage lights for Degas' featured dancer. Both artists emphasized the middle ground visual destinations with high levels of contrast and detail and simultaneously blurred these aspects in the backgrounds.

While the abstract value structures in Degas' and Cozens' drawings work in similar ways to take viewers to the destination, the sense of space in each differs. As we have seen, value contrast visually separates foregrounds and middle grounds, but scale change specifies the actual distance between spatial layers. Notice the large size of the fan compared to the dancer's skirt in Degas' drawing and the relative size of the buildings in Cozen's foreground and middle ground. Cozens' stormy night feels dramatic and frightening, but viewers are at a comfortable distance from nature's fury. In the Degas drawing, however, the viewers' position is more confined as they watch over the woman's shoulder, perhaps uncomfortably close, as the brilliantly lit dancer pops up abruptly from behind her dark fan. Although Degas' drawing depicts a pleasant evening's entertainment, his compositional effect has a sharper

drama of confrontation than Cozen's distanced view. The abstract value structures, narrative ideas, and subjects in both of these drawings work together to define visual destinations and express the individual artists' intentions.

Having some similarity in subject and abstract value structure to Cozens' drawing is contemporary artist Pat Steir's large scale panoramic drawing (**Figure 7.26**). Expressing her interest in finding a relationship between landscape and abstraction, Steir used a reference to horizon line as Cozens did but without the specific details of landscape. She also created a similarly defined destination with a light value shape but further to the right than Cozen's central one. Steir's path to the destination contradicts Cozen's traditional movement into deep space as she slips viewers' eyes across the surface of the page progressing gradually from transparent midvalues on the left to a denser darkness on the right. When viewers stop at the destination, they see that—in addition to value contrast—this rectangle is the smallest and the most opaque shape in the enormous drawing furthering its importance. Steir's ideas of the passage of time, the rhythm of a metaphoric change of light, and the horizontal journey in infinite and indefinable space will ultimately stay with viewers. The drawing's size makes viewers acutely aware of the motion of Steir's arm and body working from one end of the paper to the other. Her physical use of mixed media allowed the ink to drip vertically down the paper creating a sense of looseness and spontaneity.

Figure 7.26 PAT STEIR, *Untitled* (1987), mixed mediums on paper, 60 x 180 3/4 in.

Continuous Search

Some drawings that use compositional paths of light and shadow may lead viewers on a continuous search without a main point of focus. Yvonne Jacquette's aerial view of a city and a bridge (**Figure 7.27**) has a value structure with many dots of light forming parallel lines and a steady repetitive rhythm but without a single visual destination. Viewers' eyes move around and around, hovering above angular and curving paths of lights set against inky darkness. Peacefully detached from the view by distance, the viewer is not involved with a narrative or unfolding hierarchy but is engulfed by the endless dark space.

Max Beckmann (**Figure 7.28**) leads viewers through a jam-packed beach scene of illuminated

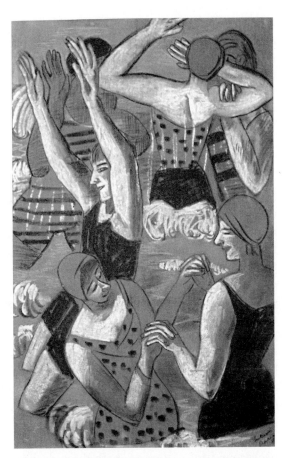

Figure 7.28 MAX BECKMANN, (German, 1884–1950), *The Bathers* (1928), black, white and yellow pastel with touches of blank conte crayon and stumping, on tan wove paper, prepared with blue gouache, 34 × 23 in. [max.] (Gift of Mr. and Mrs. Stanley M. Freehling 1964.902 Reproduction © 2007 The Art Institute of Chicago. All Rights Reserved.)

Figure 7.27 YVONNE JACQUETTE, (b. 1934), *Verrazano Composite I* (1980), crayon, and pencil on composition board, 64 × 47 3/4 in. (162.5 × 121.4 cm). (© Copyright Verrazano Composite I. Gift of Donald B. Marron. [75.1981] The Museum of Modern Art, New York, NY, U.S.A./Digital Image © The Museum of Modern Art/Licensed by SCALA/Art Resource, NY)

arms and backs and patterns of stripes and dots in a deliberate path but—like the Jacquette drawing—not to a particular destination. Unlike the Courtois (Figure 7.21) and Degas (Figure 7.24), none of the figures takes on a leading role, but all are a part of the larger crowd interacting, playing, gesturing, and talking, to create a narrative in a general but not specific sense. Beckmann's linkage of value areas along a path on arms, legs, faces, hands, and patterns stands out because of their contrast with the toned page. The figures are close together, so the path is predominantly two dimensional; it does not venture deep into space. Some figures run off the edge of the page giving the sense that viewers see just a few members of the throng at the beach and that they are very much a part of

that cramped pressurized space. Beckmann did not depict a distant, calm space as Jacquette did, but both artists used the value structures to create continuous pathways through their drawings. This links to their shared idea of leading viewers on a non-hierarchical search without a destination.

Layers of Similar Value

Similar values in different spatial layers can be used to influence a drawing's composition and the movement through it. Rather than following historical art tradition and assigning different values to separate the close and distant areas of his landscape, Charles Burchfield used the same heavy dark value in his extreme foreground sunflower that he used in the far off trees (**Figure 7.29**). At the same time, the more lyrical light value is used in the foreground, middle ground, and background. Thus, the value structure of the composition pulls together as a two-dimensional arrangement in an effort to flatten or deny the space suggested by overlap and extreme scale change from the foreground sunflower to the background trees. Viewers' path through the drawing is not always clear, but as their eyes follow the value structure across the surface of the

Figure 7.29 CHARLES E. BURCHFIELD, (American, 1893–1967), *Moon Through Young Sunflowers* (1916), gouache, pencil, and watercolor on paper, 19 7/8 × 14 in. (Carnegie Museum of Art, Pittsburgh, gift of Mr. and Mrs. James H. Beal, 67.3.5)

ISSUES AND IDEAS

❐ The relative placement of light and dark value shapes of a drawing can determine the composition's structure.

❐ The pattern of light and dark values often determines the path viewers follow through a drawing.

❐ The character of light and dark shapes influence the rate of speed at which viewers move through a drawing.

❐ Emphasis of flatness in a three-dimensional subject through value shape can create compositional tension through ambiguity.

Suggested Exercises

page and the scale change into space, the mixed message sets up a tension that can actually be felt as a kind of restless energy. In this and other drawings, Burchfield linked the drawing's energy with the exploding vitality he felt in the natural world.

In contrast to Burchfield, Jaune Quick-to-See Smith created a value structure without reference to a representational space. As a Native American artist, she creates images that reflect her roots; her abstract composition shown here merges an **iconic** landscape and its inhabitants with layers of value (**Figure 7.30**). Moving through the drawing, viewers may float into space for a moment but are snapped back to the two-dimensional surface by the dark value shapes that cling to the page's edges. Countering the spatial reference implied by overlapping, Smith further emphasized the two-dimensional structure by using the same values in the figures and the background shapes. For example, note the similar light value used for both horse and background areas and the darkest value used for both the figure behind the horse and background areas. The viewers' route is ultimately a changing path from figure to figure and then from like value to like value. This shifting spatial union of like values adds to the complexity of the image and refers to the layered history of the United States and its native people. Viewers are free to construct a narrative as

Figure 7.30 JAUNE QUICK-TO-SEE SMITH (Enrolled Flathead Salish, member of the Confederated Salish and Kootenai Nation Montana), *Cowboy (1986)*, acrylic, charcoal, pastel

this inventive gathering of images unfolds in many ways and can be appreciated for its non-hierarchical, seemingly random presentation.

Exercise 7.1 Experimenting with Value Proportions

Set up one or two objects in an environment and use an artificial light source that you can move and control to create clear light and shadow areas. Do five quick studies, each with a full range of values from the white of the page to the densest dark you can develop. Give each study different proportions of light and dark values. In the first two drawings, vary the proportion of your light and dark values to be as different as in the Bachardy (**Figure 7.4**) and Ferriss (**Figure 7.5**) drawings. The other three drawings should be somewhere between. Experiment with the shape characters, pushing some to be harsher than they really are and some to be softer in edge than they appear. You will need to move the light to change the proportions of lights and shadows.

Exercise 7.2 Silhouetting a Three-Dimensional Object

Find a situation or create one where you can backlight the subject. The light should be shining toward your eyes. Choose a figure, a bold plant form, or something that will give you a strong, interesting two-dimensional shape. Look for a situation as in the Grotfeldt (**Figure 7.20**) or Burchfield drawing (**Figure 7.29**) where you have foreground and background. With a very limited number of values, draw in bold shapes, varying the tone to increase the interest of the arrangement. Maintain the strength of the shapes in this drawing as you work, emphasizing the effect of the backlighting.

Exercise 7.3 Still Life With Clear Light and Shadow Rhythms

Take your time to carefully set up a still life of several similar objects. Light the setup so that you have interesting areas of light, shadow, and cast shadow. As you adjust the arrangement, think about the issues raised in this chapter: composition of light and dark shapes, variation of rhythms, light and shadow paths to destinations, value range, merging/emerging forms, and proportion of light values to dark values. Use value change whether caused by local color or the effect of the light source to move the viewer's eye through the composition, defining focal points.

Consider your process; leave evidence of your hand in the making of the drawing. Remember that the charcoal will always be charcoal and should be appreciated for its sensual qualities even as it describes the objects you are drawing. Be certain to have a strong setup and a clear compositional idea. Do several small tonal studies of different views with different lighting positions before you decide how to approach the final drawing. **Figure 7.31** by Marialejandra Garcia-Corretjer is an example of this assignment; the value structure combined with the gesture of the nature objects keep viewers' eyes darting through the shifting rhythms of the drawing. Dark tones anchor the energy of this active composition.

Figure 7.31 MARIALEJANDRA GARCIA-CORRETJER, *Untitled Still Life*, student work (2005), charcoal on paper, 30 × 40 in.

Exercise 7.4 *Illuminated Full Figure, Self-Portrait*

Make a number of small studies that consider the same issues defined in the previous assignment as the basis for a life-size, full-figure self-portrait with a clear emotional overtone. Use light and shadow to compose the page, and look for abstract compositional ideas: a considered balance of light and dark and rhythms that might suggest emotion or energy. Do you want high drama with contrasting light and shadows or a subtle effect with softer indirect light? Work to make the lighting, pose, costume, composition, and idea all work together. Three examples from this assignment are by Josh Wood (**Figure 7.32**), Natalie Bluhm (**Figure 7.33**), and Daryl Goldsmith LaVare (**Figure 7.34**). Each has a different lighting effect and therefore varied value structure appropriate to the mood being communicated. For instance, Josh Wood used a complex value composition weaving the figure and background together. The figure's face and body are turned slightly away as though to avoid viewers' direct gaze. The softly shifting light and dark value areas in Natalie Bluhm's drawing work well with the costume to focus on the hands and face with an overall expression of anxious but honest questioning. In contrast to Wood's complexity and Bluhm's subtlety, the straightforward but dramatic black and white value shapes of the background in Daryl Goldsmith LaVare's drawing are so forceful that they push her forward in space almost out of the

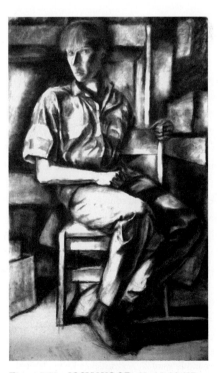

Figure 7.32 JOSH WOOD, *Untitled Self Portrait*, student work, charcoal on paper, 40 × 60 in.

drawing. The strong graphic quality of the shapes is consistent in the figure and the ground creating a dynamic composition.

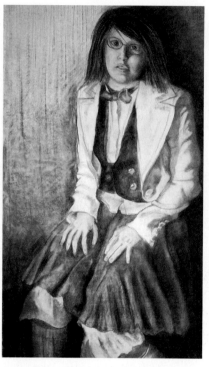

Figure 7.33 NATALIE BLUHM, *Untitled Self Portrait*, student work (2005) charcoal on paper, 40 × 60 in.

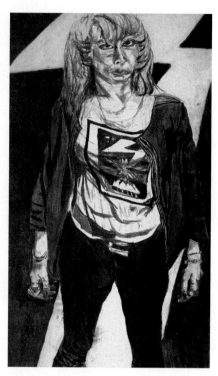

Figure 7.34 DARRYL GOLDSMITH LAVARE, *Self Portrait*, student work, charcoal on paper, 36 × 66 in.

Exercise 7.5 *Journal of Moving Through a Space*

Write a journal of your experience of light and shadow as you move through an extended space such as a landscape, a large building, or a long city block. Standing still, describe the space around you in terms of light and shadow, and then describe the spaces as you pass through them. What kind of light do you encounter? It could be directly from the sun, reflected by a wall, or filtered through leaves. If you are inside, does the light come from an artificial source, or does it stream through the windows? Repeat the same journey at a different time of day or night and move at a different rate of speed, running or moving very slowly. Note visual rhythms and changes to the characteristics of value, light, and shadow. Transform the written descriptions in your sketchbook into a series of small abstract compositions using your drawing materials to interpret your written notes. Then combine selected elements from different drawings (staccato marks, flowing lines, etc.) and bring them together in an invented composition. You could order your drawing around determined destinations, never-ending rhythms, or a combination of both.

Note

1. Tanizaki, Jun'ichiro, *In Praise of Shadows,* translated by Thomas J. Harper and Edward G. Seidensticker, Leete's Island Books, 1977, pages 18 and 30.

—— **Critique Tips** Chapter 7: Value, Idea, and Response ——————

During critiques for this chapter's exercises, think about your and your classmates' work for qualities based on the following topics.

What are the drawing's prevailing ideas and mood? *How do the direction, intensity, and proximity of the light source influence it? Is the mood communicated clearly enough?*

How do you move through the drawing? *Does the value structure influence the movement in the drawing? Do your eyes move toward a specific destination or meander? Does the composition seem to have a hierarchy?*

Can you find rhythms in the light and dark values? *If so, what are they? Does the drawing have a secondary rhythm? Are the rhythms linked to the ideas of the artist?*

Are you more aware of the abstract composition of the drawing's light and dark value shapes or its subject matter? *How are these two elements balanced? Do you think the drawing could be pushed in one direction or the other to make a bolder statement or a more subtle statement?*

Do the merging and emerging shapes of light or shadow reveal the structure of the objects and the space around them? *Or do the merging and emerging shapes ignore the composition's structure and space?*

Is the range of values varied enough to make a visually interesting drawing? *Is there experimentation with the medium?*

Color and Light

8

INTRODUCTION: THE POWER OF COLOR

As we discussed in previous chapters, light is an important part of visual experience and has great potential as an expressive and structural component of drawing. Light softens the visual sense of form or solidifies it. It evokes depth and air and emphasizes divisions of space. The passage of light through the world is one of the most exciting visual spectacles, on both a grand and intimate scale. Light helps to reveal the world to the eyes and can greatly enrich or explain surface and composition in drawings.

So far the discussion has concentrated on the use of an **achromatic** or gray range of tone to suggest light and shadow, but the world is, of course, in color. The experience of color, in fact, can be one of the great joys of using your eyes in obvious ways (sunsets, flowers, and fall foliage come quickly to mind), but in more subtle ways as well.

Color has an emotional dimension which may be connected to specific life experiences. During your life, you develop emotional associations with color based on your experience. Other people may share some of these feelings and some may be only yours. Like any of the other visual qualities you have studied so far in this book, color can be used very effectively as an expressive tool based on these emotional or psychological connections.

Color also has a very precise structural dimension based on quantifiable relationships between colors. The interplay of this structure with the more ephemeral psychological aspects of color association is one of the most fascinating and rewarding dimensions of visual art.

Many elements of drawing—movement, solid form, or effects of light source—are illusions or evocations, but color in drawing is real—like line, shape, and value. Color is actually there on the paper, radiating or reflecting light of particular hue. Its effect is immediate and can work almost subconsciously on the viewer. Like line, color can work simultaneously on multiple levels, creating the illusion of light in a depicted scene, while affecting the eye and the mind in an abstract, sensual way.

Memory, Association, and Visual Poetry

The pastel drawing by the Czech artist Frantisek Kupka (**Figure 8.1**) has a feeling of distance and deep emotion or meditation. Kupka's subject, the blue light filtering through the stained glass windows in the interior of a cathedral, generates the choice of color to a certain extent, but Kupka is clearly thinking about, or feeling, the psychological associations of blue as a color experience. As articulated by Johannes Itten,* the Swiss color theorist who was Kupka's contemporary, blue is a color of meditation, faith, and introspection. You might also associate blue with being melancholy or sad and as the color of the sky and of space. Strong blue has a deep radiance that can seem connected in an almost physical way with these associations. These factors combine to create a **transcendental,** emotionally charged effect in Kupka's image, in line with, but going beyond, the realistic depiction of the subject.

*Johannes Itten *The Art of Color: The Subjective Experience and Objective Rationale of Color,* Van Nostrand Reinhold, 1973.

Figure 8.1 FRANTISEK KUPKA (1871–1957) *Study in Verticals (The Cathedral)* (1912), pastel on colored paper, 16 × 8 7/8 in. (The Joan and Lester Avnet Collection. [116.1978] Location: The Museum of Modern Art, New York, NY, U.S.A. Digital Image. The Museum of Modern Art/Licensed by SCALA/Art Resource, NY. © 2009 (ARS), New York/ADAGP, Paris

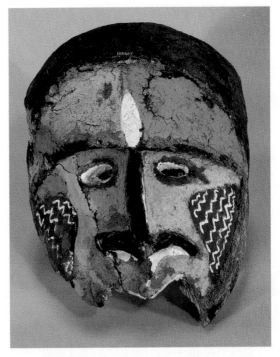

Figure 8.2 Mask, Malekula, Vanuatu, painted wood, 25 inches high (#A019287 c. © The Field Museum, Chicago)

The mask in **Figure 8.2** from Vanuatu in the South Pacific is carved from wood and has drawn elements based on the human face interspersed with geometric pattern. The artist has also included black and white pigmented areas, but the first thing you might notice about the mask is the blue pigment on the forehead and cheek. In fact, this color effect is startling, opening the surface of the mask to another dimension. While the blue color in Kupka's church interior seems an appropriate extension of an expected mood and spatial effect, on the mask its effect is weirdly dematerializing. The emotional associations of blue (and

these are subtly different blues with slightly different "feelings") are transferred to the spiritual entity whose face is depicted. As a result of these associations, this face is **transformed poetically,** that is, it is opened to many other associations while still remaining a face. Verbal poetry thrives on simplicity, saying the most with the fewest, and most potent words. Nothing could be technically simpler than the application of blue paint to this mask, yet the effect is powerfully, emotionally effective.

Willem de Kooning laid down a pattern of gestural geometry in his *Woman* (**Figure 8.3**) and built up areas of deep yellow and red. The effect is wild, suggesting a hot violence and frenetic action. Perhaps the artist was actually sketching someone wearing a yellow dress, but more likely this is a vision from his imagination, and the color is **arbitrary,** or freely chosen. Yellow is an attention-getting color, outwardly active and warm. According to Itten, dark yellow suggests treachery and ambition. Paired with black, it suggests a warning as in the coloration of bees and snakes. This common association in our culture can be understood

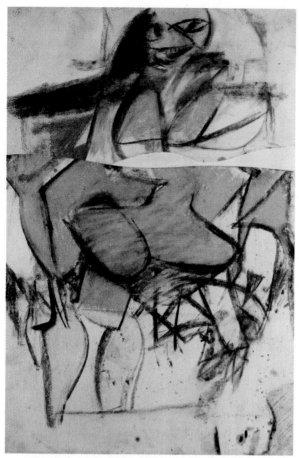

Figure 8.3 WILLEM DE KOONING (1904–1997), *Woman* (Ca. 1952), charcoal and pastel on paper collage on paper, 74.0 × 50.0 cm (AM 1976-946. Location: Musée National d'Art Moderne, Centre Georges Pompidou, Paris, France, CNAC/MNAM/Dist. Réunion des Musées Nationaux / Art Resource, NY, © 2009 Lisa de Kooning/ Artists Rights Society (ARS), New York)

Sketchbook Link: Noting Color

Experiment with some of the color media listed in Appendix A. Try to find one that is comfortably portable, and that gives you a versatile and appealing range of color effect. Practice using this material to make color notes as you go through your daily routine. Look for effects of color that seem noteworthy, for their strength or intensity, or for their quiet presence. Perhaps you can add a personal dimension, thinking of certain colors as "my colors." Do not worry too much about making recognizable scenes or objects; just assemble shapes or areas, but try to be as specific as you can about the exact character of the color you are trying to describe. If the medium is lacking in some way, note it. Written labels or descriptions can also add to the usefulness of this exercise.

by the color scheme of traffic warning signs: yellow and black.

Various cultures have different associations, and generalizations can be tricky. The following are some documented cultural color associations, as well as some obvious connections based on nature. You will note, despite the differences, commons threads of association between cultures.

Red: The zenith of color; the sun; war; love; fire; blood; passion; anger; joy (**Amerindian**); death (Celtic); fertility (Aztec); summer; the South; happiness; luck (Chinese); in combination with white suggests death.

Orange: Happiness; warmth; sweetness; luxury; splendor (Hebrew).

Blue: Truth; wisdom; loyalty; space; night; melancholy; water; peace; the sky; the Great Mother (Amerindian); meditation; faith (Christian).

Bright Yellow: the sun; intellect; intuition; faith; goodness; bright heat; thought; warning; summer; afternoon; sourness.

Dark Yellow: treachery; jealousy; ambition; avarice.

Black: The unknown; shadow; night; silence; death (Western); evil (Western).

White: Transcendent perfection; simplicity; air; innocence; purity or goodness (Western); snow; blankness; emptiness; neutrality; death and burial; life beyond death; pure consciousness (Hindu); Joy (Hebrew).

Violet: Intelligence; religious devotion; sorrow; mourning; old age.

Purple: Mystery; eroticism; evil; royalty; pride; underworld; divine ritual.

Green: Nature; sickness (gray-green); spring (yellow-green); youth; hope; change; equality; death (pale or gray-green); immortality (Christian); the Sacred Color (Islam).

Brown: Earth; dullness; ordinariness; sobriety; renunciation (Christian).

Gray: Lifelessness; dullness; subtlety; quiet; death of the body and immortality of the soul (Christian); wisdom (Quabalism).

ISSUES AND IDEAS

❐ Color and light are closely connected, clarifying and enriching visual aspects of the world.

❐ Color can function in a drawing on an **associative** level, bringing emotion or memory into the image.

❐ Some color associations are cultural, and some are personal. Some are learned or logically understood, and some are more instinctual.

Suggested Exercise

8.1 Associative Color Studies, p. 216

Silver: The moon; femininity; virginity.

Gold: Divine power; the sun; enlightenment; radiance; the West (Amerindian); life; light; truth; the seed (Hindu).

Color, like line, can work independently of subject matter. Its associations add to those created by the subject or other aspects of the drawing.

THE STRUCTURE OF COLOR

Color Connections: Warm and Cool

Returning to the list of color associations, it is apparent that you can organize groups of colors based on shared associations. Blue seems to be a moody color, as does purple. Red, yellow, and orange are fiery colors while brown and gray share a sense of dullness or ordinariness. Black and white are stark and blank. In addition to these connections based on emotional overtones, color can be organized in a way that is purely scientific. Remarkably, the connections that can be made by virtue of this scientific organization often parallel associative connections.

Figure 8.4a shows a color wheel, a diagram of the connections between colors. Most immediately, the differences in **color temperature** in different parts of the wheel are apparent: The bottom is "warm" with yellow, orange, and red; the top is "cool" with violet, blue, and green. There are border colors whose temperature might be uncertain, and it is important to remember that color qualities are relative and variable. For example, there can be such a thing as a cool red (moving toward violet), but all reds will seem warmer than blue. It is possible that a red violet will seem warmer than a cool yellow approaching green, but these are such different colors that it is difficult to compare them. Color temperature is a terminology to aid in the verbal description of color relationships and to refer to associative qualities. Like other aspects of color description, color temperature often does not represent an absolute or invariable value but gains meaning in a particular instance of comparison.

Neighbors and Complements

Each color has a close similarity to its neighbors on the color wheel and is directly across the wheel from its opposite or **complement**. This organization makes an important point because most color relationships are based on similarity or dissimilarity, connection or contrast. As you move beyond the use of a single color in drawing, you will find

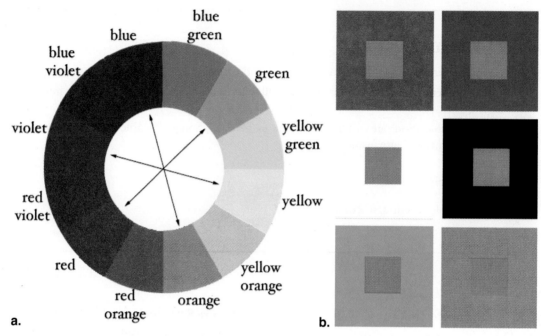

Figure 8.4 **a.** The color wheel, showing complementary pairs; **b.** simultaneous contrast

that the knowledge of color and its use in art almost always involve understanding and adjusting the **contrast relationships** between colors.

Strong contrast, or dissimilarity, produces visual vibration or mutual intensification between two colors. This principle is called **simultaneous contrast. Figure 8.4b** shows the effect of various colors on a square of blue. Even though all the blue squares are the same, the surrounding colored boxes change the blue's appearance in the opposite direction from the varying color. The darker the surrounding color, the lighter the blue will seem. The more orange the surrounding color, the bluer the blue will seem. The violet box emphasizes the greenness of the blue, while the green box emphasizes its violet character. The strong surrounding blue makes the central blue look less intense.

Sketchbook Link: Warm and Cool

In your sketchbook, devote four pages to pairings of color mixtures: one warm, one cool. Try to use at least 24 pairs. There will be obvious pairs, and not-so-obvious pairs. You might start with a color you see around you, whether it is strong like orange, or dull like brown or gray. Designate this color as warm (or cool) and then try to pair it with a color that has the opposite temperature. Challenge yourself by starting with a color that is not so obvious in its character or by comparing two versions of the same color. The more surprising the comparison, the better, but the difference in temperature should be clear. Greens work well for this exercise as do violets and neutral tones like brown. A variation of this exercise is to make a four-part comparison, with each succeeding color moving further toward warm or cool. This could require a thoughtful selection of the initial color to be fully successful, but there is no harm in taking a chance with a spontaneous choice. Consult the color wheel in Figure 8.4a for guidance.

ISSUES AND IDEAS

❏ Color can be organized logically on a color wheel. Temperature—warmer or cooler—is a basic distinction between colors.

❏ Neighboring hues often share emotional qualities as well as a basic visual nature. Opposites, or complements, lie across the color wheel from each other.

❏ Juxtaposition of colors can alter the perception of their character, emphasizing any dissimilar characteristics. This effect is called simultaneous contrast.

Suggested Exercise

8.2: Working with Simultaneous Contrast, p. 217

Complementary Colors and Low-Saturation Mixtures

It is natural to associate the idea of color in life and in art with bright colors or **high-saturation** colors, such as red, yellow, and blue. However, there is an infinite range of colors in the world, and all are available to art with interesting effects. Red, yellow, and blue are called **primary colors** because they are the hues from which all other colors derive. At the simplest level, red and yellow combine to form orange; red and blue form violet; and yellow and blue form green. Orange, violet, and green are called the **secondary colors** and are important because, along with the primaries, they make up the **color spectrum,** the range of visible light in its purest state. The color spectrum can be seen whenever sunlight is prismatically filtered, breaking the "white" light into its components. This is what happens when rays of sun pass through tiny water droplets in the air, creating a rainbow.

The secondary colors are important to artists for another reason. As you can see in the color wheel in Figure 8.4a, each one of them is the color opposite of (or complement to) a primary color: orange/blue; green/red; violet/yellow. This means, for example, that there is no blue content in orange and vice versa. When the two do mix, something very interesting happens: The new color is softer in intensity, moving toward the **low-saturation** range of brown and gray.

While it might seem at first that this lack of brilliance—bringing the color of an image toward dullness—would be undesirable, this new kind of color is more useful for drawing in some ways than full-saturation color. There are two reasons for this. First, the world is composed of many more colors than the pure primaries and secondaries. In fact, with the exception of the sky, it is mostly brown, gold, gray, olive, and other lower saturation tones that may be almost unnameable. Second, related low-saturation colors can combine to suggest **color atmosphere** or **light harmony,** an effect of quiet variation and interdependence that suggests a variety of distinct colors bathed in a unifying light.

Figure 8.5a shows a variety of tones made by mixing orange with its color opposite, blue. The soft colors that result feel very much at home with each other. Even the stronger blue and orange blocks feel linked to the other tones because they are present within the mixtures. The two blocks might seem to be pure blue and orange, but they are not. The rectangles in **Figure 8.5b** show the "orange" and "blue" from Figure 8.5a in comparison with full-saturation orange and blue (on top) and reveals their relative dullness. The saturation level of a given color is accurately perceptible only in relation to other surrounding colors and can seem to change as the surrounding colors change. Thus, duller neighbors make the orange and blue blocks seem brighter, and comparison with full-saturation colors makes them seem dull.

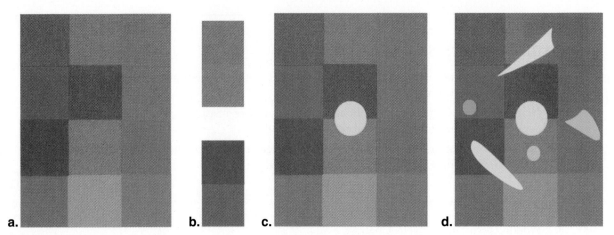

Figure 8.5a–d Color contrast and connection

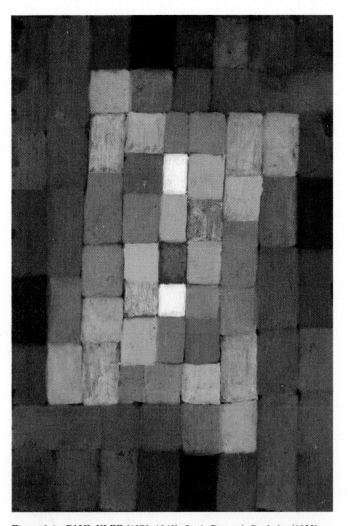

Figure 8.6 PAUL KLEE (1879–1940), *Static-Dynamic Gradation* (1923), oil and gouache on paper, bordered with gouache, watercolor, and ink, 15 × 10 1/4 in. (38.1 × 26.1 cm) (The Berggruen Klee Collection, 1987 [1987.455.12]. Location: Metropolitan Museum, New York, NY, U.S.A. © The Metropolitan Museum of Art/Art Resource, NY, © ARS, New York)

In **Figure 8.5c**, the orange/blue mixtures are overlaid with a circle of color from another end of the spectrum—yellow-green—and this extreme comparison has several interesting effects. First, the stronger blue and orange are pushed closer to the neighboring mixtures, and the new color stands out boldly from all other colors, intensified by its relation to the contrasting background.

There is also an effect that could be described as spatial: The orange/blue mixtures are functioning almost as a distinct spatial zone in relation to the yellow, falling back. In **Figure 8.5d**, three irregular shapes, related in color to the yellow circle, have been added to the composition. They seem to float above the orange/blue background, asserting themselves with slightly varying force. The small dots of orange-yellow and green-blue have a noticeably closer hue relationship to the background tones and seem to retreat spatially.

This principle of **connection versus contrast** is key to understanding the structural use of color in drawing. Similar colors suggest a unity of light or a similar spatial position. Strongly differing colors pull away from this unity, seeming to pop forward spatially, asserting themselves as a

compositional focus or suggesting a difference of light. Paul Klee's *Static-Dynamic Gradation* (**Figure 8.6**) shows this effect dramatically, with a sense of gradually increasing three-dimensional (3D) protrusion toward the center of the composition as the colors contrast increasingly with the dark browns on the periphery.

Hue, Saturation, and Value

Differences of color are expressed in terms of three variables: hue, saturation and value. **Hue** represents a position on the spectrum: red, reddish orange, and so on. **Saturation** (or chroma) represents the level of brilliance or closeness to spectrum color: Primaries and secondaries are high-saturation colors, and browns and grays are low. **Value** is a position on the light/dark continuum: Black is the lowest value and white the highest. There is sometimes confusion between saturation and value, and it can take a practiced eye to distinguish between these characteristics. **Figure 8.7** shows a color wheel with gradations of value created by mixing white and black with spectrum color. The graying effect of both the white and black mixtures, higher and lower in value respectively, also diminishes their saturation. You might recognize on this wheel some of the same tones created by mixing orange and blue complements.

The best way to approach color analysis is to remember that all color effects are relative and that the characteristics of a given color can best be understood in comparison with another color. **Figure 8.8a** shows the color red in full saturation at the upper left and in a variety of value and saturation levels. The upper-right quadrant has a higher satura-

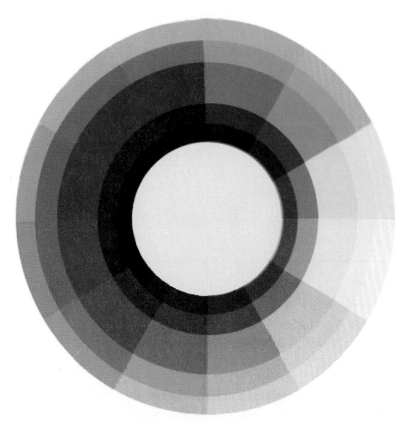

Figure 8.7 Gradations of value and saturation (Adapted from *Color: A Workshop Approach*, by David Hornung, McGraw-Hill, 2004.)

a. b.

Figure 8.8a–b Gradations of value and saturation

ISSUES AND IDEAS

❑ Red, blue, and yellow are the primary colors. Orange, green, and violet are the secondaries.

❑ Colors are defined by three variables: hue, value, and saturation (or chroma). Two colors will connect or contrast with each other to a varying degree in terms of one or more of these variables.

❑ The mixture of complementary colors will result in a more neutral, or lower saturation, color.

❑ Related colors or mixtures can combine to form a color atmosphere or harmony.

Suggested Exercise

8.3: Atmospheric Color Harmony, p. 218

tion level than the lower two (perhaps described as "richer" or "fuller") but is a low-saturation color compared with the spectrum red.

Figure 8.8b shows two colors of different hue at different value and saturation levels. Notice that the yellow colors in this chart have higher value than the reds in Figure 8.8a. Yellow has an innately high-value level, red is medium, and blue is the lowest or darkest.

(*Note:* It can be helpful in determining value relationships between colors to squint your eyes. This shuts down the amount of light reaching your retina and mutes the perception of hue, allowing you to concentrate on the value comparison. Perception of hue requires fairly strong light, an important consideration when you are setting up to work!)

Sketchbook Link: Contrast Studies

Do some loose sketches of outdoor scenes, experimenting with different kinds of contrasts: hue, saturation, and value. Begin with an idea of connection or similarity and then add divergent color choices. Another strategy is to begin with strongly contrasting colors and then use overlaying tones to bring the colors together in certain areas. You can tie contrast effects to spatial position or to compositional focus.

Color Atmosphere

Close grouping of colors around a given characteristic, whether hue, saturation, or value, can establish a strong connection between the colors and a sense of general color condition or "atmosphere." Yun-Fei Ji's *Wedding Ballad* (**Figure 8.9**) features just such an atmosphere: a rich wine-colored tone, with variations of red, gold, and soft, low-saturation blues. The blue stands out strongly due to its hue contrast with the dominant red but is held in place in the atmosphere because of its low saturation and its similarity in value to the other colors. Many of the browns or **neutrals** in the composition seem to contain both the red and the blue in a manner similar to the orange/blue tones in Figure 8.5a. As a result of the unified color sense, the picture is dominated by a mysterious, oddly sweet feeling that plays off the whimsical, secretive activity pictured.

Edgar Degas worked with a broader value range in **Figure 8.10**, but the atmosphere is also closely connected by hue. The luminous green-blue tonality and gray skin tones might seem to be odd color choices, perhaps lending a slightly perverse air to the scene. In fact, this hue range may simply be the effect of cool daylight entering through an unseen window, although exaggerated by the artist.

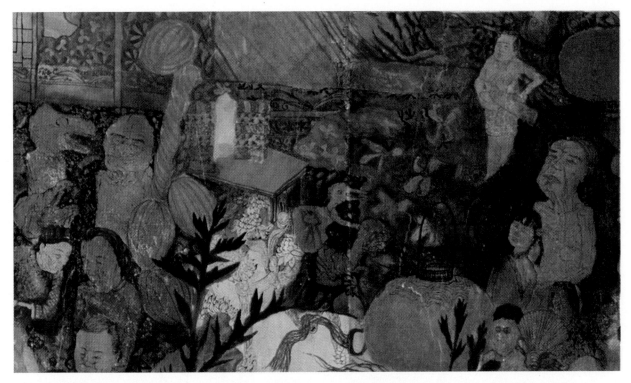

Figure 8.9 YUN-FEI JI, detail from *The Wedding Ballad* (2002), mineral pigments on rice paper, 28 1/2 × 171 in., James Cohan Gallery

The Energy of Contrast

Compared with the works by Yun-Fei Ji and Degas, Wassily Kandinsky's watercolor in **Figure 8.11** seems to be a wild party of disparate colors and charged gestures. He included high-saturation red, blue, and yellow in the image, all full saturation primaries, guaranteeing a lively atmosphere and avoiding the thick mood in Yun-Fei Ji's work. On closer inspection, however, the two works are actually quite similar: Yun-Fei Ji also has red, blue, and yellow, but in muted forms, and Kandinsky knit his composition together with warm browns linked to the reds and yellows. The principal difference is in the level of value and saturation contrast, which in the Kandinsky is total: The powerful black on white armature of the composition is also a color effect, and an extremely "noisy" one, while Ji's close value range softens the tone of the whole.

Henri Matisse's *La Gitane* (**Figure 8.12**) has an aggressive character based on color choices similar to those Kandinsky used, and there is an effec-

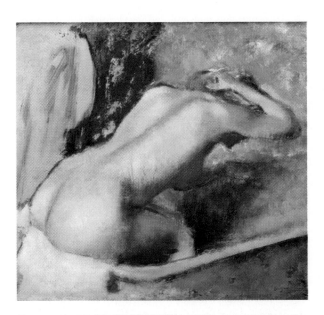

Figure 8.10 EDGAR DEGAS (1834–1917), *Woman Seated on the Edge of a Bathtub, Washing Her Neck with a Sponge* (Ca. 1880-1895), pastel, 51.1 × 66.2 cm (Photo: Daniel Arnaudet. Location: Musée d'Orsay, Paris, France. Photo Credit: Réunion des Musées Nationaux/ Art Resource, NY)

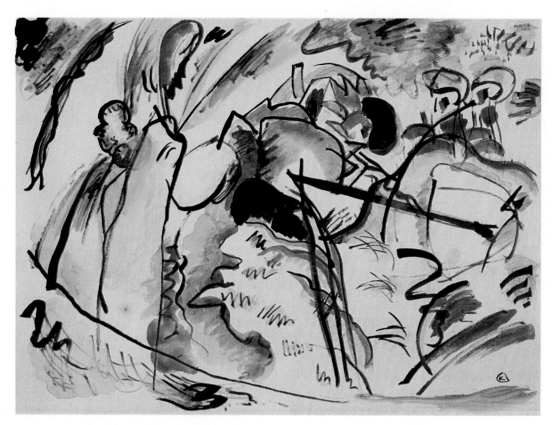

Figure 8.11 WASSILY KANDINSKY (1866–1944), *Study for Painting with White Form*, (1913), watercolor and ink on paper, 10 7/8 × 15 in. (Katherine S. Dreier Bequest. [157.1953] Digital Image. The Museum of Modern Art/Licensed by SCALA/Art Resource, NY. © 2009 ARS, New York)

tive linkage made between the jubilant energy of the color-packed treatment of the figure's body and her implied emotional nature. Despite the artist's believable depiction of directional light, the color choice is clearly arbitrary, based on an artistic priority for high-powered sensuality.

Connection and Contrast: Earth Tones

The basic structural principle of color use, **connection and contrast,** is the same whether the effect is dramatic brilliance, soft harmony, or any other effect. It is possible to work effectively with color based on a knowledge of this principle in the context of either a full or a limited hue range.

Because of drawing's traditional use of simple materials (as opposed to painting, for example),

many artists have chosen to work within a **limited palette** of colors: a diminished hue or saturation range. In fact, most drawings are in the most limited hue range of all: black and white. Still, it is possible to have a positive role for color in a drawing with even a tiny variation of hue or saturation. Apart from simple black and white, or a **monochrome range,** the most common limited palette in the past was **earth-tone** based, revolving around browns, ochers, and black. In part this happened because these were common, inexpensive pigments available in natural chalks, but the coherence and "down-to-earth" nature of this range also makes it suitable for a wide variety of natural subjects, from landscape to the human face. The challenge is to bring this somber palette to life.

Peter Paul Rubens was a master of color in painting, expanding from an earth-tone underpainting to a final palette of surging, luminous hue dominated by red and gold, but including blue,

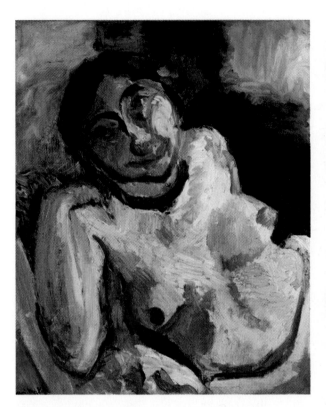

Figure 8.12 HENRI MATISSE, *La Gitane* (1908), oil on canvas

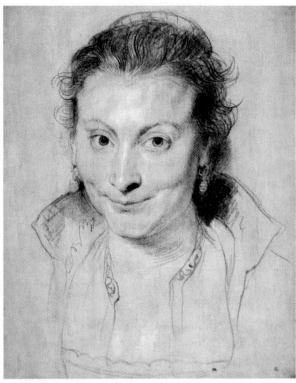

Figure 8.13 PETER PAUL RUBENS, *Portrait of Isabella Brandt,* black and red chalks heightened with white

green, and violet. In the drawing of his wife in **Figure 8.13**, he obtained vibrant energy and rich color similar to his paintings using only red, black, and white playing off the buff color of the paper. This work has a confrontational effect related to Matisse's *Gitane* despite its lower level of hue saturation. Within his low saturation palette, Rubens pushed the value and hue range as far as it would go, with pure white highlights, deep reddish shadows, and profound black in the eyes and nostrils. This face seems to materialize out of the surface of the page, fully integrating its color into the skin tones. Touches of cool white chalk highlight the forward surface of the polished skin, contrasting with the punchy darks in the nostrils and pupils. Subtle changes of warm earth-pink and cool gray enliven the cheeks and forehead.

Lucien Freud's *Lord Goodman* (**Figure 8.14**) creates a very different mood. Here the drooping folds

Sketchbook Link: Contrast Comparison

Make ten pages of sketches of people in a public place, using a variety of colored pencils in an arbitrary manner. For some sketches use strong colors: red, green, yellow, and so forth; for others use neutral tones. Vary the tonal contrast as well, with pale sketches in comparison with high-value contrast marks. Note the effect on the sense of light and space, and on the sense of energy in the scenes. Try some sketches in which there is a mixture of color choice in terms of saturation and value.

of skin and smudge of beard stubble provide an opportunity for a mottled exploration of browns, greens, and grays. The colors of the face are a churning mixture of the rusty background and mossy yellow grays of the subject's robe. Freud uses diverse earth tones to define the faceted planes of the powerfully modeled head while indicating a cool light source, perhaps a bedside lamp, off to the right of the frame.

These portraits by Rubens and Freud differ from Matisse's image principally in their priority for connections of tone. There is a sense of "skin" or continuous surface, and the close-hued earth-tone palette helps build this continuity. The lively range of value contrast in both drawings is nearly equal to Matisse's work, but intermediate tones and coherence of hue create a more directly tactile sense of surface in the form. (See Sketchbook Link: Contrast Comparison box on page 203.)

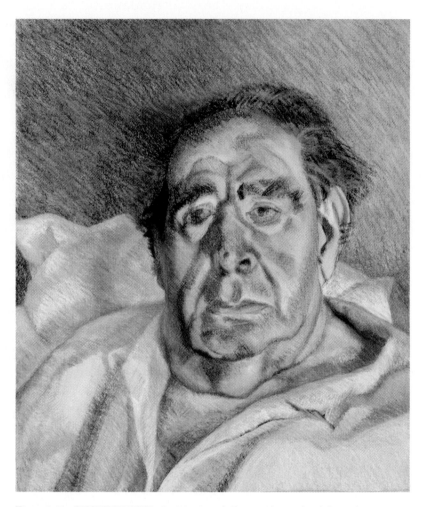

Figure 8.14 LUCIEN FREUD, *Lord Goodman* (1986–1987), pastel and charcoal, 25 3/4 × 21 7/8 in.

ISSUES AND IDEAS

❏ Strong contrast of value or hue can suggest brilliance, energy, noise, or even violence.

❏ A limited palette creating a connected range of color unifies the effect of color atmosphere in a drawing.

❏ Strong contrast within a limited palette stretches the range or effect through simultaneous contrast, emphasizing differences within the limited range.

❏ Closely related or connected tones within a depicted surface (like skin) help to keep the surface unified while tonal variety increases brilliance and interest.

Suggested Exercise

8.4: Warm and Cool Self-Portrait, Limited Palette, p. 218

Color and Space: Layers and Spectrum Triads

Connections and contrasts of color can play a strong role in organizing the perception of space in a drawing. Contrast causes marks or color areas to jump apart visually, seeming to separate them in the illusory space of the page. In addition, areas of similar hue, value, or saturation can define spatial regions in a composition, ordering a complex situation into distinct zones or planes of light.

Anthony Van Dyck's landscape in **Figure 8.15** shows the delicate enhancement of spatial effect that color can provide. He created a series of planes, pale gold, deep olive, blue-gray and brown-pink, which subtly expand the sense of space in the drawing. The color sequence has no particular order except that strong lower values are grouped in the foreground in keeping with principles of atmospheric perspective discussed in Chapter 6. Still, overlap and a steadily rising ground plane make it very clear how the landscape unfolds into depth. The color adds interest and specific character to each area, allowing the imagination to construct atmospheric zones with subtle emotional overtones. Small notes of the color of each plane are included in the others, threading the whole composition together.

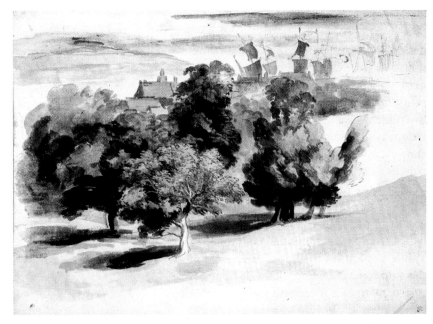

Figure 8.15 ANTHONY VAN DYCK, *A Wood near a Harbor*, watercolor, pen and brown ink, 7 3/8 × 10 1/2 in.

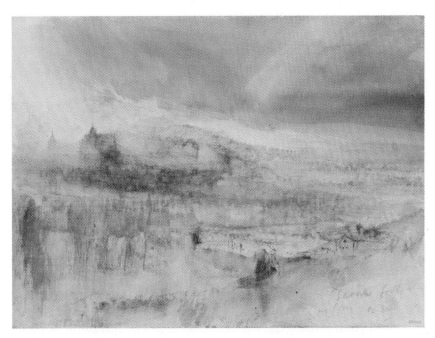

Figure 8.16 JOSEPH MALLORD WILLIAM TURNER, *The Town and Chateau of Eu* (1845), pencil and watercolor, 9 1/16 × 13 in.

J.M.W. Turner, the English pioneer of full-spectrum color in the landscape, was heavily involved with atmospheric effects and great sweeping spaces of mountains and ocean. **Figure 8.16** shows the power he achieved with delicate

washes of watercolor. His color atmosphere dissolves the edges of form so that space is defined only by color relationships. Turner used real red, yellow, and blue rather than an earth-tone palette, but notice that the relationships remain the same, with blue taking the place of black, red working for brown, and chrome yellow replacing ocher. His work shows the versatility of a **spectrum triad,** a palette composed of three colors, each related to one of the primaries. Because the primary colors can be mixed to create all other colors, including secondaries and neutrals, this is a logical and potent simplified color plan. While a spectrum triad does not have quite the automatic coherence of an earth-tone palette, with care it can still facilitate color coherence while allowing a broader or more vivid range of hue. Turner's landscape achieves a brilliant richness with a much smaller value range than Van Dyck's work, due in large part to the notes of chromatically purer or high-saturation color.

The diagram in **Figure 8.17** shows a typical color wheel triad and resulting mixtures.

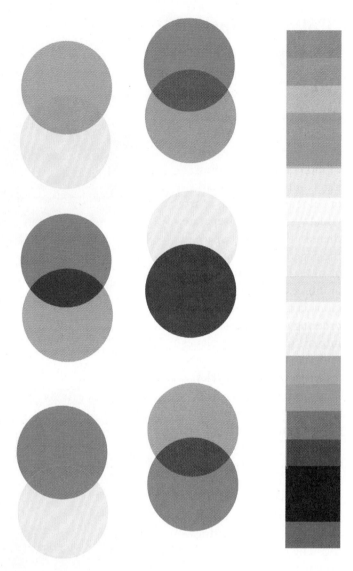

Figure 8.17 Mixtures from a spectrum triad

ISSUES AND IDEAS

❑ Color areas can be organized in layers of similar hue, value, or saturation. These overlapped layers can help show space in drawing.

❑ Areas of strong contrast seem to jump forward spatially, as do high-saturation colors.

❑ Warmer colors come forward and cooler colors tend to recede, but a warm background tone reverses this equation.

❑ Mixtures from a color triad yield a palette of related colors, including both high- and low-saturation colors.

Suggested Exercise

8.5: Planar Color Organization, p. 219

Note that there are limitations to the range; because of the somewhat purple character of the blue, the greens are dusky and gray, while the violets are rich and strong. The column of mixtures on the right shows that, despite the theoretically unlimited mixtures available with a spectrum triad, there is still a distinct character to the colors that can be made from this particular group. In fact, this is true of all spectrum triads simply because the individual color components always have a special character due to the pigments involved, which can never duplicate pure spectrum color. Rather than being a problem, this limitation should be appreciated as providing the character and "taste" of a given spectrum triad palette, as is true in this diagram, a delicate violet-based range like the sky at dawn.

Sketchbook Link: Layered Color

Make eight pages of sketches of interior scenes, using lines made with colored pencil. Use three main colors to define spatial layers within the scene: foreground, middle ground, and background. You may use the colors in any order, but try to keep the spatial layers distinct. Work other colors into the sketches, but keep each layer in a specific range of hue and value, adding new colors to each layer that are closely related to the original choice.

COLOR EXPRESSION AND NARRATIVE

Color Intensity and Expression

Understanding the connection and contrast between primaries, secondaries, and more complex mixtures is the key to the use of color in describing spatial structure and light harmony, but it is also important to remember color's innate emotional power: its ability to stir a psychological response through association and its own abstract radiance. Simultaneous contrast can make a brown function as a red, but it is still a brown and will look dull next to a fully saturated hue. The disadvantage of high-saturation colors is their abstract nature; they are pure in a way that does not allow the softer connections of space, air, and surface that constitute some of the more vital aspects of drawing. An image composed entirely of full-saturation color is extremely powerful but unyielding. Sonia Delaunay's *Electric Prism* in **Figure 8.18** at first glance seems to be composed entirely of primaries and secondaries, but closer inspection reveals a great deal of value and saturation variation, providing contrast and spatial tension

Figure 8.18 SONIA DELAUNAY-TERK, *Electric Prism* (1914), oil on canvas, 93 3/4 × 98 3/4 in. (Inv.: AM 3606P. Musée National d'Art Moderne, Centre Georges Pompidou, Paris, France Photo Credit: CNAC/MNAM/Dist Réunion des Musées Nationaux/Art Resource, NY © L & M SERVICES B. V. The Hagues 20080912

with the chromatically pure color notes. Many of the most engaging parts of the composition are areas of mixed hues of lower saturation that open into atmospheric unity in the ways you have been studying.

In fact, finding works of art that are purely composed of spectrum color is difficult; the range is too inflexible. Still, the seductive power of pure color is undeniable, and a goal of art since the Impressionist period in the late nineteenth century has been to integrate stronger color into visual art. Strong color has even been identified as a characteristic of modernity compared with the brown tonalities of "old master" paintings.

One technique developed by the Impressionists and used by modern artists is called **optical mixture.** This approach integrates high-saturation color into subjects with diverse tone by hatching with small strokes of pure color, often in complementary pairs: orange/blue, red/green, and so on. When the image is viewed from a normal distance, the complements seem to blend into each other, creating a composite effect of neutral tones. The radiance of the pure color is still present in the image, but more neutral colors in a face or landscape can be convincingly achieved.

Optical mixture was in fact thought to be more scientifically accurate than the use of mixed neutrals, re-creating the prismatic character of natural light. **Figure 8.19** shows Vincent van Gogh, one of the inheritors of this principle, in a pastel drawing by Henri de Toulouse Lautrec. Pastel is a perfect medium for this technique, lending itself to hatching in pure color, and Lautrec projected a fantastic golden radiance on his subject, perhaps caused by the sun entering a dark café. Van Gogh seems to be dissolved in, or radiating out, the light of the sun (with which he was artistically obsessed). The yellows and oranges play off the violet blues that dominate the background, and the complements are connected by rich greens. Lautrec, who rarely drew landscape, has brought his friend out into countryside, under the summer sun, through color.

Contemporary artist Chuck Close updated this technique in his massive self-portrait (more than eight feet high) in **Figure 8.20**. He works within a **grid** over the entire surface of the image, each tiny rectangle filled with concentric circles of pure color which blend to form the diverse tones for the face with quasi-photographic precision. The mechanical character of this method recalls the television screen as much as Impressionism, but the image

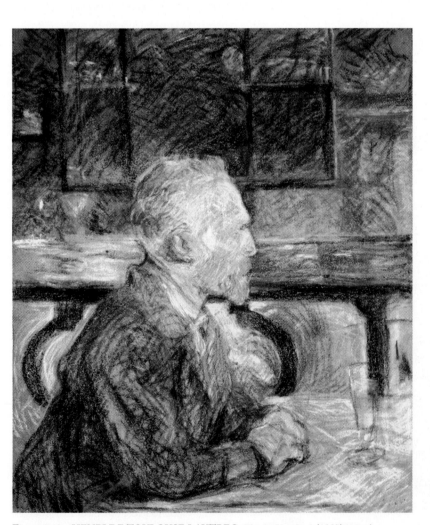

Figure 8.19 HENRI DE TOULOUSE LAUTREC, *Vincent Van Gogh* (1887), pastel

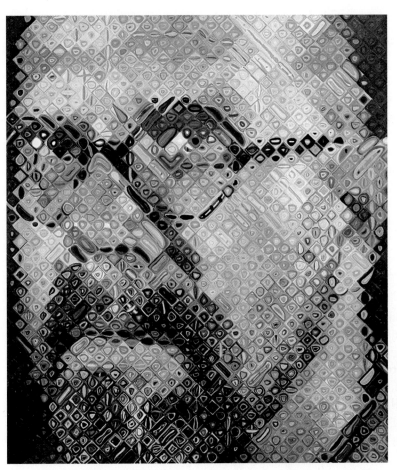

Figure 8.20 CHUCK CLOSE, (left) *Self Portrait* (1997), oil on canvas, 102 × 84 in. (259.1 × 213 cm); (right) detail of *Self Portrait*. (Gift of Agnes Gund, Jo Carole and Ronald S. Lauder, Donald L. Bryant, Jr., Leon Black, Michael and Judy Ovitz, Anna Marie and Robert F. Shapiro, Leila and Melville Strauss, Doris and Donald Fisher, and purchase. [215.2000] Location: The Museum of Modern Art, New York, NY, U.S.A./Digital Image The Museum of Modern Art/Licensed by SCALA/Art Resource, NY, courtesy PaceWildenstein, New York

ISSUES AND IDEAS

❏ Strokes of high-saturation colors can be juxtaposed to mix optically into tints and neutrals.

❏ Working with high-saturation or "pure" color is most effective when its use is based on the knowledge of the spectrum or color wheel.

❏ Drawings that employ high-saturation colors have a "hot" power, a priority for luminosity that can suggest brilliance of light or emotional excitement.

❏ Modeling with value is the most direct method to suggest solid form but can be combined with the use of strongly saturated color.

Suggested Exercise

8.6: Warm and Cool, High Saturation, p. 220

Sketchbook Link: Optical Mixture

Make some quick sketches of your hands or other available objects with interesting form. Light them strongly with a window or a desk lamp. Use strokes of colored pencil or crayons to depict the light and shadow falling across the surfaces, but confine your colors to high-saturation primaries and secondaries. You can obtain value effects by using thin mark density in light areas and heavier buildup in shadows, but do not use white or black marks. As you work, experiment with different combinations of hue to achieve neutral or middle saturation tones. You can use any number of colors as long as they are all full saturation spectrum color.

has a vibrating life and a unique hallucinatory intensity. Close's paintings must be seen from across the room to resolve into legible portraits. Up close, they become an abstract pattern of pure color at its most intense, as seen in **Figure 8.20b**, a magnified detail. (See Issues and Ideas box on page 209.)

Expressive Color: Value and Form

Chapters 6 and 7 explored the use of light and dark value structures to define form, express space, and suggest light situations. Achromatic tonality remains an excellent—in some ways the best—means to accomplish these goals. Sculptural qualities of form are most effectively defined through value change, and strong color can actually be distracting. For this reason, the use of color has historically been limited in drawing, especially in periods that were particularly concerned with solidity and weight. It might be said that the sober earth tones are more suited to heaviness and density than full color, which suggests dematerialized energy. Still, full color has impressive qualities that earth tones lack, a radiance and freshness that can add an important sensual dimension.

David Hockney's portrait of his father in **Figure 8.21** is a simple, but effective drawing in colored pencil. He used directional light expertly to reveal the volume of the forms of body and chair and to give the whole drawing a pale warmth that suggests morning light. Hockney, an international sophisticate, treated his old dad's self-conscious pose with a fond humor but interpreted the contours and shadow areas as luminous, high-saturation red and yellow-green accents. This hot color gives a sense of exuberant style to the subject, probably more in keeping with the tastes of the son than of the father. The strong color is integrated well despite its intensity because of its hue connection with the warm yellow tint of the paper and dominant brown line.

Hal Forrstrom's supercharged fantasy machine, a dark power generator with an air of menace, in

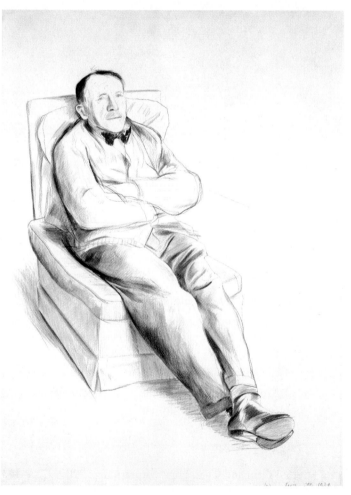

Figure 8.21 DAVID HOCKNEY, *My Father* (1974), colored crayon, 25 1/2 × 19 5/8 in.

Figure 8.22 is quite a different subject than Hockney's father. Yet, apart from the hard blue in Forrstrom's work, the two drawings share the same set of hues: yellow-green, hot red, and a dominant brown. Their emotional effect differs so greatly because of the subject matter and of a completely opposite approach to value structure. The Hockney is hyperpale, like an overexposed photograph, with the strong color confined to the shadow areas, almost like a secret. Forrstrom's color is in the light areas, standing for the glowing, barely contained energy pulsing in the pipes of the monstrous engine. The dark brown shadows that give the machine its powerful sense of form are set off by the brilliance of the highly saturated primary and secondary color, some silhouetted by backlighting. Like Hockney, Forrstrom integrated the stronger colors by relating them to the neutral tones; the deep browns are really optical mixtures of a high-saturation red modified by black.

Narrative Uses of Color Range

Forrstrom's hell machine in Figure 8.22 uses the power of color to advance a narrative idea of hot power. It is a simple and effective formula, but the narrative possibilities of color can be much more subtle and complex. One way that color functions narratively is through the psychological associations discussed at the beginning of the chapter. The narrative associations of individual colors can also be extended to a range or grouping of colors with similar properties of hue, value, or saturation. The **Rajasthani** watercolor in **Figure 8.23** entitled *Jyestha, The Month of Heat* is a particularly wonderful example of a color range with a narrative dimension. Few schools of art can match Indian watercolor for delicacy and lyricism of color. Using opaque watercolor called **gouache,** the artist infuses this scene

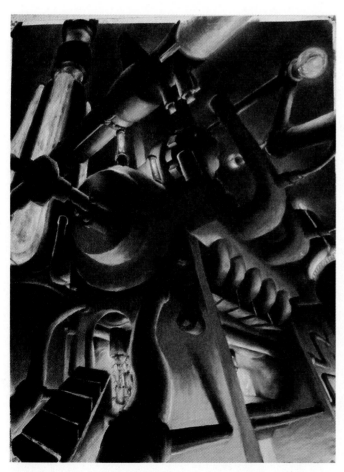

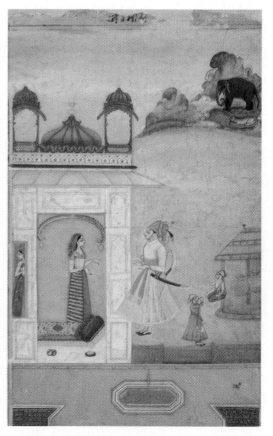

Figure 8.23 URSTAD MURAD, *Jyestha, the Month of Heat* (c. 1725), tempra on paper, 10 1/8 × 6 5/8 in.

Figure 8.22 HAL FORRSTROM, *Machine,* charcoal and pastel, 24 × 36 in., student work

with a miraculous range of pinks, violets, and yellows, perfectly evoking the atmosphere of a hot summer evening. The sensation is not unpleasant, however; these are very sweet, almost candylike colors. Perhaps the sense of sweet warmth is further tied to the anticipated social interaction between the well-dressed gentleman traveler and the elegant woman who greets him inside her tiny palace.

Contemporary artist Laura Owens also evoked a seasonal color association of delicacy and pleasure, the pale (high-value) greens and blues of spring, in **Figure 8.24**. Her mythical lovers are so faint as to be almost invisible, like a memory or dream. Their gentle activity is given a more physical form by the oddly extended flower stems that screen their conversation from us. Each flower is tipped with a brilliant, contrasting color that plays off the dominant pale tones. Together with the tiny marks that make up leaves and details of the persons, they give a sense of the fluttering energy of a day in May laced with the bright strength of new life.

In addition to evoking nature, color can also refer to aspects of social culture. Many people can be as strongly connected to colors that come through the media, manufactured products, or other art forms as they are to those that come through nature or weather. Georgeanne Deen is a Los Angeles artist whose work is a highly personal meditation on cultural concepts of femininity, and she addresses this subject through the artificially feminine language of the fashion/cosmetics industry. The bland sweet colors and stylized forms clash with the oddly surreal imagery and anxious mood in **Figure 8.25**, defining the oppressive tension caused by societal pressure to be light, graceful, and pretty.

Figure 8.24 LAURA OWENS, Untitled (2001), pencil and wc on paper, 30 × 22 1/2 in.

Figure 8.25 GEORGEANNE DEEN, *Hope etc.* (1996), oil and collage on silk, 34 × 48 in.

Contemporary Artist Profile
NEO RAUCH

Neo Rauch (**Figure 8.26**) is a contemporary artist from an area in Germany that was part of the communist bloc until recently. His images of teams of men and women engaged in seemingly pointless activity evoke the collapse of the "socialist project" in which East Germany was immersed for 40 years. Rauch's color range also taps into a finely conceived association with obsolete or old-fashioned manufactured goods (**Figure 8.27**). The muted primaries and secondaries, grayed with white into a milky blandness, suggest the enamel finish of on an old washing machine, reminiscent of the 1950s, but with a foreign flavor. Although less universal than color references to nature, manufactured color can evoke emotional memory in those who can make the connection.

Figure 8.26 NEO RAUCH

Figure 8.27 NEO RAUCH, *Park,* oil on paper

ISSUES AND IDEAS

❏ Color ranges can impart an associative "weather" to a drawing, tapping into memories of times of year or day.

❏ Color ranges can also refer to styles of fashion, decor, consumer products, or other aspects of social culture.

❏ Color can function simultaneously on a subliminal and a descriptive level.

Suggested Exercise

8.7: Color Memory, p. 220

Sketchbook Link: Color Range Swatchbook

Dedicate five pages of your sketchbook to one-inch color swatches, perhaps ten per page. Divide the swatches into categories based on aspects of your daily life. These categories might include Kid's Clothes, Nature Colors, Gloomy Day, Light at Home, and so on. Use any medium to fill in the squares with representative colors for each category, trying to make selections from observation that seem to sum up a mood or feeling that you discern about each "subject." When you have finished, compare the groupings. Are there clear differences? Is there coherence within each category? Do any colors feel "wrong," or is there a color that perfectly stands for the theme? Try the exercise again with the same subjects or new ones, refining your ability to choose and mix representative colors.

Color and Compositional Emphasis

The discussion at the beginning of this chapter mentioned the capacity of color to attract attention. Color's unique property of radiance means that it can be utilized to prioritize a composition, identifying elements of narrative interest or establishing patterns of movement or visual rhythm. Franz Ackermann's enigmatic drawings are intersecting jumbles of imagery and architecture sug-

gesting an ambiguous 3-D/2-D reality. In **Figure 8.28**, he combines an achromatic figure with skewed brightly colored buildings sunk in shadow. The color continually draws our eye to explore the buildings, while the brightly lit grey figure seems oddly lifeless, possibly a printed reproduction. Color functions as life and energy even in a dark value range.

On a more subtle level, Kara Walker's *Negress Notes* (**Figure 8.29**), an African American woman in the costume of a "southern belle," is outlined in white contour on a black background. The woman's interior is dematerialized into a gray wash with warmer shapes appearing through the illusion of transparent surface. She seems to be made of glass, a fragile, unknowable entity. The warm shapes within are ultimately recognizable as another scene, oriented vertically as though the present drawing has been made on top of an older one. The underlying image is unclear, not necessarily meant to be known, but suggestive of deeper layers of richer color contrasting with the ghostly principal figure.

Norman Paris's street scene (**Figure 8.30**) is a more narratively neutral subject, suggesting a detachment of the observer from the activity depicted. The overhead viewpoint and graphic simplification of the figures reinforce this reading as does the color coding of the figures, which are less individuals than elements in a visual rhythm. The viewer's eyes bounce around the rectangle, following the blue-green group, or the red-brown. Figures come into focus or fade, and the impersonal spectacle of a city street comes to life.

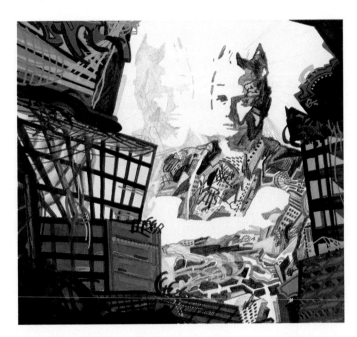

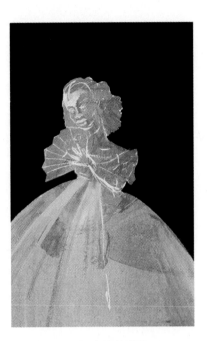

Figure 8.28 FRANZ ACKERMANN (b. 1963), *"and she stepped in and couldn't believe what she'd seen—myself as a king—corrupted"* (2001), pencil and synthetic polymer paint on paper, 10 7/8 × 12 in. (Gift of Susan G. Jacoby in honor of her mother Marjorie L. Goldberger. [2398.2001]/The Museum of Modern Art, New York, NY, U.S.A./© Franz Ackerman/Galerie Neuger-riemschneider/Digital Image © The Museum of Modern Art/Licensed by SCALA/Art Resource, NY)

Figure 8.29 KARA WALKER, *Negress Notes* (1996), watercolor on paper, 10 1/4 × 7 in.

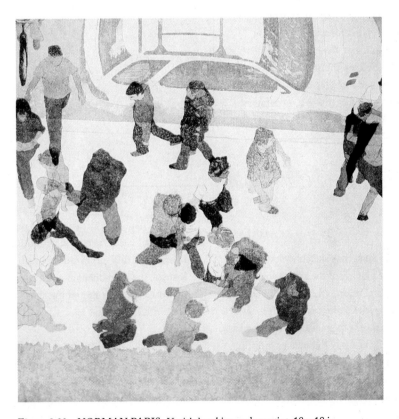

Figure 8.30 NORMAN PARIS, *Untitled,* etching and aquatint, 18 × 18 in.

ISSUES AND IDEAS

❏ Color can be used to create a narrative emphasis in a composition.

❏ Patterns of similar color in a composition create a visual rhythm, suggesting movement or narrative association.

❏ Compositional color structures can be adjusted emotionally through color association.

Suggested Exercise

8.8: Narrative Color Emphasis. p. 221.

Sketchbook Link: Studies of Color Emphasis

Make a number of quick compositional studies from paintings by other artists in your sketchbook. You should select works that seem to use color in an interesting way: a pattern based on color that leads the eye through the frame in a certain way or a simple use of color to highlight a part of the composition that seems important. Perhaps there is a comparison between two colors in the composition that expresses a relationship—narrative or simply spatial—between elements in the subject matter. If you keep the studies on an abstract level, you will be better able to assess their visual effect apart from the motif. Try this as a preparatory exercise to Exercise 8.8.

Exercise 8.1 Associative Color Studies

Materials: Pastels, Old Drawings

Select four drawings from your class sketchbook or another source. They should all be roughly of the same subject: natural objects, figures, interiors, and so on. Work each one in turn with pastels, using a few specific colors that you feel have clear emotional overtones. The goal is to transform the image associatively, but not necessarily in a way that makes realistic "sense." For example, the famous painting *Red Studio* by Henri Matisse (**Figure 8.31**) uses the color red as an abstract associative influence on an interior scene. The viewer can

imagine that Matisse's studio had red wallpaper, but not that the entire space was coated with this glowing, full-force color. It would be difficult to work in such a charged environment! Instead, the excitement and hot energy of the red transforms the space and tells something about the artist's feelings associated with his studio.

Each of your drawings should take on a different mood based on different colors. You do not need to be as obsessively devoted to one hue as Matisse was, but one color should probably predominate to set an expressive priority in each image.

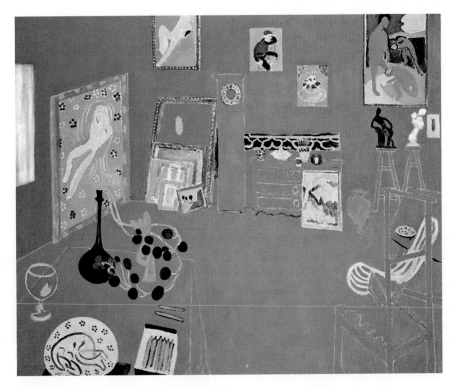

Figure 8.31 HENRI MATISSE (1869-1954), *The Red Studio*, 1911. Oil on Canvas. 71 1/4 × 88 1/4 in. (1.81 × 2.19 m). (Mrs. Simon Guggenheim Fund. © The Museum of Modern Art/Licensed by Scala-Art Resource, NY. © 2009 Succession H. Matisse, Paris/Artists Rights Society (ARS), New York)

Exercise 8.2 Working with Simultaneous Contrast

Materials: Pastel or Colored Pencil

Arrange a number of objects on a colored cloth. Choose a cloth with a clear, strong tonality, like blue or red. Choose objects that have a variety of contrast relationships to the cloth's color; some objects should be strongly red, orange, or red violet and others blue, green, or blue violet. You can also include some gray or brown objects. As you arrange the elements of the still life, plan a design based on the levels of contrast, the strongest contrast, and therefore the strongest effect, will be made by bright objects that are least like the cloth in color.

Objects that are like the cloth in color will fade into it, asserting themselves weakly in the composition. Value levels and color purity (saturation) also affect the contrast, as shown in Figure 8.4b. Try to make an interestingly varied pattern based on the different color effects, first in the arrangement you make on the cloth and then in the way you place the composition within the rectangle of your page. As you work, take careful note of the contrast effects and see if you can clarify your understanding of the principles involved in reference to the color wheel.

Exercise 8.3 Atmospheric Color Harmony

Materials: Wet or Dry Color Media on Paper

This is a free exercise in mixing color and working within a range of related hues and tones. You may use dry media such as colored pencil, pastel, watercolor, or a mixture of the two. The goal is to use variation within a narrow color spectrum to suggest a diversity of space, texture, and light within a coherent atmosphere created by the color. If it is easier for you to base your image on a real scene or a photograph of one, that is fine, but choose it with care in relation to the goals of the exercise. You should use the scene only as a starting point and concentrate on the colors you are producing with the material. Whether you are working from a source or inventing form, try to get as many different colors as possible within a close range based on no more than one-third of the color wheel. You may vary value and saturation as much as you like, creating contrasts that jump forward in relation to areas of very similar color. **Figure 8.32** makes a good comparison of different levels of color "activity": quiet zones and tangles of mark, small amounts of strong color playing off gray, brown, or intermediate hues. Finally, you may integrate a small amount of a color outside your range to "spark" the dominant colors, but do not add too much, or you will lose the overall character.

Figure 8.32 FEATHER SEDAM, student work (1989), watercolor and pastel, 12 × 16 in.

Exercise 8.4 Warm and Cool Self-Portrait, Limited Palette

Materials: Warm or Cool Tone Paper; Conte Crayon or Nupastel in White, Black, Burnt Sienna, and Ocher

For this exercise, you should plan a self-portrait in a simple palette of one or two neutral colors plus white and black. One of your most important decisions is the choice of paper color, and you might want to spend some time constructing the setup that you will use before choosing your paper. If your workspace has a cool ambient light, it might make sense to start with a paper of cool gray or soft blue or green. Your marks, including the whites, will seem warmer if laid on this paper as in **Figure 8.33**. Conversely, it might work better for you to base your paper color on an idea of skin tone or on the dominant light source. If you choose a warmer toned paper, your marks, including white, will seem cooler. Try to anticipate the colored chalk you will need to get the effects of light source and shadow. It is usually a good idea to have a way to approximate the color of the paper with your chalk and build out from it.

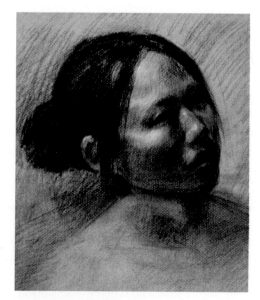

Figure 8.33 GRACE ZONG, student work (2002), conte and charcoal, 14 × 14 in.

Begin simply, using faint line to place the forms of the head. As soon as possible begin defining the surfaces of the face with hatching or smudging. Try to concentrate on the light falling on the surfaces of the face rather than the details of the features. Make sure that you have a simple, clear understanding of the color relationship between the light source, the shadows, and the background. Remember that color works through comparisons; save your warm colors for the warmest parts of your subject, for example, where a warm light source falls on skin; push the cooler colors to play off of and intensify the effect of the warmth. Whenever appropriate, let the color of the paper shine through, as though the head is partly immersed in the "air" of the page.

Exercise 8.5 *Planar Color Organization*

Materials: Red, Blue, and Yellow Watercolor

Find a landscape subject in nature or from a photograph that has at least three distinct spatial layers or zones. Divide the composition into these three parts and lightly pencil them onto your paper with lines you can easily erase if necessary. Take special care to map out areas that you want to leave pale, and keep them from getting painted over in the first stage of the work.

Using a simplified, three-color palette, mix a separate basic color for each area, approximating the colors you see in the different parts of the subject, but also to distinguish the three areas in terms of light, depth, or local color.

Atmosphere in a landscape generally causes an increase in blue—except at sunset or dawn, when the air can turn pink or gold—as well as a rise in value level and a decrease in saturation as forms recede into depth. It is not necessary to follow this plan exactly, as the cityscape by Jason Brockert in **Figure 8.34** makes clear. In Brockert's image, value varies inconsistently with depth; the tower at the center of the picture gets suddenly darker while there is an increase in color temperature, moving back into space in the foreground plane. In general, however, the composition as a whole conforms to the basic plan of atmospheric perspective, getting lighter and cooler as it recedes. The deviations from this progression create sudden, unusual visual sensation that provides drama and visual interest.

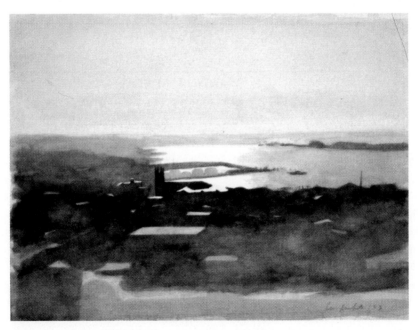

Figure 8.34 JASON BROCKERT, *Harbor* (1992), watercolor, 14 × 12 in.

Exercise 8.6 Warm and Cool, High Saturation

Materials: Pastel or Nupastel on Black, White, or Gray Paper

Plan and execute two self-portraits, both with the same strongly contrasting warm and cool light sources as in **Figure 8.35**. The easiest way to set up the light situation is to work near a window (the cool light) with your face partially illuminated by a desk lamp (the warm light). Fluorescent light is also cool and is good to use as an ambient or "fill" light source.

In the first drawing, try to duplicate the colors that you see as closely as you can. You can use an earth tone palette or a triad, or you can try to build optical mixtures with hatching of stronger color. In any case, be sure to clearly define the interplay of warmth and color within the picture, including a color role for background tones. When you have achieved a satisfying sense of the light in the situation in your drawing, redraw the image, using your first drawing as reference. The goal is not to duplicate the first drawing or to "practice" but to reinterpret the color in a stronger saturation range, building the power of pure color into the image. Confine the colors in your palette to pure spectrum color: primaries and secondaries only! You can use a small amount of white and black if you are having trouble getting value contrast, but try to limit the amount because using them will gray the color. Your second drawing may not be as realistic as the first but should have new properties: the rich power of strong, radiant color.

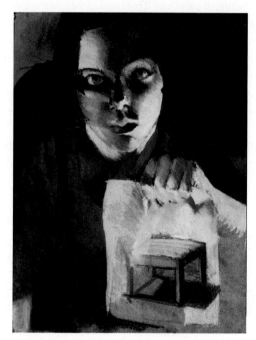

Figure 8.35 AARON FLYNN, *Self Portrait with Drawing* (2002), student work, pastel, 24 × 28 in.

Exercise 8.7 Color Memory

Materials: Tracing Paper, Heavy Drawing Paper, Pencil or Felt Tip Pen, Wet or Dry Color Media

Choose a photographic image as the basis of a composition, The scene can be taken from a magazine, book or can be a personal snapshot. You should have some idea in your mind about what is going on in the picture: It may be a certain time of day or year, or an activity can be in progress that you recognize and have some clear feelings about. Place a piece of tracing paper over the photo, and draw the contours of the major forms with a pencil or felt-tipped marker. Turn the paper over and scribble over the reverse of all contours with a soft pencil. (You can also use transfer paper for this process. See Appen-

dix A.) Then transfer the drawing to a piece of heavy drawing paper by flipping the tracing paper so that the pencil scribbles are face down, and go over all lines again with a pencil or other sharp instrument. Make three more composition tracings this way. You can use the same image or different ones in a similar vein.

Next prepare a color palette for each image. Begin by identifying a range of color that has strong associations for you and that connects well to your subject. If your image choice was connected with a time of year, choose four or five colors that evoke the season in your mind. These do not have to be "typical" colors, but they may have a personal reference for you.

However, you should be prepared to explain and defend your choices in critique. When you have made your color choices, work them into the drawing. You can use the photo for reference and for modeling of form, cast shadows and so forth, but do not try to imitate the colors in the photo unless they seem appropriate to your idea. Instead, you should feel free to develop the color on its own terms as in Exercise 8.3.

Exercise 8.8 *Narrative Color Emphasis*

Materials: Pencil, Wet or Dry Color Media

Plan a self-portrait or a scene with some of your friends. This can be drawn from life or invented but should convey some aspect of your daily life or a feeling you have about your current situation. First do some quick pencil sketches on a small scale considering the way you would like to arrange the figure(s) and space(s) in your image. The space does not need to be real, but the figure or figures and the environment they inhabit should have some relationship. When you have a composition you like, plan the use of color to complement the idea behind your composition or to direct the viewer's eye to one or more elements that you feel are important. If there is no central focus, you should consider placing the points of emphasis around the composition creating a pathway that your viewer's eye might take.

Snejina Latev has placed her tiny figure low and in the center of a vertical space in **Figure 8.36**. There seems to be a large window on the back wall, and light and shadow from this source help define the room's space. The figure has its own light created by color: a vibrant orange-red that contrasts vividly with the low-saturation browns dominating the image. Despite the somewhat claustrophobic character of this room, this figure is filled with excited energy. Closer inspection reveals that he or she is eating a bright green leaf, a color echo of the tree outside. Has the power of nature entered this room to sustain its inhabitant?

Julia Rothman's complex composition is clearly an evocation of college life (**Figure 8.37**). The jerky pattern composed of furniture surrounds a stylized young man who presides over the chaos. The color scheme is related to that in the Neo

Figure 8.36 SNEJINA LATEV, *Red Boy* (2002), student work, monotype, 10 × 14 in.

Rauch work in Figure 8.27: institutional greens, pale blues, and maroon on a beige undertone. The color mood is comforting and bland, suggesting a familiarity and gentle affection for this particular time of life. The placement of the various color areas causes the eye to bounce around the composition in a way that suggests the spontaneous unfolding of events that might characterize the life inside a dorm full of friends, casual acquaintances, and those passing through.

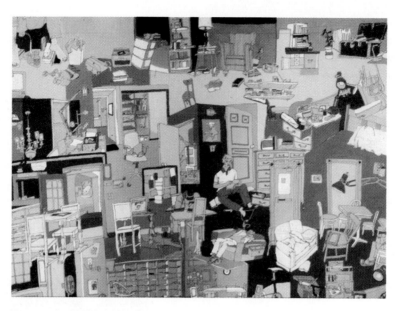

Figure 8.37 JULIA ROTHMAN, student work (2002), gouache, 36 × 24 in.

—— Critique Tips Chapter 8: Color and Light ——

During critiques for the assignments in this chapter, look at your own and your classmates' drawings for qualities based on the following questions. You might also want to review the vocabulary in the Using Specialized Vocabulary in Chapter 1.

What role does color play in the drawing? *Does color do more than just describe the objects included in the composition. Does color help to define light, atmosphere, form, mood, or narrative?*

Is the color "warm" or "cool" or a comparison of the two? *What role does the color of the paper play?*

Are there comparisons of color that seem important? *Color often works through relationships. How does one color relate to another in the image to produce a certain effect?*

Is there a directed or coherent range of color? *Is there unity of light, space, or mood established by a unity of color character? This may be based on hue, saturation, or value. Is the range broad (strong variety) or narrow (limited palette or monochrome)?*

How does the expression of the drawing through color work with the subject matter? *Are there associations to the particular color mixtures used to which you respond on a level of emotion or memory?*

Where is the strongest contrast in the drawing? *How does this relate to an emphasis of gesture, space, or narrative?*

Is there an effective organization of the composition with color, either on a spatial level or as a graphic pattern?

PARTthree

Expressive Directions

INTRODUCTION

The chapters in Part 3 depart from our focus on formal elements of drawing to concentrate on particular expressive application of the basic principles and structures you have been studying. These chapters are intended as extensions of the concepts already discussed, opportunities for in-depth study, and examples of the artistic usage of formal elements within a defined thematic territory.

Chapter 9 centers on the human figure as an example of the use of a specific subject to give direction and expressive context to the means and methods of drawing. The study of the figure includes a review and extension of the discussion of organic form begun in Chapter 3, with elements of gesture from Chapter 2, geometric organization from Chapter 4, spatial context from Chapter 5, and tonal issues from Chapters 6 through 8. In support of the study of the body, Appendix C at

the end of the book provides a thorough overview of human anatomy in diagrams and text.

Chapter 10 focuses on issues of expression through composition. Methods of suggesting meaning through abstract structures are discussed in relation to both abstract and figurative imagery, elaborating on issues raised in Chapters 2 through 8. Chapter 10 introduces techniques that have extended the territory of drawing in the Twentieth and Twenty-First Centuries such as collage, frottage, applied texture, image transfer, and complex or three-dimensional format. Appendix A supports the discussion of media in Chapter 10 with technical specifications for various techniques. The goal of Part 3 is to move you forward in considering drawing as a personal creative vehicle, uniting subject and means in service of expression. It is important to refer back to previous chapters of this book to reinforce the continuity between new topics and methods and the basic concepts already addressed.

The Living Figure

<div style="text-align: right">9</div>

Chapter 9 concentrates on a particular subject for drawing: the human figure. Study of the figure will help you learn about the art of drawing, and the art of drawing will acquaint you with some interesting propositions on the subject of the body, individual personality, and humanity in general.

The relationship people have with their bodies is complex and ambiguous, and so is the role that the body has played in artistic expression. The human spirit or consciousness is at the heart of what people think of as themselves, and its origin and nature are mysteries that have been the subject of religious and philosophical investigation for centuries. The spirit, abstract in nature, is difficult to represent objectively in visual art, however, and so the body has been humanity's usual means of self-representation.

It is important in approaching the figure as a subject for drawing to remember that the goal in art making is *expression*, rather than simple description. Like other types of subject matter, or **motifs**, the body is something to study as a way to make a larger point about life, emotion, society, or personal experiences. Because figure drawing can be an especially complex and involving area of study, it is particularly important to keep this basic truth about drawing as an art form in mind.

FIGURE-BASED NARRATIVE

Narrative Sign and Form

The figure has been used in art throughout history to describe human experience, often in retelling important events. Many past cultures have told stories through simple imagery made up of lines, shapes, and two-dimensionally simplified forms. These **pictograms** have a primary function as easily understandable components of a visual narrative, but there are more developed styles in which the qualities of graphic forms are refined and used for expressive means.

The ferocious warriors depicted in the section of the Bayeux Tapestry from eleventh-century France in **Figure 9.1** might seem like stiff toy soldiers to modern viewers. The tapestry uses simplified **signs** for figures, armor, weapons, horses, and even dismembered corpses, to visually tell the story of the Norman invasion of England in 1066 A.D. There is a premium on simplicity for the sake of efficiency in the making of the enormous work (70 meters of stitching and cut fabric!) and to allow viewers to concentrate on the important aspects of the scene as determined by the artists. You can imagine that there were many other components of the actual invasion: clouds, elements of landscape, larger numbers of people, maybe some plants and rocks. These have all been left out (except for one rather odd tree) due to their lack of importance in relation to the central events and the technical limitations of the medium. Weapons, however, have a special prominence due to their role in the battle, as do the details of the enemies' distress and the identification of key individuals in the action.

One could fault this depiction in a number of ways, especially for its neutral emotional tone and lack of a sense of action, despite the gruesome details. The almost childlike quality and weightlessness of the figures seem inappropriate given the grim nature of the events. Viewers

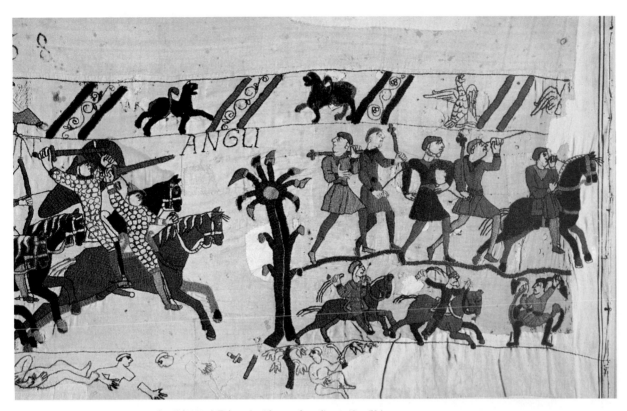

Figure 9.1 *The Bayeux Tapestry*, detail (1080 A.D.), embroidery and appliqué, 40 × 53 in.

must "read" the gestures of the figures rather than truly feeling them.

You might think of the pictograms in this work as visual words that tell the story. For example, a line with attached diagonals is an arrow; a series of overlapped circle shapes is "armor"; and a thick wavy line is the ground.

A stronger role for personality or spirit, accessed through the power of expressive shape, is evident in a rock painting near Santolea, Spain, dated about 8,000 B.C., in **Figure 9.2**. Narrative detail is present here too: It is clear that the man is an archer. This figure differs strongly in visual character from the Bayeux warriors, however. He has an extraordinary grace and self-possession, intangible qualities that are given life by the language of curvilinear shape that the artist employed. The hunter's stance has a lithe rhythm, almost like that of a dancer, as though he might sprint off at any moment with graceful leaps.

Contemporary artist Jockum Nordstrom's work is in **collage,** a medium of cut paper that

Figure 9.2 *The Archer* (c. 8,000 B.C.), rock painting from Santolea, Spain

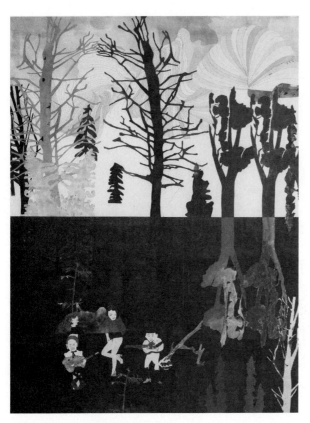

Figure 9.3 JOCKUM NORDSTRUM, *The Forest of Death* (2001), mixed media and collage, 50 3/4 × 39 5/8 in.

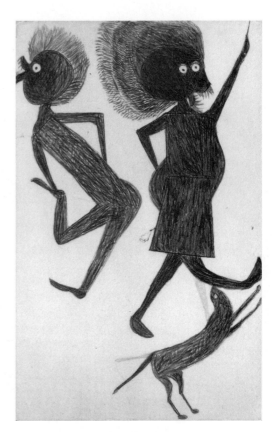

Figure 9.4 BILL TRAYLOR, *Dancing Man, Woman, and Dog* (c. 1939–1942), crayon and pencil on paperboard, 22 × 14 in. (Smithsonian American Art Museum, Washington, DC, U.S.A. © Smithsonian American Art Museum, Washington, DC/Art Resource, NY)

bears some resemblance to the technique of the Bayeux Tapestry (see also Chapter 10, Figures 10.26 and 10.27). The people in **Figure 9.3** also seem a bit like toy people, but Nordstrom's work has a powerful mood, an odd mix of humor, and ominous gloom. Like earlier artists, he is very interested in detail—it is possible to see how many strings are on the guitars of his tiny figures and what color pants they are wearing—but he is also a master of shape and color for expressive purposes. The trees dominate mysteriously, and the figures seem to be sunk in the blackness dominating the lower half of the image. The sky is a layering of abstract of fanlike shapes in soft tones, and the trees cast reflections or shadows into the blackness. The story is "told" through shape, color, and scale as well as detail; it is **evocative** rather than **explicative.**

Bill Traylor's wild dancers are bouncing off the sides of the picture in **Figure 9.4.** Their poses exist in a weightless graphic space, forming jagged negative shapes between them that seem to bear some

thematic relation to the sharp teeth that line their mouths. The party is apparently well on its way out of control. Each shape has been carefully weighed for expressive effect, and linked with diagonal rhythms to suggest the force of the dancing. Despite the simplicity of the technique, the artist's choices in the presentation of his subject are mysteriously involving.

Narrative Sequence

More complex or extended action can best be approached by means of a sequence of images read linearly to suggest ordering in time. The Bayeux Tapestry is a sequential image: It is so long that a viewer must walk along its length to follow the unfolding story but can never really see the image as a whole.

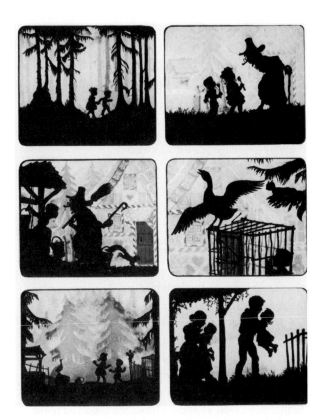

Figure 9.5 LOTTE REINIGER, scenes from "Hansel and Gretel"

and casting everything in a romantic sort of twilight. This mood beautifully suits the story of Hansel and Gretel's encounter with the witch deep in the woods, but the diminished detail also focuses the narrative. Only elements with narrative significance enter the visual field, and the viewer's eyes move around the various shapes, interpreting them and piecing the story together.

Sequential images are the essence of the modern art form of comics and the related field of animation storyboarding. **Storyboarding** involves multiple frame drawings simulating the linear passage of time in a film. Frames within frames suggest camera zoom and graphic devices such as arrows and explosion lines show movement or impact.

Figure 9.6 shows a storyboard panel from the animated series *Avatar* created by artist Bryan Konietzko. Although the final animation would have many intermediate images connecting this sequence, Konietzko must choose representative scenes for his storyboard to enable his collaborators to understand the essence of the action. This skill is related to the choices that all "comix" artists must make to be effective storytellers.

Konietzko's stylization of his characters with simple elliptical volumes conveys the essential humor of the story and allows the many other artists involved in the production to imitate the look of the drawings easily (see Chapter 3, Figure 3.33). There is a premium in this type of image for a simple drawing style; a few seconds of film can require hundreds of drawings in a final animation.

Another approach to depicting a story in time is by separate framed scenes meant to be read one after the other. **Figure 9.5** shows a series of panels from *Hansel and Gretel,* an animated film by Lotte Reiniger in **silhouette.** The actual work, a film, plays in a fixed time sequence, but these six images can also be read as a quick summary of the story, defining key moments in the action. The effect of silhouette is mysterious, denying access to visual details about the figures and their surroundings,

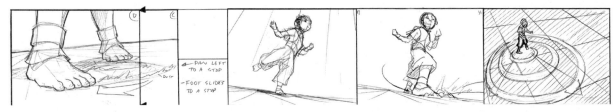

Figure 9.6 BRYAN KONEITZKO, MICHAEL DANTE DIMARTINO, KENJI ONO, storyboard from *Nickelodeon Avatar, The Last Airbender* (Avatar material re-printed with the permission of Viacom. © 2006 Viacom International. All rights reserved. Nickelodeon, Avatar and all related titles, logos and characters are trademarks of Viacom International, Inc.)

ISSUES AND IDEAS

❑ The simplest role a figure can play in a drawing is as a sign or symbol for a human being.

❑ Narrative use of a figure as a sign focuses on clearly described action often by means of detail.

❑ Line and shape character, and compositional arrangement, can affect the narrative message of a figure or scene.

Suggested Exercises

9.1: Narrate a Story in a Sequence of Four Panels, p. 264.

Sketchbook Link: Narrative Sketching

Fill several pages of your sketchbook with quick, simplified drawings of people in your school or town engaged in routine daily activities. See if you can distill the essence of their movements into a clarity of narrative description. It might be less necessary to document the actual look of their gestures or expression in every regard, but more important to focus on one or two important details that will tell the story of the figure's actions.

THE BODY AS OBJECT

Physical Presence

The body, the visible self, is the obvious choice for representing the human presence in visual art. It might follow that artists could increase the expressiveness of human representation in their work by making their drawings resemble more closely the physical presence of people as they exist in the world. On the other hand, if the overall goal is to make art about ideas and emotions, the relevance of the specific depiction of the body might be questionable. Ideas and emotions are not inherently physical entities. If relatively simple graphic depictions can effectively convey meaning, what can an increased representation of

physicality evoke in drawing besides the simple fact of the figure?

As it happens, important qualities have been added to the repertoire of art through concerted study of the physicality of the body and by the development of new techniques to bring these into the art of drawing. An understanding of these qualities, as well as the techniques used to create them, can clarify your sense of purpose in studying the figure through drawing beyond a simple desire for "realism" or "rightness."

The most basic characteristic of the body is that it is a solid object; it has volume, weight, an interior structure, and a surface. Many things are known about the body's physical makeup and function in the Twenty-First Century that were not known in past centuries, but its essence as an object must always have been apparent. Nonetheless, physicality was not an important factor in the representation of the body in many cultural periods, or it was not known how to emphasize this aspect in two-dimensional (2-D) art such as drawing (see Figures 9.1 and 9.2).

The Italian painter Giotto (1266?–1337) is often credited with initiating the "solidification" of the figure in painting. **Figure 9.7** shows some of the techniques Giotto devised to suggest three-dimensional (3-D) form in a flat work of art. First, he simplified his figures. The robes they wear helped him do this, covering the complexities of the body and presenting the form as a simple shape. Giotto then applied a technique explained in Chapter 6: directional light. The idea is

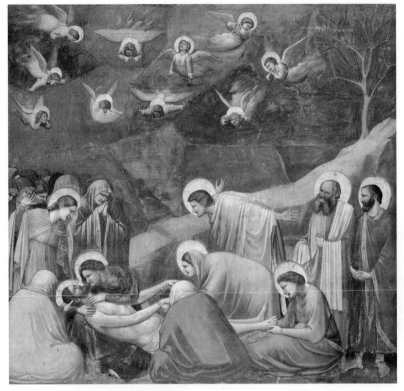

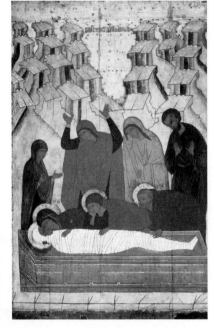

Figure 9.8 *The Entombment,* (15th C.), from the Church Feasts Range, Novgorod school, egg tempera on lime board, canvas, gesso, 35 7/8 × 24 3/4 in.

Figure 9.7 GIOTTO DE BONDONE, *The Lamentation* (C. 1305), fresco, Chapel of the Scrovegni, Padua. (Arena Chapel/SuperStock)

to show that the form is getting light on one side, but not the other, and therefore must be three-dimensional. This works only if the light is coming from a clear angle so that viewers can see both the light and the dark side at once; in fact, every Giotto painting has light coming from the side or above.

Giotto's compositions might appear strangely clunky to the modern eye, a grouping of simple, solid things, like rocks or pillows arranged on a shelf. In fact, the "shelf" effect is another of his important innovations, allowing for the weight of solid figures by giving them a solid ground on which to stand. Giotto understood that the ground had to seem three-dimensionally horizontal, projecting back in space under the figures.

A comparison with the Russian **Icon** painting of the Fifteenth Century in **Figure 9.8** shows the importance of this principle. The Russian composition relies on graphic shape for its narrative legibility and visual impact, and the space is "stacked up" with objects that are deeper in space rising high on the picture plane.

As Giotto's ground plane moves back in space, it is **foreshortened** in a way previously studied in Chapter 2 and Chapter 5 and demonstrated in **Figure 9.9**. Figures standing behind other figures are overlapped and hidden rather than being projected higher so they can be seen. This further emphasizes the realistic objecthood of the figures. They are participants in a human drama, but also physical entities in a 3-D world, in front of or behind other such entities. Even the body of Jesus, the narrative centerpiece of both images, is partially covered by an anonymous foreground figure in Giotto's work; iconic emphasis is actually sacrificed for 3-D realism. The end result is that viewers can "move into" Giotto's scene, participating in the dramatic moment as though they were actually present. It is not known whether Giotto made small-scale models of his scenes in clay, but he might have. They are arranged with a 3-D certainty that could easily be observed by using a

Figure 9.9 Ground plane recession

Figure 9.10 PAULA REGO, Study for *The Family,* Pen and Wash, 11 5/8 × 15 1/8 in.

sculptural material for a "sketch." This certainty gives a sense of solid strength or factuality to the image.

Contemporary artist Paula Rego has adopted many aspects of Giotto's vision to depict her psy-chologically loaded narratives. The blocky charac-ter of the figures in stark side light and the simple spatial clarity of the room give a vivid physical presence but also a sense of staged ritual and an anachronistic aura to the scene in **Figure 9.10**.

ISSUES AND IDEAS

❐ The figure's character as a solid object can be a special focus of interest for drawing.

❐ Artists in the late Middle Ages, notably Giotto, developed a technique for projecting 3-D solid-ity in a flat work of art: simplified, rounded form modeled in directional light.

❐ Weight and solidity can be emphasized compositionally by arrangement on a foreshortened ground plane.

❐ Evacuation of physical reality in an image can increase the viewer's sense of involvement.

Suggested Exercises

9.2: Solidity of Form: Stores as Figures Parts I and II, p. 264.

9.3: Composition with Clay Figures, p. 265.

Solidity and Expression

Giotto's innovations could have been intended to increase the believability of his scenes, but they have another interesting effect. The sense of physical weight that he brings to his figures also has a kind of emotional weight. It is as though the tactility and density of the figures translates into a sober strength of emotional message (**Figure 9.11**). It is interesting to note that contemporary accounts of reactions to Giotto's work, which was considered miraculous in its effect, concentrate on the emotional intensity of his dramas rather than his illusionistic technique.

Contemporary artist Odd Nerdrum's image of a bald woman staring at the sky (**Figure 9.12**) lacks the pathos of Giotto's burial scene, but the heaviness of the forms—you can really feel the weight of her head on that rock—and the dim light of the setting sun give a somber power to the emotional moment, as blank as it is. Note the clear indication of the ground plane angle by the placement of the figure's shoulders and the low horizon line.

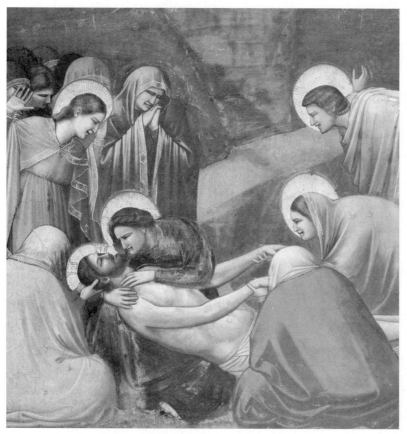

Figure 9.11 GIOTTO, *Entombment* detail

ISSUES AND IDEAS

❏ Weight and solidity in the figure can be connected with diverse human qualities, such as strength, fatigue, sadness, or moral power.

❏ Point of view increases the emotional impact of the scene by drawing the viewer in.

Suggested Exercise

9.4: Solid Self-Portrait, p. 265.

Bilateral Symmetry: The Head

One aspect of the human body that presents important possibilities for evoking solidity of form in drawing is its **bilateral symmetry;** the body is the same on the left and right sides of a vertical line running down its center. The significance of this quality lies in the geometric division it makes possible in relation to **3-D projection.** The obsession with mathematics in the Renaissance led artists such as Albrecht Dürer in Germany and Piero Della Francesca and Leonardo da Vinci in Italy to analyze the structure of the body in terms of proportion and symmetrical division. They reconstituted the face, which is almost always subtly different from side to side, as a series of perfect geometric solids in clear relation to each other. Orientation of a turning head becomes much clearer when this type of division is imposed. You can almost imagine "steering" the head by grabbing the ends of the horizontal axis formed by the ears and twisting it up, over to the right, and so forth. The **axes** and their component proportions will diminish in scale or foreshorten as they tip into the implied "depth" of the page.

Albrecht Dürer projected three baby heads with an almost mechanical precision in **Figure 9.13a and b**. Although the artist's geometric clarity might lessen the soft humanity we usually associate with babies, it certainly makes the spatial position or "gesture" of each head extremely forceful.

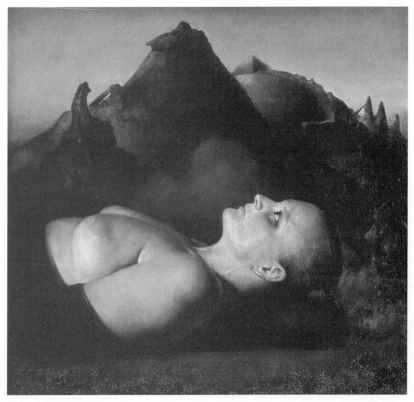

Figure 9.12 ODD NERDRUM, *Profile,* (1991), 33 1/2 × 34 1/2 in.

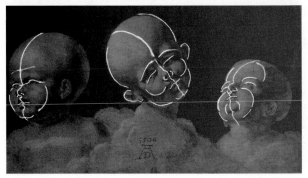

Figure 9.13 ALBRECHT DÜRER, Three Heads of Children, (1506), brush heigtened with white, on blue paper, 8 3/4 × 15 in. (with diagram of axes by F. Drury)

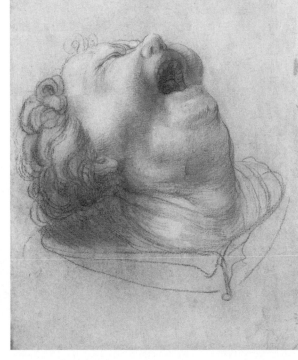

Figure 9.14 MATTHIAS GRUNEWALD, Head of a Weeping Angel, black chalk, 10 7/8 × 7 3/4 in.

Matthias Grunewald, another German artist of the Renaissance, gave an expressive life to this approach, using an extreme foreshortening of the upper face and skull and a dramatic preoccupation with the neck of the screaming child in

Figure 9.14 to suggest a wild spasm of grief. Through its distortion of form and violent gesture, the work is an amazing example of the vividness that a sense of physical form can bring to the experience of a 2-D medium.

ISSUES AND IDEAS

❏ The human figure is bilaterally symmetrical; seen from the front or back, the right side mirrors the left.

❏ Comparison of the two halves allows for easy orientation of overall pose.

❏ Axes, or linear divisions, can be imposed on the vertical center line and on horizontal lines linking similar forms on the left and right (eyes, ears, shoulders, etc.).

Suggested Exercises

9.5: Head Gesture, p. 265.
9.6: Skull in the Head, p. 266.

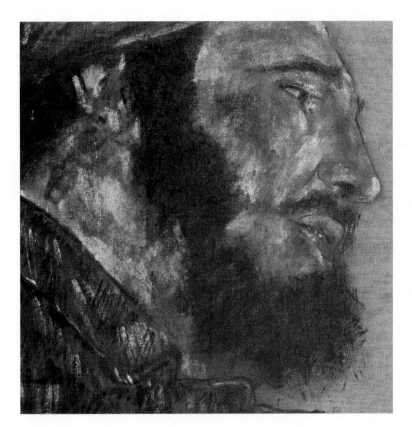

Figure 9.15 LEON GOLUB, *Fidel Castro I* (1977), 18 7/8 × 18 7/8 in.

face suggests distance; Castro is pre-occcupied with his public persona, unaware of the viewer. Golub's scratchy technique almost suggests a peeling poster, giving a flatness to the image that works ironically against the heroic physical proportion of the head.

The Skeleton: Part I, Foreshortening

The preceding discussion explored two different methods of analyzing the structure of the body: simplification as rounded solids and orientation based on bilateral symmetry. Underlying these observations of surface is the basis of all structure in the body, the skeleton. The skeleton gives the body its basic volume and can play an important role in bilateral orientation. Skeletal landmarks divide and map the form symmetrically. (See Appendix C for definitions and diagrams.) The windpipe, the center of the clavicle, the sternum, the centerline of the abdominal muscles, the navel, and the center of the pelvis form a centerline in the front. In the back, this line is echoed by a furrow made by the spinal column. Leonardo da Vinci's heroic Vitruvian man (a self-portrait) demonstrates the mathematical interpretation of these divisions popular in the Renaissance, inscribed in a square and a circle in **Figure 9.16a**.

A number of horizontal axes cross the centerlines, many associated with the skeleton. These axes are straight lines when viewed frontally, as in **Figure 9.16b** but actually are borders of elliptical solids such as cylinders or **ovoid** forms. The rib cage appears as one of these ovoids vertically divided by the spine in the back and the line of the sternum in the front. The shoulder girdle, consisting of the right and

Contemporary artist Leon Golub, on the other hand, dematerialized his foreshortened head of Fidel Castro, the legendary dictator of Cuba, in **Figure 9.15**. In this case, the vivid sense of looking up at the

Sketchbook Link: Casual Portrait Sketches

Draw portraits of your friends, but rather than asking them to pose, try to capture whatever position their heads might be in at a given moment, using a simple axis-based planning technique and side-to-side comparison based on bilateral symmetry. Look for unusual positions: head bent over to work, lying back asleep, turning to talk to someone behind, and so on. Concentrate on getting the orientation right more than on likeness or facial expression.

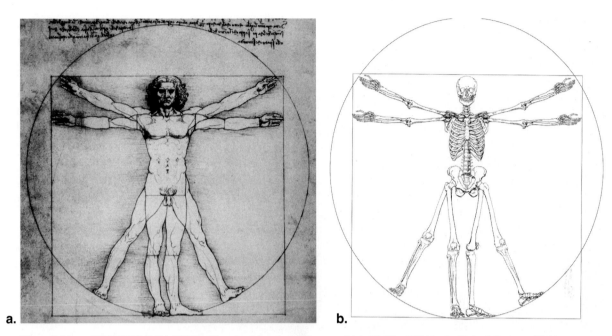

Figure 9.16 a. LEONARDO DA VINCI, Vitruvian Man, (c 1490), pen and ink, 13 1/2 × 9 3/4 in.; **b.** Skeletal diagram of 9.16a

left clavicles in front and the two shoulder blades in back, circles around the neck in a kind of football shape with the points at the shoulders. The lower border of the ribs is usually clear in the front and back, creating an elliptical border in the middle of the torso. Further down the figure, the outer ridges of the pelvis form a beltlike ring, complemented by the crease that cuts through the navel in front. The joints of the knees, elbows, ankles, and wrists are other important segmentations of form in the figure. (See Appendix C, Figures AC.1, AC.2, and AC.3.)

Other landmarks are made by muscle or fat zones: the lower border of the pectoral muscles in men and the breasts in women; the crease under the buttocks; and, at certain angles, the muscles of the legs and arms. (See Appendix C, Figures AC.4, AC.5, and AC.6.)

Figure 9.17a by contemporary artist Antonio Lopez Garcia shows these divisions in the context of a characteristically meditative drawing. Lopez Garcia's careful attention to the forms of the figure in depth, unidealized yet softly poetic, gives timeless power to this realized moment of existence. Although you look from a position near this woman's feet, you feel as though you are, in fact, the woman looking at her own body. This is accomplished by skillfully locating the point of view at her eye level and by the drawing's stillness conveying the experience of quietly soaking in the tub.

Sketchbook Link: Foreshortening Sketches

In a public place, like a city park, draw people walking, sitting, lying on the grass, and so on. Practice your ability to rapidly note the basic landmarks of the form on the figure, looking through the details of clothing to identify the segments of the skeleton and musculature. Concentrate on orienting the forms in three dimensions, trying to push each drawing into a spatial reading from a particular point of view.

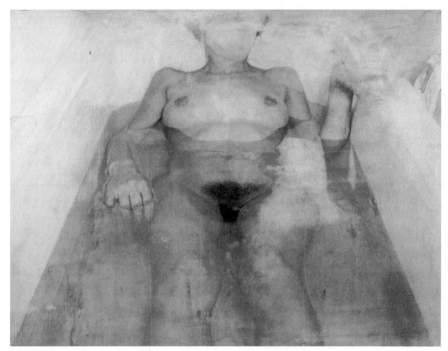

a

b

Figure 9.17 a. ANTONIO LOPEZ GARCIA, *Mujer en la bañera.* (1971), pencil on paper, 20 1/2 × 27 1/2 in.; **b.** Diagram of foreshortened segments. Antonio López Garcia © 2009 Artists Rights Society (ARS), New York/VEGAP, Madrid

with foreshortened poses is to overlap segments of the torso and limbs. **Figure 9.17b** shows some important divisions within the torso: the ovoid form of the rib cage, the beltlike border created by the pelvis, and the segments of the arms and legs. Each segment can be simplified conceptually into an elliptical solid, either a cylinder or an ovoid, with one placed atop the other, extending from the background toward the viewer's space, as the diagram shows. Of course, Lopez Garcia softened these divisions in the actual drawing for the sake of his subject's humanity, but you can still sense this underlying structure. Note the relationship of the body's foreshortening to the perspective rectangle made by the surface of the water.

Figure 9.18 shows these same principles applied to a figure seen from the side. In this case, the lateral dimensions are foreshortened; the front plane of the figure turns into depth and becomes narrower, although its height is maintained. The centerline moves toward the far side of the figure and the rib cage is seen in partial profile (three-quarter view). Contemporary artist Marlene Dumas, noted for her tender, tactile sense of humanity, used this gesture to suggest shyness and vulnerability; the figure seems to turn away from direct confrontation.

To clarify the positioning of the forms of the figure in depth, it is important to pay special attention to overlap. In a figure, overlap can be very obvious, as when an arm covers the torso, but in many ways the most useful form of overlap in connection

ISSUES AND IDEAS

❐ The skeleton is the basis for the 3-D form of a figure.

❐ The body can be analyzed in terms of segmented elliptical form with divisions made by landmarks of the skeleton and the soft forms of muscle and fat.

❐ Overlap of these forms, organized along the vertical and horizontal axes made by skeletal landmarks, can help orient the figure in 3-D space by foreshortening.

Note: Full diagrams showing anatomical landmarks can be found in Appendix C.

Suggested Exercises

9.7: Foreshortening, p. 267.
9.8: Monumental Body, p. 267.

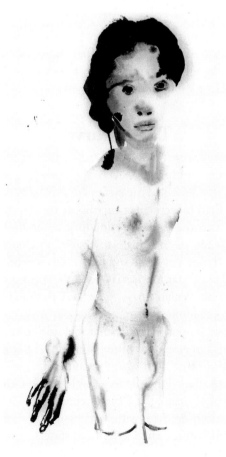

Figure 9.18 MARLENE DUMAS, *Young Boy,*
from the young boy series, inkwash, wc on paper,
79 1/4 × 27 1/2 in.

The Skeleton: Part II, Flexibility and Spatial Fluidity

The second role that knowledge of the skeleton can play in drawing the figure is to establish the flexibility of the form. This might seem odd; the bones in the body are there to give rigidity against the pull of gravity and to provide firm anchors for muscular structure. Perhaps a more accurate way to put it is to say that the skeleton can help define the flexibility of the rigid parts of the body in relation to each other, for the skeleton is flexible at specific points and in specific ways.

The core unit of flexibility in the skeleton is the spine, which connects the head, rib cage, and pelvis. The spine is flexible because it is composed of many small parts, like a train, which can move slightly in relation to each other. The result is a structural element that provides a combination of rigid support with a remarkable ability to turn, twist, bend, stretch, and compress. Sensitivity to the orientation of the spine is one of the most important ways to breathe life into a figure in your drawing. The spine seen from the side is an S curve, like a swimming snake as shown in **Figure 9.19** and **Figure 9.20**. This shape is an inspirational one; it connects the form of the figure with natural phenomena of fluid movement.

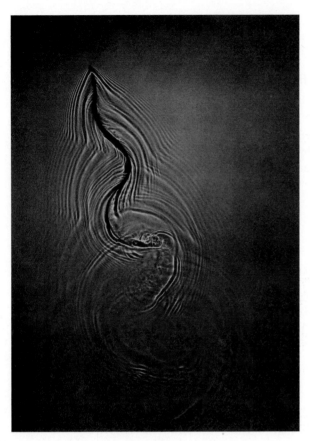

Figure 9.19 ADAM FUSS, Untitled (1996), Unique Cibachropme photo, 40 × 30 in.

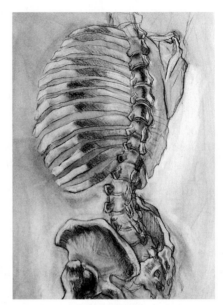

Figure 9.20 RORY KELLER, *Skeleton* (2007), student work, charcoal, 32 × 20 in.

gers. In beginner's drawings, however, the flexibility of the torso is the factor most often underestimated, even though it can contribute most dramatically to a sense of living movement in the figure.

The *S* Curve

The *S* curve in the side view of the spine (Figure 9.20) might be called the symbol of flexibility: side-to-side fluid movement, a curvilinear waving motion around a central axis, an exploratory search for balance. We return now to an issue raised in Chapter 3, motion defined by line. Applied to the *S* curve, the principle of linear motion is one of the most powerful concepts available to suggest fluid, flexible movement in the human figure, or in fact in any form.

There is good evidence that this side-to side undulation is inherently soothing for people; think of the motions that calm a baby or those of a rocking hammock. Few sights are as graceful as the meanderings of a stream; the *S* curve represents contained continuous movement with soft changes of direction and a constant return to a balanced state.

The drawing of the crouching woman by Amadeo Modigliani in **Figure 9.23** uses a sweeping *S* curve to describe the luxurious stretching of the body. From a starting point in the lower left-hand corner, the curve moves from the contour of

The spine is important structurally in that it allows for the compression and extension of the column supporting the head and gives an opportunity for bending, particularly at the cervical curve of the neck and at the lumbar curve in the lower back. The convex curve surmounting the rib cage and the sacral curve attached to the pelvis do not flex so much. Their convexity helps instead to establish the volume of these forms, which represent the major units of skeletal mass.

Drawings by Egon Schiele in **Figure 9.21** and Peter Paul Rubens in **Figure 9.22** show the importance of the spine to the flexible sense of the figure in action. Schiele's scrawny self-portrait arches backward while Rubens' rippling muscle man hunches to lift a heavy burden. In either case, the physicality of the figure is expressed not through block-like solidity as in Giotto's work, but in relation to its capacity for springy, energetic change.

The skeleton is flexible in many other ways, of course, especially the joints of the arms, legs, and fin-

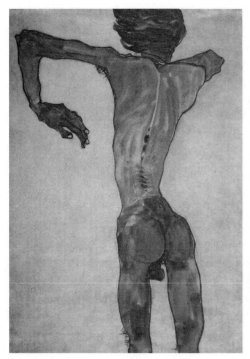

Figure 9.21 EGON SCHIELE, (1910) Standing Male Nude, Back view, black chalk, wc and gouache, 17 5/8 × 12 1/8 in.

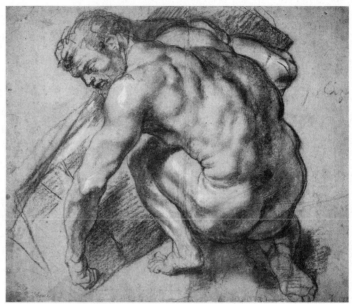

Figure 9.22 PETER PAUL RUBENS, crouching figure, black chalk

the hip into the spine, between the shoulders, connecting with the upper contour describing the hand, wrist, and forearm of the figure. It is almost a perfectly balanced reverse *S,* but something else happens here. The figure is twisting—extremely so. The lower half of the body faces you, but by the time your eye gets to the upper torso, you are looking more at the woman's back. The forearm folds back toward you from the furthest point of the pose. It is an elaborate and contorted pose that brings your eye around the back and out again. The effect is to increase the physicality of the action with stretched

ISSUES AND IDEAS

❒ The spine is the basic structural unit of the figure and is designed for flexibility.

❒ The spine naturally forms an *S* curve, which can straighten or bend in many directions.

❒ The *S* curve can be found in many forms of nature and is a visual sign of flexible movement.

❒ An *S* curve can be configured as a spiral twist in the figure, taking the viewer's eye around the form in implied depth.

Suggested Exercises

9.9: Centerline Gestures, p. 267.

9.10: Drawing the Skeleton in the Pose of the Figure, p. 268.

9.11: *S* Curve Gesture, p. 268.

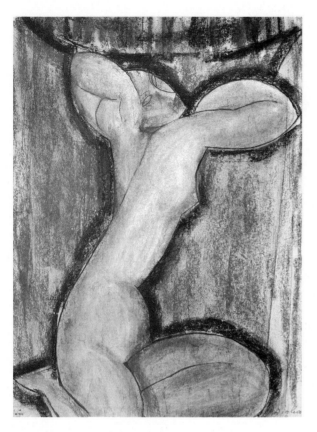

Figure 9.23 MODIGLIANI, *Caryatid*, (c.1913–14), pastel, water-color and pencil on paper, 20 7/8 × 17 1/4 in.

tension complementing folded compression, making an intriguing visual configuration for your eye to explore. The drawing takes you on a spiraling roller coaster ride across the surface of the composition, but also around and behind the imagined form of the figure's body and the space that surrounds it.

> *Sketchbook Link: S Curves in Nature*
>
> The principles of figure drawing can bring a sense of movement to other subjects, particularly living things. Make ten sketches of trees and plants, looking for opportunities to apply spiraling lines to the contours of the forms of trunks, branches, and even leaves. Do not simply apply *S* curves arbitrarily, but try to find them occurring naturally in your subject. You can approach animals too if you have good access (the family dog, for example).

Spiral and Contraposto

The *S* curve principle is also at work in the drawing by Michelangelo in **Figure 9.24a**. **Figure 9.24b** shows curving spirals (3-D *S* curves) that draw your eye around the pose in implied depth.

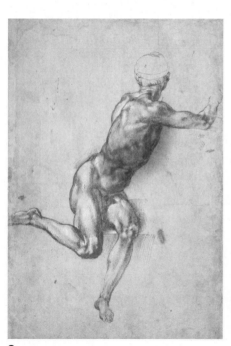

a

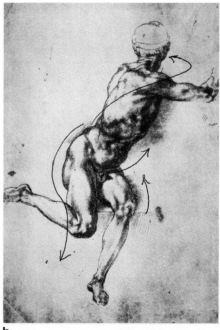

b

Figure 9.24
a. MICHELANGELO, Study for the battle of Cascina, (1504), pen, brush and warm grey ink, heightened with white, 16 5/8 × 11 1/4 in. (© The Trustees of the British Museum/Art Resource, NY); **b.** Diagram with spirals

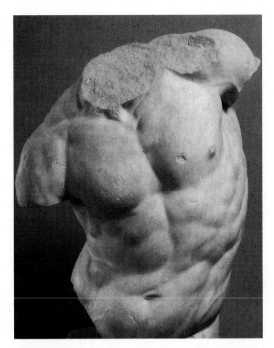

Figure 9.25 *Bust of a Satyr*, Greek (2nd C. BC,) marble

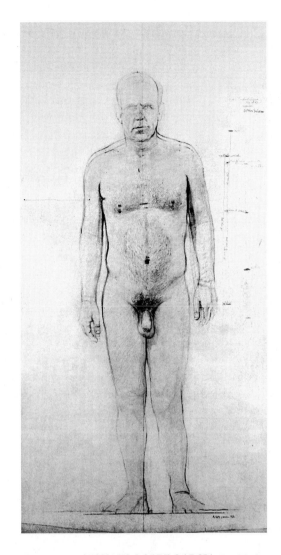

Figure 9.26 ANTONIO LOPEZ GARCIA, *Jose Maria*, (1981), pencil von paper, 80 3/8 × 40 1/8 in.

This powerful drawing has other elements that raise new issues. Unlike the woman in Modigliani's drawing, this figure is very sculptural, with a developed sense of 3-D form. This aspect of the drawing is a tribute to ancient Greek sculpture, as shown in **Figure 9.25**, one of Michelangelo's primary sources of inspiration. Despite an extremely convincing sense of solidity and movement, this is is not a "realistic" drawing in the sense that it represents an everyday person from the artist's time. It is instead a heroically idealized image, modeled to emulate ancient Greek or **classical** tradition. Renaissance artists including Michelangelo looked to Greek art for guidance in attaining a certain visual and ideational perfection. The Greeks made a careful study of the body from life, but always in connection with geometric principles. Some of these principles had to do with ideals of proportion and symmetry, but the Greeks also developed techniques to express movement, including **contraposto.** Contraposto means "placed in opposition" and implies the shifting of weight to one side or the other of a standing pose. The Greeks discovered that this asymmetry of weight distribution created a series of alternating angles in the skeleton as it balances itself against gravity. It also creates a sinuous curve (an *S* curve) in the centerline of the figure. The effect is to give a sense of movement or life to even the most subtle pose. As a result, after a certain point in Greek art, few figures stand with equal weight on both feet. You might think of contraposto as **dynamic balance.**

Contraposto can be almost unnoticeable, as in Lopez Garcia's standing man in **Figure 9.26**, or it can be quite extreme as in Michelangelo's twisting figure or the Greek sculptural fragment in Figure 9.25. In all these works, the fundamental issue is the figure's physical flexibility.

Line Weight and Spatial Movement

In drawing, movement can also be approached through the illusions created by different weights of linear contour. Variable line weight—changes in thickness or density of marks within one drawing—has a profound effect on spatial reading and the sense of flexible movement a drawing can show.

In comparing the drawings by Michelangelo (Figure 9.24a) and Modigliani (Figure 9.23), you see that both employ spiral curves to show the twist in the poses of the figures. While Modigliani's line is of even weight and looks very much like flat designs on the paper, the thickness and darkness of Michelangelo's line constantly varies and repeatedly overlaps itself to suggest one form in front of another. This variable **line weight** suggests that certain parts of the form are closer to the viewer than others, setting the *S* curve into an increasingly 3-D context.

Line weight works through the application of principles of tonal contrast and the illusion of spatial relationship that it creates, as shown in the diagram in **Figure 9.27a and b**. As you saw in Chapter 6, the more similar two tones are, the more they connect. The more different they are, the more they disconnect, or visually jump apart. In line drawing, the principal tonal relationship is between line and background. Strong difference from this background tone causes a line to jump forward from the background. In a drawing on a white piece of paper, blacker marks will jump forward the most as in Figure 9.27a. The same effect can work within one line, modulated by the pressure on the drawing tool, as shown in figure 9.27b. In fact, it is possible to connect this spatial effect with your own tactile force as you draw: Push to bring the form forward (emphasis) and lift (or erase) to let it fall back (de-emphasis).

When contours are paired to define a form between them, the implied form can vary in relation to the interaction of the marks. In **Figure 9.27c**, the form appears to move closer at the bottom as

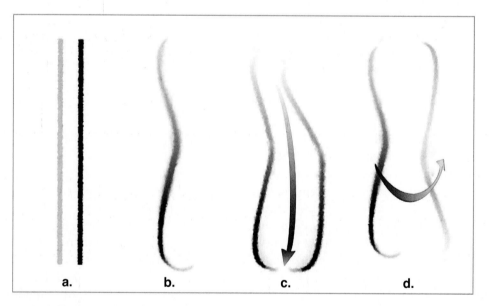

Figure 9.27 a., b., c., d. Line weight

the two contours strengthen. In **Figure 9.27d**, the form "rolls over" as the left contour pushes forward and the right one falls back.

Graham Little's drawing in **Figure 9.28** shows the energizing effect of a spiral gesture line coupled with variable marks. This elegant figure is calmly graceful, yet fused with restless energy, emerging from an environment of brilliant radiance to gaze down on the viewer. The brilliant white of the paper is brought into the tonal atmosphere of the drawing by pale marks that fade into it. For other examples of variable line, look again at the Rubens (Figure 9.22) and Schiele (Figure 9.21) drawings.

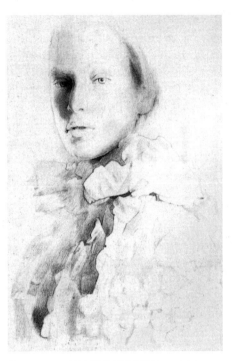

Figure 9.28 GRAHAM LITTLE, *Untitled 2001,* colored pencil on paper, 16 7/16 × 11 13/16 in.

Sketchbook Link: Experimenting with Variable Line Weight

Do ten pages of lines—curving, straight, paired contours, overlapping lines, lines enclosing shapes—in which you experiment with at least five different drawing tools, both wet and dry media. In each case, practice varying the line thickness, value, and the pressure you use to make a mark. As you draw, be sensitive to the spatial effects that result, and try to modulate them in interesting 3-D configurations.

ISSUES AND IDEAS

❒ Dynamic balance is present in the contraposto of Greek and Renaissance art.

❒ Line weight works with tonal contrast of the mark against the background tone; difference jumps forward, and similarity shrinks back.

❒ Imbalance or variability in line weight can augment the spatial flexibility of a figure in a drawing.

Suggested Exercises

9.12: Variable Line Weight: Thickness, p. 269.

9.13: Variable Line Weight: Value, p. 270.

Contemporary Artist Profile
BARRY MCGEE

Barry McGee (**Figure 9.29**) uses drawing to bridge the world of the museum and the world of the street. His drawings, paintings, and mixed-media installations take their inspiration from contemporary urban culture, incorporating elements such as empty liquor bottles, spray-paint cans, and other city detritus. He began as a graffitti artist and continues to value the popular exposure this venue affords him beyond gallery or museum. "Compelling art to me is a name carved into a tree," says McGee. His figures, exhausted, downtrodden, or dazed but drawn with a supreme elegance of variable line, suggest the human toll taken by an oppressive culture. They are the emotional opposite of Rubens (Figure 9.22) and Michelangelo (Figure 9.24a). Still, the effect of the variable contour is to flexibly relate the figure to its environment and to "turn" the form in space, giving these pathetic characters a gentle grace as in **Figure 9.30**. It is ironic that McGee's "loser" art has landed him at the forefront of the art world in shows at the Whitney Museum in New York, the Walker Art Center in Minneapolis, the San Francisco Museum of Modern Art, and the UCLA/Armand Hammer Museum in Los Angeles.

Figure 9.29 BARRY MCGEE drawings, photographs and found objects, installation at Deitch Gallery

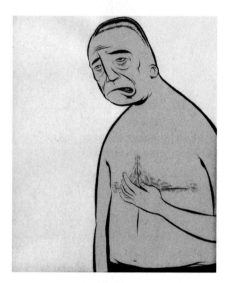

Figure 9.30 BARRY MCGEE detail of Figure 9.29

FORM AND SURFACE

Working with Tonal Contrast: Contour and Modeled Shadow

Another important technique for adding physical intensity to drawings of the figure is the use of varied tone inside the form to document the effects of light on the skin or fabric. You have already seen how Giotto used a version of this technique; later artists picked up and followed his example with variations as discussed in Chapter 6 on page 148.

The drawing in **Figure 9.31** relies principally on a gradually diverging tonal contrast between the figure and the background, which in this case is heavily darkened with charcoal. The lighter areas of the figure are found in the center of the form due to a frontal angle of lighting, and contrast most strongly with the background, pulling out from the page as a result. **Figure 9.32** features an extreme form of Giotto's side lighting. Very powerful peaks and valleys of form are identified at the shoulder blades and spine, creating deep shadows. The only danger of this approach is that the surface of "skin" within the figure is almost cut or divided by these hard black shapes. On the other hand, an advantage is the powerful abstract

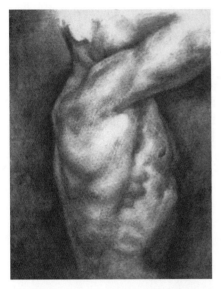

Figure 9.31 JODY CORBO-PORCO,
student work, charcoal, 24 × 18 in.

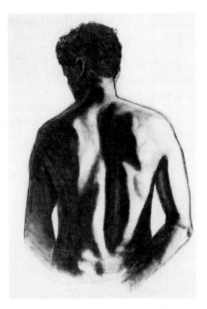

Figure 9.32 CHRISTIAN EVANS,
student work (2001), charcoal, 24 × 18 in.

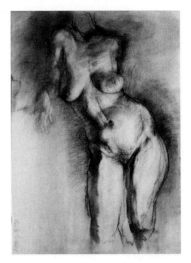

Figure 9.33 PATRICK THEAKER,
student work (2002), charcoal, 24 × 18 in.

pattern that is created, which is visually arresting and suggestive of a tough emotional tone. **Figure 9.33** interweaves both of these techniques and combines them with a fluidity based on an extreme *S* curve found in the centerline. A powerful side light creates a sinuous shadow line that runs up the left side of the figure, taking visual precedence over the contour on the right side. The individual volumes of the legs, pelvis, breasts, and shoulders are all identified as fully rounded forms but are not separated from each other. This combination of clarity and interconnection is due in part to the restrained use of tonal range compared with the previous example, this is a fairly pale drawing despite its vivid sense of light and shadow. The integrated flexibility of the figure is also structural and gestural, however, stemming from the dynamic asymmetry of the arrangement of the rib cage, spine, and pelvis as well as the repeated use of meandering snakelike lines.

ISSUES AND IDEAS

❐ Tonal variation can document the passage of light over the surface of the figure, showing roundness or cast shadows.

❐ Strong contrast at the shadow line helps to bring forward the center of the form, but overly sharp shadow edge can "cut" the sense of surface.

❐ Shapes of shadow can have their own expressive life in a drawing.

Suggested Exercise

9.14: Modeling the Figure with Light, p. 270.

Sketchbook Link: Angles of Light

Make ten quick self-portrait sketches, experimenting with different angles of light to create modeling and shadows. Vary the level of tonal contrast or intensity of shadow that you use, and experiment with different types of shadow edge, sharp to soft.

Surface and Skin

When you are drawing light on the figure, you are really drawing the effect of light on the skin. In fact, all the structural approaches discussed so far in this chapter have the ultimate visual effect of causing changes to the form of the skin. An awareness of skin (or clothing) as the actual visual surface of the figure is important, especially as it relates to surfaces in your drawings, whether drawing material or paper.

In some ways, this issue has already been addressed in previous chapters. Chapter 3 discussed mapping the surface of the form with cross-contour lines. Many artists use this approach to describe the sculptural character of the surface of the figure. The addition of opaque drawing materials such as white chalk, acrylic paint, or gouache can also play a significant role in establishing a sense of skin, as can delicate tonal progressions. The drawing by the French academic master Pierre Paul Prud'hon in **Figure 9.34** combines these techniques. Prud'hon worked with delicate white chalk cross-hatching on a blue-gray paper, carefully selected to push the chalk toward a warmer tonality through **simultaneous contrast** (see Chapter 8). Working from a model bathed in clear directional lighting, he built up a nearly opaque surface of material, subtly varying the tone to model the rounded surface of the body. The darks are actually thinnest, allowing the paper to show through and suggesting reflected light in the shadows. Strongly influenced by the French academy's nostalgic dream of ancient Greece, this figure resembles a sculpture but also seems truly alive.

The contemporary painter John Currin has **appropriated** Prud'hon's style and even his materials for the portrait of his wife Rachel pictured in **Figure 9.35**. Much debate has surrounded Currin's work, which in other examples seems to waver between a reverent technical approach to the figure

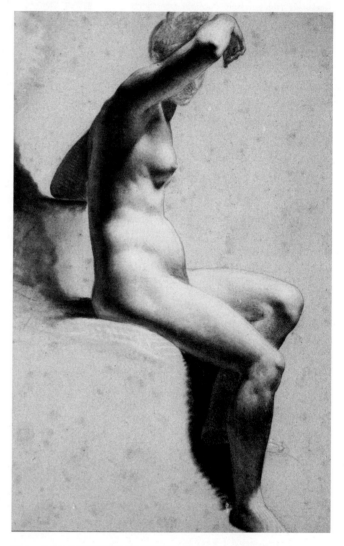

Figure 9.34 PIERRE PAUL PRUD'HON, (1758–1823), *Seated Female Nude,* c. 1810, black and white chalk, stumped, on blue paper, 22 × 15 in. (55.9 × 38.1 cm) (The Metropolitan Museum of Art, New York. Bequest of Walter C. Baker, 1971 [1972.118.226a.b] Digital Image © 2008 The Metropolitan Museum of Art)

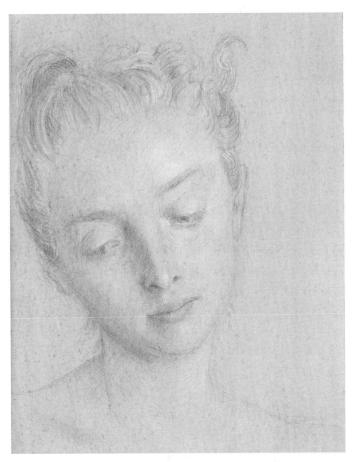

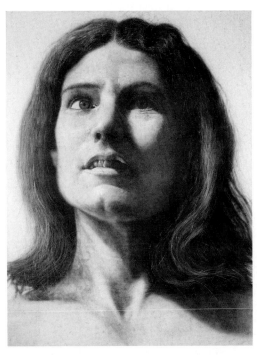

Figure 9.36 CHUCK CLOSE, (American, b. 1940) *Nancy*, 1968, Acrylic on canvas, 108 3/8 × 82 1/2 in. (Milwaukee Art Museum. Gift of Herbert H. Kohl Charities, Inc. [M1983.207] Photo by Larry Sanders © Chuck Close, courtesy of PaceWildenstein, New York)

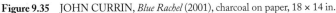

Figure 9.35 JOHN CURRIN, *Blue Rachel* (2001), charcoal on paper, 18 × 14 in.

and a kind of sarcastic irony (see pp. 342–343). In this case however, the feeling for Rachel's delicate beauty as described by his soft but sure touch with the materials seems very genuine.

> ### Sketchbook Link: The Back of Your Hand
>
> Use your own hand as a model of complex form covered with a variable skin texture. Begin by lightly sketching the "pose" of your hand, and then go to work defining the skin textures. Use hatching, rubbing, gentle shading, or cross-contour. (See Figure 3.37.) Try to see creases not as lines, but as folds in the surface. Similarly, nails should emerge from the surface of the skin, not just sit separately on top.

Two other examples of surface description are pictured here with very different approaches to texture, mark and expression. Chuck Close's *Nancy*, **Figure 9.36**, is an enormous photo-based painting from his earliest period in the 1970s. *Nancy* features a supersmooth and detailed surface in which every pore and tonal variation has been painstakingly, mechanically recorded. Interestingly, the effect is rather inhuman, and the skin seems like some horrible artificial fabric. Lucian Freud also achieved an anxiety-producing result, but with an approach springing from expressionist impulse in **Figure 9.37**. Working from life, he has exaggerated the tonal changes on the surface of the face, giving a sense of disturbed, earthy intensity and energy of mark.

ISSUES AND IDEAS:

❒ The skin is the primary visual surface of the figure, reflecting changes in structure and responding to light.

❒ Hatching, smudging, or layered use of transparent and opaque materials can build a sense of skin into the drawing's surface

❒ The character of mark used to animate the skin or surface texture can contribute to the expressive statement of the drawing.

Suggested Exercises

9.15: Figure on Toned Paper, p. 271.

9.16: Oversize Portrait Drawing on Toned Paper, p. 271.

9.17: Organic Texture, p. 271.

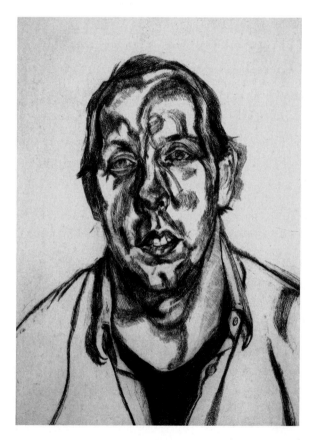

Figure 9.37 LUCIAN FREUD, *David Dawson* (1998), etching, 7 7/8 × 10 in.

THE FIGURE IN CONTEXT

We have been looking at the figure as a singular focus for our images, an object of beauty or structural interest and a vehicle for expression. At the beginning of the chapter, we touched on the origins of figurative art in narrative, and in the role of the figure as a sign of human presence in the world and human experience. We will return to those concerns now, with particular interest in placing the figure in context: the context of other figures; the context of the physical world we inhabit; the context of graphic composition; and the context of narrative storyline. This might seem like a sizable new undertaking, but the techniques for making a successful composition involving a figure or figures are almost always closely related to those which apply to single figures. The effects, however, are often dramatically distinct and open broad new territory for us as artists.

Group Gesture

One of the principles discussed earlier in this chapter and in Chapter 3 (Exercise 3.3) was the concept of gesture line, the use of linear force to suggest movement or life in the representation of a human figure. This same technique, combined with associated principles such as line variation, spiral organization, and dynamic balance, can give unity and force to groups of figures. These qualities can be practiced by observing models in group poses, although this is usually impractical outside a specialized setup in the classroom. From a practical standpoint it is more important to understand how these factors can be used artificially to link and manipulate the sense of movement or energy of figures in a group composition.

Michelangelo, a supreme artist of the spiral gesture in the figure (as seen in Figure 9.24a), used this same principle to organize what is possibly the world's largest group gesture painting, *The Last Judgment*. Christ's pose at the top of this image is a basic spiral gesture, and, as you can see in a study for the composition in **Figure 9.38**, the masses of tumbling or surging figures that surround him react to his power in twisting pools and eddies. In effect, the entire group is a unified body, responding to the cataclysmic spiritual energy that is the subject of the painting.

Luis Caballero projected a similar vision of writhing bodies, but without the specific biblical reference in **Figure 9.39**. In fact, the struggle this group is engaged in seems more innately carnal or violent. Still, the essential approach is the same: Linear rhythms bind the group visually and suggest interactive motion. Alternating areas of light and shadow create a dizzying strobe-like effect while interweaving the figures spacially.

Sketchbook Link: Analyzing Group Compositions

Find reproductions in the library of group figure compositions, especially those featuring strong movement. Make quick gestural analyses of each composition, trying to simplify it into one gesture line or a number of gestures. Include a role for line weight variation to animate the group spatially.

Figures and Space

The inclusion of background elements or strong effects of space or light can have a profound impact on the sense of narrative context of a single figure or group. Architectural elements can place the figure in a specific world, often with the implication of a sequence of events. Clara Lieu's self-portrait in **Figure 9.40** was done with a mirror placed on the floor of a closet, which had the

ISSUES AND IDEAS

❑ Principles derived from drawing the single figure, such as the gesture line and contour variation, can unify groups of figures.

❑ A group of figures unified by a gesture line has a shared energy and movement associated with that line.

Suggested Exercises

9.18: Gesture Studies of Posing Model Group, p. 272.

9.19: Invented Gesture Composition, p. 272.

Figure 9.38 MICHELANGEO, study for *The Last Judgement* (1534), black chalk, 16 1/2 × 11 3/8 in.

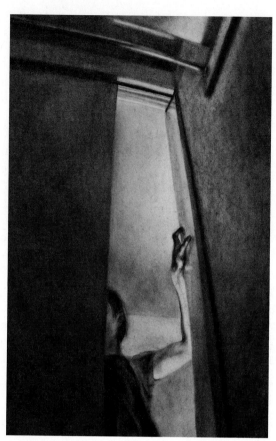

Figure 9.40 CLARA LIEU, student work (1997), charcoal, 24 × 40 in.

Figure 9.39 LUIS CABALLERO, *Untitled* (1990), mixed media, 38 × 28 in. (Courtesy Remy Toledo Gallery)

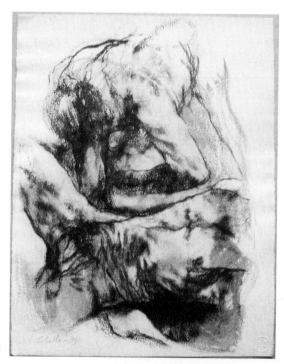

ISSUES AND IDEAS

❒ Context for the figure can be provided by light, background elements, or a strong point of view.

❒ Even minor inclusion of these elements can dramatically alter a drawing's implied meaning.

Suggested Exercises

9.20: Figure and Furniture, p. 273.
9.21: Moving Figures, p. 273.

Sketchbook Link: Situations

Sketch figures in an architectural context at school, on a bus, or in town. In each sketch, carefully note each figure's relationship to the immediate physical environment and include at least one object (a window, a table, ceiling, etc.) in your drawing. Pay special attention to the scale of the figure and the environment.

effect of tilting the point of view dramatically upward. She increased the mystery of the situation by drawing the closet door over her own face, giving a sense of unseen narrative activity. Clearly, there is a very important psychological role in this composition for the viewer, who is in an extremely low position established by linear perspective in a dark, claustrophobic space.

"Real-Life" Drawing

One of the most compelling ideas for figure drawing, but often problematic in practice, is to move beyond the studio, capturing human life as it is lived each day. The problem is that the world does not hold still, and the moment that a pose is taken and held, some of the sense of realness dissipates. Many artists have approached this problem with a variety of strategies. David Hockney, a British artist who spent much of his time during the 1960s and 1970s traveling in Europe and America, produced a group of informally posed, but wonderfully elegant portraits of his friends such as **Figure 9.41**. Hockney's playful use of color (see Figure 8.21) and simple (but exceedingly deft) line give a lightness and humorous conversationality to these images, as though they occurred offhandedly in the midst of a leisurely afternoon.

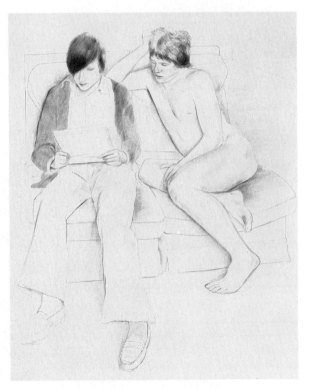

Figure 9.41 DAVID HOCKNEY, *Yves-Marie and Mark, Paris, October, 1975*, Red Conte Crayon, 25 1/2 × 18 5/8 in.

Edgar Degas was another master of the quick, accurate sketch, but he was also a scientist of composition, using structures derived from photography to create artificial scenes that feel as though he sketched them on the spot, in public, unobserved. Many of his original figure sketches are in fact from posed models, but even at this early stage in the studio, he knew how to give the feeling of a quickly glimpsed moment.

The ballet dancer pictured in **Figure 9.42** is seemingly caught in the middle of tying her shoe, but in fact this is a carefully contrived pose. The gesture is conceived as a piece of frozen movement, bending down and looking away from the viewer, that gives a kind of narrative neutrality to the pose. Using this sketch in a larger picture in **Figure 9.43**, Degas sets the pose off center, partially hidden by jumbled foreground activity. An odd use of focus, or lack of focus, also shifts the viewer's attention, concealing the artist's original interest in the dancer. The result is something that feels very much like the haphazard manner in which elements and events can move past our eyes and consciousness in real life.

Ed Bray conceived the series depicted in **Figure 9.44** and **Figure 9.45** based on the lives of his high school friends, with an acute personal awareness of some of the struggles they encountered. A gifted portraitist, he sketched them on the spot at their workplaces or in the living room, later reconstructing particular narrative scenes keyed to the detail of their individual stories. Bray's use of spatial context is excellent and very natural. One of his friends who spent time in jail is depicted next to a chain-link fence in dramatic perspective, emphasizing the overwhelming reality of his confinement. Another friend, oppressed by the lack of opportunities in their small town, is shown walking in front of the gas station where he works. The emptiness of the place and the dead tree against the sky help tell the story just as much as his downcast attitude does.

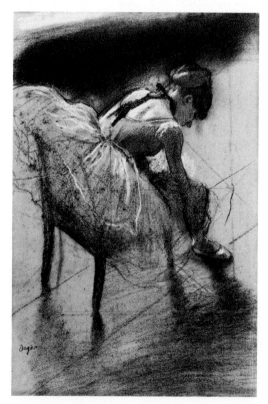

Figure 9.42 EDGAR DEGAS, *Dancer Fixing Her Shoe* (c. 1885), charcoal and pastel on paper

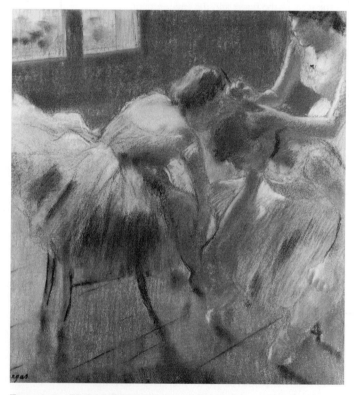

Figure 9.43 EDGAR DEGAS (1834–1917), *Three Dancers Preparing for Class* (after 1878), pastel on buff-colored wove paper, 21 1/2 × 20 1/2 in. (54.6 × 52.1 cm) (The Metropolitan Musuem of Art, H. O. Havemeyer Collection, Bequest of Mrs. H. O. Havemeyer, 1929 [29.100.558] Digital Image © 2008 The Metropolitan Museum of Art, New York)

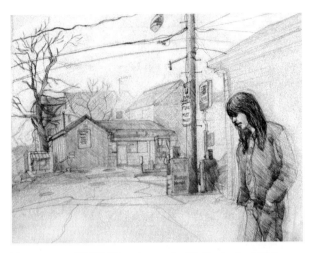

Figure 9.44 ED BRAY, student work, *The Gas Station* (1996), pencil, 20 × 24 in.

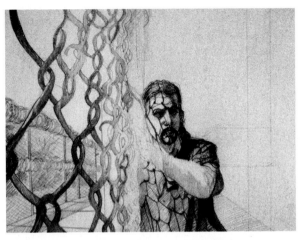

Figure 9.45 ED BRAY, student work, *Inside* (1996), 20 × 24 in.

Sketchbook Link: Combined Figures

From the previous sketchbook link, select three sketches of people in a specific environment. Try to combine the sketches into one drawing that feels like a caught moment of life in that setting. The figures can be acting together or independently, but the overall scene should feel "real." Try three different configurations, each involving a different kind of grouping and a different role for empty space.

ISSUES AND IDEAS

❑ Drawings that convey a feeling of "real life" are often artificially constructed.

❑ Off-center composition, choices of media and touch, and purposefully casual or informal poses can help suggest a "slice of life."

❑ Conceiving a figurative composition in relation to specific environment can give a figure a feeling of connection with a particular situation.

Suggested Exercise

9.22: Slice of (Your) Life, p. 274.

Exercise 9.1 Narrate a Story in a Sequence of Four Panels

Your emphasis in planning and executing this assignment should be on the clarity of narrative and the simplicity of form through the technique of silhouette. Stylistic character of mark and line should reinforce the narrative in terms of motion or emotion. You may use cut paper or filled-in outlines with black pencil or ink and brush. Your silhouettes can be invented or traced from photo sources (these can be effectively sized with a photocopier set to reduce or enlarge). Whatever your technical approach, you must be particularly careful about legibility: The outline of your figure must convey enough information to suggest who or what a given figure or object is and what he or she is doing. Avoid extraneous or confusing details. The goal of each form and each frame is clarity. The story line of all four frames may be discontinuous, jumping from one scene to another but should make sequential sense in framing a chain of events.

Exercise 9.2 Solidity of Form: Stones as Figures

These two exercises involve the use of solid objects—rounded stones—as simplified stand-ins for human figures. Although they lack the full complexity of the human body, rounded stones will respond to the effects of gravity and directional light in a way that allows you to practice giving "objecthood"— volume, weight, and depth—to the forms in your drawings. Part II explores spatial arrangement of volumetric objects on a receding ground plane, with possibilities for overlap and varied grouping to suggest a human gathering.

Part I

Set up a smooth stone with a fairly even shape near a window or other light source so that the light falls onto the stone from the side. With a 2B pencil, outline the outside contour of the stone, taking care that your line evokes the form's roundness, areas of concavity, and other complexities. When you have finished your linear treatment, it should have a good sense of the stone's volume and weight, even though it has been simplified to its contour. Now work into the drawing to gently describe the play of light and shadow over the stone's surface. In particular, look for the line of shadow that runs across the front of the stone where the light stops hitting it and the shadow area begins. Try to be as accurate as possible about this shape and the way it follows the surface of the stone. You can darken the lighter side of the stone to show its color, but be careful that this color does not compete with the shadow effect that should be darker.

Part II

Arrange four or five smooth stones of somewhat similar shape and size on a tabletop or shelf, lighted from the side as in Part I, as in see **Figure 9.46**. Arrange the furniture so that the level of your view of the scene is five to six inches above the surface of the table; this may mean that you have to sit on a low stool or raise the table. The rocks should be at different distances from your eyes with some areas of overlap. Move them around until they form an interesting arrangement in depth suggesting a group of people. Then draw the group according to the procedure described in Part I. You may show the shadow shapes that the stones cast on the tabletop to help unify the scene. As you draw, try to imagine what it feels like to be a stone: cool, heavy, smooth, unmoving, pressing down on the surface of the table while the light slips across the undulations of your surface, creating pools of shadow in depth.

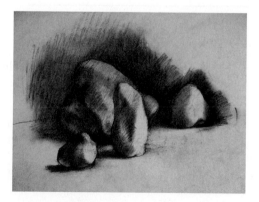

Figure 9.46 Rock Group

Exercise 9.3 Composition with Clay Figures

Make a sculptural model of figures or animals in clay in a simple scene on a ground plane. There may be hills, houses, or other background elements, but they should be simplified and in a scale that makes them easier to fit into a composition with the figures. The figures do not need to be detailed but should be smoothed out so that it is easier to observe and record the passage of light across their surfaces. Light the scene from the side so that a gentle light reveals the roundness of the forms. Avoid harsh cast shadows; concentrate instead on showing the sculptural character of your arrangement. Experiment with the grouping to suggest an interaction of some figures and a distancing of others. You can attach a simple story to the scene if that makes it more meaningful. Draw the scene from a low eye level as in Exercise 9.2, Part II, but this time use charcoal on **gessoed** paper. (See Appendix A for a description of this technique.) Work into the tones with an eraser and **chamois** so that the claylike character of the surface evokes the surface of the forms.

Exercise 9.4 Solid Self-Portrait

Draw a large-scale (30 by 40 inch) self-portrait, full figure, wearing simple clothing such as shorts and a T-shirt. The pose may be seated or standing, but in either case, show the ground plane or floor and the contact of the figure with the seat. Simplify the masses of the figure into cylindrical or ovoid forms, using elliptical contours (see Chapter 3). The figure need not be anatomically detailed but should have a solid and sculptural feeling. Model the form using light coming from the side. You may use gessoed paper as in the previous exercise or raw paper, but in either case, begin with vine charcoal to block in the shadows and work over these tones using soft compressed charcoal when you are sure of the shape of the shadow forms. Be careful not to make the shadows too hard-edged or black, or they will start to interfere with the coherence or "skin" of the form. Be careful to show the places where the figure hits the ground, such as the feet and pelvis if the figure is seated. You might experiment with poses that suggest the force of weight, like a hand planted on a knee or an arm resting on a table. Finally, darken the background slightly to set off the lights in the figure as in **Figure 9.47**.

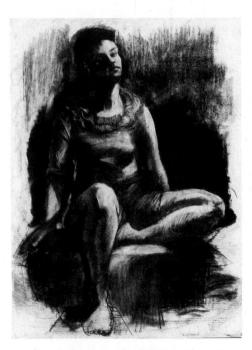

Figure 9.47 NANCY DIAMOND, student work (1983), charcoal, 36 × 26 in.

Exercise 9.5 Head Gesture

Do eight self-portraits using the axes of bilateral division to orient the head (see Appendix C, Figures AC.8 and AC.9). Each drawing should be a particular "gesture" of your face, head, and neck as in **Figure 9.48**. You may use a light source to model the form as in the previous exercises, but concentrate on form rather than strong cast shadows. No two poses should be alike. If a pose is subtle, make sure your definition of the axes is precise so that the exact position of the head is clear. If

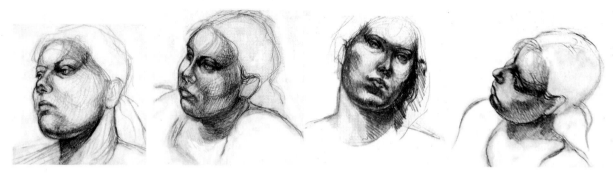

Figure 9.48 LINDA WINGERTER, student work, (1995), pencil, 12 × 12 in.

the pose is more dramatic, turning strongly away, or tilting backward or forward, make sure that you emphasize the differences in proportion from left to right or top to bottom. As the head turns, the farther side will always be diminished in scale and will move gradually behind the closer side. You may add emotion or drama to the poses by your facial expression, but this is not necessary. The real point is to project the over-all form of the head convincingly in 3-D space. You may find it helpful to impose a bilateral grid artificially, either at the beginning of the drawing or at some point during the process of working from life (see Figure 9.13b). You may do several heads on one page, but do not cramp the composition. They should be roughly life size. Utilize the neck or shoulders to help orient the position of the head.

Exercise 9.6 Skull in the Head

Select one of the sketches from Exercise 9.5 that you think is particularly successful in terms of an interesting and coherent orientation of the form of the head. Position a human skull (or a model of one in plastic or plaster) in the position indicated by the sketch. Light the skull clearly from a single direction, corresponding roughly with the direction of light in the sketch. Adjust the light to reveal the form clearly, emphasizing the cheekbone, bridge of the nose, jaw, forehead and so on, as in **Figure 9.49**. Draw the skull at the same scale as in the head sketch, copying the bilateral grid from the sketch and making sure the skull conforms to it. Rough out the form using linear contour but vary your line weight in relation to the 3-D protrusion or recession of the form. Using hatching or other modeling, map the play of light across the bone, adjusting contrast to emphasize the form's roundness or solid geometry. When your skull is complete, start a new drawing based on the sketch, referring to your drawing of the skull to emphasize bony structures within the face and head, as well as the impact of the light source on the forms. You may return to

working from life when the drawing is fairly far along, but try to retain both the clarity of gesture from the sketch and the strong sense of form contained in the skull drawing.

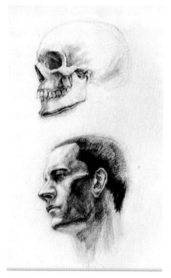

Figure 9.49 JOSH TALLMAN, student work (2001), pencil, 18 × 12 in.

Exercise 9.7 Foreshortening

Do a working sketch of an imaginary figure constructed out of simple elliptical or planar solids. The figure should be facing the viewer and clearly articulated into segments that correspond to the components of the skeleton: the forehead, cheekbones, upper and lower lips, neck, rib cage with pectoral muscles or breasts, abdomen, pelvis, thighs, knees, shins, and feet. The arms should be outstretched to the side and consist of shoulders, upper arms, forearms, hands, and three-jointed fingers. (See Appendix C, Figures AC.1–AC.6)

Now do a second, life-size drawing. (Your paper should be approximately 40 by 30 inches.) Draw the figure lying back on a couch with the feet up on a table. You can accomplish this by "building" the figure from the blocks you mapped out in your first drawing but rotating them to correspond with the new pose. If you have trouble visualizing the orientation of the various parts of the figure, study yourself in a mirror placed at a low-angle point of view corresponding with the viewpoint you wish to have in your large drawing. Take special care to put closer segments firmly in front of those behind, partially obscuring them if necessary. Remember that each segment, viewed down its length, will diminish in the dimension that recedes into depth (see Figure 9.17b).

Exercise 9.8 Monumental Body

The ancient world was apparently filled with huge figurative statues expressing the might of various rulers. Most have now crumbled, and the statue of Emperor Constantine, for example, which towered over Rome, can be judged only by the remaining fragments, including a four-foot finger.

For this assignment, build a drawing of a large figure out of geometric solids, working with an angle of extreme foreshortening, as in Exercise 9.7. When you have clarified the structure and are satisfied with the figure's overall effect and coherence, position a mirror so that it reflects you at the same angle in the drawing. Arrange the light source to reveal the form in a powerful manner as in see **Figure 9.50**. The figure should wear simple, form-fitting clothing, showing as much of the body as possible and accentuating the divisions of the form mentioned in Exercise 9.7. Build the light and shadow, clothing, and anatomical details into the structure of geometric solids. Develop the form and light with a medium that allows layering and a rich tonal range (see Appendix A).

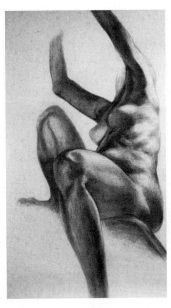

Figure 9.50 CLARA LIEU, student work (1999), charcoal, 32 × 26 in.

Exercise 9.9 Centerline Gestures

From a posing model, execute 50 quick sketches concentrating on defining the volumes of the rib cage and skeleton and showing them in a flexible relation to each other, as in **Figure 9.51**. The model should be instructed to take poses that bend, twist, or lean. Use the centerline to orient the torso's sternum, abdominal line in the front, and spine in the back. Take

Figure 9.51
CHRISTINA
LIVESEY, student
work (1997), charcoal,
18 × 14 in.

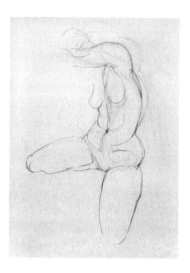

special care in looking for this line to "feel" the nature of its curve. Drawing the centerline accurately and with feeling is probably the single most important thing you can do to ensure fluidity in your figure. Also pay special attention to the torso's bilateral symmetry. The "far side" of the pose in a twisting figure should be drawn smaller—or foreshortened—and hidden behind the closer side. Pay special attention to the horizontal axes formed by the clavicle and the points of the pelvis in the front and the axes of the shoulder blades and sacrum from the back. (See Figures AC.1 and AC.2.) The upper axes can be a little confusing because they change with unusual movement of the arms, but try to understand this variation. Walk around to look at the model from a different point of view if you have to.

Exercise 9.10 Drawing the Skeleton in the Pose of the Figure.

From Exercise 9.9, select a drawing of the model in which you feel you successfully captured the pose and identified the major forms of the skeleton (rib cage, spine, pelvis). Working from a model of the skeleton, make a new drawing in which the skeleton assumes the pose represented in your drawing of

the model. The goal is not so much to show every detail of the skeleton but to evoke its basic form in 3D projection and to bring it to life, fully realizing the energy and sense of weight in the model's pose as in **Figure 9.52** and **Figure 9.53**

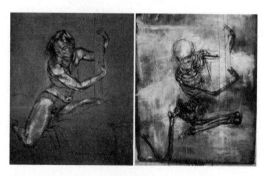

Figure 9.52 ANGEL STEGER, student work (2000), charcoal and conte, 2 sheets, 32 × 26 in.

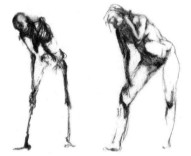

Figure 9.53 MATT BELL, student work (1988), conte, 2 sheets 18 × 24 in.

Exercise 9.11 S Curve Gesture

For this exercise, return to the posing model but with a slightly different priority. While you should still be conscious of the figure's centerline, look primarily for abstract movement expressed by lines. This is a reprise of Exercise 3.3 and involves

similar techniques: "feeling the pose" by momentarily taking it as you prepare to draw, looking for lines of force suggested by the figure's contours. Next establish the volumes of the rib cage and pelvis. Again, you might refer to Chapter 3 and the

use of elliptical contours to define solid form as in Exercise 3.7. Always try to find some evidence of the ovoid form of the rib cage and the bowl-like pelvis in the contours of the figure and express them in your drawing with convex elliptical lines. Look for evidence of an *S* curve formed by the centerline, on its own or in conjunction with the contours of the figure. This *S* curve should express the nature of the gesture as well as the inherent flexibility in the body, as in **Figure 9.54**.

Do as many of these drawings as time allows, spending seven minutes on each. Ask the model to experiment with different types of bending and twisting poses, alternately showing the front, back, or sides of the body to your view.

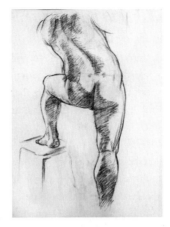

Figure 9.54 TIM WILSON, student work (2007), charcoal, 24 × 18 in.

Exercise 9.12 *Variable Line Weight: Thickness*

It is sometimes very hard to put all aspects of figure drawing together at once, and it makes good sense to consider various components individually. Variable line weight can be practiced independently of a human body to describe spatially fluid form without reference to specific anatomy.

For this exercise, use a watercolor brush and India ink. You may dilute the ink slightly if the full strength seems too powerful, but the point here is to vary line weight through thickness of stroke, which you will achieve by varying pressure rather than tonal change. You can work from a source (model, self-portrait, or still life) or use invented forms as Sue Williams did in **Figure 9.55**. However, always be clear, as you prepare to make your line, whether the form as defined by the contour should be pulling forward in space or falling back. To make it come forward, start thin and gradually apply more pressure. Start thick (close) and thin out the line to make it move away from you. Remember that rounded forms are always in a state of spatial transition, moving back into space or out to a closest point. The more subtle the change in your line variation, the more subtle the implied spatial change will be.

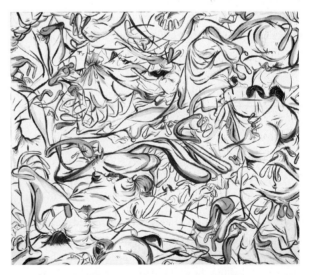

Figure 9.55 SUE WILLIAMS, *Three in Blue* (1997), oil and acrylic on canvas, 15 × 18 in.

Exercise 9.13 Variable Line Weight: Value

For this exercise, return to the posing model and use soft charcoal and a large pad. The goal here is to put together a number of the aspects of drawing the figure that have been discussed: geometric analysis of form, skeletal flexibility, and variable line weight.

The model should take spatially active poses, twisting into space, bending, or thrusting. As in Exercise 9.11, identify the simple forms of the skeleton, rib cage, and pelvis linked by the spine. Again, be careful to look for curvature in the spine and asymmetry in the outside contours. Be sure to compare the bilateral symmetry of the two sides of the figure and diminish the farther side in size. As you study the figure on these levels, keep the charcoal stick very loose in your hand, resting gently on the page. This will enable you to make very faint lines—planning lines—that are easy to erase or work over. You should have an ongoing priority for fluidity of line, identifying ellipses and S curves in particular. When you have roughly mapped out the forms of the figure in this way, lightly go over the contours but gradually increase the pressure on those parts of the form that pull forward out of the pose. Usually these areas are closer to your eye than other parts, but sometimes they can be a part that, if it were to continue its implied movement in the gesture, would move toward your viewpoint, as in **Figure 9.56**. Contours that are describing the edge of the form farthest away should be made with a faint line, whether erased, smudged, or drawn very thinly. After a while,

you can rely on "expressive pressure" to adjust the spatial positioning of the forms. Push for protrusive emphasis and lighten up for recessive de-emphasis.

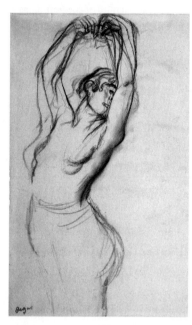

Figure 9.56 EDGAR DEGAS, *Nude Dancer with Upraised Arms* (1890), black chalk, Den Kongelige Kobberstiksammling

Exercise 9.14 Modeling the Figure with Light

For this assignment, plan and execute an extended drawing of a human figure using a clear lighting strategy to help describe the roundness and spatial position of the forms of the body. If you use side lighting, be a bit careful of cast shadow shapes; they may be included for pictorial drama, but they should not interfere with or "cut" the continuity of the form's surface or "skin." Begin your drawing with a clear indication of the skeletal structure, making sure that the basic forms of rib cage, pelvis, and centerline or spine are in a dynamic relationship to

each other. Identify and express elliptical contours and S curves. As you approach the interior of the forms and the effects of light, block in shadows in large areas with a broad material such as charcoal, chalk, or sepia conte crayon (see Appendix A). Pay special attention to those shadow edges that identify the leading edge or closest part of the rounded form of torso, legs, or arms. These are the areas where the tonal contrast should be emphasized to create a 3D effect. For further discussion of these issues, review Chapter 6, pages 147–151.

Exercise 9.15 Figure on Toned Paper

On colored or toned paper, make a drawing of the figure in
black and white chalk. The paper tone that you select should
be in a middle value range, not too dark or light and some-
what muted in hue. Using black chalk or compressed stick
charcoal (see Appendix A on materials), lightly sketch the
contours of the figure, using variable line weight to suggest re-
ceding or advancing parts of the form as in Exercises 9.12 and
9.13. Do not go too far in modeling the form with shadow.
Instead, begin to use the white chalk (or conte crayon) to de-
fine the areas of strong light on the figure. For middle tones,
you can let the paper color do the job or blend the black and
white chalk, but be careful! The mixed chalk color can make
an excessively cold tone (especially if you are working on
warm tone paper). It takes practice to anticipate the different
hues you will create with transparent grays and opaque grays.
You may proceed to build up an opaque surface, but it may be
more satisfying (and quicker) to leave the drawing in a semi-
transparent state, as Joon Song did in **Figure 9.57**.

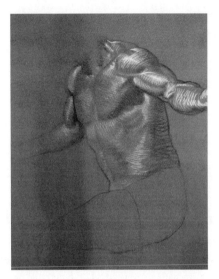

Figure 9.57 JOON SONG, student work
(1998), conte crayon, 34 × 28 in.

Exercise 9.16 Oversize Portrait Drawing on Toned Paper

On brown butcher paper, or another large sheet of middle
value colored paper, do an oversize self-portrait (at least 36
inches square) using cross-hatching or other means to build
up surface tones. You might refer to the head gesture exercises
earlier in this chapter for interesting "poses" of the head, but it
is also possible to start fresh. You can also draw other parts of
the body if that is your interest. The point here is to sensi-
tively record the changes of light and texture of the face,
building a rich skin of material. Layering paint and various
colors may help you get in touch with the surface; paper or
other materials can be collaged onto the original surface with
paste and drawn over. (See Appendix A.)

Exercise 9.17 Organic Texture

For this assignment, you will plan and execute a collection of
drawn surface textures representing variations on the idea of
human skin or tissue. The variations may be based on change
in light or scale, differences of skin due to age, race, or area of
the body, or result from the use of different media. The goal is
to create an interesting comparison of textures while making
each adhere to the concept or feeling of human tactile sensi-
tivity. You may draw from life, use photo reference, or invent
the textures. A grid arrangement of some kind will probably
be appropriate, but the overall pattern should facilitate com-
parison and appreciation of differences in the textures. Matt
Westervelt chose an evenly spaced grouping of disks in
Figure 9.58 to present his textural explorations, which are
based on human tissues from inside the body and rendered in
a delicate pen and ink technique. The circularity of the shapes
permits a spatial reading of each disk as a sphere of material
but also refers to the field of view of a microscope, or the
shape of a petri dish from a scientific laboratory, giving a

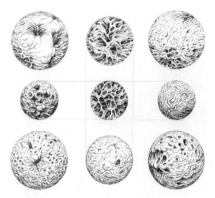

medical undertone to the piece. His tonal variations are exquisite despite the uniform blackness of the pen lines and give a spongy realism to each "tissue ball."

Figure 9.58 MATT WEST-ERVELT, student work (2000), pen, 24 × 24 in.

Exercise 9.18 Gesture Studies of Posing Model Group

Two or more models should be instructed to pose together, taking positions with a strong sense of directional or spiral gesture. Each model should be aware of the other's poses and should try to complement or play off them. After a while, good models will be able to interact creatively, and their movements can be almost like a frozen dance. As you draw, try to look for structures that take the viewer's eye from one figure to another. These might include linear connections or abstract shapes that link or suggest complementary forces, as in **Figure 9.59**. Another important factor is tonal color, and, if the group is well lighted, you can use areas of shadow or light or patterns of dark mark to bring the eye around the group and the composition as it fills the page. Empty areas can also play an important role in the general sense of movement, giving a place for the figures to enter, a place from which they have come, or an effect of distance or rest from the action.

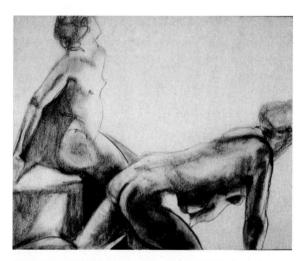

Figure 9.59 GWEN CORY, student work (1985), charcoal, 18 × 24 in.

Exercise 9.19 Invented Gesture Composition

Part I

Using drawings from your class sketchbook, weave three or more figure poses into a coherent, dynamic group on a large new sheet of paper. The easiest way to get started is to find poses that have a strong, but simple, graphic character such as powerful gesture lines or strong shapes of light and shadow as in **Figure 9.60**. These graphic forms can then be linked or played off the forms in other poses. You can also alter the drawings as you copy them into your new composition, emphasizing new lines of force or imposing areas of tonal color where they make sense in your composition. Varying line weight, scale, and contrast level with those of the background will also help establish a connection of the figures with the overall situation. It is not necessary to crowd the page with bodies; try to find a role for empty space or blank graphic interval, whether light or dark.

Part II

In a second drawing, combine a group of poses from your sketchbook with a new pose that you can control more exactly, such as a self-portrait or a sketch from another source. The new pose can play off the existing group in a more consciously narrative way or be just a graphic or a sculptural complement.

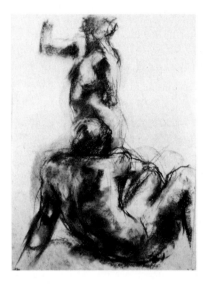

Figure 9.60 LINDA WINGERTER, student work (1995), charcoal, 24 × 18 in.

Exercise 9.20 Figure and Furniture

Pose a figure on or next to a table. Position yourself carefully so that your point of view of the situation sets up an interesting relationship between the figure and the space of the room as in **Figure 9.61**. Take care as you draw the table, to express your point of view through perspective (see Exercise 5.5) and dynamic placement within the rectangle of the page. When drawing the figure, make sure that your treatment of the bilateral symmetry of the figure and the connection of the body with the furniture completes the idea of a coherent, powerful point of view. Finally, use tonal color and depiction of cast shadows (see Exercise 7.2) to project a feeling of specific light source into the scene.

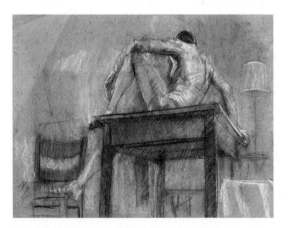

Figure 9.61 DOUG OLSON, student work (2001), nupastel, 22 × 24 in.

Exercise 9.21 Moving Figures

Have a model walk around the studio, with some basic furniture in a casual arrangement. Let the model get comfortable with the space and then take a pose somewhere as though in the midst of moving from one part of the space to another. Sketch this pose, connecting the figure with an article of furniture or an interval of empty space within the studio. If there is a particular aspect to the light situation, include this in your sketch even if it takes away from the emphasis on the figure, as in **Figure 9.62**, by backlighting. The model should then take a second pose with the same priorities in a different part of the studio. Sketch this pose also, including information about the context of the scene. Follow the same procedure

with a third pose. Now examine your drawings, and try to make a composite image utilizing two of the poses. Try to keep an important role for empty space or other aspects of the room situation. Do not place the figures in an excessively balanced or symmetrical relationship to each other; one figure can overlap or partially obscure the others. The model should cycle through the three poses for the rest of the session, giving you an opportunity to work into the drawing, developing qualities of light, form, and space. If the model is in a pose that you have not included in your composition, work on the studio environment, making it a strong part of your image.

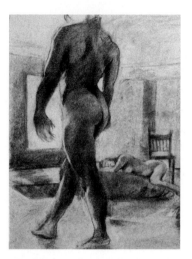

Figure 9.62 LINDA WINGERTER, student work (1995), charcoal, 24 × 18 in.

Exercise 9.22 Slice of (Your) Life

This is an extended assignment involving some "research sketching" and the construction of a series of compositions. It might be a possible blueprint for a large project such as those outlined in Part 4 of this book.

Choose a subject from your daily life or personal history. It should be a subject that you can reconstruct for the purposes of a drawing study, such as a place you can work in or revisit or people who will pose for you (at least for photographs) or for whom you can find stand-ins. Plan and execute a series of drawings to show the character of this scene or scenes. You might concentrate on the personalities involved, the sense of movement or action, or the feeling of the place and time. In any case, your compositions should include a role for both figures and background elements.

In **Figure 9.63**, Gamal Wilson did a series of studies of his college roommates while they were studying and sleeping. In part, this subject suggested itself naturally: The models were easily available and would pose for long periods without mov-

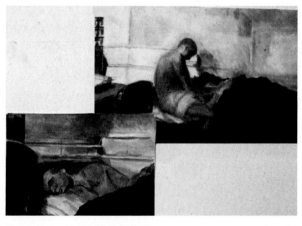

Figure 9.63 GAMAL WILSON, multipanel, student work (2002), mixed media, various sizes

ing. On the other hand, it is a perfect subject to express one aspect of the reality of Gamal's life as a student, and he approached it very matter of factly, giving a quiet sadness to the mundane activities.

────── **Critique Tips** Chapter 9: The Living Figure ──────────

During critiques for the assignments in this chapter, look at your own and your classmates' drawings for qualities based on these suggested topics below. You might also want to review the vocabulary in the Using Specialized Vocabulary section in Chapter 1.

How is energy or character shown in the drawing of the figure? *Is there a sense of gesture conveyed through line? Does the line quality or sense of form contribute to a particular feeling conveyed by the figure in the drawing?*

Does a sense of solidity play an important role in the drawing? *Is the basic skeletal structure apparent under the skin or clothing? Is there a sense of volume?*

Is the flexibility of the human body apparent in the drawing? *Is the spine flexible? Does the configuration of the upper and lower halves of the torso reflect this?*

Is there a role for foreshortening? *Is the body tipped into space? Is one side closer to the viewer than the other? Is this reflected in the proportions and overlap in the drawing?*

Is there a role for light in the drawing? *How are the surfaces of the form defined? Is there a sense of skin?*

How does line show volume? *Is there a role for elliptical volumes in the definition of the body? Is there variation of line weight in a way that adds to the figure's three dimensionality?*

In a group of figures, is there a sense of integrated movement or counterbalanced gesture?

If the figure is shown in a situation, how does the figure play off the space around it to suggest movement, psychological state, or narrative? *Does the movement of the eye through the composition have a connection with a narrative or the passage of time? Is the overall composition used effectively to make an expressive point?*

──────────────────────────────

Composition and Expression 10

FIELD AND SHAPE

Visual Emphasis and Unity

There is an old saying that "every picture tells a story." This is certainly true of drawings. Beyond any narrative subject matter that might be included, a drawing is a record of the artist's ideas and feelings. Through the visual force of mark, form, and value as well as references to such real-world phenomena as light and space, a drawing can suggest intricacies of meaning and sensation to a viewer quickly and powerfully, or slowly, in contemplation.

The organization of this experience by the artist is called **composition.** People usually think of composers as people who arrange music, but every art form has principles of composition. The elements of the art form are arranged in relation to each other to effect qualities of harmony or opposition, fast or slow movement, strength or gentleness, and so on. Think of the opening bars of a piece of music that is familiar to you; most likely they set a certain tone that is sustained and developed throughout the piece.

Drawing does not generally work with time in the same way that music does, but it can have a strong aspect of sequence. There might be a powerful emphasis in a drawing that is meant to be noticed immediately, with subtler details or layers coming to attention gradually, or a spatial passage or movement of form through a drawing could be emphasized through pattern or gesture.

In all cases, **visual emphasis** defines the character of a composition in drawing. An effective composition emphasizes the expressive or conceptual point of a drawing through organization of its visual components. That is, the structure of a good composition clarifies the meaning or feeling of the drawing. Jake Berthots' meditative studies of trees in the landscape thrive on a simplicity of approach and a sensitivity to both 3D space and graphic arrangement. By subtly changing the field's format and the placement of the tree in **Figures 10.1 a & b,** he is able to alter not only the sense of the tree's location, but also the viewer's placement in relation to the scene. Berthot's mark slips into a soft fog, and then returns to sharp clarity at given moments, allowing him to orchestrate the experience of form and space in the drawings with a fluid freedom, feeling his way through atmosphere and object, as though traversing a passage of woods.

The principles of composition derive from the experience of everyday vision reinterpreted through the vocabulary of drawing. Making a connection between the visual events and relationships that can be a part of a drawing—gesture, form, associative shape, space, value, rhythm, and so on—and aspects of your life experience is the key to making meaningful decisions in your compositions. Ultimately, the goal is to have the accumulated decisions you make in a given drawing work together to make the point of the piece. More than any other aspect of drawing, composition means pulling back from the work, seeing it as a whole, and reading or feeling the way everything works together.

Like the editing process of a film, the composition of a drawing brings the threads and details of the image together in a way that asserts an idea, mood, or meaning. **Unity** is an excellent guiding principle for effective composition; it refers to the

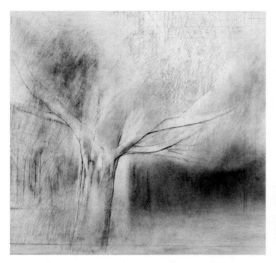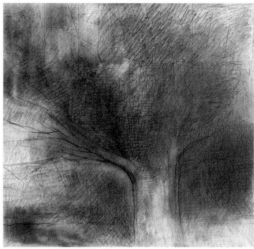

Figure 10.1 JAKE BERTHOT **a.** *Untitled* (2004), graphite on paper, 21 3/8 × 27 in.; **b.** *Untitled* (2005), graphite on paper, 16 7/8 × 17 7/8 in. (Courtesy Betty Cunningham Gallery, New York. Private Collection)

interconnection of visual components and a clear overall character for the image. In working toward unity, it is possible to determine a compositional structure at the outset of a drawing or to impose it at a later stage. The most useful approach is a combination of initial planning and continued re-assessment as the drawing progresses. The important thing is to familiarize yourself with the vital role that composition plays in the expressive impact of a drawing, and with the numerous options in pictorial organization open to you. This chapter explores a number of these options and experiments with their use and adjustment.

The Field

Perhaps the most basic aspect of composition is concerned with the division of the **field,** also called the page or the **picture plane.** Every drawing begins with the basic fact of the surface on which it is made and the **perimeter** or boundary of that surface. The proportions in which the field is divided among various parts of the subject and the placement of those parts in relation to the vertical and horizontal axes of the image can profoundly affect the drawing's expression.

There are too many possible configurations of the division of the field to document even on the simplest level. Still, some basic principles are

shown in **Figure 10.2**. Centrality obviously commands attention and suggests either an object on a background, or a compelling tunnel or opening (a). Lower, off-center placement invites you to look past the black element into a white "space" beyond, due to the general rule that closer objects are lower in the field of vision (b). (See Chapter 5.) If the black form is placed against the middle of the right edge of the field, it seems farther away, possibly extending off the side of the picture plane (c). You look "to" the form rather than around it. Some of this effect could be due to the habits of reading text (left to right in Western culture) and could vary culturally.

The second row of diagrams features a more even division of black and white, and the horizontality of both shapes suggests an overall landscape space. The density of the black in relation to the airier quality of the white shape could suggest crushing weight when on top (d) or a solid plane leading to a "sky" when underneath (e). When sandwiched, the black itself can seem squeezed (f).

The bottom row shows variations of left-right division, suggesting events occurring in the sequence: white, then black; black then white, and so on. There is also an undertone of architectural reference: walls which we might peer around into another space.

There is a high degree of subjectivity, or personal interpretation, in the viewer's reaction to

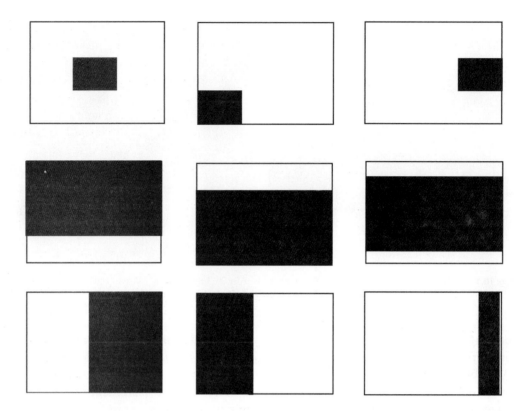

Figure 10.2 Division of the field

compositional structure. Different people can see the same composition differently, and it is impossible as an artist to completely predict the effect of a given configuration. Still, visual effects in a composition can have an experiential basis that is common to many people, and you have reason to hope that some members of your audience will share the reaction that you, as its creator, felt. The first step, and the most important one, is for you to see, to interpret, and to adjust your compositional structures so they evoke or reflect your desired meaning.

ISSUES AND IDEAS

❏ Composition is the orchestration of a visual experience in a drawing by the artist.

❏ Visual emphasis is the underlying force of composition.

❏ Choice of format, (proportion of height to width) and division of the field or page are the most basic compositional decisions.

❏ Effects of the division of the field often refer to aspects of everyday visual experience, such as navigating space.

Suggested Exercise

10.1: Compositional Proportion and Meaning, p. 301.

Graphic Position

Pictorial elements or relationships that exist primarily on the surface of the picture plane rather than in illusionistic space can be broadly categorized as **graphic** features. These include shape, line, **interval,** two-dimensional (2-D) orientation, and **graphic position,** or location on the field.

Figure 10.3, a drawing of a couch by Roy Lichtenstein, is a humorous example of the most obvious graphic position. It puts the object squarely in the middle of the field, symmetrically and frontally depicted. There is a role here for three-dimensional (3-D)

depth due to the perspective recession of the sides of the couch, but the even linear treatment pushes the drawing strongly toward a flat graphic reading. Lichtenstein's image is comically inert, just sitting there waiting for someone to have a seat.

In **Figure 10.4,** Joel Shapiro evokes a sense of energetic action in direct contrast to Lichtenstein's stable inertia. Not only is the "figure" in this drawing composed entirely of interactive diagonals (see Chapter 4, Diagonals), but the composition is highly asymmetrical, with all the form bunched on the right, and the lower left corner completely empty.

Robert Longo uses a similar graphic strategy in **Figure 10.5,** but his dancing man seems even more unstable due to an overall diagonal axis which is left unbalanced in the image. The ambiguously tangled forms of the legs and the windmill configuration of the arms complete the image of wild motion, while the flapping necktie trails precariously in the void to the left, reinforcing the sense of the figure's fall into the emptiness on the right.

Figure 10.3 ROY LICHTENSTEIN, *Couch, 1961,* pen and blue ink, 68 × 78 in. (© Estate of Roy Lichtenstein)

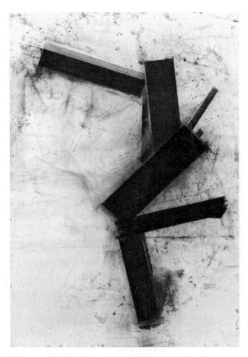

Figure 10.4　JOEL SHAPIRO (1941–) Untitled (1988), charcoal and chalk on paper, 88 × 60 in. (223.5 × 152.4 cm), acquired with matching funds from the Robert Lehman Foundation, Inc. and the National Endowment for the Arts, (330, 1989) The Museum of Modern Art, NY, U.S.A./Digital Image © 2007 The Museum of Modern Art/Licensed by SCALA/Art Resource, NY. © 2008 Artists Rights Society (ARS), NY

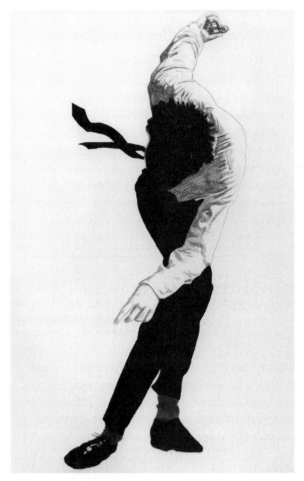

Figure 10.5　ROBERT LONGO, Untitled (1981), charcoal, graphite, ink on paper, 29 1/2 × 22 in.

ISSUES AND IDEAS

❏ Graphic compositional relationships include 2D aspects of drawing such as placement on the page, shape, and interval between shapes.

❏ Strong graphic position involves a considered relationship between figure and ground, and an awareness of the edges of the page.

❏ Cropping, symmetrical or asymmetrical placement, and an active role for empty intervals can be significant aspects of graphic position.

Suggested Exercise

10.2: Graphic Position, p. 302.

Positive and Negative Shape

Both the Shapiro and Longo images also have active roles for the "empty" areas, or **negative shapes**, of the composition surrounding the figures, but the white emptiness works in very different way in each image. Longo's figure seems to be tumbling through a limitless, airless void, isolated and unsupported. Shapiro's dark form actually seems buttressed by the wedges of surrounding white. Despite the freedom of movement, there is balance and even control; this dance can continue without collapse.

Although many drawings involve carefully crafted relationships of depth that refer to 3-D space, they are still flat, graphic surfaces and have 2-D compositional structures that work alongside or in counterpoint to spatial readings.

David Park's portrait in **Figure 10.6** has a strong sense of sculptural form but also has a powerful architecture of interlocked shapes and bold contours. The white forms that describe the background between the profile and the hand actually occupy the center of the composition and are every bit as assertive as the shapes associated with the head. There is also a **graphic linkage** between the thick line on the bridge of the nose and the one that runs along the thumb. The upturned forefinger echoes the hook shape made by the line of the neck. All the forms combine to stress the physicality of the graphic surface of the picture with a blunt power that is characteristic of the artist's work.

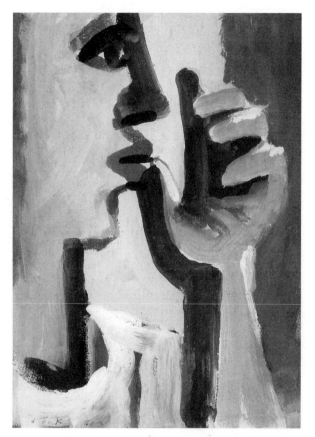

Figure 10.6 DAVID PARK, *Head with Hand* (1960) gouache on paper, 12 1/2 × 9 1/4 in. col *Natalie Park Schutz*

Park's friend and colleague Richard Diebenkorn uses a similar strategy in what is otherwise a more realistic image drawn from life in **Figure 10.7**. Mapping out interlocked black and white areas in a scene of a woman's head and shoulders in an interior space, the artist let some shapes blend together while others are set off by stark tonal contrast. The result is an image that has a compositional force of shape far greater than the simple subject would suggest. There is an abstract arrangement of shape disconnected from the motif that emphasizes the artist's imagination and free will in making the drawing.

Line, Shape, and Dynamic Tension

The discussion of organic line in Chapter 3 introduced the ability of linear forms in drawing to suggest movement. Energizing a static drawing by

directing the viewer's eye with line is a powerful technique, with a special application in figure composition, discussed in Chapter 9 (Figure 9.38). This use of line is also important to Willem de Kooning's abstract work in **Figure 10.8**.

In addition, this drawing demonstrates other important methods for infusing a drawing with energy. The power of tonal contrast is one method. Black and white values vibrate in each other's presence, causing a tension in the viewer's perception.

De Kooning further increases the sense of action by creating equally strong positive and negative shapes. The composition flips back and forth in a **dynamic tension** between a reading of black shape on white background and one of white shape on a black ground. Combined with the serpentine linear structure flowing around the page, this fluctuating **figure/ground** relationship makes for a wildly vital, if unsettling image, full of a sense of struggle and life.

De Kooning's image suggests his **push/pull** creative process, which has been documented on film. Individual gestures or shapes are created by the artist and worked into the composition, in turn suggesting new forms. Connections are made; individual elements are emphasized or suppressed. Larger structures are found and then fragmented. Completed, the composition continues to shift and change before the viewer's eyes through the dynamic tension achieved by the careful balancing of competing gestures and shapes.

It might seem odd to actually seek tension as a compositional quality, but in fact the creation of this kind of tension has proven to be

Figure 10.7 RICHARD DIEBENKORN, Untitled, conte crayon, 12 1/2 × 7 in.

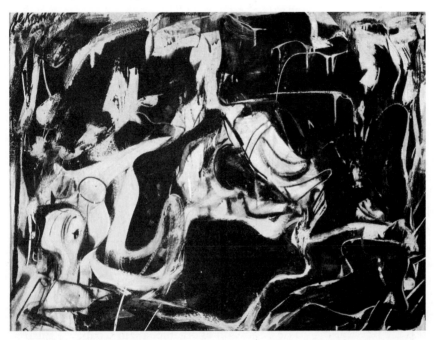

Figure 10.8 WILLEM DE KOONING (1904–1997), *Black Untitled* (1948), oil and enamel on paper, mounted on wood, 29 7/8 × 40 1/4 in. (75.9 × 102.2 cm.) From the Collection of Thomas B. Hess, Gift of the heirs of Thomas B. Hess, 1984. The Metropolitan Museum of Art, New York, NY. Image copyright © The Metropolitan Museum of Art /Art Resource, NY/© The William de Kooning Foundation/Artist Rights Society (ARS), New York.

ISSUES AND IDEAS

❒ Interlocking positive and negative shapes can strengthen a sense of abstract composition.
❒ Positive/negative shape relationships can create dynamic tension through ambiguity of spatial reading.
❒ Dynamic tension like line functions to create the appearance of movement or energy in static forms.

Suggested Exercises

10.3: Positive and Negative Shape Composition, p. 302.
10.4: Dynamic Tension: The Jungle, p. 302.

Sketchbook Link: Positive and Negative Shape

Review your sketchbook for compositional sketches that you have already made involving figure/ground relationships. Copy a few of these onto new sheets of paper, interpreting the various forms and shapes as active positive and negative shapes by strengthening their outside contours or filling them with tone. Pay special attention to the perimeter of the page and shapes that result from the intervals between forms. Strengthen the definition of negative shapes, and experiment by emphasizing certain shapes, sometimes positive, sometimes negative.

a very positive principle in art and design. Dynamic tension is a form
of balanced opposition in many ways suggestive of the restless forces of nature: growth and decay, gravity and expansion, patterns of weather and season. Life as we know it exists in an environment of change and requires evolutionary instability to diversify and grow.

People value peace and centered assurance at times, but ideas, like living beings, tend to be more vigorous when tested, pushed, and transformed by contact with possibly contradictory concepts. De Kooning's push/pull compositional structure reflects not only natural energy, but

also our human character as questioning, exploratory beings.

ABSTRACT FORM AND EXPRESSION

Associations of Abstract Form

Abstract art was a powerful, even dominant, direction in art for much of the Twentieth Century and continues to have a strong presence. One of the significant efforts of this period was to refocus drawing on the simple strengths of visual media through shape, mark, material, color, format, and dimension. Your work can gain strength from attention to these common bases of visual expression.

For young artists, abstract art can seem intimidating; it does not seem to have a familiar subject or identifiable reference to "real life." This may ultimately represent a serious flaw in a purely abstract approach to some artists or viewers and they may decide that they prefer representational or **figurative** art for its accessibility. It is nonetheless important for anyone learning to draw to understand the vital role that abstract structures play in a viewer's reaction to a work of art, whether figurative or abstract. The ability to see abstract structures in a figurative subject is

Figure 10.9 WES MILLS, no title (1997) graphite and pigment on paper, 6 5/8 × 6 3/4 in.

often the key to producing forceful and evocative work.

A comparison of the two drawings in **Figure 10.9** and **Figure 10.10** might help you to determine something about each work and the artists' intentions. First, they have some things in common: dark forms on white ground; a role for curved, symmetrical geometry; and a certain sense of wiggling movement. There are obvious differences too.

Wes Mills created a small, simple composition with two nearly identical forms in Figure 10.9. In some sense, the composition is dominated by the empty white field, which imparts a sense of isolation and microscopic scale to the dark forms. The forms' isolation is heightened by their simple, comma-like shapes and by their "dissolved" edges. The subtle change of position and shape be-

tween one form and the other suggests slight movement: a primitive reaction to stimulus. The lower form seems to be more stable—centered, vertical, and attached to the ground—while the upper form seems to float up and away. The drawing is quiet and slight, which can be seen as expressive virtues.

In contrast to Mill's quiet void, Alun Leach-Jones has drawn a party that is crowded and chaotic with lots of overlap and physical contact in Figure 10.10. In fact, the whole scene seems to glow with energy, suggested by a white halo. The diversity of form suggests an odd, but amiable, gathering of distinct beings. This drawing has a clear organic reference—flowers or undersea creatures—and the diagonal orientation of the group evokes a certain weightlessness, although there is a kind of tilted ground plane from which the forms are "growing."

Another comparison has more to do with an abstract tactile character of constructed form. Eva Hesse's watery stroke agglomerates into a dark

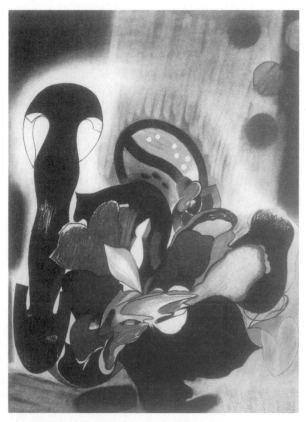

Figure 10.10 ALUN LEACH-JONES, *Cult Hook with Dark Flower* (1996–97), pastel and charcoal on paper, 24 1/2 × 18 in.

Figure 10.11 EVA HESSE, *Untitled* (1969–70), gouache 30 3/4 × 22 1/2 in. Fourcade Droll, NY

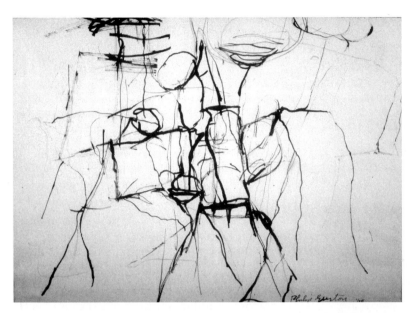

Figure 10.12 PHILIP GUSTON Untitled, (1960) ink on paper, 18 × 24 in. (Lent by Stephens Inc., Little Rock, Arkansas)

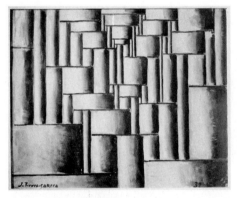

Figure 10.13 JOAQUIN TORRES-GARCIA, *Abstract Composition*, (1937) tempera, 31 7/8 × 39 3/4 in., coll. Bernard Chappard, NY.

presence within gray folds in **Figure 10.11**. The centrality of this form and its deep intensity make it impossible for you to look at anything else for long, and its high position means that you either travel up to it or that it looms over you.

Philip Guston's work in **Figure 10.12** also features a delicate, "feeling" stroke, but his airy lightness is achieved by wirelike lines against pure white. The work is some sort of architectural or anatomical structure, but its fragility and complexity give it a pathetic emotional quality.

Joaquin Torres-Garcia's wall of cylindrical forms in **Figure 10.13** is clearly an architectural

construction, but its heaviness is tempered by the musical rhythm in the changing scale and placement of the units. The smooth interlocking forms suggest weaving or intricate stone walls. His message is one of solidity and strength, but one that is achieved sensitively.

In each of these works, the compositional structure is connected to the character of the form in the drawing: transparent or dense, fragile or solid, organic or constructed.

Abstraction, Realism, and Double Reading

Abstract form can also work in an associative manner within a figurative image, as in the 15th century Russian icon in **Figure 10.14.** The work relies heavily on the power of shape and value contrast to inflect the drama depicted. Christ's followers are carefully removing his lifeless body from the cross and a great curving sweep reinforces the movement of the group. Jesus' white garment gleams from the midst of the other figures' somber tones. Their bodies curve around his, like two hands gently cupping a fragile object or a flame. A strange opening in the ground at the bottom of the picture contains a tiny skull in an obvious reference to death; perhaps this is the tomb into which Jesus will be laid. Indeed, the motion of the group clearly connects the circular hole, but rather than suggesting the downward movement of interment, the overall compositional movement seems to be upward. The linear gesture of the image, while evoking the process of deposition and burial, is simultaneously suggesting Christ's eventual ascension to heaven, as it arcs upward like a curl of smoke into the sky.

The combination of abstract forms with overtly figurative imagery sets up a **double reading** in which the sense of the figurative subject matter is influenced by the almost subconscious

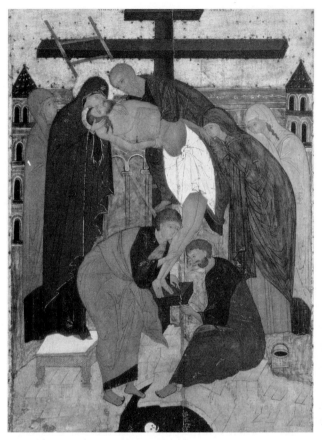

Figure 10.14 SCHOOL OF NOVGOROD, *The Deposition* (15th century), Russian icon

reaction of the viewer to the character of abstract shape. The narrative connection need not always be as clear as in the icon to be effective, however.

In the conte crayon drawing by Georges Seurat in **Figure 10.15**, the artist's approach to form is through geometric simplification and concentration on the effects of light. His stylistic transformation is so radical that it can be difficult to see the subject of the study, a little girl in a white dress for the center of his great painting *Sunday Afternoon on the Isle of La Grande Jatte*. Out of context, this drawing is almost indecipherable as a human figure, but it has an undeniable luminance and a realistic quality of atmospheric space due in part to the softly articulated edges. There is a poetic mystery here, however, as the squarish body seems to dematerialize and forms instead a glowing void, a doorway at the end of a darkened room with bright sunlight spreading toward the viewer on the floor. A moment later, the

viewer is back with the little girl, but with a lingering awareness of the alternate vision.

Randy Twaddle's drawing in **Figure 10.16** depicts an electric pole and transformer, a mundane subject from everyday life. The artist imparted a great strength of presence to the subject by making aggressive compositional decisions and complex shape associations. He heightened the associative effect of the rectilinear character of the forms, making a clear reference to the cross, a symbol of sacrifice and of judgment with overtones of transcendent balance, purity, and rectitude (see Chapter 4). This form fills the rectangle, as though the crossbar is a set of arms pushing open a double door or blocking the viewer's way. The heaviness of the transformer and its shift to the left cause a subtle imbalance that offsets the stability of the

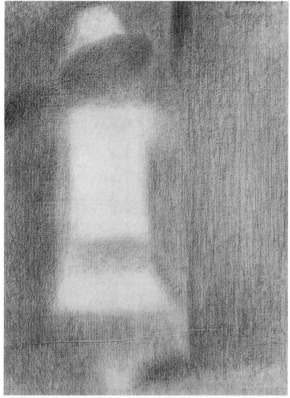

Figure 10.15 GEORGES SEURAT, *Child in White, Study for A Sunday on La Grande Jatte* (1886) *(L'Enfant blanc)*, 1884–1885, conte crayon on paper, 12 × 9 1/4 in. (30.5 × 23.5 cm) (Solomon R. Guggenheim Museum, New York, Solomon R. Guggenheim Founding Collection, Gift, Solomon R. Guggenheim [37.717])

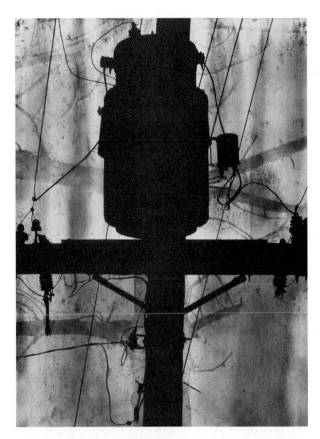

Figure 10.16 RANDY TWADDLE (1957–), *Evergreen* (1990), charcoal on paper, 60 1/2 × 43 1/2 in. (153.67 × 110.40 cm) ([1991.36]/ Addison Gallery of American Art/Museum Purchase © Randy Twaddle)

Sketchbook Link: Comparing Qualities in Abstract Compositions

In the library, find reproductions of four abstract drawings or paintings that seem to have strong, but distinctly different characters. In your sketchbook list descriptive phrases for each one, comparing and contrasting them, and explaining the expressive force behind each one from your point of view. Try to understand the artists' intentions and the way he or she gives them form in the drawings through stroke, tone, placement, complexity, or simplicity, or any of the other visual qualities discussed in this book.

rectilinear lower half. This feeling is augmented by the slanting wires, pulling the viewer's eyes down and to the left.

Unlike the Russian icon, this image has no obvious story, familiar as the motif might be. The title *Evergreen* draws a comparison between the pole and a great pine tree, but the artist's specific intentions remain uncertain. Still, a fascinating tension exists between the force and assurance of the visual character of this image and the shifting array of possible interpretations.

ISSUES AND IDEAS

❏ Abstract art concentrates on appreciation of the innate qualities of mark, shape, form, and other aspects of the art medium.

❏ Reaction to abstract qualities often stems from aspects of the viewer's daily visual experience.

❏ Figurative art can also use abstract qualities of mark, format, and compositional structure.

❏ The abstract expressiveness of a drawing with a figurative or realistic subject can work simply to reinforce the figurative message or can introduce a varying or contradictory meaning or feeling.

Suggested Exercises

10.5: Comparisons of Abstract Association p. 303.
10.6: Double Reading and Transformation, p. 303.

COMPOSITION AND SPACE

Implied Scale and Viewpoint

As you have seen, successful composition can depend on a firm awareness of the field, its edges, and the effect of graphic shape and tone on its surface. In many drawings, however, the illusion of three-dimensionality is a primary concern; the viewer's eye moves back into depth as well as across the 2-D surface. In these drawings, it is important to consider implied scale relationships within the implied 3-D space.

Drawings have real scale, of course: the scale of marks and shapes to each other and to the dimensions of the page, as in Figures 10.9 to 10.12. In an image with implied depth, however, scale is infinitely adjustable through the context of the scene. You can assume that tiny ink strokes are in fact gigantic trees, as Fan Kuan suggests in the foreground of **Figure 10.17**. Furthermore, after having established the scale of these trees, Fan pushes up a great shape behind them, by implication far larger. The vertical format of the drawing means that the height of this odd, tufted mountain can really stretch up and emerge from the fog behind the now miniscule foreground trees. The trees are still essential for the overall impact of the image; scale always depends on a comparison of size, either in relation to the page itself or to forms within the image.

On the other hand a foreground object can be so big that it extends off the edges of the paper, as is true in Hiroshige's image of the stables at Yotsuya in **Figure 10.18**. Here you are looking past a horse (or two) toward tiny figures in the distance. The effect is quite different than that in Figure 10.17. Instead of being impressed by the size of the objects in the second layer of the composition, you are aware of the objects' great distance and the plunge you must make into space. The following scale-comparison hypothesis summarizes the structure of Figures 10.17 and 10.18:

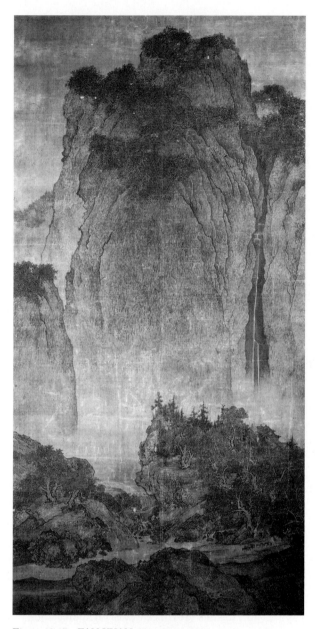

Figure 10.17 FAN KUAN, *Travelers amid Mountains and Streams* (China, northern Song dynasty, c. 990–1030 CE)

Small foreground scale/big background scale = sense of huge size

Big foreground scale/small background scale = sense of huge space

Sketchbook Link: Sketches for Exercise 10.8

See p. 305.

ISSUES AND IDEAS

❏ In compositions involving a sense of space, scale relationships between objects help convey depth and the viewer's spatial relationship to the scene.

❏ Scale relationships can also connect with strong emotional qualities, inspiring awe, fear, or exultation.

❏ Scale relationships also play off a graphic relationship of forms to the page, such as small and isolated within it or stretching beyond its boundaries.

❏ Scale and placement of an object within a composition can refer to its actual size in nature or to the viewer's closeness or distance from it.

Suggested Exercises:

10.7: Scale and Space, p. 304.
10.8: Point of View and Spatial Composition, p. 305.

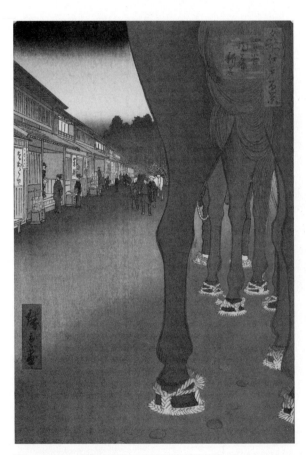

Figure 10.18 NAITO SHINJUKU, YOTSUYA, *No. 86 from One Hundred Famous Views of Edo*, Edo Utagawa Hiroshige, Japanese, 1797–1858, Edo Period, Ansei Era, 11/1857. Woodblock print. Sheet: 14 3/16 x 9 1/4 in. (36.0 x 23.5 cm); image: 13 3/8 x 8 3/4 in. (Brooklyn Museum [30.1478.86] Gift of Anna Ferris)

Point of View and Narrative

In **Figure 10.19**, contemporary artist Richard Artschwager also utilized an outsized foreground object that extends off the top edge of the page, but the effect does not seem to be so much about exaggerating the space of the rather ordinary room depicted, but about giving the viewer an odd vantage point under the coffee table. The absurdity of the situation is complimented by the meticulous attention to the wood-graining texture on the table and the strange emptiness of the interior.

The assertion of point of view in an image provides a compositional role for an observer, bringing the scene into a dynamic relationship with the viewer's space. Sometimes, as in Figure 10.19, the observer remains narratively neutral or uninvolved, but this does not have to be the case.

Edgar Degas experimented radically throughout his career with dramatic and intimate points of view that thrust viewers into the space of the figures in his drawings. In **Figure 10.20**, you are literally breathing down the neck of a woman at her dresser, although you do not know whether she is aware of your presence. Degas achieved his vivid effect by using dramatic scale comparison, steeply angled point of view, and cropping or close-up framing, which cuts out all but a small part of the scene.

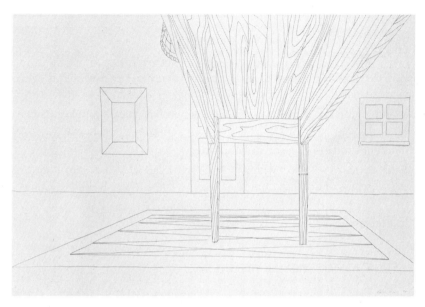

Figure 10.19 RICHARD ARTSCHWAGER, *Door, Window, Table, Basket, Mirror, Door, No.18*, ink, 24 × 36 in. David Nolan Gallery

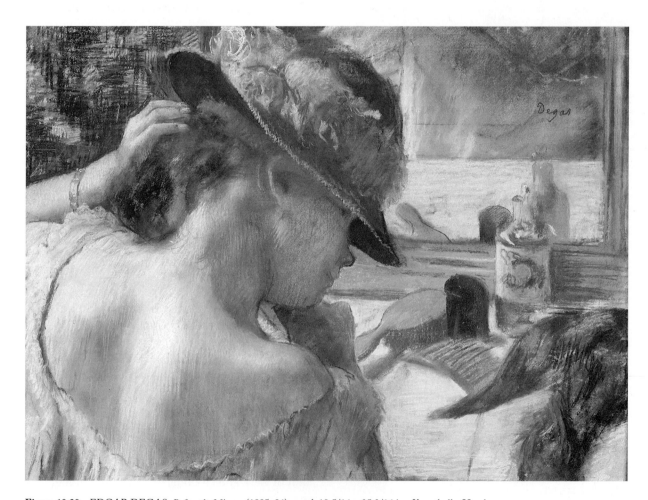

Figure 10.20 EDGAR DEGAS, *Before the Mirror*, (1885–86) pastel, 19 5/16 × 25 3/16 in., Kunsthalle, Hamburg.

Contemporary Artist Profile
ELIZABETH LAYTON

Elizabeth Layton (**Figure 10.21**) came to her artistic career late in life after a bout with serious depression led her to a therapist's care. The doctor prescribed creative activity, and Layton immediately became deeply involved in drawing, documenting many aspects of her life, from political views, to her struggle with mental illness, to her happy marriage and other joys. Her work is technically inventive, free, and life affirming. Layton's life was not easy, but she defined an attitude of truthfulness and celebration to which all might aspire. In addition, her work became celebrated in her community and gradually on a national level. She died in 1989, having embraced living fully and leaving a remarkable legacy of drawings.

In *Capital Punishment* (**Figure 10.22**), Layton adopts an imaginary point of view; looking down on herself on the gallows. The noose forms a frame around her grim expression of total despair, while the radical foreshortening of the figure and plunging perspective of the background effectively suggest isolation and emotional vertigo. As someone who spent agonizing time on the margins of society due to her mental illness, Layton clearly has sympathy with those whom society has deemed without value as human beings. She is able to a direct connection between her feelings and sophisticated compositional choices that communicate her message to the viewer.

Figure 10.21 *Elizabeth Layton*

Figure 10.22 ELIZABETH LAYTON, *Capital Punishment* (1981), colored pencil, 22 × 30 in.

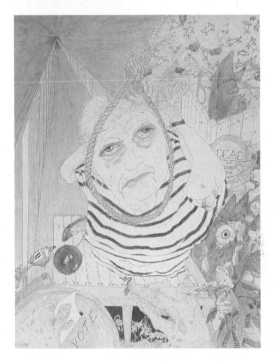

ISSUES AND IDEAS

❐ Suggestion of a clear point of view in a drawing provides an opportunity for psychological connection for the viewer with any narrative suggested in the image.

❐ Association of spatial position—emotional or physical—can influence the quality or content of a narrative drawing.

Suggested Exercise

10.9: Narrative Point of View, p. 305.

Sketchbook Link: Psychology of Composition

Think of four moments in your past when you have felt a particularly strong emotion that had to do with a particular location and your place in it. Perhaps you felt especially alone while waiting for a ride home on the street or claustrophobic or at peace in the bathtub. Try to sketch each scene (use a real room for reference if necessary), beginning with a rectangular frame. Pay special attention to setting up the point of view in your drawing. The composition should have a vivid character determined by the positioning of the viewer in the scene. Keep sketching each of the four memories until you get the proper feeling.

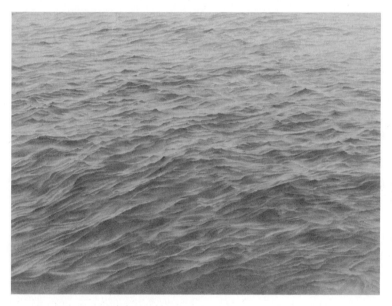

Figure 10.23 VIJA CELMINS, (b. 1938), *Untitled* (Ocean), (Venice, California), 1970. Pencil on paper, 14 1/8 × 18 7/8 in. (Mrs. Florence M. Schoenborn Fund. [585.1970] The Museum of Modern Art, New York, U.S.A. Digital Image © The Museum of Modern Art/ Licensed by SCALA/Art Resource, NY/ © McKee Gallery, New York)

SURFACE AND EXPRESSION

Material, Texture, and Detail

Textures and details often affect the sense of scale in a composition. Forms and surfaces can be trans-formed simply by covering them with larger or smaller marks or by adding details to reveal the scale of the larger object.

Vija Celmins is a master realist who has taken on what could be the ultimate textural challenge in her famous graphite drawing *Big Sea* shown in **Figure 10.23**. This is a large drawing with a meticulously realized photo-based texture of complex ripples and waves on the surface of water. This texture is so endlessly fascinating that it is possible to stare at the drawing for hours, always finding new points of interest. Celmins used a steady change in the scale of ripples, called a **gradient,** to project a sense of planar recession of space toward the light from the unseen sky. In the end, the scale of this depiction feels larger due to the focus on minute detail.

Materials on their own can provide similar complexity, projecting an imaginative world of huge scale as in **Figure 10.24**. In this work, the natural interaction of media and paper creates complexity, not through meticulous rendering, but as an **automatic texture.** Using the special process of gouache transfer, or **decalomania,** Oscar Dominguez created a fantastic landscape of canyons and peaks. Two pieces of paper, one with a gouache coating and one coated with a layer of water and glycerine, were pressed together, held until the surfaces

Sketchbook Link: Layered Materials

Make some sketches from nature, if possible a distant view of landscape or town where objects are small enough to be part of a larger texture. Work with two or three materials with different qualities that will blend and overlay each other to evoke complex textures. A good choice might be water-soluble colored pencil worked over with watercolor. You can create intricate mark-based patterns with the pencils and then overlay and partially dissolve them with the watercolor, adding atmosphere and modulating depth.

ISSUES AND IDEAS

❐ Textural complexity in nature can be described with careful attention to detail or with effects created by the interaction of drawing materials.

❐ Texture and detail have an important influence on the perception of scale in the space of a drawing.

Suggested Exercise

10.10: Textural Landscape Composition, p. 306.

merged into each other, and then pulled apart, creating odd bubbling textures and random shapes. (See Exercise 10.10a for more on this technique.)

More controlled, but also dependent on a wet-into-wet technique, are the classic watercolors of

Figure 10.24 OSCAR DOMINGUEZ (1906–1957) Untitled (1936), decalcomania (gouache transfer) on paper, 14 1/8 × 11 1/2 in. (35.9 × 29.2 cm). (Purchase. [458.1937] Location: The Museum of Modern Art, New York, NY, U.S.A. Digital Image © The Museum of Modern Art/Licensed by SCALA/Art Resource, NY/© ARS, New York)

J. M. W. Turner, whose career led him to ever-greater dissolution of form in favor of atmospheric effect. Turner relied increasingly on textural effect for scale, combining it with realistic overworking or carefully drawn detail to convey the epic sweep of space that he sought in **Figure 10.25**. Wet-into-wet watercolor requires special material and preparation to control (detailed in Appendix A), but its basic effects are relatively easy to achieve.

Layering with Collage

Another technique for bringing textures and detail into a drawing is collage. It was developed in the early Twentieth Century by the Cubists to fragment and reassemble pictorial space, building a new unity of shape and texture based on diverse materials.

A classic example is the still life by Juan Gris in **Figure 10.26**. A wonderful blending of modeled form, printed pattern, and geometric shape, the image's textural density makes it full of surprising discovery and sudden shift of tactile and visual sensation, contrasting with the mundane domestic subject matter.

Wangechi Mutu uses cut-up photographs and hand-generated material textures to suggest a complex, layered psychological reality for her female figures, as in **Figure 10.27**. Mutu draws on personal experience as a young woman of Kenyan background navigating the

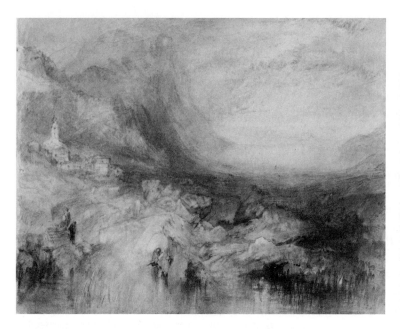

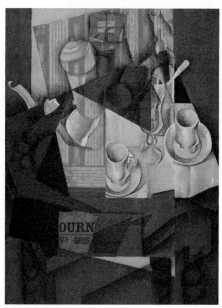

Figure 10.25 J. M. W. TURNER, *Goldau with the Lake of Zug in the Distance*, (1842–43) pencil and watercolor with pen, 9 × 11 7/16 in., Tate Gallery.

Figure 10.26 JUAN GRIS (1887–1927), *Breakfast* (1914), cut-and-pasted paper, crayon and oil over canvas, 31 7/8 × 23 1/2 in. (80.9 × 59.7 cm). (The Museum of Modern Art/Licensed by Scala-Art Resource, NY. Acquired through the Lillie P. Bliss Bequest. Photograph © 1997 The Museum of Modern Art, New York. © 1998 Artists Rights Society (ARS), New York)

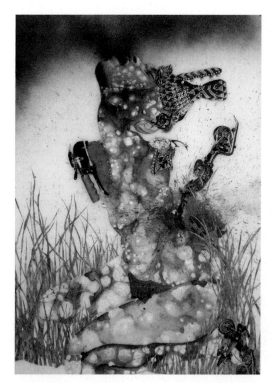

Figure 10.27 WANGECHI MUTU, *Black Girl with Thunder* (2004), paint, collage and mixed media on mylar, 81 × 42 in.

contemporary art world in the United States, reveling in newly found strength and freedom while confronting confusing contradictions.

While Gris's work evokes the jarring, mechanical transformations of everyday life in the incipient modern world, Mutu's work represents the personal struggles for identity and position that characterize contemporary culture.

Layering with Imprint and Frottage

Other ways to integrate different levels of textural reality into your work involve simplified printmaking techniques. Actual printmaking, which includes etching, lithography, silkscreen, and engraving, is a complex and subtle art form unto itself. It is closely allied to drawing, but with specialized procedures and materials beyond the scope of this book. Certain approaches and principles

can easily be accessed, however, and can enrich the surface and depth of drawings.

One of the easiest ways to generate a textured surface in a drawing is frottage, French for *rubbing*. The process involves placing your paper over an interesting surface, such as raised or incised lettering, carving, or an arrangement of semiflat objects, and scribbling or rubbing over the page with a soft medium such as charcoal, litho crayon, or graphite. You may already have discovered this effect just from working on paper pinned to a plywood drawing board. The board's wood grain will come through, sometimes in an annoying manner. Still, used purposefully, this technique can be used to generate rich textures in a controlled way and to make designs by preparing compositions of string, dripped glue, or arranged shapes of cardboard and then rubbing your drawing medium over a piece of paper laid on top.

Robert Morris's composition in **Figure 10.28** effectively suggests the confusing maelstrom of war, which appears alternatively as a smoky landscape or an overhead view of a mass grave. The textures created by rubbing charcoal into the surface of the paper create swirling gestures as a record of the artist's movement around the piece (done on the floor, it is over six feet long) and as an identification of a floorlike surface. Any gently textured form can be placed under the paper during the drawing process, its patterns transferred into the drawing by frottage.

Another technique, in some ways the opposite of frottage, involves imprinting an image on the surface of the drawing. Antoinette Hocbo began the self-portrait in **Figure 10.29** by inking parts of her body (use water-based ink only!) and imprinting her form on textured scraps of paper. She glued the pieces into the shape of a figure, and then worked on the resulting construction with a rich array of media. The life-size image effectively suggests another kind of print: an X-ray, perhaps, or a visual trace of the body's energy.

Robert Rauschenberg made a similar image by lying on architectural blueprint paper while his wife moved around him with a special light that exposes the paper, making a life-size **photogram** in **Figure 10.30**.

Figure 10.28 ROBERT MORRIS (1931–), Untitled, from the Firestorm series, 1982, charcoal, ink, graphite, and airbrushed pigment on paper, 76 × 200 1/8 in. overall; 38 × 50 in. each panel. (Gift of the Mr. and Mrs. Samuel I. Newhouse, Jr. Foundation. [320.1983], Location: The Museum of Modern Art, New York, NY, U.S.A. Digital Image © The Museum of Modern Art/Licensed by SCALA / Art Resource, NY/© 2009 Robert Morris/Artists Rights Society (ARS, NY)

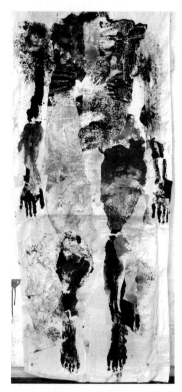

Figure 10.29 ANTOINETTE HOCBO, Imprint Self Portrait student work (2007), mixed media, 60 × 25 in.

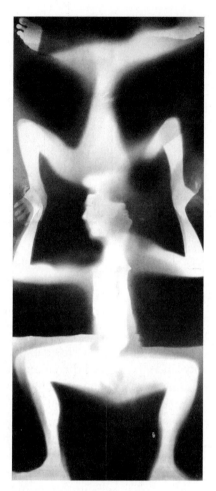

Figure 10.30 ROBERT RAUSCHENBERG, SUSAN WEIL, Untitled (2004), blueprint paper, 209.6 × 92.1 cm

It is also possible to transfer actual imagery, including photographic fragments from newspapers, photocopies, and magazines by using solvent-based transfer techniques. Wintergreen oil is a nontoxic substance that allows you to transfer printed material into your drawing. Specific techniques are detailed in Appendix A. A pioneer of photo-transfer, Rauschenberg used the disconnected layering of images drawn from the mass media to suggest the hectic pace and wild graphic barrage of modern media culture in **Figure 10.31**.

German artist Sigmar Polke has been using a similar effect since the 1960s and now stands as perhaps the ultimate **postmodern** artist, defining cryptic meaning with a vocabulary of signs, patterns, and dislocated narrative imagery from a wide variety of cultural sources as in **Figure 10.32**. The distancing of the artist's hand that image transfer allows complements the sense of **dislocated**

ISSUES AND IDEAS

❏ Layered compositions can suggest complex realities whose parts retain an individual identity within the whole.

❏ Modern art and postmodern artists have found a particular relevance of the layered image to contemporary life, influenced by mechanical process and the mass media.

❏ Layered images can build meaning by juxtaposition of disconnected elements and appropriated images that **refer to** their original source.

Suggested Exercises

10.11: Collage with Photo and Textures, p. 306.
10.12: Frottage and Imprint, p. 307.

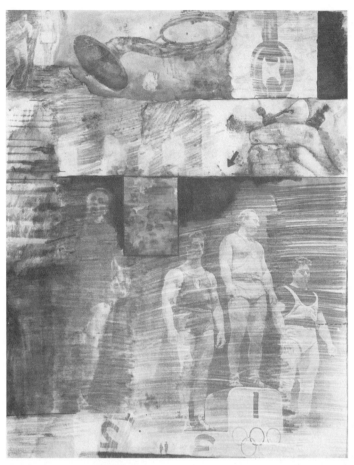

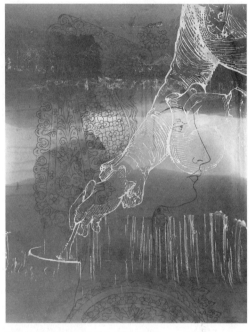

Figure 10.31 ROBERT RAUSCHENBERG (1925–), *Canto XXXI: The Central Pit of Malebolge, the Giants,* (1959–1960), illustration for Dante's Inferno, transfer drawing, colored pencil, gouache, and pencil on paper, 14 1/2 × 11 1/2 in. (Given anonymously. [346.1963.31] Digital Image © The Museum of Modern Art/Licensed by SCALA/Art Resource, NY/© VAGA, NY

Figure 10.32 SIGMAR POLKE, Untitled (2001–2006), artificial resin on polyester fiber, 54 × 46 in.

meaning that he is seeking. Polke's technique of appropriation, or the use of imagery borrowed from another source, is one of the most popular strategies of postmodern art, with its emphasis on the impossibility of uninfluenced perception in contemporary life and art. Direct image transfer allows the postmodern artist to incorporate a preexisting image wholly into a drawing, altering only the context in which it is seen. The narrative content of the appropriated image becomes part of the new drawing. Social or cultural associations the viewer might have with the image from its previous context in the world of fine art, applied art, or mass media are carried forward to the new work.

Frame and Format

Also of increasing importance to contemporary drawing is the format in which the image is presented. It is natural to assume that the primary or "normal" format for drawings is a rectangular sheet of paper within a certain convenient range of size, but many contemporary artists have found that moving beyond these boundaries expands the impact of their work.

Asian artists, particularly in China and Japan, have been working with scrolled paper for centuries, allowing them to make exceedingly long or tall drawings They are really meant to be looked at sequentially, with the viewer's gaze moving

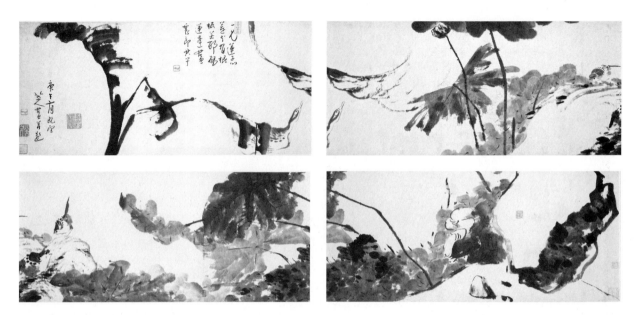

Figure 10.33 BADA SHANREN (ZHU DA), *Lotus and Birds,* hand-scroll ink on paper

through the forms and spaces of a garden or land-scape as the scroll is unfurled a little bit at a time as in **Figure 10.33**.

Judy Pfaff's work in **Figure 10.34** can be explored in another way. Its graphic forms actually exist in three dimensions as suspended wire and plastic shapes in midair and on the walls and floor. While her vocabulary of mark and shape is clearly taken from drawing, the format allows the viewer to actually enter the work and move around inside it.

Contemporary artist Kara Walker has updated the old-fashioned medium of silhouette in her enormous **tableaux** applied directly to the walls of the gallery in **Figure 10.35**. Narrative

events unfold as the viewer walks by the work. There is a postmodern irony inherent in her transformation of a nostalgic, decorative tradition of

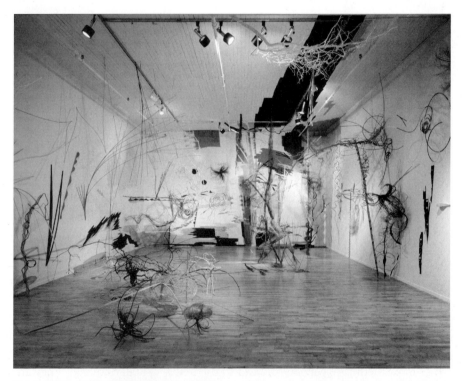

Figure 10.34 JUDY PFAFF, *Deepwater,* (1980) wire, plastic, paint, wood, mylar mirrors and contact paper, 14 × 60 × 30 ft. Holly solomon gallery

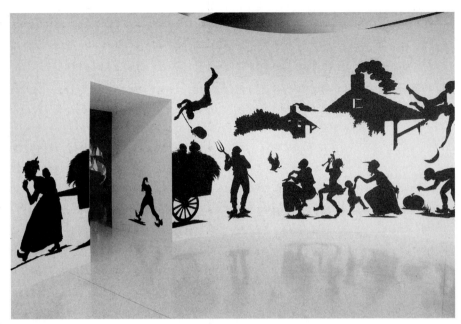

Figure 10.35 KARA WALKER, *Slavery! Slavery!* (1997), cut paper and adhesive on wall, installation dimensions variable, installation view at The Walker Art Center, Minneapolis, MN, 2007.

book illustration into room-filling imagery of a harrowing nature, detailing the surreal violations of eighteenth- and nineteenth-century plantation slavery. In this instance, the shift in the context of the presentation of the work from book to billboard scale has particular significance for the artist's theme, suggesting a public airing of hidden realities.

Other experimentation with format works with **juxtapositions** of narrative content connecting across frames or 3D boundaries. Francesco Clemente used a picture within a picture on top of another picture to build his dreamlike symbolic narrative in **Figure 10.36**. Direct connections of meaning are left to the viewer and may be more evocative than concrete. The image as a whole is beautifully designed but suggests three separate worlds united simply by juxtaposition and comparison.

Elliott Green has used new technology to play out his narratives of playful but edgy fantasy

Figure 10.36 FRANCESCO CLEMENTE (1952–), etching, aquatint and drypoint, printed in color with chine collé, plate: 61 1/8 × 19 1/16 in. (155.3 × 48.4 cm), sheet: 62 5/8 × 24 1/8 in. (159.1 × 61.3 cm). (© Copyright "Not St. Girolamo". Gift of Barbara Pine [through the Associates of the Department of Prints and Illustrated Books]. [381.1981] Location: The Museum of Modern Art, New York, NY, U.S.A. Digital Image © The Museum of Modern Art/Licensed by SCALA/Art Resource, NY, © 2009 Gagosian Gallery, NY)

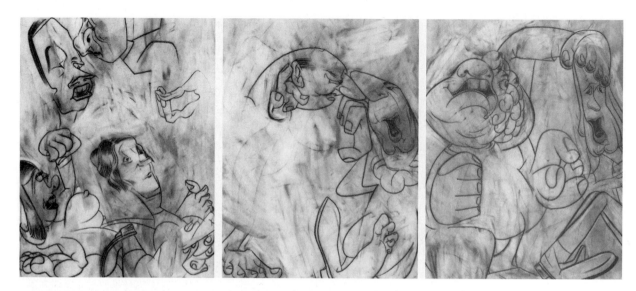

Figure 10.37 ELLIOTT GREEN, Sketchmovie stills, *Rumors of Swelling* (2000), graphite, digital, 11 × 8 in.

(Figure 10.37). Based on graphite drawings which are digitally scanned, Green's "Sketchmovies" are exhibited on a computer screen mounted on the wall. As the viewer looks on, the drawing on the screen seems to make and then unmake itself as forms are drawn and erased, creating a shifting group of oddball characters engaged in slapstick antics. Notable for their formal inventiveness and elegance of design, Green's work shows the artistic process of imaginative experimentation in actual time, a dimension outside the limits of traditional drawing.

One of the most familiar formats for telling a story with linked images is to be found in comic strips where the narrative line tends to be much clearer than in the work of Clemente or Green. Still, the basic principles of this art form have a great deal to do with compositional methods we have been discussing in this chapter. Special comic

Sketchbook Link: Format Design.

In the library, on the Internet, or in a gallery or museum, find a number of works of art that have unusual formats such as sequential panels, interesting approaches to presentation, and so forth. Make simple sketches of each, emphasizing the overall design by using physical construction, graphic or narrative relationships between panels, and so on.

ISSUES AND IDEAS

❏ Expanded formats for drawing can include multiple panels, installation in a space, or special framing elements.

❏ Unusual format alters the way a viewer experiences a drawing as sequence, as an experience in actual space, or as a juxtaposition of images.

Suggested Exercise

10.13: Sequence and Hierarchy, p. 308.

strip techniques of connection and implication allow for more efficient and expressive storytelling and are being continually reinvented. Among the most sophisticated and innovative examples of the art form now known as the **graphic novel** is David Mazzucchelli's work in *Rubber Blanket*, a limited edition graphic magazine, that set out new territory of visual sophistication and narrative complexity in the 1990s (**Figure 10.38**). Mazzucchelli's background in the dramatic narrative techniques of super-hero comics combined with his independent sensibility to produce images of distinctive visual character notable for their use of strong lighting effects interpreted as graphic shape, and the elegant design of the page. His stories are told with clarity, but in a style as memorable as the narrative.

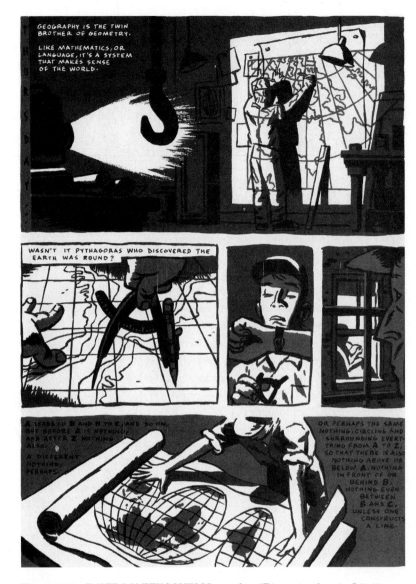

Figure 10.38 DAVID MAZZUCCHELLI, page from "Discovering America," *Rubber Blanket* (1992), 2 in.

Exercise 10.1 Compositional Proportion and Meaning

Make three compositional variations of an interior space in which you alter the proportions of the basic division of the rectangle. Experiment with left right, up down and **figure/ground relationships** as detailed in Figure 10.2. The forms in the image do not need to be strictly rectangular, but try to make your arrangement in a decisive relationship to the four edges of the page by connecting with them or separating from them. Think about the implication of each composition in relation to ideas of movement, confinement, pressure, interval, or other qualities relating to a viewer's experience of space.

Exercise 10.2 Graphic Position

Plan a self-portrait in an interior space with a clear and un-usual graphic position for the figure in relation to the 2-D space of the page. Pay special attention to the role of empty areas or intervals in the composition, and consider how they interact with the figure. Review some of the principles exem-plified in Figure 10.2 to give the composition a feeling that articulates a particular predicament or mood for the figure.

Exercise 10.3 Positive and Negative Shape Composition

With a friend posing in a chair, make four different composi-tions that experiment with different arrangements of the figure and background. Allow the subject to fill your page to the edge, cropping parts of the figure in each drawing. Begin by identify-ing the negative shapes made by the background against the contours of the figure and furniture. Simple tonal areas will help you identify and separate specific shapes from each other. Try to "strengthen" or clarify each shape by smoothing out its contour or finding geometric arcs and angles.

In **Figure 10.39**, Balthus strengthened the shapes surrounding this figure by using a powerful hatch mark. The edges are clear, simple arcs or straight lines that tie the image to the 2-D field of the page despite its strong sense of 3-D form in the figure.

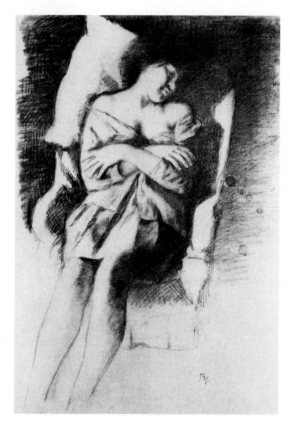

Figure 10.39 BALTHUS, *Katia Asleep,* (1969–70), pencil and charcoal on paper, 70 × 50 cm, Galerie Jan Krugier, Geneva.

Exercise 10.4 Dynamic Tension: The Jungle

Compose a still life of natural plant forms or find a setting in a garden or woods to draw. Your subject should be fairly com-plex with a variety of shapes made by leaves, branches flowers, rocks, and so on. There should also be a role for strong light, particularly light coming from behind and through the ob-jects. On a large sheet of paper, using compressed charcoal or ink with brush, build a composition extending to the edges of the page that features both a linear dynamism or rhythm and a dynamic tension between positive and negative shapes made by the object and the spaces between them. The goal is to open up the composition to a **spatially ambiguous** play be-tween the positive and negative shapes, creating a sense of en-ergy and struggle in keeping with the "jungle" theme.

Exercise 10.5 Comparisons of Abstract Association

Make three compositions with each featuring a comparison of two different kinds of form or marks that have contrasting qualities, using a variety of media. Base your approach to these qualities and the nature of their difference on the associations they evoke for you, such as static/active, organic/crystalline, sensual/violent. The two types of form may have something in common that unites the composition and gives it direction as well as diversity. Work the forms into your composition so that their arrangement emphasizes the comparison you are making. You can involve a sense of depth as well as 2D

graphic arrangement, but avoid creating a truly representational scene; let the forms work on as purely an abstract level as possible. Try to make each of the three compositions as distinct from the others as you can.

Julie Mehretu combined vaporous fluttering forms with sharp arcs to create a conceptually intriguing dialogue between organic and geometric forms in **Figure 10.40**. Still, a shared priority for movement between the distinct types of form gives the image its explosive energy.

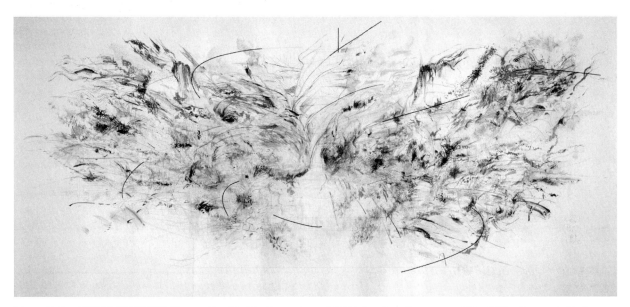

Figure 10.40 JULIE MEHRETU, *Transcending: The New International,* (2003) ink and acrylic on canvas 107 × 237 in. Contact the Project, New York.

Exercise 10.6 Double Reading and Transformation

Find an everyday object or group of objects to feature in a large composition. Your choice should be an object or objects with which you are familiar and that you can expect most viewers to recognize. Turn the object around or look at it from different angles until it suggests an interesting simple shape or another object from a different context. For example, your original object might be a high-heeled shoe, but you might find that from a certain angle it resembles a bird.

Now do five small (five-by-seven-inch) compositional studies in which you experiment with the use of placement on the page, scale, and positive and negative shape to strengthen and elaborate on the double reading you would like to suggest. The identity of the original object should remain basically apparent, but the new interpretation should be equally forceful.

Choose the most effective study and make a larger
(18 by 24 inches), more developed version in which
you stress the qualities of shape association and com-
position suggested in the sketch. Donald Sultan made
a powerful graphic statement based on geometry in
Black Tulip (**Figure 10.41**). Backlighting heightens the
object's shape character.

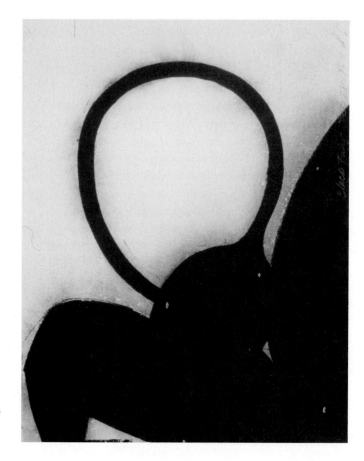

Figure 10.41 DONALD SULTAN, *Black
Tulip*, (1983) charcoal and graphite on
paper, 50 × 38 in.

Exercise 10.7 Scale and Space

Find a landscape or cityscape to draw outside. The scene
should have at least two spatial "layers" or areas of interest
separated by distance. In fact, the goal of this exercise is to
stretch and heighten the sense of distance or size by using a
scale comparison. In the foreground, find a textural detail—
bricks, grass, even people—to document or evoke with your
mark. As you begin to draw, emphasize the delicacy and
smallness of this texture; compress the mark and exaggerate
its density. In the second layer of the composition, do the
opposite. The form should be perhaps a bit larger than it
actually looks, but with less detail. You can also experiment
with different levels of contrast or different media in both
layers. Stronger contrast in the farther layer will cause it to
loom forward, weaker contrast will cause the form to seem
farther away in the misty distance (see Chapter 6,
Figures 6.27–6.31).

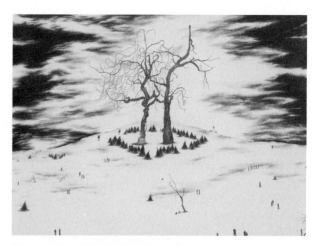

Figure 10.42 ROBYN O'NEIL, detail from *As darkness falls on this
heartless land, my brother holds tight my feeble hand* (2005), graphite on
paper, 167 × 92 1/2 in.

For your second drawing, reverse the scale relationship. This time, find a large foreground element and draw it to dominate the page's scale and exaggerate the smallness and fine detail of the elements in the background.

Robin O'Neil created a powerful comparison between miniscule people in the foreground, and enormous trees in the background in **Figure 10.42**. The overpowering sense of hugeness combines with the desolation of winter to give a feeling of isolation as well as grandeur. This emotional/spatial effect ties in with the idea of "the sublime" discussed in Chapter 5.

Exercise 10.8 Point of View and Spatial Composition

Using your sketchbook and a simple drawing tool like an Ebony pencil, do six compositional sketches of five by seven inches around your dormitory or apartment building or house, concentrating on defining the scene from interesting and unusual points of view.

The first step is to place yourself in a particular vantage point—high, low, behind, under, or on top of furniture. As you set up to draw, pay special attention to physical aspects of the situation that you could use to show your position in relation to the scene. Framing elements such as doorways or the side of a chair that you are looking beyond are of particular importance. Stress changes of scale that will indicate distance. Fill out your compositions by looking up, down, to the left, and to the right, and find landmarks to define the arrangement of the space. Note these in a quick linear way, emphasizing edges and surfaces.

Choose the best of these sketches and develop a larger drawing based on them. Preserve and enhance the proportional and scale relationships, including cropping for close forms. Add tone and detail to enliven and clarify the scene.

Exercise 10.9 Narrative Point of View

For this project, you will combine a human figure (using self-portraiture, a model, or a figure from a photograph) with an architectural scene featuring a strong point of view. The goal is to have the point of view define a feeling of tension in the figure's relationship to the space or to the viewer's implied human presence. Begin by sketching possible spaces as in Exercise 10.8. Then review the sketches and experiment by placing a figure somewhere in the scene, using scale adjustment, overlapping, or cropping to help unite the figure with the scene compositionally. At this stage, the figure does not need to be specific on a human level but should be placed thoughtfully and in roughly correct proportion as a compositional element in the space. It may help you to think up a narrative for what the figure is doing and adjusting its position to suggest your idea.

When you are satisfied with your sketch, begin work on a larger drawing, of at least 18 by 24 inches, based on the sketch. Work first to establish the particulars of the space and then carefully build in the figure. Light and shadow will help unite the figure with the space, but you must take care that the source of light for the space and for the figure match. As you work into the drawing, imagine that you are another person looking into the room at the drawn figure. What compositional adjustments can you make to give yourself, as the viewer, a vivid placement in relation to the space and a vivid psychological or narrative relationship to the other figure? Try to get the viewer's eye to move into the drawing and toward the drawn figure in an particular way. Foreground elements, cropping, and compositional proportion will be especially vital to consider.

Exercise 10.10 Textural Landscape Composition

This assignment combines textures generated by materials with hand-drawn details. The process begins with the use of a gouache transfer technique. Paint a thick color layer of gouache mixed with glycerin and water on a sheet of acetate (glycerin retards the drying time of the material). You can fully coat the sheet, or paint selected shapes according to a composition you visualize. Quickly press the wet sheet onto a presoaked sheet of smooth watercolor paper and then lift it off. You should have an interesting, variegated set of patterns and shapes, somewhat like the ones you painted on the acetate, but with new contours and textures. If you wish, you can repeat this process using different colors and patterns.

Allow the sheet to dry. Return to the drawing with **reed pen** and ink, working some areas of the **automatic textures** with hand-drawn detail. You can actually describe trees, houses, or other realistic details or just experiment with small marks, but concentrate on getting a strong sense of minute scale.

Finally, work over the whole composition with light veils of watercolor or ink wash, focusing on the composition and separating spatial layers with light and shadow (see Chapter 6).

Victor Hugo used a variety of techniques to create a fantastic world of form and atmosphere in **Figure 10.43.** The drawing plays off the contrast of detailed textures in the foreground and a washy miasma lurking in the distance to convey a great sense of scale and gloomy resonance.

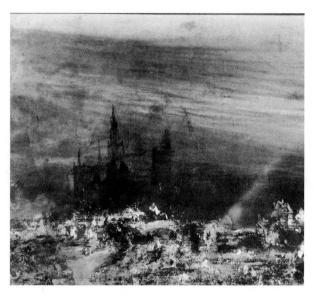

Figure 10.43 VICTOR HUGO, *The Dead City* (c. 1850), ink, wash, and watercolor on paper, 23 5/8 × 15 3/8 in.

Exercise 10.11 Collage with Photo and Textures

Assemble a resource file of full-page magazine reproductions on a theme of your choice to use in a collaged image. It could be nature scenes or urban situations or be centered around the idea of a family portrait. Do not worry too much about how you will fit everything together perfectly; changes of scale and color from photo to photo will add to the image's character. Begin to cut up the photos into usable fragments; select and arrange them on a large piece of heavy drawing paper.

You can manufacture your own collage elements by using gouache or watercolor to make colored paper. Swatches of patterned cloth or printed textures such as wood-grained con-tact paper are also useful. In addition to filling out the subject matter of your scene, try to visually integrate the variety of textures with each other, creating interlocked patterns or rhythms of color of different types of material across the surface of your collage.

Begin to glue the arrangement into place using white glue (see Appendix A). When the glue is dry, make connections between the fragments using drawing, filling in missing pieces, adding details or new elements, and shading or making changes of emphasis. It will help to unify the piece and give it a sense of wholeness if you finally draw and paint over the

surface to clarify the composition and emphasize structures that help to establish point of view as in Exercise 10.2.

Romare Bearden used the fragmentary character of collage to give a loose rhythm and sense of lurching energy to his *The Prevalence of Ritual: Baptism* in **Figure 10.44**.

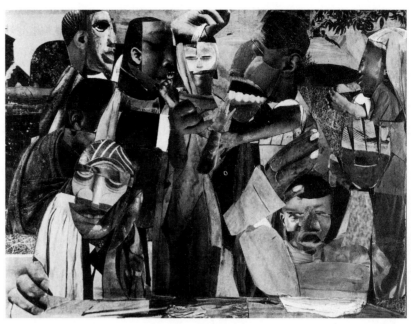

Figure 10.44 ROMARE BEARDEN, *Prevalence of Ritual: Baptism,* (1964), photomechanical reproduction, synthetic polymer and pencil on paperboard, 9 1/8 × 12 in. (Coll. Hishhorn Museum and Scultpure Garden, Smithsonian Inst., Washinton D.C.)

Exercise 10.12 Frottage and Imprint

The goal of this assignment is to create a composition that works with textural transparency and layers to suggest a layered sediment of memory, like a pictorial version of an archaeological dig. The lowest layer will consist of the traces of 3D objects produced by frottage. The second layer will be transferred photographs or printed textures. The third will be handdrawn elements in wet or dry media, and the fourth will be imprints in water-based printing inks made by inking and pressing down objects onto the surface of the paper. It is also possible, after wet media used to paint or print have dried, to impose a new layer of frottage on top of the composition, continuing to work the various techniques to build more layers. Develop a narrative theme, like a diary or personal history in your choice of objects, images, and patterns. The goal is to give a sense of integrated complexity and richness built up over time.

The textures in *Vestibule* by Kristie Valentine (**Figure 10.45**) derive from the chipboard building materials used to construct the modular home she depicted in the image. In

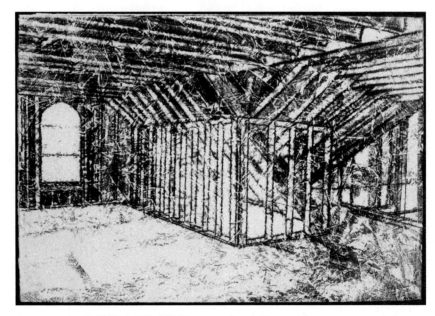

Figure 10.45 KRISTIE VALENTINE *Vestibule,* (2004), Frottage Monoprint on paper, 20 × 26 in. (By permission of the aritst.)

addition to making a conceptual reference to her subject matter, the transferred texture emphasizes the picture plane, creating a dynamic tension between the surface and the vivid sense of architectural space created by perspective. It feels as though a dense screen of textured atmosphere, if such a thing can be imagined, is between the viewer and the room depicted.

Exercise 10.13 Sequence and Hierarchy

Devise a plan for organizing three images in a framing arrangement that will convey a hierarchy of content between them or suggest a sequence in which they should be read. Some common formats are a central image flanked by two secondary ones (called a **triptych**) and three sequential frames reading narratively left to right or up to down. Try to deviate from these basic schemes in such a way that the structure of your formatted composition is as interesting and unusual as the content of the drawings themselves.

Your imagery for this assignment is completely up to you, but you may use one of the compositions you have already done for an earlier exercise in this chapter as a starting point, and then generate the other two images as sequential or hierarchical extensions.

Kirk Fannelly, experimented with three-dimensionally superimposed images that reveal themselves in new ways as the viewer walks by in **Figure 10.46**. As the top panel, raised from the surface of the bottom panel by about two inches, shifts with changing point of view, aspects of the interior scene change and new narrative elements are uncovered, suggesting the unfolding of an actual event, memory, or daydream.

In **Figure 10.47**, Dan Ruiz combined a hierarchical arrangement featuring a majestically posed box on a ladder in the center with a left-to-right sequential narrative suggesting a mock tragedy. In this case, the emotional tone is completely transformed, and a very mundane object of furniture takes on a curiously complex emotional dimension. Note the strong and effective role for point of view in each individual composition.

Figure 10.46 KIRK FANNELLY, *Interactive drama,* student work (1997), mixed media on two boards (By permission of the artist.)

Figure 10.47 DAN RUIZ, *Box Drama,* student work (2002), oil on paper, three panels, each 24 × 28 in. (By permission of the artist.)

Critique Tips Chapter 10: Composition and Expression

During critiques for the assignments in this chapter, look at your own and your classmates' drawings for qualities based on these suggested topics below. You might also want to review the vocabulary in the Using Specialized Vocabulary section in Chapter 1.

What does the composition emphasize? *Is there an element or form to which your eye is immediately drawn? What technique or visual quality gives that element its force?*

What techniques or approaches are used to unify the drawing? *Does the technique that creates the primary emphasis (gesture, tonal shape, relationships of space or light) extend in other ways through the composition? Are there other unifying factors?*

Are there any elements or techniques in the drawing that do not seem to fit or that compromise the unity or force of the image?

Is the page being used effectively? *Do you immediately notice an aspect of the placement of forms on the page as positive or as negative? Is negative shape or empty area being used effectively?*

Within the composition, are the forms and shapes in a considered relationship to each other? *Is there a role for balance or imbalance in the configuration? Is there a role for positive and negative shape? Is there a role for movement? How is it established?*

Do the forms in the drawing have a strong abstract character? *Whatever the subject might be, do you feel that the artist has put a personal interpretation on the depiction? Can you make any connection between the character of shape in the drawing and a sense of emotional content or other association?*

Is there a role for an illusion of space or relationships of scale? *Do you feel you have a specific point of view as you look at the drawing? Does this influence your feeling about the subject?*

Does texture of mark or physical texture play an important role in the composition? *What is its effect?*

Does the composition have an important role for format or special material approaches? *If so, are they effectively unified with the subject? Do they contribute to the meaning or feeling of the drawing in an important way?*

PART four

Approaching a Series

INTRODUCTON

The chapters in Part 4 take you beyond specific drawing asssignments to the develoment of a personal series of drawings. A series of drawings is a related body of work created around a unifying visual idea or approach to drawing. As preparation for the series, Chapter 11 focuses on in depth media experimentation. Understanding the making of other artists' drawings is the starting point for media experimentation that will lead you to a richer range of mark making and encourage you to pursue drawing in ways that you may not have tried. This experimentation with media can have a freeing effect on your series. Chapter 11 also includes further discussion of varied approaches to sketchbook and study page development. Understanding different approaches to sketchbook drawing and how they influenced artists work will give you ideas for the use of sketchbooks and studies in your series.

Chapter 12 looks at contemporary drawing processes and discusses methods of working from planned to spontaneous. Then Chapter 12 discusses four different artists' approach to the female figure in their work. This stresses the importance of looking beyond the subject matter to the ideas being expressed in the drawings. Finally, Chapter 12 presents series of drawings by several contemporary artists who are actively engaged in making and exhibiting their drawings. This section follows each artist's visual ideas through their drawing series.

Building on every aspect of this book, and on Chapters 11 and 12 specifically, Chapter 13 offers suggestions for getting you started on your own series of drawings. You will determine your own ideas, imagery and media and develop a body of related drawings. Student series are offered as examples of different approaches and their stages of investigation, frustration and reward are specifically discussed.

Investigations with Media and Sketchbook Studies

11

Two aspects of drawing will be discussed in this chapter with suggestions to lead you to a deeper awareness of them in relationship to your own work. First of all, a direct look at stretching your **vocabulary of mark making** through open experimentation with drawing media will be considered. One important phase of this will be to carefully study the making of a range of drawings. Secondly, in a more comprehensive way than in earlier chapters, different approaches to idea development and research with sketchbook drawing and **study pages** are presented. Ultimately, these further understandings of the possibilities of media and sketchbook use will help you to generate ideas and directions for a personal body of work, or a **series** of drawings, the major project of Chapter 13.

EXPERIMENTATION WITH MEDIA

Experimentation with drawing media is an exercise beneficial to artists at any stage of their artistic life, as it keeps their use of media fresh and leads to a continuous development of a personal vocabulary of mark making. As you further your sensitivity to drawing processes, you will become more aware of how your hand's motion, pressure, and path are recorded by the media onto the paper and reveal the making, or the **facture**, of the drawing. Each combination of the action of the hand with the textural character of the paper and medium is unique and shows the history of how a drawing was made.

Redrawing Drawings

A first step in expanding your own vocabulary of mark making can be to redraw the drawings of others in your mind, or to envision the way artists put the marks, lines, and tones on their paper. This will increase your understanding of the making of the drawing, sharpen your response to the work, and bring more insight into your methods of working. Engagement at this level is important as you begin to think about the series project.

Paying close attention to the way drawings are made and responding to the evidence of the physical act of drawing, Holland Cotter, art critic for *The New York Times,* wrote, "People always say that you can't know painting from a book, that you have to experience it. This is at least as true of drawing, a profoundly physical medium, where a smudge or erasure can be a heart catching event, and a pen stroke can leap like a solar flare."[1] Understanding just how that smudge was put on the page, and why it feels like a "heart catching event" and how the pen stroke was applied and why it "leaps like a solar flare" comes through redrawing drawings in your mind. This active looking brings you closer to the essence of a drawing and makes you feel the work rather than merely gaze at it.

As you begin to redraw drawings in your mind, you will want to bring all your drawing experiences to the forefront of your consciousness and sensitize yourself to how it feels to draw one line compared to another line. One thing to determine is the effect of the scale of the drawing on its making. Did the artist need to climb a ladder to stretch to the top portion of a ten-foot drawing? Move up and down that ladder over

and over again, or lie on the floor to reach the bottom of the paper? Was it a physically exhausting process? Or was it a quiet experience, working on a small intimate scale in a private sketchbook only inches wide while seated at a table, eyes close to the page? Second, notice what media were used and whether they were applied directly by hand, or, with a brush, pen, or other implement. Third, and equally important, is to feel the specific motion and variation of the speed of the hand, while considering what the change in pressure was as the media moved over the paper. In other words, visualize just how the marks, lines, and tones became part of the drawing. As an involved viewer, move in closely to every drawing, large or small to understand how its areas were built. Then, step back to understand the relationship of individual rhythms of marks to the whole, and how they interact with the surface of the paper.

The redrawing exercise will make you more aware of your entire physical self in drawing. Both athletes and artists must be intuitively aware of their bodies, and in sports, as in drawing, keen focus of the mind and subtle movements of the body make all the difference to the outcome. For instance, just as a fencer must consider the foil or saber as an extension of his hand and arm, so an artist must consider the charcoal, graphite, or pen as an extension of her hand. The attentive fencer or artist will vary her attacks, because repetition becomes predictable, but too much change will lead to chaos. Often, the well-placed surprise or feint can be key, so the fencer or artist must be ready to act. In both activities, the motion of the entire body is what counts; the legs move the fencer or the artist closer or farther from the target. Pressure, speed of attack, and motion of the hand, arm, shoulder, and upper body determine the variation and the outcome. The character of those motions matter. In looking at a drawing, consider whether the movement was a quick jab, a slow undulation, a speedy slash, a flow, a swirl, or a nervous twitch. What were the changing rhythms of touch, or weight behind the medium? Experience the physicality of the drawing and determine the essential, *innate character* of the marks.

Sensing the Touch and the Motion

The first three drawings in this chapter have their subject of plant life in common. As you redraw them in your mind, pay specific attention to the artist's touch in putting the marks, lines, and tones on the page. The differences among them are striking from a gentle touch with the medium barely skimming and skipping across the surface to a heavy digging into the surface, with the charcoal embedding itself into the paper's texture. Sense the motion of the arm: Is it from the shoulder, the elbow, wrist, fingers, or all of these? Is the motion quick, slow, jagged, smooth, or changing?

In a quick repeating motion, made up almost entirely of short *staccato* marks **(Figure 11.1)**, Vincent van Gogh developed a complex, intensely packed drawing literally covered from top to bottom with marks that refer to a lush density of foliage. The *reed pen* and ink were manipulated to create marks every bit as varied as the leaf and vegetation types he observed. Ultimately, of course, these marks are van Gogh's *interpretive* marks, of the actual vegetation. Having made deliberate choices about the spacing of the marks and the force or touch of his pen on the paper, he analyzed in a split second their change of size, value, and gesture and the attendant wrist and arm motion needed to create these variations. The pen point was put on the paper to create a single, but definite straight, curved, or squiggle mark, then raised slightly, moved slightly, put back down, raised, moved, put back down over and over. As you imagine the frequent action of the pen being dipped into the ink, consider how this affected the flow of the drawing process.

It is clear that van Gogh developed contrasting rhythmic areas, almost separate from each other, but still of critical importance to the whole. Indeed, there is evidence of careful transitions from one area to another, uniting the drawing. If this balance of control and clear seeing were not present, a drawing with this many different mark touches and expressive turmoil could easily appear chaotic and confusing. Each mark exists and functions as itself,

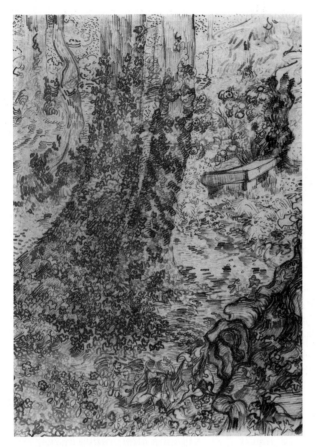

Figure 11.1 VINCENT VAN GOGH, *Tree with Ivy in the Garden of the Asylum* (1889), 24 1/2 ×18 1/2 in., reed pen, pen and ink on wove paper

as well as contributes to the conversation among all the marks and the surface of the paper. Ultimately, this expressive, textural, active drawing is built of coordinated, related marks that add up to a cohesive whole. Try to imagine yourself making this drawing. What would be the motions of your arm, hand, and fingers? How would it feel to make these marks?

Martin Johnson Heade's sketchbook study in graphite **(Figure 11.2)** has similar qualities to the van Gogh in its wide-ranging response to textures of foliage and development of rhythms. However, the medium of graphite, a more lyrical touch, and resulting finer scale of marks make this a significantly different drawing. As you redraw this drawing in your mind, find evidence of the delicate, but active touch and wrist action in the lines, many of which barely skim the surface of the paper. Note the areas where Heade drew for longer periods of time, building and building, while in other areas quick short textural marks develop the illusion of dense tropical vegetation against the open atmospheric sky. Imagine the different pressures, motions, and physical responses that he used to create this drawing in contrast to the one by van Gogh. Both artists made definite choices about medium, how to put their marks down, what to exaggerate, and what to leave out to create their drawings. These choices distinguish one drawing from the other.

At approximately 5 by 7 inches, the Heade drawing is quite small; David Bates's larger 41-by-26-inch paper **(Figure 11.3)** and choice of compressed charcoal demand a very different touch. In his physically aggressive drawing of a close-up view of a single flower, the heavy line contrasts dramatically with the character of the marks of both the van Gogh and Heade drawings. As you redraw the Bates's drawing in your mind, imagine the brash attack: the repetition of sweeping motions of his arm

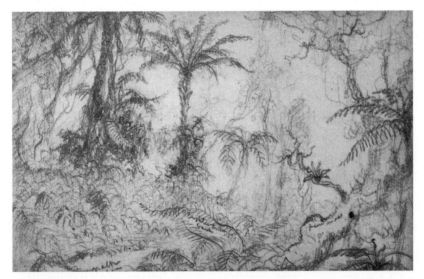

Figure 11.2 MARTIN JOHNSON HEADE, (American, 1819–1904), "Fern Tree Walk," a page from *Jamaican Sketchbook,* 1870, graphite pencil on paper bound in notebook (Catalogue Raisonne: Not in Karolik [1962] cat., Book: 12.32 × 18.41 × 1.27 cm [4 7/8 × 7 1/4 × 1/2 in]. Photograph © Museum of Fine Arts, Boston. Gift of Richard and Susanna Nash, [19097.297])

beginning at the shoulder along with the heavy pressure applied to attain the rich, embedded charcoal lines. The lines referring to the jagged edges of the flowers contrast strongly to those representing the swooping gestures of the stems, and en-

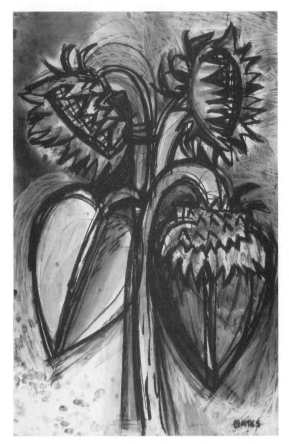

Figure 11.3 DAVID BATES, *Sunflowers I* (2003), charcoal and watercolor on paper, 41 × 26 in.

tirely different motions of the arm had to be used to create them: some short and choppy and others long and fluid. Feel how the heavy lines, tied to a sense of the physical and visual weight of the flower, pull the stem over. Atmosphere forms in the background erasures, a subtle touch following the force of the flower's arching shape. Bates showed his hand gesturally, in the repetitive strokes that built areas of dense tone, and literally, in the form of his fingerprints on the surface of the paper. Perhaps he left those prints as he braced himself to lean into and apply the heavy charcoal lines. Imagine the charcoal dust flying and how covered in it he must have been when he completed the drawing.

As different as the touch and motion of the arms and hands of van Gogh, Heade, and Bates, there are a continuity and similarity of mark type within each drawing. Each artist was aware of the range of possibilities within his medium coupled with his personal *vocabulary of marks* as he worked. In all cases new marks responded to and

Sketchbook Link: Redrawing Drawings

Choose two or three drawings by different artists with similar subject matter, but done in different media. In your mind redraw the drawings and make notations in your sketchbook about the differences in the redrawing experience. Think especially about the medium used and your sense of the touch, pressure, and motion of the arm of the artist.

ISSUES AND IDEAS

❏ Choice of medium and the size of page can strongly influence the range of marks and the expression of the drawing.

❏ Sensing the variation of touch, pressure, and motion of the arm, hand, and wrist in drawings is paramount to experiencing the work.

❏ Viewing a drawing close up to see how it was made is as important as viewing it from a distance.

Suggested Exercise

11.1, Media Exchange, p. 326.

built on the character of the existing marks. Studying these drawings can stretch your range of touch and motion in the drawing process and enhance your personal vocabulary of marks to open up possibilities for series.

Pushing the Range of Invention

Expanding the inventive range of line, mark, and tone can be another priority in drawing. Redrawing in your mind is a way to find, experience, and understand the inventions. Miriam Cahn **(Figure 11.4)** used vine charcoal and charcoal dust for her rich combinations of mark and medium. It is easy to be swept along by this drawing triptych while imagining her complete involvement with the material and impulsive shifts in energy. Working on the floor, she used a great range of approaches including, outline, silhouette against the white of the paper, silhouette against toned areas, hand prints, fingerprints, changing lines, squiggled lines, repeated lines, nervous lines, bold lines, and so on. Visualize Cahn developing each line and tone type. As her mind zipped along in the act of drawing, lines were drawn over tone, their densities changed, and their weight and speed shifted. Make special note of the evidence of Cahn's immersion in the charcoal dust, as she pushed the powdered charcoal across the surface with her hands and fin-

gers, lending freeness to the drawing. Simple, unchanging lines depict **petroglyph**-like animal images that float around humanlike figures while murky dark tones create atmosphere with underworld associations. Also, variations of edge, overlap, and scale of mark result in an ambiguous, shifting spatial arrangement of her invented wild menagerie. Visually, the quick, but sensual use of the medium and the large value shapes hold the drawing together as a unified experience but also lead our minds in many directions.

The variation in line weight in sculptor Bryan Hunt's abstract drawing **(Figure 11.5)** is dramatic in its invention and made possible by the range of media: graphite, dry pigment, and wax. Imagine the forming of the lines as they were drawn on the paper. Hunt moved his arm freely to develop the fluid changes in the line, from light to dark in value, from airy to thick in density. While the opaque, dark areas burst forward, the transparent lines quiver with the whiteness of the paper shimmering through. This gives evidence of the tension Hunt must have felt as he sensed just when to allow the medium to lightly graze the page and when to widen the line and press harder for a darker value. Just as straight lines make the curved lines seem free, the quickly drawn lines are a change of pace from the slowly drawn ones. Hunt's sensitivity of touch and inventive range give a powerful connection and experience of the making of his lines.

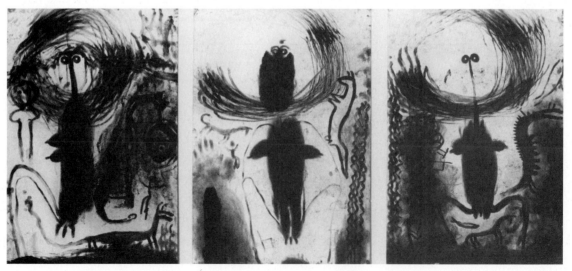

Figure 11.4 MIRIAM CAHN, *L.I.S. Seen Precisely* (*L.I.S.* = Lesen in straub or *reading in the dust)* (1987), charcoal, each 67 × 39 1/4 in.

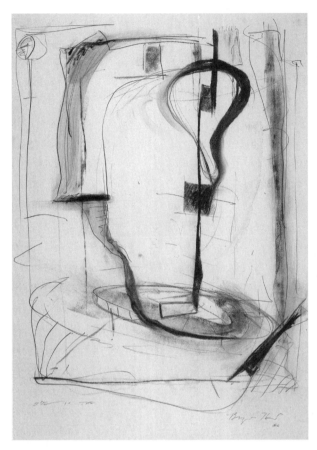

Figure 11.5 BRYAN HUNT, *Ode to the* (1986), wax, dry pigment, and graphite on paper, 29 3/4 × 22 1/4 in.

Tough, heavily worked marks give a raw sense of reality to South African artist, William Kentridge's drawing entitled *Colonial Landscape* **(Figure 11.6)**. Working from old **engravings**, real life, and imagination, Kentridge pokes holes in the **idealized** nineteenth-century **Romantic** notion of Africa. His inventive range of marks is immense, as bold as the David Bates drawing, as delicate as the Heade drawing, jabbed at like the van Gogh drawing, and as spontaneously direct as the Cahn and Hunt drawings. Imagine Kentridge drawing with charcoal and eraser: building up, erasing away, building again, struggling to define complex form and space. Feel the erasures requiring a lot of pressure, and vigorous digging down to the white of the page. Dense detail, disparate textures and marks are not just put down and left but are integrated with each other through the drawing and redrawing process. As you sense the physicality of this drawing, think about how this quality resulted in a ragged, brutalized landscape. Kentridge's inventive and rich use of the media energizes the page and also has a narrative concept. The making of the drawing is metaphorically connected with Africa's long and complex history; idea and mark making cannot be disentangled.

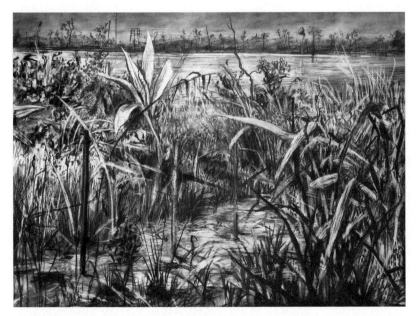

Figure 11.6 WILLIAM KENTRIDGE, *Colonial Landscapes* (1995–96), charcoal and pastel on paper, 120 × 160 cm [47.2 × 63 in.]

Reading the Layers

The **history of a drawing** can be seen when remnants of early efforts are left as a vital part of the drawing. This reveals the artist's thought process as he moved elements from one position to another. History or **ghost lines** can often make a drawing richer, more active, and perfect for redrawing in your mind.

Close observation rewards the viewer with an understanding of the making of Henri Matisse's drawing **(Figure 11.7)**. As he observed the reclining figure he repeatedly drew, wiped away, and redrew his lines. This

resulted in the visibility of the entire history of the drawing through the rubbed charcoal tones and the layers of **pentimenti** (earlier erased lines). Further, the transparent tones merge with the layers of lines so that they are seen as one image. Allowing the multiple adjustments to remain, Matisse lets the viewer see him wrestling with nuances of placement of the subject on the page. His awareness of the relationship of his mind to his hand is made clear in one of his compelling statements on drawing. Imagine the dialogue between the two as **Figure 11.7** was drawn and redrawn. "If I have confidence in my hand that draws, it is because as I was training it to serve me, I never allowed it to dominate my feeling. I very quickly sense, when it is paraphrasing something, if there is any disaccord between us: between my hand and the "je ne sais quoi" in myself that seems submissive to it. The hand is only an extension of sensibility and intelligence. The more supple it is, the more obedient. The servant must not become the mistress."[2] It is this kind of thinking about the drawing process that can lead you to a stronger insight into your natural methods of working and help you focus in the development of your series.

Like Matisse, Eve Aschheim encourages us to experience the layered history of her drawing **(Figure 11.8)**, and it seems impossible to look at it without redrawing it in our minds. Working on both sides of frosted mylar she used graphite, **gesso,** as well as **wax crayons** in a loose, sweeping manner to build an eloquent composition that resonates with its own creation. You may feel yourself floating through the drawing, and without a prescribed destination because the deep hallway-like space is established, then collapsed by the muffled tiers of line. Complex and ambiguous veils emerge as layers of angled and curved lines form

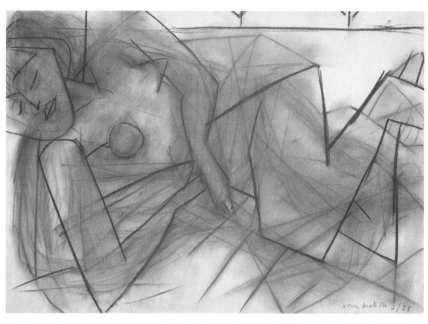

Figure 11.7 HENRI MATISSE, *Reclining Nude* (July 1938), charcoal on paper. 23 5/8 × 31 7/8 in. [60.5 × 81.3 cm] Purchase. [79.1981] Location: The Museum of Modern Art, New York, NY, U.S.A. Digital Image The Museum of Modern Art/Licensed by SCALA/Art Resource, © 2009 Succession H. Matisse/Artists Rights Society (ARS) NY

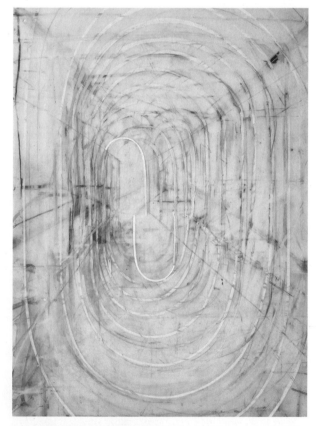

Figure 11.8 EVE ASCHHEIM, *Untitled (with perspective)* (1989), graphite, gesso, black gesso, Koh-i-noor negro wax crayon on Duralene, 12 × 9 in.

their own distinct spaces, and ghosts of black lines deny the illusion of depth of the repeating curved white lines. These synchronistic groups of lines build on the history of earlier ones as translucency is preserved to let viewers experience a fluctuating space where the layers also create the idea.

Understanding the way a drawing was made through redrawing it in your mind, will sensitize you to the possibilities of media use in the drawing process and your response to marks and lines will bring meaning to drawings. A drawing's individuality of line, mark, and attitude helps to involve viewers, and a "just so" smudge nudging up to a line or veiling it transparently can be very moving to experience. If the visual relationship is convincingly defined, combinations such as a calm tone with an overlapping heated or vigorous line can cause a tense sensation. Some marks and lines have clear roles, such as describing an edge, or giving specific information about the artist's concept. Other marks might not have so definable a role but can still be critical to the overall drawing. They may be ghost lines, repeat lines, searching lines, or energy lines, all showing the history of the hand. These lines have meaning, but perhaps not one that can be defined. They should not be considered "left-over" bits of the

Sketchbook Link Quick Media Experimentation:

Experiment freely with various media in your sketchbook. Develop pages with as much variation of mark making, line variation and tonal innovation as possible. Combine and build areas of tone, line, mark, tone, erasure, and so on.

drawing, but integral aspects as crucial as more intentional lines and marks. The interaction of marks, tones, lines, erasures, and drips is complex and cannot be separated from the meaning of the work. Sensitizing yourself to drawings done by other artists will help you to understand these interactions and their important roles as you develop your own series of drawings.

SKETCHBOOKS, STUDY PAGES, AND RESEARCH

The sketchbook links in earlier chapters introduced varied approaches to their use. By now, carrying a sketchbook with you might be routine if

ISSUES AND IDEAS

❏ Redrawing a drawing in your mind can give you a clearer understanding of the use of the medium and the process the artist used in creating the piece, deepening a dialogue with medium that can form the core of a personal connection for a series of drawings.

❏ Redrawing can also bring you to a new level of comfortable familiarity with the drawing process and help to break passive looking habits.

❏ Experimentation with different media and a wide range of marks, lines, and tones can help to build a broad visual vocabulary for drawing, giving you a sense of a personal language in drawing and allowing you to assess possibilities or parameters for a series. Study pages and sketchbooks are excellent places to experiment with media.

❏ Understanding the way drawing media are used in a drawing is a key element to understanding its meaning. Look at the drawings in this chapter for ideas for media use in your upcoming series.

Suggested Exercise

11.2, Extended Media Experimentation, p. 326.

you have come to rely on having one handy. Looking more specifically at how a sketchbook or study pages can support an individual artist's work can be helpful to you at this point, just as you are about to begin developing a series of your own work.

Although artists are often willing to share their sketchbook or study pages with the public after the fact, a sense of privacy at the time of study and creation can be essential to the special character of work done in a sketchbook. Privacy provides an opportunity to fully investigate ideas and experiences without self-consciousness: to interpret, play, concentrate, scribble, doodle, and record personal thoughts and images. You control the access to your sketchbooks, and you should be able to feel that they are for your eyes only.

Artists and designers use sketchbooks and study pages in many different ways. On each blank page, an artist imposes a particular view, perhaps a sense of order, perhaps chaos. One page can be a cohesive compositional study and the next a random group of images. Fragments of thoughts and ideas may be next to concrete, developed works. Many sketchbook drawings are done so the artist can remember fleeting ideas that may otherwise be forgotten as life rushes along. Scenes or sensations experienced while traveling, for example, can be preserved as sketches. Some drawings are made purposefully as reference; others find use accidentally, "discovered" months or years later by their creator. Whether developing an involved idea or a random observation, each sketchbook user finds his or her approach. Many artists keep numerous books in use at the same time, some organized by type or subject and others placed in strategic locations, so one is always available when needed.

Studies and sketchbook drawing can be a means to generate, research, and develop ideas. "First-thought" sketches, involving thinking on paper, can be a direct link to the artist's mind. Sketching can have a crucial role in the creative process because it triggers a personal, intimate play of images through your mind. As artists sketch, the drawings merge with other experiences and images; these accumulate and the mind interprets them. New connections can be discovered as one discrete element attaches to another and a creative momentum begins. The process of periodically reviewing your sketchbook and study pages can further ideas and lead to new territory. As you begin to develop ideas for a series, consider using one of the sketchbook approaches discussed in the next part of this chapter.

Making study pages and sketchbook drawings from observation with the intent to understand a particular object or form is the first approach considered in this section. This is followed by discussion of the ways your sketchbook can help you to remember and gather images, to record thoughts and inventions, and to resolve compositions. These approaches have much in common, but unique aspects as well.

Understanding Deeply

Leonardo da Vinci

Sketchbook drawing can be a means to research and gather information. There are many examples of study pages and sketchbooks that helped an artist or scientist develop a clear understanding of a subject. As visual awareness can be heightened through drawing, strong observational drawings can bring about a thorough and intimate understanding of a subject's structure, texture, shape, and/or volume. Many drawings in Leonardo da Vinci's extensive notebooks are filled with studies of his architectural and military inventions. He also made numerous studies from direct observation of plant forms, water, and animal and human dissections, to name a few. Leonardo understood that research through observational drawing brought him a conceptual understanding of his subject. In a cyclical way, understanding a subject helps the artist to draw it well and drawing helps to understand the subject more comprehensively. This approach is about deeply studying what you see and drawing to sharpen your observation. In these cases drawing and knowledge depend on each other.

To Leonardo, there was not a line between science and art; he moved fluidly between the two. Both were informed by his study of the human body as his notebooks reveal. **Figure 11.9** and **Figure 11.10** show two of hundreds of pages he

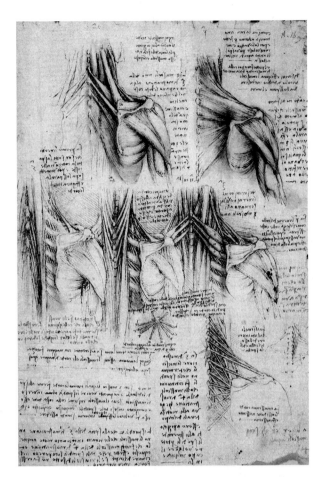

Figure 11.9 LEONARDO DAVINCI, *Plate 16, Myology of Trunk* (c. 1510)

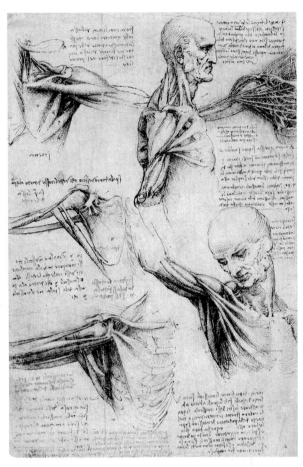

Figure 11.10 LEONARDO DAVINCI, *Plate 48, Myology of Shoulder Region* (c. 1510–13)

devoted to the human body and ***comparative anatomy*** as he sought order within complexity and function within systems and structures. These drawings are the result of pure research: They were not preparations for another work of art but were done to deeply understand anatomical forms and systems. Packed with visual and verbal information, Leonardo's pages of studies are evidence of the focused and involved observation that this type of drawing demands. Leonardo wrote, "This my depiction of the human body will be shown to you as though you had a real man before you. The reason is that if you wish to examine him from different aspects, from below from above and from the sides, turning the subject around and investigating the origin of each member, and in this way, satisfy yourself as to your knowledge of the actual anatomy."[3] Though done to acquire knowledge, Leonardo's

pages are beautifully drawn and composed. Envision his process of intense observation and drawing.

Henry Walter Bates

Research through drawing was also the goal for Henry Walter Bates, an explorer and ***naturalist*** of the eighteenth century. Spending 11 years in the Amazonian Basin, he collected, observed, and recorded information on insects. **Figure 11.11** and **Figure 11.12** show the value of drawing as an active part of the process of his scientific research, as a means to understand the characteristics of the insects. Bates's awareness of the complexities of the insects was increased through the process of drawing. In addition, he recorded thorough and highly descriptive written notes to accompany the drawings; the visual and verbal in his work are

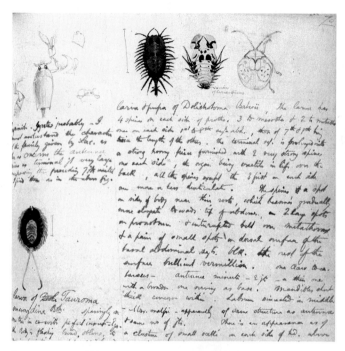

Figure 11.11 HENRY WALTER BATES, *Untitled,* pencil and watercolor

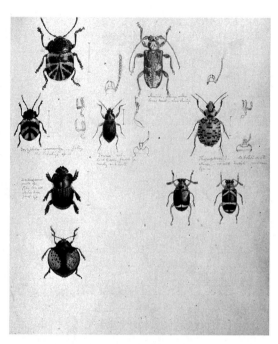

Figure 11.12 HENRY WALTER BATES, *Untitled,* pencil and watercolor

absolutely linked. Sometimes the drawings clarify the written descriptions of the insects for example, a drawing showing a particular color, pattern, or shape can be more specific than a verbal description of the same information. And of course, written notes may cover information about habitat and behavior that the drawings do not address. Scientists have historically relied heavily on visual as well as verbal descriptions and continue to do so.

Alberto Giacometti

Using a similar method of observation and drawing to increase understanding, Alberto Giacometti's subjects were great works of art. This twentieth-century artist consistently made sketchbook drawings from important works of art so that his experience of them would go beyond just looking. He made studies from ancient artifacts such as Egyptian sculpture, and from paintings by artists such as Rembrandt and Velazquez, to name a few. Explaining his need to draw from art, he said, "Ever since I first saw reproductions of works of art—and this goes back to my earliest childhood, to my earliest memories—I felt an immediate desire to 'copy' all those that I liked the best, and this delight in copying has never really left me. . . . From that time, up to last year, I could say to this year, whenever I have seen something that interests me, I have been unable to resist the desire to copy it."[4] Many of these copies were made in small sketchbooks in front of the work of art. Giacometti remembered being in Rome drawing from a Rubens, and four years later drawing from a Matisse in his studio as he said, "How can one describe all that? The entire art of the past, of all periods, of all civilizations rises before my mind, becomes a simultaneous vision, as if time had become space."[5] Cartons and cartons of these sketchbooks and study pages exist as he recorded every work of art that he felt was important to him.

Sketching from these works gave Giacometti a better understanding of the art and the artist's intentions and brought him closer to the moment of their making and their reality. The drawings are not faithful copies meant to look like the originals but very much Giacometti's interpretations from a twentieth-century point of view, as he used his own searching line. In two pages, **(Figure 11.13)** and **(Figure 11.14)**, he found new insight into the structure and gestures of the heads from Fifteenth century French artist, Enguerand Charonton's *LaPieta de Villeneuve-lés-Avignon,* Fifteenth

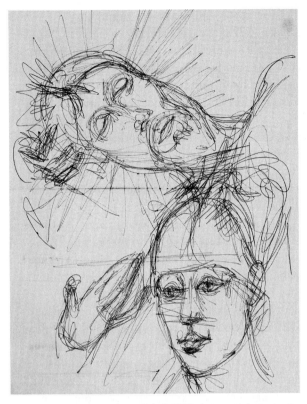

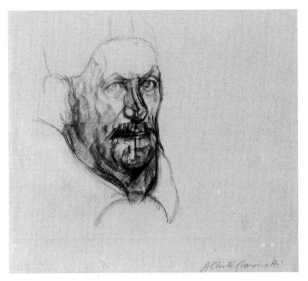

Figure 11.14 ALBERTO GIACOMETTI, (1901–1966), *Portrait of Pope Innocent X after Velazquez* (1942), black chalk on paper, 20.5 × 22.5 cm (Inv. MP3599. Photo: Thierry Le Mage. Location: Musée Picasso, Paris, France. Photo: Réunion des Musées Nationaux/Art Resource, NY/© 2008 ARS, NY)

Figure 11.13 ALBERTO GIACOMETTI, (1901–1966), *Copies of Heads after Old Masters* (© ARS, NY [Christ of the Villeneuve-lès-Avignon Pieta by Enguerrand Quarton at the Louvre and a female portrait after a painting by Rogier van der Weyden at the National Galle] Location: Musée National d'Art Moderne, Centre Georges Pompidou, Paris, France, Photo: CNAC/MNAM/Dist. Réunion des Musées Nationaux/Art Resource, NY/ Giacometti © 2009 ARS, NY/ADAGP/FAAG, Paris)

century Flemish artist Rogier van der Weyden's *Portrait of a Woman,* and Seventeenth century painter, Diego Velazquez's *Portrait of Pope Innocent the X.*

Drawing from observation as seen in the studies by Leonardo, Bates, and Giacometti demands intense concentration. When musicians perform, it is clear when they are fully consumed by their playing; they seem to be in another world. Similarly, when an artist draws, it is easy to see the concentration, whether it is a physical, intense engagement or a quieter focus. However you fix your attention, you are in another state of mind if you are fully connected with your study and beyond the mechanics of looking and drawing.

ISSUES AND IDEAS

❏ Drawing can deepen observation, clarify information, and sharpen focus.

❏ Artists and scientists throughout history have worked in similar ways to record their intensive observation of the world.

❏ Drawing is an important way to further your understanding of nature, objects, and works of art.

Suggested Exercise

11.3 Large-Scale Study Page of a Natural Object, p. 328.

Gathering and Remembering

Eugene Delacroix

Some artists and designers develop sketchbooks of images as compilations of ideas and information for later use. French Romantic painter, Eugene Delacroix of the Nineteenth Century is one who did this, specifically as an aid to memory. Delacroix had the opportunity to travel in North Africa for six months in 1832, where the people, landscape, patterns, interiors, clothing, and most of all the brilliant sensation of color and light caught his attention. Overwhelmed as he traveled, he decided that he must make a vivid visual record of his experiences in this new land **(Figure 11.15 and Figure 11.16)**. This determination led him to gather images and fill seven albums with drawings and written details of his personal interpretations of the world he witnessed.

While in Morocco, Delacroix said, "At this moment I am like a man who is dreaming and who sees things that he fears are going to escape him."[6] Traveling in Morocco in 1832 was not an easy venture, but Delacroix's dedication to his sketchbooks was intense as Claude Roger-Marx revealed, "Dazzled by reflections of light and heat" and "harassed," as he says, "by the long rides on horseback, the swimming across rivers amidst gunshots and all the emotions of a life of adventure," this man of delicate appearance still found the

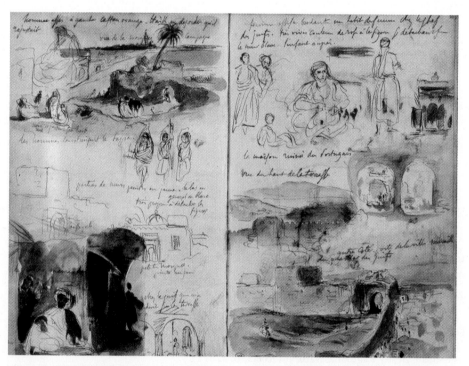

Figure 11.15 EUGENE DELACROIX (1798–1863), *Moroccan Sketchbook. Album of North Africa and Spain* (1832), watercolor, brown ink, pen, 19.3 × 12.7 cm [7.6 × 5 in.]. (Folio 23 v–24 r. Location: Louvre, Paris, France, Réunion des Musées Nationaux/Art Resource, NY)

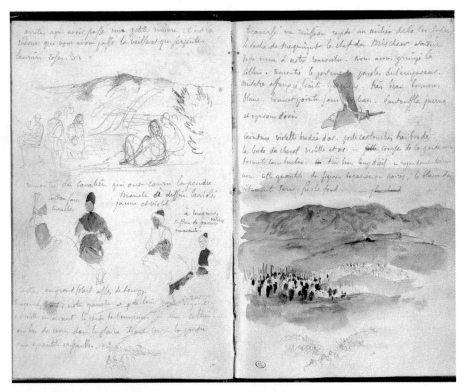

Figure 11.16 EUGENE DELACROIX, *Sketch of Arabs and Horsemen in a Mountainous Landscape,* black crayon and watercolor, 19.5 × 12.5 cm [7.5 × 4.9 in.] (Inv. RF1712bis, folio 16v–17r. Photo: Michèle Bellot. Louvre, Paris, France. Musée du Louvre/RMN Reunion des Musées Nationaux, France. SCALA/Art Resource, NY)

strength in the evening, in the silence of his tent while everyone slept, to complete these studies and heighten them with watercolor. He felt that he must not lose anything of such an experience, from which so many future works would benefit."[7]

These sketches were done from life—light-filled open markets, landscape vistas, and exotically dressed people—with fluid lines and spontaneous washes of color. Imagine the act of drawing these pages: the quick gesture of the figures, the more developed watercolor areas, and the written notations layered with various scenes on each page. The artist carefully recorded date, location, route, change in air, notes about color, light, and other details of what he saw. Indeed, artists such as Matisse and Paul Klee were inspired by Delacroix's work to travel to North Africa. As you look at Delacroix's album of drawings, note that they are open for the viewer's imagination; he recorded his interpretation of the sense of things, not a literal transcription. This **subjective** interpretation of his observations was very different

from the more objective recording of information that we saw in the Leonardo notebooks and Henry Walter Bates's studies.

Thomas Lyon Mills

Like Delacroix, contemporary artist Thomas Lyon Mills draws to gather images and to remember. Mills emphasized this when he said, "Above all, my sketchbooks are my endless library of memory."[8] Travel is another common aspect of sketchbook drawing for Delacroix and Mills however, they each respond to different aspects of their travels. When in places such as Greece, Russia, Turkey, Italy, or even at home in the United States, Mills seeks out uninhabited, scarcely known spaces such as quiet museums, or overgrown, dense pockets of nature. Once he finds a place that is meaningful to him, he returns year after year, again and again to draw. Within these special locations, it is not the people, culture, or architecture of his own time that Mills pursues but the distant cultural remnants of

people long gone. Some favorite sites are the cool, damp underground spaces of ancient Rome including the early Christian catacombs and the first-century drainage system of Vespatian under the Colosseum. Most are places Mills can go and be absolutely alone to work, as the sites are inaccessible except to a very few with rare, special permission. Having descended alone into the mysterious subterranean, Mills draws from the architectural elements, but he is also entranced by minute details. "It is within this drainage system (under the Colosseum) that the most interesting mosses and exotic plants flourish, originally transplanted from Africa and the Middle East via the hoofs of animals used in the ancient games."[9] Similar mosses and plant life thrive in another location he returns to each year, in late spring, deep in the Adirondack Mountains of New York, a secluded, lush, untamed, bit of nature. At each site, whether underground, in nature or in a museum, the colors, details, structures, and memories are carefully observed and recorded in the sketchbook drawings.

Eventually, even years later, imagery from many time periods and locations come together in one of Mills's large-scale works on paper. These are worked on over extended periods and have the same elusive quality of time and memory of the original sketches. In a sketchbook page done from an Etruscan **antefissa** (Figure 11.17), the face, more than 2,000 years old is still bright with color, though obviously scarred by time. Mills layered his enigmatic antefissa image with a drawing from the Roman catacombs to create *Number 63* from the series *73 Prayers in the Underground* (Figure 11.18).

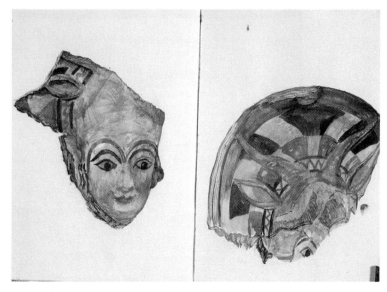

Figure 11.17　THOMAS LYON MILLS, Sketchbook pages from Palatine Antiquarium, watercolor and pencil, 9 1/2 × 13 1/2 in., courtesy of Luise Ross Gallery, New York, NY

Figure 11.18　THOMAS LYON MILLS, *Number 63* from the series, *73 Prayers in the Underground* (2001–2006), watercolor, charcoal, conte crayon, collage on pieced paper, 40 3/4 × 35 3/4 in., courtesy of Luise Ross Gallery, New York, NY

Figure 11.19 THOMAS LYON MILLS, detail from *Number 63* of the series, *73 Prayers in the Underground* (2001–2006), watercolor, charcoal, conte crayon, collage on pieced paper (Courtesy Luise Ross Gallery, New York, NY.)

The solitary sketchbook fragment lost its sharp edges in its new environment to become part of an atmospheric space as seen in a detail of the image **(Figure 11.19)**. Mills's statement on his work resonates for this mysterious piece: "Many of the things I saw will mutate in some as yet unforeseen way and find themselves part of my imagery. I have been given a great gift—the gift of being able to look deeply inside several remarkable places. Within these sites I see how the visible suggests pathways to the invisible. I seek to transfer the tangible, visible world into the faint, elusive scent of memory and the truly unseen—the spiritual."[10]

As dependent as Mills is on his sketchbooks for a place to gather images and as his "endless library of memory," it is not surprising to know that he has been keeping sketchbooks for more than 25 years. With several in progress at any given time, he has filled more than 30. Particular about their quality, Mills chooses his own paper, a lightweight version of the paper his large works

are done on, ensuring the same surface and color, and has the books custom made. They are bound in covers of old books or in covers handmade in Assissi, Italy. Each sketchbook has various sections: one for architecture, one for animals, one for portraits, one for landscape, and another for his dreams.

Nancy Graves

When she was young, Nancy Graves's father was the associate director of the Berkshire Museum, a natural history and art museum. Perhaps this influenced her to see the worlds of nature and art as one which greatly influenced her considerable and important body of work. To Graves, study pages and sketchbook work were a means to gather images related to her broad interest in nature, cartography and **visual systems.** She studied and drew maps from different cultures and natural phenomena such as air and ocean currents **(Figure 11.20)**. Other investigations

Figure 11.20 NANCY GRAVES, *Falkland Current*, 1973. Graphite on paper, 22.5 × 30 in. (© Nancy Graves Foundation Licensed by VAGA, NY)

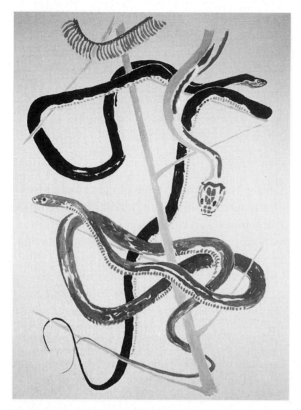

Figure 11.21 NANCY GRAVES, *Three Snakes*, 1971, gouache on paper, 20 × 14 in. (Collection Museum Ludwig, Cologne, acquired 1971/© Nancy Graves Foundation/© VAGA, NY)

Figure 11.22 NANCY GRAVES, *Ladybug Beetle Swarm Wintering in California*, 1971, gouache on paper, 22 × 30 in. (© Nancy Graves Foundation/Licensed by VAGA, NY)

were in geology, anthropology, natural camouflage, and zoology, **(Figures 11.21 and Figure 11.22)**. The final form of her work in painting and sculpture brought together references to maps and nature in which she sought abstract visual rhythms and patterns that she found within the diagrammatic and representational images. In addition, her attention to detail, inventive use of medium, and interest in process evident in the sketchbook images come through in her painting and sculpture. The studies are the research and gathering place of ideas and resources, and Graves recycled, reused, or reformatted her bank of sketch images. Her later work had fewer direct references to these visual systems, but the accumulation of this knowledge and understanding continued to come through. There is a beautiful transparency and delicacy of touch to all of her work: a lyrical quality in concert with the intellectual investigations.

Referring to their sketchbook drawings of gathered images, Delacroix, Mills and Graves merged their studies with their imaginations to create works of art. Even many years later, their observations and experiences were familiar to them because the sketchbooks refreshed their memories.

Recording Surroundings and Inventions

Using sketchbooks and study pages to record surroundings and responses to surroundings can lead artists to inventive and imaginative thinking. There are as many ways to do this thinking on paper as there are artists. Some use sketchbooks as seeds of ideas, development of in-progress ideas, or a place to grown a personal vocabulary of abstract shapes.

Dawn Clements

Although done as the final, rather than study phase of the work, the innovative drawings of her surroundings by Dawn Clements have the sensibility of large-scale panoramic sketchbooks. Similar to the way a sketchbook is filled over a period of time, Clements' drawing *Kitchen and Bathroom* **(Figure 11.23)** grew over time. She drew

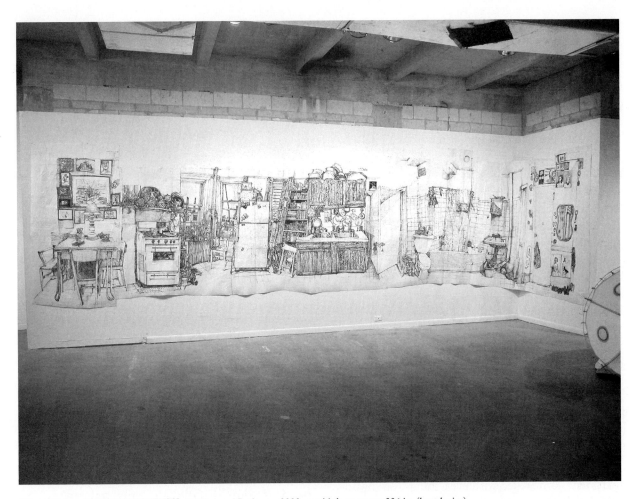

Figure 11.23 DAWN CLEMENTS, *Kitchen and Bathroom*, 2003, sumi ink on paper, 336 in. (lengthwise)

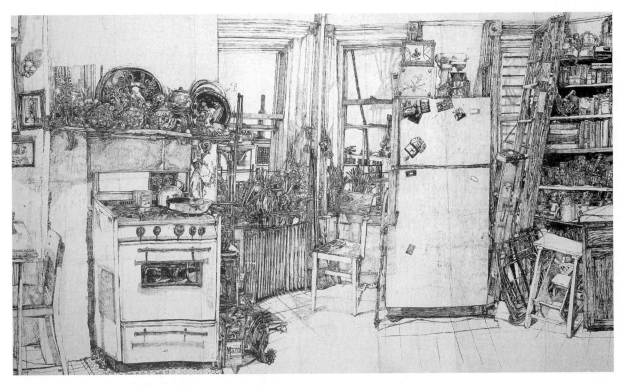

Figure 11.24 DAWN CLEMENTS, Detail of *Kitchen and Bathroom*

it piece by piece gluing additional paper to the drawing as it was made. It is as though study after study were put together to form the final drawing. The casual rumpled quality that many sketchbooks acquire from long-term handling is also present in this drawing as it hangs directly on the wall in a loose offhanded way, folded around corners or their architectural elements.

Describing the making of *Kitchen and Bath*, Clements wrote, "My work often begins as a small drawing of a single figure, object or space from life, film or TV. To these small drawings I sometimes add more paper as I draw more . . . In *Kitchen and Bathroom* (2003) I drew in sumi ink, each wall of each room from floor to ceiling over the course of a year in my railroad apartment in Brooklyn. The result is a panoramic drawing of the entire kitchen and bathroom "flattened" out. This 28-foot work is composed of many pieces of paper joined together. The vertical dimensions vary according to my distance from the wall/object."[11]

Kitchen and Bathroom is an eccentric visual accumulation of objects and textures in Clements' apartment. Jampacked with everything from basic necessities to personal collections, it includes appliances and bathroom fixtures, plants, dishes, books (with titles), and pictures on the wall all accounted for in minute detail. Rather than considering the overall composition, Clements drew object by object as though making an inventory and leading us to associate each object with its verbal equivalent.

While descriptive in terms of details of each object, Clements took liberties with space. Her point of view shifts and this is recorded in the change of floor tile angles under the window, refrigerator and cabinets and in the impossible to fit together views of large objects such as the stove, refrigerator, chair, doors and so on (**Figure 11.24**).

Hyper-focus or very close observation is the dominant method of seeing and representing throughout the drawing. But the wood grain on the cabinets becomes exaggerated even more acutely (**Figure 11.25**) where the rendered texture is drawn with a fixated, zealous attention taking on much more importance in the drawing than it would in real life. Clements invented a way to represent the wood grain and then literally and consistently covered the surface.

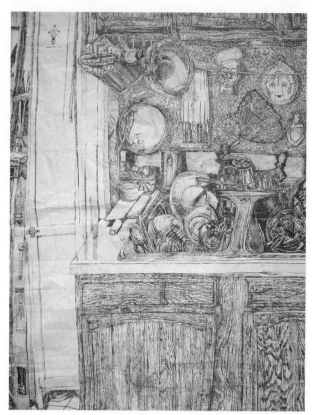

Figure 11.25 DAWN CLEMENTS, Detail of *Kitchen and Bathroom*

There are many levels of dialogue between Clement's inventive large-scale drawings and the traditions of sketchbooks, but perhaps *Kitchen and Bathroom* is most sketchbook-like in its straightforward honesty. Clements lets us see her private living space and all of its quirks. We see the idiosyncratic clutter over the stove, the stacking of multiple ladders in front of the bookshelves, and the dishes piled in the sink. The intimacy of her home is on view for all to see. Only Clements is absent, but her presence is clearly felt.

Lee Bontecou

Lee Bontecou was an important member of the twentieth-century art world and her work is receiving attention again in the twenty-first century as being imaginative and having a unique point of view. Different critics have categorized her as a **feminist, surrealist,** or **minimalist,** but the work crosses boundaries and remains larger and more complex than any of these labels. Her father was an

inventing, and working with her hands came naturally to Bontecou. Spending summers in Nova Scotia, she became interested in natural form, particularly insects and marine life. Further interests were in the planes, rockets, and instruments being developed in the 1950s and 1960s. Her pages of studies **(Figure 11.26 and Figure 11.27)** refer to these natural and industrial forms, but not in a literal sense; they are invented abstractions. The merging of these worlds brings a duality to the studies; they are delicate yet strange and menacing, with a meticulous focus evident in the detail of the drawings. Also, current events and tensions of the Cold War contributed to a general sense of foreboding in the world and this work reflects an atmosphere of fear. Mysterious dark voids are not explained but presented and played with over and over in her drawings, leading

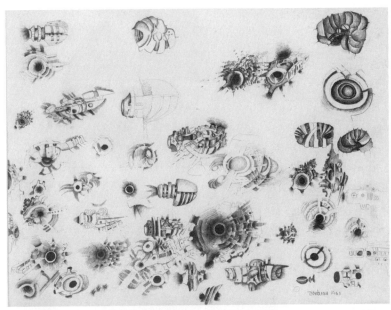

Figure 11.26 LEE BONTECOU, *Untitled* 1961, charcoal and pencil on paper, 22 5/8 × 28 1/2 in. (57.5 × 72.6 cm) (Gift of John S. Newberry. [124.1962] Location: The Museum of Modern Art, New York, NY, U.S.A./Digital Image © The Museum of Modern Art/ Licensed by SCALA/Art Resource, NY)

inventor and her mother worked with submarine transformers, so it is not surprising that making,

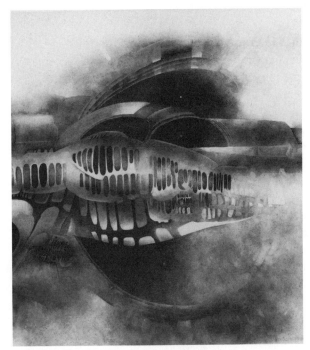

Figure 11.27 LEE BONTECOU, *Untitled,* 1966, graphite and soot on paper, 19 3/4 × 28 1/8 in. Albert J. Plavin Collection: Twentieth Century American Art, 1972. © Lee Bontecou, courtesy Knoedler & Company, NY

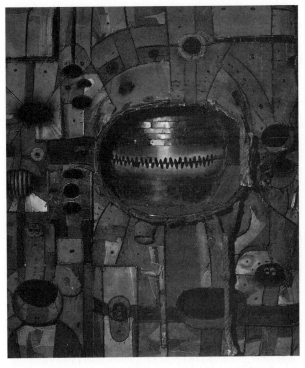

Figure 11.28 LEE BONTECOU, *Untitled,* 1961, welded steel, canvas, wire, and rope, overall: 72 5/8 x 66 × 25 7/16 in. (184.5 × 167.6 × 64.6 cm) (Collection of the Whitney Museum of American Art, New York. © Lee Bontecou/Leo Castelli Gallery)

to endless variations of invented forms to serve as a vast vocabulary for her large-scale paintings and sculptures **(Figure 11.28)**. A direct, obvious relationship between the sculpture and the drawings exists as they are clearly developed from the same metamorphosed forms. Familiar, yet strange, the imagery is ultimately highly personal. We may feel that we have seen these forms before, but we have not; Bontecou has invented them. Like nature and technology, her work can be recognizable, threatening, mysterious, complex, and absolutely fascinating at the same time.

Ellsworth Kelly

Minimalist painter and sculptor Ellsworth Kelly found elegant design in architecture as well as mundane, everyday items such as envelope windows, plumbing pipes, and paper cups. Sketching to develop **formal** ideas and to invent abstract shapes has been his habit for more than 50 years, and hundreds of his study pages exist. In the final form of his work, the viewer is unlikely to recognize the origin of the idea, but when the origin is revealed, it makes sense. Two examples of this transformation from sketchbook studies to abstraction are pictured here. In the first one, Kelley inverted a tentative set of linear drawings from Notre Dame Cathedral in Paris **(Figure 11.29)** and

Figure 11.30 ELLSWORTH KELLY, *Vaults/Flower* (1949), ink, 16 1/2 × 12 1/2 in.

changed them into the bold **silhouette** image of an abstract flower **(Figure 11.30)**. In the second case, observed shape transformed into abstract shape is at play again, beginning with a study page based on envelope windows **(Figure 11.31)**. A more developed study from one of the envelope composition variations **(Figure 11.32)** is very close in form to the painting it eventually became.

Just as Leonardo and Henry Walter Bates used drawing studies as a process to learn about and understand their subjects, Bontecou and Kelly used drawing studies as a process to invent theirs. The main difference in their method of working is that Leonardo and Bates worked from observation while Bontecou and Kelly worked from their imaginations. Kelly often started from observation, but, unlike Leonardo and Bates, he pushed the image quickly into abstraction. All four of these artists used their studies to understand and develop their ideas further.

Figure 11.29 ELLSWORTH KELLY, *Vaults, Notre Dame, Paris* (1949), pencil, 13 × 18 in.

Figure 11.31 ELLSWORTH KELLY, *Five Sketches* (1954–1955), ink, 15 5/8 × 21 in.

Figure 11.32 ELLSWORTH KELLY, Study for Black and White Panel of *Painting in Three Panels* (1955), ink and pencil, 13 3/4 × 10 7/8 in.

Resolving Compositions and Details

Philemona Williamson

Whether it is a composition or a detail of a painting that needs resolution, an artist's sketchbook is an obvious place to pursue these issues. Philemona Williamson very purposefully sketched compositional ideas for her paintings and the direct relationship of the drawings to the paintings is clear **(Figure 11.33 and Figure 11.34)**. Her paintings **(Figure 11.35)** are made up of figures and objects in odd juxtapositions that convey symbolic and narrative meaning through invented arrangement. With figures as the main focus, the background and objects play an important, but supporting, role. The ideas, design, and awareness of visual elements are clearly laid out in the drawings, while further development, addition of color and detail, are added in the painting process.

Most of Williamson's work deals with the transition from one stage of life to another, most often from preadolescence or adolescence into adulthood. Complexity, identity, and misguided decisions crop up over and over again. Tumbling through space

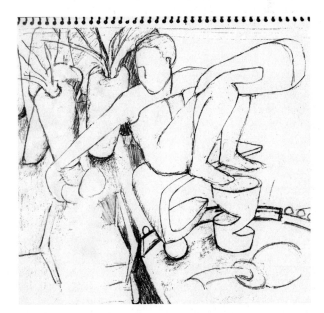

Figure 11.33 PHILEMONA WILLIAMSON, *Sketchbook Compositional Study*, graphite on paper (Courtesy June Kelly Gallery, New York)

Figure 11.34 PHILEMONA WILLIAMSON, *Sketchbook Compositional Study*, graphite on paper (Courtesy June Kelly Gallery, New York)

awkwardly and self-consciously, the girls interact with each other through nature and sports. Tensions are carefully set up in the sketchbook drawings, evoking unsettled moments in life, with every

gesture, object, and juxtaposition holding symbolic and sometimes literal meaning. Many of us can relate to these rich narrative paintings that can often be painful to view.

Federico Barocci

The sixteenth-century painter Federico Barocci is known for the many studies he executed in preparation for a painting. He took the composition for the painting *Madonna del Popolo* and its twelve or more figures through numerous changes. After working out the overall design, he focused on important details of each aspect of the painting. The study pages in **Figure 11.36 and Figure 11.37** show his concern for resolving the angle, gesture, and form of the torso, head, and hands for one figure. Trying each in several variations, he turned them slightly, to find and understand the nuance of the particular pose. He drew to understand, to discover, and to resolve. The pages are remarkable for the quality of the drawing; the changing line, layering, and varied use of the medium make them beautiful works of art in themselves. These are excellent drawings to practice redrawing in your mind as the variation in line weight alone is worthy of involved study.

There are numerous approaches to sketchbooks and study pages. Consideration of some of the ideas presented here from master and contemporary artists will help you to fine tune personal working methods and influence your approach to a series of drawings.

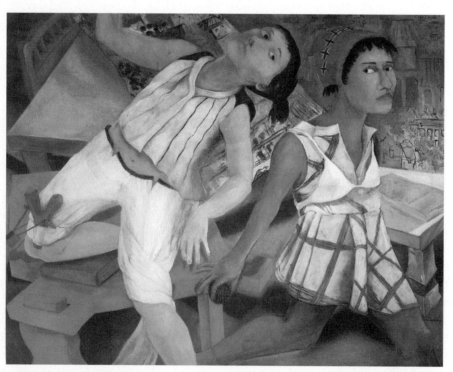

Figure 11.35 PHILEMONA WILLIAMSON, *Prickly Pear 2002*, oil on linen, 48 × 60 in. (Courtesy June Kelly Gallery, New York)

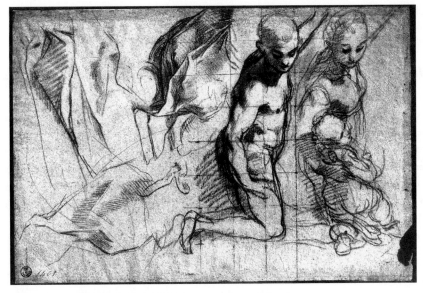

Figure 11.36 FEDERICO BAROCCI *Study: Madonna de Popolo*

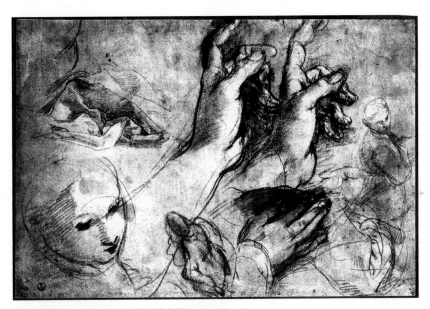

Figure 11.37 FEDERICO BAROCCI *Study of hands*

ISSUES AND IDEAS

❏ Sketchbook drawings are useful as a reference to remember ideas and imagery discovered in travel, in dreams or everyday life.

❏ Some artists use sketchbooks to develop a bank of imagery that they use in subsequent work.

❏ Many artists use sketchbooks to invent and develop ideas and images from their surroundings.

❏ Sketchbooks are often used to create and develop compositions for paintings, sculpture, designs, or more developed drawings.

Suggested Exercise

11.4 Developing Your Personal Use of Sketchbooks, p. 339.

Exercise 11.1 Media Exchange

This exercise consists of three drawings, one in 2B graphite pencil, one in compressed charcoal, and one in either a fine-point marker or pen and ink. Work on paper that you feel is appropriate in size and surface for each medium. Choose a single natural object that lends itself to being drawn in a variety of ways. On each page, draw the same object, and use one of the media in a wide a range of ways, experimenting with mark making and line quality. Be especially aware of the pressure variation and motion of your arm and wrist. Once you have started, new marks and lines should respond to prior marks and lines. Seek as much variation within each drawing as you can while maintaining a cohesive drawing. Let each of the three media lead you in your investigations; don't limit their scope with preconceived ideas. Find the range and the limitation of each medium.

Exercise 11.2 Extended Media Experimentation

In this assignment, you will be developing study pages of pure experimentation with a variety of media and papers. Your experimentation will not be tied to observation or image, but will consist of making marks for their own sake. First of all, study again the examples of artists' drawings shown at the beginning of this chapter (**Figures 11.1–11.8**). These examples show a good range of experimentation in the use of the medium within each drawing as well as from drawing to drawing. Look for more examples throughout the book. The pages you will be developing should show that you have tried as many as possible of the approaches shown in the book.

Note: It would be best to read this assignment all the way through before you begin, and come back to the beginning to reread as you proceed.

The main goal is to experiment with a wide range of lines, tones, marks, and erasures through

- a variety of arm and hand motions.
- a range of energies and drawing tempos.
- a range of pressures with the medium.
- a variety of media on different types of papers.

It will be important to learn how each medium responds on different types of paper from smooth to rough and to discover the expressive possibilities of each medium in order to stretch your idea of making marks, and working with the surface of your drawings.

Isolating media use from observation and concept, you will be able to experiment freely. The process of putting the various media down, moving them around, erasing them, treating them with care, with energy, with aggressiveness will be the focus. Try all the processes suggested below, plus anything else that you want. This is pure experimentation; the only way not to succeed here is not to push it far enough. Keep moving from one page to the next, using each medium on each type of paper, looking for ways the same medium responds differently on each paper.

Remember that you will be making lines, marks, and tones that are pure experimentation, do not try to make them represent an image.

Media: Experiment with the following, plus more that you choose:

> woodless pencil (medium to very soft)
> powdered graphite
> compressed charcoal (medium to very soft)
> powdered charcoal
> vine charcoal (thin and wide sticks, medium to very soft)
> conte sticks or conte pencils (medium to very soft)
> water in a spray bottle
> kneaded eraser
> hard eraser (such as a white staedtler mars)

Step 1: Securely fasten pieces of four different types of good-quality drawing or printmaking paper (one smooth, one

rough in texture; one soft, one hard in surface) at least 18 by 24 inches each on a smooth wall. Be certain to cover the wall and floor with a protective layer of paper.

Step 2: Isolate Joints:

An interesting experiment to begin with is to isolate the different joints of your arm and hand—shoulder, elbow, wrist, and knuckles—and practice moving one joint at a time. Observe the latitude of movement of your shoulder compared to your elbow and wrist and knuckles.

Draw with the motion coming only from your shoulder. Keep all the other joints inflexible. Stand back from the page and then draw with great arching motions, from your shoulder. Try this with each of the media, on each piece of paper.

Next move only your elbow to see what the range of motion is. Be certain to keep your shoulder, wrist, and knuckles locked in place.

Next isolate your wrist, locking all other joints. See how quickly and how flexibly you can move your wrist; push the limits to see just how convoluted you can get the motion. The motion will be shorter than in the shoulder and elbow drawings, but perhaps more controlled.

Next draw with only your knuckles to see how restrictive this feels.

Move back up to add wrist, then add the elbow, and then your shoulder. Identify where the sweep comes from, where the control comes from, and how all the joints work together to give you maximum possibilities in drawing with variation in weight, speed, value, rhythm, and expression. Sensitize yourself to the varying pressure that you can exert, from very light to very heavy and how this pressure influences the drawing process.

Step 3: Tones:

Now with each of the media, create tones on the pages. Each time you create tone, be certain to make a complete range from very light to medium to very dark. Experiment with the buildup of the tones by drawing with the side and with the point of the charcoal, conte, and other media. Then, rub into each with a soft cloth and a chamois. Experiment with the powdered graphite and powdered charcoal, putting them on a soft cloth to apply to the paper. Push them around with your fingers and hands and the cloth or chamois. Try erasing into the toned areas in as many different ways as you can, developing as many different tonal and erased surfaces as possible. Experiment with soft and sharp edges and create space with changes in tone and edges.

To push your experimentation further, think about atmospheric weather changes and create areas of energy based on wind storms, dust storms, hurricanes, torrential rains, cloud formations, hot windless atmosphere, cold damp atmosphere, and so on. In other words, without drawing from anything, imagine different energies and try to address them with the media. Go for rich, deep, dark areas and beautifully changing middle tones. Put the medium down, erase into it, put it down again, push it around, smush it, erase it, build it up with dark fresh tone on top of rubbed middle gray tone, and so on.

Use every combination of media: vine with compressed, conte with compressed, and so on. Sensitize yourself to the obvious and subtle differences among them. Prod the medium, coax out nuances, until you have developed tones that amaze you. Continually stand back from the drawings to see the developments.

Step 4: Lines and Marks:

Now, using each medium on each paper, draw lines and marks on top of the tones that you have already developed as well as on any bare areas of the papers. Range from large, gestural slashing lines to minutely, carefully done attentive marks. Draw at different speeds, quick, quick, quick, for two minutes and then frantic for 30 seconds. Then slow down and draw as slowly as you can with as much pressure change within the lines and among the marks as possible. Make marks and lines change from light to dark, thick to thin, using the side of the charcoal and other media, then the tip of the charcoal, twisting your wrist into contortions, then using no wrist, but just the shoulder, then all from the elbow, twisting the charcoal in your fingers, and so on. Make sharp, jabbing marks as well as long, undulating, curving lines; change the rhythm again and again: short, staccato, long, and drawn out. Try holding one type of charcoal in one hand, and another medium in the other hand, and then draw with both hands simultaneously. Have hands and medium create mirror images of each other; start them together at the top of the page and circle out to the edge. Stand back and edit.

Step 5: Erasing and Drawing:

Focus on the two types of erasers. Hold the eraser in your writing hand and charcoal in the other and continue to create tones, lines, and marks, but draw with the eraser. Do not think of it as erasing, but as drawing. Change surfaces, and transform areas with the eraser. Stand back, consider, edit, push, and change.

Step 6: Spritz Water:

Using water from a spray bottle, spritz a small area of the paper and draw into the damp surface. Using all of the media, in and out of the damp areas, continue to layer lines over tones, tones over marks and so on. Create areas of transparency with vine charcoal, put compressed over it, push it around with your hands, and fingers. Develop opaque areas of dense surface and create different spatial illusions; push it.

By the time you stop, you, your sheets of paper, and the floor should all be covered in charcoal, conte, eraser bits, and so on. You should have developed rich, varied, free experimentations, and you should feel loosened up, and have a sense of what the various media can do on the different types of paper. Think of "solar flares and heart catching smudges."

Exercise 11.3 Large-Scale Study Page of a Natural Object

Create a minimum of eight structural studies of one natural object on a single sheet of paper approximately 36 inches by 48 inches. Using your stretched vocabulary of marks, line character, and tonal range from Exercise 11.2, draw the object in many different ways from a variety of angles and views. This assignment has many aspects to it and can be done over and over again with different objects.

Heighten your visual awareness through drawing by paying careful attention to seeing and understanding your natural object. Give equal attention to understanding the structure of the form and continuing your investigations of inventive use of the media.

Note: It would be best to read this assignment all the way through before you begin and come back to the beginning and reread as you proceed.

Step 1: Choose a natural object about which you have great curiosity to draw. This could be a large insect, a seedpod, bone, skeleton, or other complex natural object that you can draw over and over again and still find more ways to draw it.

Step 2: Affix a sheet of good strong paper about 36 inches by 48 inches firmly to a smooth wall or drawing board. Choose several drawing media and a paper that work well for you based on Exercise 11.2.

Step 3: As you work, try to give each of the drawings different characteristics or attributes in these ways:

Duration: Vary the time you spend on each drawing on the page. Develop at least one fully resolved study of one hour, several 10- to 30-minute studies, and some 30-second gesture drawings all on the same page. Try to see quickly and slowly, as the speed and character of lines and marks reveal the duration of your attention to the object. A quick drawing of 30

seconds will give you a very different understanding of a subject than a prolonged one-hour study. But they both give you valuable information and can inform each other. They also will invigorate the page in different ways adding to an overall visual richness.

Alter the scale and space: Do some of the drawings larger than others so that the scale change of objects creates a varying spatial affect. The space will be activated as objects are moving closer and farther away, and as the angle of the object shifts from straight on, to side, to three-quarter, from top, from underneath, and so on.

Make each study different: Work with line, tone, and marks in as varied a manner as possible. Be inventive and experiment. Some of the drawings might be linear; try some twitchy, nervous, searching lines, where one edge has many lines. In other drawings, lines could be confident, bold, and have a single line define an edge. Tones can be built up and left in one area and in other areas, smushed around, erased into and drawn on top of. Tone part of the page with vine charcoal and pull the object out of that tone with your eraser. Combine tone with line; some edges may be defined with tone, some with line in a fluid movement from one to the other. Use cross contour lines with tone, and without tone.

Vary the rhythm, density, and character of the marks and lines; quick to slow, thick to thin, light to dark, straight to undulating. Erase into areas, and leave other areas freshly drawn. Move from graphite, to charcoal, to conte, for example.

Stay aware of the lines, marks, and tones as having a dual role of being physical marks on the page as well as being participants in creating the illusion of an image. Let layers of the medium become complex, as you study and draw simultaneously, not just to represent, but to know, and understand your object. The way you draw—the rich combinations of marks, tones, line, transparencies, layering—will make the viewer

want to look and will also reflect how you see and feel. Notice the different kind of information that you gain through different approaches to the drawings. The tactility and the physicality of drawing—the facture—become paramount here as you seek to understand the form and structure of this natural object in many dimensions. As you study tactile surface, structure, gesture, it is necessary to probe, focus, squint, and stare. Do not gloss over anything. Be sure to draw in ways that you have never drawn: stretch and invent new ways.

Look at many of the sketchbook studies in this chapter as examples of study pages. Also consider the student examples done in response to this assignment. Hyo Eun Grace Park's studies from a dragonfly **Figure 11.38** show a wide range of approaches to drawing. She experimented with tonal, linear, developed, and quick studies as well as drawing with her eraser. The many layers of studies take advantage of the transparency of the dragonfly's wings. Sangram Majumdar's skeleton and insect study pages in **Figures 11.39** and **11.40** reflect his strength in drawing volumetric structures while experimenting with the approach and the use of his media.

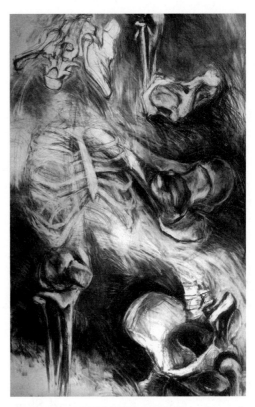

Figure 11.39 SANGRAM MAJUMDAR, student work, study page of skeleton, charcoal on paper, 48 × 36 in.

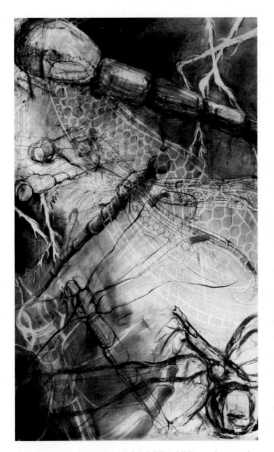

Figure 11.38 HYO EUN GRACE PARK, student work, study page of dragonflies, charcoal on paper, 48 × 36 in.

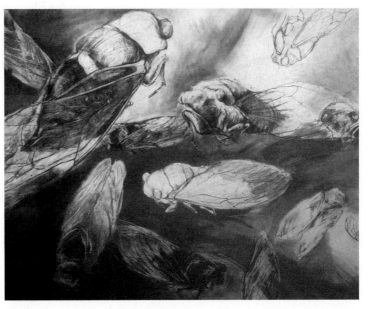

Figure 11.40 SANGRAM MAJUMDAR, student work, study page of insect, charcoal and conte on paper, 48 × 36 in.

Exercise 11.4 Developing Your Personal Use of Sketchbooks

Begin by studying different ways in which artists use sketchbooks, as demonstrated by the images and descriptions in this chapter. Some draw from observation, some develop compositions for paintings, others do research drawing, and some draw their dreams. Many work in all of these ways. You have been doing a variety of types of sketchbook assignments throughout the preceding chapters. It is time now for you to come to terms with just how a sketchbook can best serve you. It may be helpful to you in many different ways, and these will evolve as you change as an artist. Look back through your sketchbooks and think about the most meaningful pages to you. Perhaps this is a direction to pursue. Was there a Sketchbook Link assignment that you particularly liked doing?

You could do several more in a similar direction to see where it leads.

Think about the type of sketchbook you use. Some artists make their own books with the paper they most like to use, even binding them with leather. Whether you use a spiral ring sketchbook, an inexpensive book, or a custom-made one, make sure it is of a size and weight that feels good in your hands. Continue to use your sketchbook and to have it with you at appropriate times. In the next two chapters you will be developing a body of work of your own ideas, and sketchbook ideas will be very valuable in that project.

—— Critique Tips Chapter 11: Investigations with Media ————— and Sketchbook Studies

These suggestions are not for group critiques as much as questions to ask yourself and discuss with your teacher in looking at your sketchbooks. They will help you find direction for your future use of sketchbooks.

In using your sketchbook (other than for Sketchbook Links) did you fill it with inventive or subconscious doodlings? *Did you make plans for specific projects, drawings from observation, media experimentations, or all of these?*

Do you feel that your sketchbook should be for your eyes only? *Are you comfortable sharing it with your teacher and classmates?*

Are there more written notes or more visual work in your sketchbook? *Which seems more relevant to you now?*

Do you like to use your sketchbook to consider variations in compositions and drawing styles before you begin a drawing? *Are your sketchbook drawings more gestural or more developed, or is there a range from one to the other? Is there freshness, or immediacy in your sketchbook drawings, and are you able to translate that to your more developed drawings?*

If your work is evolving or changing, can you see evidence of this in your sketchbook first? *Do you use your sketchbook drawings to think ahead of your more developed work?*

Is there an example of an artist's sketchbook in Chapter 11 of particular interest to you as an artist? *If there is you may want to reseearch the work in more depth.*

Notes

1. Holland Cotter, "Leonardo, The Eye, The Hand, The Mind," *The New York Times*, January 24, 2003, p. E37.
2. Henri Matisse, quoted in Jack Flam, *Matisse on Art*, University of California Press, 1995, p. 172.
3. Leonardo, quoted in Charles O'Malley and J.B. De C.M. Saunders, trans., text and Introduction, *Leonardo on the Human Body*, Dover Publications, Inc, New York, 1983, p. 32.
4. Alberto Giacometti, quoted in Luigi Carluccio, *Giacometti, a Sketchbook of Interpretive Drawings*, Harry Abrams, New York, 1967.
5. Alberto Giacometti, quoted in Luigi Carluccio, *Giacometti, a Sketchbook of Interpretive Drawings*, Harry Abrams, New York, 1967.
6. Eugene Delacroix, quoted in Roger-Marx, Claude and Sabine Cotté, Delacroix, The Great Draughtsmen, Lynn Michelman, translator, George Braziller, Inc. 1971, p. 43.
7. Roger-Marx, Claude and Sabine Cotté, Delacroix, The Great Draughtsmen, Lynn Michelman, translator, George Braziller, Inc. 1971, p. 47.
8. Thomas Lyon Mills, "Pathways to the Invisible", RISD Views, spring 1999, p. 22.
9. Thomas Lyon Mills, "Pathways to the Invisible", RISD Views, spring 1999, p. 22.
10. Thomas Lyon Mills, "Pathways to the Invisible", RISD Views, spring 1999, p. 23.
11. Dawn Clements, Artist statement, May 4th, 2005. (found on www.kftgallery.com/past/?object_id=95&show-press&pressid=117.

Contemporary Processes and Series 12

IDEAS INTO SERIES

The focus of Chapters 12 and 13 is to build on all your previous drawing experience in the development of a **series,** or a body of related work around an ongoing, evolving idea. Focusing on an idea for your series will take some time and effort and involve decisions on many levels. Chapter 12 discusses contemporary drawing **processes** from **planned** to **spontaneous,** considers varied approaches to the same subject matter, and explores drawing series by contemporary artists, to help you begin to think about your ideas for a series in a general way. Chapter 13 suggests specific steps to develop your own series of drawings.

Benefits of Working in a Series

Why work in a series of related drawings? Why not invent a new approach each day? Simply put, staying with an idea or theme over a period of time enables artists to establish a definite and considered **attitude** in their work as possibilities inherent in the subject are discovered. This particular attitude and the specific possibilities that are pursued in a series of drawings distinguishes one artist's work from another. Work that remains on the surface of an idea merely travels where many others have been. Conversely, an intense immersion in a focused direction will get you to a place in your work that you did not realize existed. In other words, working in series most often leads you to do drawings that you would never have made otherwise: drawings that will communicate your ideas, insights, feelings, and/or gut responses in greater depth. With this level of involvement, it stands to reason that you will have more invested in your series than in daily class assignments because you will determine its direction.

The Creative Idea

Artists must be willing to take chances, fail, and go off in tangents, but their work does not have to be absolutely 100 percent different from anything previously done to be a genuinely creative effort. Often, ideas spring from a new perspective, or a gradual evolution of an approach. Being flexible and intuitive in looking for new connections can lead to creative insights, building on the foundation of ideas already established. Most contemporary artists cite artists from the recent and/or distant past as influences. For example, contemporary artist Carroll Dunham has a unique way of viewing the world (**Figure 12.1**) but acknowledges his artistic debt to twentieth-century artists such as Willem DeKooning (Figures 8.3 and 10.8) and Philip Guston (Figure 10.12). Dunham studied art history and consistently visited museums to follow the evolution of art through the centuries. In a talk at the Museum of Modern Art, Dunham said his ideas came from "a combination of loving tradition and wanting to find my own way." He viewed the movements in art history "as an ongoing conversation that I could step into."[1] No one would argue that Dunham copied anyone's work, for he certainly has a clear and unique vision; rather his work came from his study of art history coupled with his response and reaction to aspects of twentieth- and twenty-first-century art.

As in art, completely original ideas, disconnected from any precedent, are very rare in most fields of study. Consider the scientists who first understood the structure of DNA. Simply put, James Watson and Francis Crick studied research done by Rosalind Franklin from a different point of view, which led to their discovery of the structure of DNA. Her work clearly led to theirs, just as her work built on what had come before. But, Watson and Crick had to be flexible and intuitive in their thinking and bold in their approach to make their leap. In the same way, as we have seen with Dunham, most artists understand what came before them and make a bold leap. The creative ideas of their work are considered in that context.

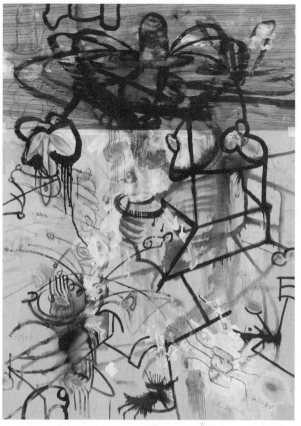

Figure 12.1 CARROLL DUNHAM, (b. 1949), *Untitled* (1985), casein, synthetic polymer paint, emulsion, pencil, charcoal, ink, felt-tip pen, and linen tape on wood, 42 5/8 × 30 1/8 in. (Gift of the Louis and Bessie Adler Foundation, Inc., Seymour M. Klein, President. [446.1986] Location: The Museum of Modern Art, New York, NY, U.S.A./Digital Image © The Museum of Modern Art/Licensed by SCALA/Art Resource/Caroll Dumham © 2008 Courtesy of the David Nolan Gallery, NY)

Sketchbook Link: Influences on Artists

Research an artist to find which artists influenced him or her. Do some studies of all the artist's work, seeking the connections and influences. You may want to study Carroll Dunham's work to find its relationship to DeKooning and Guston.

ISSUES AND IDEAS

❏ Artists work in series to find possibilities beyond immediate or predictable ones, and to develop a specific attitude toward a visual idea.

❏ In visual art, creative ideas are usually new ways to look at something or a different way to interpret an idea that has been worked on before. Bold leaps spring from something that came before.

The Visual and the Verbal

In moving toward ideas for a series of drawings, it is important to understand the relationship of **visual ideas** to **verbal expression.** Generally speaking, visual thinkers see images in their minds, and verbal thinkers hear words in their minds. Even though all people have the capacity to think visually and verbally, it is a good idea to consider the balance of these two modes in your own thinking and to identify your strengths. Of course, some types of visual art are more related to language

than others: Film, theater, graphic novels and some interdisciplinary art function simultaneously on visual and verbal levels and depend on the successful mixing of verbal and visual messages.

Artists make visual expressions to reach visual thoughts and sensations; this visual realm is not entirely explicable by language. However, language is a primary means of communication for people and therefore it is essential to think about its value as well as its limits in describing visual art. While critics, art historians, and artists write about visual art, most often it is not their intention to define the intrinsic nature of the work, but more to describe, or contextualize the work. Connections can be made to other works of art, art history and social issues. Also, the **formal elements**, the **abstraction of the marks**, the **subject matter**, and other **content** can be discussed.

A great work of art dealing with a compelling visual idea will affect you first and foremost on a visceral, instinctive level, though a more conceptually complex or cerebral aspect of the work's content might emerge after longer contemplation. You may have had the experience of walking into a museum or gallery and being overcome by a particular work, unable or even unwilling to verbalize the feeling. Perhaps this piece had a particular balance of visual form and concept and a provocative use of medium, affecting both eye and mind. Eventually you might try to verbalize or **analyze** just what it was that affected you, but you may be able to fully understand it only through direct visual experience. The words used in your analysis are definable and perhaps limiting, and you can look up their meaning in a dictionary, but no such resource exists for the marks and lines you are attempting to comprehend. These marks and lines reach to places unknowable by descriptive words as they communicate differently than words and often function on an encompassing, subconscious level, rather than on a linear, sequential level. Drawings and other forms of visual art often have multiple, shift-

ing threads of meaning that evoke a sense of mystery: The full impact cannot be expressed in words. Look again at some drawings in earlier chapters. Works by Jasper Johns (**Figure 7.5**), Miriam Cahn (**Figure 11.4**), and William Kentridge (**Figure 11.6**) are just a few examples of the drawings in this book that must be experienced; their full visual ideas and emotional content defy verbal description.

Emphasis on the visual in your work does not necessarily limit your consideration of verbal sources as inspiration for visual statements. As you will see later in this chapter in the section Series of Drawings by Contemporary Artists, some artists use literature or myths as starting points for their visual work. Other verbal sources that artists often use such as graphs, charts and diagrams have visual aspects. Graphs, charts, and diagrams present verbal facts and information through visualized data, but the data does not contain ideas or reveal how the statistician felt about the information—content and meaning end with the facts, or with a conclusion that can be drawn from their presentation.

In a large-scale drawing, contemporary artist Tim Hawkinson played with the visual/verbal relationship in fact-filled history charts when he used the form of a history chart but pushed its visual expression to the extreme. He chose the title *Wall Chart of World History from Earliest Times to the Present* (**Figure 12.2**) as a verbal cue to the viewer. Hawkinson's statement, ". . . the reference

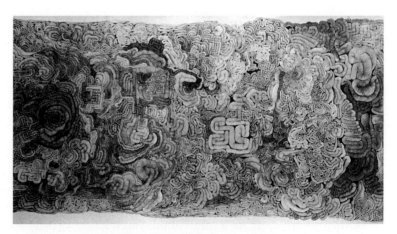

Figure 12.2 TIM HAWKINSON, Detail *Wall Chart of World History from Earliest Times to the Present* (1997), pen and pencil on paper, 51 × 396 in.

to history came after making this drawing and seeing it as kind of a time line because it has this feeling of different events being portrayed, one taking over another,"[2] shows that his choice of title was in response to the drawing; a previously chosen verbal title or theme did not determine the visual drawing. There is not any historical information in the drawing as there would be in an actual wall chart of history. But within the format of a large-scale time line, there is a visual interpretation of history formed by complex, convoluted interactions on a global magnitude with events and territories pushing into each other and changing the course of the world. This visual version of the feeling of history embodies more of the tense emotions of world history than an informative, fact-filled chart ever could.

This discussion of visual primacy in art does not mean that there is not a role for verbal thinking. Many artists will work for a while on an intuitive, subconscious level and then stand back to consider and verbally analyze what they have done. Writing about a drawing or series in progress can be a beneficial way to think about the work and prompt new ideas. Individuals have different processes of working, and the balance of visual intuition and verbal analysis differs for each artist. You will consider different working processes more specifically in the next section of this chapter.

Sketchbook Link: Reading about Art

Find a drawing that you respond to and read something about it. Consider how limited or complete the writing is in relationship to your ideas and feelings about the piece. Make notes in your sketchbook.

ISSUES AND IDEAS

❑ Visual art communicates visually; its meaning or expressive character cannot be fully described verbally.

❑ It is important to be able to speak and read about artists' work and to write about your own ideas for your series, to clarify the goals or context of the work, while understanding that the essential impact of the work is visual.

PROCESS: PLANNED OR SPONTANEOUS

Working process, or approach, is another important issue for artists and the balance of preplanning and spontaneity is something to consider. Some artists know what the outcome will be before beginning their drawings and other artists make most of their decisions during the process of drawing. Visualizing the working process and preparing for it are extremely important, but there can be a vital role for discovery and creative accident once the work has begun. Qualities of marks such as degree of expressiveness or refinement in a finished drawing can reveal a sense of the artist's process, but more than mark making must be considered in determining the artist's balance of planned or spontaneous process.

In looking at a drawing, ask yourself some questions about its formation. Is the drawing a spontaneous first response to a visual or mental stimulus, or does it seem to be the result of numerous sketches and much prior planning of

compositional ideas? Did the artist develop the piece **intuitively,** feeling his or her way as the drawing evolved, taking the lead from the act of making the drawing itself? Or did the artist work more **deductively** and deliberately, controlling the outcome from the beginning? What is the balance between rational thought and spontaneous action? Four very different artists will be considered in relationship to these questions to see how their diverse approaches to planned and spontaneous processes, coupled with their use of drawing media, give meaning to their work. As you read, think about your own inclinations in drawing, and how you might want to approach the process in your upcoming series of drawings.

Searching without a Plan

Looking at the drawing by British artist Frank Auerbach **(Figure 12.3)** the viewer immediately senses an intuitive, passionate process that was not preplanned. As he developed the drawing, Auerbach responded both to the subject and to the marks building up on the paper. Art critic and writer Robert Hughes described his experience of sitting for a portrait: "The work of drawing begins. Auerbach has a sheet of paper, or rather two sheets glued together, ready on the easel. The paper is stout rag, almost as thick as elephant hide, resistant to the incessant rubbing-out that will go on for days and weeks. As he scribbles and saws at the paper, the sticks of willow charcoal snap; they make cracking sounds like a tooth breaking on a bone. When he scrubs the paper with a rag, clouds of black dust fly. An hour into the sitting the sitter blows his nose and finds his *snot* is black. The studio is like a colliery; the drawing easel is black and exquisitely glossy from years of carbon dust mixed with hand grease. Auerbach works on the balls of his feet, balanced like a welterweight boxer, darting in and out. . . . Through the next twelve sittings . . . this creature will mutate, becoming dense and troll-like one day and dissolving in furioso another, eye contact almost obliterated in a third as the mass of the face is lost in a welter of hooking lines and zigzag white scribbles of the eraser."[3]

As Auerbach pulled the image out of the paper, his real subject was the drawing process: the

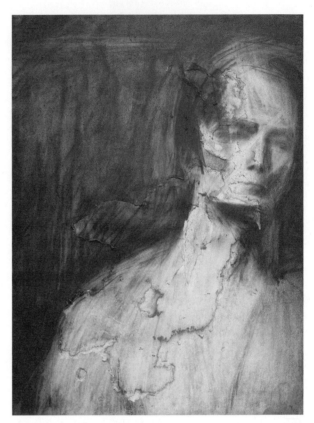

Figure 12.3 FRANK AUERBACH, *Head of E.O.W.* (1960), charcoal on paper, 30 3/4 × 22 3/4 in.

relationship of marks to marks, marks to tone, tones to tones, and so on. Certainly, tones and marks refer to the head's structure, but simultaneously they are records of process: a cycle of drawing, erasing, drawing, rubbing, creating layers of tones and slashing energetic marks; all built, torn away and rebuilt. In other words the drawing is an act of expression tied to observation and the marks have a dual role to play: one in their descriptions of the subject, and the other as a record of the gesture of Auerbach's hand. The sense of frenzied, responsive process helps determine the drawing's meaning. Requiring up to 40 sittings from his portrait subjects, Auerbach said, "I can do something that looks like one of my drawings in half an hour—but I find it unsatisfactory; it never seems specific enough for me, it never seems to be new enough. So I find myself going on . . . and as I go on I find the problem more and more impossible, and because, I suppose, of my temperament I find myself behaving in an excessive way in order to solve the

problem." He also said, "To do something predicted doesn't seem to be worth doing at all . . . But to do something both unforeseen and true to a specific fact seems to me to be very exciting."[4]

After working on a drawing for days, Auerbach arrived at a drawing that revealed his raw and searching process. It is a process that he believed in as he created the portraits with an intuitive, unplanned approach: Slashes, tones and marks work together, added and deleted, moving from chaos to image.

Spontaneity with a Planned Process

Unlike Auerbach, contemporary sculptor Richard Serra does not adjust or build his drawings in response to the stimulus of mark or observed form; instead, he follows a predetermined drawing process. The resulting drawings are material evidence of the actions he took to create them, and it is the actions that he values as much as the outcome on the paper. Paradoxically even though the steps of Serra's plan are **automatic,** or regulated, the drawings produced have a spontaneous aspect **(Figure 12.4)**. Swept into the visceral, swirling black lines, the viewer is spun around and around in a repetition just short of a chaotic force of nature. Due to the size of the drawings and the density of the smudgy lines, this is an experience for the entire physical self. But, this gestural quality of line is at odds with the methodical process of their creation. Serra has written about these drawings; as you read his statement visualize his process and contrast it to Auerbach's. "In this series of line drawings the process is more important to me than analyzing and placing a line in relation to other lines . . . Melted paintstick is poured onto a hard surface on the floor. Some times, not always, a sheet of window-screen is placed on top of the liquid paintstick. The paper is laid down, either on top of the screen or directly on top of the liquefied paintstick. Pressure is exerted on the back

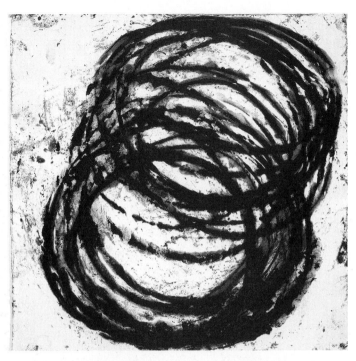

Figure 12.4 RICHARD SERRA, *In Spite of the Other* (2001), paint stick on handmade paper, 39 1/2 × 39 1/2 in.

of the paper with a hard marking tool. The front side of the paper picks up the mark. With a few exceptions where the front is marked through a blackened screen no direct drawing is done on the front of the paper. I don't see the drawing I am making until the paper is pulled off the floor and turned over or the screen is lifted."[5] Serra did not look at the drawing as it was made and most often did not draw directly on it after the process. He was truly more engaged with the plan rather than a responsive, hands-on search for form and image.

Planned Image and Process

In sharp contrast to the expressive physicality of the Auerbach (Figure 12.3), and Serra drawings (Figure 12.4), Glexis Novoa's graphite drawing on marble (Figure 12.5) communicates its message primarily through the specific details of the image. These drawings are large-scale, precise renderings of invented cities, some as large as 166 feet in length. Planning and determining his work before beginning to draw, Novoa incorporated everything from the Pyramids of Giza to generic skyscrapers.

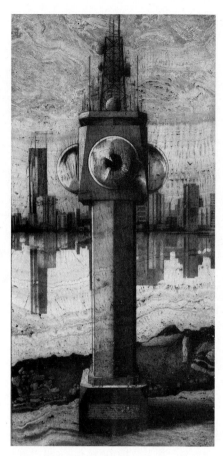

Figure 12.5 GLEXIS NOVOA, *Esperando el Enemigo,* graphite on marble, 24 × 12 in. (Courtesy Glexis Novoa and Bernice Steinbaum Gallery, Miami, FL)

Novoa has lived in the United States since 1995, but his early years in Cuba are still very much with him, "My personal experiences as an immigrant has defined my interest for the horizons that I leave behind and those which I approach. What was my home yesterday, today is a visionary line between the sky and the sea with barely recognizable characteristics and vice versa. Logic is subverted from a realistic point of view."[6] Metaphorical horizon lines are important elements of many of Novoa's drawings addressing the social and political issues of privacy in an age of information technology. The expression was planned, controlled, and realistic, but Novoa gave this hyper-planning and hyper-realism a negative social connotation in relation to the subject matter and concept.

Systematic Process

Like Novoa, Sol Lewitt was concerned with a planned process, but, unlike Novoa, he was committed to the development of the **system of the drawing** as process. Wanting to have the idea of the system paramount in the drawing, Lewitt created elegantly deductive plans, wrote up sets of clear directions, and hired assistants to execute the pieces. All decisions were made before the drawing began. In the execution, the lines are varied as little as possible at complete odds with Auerbach's aesthetic. The title of the wall drawing (**Figure 12.6**), *All Combinations of Arcs From Corners and Sides: Straight, Non-Straight and Broken Lines,* suggests the editing out of the opportunity for spontaneity in execution. These are cerebral, geometric systems and Lewitt's intellectual passion for the original concept of the system held his interest. Nonetheless, the drawings are evocative and wondrous, conceptually clear to be sure, but also full of mystery. As critic Robert Rosenblum stated, "The immediate experience, like that of any important work of art that stops us in our tracks and demands lingering attention, is visual and visceral, rather than exclusively intellectual, and as such bears an intensely personal flavor that distinguishes it at once from the work of other contemporary artists concerned with, say, modular systems or the realization of verbal-visual equations."[7] For

Observed, remembered, and imagined city landscapes all have roles in his work including buildings with cameras, satellites, science-fiction insects, microphones, and in (Figure 12.5) a large eye on a tower. In this image, the cityscape is distanced through scale change, as well as linear and atmospheric perspective, leaving the viewer adrift, removed, and alienated. This alienation is reinforced by Novoa's characteristically precise use of materials to create an expressive distance and omnipresent control that is exaggerated by the absence of humans in the image. What kind of world is it that has this tower with a giant surveillance eye watching the city and the viewer? Novoa's drawings embody a past or future society, failed, desolate, and uninhabited, led astray by authoritarian power. Beautifully rendered and perfectly depicted, this world is not a place the viewer wants to live or visit.

Figure 12.6 SOL LEWITT, *All Combinations of Arcs From Corners and Sides: Straight, Non-Straight, and Broken Lines (Wall Drawing)* (1972), blue chalk

Lewitt the developmental process of an idea rather than the execution embodied the expression; however, the expressive outcome is still predominant. Lewitt's visual poetry is undeniable, but surprising in light of his chilly process and geometric form.

Auerbach, Novoa, Serra, and Lewitt have powerful approaches due to their commitment to process, and the clear direction each takes. All the drawings convey meaning through the marks, lines, and tones, embodying passion or distance, but there is great variety in the balance that occurs between spontaneity and plan in their processes. Drawing can be the immediate indication of the artist's responsive hand, or the revelation of his or her preplanned intellectual process. Each artist must learn to listen to his or her own natural incli-nations and decide which sort of process is consistent with his or her ideas. As preparation for your series, think about what your balance of preplanned to spontaneous process may be.

> *Sketchbook Link: Process: Planned or Spontaneous?*
>
> Look back at several of the assignments you have done. Make notes in your sketchbook about the process you used. Did you preplan the drawing, having a clear idea of what it would look like when it was complete, or did the drawing evolve as you drew? Think about what feels more natural for you, a plan or spontaneity.

ISSUES AND IDEAS

❐ In approaching a drawing or a series, the process should be clearly considered and linked to the ideas being expressed.

❐ The balance of preplanning and spontaneity varies greatly from artist to artist, and each artist must determine his or her comfort with intuitive and deductive approaches.

❐ Even the most planned drawings have expressive content.

DRAWING CONTENT FROM LIFE

When considering possible themes, artists often try to work with ideas that have meaning to them personally about which they have strong feelings and can express a definite attitude or idea. The subject matter alone is not enough to state as an idea. An artist who wants to draw people must then ask what it is about people that he or she wants to communicate or investigate. Even drawings with similar subjects can vary greatly in meaning and content, and as an example of this, works from four twentieth-and twenty-first-century artists dealing with the female figure will be considered. The final outcome and expressions are distinctive, as formal issues, process, and subject matter are adjusted in relation to the individual artist's priorities. Of great importance are the time period in which the artists worked and the social issues relevant at that time. The goal in comparing these drawings is to give some insight about particularizing a subject for a series. It is not enough to say that a series is about the figure because artists address questions of broader meaning accessible through the figure in planning and making drawings.

Personal Connection: Alice Neel

Alice Neel's drawing *Two Girls* (**Figure 12.7**) depicts children from her Spanish Harlem neighborhood in New York City. Characteristically expressive, her drawings have an unforgiving directness, and this one captures the very essence of the two young girls. Never pausing, the line moves rapidly with a distinctive, playful gesture over details of clothing. But then, the line slows at the faces and hands where tonal shapes individualize their appearance. Gradually, the portraits become strangely adult in facial expression, and the girls seem world-weary; perhaps momentarily so, perhaps longer term. Or, did only Neel herself feel weariness and express that through them?

Forming one visually bonded shape, the pair seem mutually dependent; as one girl sinks back,

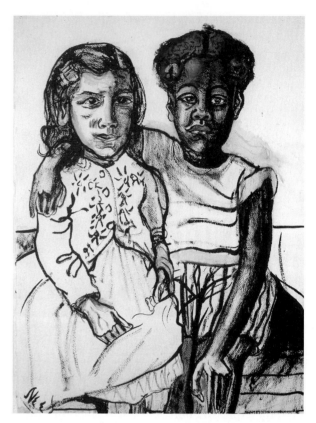

Figure 12.7 ALICE NEEL, *Two Girls* (1954), ink and gouache on paper, 29 1/4 × 21 3/4 in. (74.3 × 55.25 cm) (© Estate of Alice Neel. Courtesy Robert Miller Gallery, New York)

she stares directly at viewers and seems to protect the other with her arm raised around her. The other is moving forward but looks beyond viewers at a slight angle. Is this relationship a visual statement about this particular friendship or female friendship in a universal sense? Further, what roles do gender and race play in the friendship? What lies in the future for these children? Will they still know each other in adulthood? The viewer cannot answer these questions definitely, but Neel's drawing provokes speculation through her convincing evocation of the girls' humanity. The artist does provide some clues in her compositional choices. There is a visual stability in the drawing based on the vertical and horizontal elements, and a quiet, assured solidity in the attitude and pairing of the figures. Neel said she never posed her sitters but engaged them in conversation: "When I talk to the person, they unconsciously assume their most characteristic pose, which in a way involves all

their character and social standing—what the world has done to them and their retaliation."[8] Viewers see a merging of Neel's investigations and the individuals' uniqueness. She worked all her life drawing and painting people she knew personally—her neighbors, her family and friends—and she is able to convey to the viewer her vivid personal connection with her subjects.

Identity: Ellen Gallagher

Contemporary artist Ellen Gallagher drew and collaged onto advertisements from the 1940s to the 1970s that she found in magazines with a black audience, such as *Ebony*, *Sepia*, and *Black Stars*. These ads suggest that personal physical transformations such as lightening one's skin, straightening one's hair, and losing weight are easy to achieve and that the transformations will lead to a better life for black women. The found images are startling out of their time and now, of course, seem dated and strange. Gallagher has a large collection of these magazines, some of which featured interviews with prominent black writers and politicians; the irony is that the interviews were paid for with ads that diminish the qualities of blacks and women.

In *Skinatural* (**Figure 12.8**), Gallagher imposed her own changes onto the ad that promotes the makeover possibilities of stretch wigs. Masking the model's eyes because she cannot believe they realize what they are promoting, Gallagher also drew hundreds of googly doll eyes on the right half of the page as a comment on seeing, pretending, and understanding. Her applicaton of pink plasticine to the face of the model on the bottom row is a reference to race. In other collages, she blocked out brown eyes and inserted blue ones, put glitter over eyes so that the models cannot see, and covered black hair with yellow plasticine. Gallagher pushes the already offensive ads to be even more unsettling annd grotesque in their abusive attitudes towards women and blacks.

Through the transformations, Gallagher questions identity, physical appearance, and the use of advertising to make women and minorities uncertain and even disdainful of their natural physical appearance. The ads want viewers to believe that the models were plain and unhappy until they discovered the transformative powers of the stretch wigs, fancy skin-lightening creams or weight loss formulas. But the ultimate fate for the models was to be transformed again by Gallagher, learning the lesson that they were duped by a society that only addressed the surface qualities of women.

With a sense of humor and an intellectual interpretation of advertising, Gallagher calls to question the claims of easy transformation but also pushes viewers of all races to think about the state and effect of advertising in our contemporary

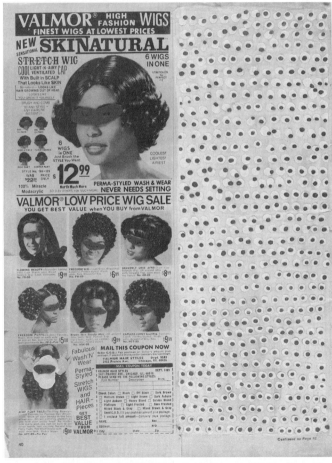

Figure 12.8 ELLEN GALLAGHER (b. 1965), *Skinatural* (1997), oil, pencil, and plasticine on magazine page, 13 1/4 × 10 in. (Gift of Mr. and Mrs. James R. Hedges IV. [296.200] The Museum of Modern Art, New York, NY, U.S.A./Digital Image © The Museum of Modern Art/Licensed by SCALA/Art Resource, NY © 2009 Ellen Gallagher/courtesy Gagosian Gallery, NY)

lives. We cannot help but ask whether the ads focused on us now are just as outrageously manipulative, silly and destined to look dated in a few years. Of course, the answer has to be yes.

Personal Concern: Kaethe Kollwitz

Kaethe Kollwitz's work is direct, personal, and about life experiences. As a *social activist* in Germany during the two world wars, she experienced suffering and political turmoil. Her own son was killed at a young age in World War I, and her grandson died in World War II. Married to a doctor who cared for factory workers in the poorest area of Berlin, she saw their hardships first hand. As a result, death was a reality she dealt with in her life and in her work.

In *Death Seizes a Woman* (**Figure 12.9**) Kollwitz suggests a loss of physical and emotional

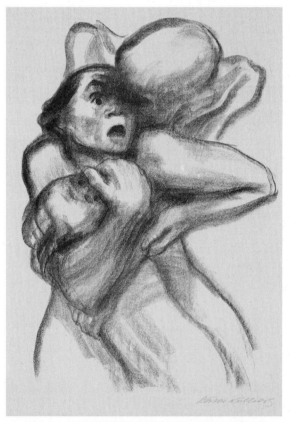

Figure 12.9 KAETHE KOLLWITZ (1867–1945), *Death Seizes a Woman* (1934), from the series *Death* (1934–1935), lithograph, printed in black, composition: 20 × 14 7/16 in. (50.8 × 36.7 cm) (Abby Aldrich Rockerfeller Fund. [1655.1940.4] Location: The Museum of Modern Art, New York, NY, U.S.A./Digital Image © The Museum of Modern Art/Licensed by SCALA/Art Resource, NY/© 2009 Artists Rights Society (ARS), NY, VG Bild-Kunst, Bonn)

control through her approach to the drawing. Not surprisingly, the subject is the arrival of early death due to social injustice. The woman portrayed is not a particular individual as in Neel's portraits, but an anonymous victim from a downtrodden social class. Kollwitz drew her lines rapidly and forcefully, with a passionate velocity, as she expressed the agony and hopelessness of resistance to Death's advances. The strong angles give the composition an active and terrifying feeling, furthering the look of panic on the woman's face as she desperately shields her child from the image of death. Kollwitz clearly identified with this woman; the viewer feels her personal psychological involvement through human gesture, mark, use of medium, and composition. Many of her drawings of figures have a weary weight in their gestures, expressed in the stroke of her charcoal and lithography. Understanding her passions she said, "Everyone works the best way he can. I am content that my work should have purposes outside itself. I would like to exert influence in these times when human beings are so perplexed and in need of help. Many people feel the obligation to help and exert influence, but my course is clear and unequivocal."[9] Kollwitz's desire to make her work an agent for social change is admirable and valid, and it led her to create a moving body of work. Furthermore, her personal concern gave a public voice to oppressed groups of people as she looked outside of her studio and her own life for inspiration.

Referencing Stereotypes: John Currin

In his drawings and paintings, John Currin intentionally brings up forbidden **stereotypes** and **politically incorrect** attitudes our society has about women, including the controversial issue of the representation of women in art by men. By drawing women with exaggerated physical features—glistening white teeth (**Figure 12.10**), huge breasts, distorted thin bodies—he disparages these stereotypes but simultaneously pokes fun at his generation's mandate of **political correctness.** Overstating these characteristics that media and advertising have made seem desirable, he transforms many of his women into deformed monsters, gaining attention for his art by courting angry reaction.

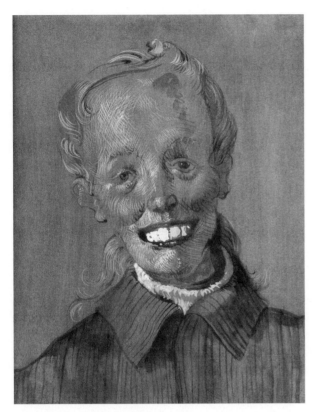

Figure 12.10 JOHN CURRIN, *Mrs. So-and-So* (2000), ink and goache on prepared paper, 13 7/8 × 10 7/8 in.

Currin **appropriates** his varying drawing styles from old masters and illustrators, representing his vacant, vapid women with styles based on artists such as Watteau, Fragonard, Durer, Cadmus, and Rockwell. His ability to jump easily from one style to another distances his work from sincere expression, as though he is assuming a persona for the sake of the statement. To general acclaim, he executes his stylistic quotations faultlessly, effectively evoking the virtuosity of the artists he imitates. Challenging the viewer to re-

spond to his calculated, unsettling images, Currin skewers societal attitudes strongly held by much of the art world, revels in forbidden subject matter, and at the same time seems to criticize the stereotypes. Currin succeeds in intriguing the art public, adopting a shifting stance that is difficult to pin down, but clearly inflammatory.

Neel, Kollwitz, Gallagher, and Currin all worked from their own feelings and ideas—intuitive or calculated—tapping into personal experience and the social realities of their respective eras. The uniqueness of their content and styles came from a clearly determined approach based on personal experience and expressive priorities. None of them went against their nature or resisted it, and all worked from insight into their own concerns toward an appropriate means of expression. Similarly, every artist must discover her or his own means of expression: the use of composition, medium, and character of mark to support the ideas behind the work. It is an essential step to take the art of drawing beyond simple exercise: to make decisions and take control of your work in personally directed ways, working from your own ideas, with your own approach to subject and process outside of any specified class assignments.

> *Sketchbook Link: Influences on a Drawing*
>
> Research a drawing to discover how the artist's life, times, and personal inclinations influenced his or her approach to the piece. Make notes about this in your sketchbook along with a study of the drawing that can be an interpretive one; it need not be a copy.

ISSUES AND IDEAS

❏ Artists work with ideas that have meaning for them on a personal and/or societal level.

❏ The time period in which the work was done often determines relevant social issues that influence the artists' attitude in their drawings.

❏ As an artist you must move beyond exercises, connecting your drawings with personal concern and stylistic approach.

SERIES OF DRAWINGS BY CONTEMPORARY ARTISTS

It is important to look at an artist's work as a body of related pieces in order to discover the influences, source materials, processes, expression, and use of the medium. Visiting museums and galleries to see a work in person rather than through reproduction is beneficial. One-person shows offer excellent opportunities to view work and usually exhibit series of works done within a specific, often, recent time period. This part of the chapter focuses on series of drawings done by contemporary artists. Drawing is the final form for these works of art; they are not studies for paintings, sculptures, or installations. As you look through them, you may get some ideas for your own series.

Elinore Hollinshead

Over many years Elinore Hollinshead has developed an impressive body of work that is rich with visual, historical, and mythological references. In addition to dealing directly with universal life issues of change, time, season, growth, death, birth, and nature, she boldly adds autobiographical content to make her work more powerful, more layered, and ultimately more meaningful. Her work can be experienced as personal history or as broad philosophical statements. The complexity of her imagery holds viewer interest over a long period of time as the numerous references unfold. Often the content is difficult and disturbing, at other times it is more comforting; but it always presents a strong and unavoidable emotional element. Artists who have influenced Hollinshead's work include the **mannerist** Bronzino with his jam-packed **allegorical** narrative painting such as *Venus, Cupid, Folly and Time.* Other influences have been Richard Diebenkorn's use of the figure to compose the page; Juan Gris' layered Cubist collages, and Frida Kahlo's strong emotional and psychological content.

 Figures 12.11 to 12.14 are from a series of eight pieces in which the metaphorical narratives are about **identity** and life. Hollinshead knows the stories of Greek myths intimately, and she connects the ancient fables to the significant and ultimately major life-altering choices people must make in contemporary life. Bringing these two interests together, Hollinshead juxtaposed fragments from classical relief sculptures with an autobiographical, contemporary figure in a dream state. The issues addressed pertain across divisions of time and culture, relevant to all people. Consider the double meaning in the title *To the Altar* (Figure 12.11). Hollinshead's reclining, drugged body is on a stone funeral slab being carried off for sacrifice to the gods, or to the marriage altar. The artist evoked her own helplessness in a ritualized societal situation and the life changes this would entail on a personal or professional level. The message is one that is broadly applicable to individuals in modern society facing the demands of adulthood, career, and family. The layers of universal and individual identity

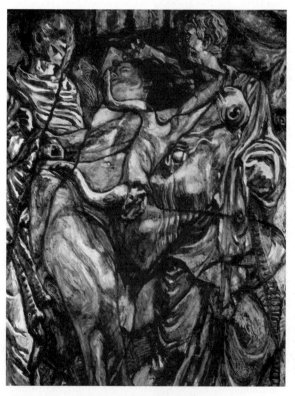

Figure 12.11　ELINORE HOLLINSHEAD, *To the Altar* (1986), India ink, beeswax, damar varnish on paper, 50 × 39 in.

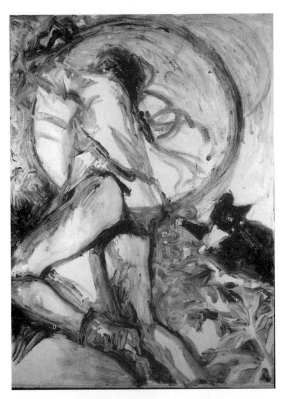

Figure 12.12 ELINORE HOLLINSHEAD, *Work in Progress: Letting Go* (1986), India ink, damar varnish on paper, 50 × 39 in.

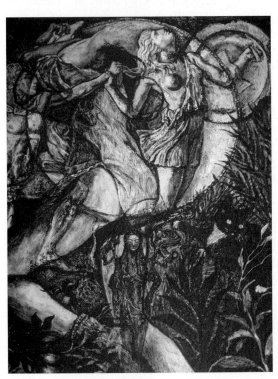

Figure 12.13 ELINORE HOLLINSHEAD, *Letting Go* (1986), India ink, beeswax, damar varnish on paper, 50 × 39 in.

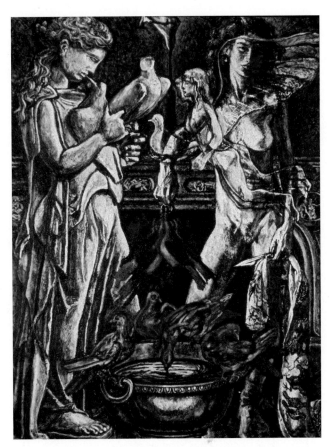

Figure 12.14 ELINORE HOLLINSHEAD, *Some Kinds of Love* (1986), India ink, beeswax, damar varnish on paper, 50 × 39 in.

occupy the same claustrophobic space and show life to be overwhelming in its complexity.

One senses that these drawings have been forming for most of Hollinshead's life. As a teenager in England, she went to the Ashmolean Museum at Oxford University where she filled sketchbooks with drawings from plaster casts of Greek and Roman sculpture and narrative reliefs. She filled more sketchbooks at Oxford's Natural History Museum and the mysterious Pitt River Museum, where she became fascinated with voodoo objects, **talismans** and **milagros**. Additionally, during travels in Greece, Hollinshead drew directly from classical sites. More than 20 years later, she continues to use these sketchbooks as source material.

On rag paper with a rabbit skin glue sizing Hollinshead used beeswax medium and india ink, which allowed her to develop layered

translucencies. Figure 12.12 shows the beginning stage of a drawing that had large compositional elements established with the first of many translucent coats of media. By the time the drawing was resolved (Figure 12.13), some areas remained lucent but others had sufficient layers to make them opaque. Her choice of medium was directly linked with her ideas for veil-like tiers to echo the narrative overlay often present in myths and dreams. The **tactile**, reworkable surface was strong enough to withstand her process of pushing around the beeswax medium with a rag, then incising it, while still tacky. She also worked up brushstrokes in a variety of thicknesses. After the beeswax medium and ink dried, she chipped into it with a putty knife or a chisel, creating a surface that ranged from rough relief to a monoprint-like slick surface. Hollinshead's emphasis of **facture** created physically active compositions, in keeping with the turmoil, agitation, and conflict of the ideas. The works are extravagantly, obsessively overdrawn, bringing the viewer into direct awareness of the artist's passion in her touch, her ideas, and her process.

Mark Milloff

Most of Mark Milloff's work, including drawings, paintings, and videos, focus on narrative. Often relating to epic literary works such as Herman Melville's *Moby Dick,* conflicts of nature and culture dominate his subject matter. In response to the magnitude of his ideas, the physical aspects of the work are pushed to the limit of medium, weight, scale, and structure. In the *Moby Dick* drawings **(Figures 12.15 to 12.18)** he used a rich pastel medium, usually reserved for small-scale work. But, without limits and against tradition, Milloff did what the work demanded and drew them on a large-scale (often ten by twenty feet). Many layers of jarring colors bring to life brutal scenes of men and beasts, weapons and blood; man struggling against nature. Man is shown as determined and obsessive, but ultimately vulnerable to nature's power; there is a sense of great risk taking and raw emotion in the narrative of the work as well as in the making of the work. Starting from the gut, Milloff delivers his work in a direct visceral form.

These monumental **homages** to Melville are not intended as illustrations; therefore the text is unnecessary to the viewer's experience of them. However, the text did play a critical role in the development of each image because Milloff began his interpretations by reading one of the vivid scenes over and over to pick up every nuance and detail. Concentrating intently on two or three carefully chosen paragraphs of a major event, he visualized a specific and colorful narrative and clarified in his mind's eye a movie with every character, action, and subtle detail worked out. Once the peak action took form and the details gelled, Milloff froze the frame.

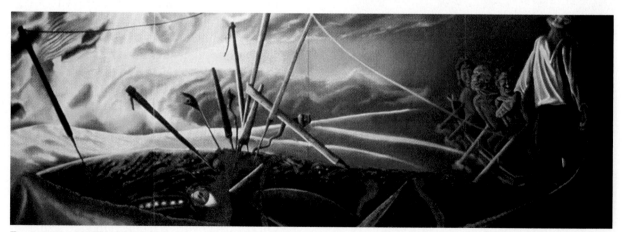

Figure 12.15 MARK MILLOFF, *The Dying Whale* (1987), pastel on paper, 84 × 200 in.

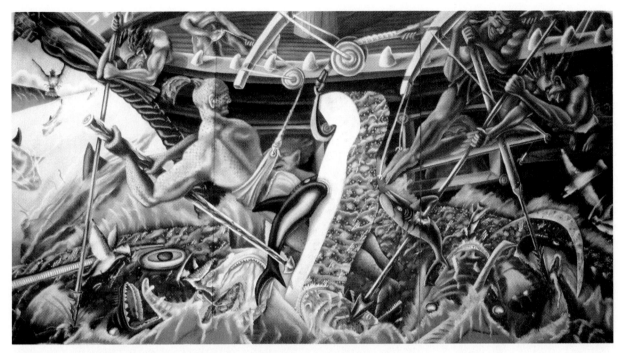

Figure 12.16 MARK MILLOFF, *Queequeg's Last Long Dive* (2002), pastel on paper

Ideas for his excessive compositional structures have come from scenes in films by Kurasawa and Eisenstein: action taken to the extreme, frames filled with characters and carefully considered details.

After the visualization process is the most time-consuming step of mapping out the linear compositional structure. He first places the large objects and figures, moving and redrawing them numerous times until he is certain of their placement. Gradually, smaller elements fall into place. Details might be as specific as areas of luminous water juxtaposed against milky, opaque water, or the exact direction the moving path of water bubbles will follow. For each drawing, Milloff

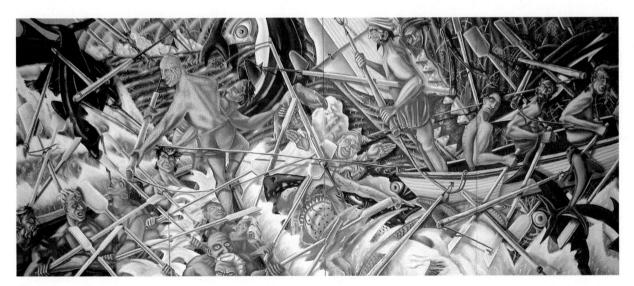

Figure 12.17 MARK MILLOFF, *Attacking the Pod, or The Living Wall* (1988), pastel on paper, 96 × 200 in.

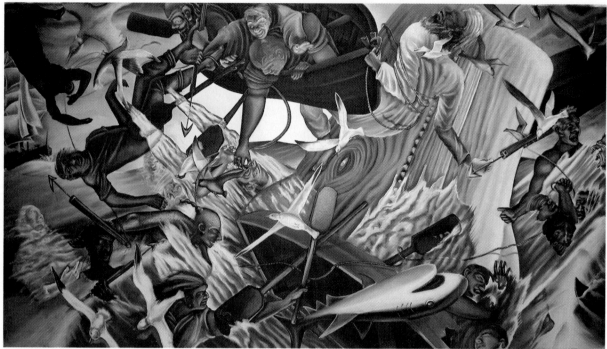

Figure 12.18 MARK MILLOFF, *Drawn Up Toward Heaven by an Invisible Wire* (2002), pastel on paper, 108 × 200 in.

considered and reconsidered his composition until he conveyed the mood he sought: a quiet death of the whale (Figure 12.15) or a raucous battle of men fighting for their lives against the sea and the whale (Figures 12.16 and 12.17).

In looking at these drawings, it is not surprising to learn that Milloff grew up near the ocean, catching and dissecting sea creatures as a daily pastime. Always aware of his own vulnerability to the powers of the sea, Milloff understood the reality of storms and hurricanes firsthand and heard tales of sea creatures pulling off predatory fishermen's arms. Fascinated with the risks of life at sea as a boy, Milloff is still obsessed and has found an outlet in his art. This does not mean that you must grow up catching and dissecting fish to do convincing drawings of aquatic imagery, but direct experience can provide the work with an immediacy and veracity. Milloff's authority of detail, his passionate drama, and emphatic design come directly from his mind, stocked with experience from his life, and he generously carries the viewer along in the swirling, chaotic circus of his imagination.

Stephen Talasnik

In Stephen Talasnik's panoramic drawings **(Figures 12.19 to 12.22)** a **visionary** world unfolds. Viewers immediately connect his drawings to the work of a number of artists including Henri Matisse in his layering through redrawing, Sol Lewitt in his systematic structures and use of the grid, and architect Hugh Ferriss in his **utopian** drawings with dramatic use of light and scale.

With an early interest in engineering, architecture, and archaeology, all of which play a major role in his drawings, Talasnik studied in Rome, where the ubiquitous archaeological excavations were sources for sketching on a daily basis. Later, while in Japan during a building boom, steel girder structures of new buildings were popping up everywhere and these proved to be visually stimulating in the same way as the Roman ruins. The juxtaposition of the old and the new, the past and the future emerged as a theme in Talasnik's work. As with Hollinshead and Milloff, an aggregation of early influences and later interests comes through in his work.

Figure 12.19 STEPHEN TALASNIK, *Resurrection* (1992–1993), graphite on paper, 15 × 60 in.

Figure 12.20 STEPHEN TALASNIK, *Floating World* (2005–2006), graphite on paper, 24 × 84 in.

Figure 12.21 STEPHEN TALASNIK, *Parallel Observer* (2005–2006), graphite on paper, 21 × 84 in.

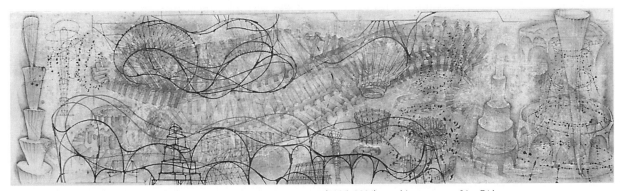

Figure 12.22 STEPHEN TALASNIK, *Laws of Unintended Consequences* (2005–2006), graphite on paper, 21 × 74 in.

In the drawings shown here, Talisnik used layers of lines and a traditional chiaroscuro to bring a sense of physical believability to his invented forms, as though the objects really existed. The illuminated, undulating spatial marvels were created through the manipulation of graphite, erasure, and scratching with steel wool and sand paper to impart a sense of beautifully

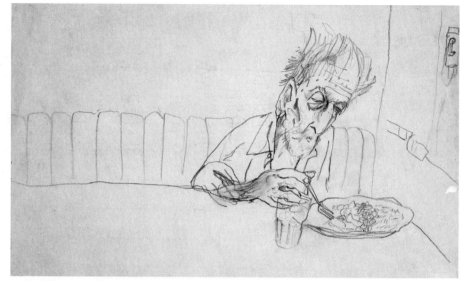

Figure 12.23 SAM MESSER, *Tired of Feeding this Body*, (1992), charcoal on paper, 11 × 18 in.

aged surfaces. The laborious process of building up the graphite, taking it down, reapplying it, removing it imitates the life cycle of architecture, allowing Talasnik's erased ghost lines and mysterious atmospheric environments to simultaneously suggest their own history and the history of civilization.

The **panoramic** format, transformed by Talasnik into an atmosphere of **illusionistic space,** stretches horizontally as well as into depth. Developed from a synthesis of his ongoing bank of sketchbook drawings of buildings and objects as well as from imagination, his personal view of abstract and ephemeral architecture emerges. The disorienting structures and their maze-like complexity toss viewers around, never letting them feel grounded as they float forever in a nether space. It is a mystery, how to navigate these foreshortened spaces, believable yet unreal. Simultaneously in control and out of control, the spinning images suggest the skeletal but visionary structures of a World's Fair. Talasnik pulls the work together with a traditional understanding of drawing process merged with contemporary format, scale, and concept.

Sam Messer

In 1989 Sam Messer, a New York artist in the process of moving with his family to Los An-

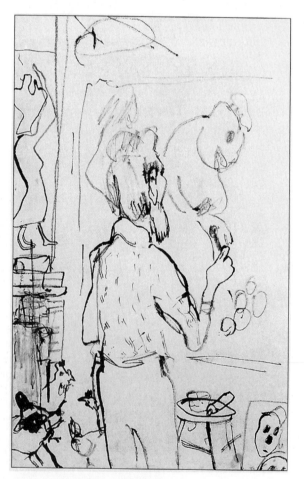

Figure 12.24 SAM MESSER, *John Working* (1993), ink on paper, 18 × 11 in.

geles, met Jon Serl, an older artist living in the California desert. Serl had a rich, but unconventional life in a simple wooden dwelling filled with roosting chickens. His days were spent in isolation, concentrating on his work, which had achieved national recognition as "outsider art." Messer felt an immediate bond with Serl, who was a fabulous storyteller as well as a great painter. He claimed to be 99 years old and had been a guest on the *Tonight* show. Over the next six years, Serl posed for Messer between his own painting sessions, and the two became fast friends. Messer would drive out from the city to work and keep company with Serl. Initially he sketched on a modest scale, but the series grew to 30 life-size paintings, moving beyond simple portraiture to symbolic meditations on life, art, and death. In some ways, however, the simplest of the early drawings are the most powerful (**Figures 12.23 through 12.26**). They convey the direct experience of one human being through the eyes of another with a fresh immediacy of drawing media. Messer's sensitive, complex line evokes Serl's plain-spoken humor, as well as his accumulated feelings of a lifetime. It seems as though the lines and marks are Serl, embodying his attitudes and life. A sense of unplanned exploration comes through in Messer's drawings. It is difficult to imagine any other approach to this unique subject; too much planning would defeat the sense of spontaneous event. Messer got it just right. There is no sentimentality here, just affection, compassion, and the genuine empathy and respect of one artist for another: a celebration and documentation of a unique, eccentric life.

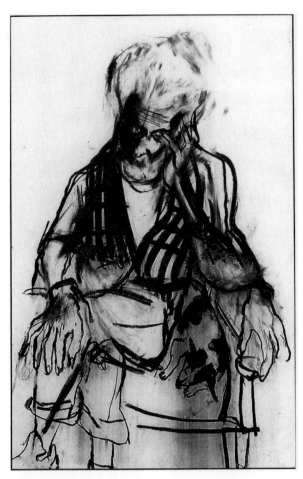

Figure 12.25 SAM MESSER, *Sadness* (199e), charcoal on paper, 44 × 30 in.

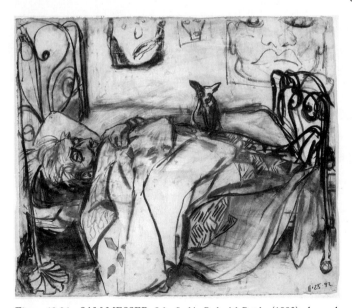

Figure 12.26 SAM MESSER, *John Serl in Bed with Patches* (1992), charcoal on paper, 38 × 48 in.

Cheryl Goldsleger

Cheryl Goldsleger's drawings (**Figures 12.27 to 12.31**) are excellent examples of an intellectually stimulating sensibility that has remained focused while gradually evolving over many years. Clearly, the maze-like forms of her recent drawings find their roots in similar geometries of the early work. Attention to detail, interest in system, layering, and transparency also persist. Viewers are set on a quest

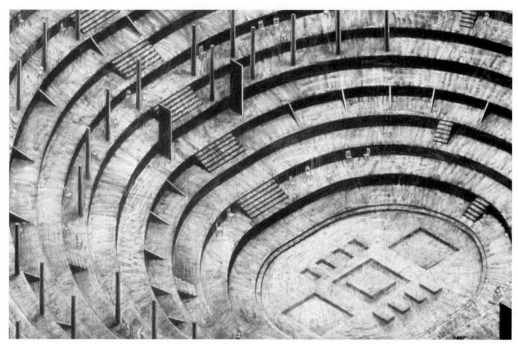

Figure 12.27 CHERYL GOLDSLEGER, *Vortex* (1993), charcoal on paper, 60 × 90 in. (Courtesy of the Kidder Smith Gallery, Boston, MA)

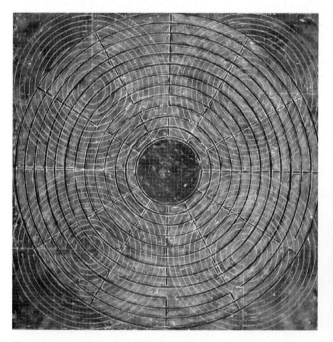

Figure 12.28 CHERYL GOLDSLEGER, *Echo* (1991), wax, oil, pigment on paper, 22 × 22 in. (Collection of OmniCom Group, Inc., New York, NY)

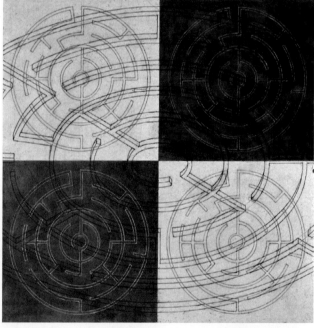

Figure 12.29 CHERYL GOLDSLEGER, *Centrum II* (2000), wax, oil, pigment on paper, 38 × 38 in. (Collection of Aurora Capital, Los Angeles, CA)

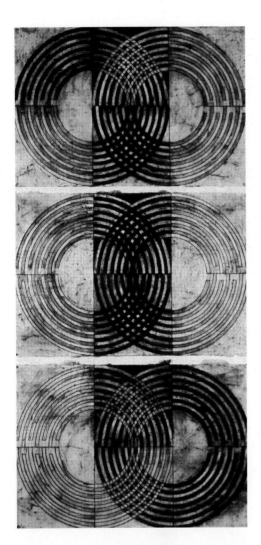

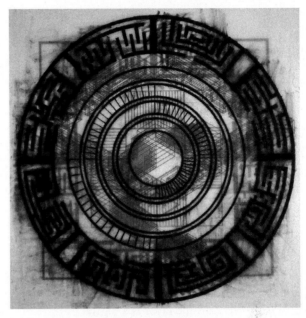

Figure 12.30 CHERYL GOLDSLEGER, *Extended* (2000), wax, oil, pigment on paper, 77 3 37 in., 3 panels; 25 × 37 in. each (Collection of Cablevision Systerms Corporation, Bethpage, NY)

Figure 12.31 CHERYL GOLDSLEGER, *Complex* (2002), graphite digital print on mylar, 40 × 36 in. (Courtesy of the Kidder Smith Gallery, Boston, MA)

to find their way through a puzzling labyrinth, historically considered to be a **metaphor** for spiritual search. Goldsleger invents, discovers, digs, searches, and questions internal paradoxes with archetypal enigmatic structures.

Influenced by the work of Giacometti, Morandi, Twombly, and Piranesi, Goldsleger's work may be largely planned and predetermined, but she also leaves room for invention and resolution during the process of drawing. As she said, "I go through hundreds of sketches until I get to the composition that I am interested in. Initially there are just many lines; I watch and respond to how they **coalesce** . . . there are several stages of rethinking the space from different standpoints . . . 'empty' versus 'full' space . . . and of course whether I think it 'works' or not . . . I have to

manipulate for a long time . . . I'm willing to start (a final version) with an area I'm still undecided about, hoping that it will resolve itself, and sometimes it works and sometimes it doesn't . . . The idea of exploring and making my way through an unknown space is part of my process."[10] Again, while doing extensive preliminary work, Goldsleger still makes important decisions as she works.

Goldsleger approaches ideas from a **sensuous** angle, inviting viewers to experience conceptual systems of drawing simultaneously through their minds and senses. In Figures 12.28, 12.29, and 12.30 this is made evident in the media chosen and in their application; beeswax and oil are combined with pigments, graphite, or charcoal and richly developed as surfaces. Goldsleger's clear

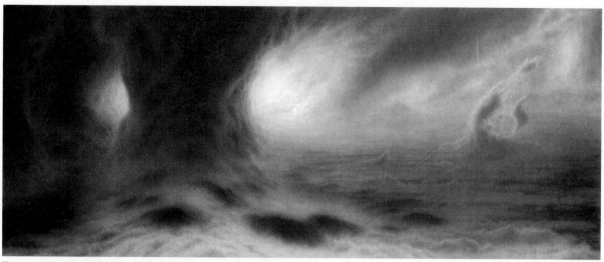

Figure 12.32 HILARY BRACE, *Untitled (#8–03)* (2002), charcoal on mylar, 3 5/8 × 8 7/8 in.

control and the mathematical exactness of her incised lines, against the drippy wax, uneven distribution of pigment within a line, and loose edges of the image creates a **dichotomy,** pushing the viewer from a cerebral to a sensory appreciation of structure and system. Continuing to experiment with process and media, Goldsleger has recently combined drawing with digital prints. Figure 12.31 is made up of several layers of translucent Mylar. One layer is a digital print of a drawing executed in a 3-D modeling program, while other layers are hand drawn with graphite. Here Goldsleger keeps new technologies and processes separate from traditional ones, but lets viewers' eyes combine them by seeing through one to the other. With a sense of mystery and beauty, Goldsleger's world seems at once public and private as well as traditional and contemporary: a view of primitive mazes, abandoned architecture, and references to ancient mythology are layered with the artist's private inner vision. Indeed, this duality makes these mechanically constructed works very expressive.

Hilary Brace

Hilary Brace's charcoal on mylar drawings may be small in scale, but the sensation of space is immense (**Figures 12.32 to 12.35**). Even though the drawings have a sense of real and amazing forms of nature, the images were invented and the compositions were built from imagination. Even if these views had been drawn from specific places, the shifting formations of clouds would never look the same for long; each scene would ultimately be clarified in the mind's eye of the artist. Brace's work may recall the vast skies of some of the **Hudson River School** artists, but without being tied to natu-

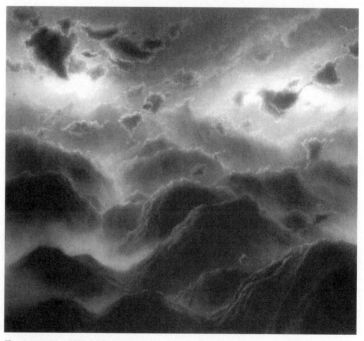

Figure 12.33 HILARY BRACE, *Untitled (#3–02)* (2002), charcoal on mylar, 3 7/8 × 4 3/8 in.

Figure 12.34 HILARY BRACE, *Untitled (#14–02)* (2002), charcoal on mylar, 3 5/8 × 8 7/8 in.

ralism or the concept of a scenic view. Instead, the tiny drawings, shown here at full or nearly full size, convey intimidating powers, mysteries, and transcendental events.

Brace drew skies, mist, and clouds; nevertheless, the real subject is invented light, dramatized with **chiaroscuro** and **atmospheric perspective.** Light and dark values compose the page, creating large dark areas pierced by small lights and vice versa. Overall designs are fairly simple, but the details are complex with tonal intricacies of light, reflected light, shadow, and cast shadow. These tonalities intimately involve viewers within the larger poetry of the space as her amazing technical ability forces a close and intent look. Brace erases into the charcoal and finds the lights by getting rid of the dark values. Ultimately the effect is almost photographic in its precision and as a result viewers are drawn in to float in an alien, lonely skyscape and hover with the clouds over a distant landscape. The sense of changing formations and the unpredictable power of natural forces keeps them just off balance. These drawings do not force viewers to have a particular response, but Brace allows us to experience aspects of nature in an individual, yet new way.

Russell Crotty

It is interesting to look at Russell Crotty's drawings (**Figures 12.36 to**

Figure 12.35 HILARY BRACE, *Untitled (#5–02)* (2002), charcoal on mylar, 4 3/8 × 3 7/8 in.

Figure 12.36 RUSSELL CROTTY, *Milky Way Northern Hemisphere* (2000), ink on paper, 36 in. diameter

Figure 12.37 RUSSELL CROTTY, *Installation View: The Universe from My Backyard* (2001)

12.39) next to those of Hilary Brace as they both bring viewers closer to aspects of the world that cannot usually be reached. While both series were drawn with precise detail, have similar subject matter, and take the viewer away from the day-to-day world to a vast universe, in the end their work is very different. For example, Brace envelops the viewer in light and space and Crotty describes what he observed from a distance, without pulling the viewer into the space of individual drawings. The concepts and processes of Brace and Crotty are not related and neither is the viewer's experience of their drawings. However, both artists convince viewers to share their awe for the infinite unknown space surrounding earth.

Inspired by his observations from his personal observatory in California, Crotty looks far into space for his images. His drawings of the night sky combine direct observation, memory, and invention in the development of detail, value, and texture. Working on paper and in books, he sometimes mounts the drawings on lucite spheres. Installations of the spheres transport viewers to his world of constellations (Figure 12.37).

Passionate about science and art, Crotty patterned his processes on the naturalist John Muir and his insistence on experiencing nature firsthand. His day-to-day life centers on the methods of nineteenth-century astronomers in keeping a scientific journal with notes and drawings that record the movements of stars, planets, and the experience of observing them. Aware that most people experience outer space through technology, he chose to hand-draw a directly observed, individual interpretation of it. Referring only to his own journals as material for his drawings, he shuns contemporary resources such as computer technology and photographs. The immediacy of direct

Figure 12.38 RUSSELL CROTTY, *M11, Galactic Cluster in Soctum* (1999), ink and pencil on paper

Figure 12.39 RUSSELL CROTTY, *Ghost in the Void/Planetary Nebular Drawings* (1998), ink on paper, bound in book, 37 × 37 in.

observation and personal participation that in the past was the only way for a scientist to explore space is a focus for him as he emphasizes his point of view from earth and "draws to understand" his environment as discussed in Chapter 11.

Crotty used repetitive marks of the pencil or pen to create value. His drawings have a unique sensibility because he invented a style: a personal diagrammatic interpretation of his observations, recollections, and discoveries. He transposed into drawing the mysterious starlight that takes thousands of years to reach our eyes.

Judy Pfaff

Installation artist Judy Pfaff finds drawing to be an integral part of her work. Her large-scale series of drawings **(Figures 12.40 to 12.42)** incorporate the same reverberating patterns and space as her three-dimensional work (see Figure 10.34). As in the installations, viewers float in and out of **intuitive** and chaotic spaces while layer after layer of images, patterns, and marks develop into a com-

plex, shifting visual experience. The drawings feel as though they evolved to become what they are; planning did not predetermine the outcome. Pfaff responded to one layer to decide on the next as she stenciled, collaged, drew with encaustic, oilstick, dye, and watercolor. As a result, a strong physical quality built up on the paper.

Much of the imagery reflects her interest in science and the structures of natural forms. Insects, botanical illustrations, leaves, and animals are a source for patterns that float around, over, and under each other. **Transparencies, opacities** and **juxtapositions** of lines with shapes create a complex visual accumulation through Pfaff's instinctive decisions. Her attitude is revealed in the following statement: "I think one of the things about being an artist is that you should be allowed to test murky, unclear, unsure territory or all you have left are substitutes that signify these positions. Having it all together is the least interesting thing in art, in

Figure 12.41 JUDY PFAFF, *Reverend M. J. Divine* (2003), watercolor, encaustic, oilstick, doilies and cast acrylic on Japanese paper, 100.4 × 53.4 in.

Figure 12.40 JUDY PFAFF, *Untitled (PF146)* (2000), mixed media on paper in artist's frame, 53 × 101 in.

Figure 12.42 JUDY PFAFF, *Untitled #2002–008* (2002), mixed media on paper in artist's frame, 53.5 × 101.5 in.

being alive." For Pfaff, the work is the "evidence to me—summations of what I've been thinking about" and what she hopes to gain from a piece is, "to get somewhere, to be able to learn something."[11] Viewers sense this process of search and discovery in her drawings; it is evident that she did not know where she would end up as she began but knew when she got there.

Jonathan Lasker

Jonathan Lasker developed his series of drawings **(Figures 12.43 to 12.45)** as finished works, not as preparatory studies for his paintings, even though he used the same visual language in both. The drawings are made up of layers of a variety of types of mark; contrast comes from the juxtaposition of these different mark types and their densities.

Even though he draws areas of doodles or scribbles, they have a deliberate, cool quality, applied through a conscious decision rather than a spontaneous response. In other words, their playful quality is part of a cerebral calculation, rather than a searching, emotionally based gesture. Line weight and quality do not vary within an area, and the white of the page is maintained in a pristine state, further evidence of a planned rather than searching process. Lasker looks for links between art and mass media, and his drawings are more stylistic commentary than personal revelation.

Just as Lasker developed a **visual language** that he continues to use over and over again, he planned the compositions as carefully as Mondrian did (Figure 4.6), looking for balance and harmony in his arrangements. Mondrian's focus on verticals and horizontals is evident is Lasker's drawings, but in a more casual, comic-book manner. There are other historical art references in the drawings, such as the borrowing of shape from abstract expressionist compositions, and the playing with figure/ground relationships in ambiguous spatial

Figure 12.43 JONATHAN LASKER, *Untitled* (2003), graphite and India ink on paper, 22 × 30 in.

Figure 12.44 JONATHAN LASKER, *Untitled* (2002), graphite and India ink on paper, 22 × 30 in.

Figure 12.45 JONATHAN LASKER, *Untitled* (2003), graphite on paper, 22 × 30 in.

arrangements as indicated by overlap, transparency, and contrast. Often the shapes become characters suggesting narrative as well as having **formal relationships** in the drawing.

In the end, Lasker's drawings are not about expressive process or the use of the media, but about the artist's own visual system, which he rearranges and uses to design his pages.

Zak Smith

Zak Smith's portraits of himself and his friends are full of references to his generation and their important cultural influences. The figures are usually shown in a jumpy space that they inhabit: interiors filled with patterns, objects, and drawings. In a self-portrait **(Figure 12.46)**, Smith is pushing out of the space toward the viewer, not enveloped by it as much as in front of it. In other drawings, the person depicted is integrated into her surroundings through foreground objects such as the backward chair **(Figure 12.47)** and **(Figure 12.48)** that helps pull figure and ground together.

Smith handles his ink and acrylic medium deftly, allowing him to create convincing and confident drawings. The plastic-coated paper offers little resistance to brush and ink, and gives the drawings a hasty quality reminiscent of finger paintings. Figurative and abstract structures are successfully woven together, and Smith's knowl-

edge of design and art history is clear. Interestingly, the traditional approach to figure drawing is contrasted with in-your-eye colors and contemporary cultural references. Though young, the subjects seem weary of their lives: downcast, bored, or just tired; perhaps the most notable quality of these drawings is the dull gaze of the subjects as they meet the viewer's eye. Their blank passivity contrasts to the chattering visual detail surrounding them. Smith's references to comic books, new music, dyed hair, and a jumble of clothing styles create a detailed image of twenty-first century **consumer culture**, showing the attitude of a young generation questioning the world just as they are seduced by the accessories it provides them.

Smith's work is clearly contemporary, of this very moment. It is interesting to compare these portraits to Max Beckmann's self portraits so evocative of the 1930s, or Alice Neel's astute observations of

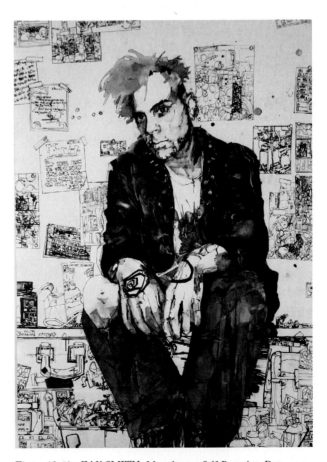

Figure 12.46 ZAK SMITH, *Most Accurate Self-Portrait to Date* (2004), acrylic and ink on plastic-coated paper, 38 × 27 in.

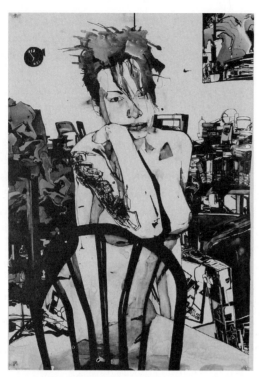

Figure 12.47 ZAK SMITH, *V in the Kitchen* (2003), acrylic and ink on plastic-coated paper, 40 × 28 in.

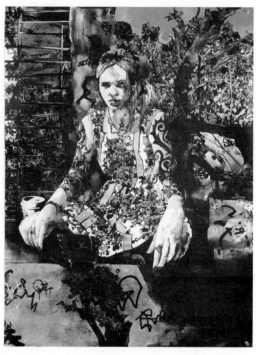

Figure 12.48 ZAK SMITH, *Girls in the Naked Girl Business: Voltaire* (2005), acrylic and metallic ink on plastic coated paper, 38 × 28 in.

individual personality (Figure 12.7), or Egon Schiele's emotionally charged drawings of himself and his friends (Figure 9.21). The work of all four artists has an immediately recognizable approach, based on traditional drawing altered in a personally expressive way.

Julie Mehretu

Julie Mehretu was born in Ethiopia and educated in the United States, and these life experiences are evident in the drawings' complex influences and layered references. Their initial impact is one of unbridled energy spewing forth from the varied, swirling lines that make up much of the drawings' surfaces **(Figures 12.49 to 12.51)**.

Mehretu's sources are numerous, varying from contemporary comic book imagery and graffiti to etchings and drawings by Durer and Leonardo. Architectural plans from stadiums, airports, and libraries layered with explosions, fire, storms, and computer imagery form themselves into a living, breathing, ever-changing drawing. Teetering on the edge of complete chaos, the pieces barely retain their sense of structural unity. As a result, viewers

are pushed, pulled, sucked in, spat out, and pulled in again in a dizzying physical involvement with the work. To add to the drama, the drawings' scale ranges from 18 by 24 inches to as large as 22 feet wide (see cover image). Marks vary as well, from thin Durer-like lines, to wild, spiraling lassolike gestures. The intricacies of individual marks call for close viewing while simultaneously a distanced overview is demanded to understand their role within the rhythms of the whole piece. Each mark reflects Mehretu's interest in the individual person within a community, and the influence one person can have on the whole. Mehretu herself is having an important contemporary impact as her fame spreads and her audience is made aware of a new viewpoint on postcolonial Africa. Ultimately these are exuberant, hopeful, passionate works of art.

Mehretu works on paper, mylar, canvas, or directly on the wall. In speaking about one of her wall drawings she said, "I really think of the drawing as growing, as behaving, as building, as acting. I don't think of the drawing as being a static representation of something."[12] There is nothing static in her work, and viewers feel as though they are seeing a moving image that is changing before their eyes.

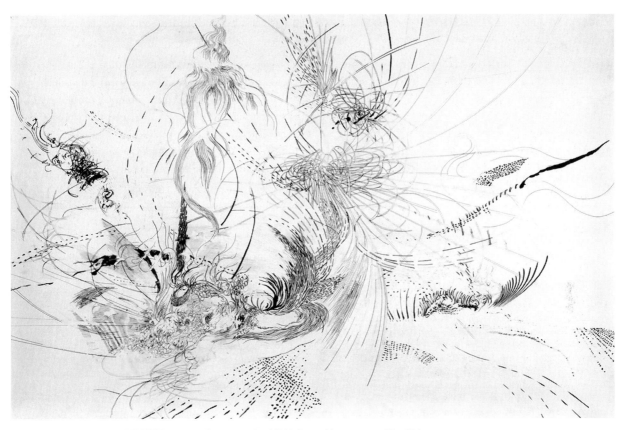

Figure 12.49 JULIE MEHRETU, *Untitled (New Drawings)* (2004), graphite on paper, 22 × 30 in.

Figure 12.50 JULIE MEHRETU, *Untitled* (2002), ink, colored pencil and cut paper on mylar, 18 × 24 in.

Figure 12.51 JULIE MEHRETU, *Untitled* (2000), ink, colored pencil and cut paper on mylar, 18 × 24 in.

Exercise 12.1 Discussion of Artist's Drawings ───────────

Look for a series of drawings by a contemporary or master artist that holds a special interest for you. Write a page about the work discussing the artist's attitude toward the subject, the process and media used, and the design or compositional decisions made. What visual ideas are at work in them? Is the process more planned or more spontaneous? Does the artist seem to respond to his or her ideas about society or express more personal feelings? What do you think the artist was trying to express in the work and what means did he or she use to do so? Does the work make you think of other artists? Do these drawings bring ideas or experiences that you have had to mind? Is it easy or difficult to articulate your response to the work? Why? You may want to find some articles or books about the artist to help you get started.

Notes

1. Carroll Dunham on Museum of Modern Art video on http://mesn.museumpods.com/video/video/show?id=917795:Video:4991.
2. Art:21 Slideshow/PBS *Tim Hawkinson.* http://www.pbs.org/art21/slideshow/?slide=183&artindex=54 2005
3. Robert Hughes, *Frank Auerbach,* Thames and Hudson, London, 1989, pps. 15–16.
4. Frank Auerbach, "quoted in." Robert Hughes, *Frank Auerbach,* Thames and Hudson, London, 1989, pps. 10 and 202.
5. Richard Serra, *Richard Serra Line Drawings,* Gagosian Gallery, New York. 2002
6. Glexis Novoa, *Artist's Statement.* http://www.bernicesteinbaumgallery.com/artists/novoa/statement_novoa.html
7. Robert Rosenblum, "quoted in." Alicia Legg, ed., *Sol Lewitt The Museum of Modern Art,* 1978, the Museum of Modern Art, New York. Quote is from an essay in this catalog *Notes on Sol Lewitt* by Robert Rosenblum, p. 16.
8. Alice Neel, quoted in Pamela Allara, *Pictures of People Alice Neel's American Portrait Gallery,* Brandeis University Press, 1998 p. 31.
9. Kaethe Kollwitz, *Diary and Letters of Kaethe Kollwitz,* Hans Kollwitz, editor, Richard and Clara Winston, translators, Northwestern University Press, 1988.
10. Peter Morrin, *An Interview With Cheryl Goldsleger,* catalog for "Cheryl Goldsleger Architectural Drawings and Paintings," High Museum of Art, Atlanta, GA, 1986.
11. *Judy Pfaff,* interview by Constance Lewallen at Crown Point Press, San Francisco, CA, 1988.
12. *A Conversation with Julie Mehretu/Ethiopian Passages: Dialogues in the Diaspora,* interview by David Binkley and Kinsey Katcha, March 28, 2003. http://www.nmafa.si.edu//exhibits/passages/mehretu-conversation.html

Individual Series Development 13

PLANNING A SERIES

Chapter 13 will guide you through the development of your own **series of drawings.** As you recall, a series of drawings is a body of related work created around a unifying visual idea or approach to drawing. Steps or guidelines are suggested here that may be helpful in the beginning stages of your series. However, keep in mind that these should be altered to fit your individual needs and circumstances. Later in this chapter, you will see examples of series of drawings created by students. You may want to refer to them as you read the guidelines and week-to-week suggestions for developing your series. It may be helpful to refer to Chapters 11 and 12 where important ideas and issues in preparation for a series, such as media experimentation, sketchbook use, process, visual ideas, and approaches to subjects were discussed.

As you think about ideas for your series, keep in mind that there is not one right approach to take or any certain way the work should look. Most important is that you feel strongly about the route chosen because that will allow a clear vision based on your ideas, processes, and feelings to become evident. In addition, a definite point of view or **attitude** should develop in the work if you push the drawings to make a clear statement, moving away from the grey area of noncommitment. In the process of developing a series, you will gain insight into personal methods of invention; the mode of expression you choose will teach you about yourself and your visual inclinations. A creative point of view is important in any field of study, and this project can help you develop one. You will make many decisions about the unfolding of the series, and when it has been completed, you will have a cohesive body of related drawings.

Keep in mind that most people pass through different stages during a series including exhilaration, frustration, struggle, and boredom. Exhilaration is better than boredom, but sometimes boredom or frustration can spur you to become more innovative in moving past a blockage to a new discovery. Questioning and positive struggling are good indications that you are challenging yourself. Above all, it is essential to stay with your natural inclinations and remain focused on the work and its development. The rewards will be very gratifying.

A series is an ambitious undertaking and to give yourself the time to develop it fully, you should plan to spend at least seven hours a week on it, for a minimum of 6 to 10 weeks. The series could be done as out-of-class work for a semester-long class, as an independent study project, or on your own, as long as you have someone to discuss the work with you. The student projects reproduced later in this chapter were done during a semester as out-of-class work guided by weekly or biweekly discussions with a teacher and by group critiques with the entire class every four weeks.

Suggested Guidelines

The following suggestions include some issues to consider during your work on the series. Although they will not all be immediately relevant, it will help to keep them in mind from the beginning.

1. *The drawings should be finished works.* They should not be seen as studies for another

medium such as painting or sculpture. Making studies is certainly a good idea, but the drawings that make up the series should be distinct from studies. In the series drawings, composition, subject, and use of media should all be considered and supportive of each other. This does not mean that they have to be highly polished drawings. They can have either a loose or finished approach in the way they are drawn, as long as the ideas are resolved.

2. *Begin with a subject or motif that can be directly observed for your first series.* The work may certainly evolve imaginatively beyond the observed subject, or become abstract, but direct observation is a good starting point. Photographs should not be the source of observation.

3. *Draw to form ideas.* Do not wait for fully formed ideas to come to you. You will probably not know just what you want to do until the drawing process begins. In other words, find ideas through drawing.

4. *Stay with one medium or a set grouping of mixed media, unless there is a compelling reason to change.* Moving randomly from charcoal to ink to watercolor to graphite involves spending time learning new media rather than developing your idea. Mixed media is fine; be experimental, but do not switch to a different set of media for each drawing, in other words let your ideas, rather than the media, become the focus.

5. *Stay within your central idea but leave room for change and invention once the series gets going.* Too much jumping around will not generate a series, but at the same time, adhering too rigidly to a narrow approach will unnecessarily limit your flexibility and your ability to respond to opportunities for creative growth. You need to find a balance here.

6. *Remain realistic about the series.* For instance, do not make a plan requiring a live model if there is not one available to you. Be sure to have a studio situation appropriate for your ideas and to have access to the source material you need whether it is still life, landscape, interior spaces, or natural objects.

7. *Try to spend seven or more hours a week on your series.* This does not mean that you will spend seven hours on one drawing each week. In

seven or more hours one person may do 50 drawings, another will do one drawing, and another may take two weeks to complete a drawing. Your ideas, process, size of drawing, and so on will determine how many drawings you complete in a given week. Since you are probably working independently and are responsible for making all the decisions, consider imposing some criteria on yourself to stay disciplined. A specific schedule for working on the series each week can be helpful. If you allot several hours two or three times a week, your drawings can take form gradually over the week. Also several working periods each week will allow you to come back to the drawing with a fresh eye while there is still time to make adjustments before you take it to class or to a critique. In most cases, there will be a direct correlation between time spent and success in the series. Commitment of time and thorough involvement with the idea and process will lead to a strong series.

8. *Stay open to unexpected developments.* Deciding how the series will develop before you begin can lock you in too early within boundaries that may become irrelevant. Therefore, define a clear, basic direction. Assume that your ideas and approach will develop as your process unfolds. Let the ideas evolve through drawing, not through verbalizing or predicting ahead.

As discussed in number 8 of the guidelines, it is important not to predetermine your series' track or destination too far ahead. If you have an idea or mental image of a style or approach you want to evolve toward, then you should begin there. Consider this quote from author Joyce Maynard in the New York Times series *Writers on Writing:*

And so without a clear idea of where my story was headed . . . I began to write . . . Here's what I think happens when a writer begins her story with an authentically realized character (as opposed to one out of central casting, formed out of the necessity to see a certain preordained action take place). If she allows him to take shape slowly on the page, if she resists the urge to make assumptions based on what she thinks he should

do, he'll take on a life of his own and very nearly reveal the direction of the story . . . this practice of ceding one's control to one's character out of the faith that he will lead you to the story."[1]

Joyce Maynard's choice of the word "ceding" means that she *granted* control to her character, not that she *lost* control. Just as Joyce Maynard listened to her writing, you will listen to your drawings; doing so involves a delicate balance of power. A good way to think about it is as a mutual agreement or dialogue between you, the drawer, and the drawings. One drawing will suggest the next. Your eye, mind, and hand will work together as you look and draw or imagine and draw.

Try to work with ideas rather than, for instance, copying the world. If you find yourself saying, "Well I drew it that way because it looked that way," this may be an excuse that suggests that you are not working with an idea, but that you have a passive engagement with the drawing process. Each drawing need not be so much a duplication or representation of what is seen, but an internalization and expression: a transformation through drawing. Like Maynard, try to resist the urge to make assumptions and predetermine your path. This is the best way to avoid predictability.

Generating Ideas

There are many ways to generate ideas for your series. You may already have several, and the difficult part will be deciding which one to pursue. But, to find ideas, look in the sketchbooks you have already done. Is there anything there you keep thinking about? If there is, this can be the beginning of a series. The inner core or beginning kernel of a series could be a particular place, an object or group of objects, a work of literature, an experience you had while traveling, an idea in philosophy, a piece of music, or a formal visual element. Look to past assignments in this book, or ones that you have enjoyed doing in other art classes. Many of them could serve as the beginning of a series. Perhaps there is something you have always wanted to pursue, but never had the opportunity; try it now. A good way to get started on some

ideas is to begin sketching. Sketching in a quick flurry of inspiration and energy as you are clarifying an idea can lead to an understanding of what interests you about a subject. These sketches can be impulsive or obsessive thoughts, caught moment to moment, recorded before they disappear.

A typical schedule of weeks 1 through 10 of working on a series follows, with specific steps for each week. Your way of working will most likely necessitate alterations to this suggested plan.

WEEK TO WEEK OF THE SERIES

Identifying Your Idea: Weeks 1 and 2 of the Series

Generate at least three different ideas for your series. To begin a series, spend at least two weeks drawing, thinking, considering, and working in a diligent manner. During this time, do not worry about having a single direction to follow. Research the work of relevant artists, and seek source materials that will inspire you. Draw, read, look, and research in a nonlinear or free manner. This will enable you to leave your options open for a while as you explore different possibilities. Your three ideas can be related or very different. For example, if you know that you want to do self-portraits, you could explore three approaches to this subject. What specifically about self-portraits interests you? Look back to Chapter 12, "Drawing Content from Life," which discussed four different approaches to the female figure. Alternatively, you might choose to explore widely varied ideas that could range for instance from an expressive investigation of paths of light through landscapes using charcoal, water, and gesso to preplanned drawings of textures of natural objects using pencil.

Do some preliminary studies for each idea, and then bring the drawings to a more developed form for discussion with a teacher, colleague, or mentor for feedback and suggestions. Listen carefully and consider their comments. Your ideas

must be clear on a visual level for this purpose, but a written explanation can also be helpful in organizing your thoughts.

Within your three ideas, experiment with more developed sketches and different media. Look for aspects of your ideas that have potential for in-depth investigation and sustained inquiry After discussion, research, and experimentation, one of your ideas should gradually take over your attention and serve as a seed for your series.

Decision on Direction and Moving Forward: Weeks 3, 4, and 5 of the Series

Identify your direction for a series. While you may initially move around within your idea, try very hard to stay with it. You will need to make conscious decisions about the size of the work, the media, and paper as well as practical preparations for access to a good working area.

One important factor now is to make drawings that go beyond the study or sketch phase. During weeks 3, 4, and 5, your series' direction will strengthen and you will create drawings that are expressively and materially resolved so that the idea, subject, composition, and media all work together to support each other. Also important is to be immersed in the work. You should be eager to work on this series; if it seems to be a chore, then the direction you have chosen is not right for you. Be open to emergent ideas as you draw; let the drawings lead you. There must be something there compelling your interest. What is it? Remember, this is the time to convey your own idiosyncratic vision through drawing.

As repeated exploration of an idea takes place, you will see the distinguishing characteristics of your series emerge. To identify these characteristics, it is important to consider each drawing as part of the group of drawings. This will reveal more about the overall direction than considering each drawing on its own. If possible, hang all the drawings together for a good look at the series so far. Look for repeating elements, patterns of thought and process. Earlier drawings will suggest new drawings, leading you to methods and im-

agery you never imagined. Allowing the work to change gradually keeps you from jumping around, and you will remain connected to a continuous thread of development. Most important, you must feel strongly about what you are doing; commitment will spur you on.

While following your chosen direction, try to see your drawings objectively as you work or discuss them with a classmate or teacher. This will help clarify your direction. Also, review the Critique Tips sections in preceding chapters and the discussion of visual analysis in Chapter 1 to gain objective distance of your drawings. There should be a balance between fidelity to your immediate instinct and a more reasoned analysis.

Breakthrough and Development: Weeks 6, 7, and 8 of the Series

A positive breakthrough may be just what your series needs. Your early series drawings may, with the benefit of hindsight, be gateways or transitions to new aspects of your central idea. As such, they may not have the clarity of later work. Perhaps your series has been going well for a few weeks now, and you are looking for something more to happen. As we mentioned earlier there will be different phases to your series: exhilaration, frustration, boredom, and so on. Exhilaration takes care of itself, but boredom or frustration should be addressed constructively; it can be the catalyst for a breakthrough. You may begin a new drawing, not suspecting that a change is about to happen. Restlessness could lead you to experiment, altering the scale or media, for example. Moving to a significantly larger or smaller scale will definitely affect the way you approach the drawing and may be just the boost the drawings need. If you feel that a drawing needs to be 10 feet by 10 feet, try to make it happen; try not to approach it tentatively. The work might call for changing from charcoal to ink or graphite to force a change in approach. Perhaps you want to continue to observe your subject matter, but work more abstractly. Don't force a huge jump to brand new territory for no reason, but if you are in a corner, a subtle change can be very positive and if it is clear that you are bogged down by a difficulty,

find a way around the impasse. You must improvise every step of the way.

This may be a good time to read about some of the student series later in this chapter to learn how some of them made breakthroughs by staying on their course but at the same time, make important shifts in their work. Above all, sticking with your central idea, resisting the temptation to "bail out." Push on, and try to find an attitude, a focus, a direction within your existing idea that will infuse it with interest and exciting possibility as a drawing experience.

Idea and Identity: Your Work in the World: Weeks 9, 10 and Beyond

Try to connect your series with the larger world of art, past or present. This is a good time to consider the drawings in relationship to other artists' work. Teachers, museum curators, and colleagues can have good ideas on artists whose work may interest you. Also perusing art books and magazines in the library can help with this. Look for a sense of how your drawings might be identified with other work in terms of subject, medium, or expression. Remember, artists you study were also influenced by their predecessors and following this artistic chain can help you link your work to artists and art movements you may not be familiar with.

Continue to assess your progress to clarify the choices you have made.

As you look at your series as a whole with all the drawings hung on the wall together and consider your influences, you can also learn about the particulars of your own process in drawing as thought and action. Is the mark making loose and expressive, or controlled and precise? Has this changed over the weeks? Are you working more intuitively, feeling your way through each drawing, or are you planning ahead and working more deductively? There is most likely an integration of the two with more weight in one direction. Find your point of balance. This personal balance of feeling and reasoning will shift within the series and throughout your life but will most likely main-

tain certain inclinations. Look again at the artists presented throughout Chapter 12 to see if there is one you can relate to in approach to process.

Again, this is also a time to listen openly to critiques of your work, either one-on-one with a classmate or teacher, or in a group. It is important to know how your work is being received and interpreted. Sometimes immersion in your series will keep you from really seeing what is going on and listening to others is very helpful in sorting out just what you are communicating or expressing.

Artists need to become comfortable with having their work seen and discussed publicly. Discussions may have an intellectual flavor, focus on political or personal expression, refer to history and autobiography, or dwell on process issues. Interchange of ideas can be confirming, or aggravating. Be honest, but simultaneously handle other people with care and expect the same in return. As you listen, try to be open and not jump to a defensive mode. Hearing others' opinions of your work can be intimidating, as discussed in Chapter 1, but the goal is insight and improvement. Discussion and critique can help you to understand the impact of your work as well as how you think, how the work reflects your experiences, who influences you, and who you are.

SUSTAINED INVESTIGATIONS: STUDENT SERIES

Consider the following drawing series: strong, focused responses developed by students based on principles and approaches discussed in this chapter. Pay particular attention to the changes they made in the process of working and note the range of approaches they found.

Anna Claire Shapiro

Every series plots a different course; some progress dramatically, and some steadily. The changes in the series by Anna Claire Shapiro came as a result of steady, sustained investigation. Gradual clarification of her ideas took hold the fourth or fifth week

Figure 13.1 ANNA CLAIRE SHAPIRO, Untitled, charcoal on paper, 18 × 24 in.

Figure 13.2 ANNA CLAIRE SHAPIRO, Untitled, charcoal on paper, 18 × 16 in.

Figure 13.3 ANNA CLAIRE SHAPIRO, Untitled, charcoal on paper, 18 × 24 in.

of work. This was a good example of the artist "listening" to the drawings, letting one drawing lead to the next, a "let me start here and see where it takes me" approach.

Shapiro began her series with drawings of coral on paper 18 3 24 inches in size. Giving herself the assignment of doing 50 quick drawings from observation in order to get to know the coral and its visual potentials, she engaged in a process of toning, erasing, toning, erasing, pulling form forward, and pushing it back. Although not in book form, these studies were similar to a sketchbook project. Examples of the 50 drawings (**Figures 13.1** to **13.3**) show her interest in light, use of charcoal, and sensitivity to touch that endure for the entire series. Thoroughly conversant with the coral, a whole new world opened up and Shapiro was able to leap beyond superficial observation to an inventive use of mark, edge, value,

and composition. Important to note is that the inventiveness came as a direct result of the early, sustained investigation and would not have happened without the initial 50 studies.

Figure 13.4 ANNA CLAIRE SHAPIRO, Untitled, charcoal on paper, 22 × 30 in.

Figure 13.5 ANNA CLAIRE SHAPIRO, Untitled, charcoal on paper, 22 × 30 in.

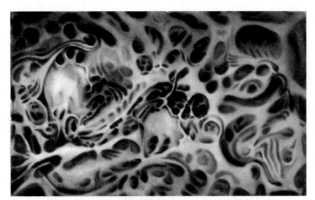

Figure 13.6 ANNA CLAIRE SHAPIRO, Untitled, charcoal on paper, 40 × 60 in.

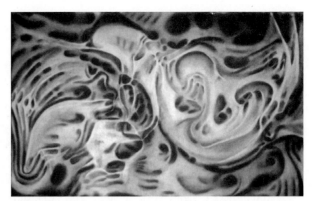

Figure 13.7 ANNA CLAIRE SHAPIRO, Untitled, charcoal on paper, 40 × 60 in.

The studies led Shapiro to superimpose the coral over a cross section enlargement of its minute texture (**Figure 13.4** and **Figure 13.5**). After a few more weeks of **transitional drawings,** Shapiro increased the scale up to 40 by 60 inches, allowing her to create an enveloping atmospheric experience rather than a picture. At the same time, the coral as an object disappeared, but its abstractions remained. In these large drawings, the viewer is moved in and out of a mysterious maze made of a web of floating, undulating motion. Flowing the image off the edges of the page as though just a

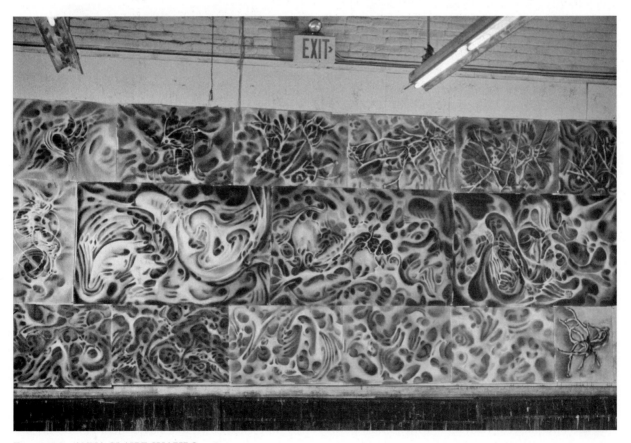

Figure 13.8 ANNA CLAIRE SHAPIRO, series

piece of the continuum is presented, Shapiro put viewers into another world (**Figure 13.6** and **Figure 13.7**).

Shapiro said of her process,

> I drew in the dark so all I could see was the charcoal sculpting light on the page. When I turned on the lights it was always a surprise. The process of drawing intuitively while focusing on depth and movement was addictive. Towards the end of the project I began working larger and expanding from 22 by 30 inches to 40 by 60 inches. Seeing all the drawings hung together was like looking into another world.[2] (**Figure 13.8**)

Viewers can sense that a meditative observation took place. This was magically transformed into a tactile process in which form and space were built through touch. Caressing tone and texture, Shapiro pulled an atmospheric world out of the paper's surface. With time suspended, everything tumbles in slow motion around and through the articulated internal forms. How much did she observe, how much did she invent? How was the charcoal applied and worked? Were the forms built out or pressed into depth?

Form modeled with chiaroscuro and the skilled creation of space show a strong grounding in basic drawing methods, but Shapiro pushed much further toward a personal statement. She built an imaginative world in which the coral forms became a metaphor for skeletons and suggestions of images appear in the abstractions. Ultimately, structured relationships of depth and movement around and through this space provide the compositional context for the viewer's physical and emotional experience of the drawings.

Mark Macrides

Mark Macrides turned his series around with important breakthroughs at crucial points. Beginning with pastel drawings of still life objects (**Figure 13.9** and **Figure 13.10**) elements of the subject matter remained intact—fruit, plates, bottles and background pattern—throughout the series. However, two important changes in the third or fourth

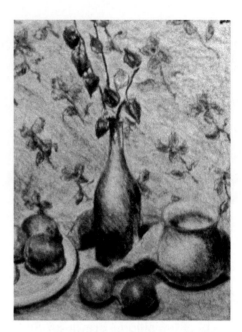

Figure 13.9 MARK MACRIDES, Untitled, pastel on paper, 24 × 36 in.

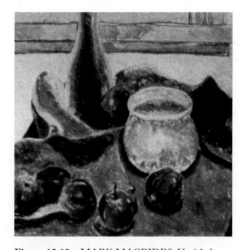

Figure 13.10 MARK MACRIDES, Untitled, pastel on paper, 24 × 24 in.

week, one in media and one in size, led to the breakthroughs.

Realizing that the early drawings were hindered by too much raw paper showing through the chalk pastel and a vague sense of space between the objects, Macrides shifted his medium to oil pastel and changed the size of his paper from 24 by 36 inches down to 12 by 9 inches and even smaller. The oil pastel covered the paper faster

and more densely and allowed him to increase the intensity of the color. The better coverage, more intense colors, and smaller scale led to a clearer statement in each drawing. In addition, he pulled the boundaries of the composition in closer deleting the empty space and cropping the objects so that the entire page was considered and activated.

A further breakthrough occurred when Macrides began to use wallpaper as a source for wall and tabletop patterns, leading to strong graphic rather than tentative designs (**Figure 13.11**). By using more than one pattern in each drawing, he was able to clarify the space by differentiating the wall from the tabletop (**Figure 13.12** and **13.13**).

Despite their small size, these drawings have complex layers and linkages of design, structure, and object relationships. As an example, in Figure 13.12 the energizing angle of the table edge slashes from upper right to lower left echoing the more subtle gesture of the pear on the plate toward the vertical pear. The angle created by the pattern on the table's surface provides a counterbalance to the harshness of the main angle of the table edge. While the design dynamics unfold, the narrative among the objects begins to reveal itself. Visually compressed on both sides by the plate and the cup, the vertical pear seems caught: will it move toward the cup that is upright like itself, or toward the other pear that is reaching over toward

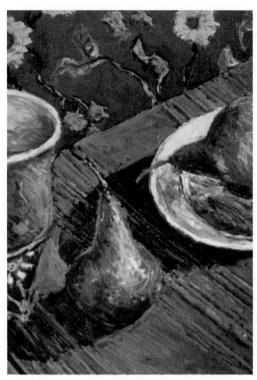

Figure 13.12 MARK MACRIDES, Untitled, oil stick, oil pastel, and wallpaper on paper, 14 × 10 in.

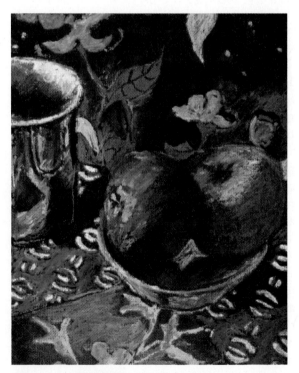

Figure 13.13 MARK MACRIDES, Untitled, oil stick, oil pastel, wallpaper on paper, 12 × 9 in.

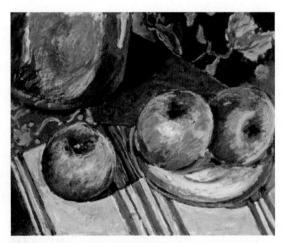

Figure 13.11 MARK MACRIDES, Untitled, oil stick, oil pastel, and wallpaper on paper, 9 × 12 in.

it? Do similar types of objects relate more to each other or do common characteristics form stronger bonds? Of course there are not any answers, but the questions help Macrides to state the complexities of society metaphorically through his objects and their relationships.

As you have seen in Macrides's series, the clearest work is usually not done in the first weeks; it takes time to search within an idea to find just what you want to do. Staying with your core idea while experimenting with new strategies to make it work usually pays off.

Eileen Gillespie

Eileen Gillespie's series began with a focus on the subject of interior space. An 18-by-24-inch charcoal drawing of a window frame inside her apartment depicted with traditional perspective was her first drawing. However, very quickly she began to distort interior spaces with sharp compositions comprised of large shapes (**Figure 13.14**). As the complexity of the spaces increased, the drawing's structural physicality became more pronounced (**Figure 13.15**). Inevitably, viewers are compelled to navigate unusual, shifting perspective constructions, as they are pushed around or even expelled from the drawing and forced to search for a suitable reentry point (**Figure 13.16** to **Figure 13.18**). Gillespie made it clear that for her, architectural mayhem functions as a powerful visual metaphor for complexity, confusion, and frustration. Further, these unpopulated dreamscapes with strange and alienating presences convey a disconcerting emptiness, telling viewers that they are in the maze alone. Was this Gillespie's private inner world or was she referring to the larger unsettled world of reality and the disturbing issues that keep all people off balance? The drawings may read as amusement park funhouse images at first glance but become

Figure 13.15 EILEEN GILLESPIE, Untitled, charcoal on paper, 60 × 40 in.

much more ominous and complex with further contemplation.

Becoming entirely engrossed with the project, Gillespie completed one enormous drawing each week, some of them 9 feet in length. Imagine the

Figure 13.14 EILEEN GILLESPIE with untitled drawing, charcoal on paper, 50 × 90 in.

Figure 13.16 EILEEN GILLESPIE, Untitled charcoal on paper, 44 × 108 in.

Figure 13.17 EILEEN GILLESPIE, Untitled, charcoal on paper, 44 × 108 in.

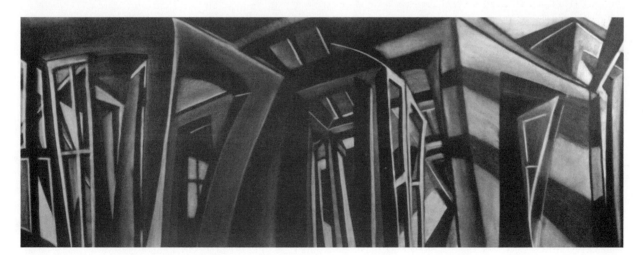

Figure 13.18 EILEEN GILLESPIE, Untitled, charcoal on paper, 40 × 108 in.

logistical complexities of drawing this large. Usually, she worked out a composition in a sketchbook and then blew it up onto a large sheet on the wall. Layer after layer of architectural structure was built on the paper in charcoal, with areas of strong illumination and dense black shadows. Gradually a world was created—twisting, contorted, and threatening.

Preot Buxton

During the time that he worked on his series, Preot Buxton wandered around the city with sketchbook and charcoal, looking for abstract shapes in the urban industrial landscape. He climbed on and off derelict bridges, and in and out of abandoned warehouses searching for the inspi-

rational forms that would prompt him to return to his studio to develop larger drawings. The result was a group of related drawings initiated by direct observation but pushed toward abstraction. Strongly angled designs activate the space, sending the viewer zooming wildly through them, an energy that becomes more and more forceful as the series progressed.

Buxton's early drawings were of telephone poles and wires, (**Figures 13.19** and **13.20**), and later, the more massive forms of buildings and bridges became the subjects (**Figures 13.21** to **13.24**). The format of the work ranged from traditional rectangular proportions to stretched verticals and horizontals, and the sizes ranged from 18 by 24 inches to 4 by 9 feet, depending on the compositional needs of the subject. Rhythms cre-

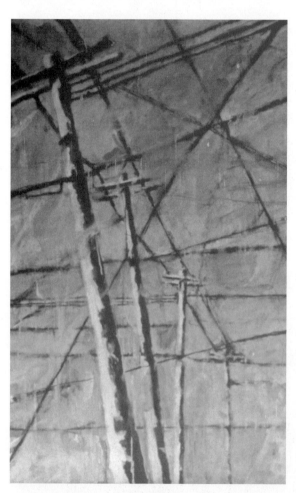

Figure 13.19 PREOT BUXTON, Untitled, charcoal, ink, and gesso on paper, 36 × 24 in.

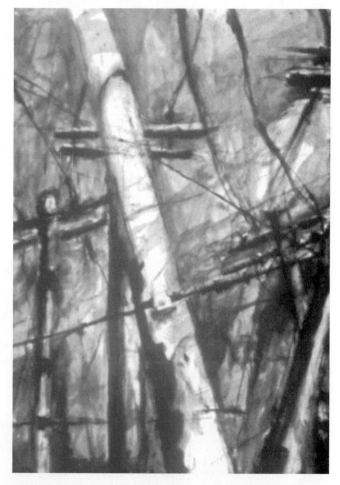

Figure 13.20 PREOT BUXTON, Untitled, charcoal, ink, and gesso on paper, 36 × 24 in.

Figure 13.21 PREOT BUXTON, Untitled, charcoal and acrylic on paper, 48 × 36 in.

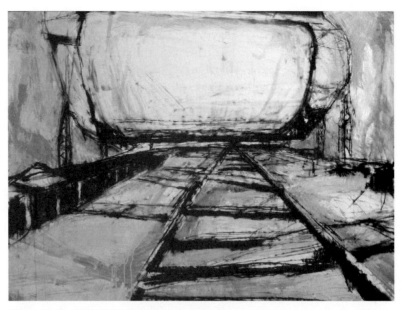

Figure 13.22 PREOT BUXTON, *Trainbridge*, charcoal and acrylic on paper, 48 × 72 in.

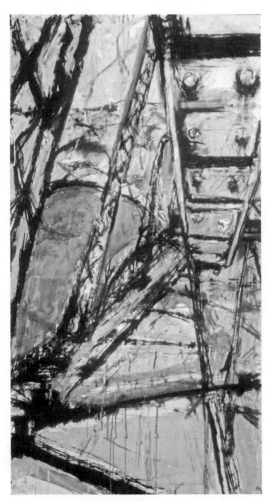

Figure 13.23 PREOT BUXTON, Untitled, charcoal, gesso, acrylic on paper, 96 × 48 in.

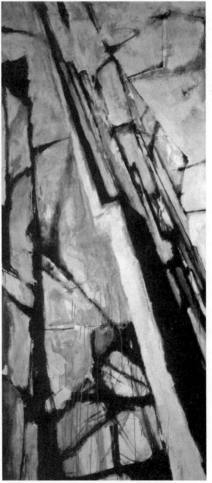

Figure 13.24 PREOT BUXTON, Buttress, charcoal and acrylic on paper, 96 × 36 in.

ated by shapes composed the page, as juxtaposi-tion of interior angles and edges of the paper took on power and importance. In each image the point of view or angle of vision determines how the space is activated. Whether the viewer is looking up at tall buildings or at a bold form on a bridge at eye level, the viewpoint is dramatic and specific in each drawing.

A strong curiosity about process and experi-mentation with media was part of the series from the start. Instead of erasing, Buxton used **gesso** and acrylic paint to brush out areas as he created a sense of space in a continuously shifting motion. The charcoal line was put down, gessoed over, put down again, regessoed in a vigorous, energetic manner. Buxton's innovative use of the medium pushed the drawings toward tactile expression, play-ing areas of opacity against transparency. This future painting major clearly had a feel for his materials and put them to use in response to his searches and explorations through the architectural structures of the city.

Eric Pike

Eric Pike knew right from the start that he wanted to do still life drawings combin-ing self-portraits with objects that had autobiographical references (**Figure 13.25**). There were not any transitional drawings, as his work was focused and strong from the beginning. This future graphic design major had a clear interest in the design of the page as he used bold angles and shapes to activate the space. The force of the angles is supported by his hard-edged, graphic use of the charcoal. Also present is a full range of tonal values from white to black, often jammed next to each other for maximum contrast. Even though his tonal values refer to light and shadow as well as local color, the latter has more emphasis especially in areas of pattern. Each object is carefully

placed, and the purposeful inclusion of angled mirrors adds to the complexity of space through layered reflections (**Figure 13.26**). In each draw-ing, Pike's well-considered approach, crisp edges, strong contrast, realistic detail, and decorative pat-tern all work together as design elements.

The series gives the viewer a glimpse of Pike's life and wit as his visual puns add another dimen-sion of interest to the compositions. For example, in one drawing, the artist's head is layered between chessboard patterns, real and reflected (Figure 13.26). In another, striped sunglasses are grouped with a ribbon tie that becomes a meandering stripe on the page, and a striped marker (that can make its own stripes) (**Figure 13.27**). The theme of see-ing and perception is articulated with a wry humor in **Figure 13.28**. The designs have a sense of easy balance despite boldly angled black against white tonal areas, and they are well-organized without seeming stiff or dry, resolved yet energetic. Ulti-mately there is a greater emphasis on specifics of objects and their arrangements rather than on the physical process of drawing. This emphasis results in a very different approach than in Preot Buxton's series despite a shared interest in diagonal compo-sitional structure. Different as their sensibilities

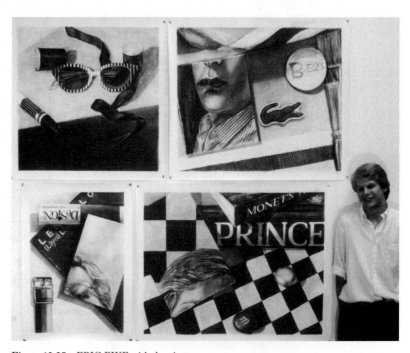

Figure 13.25 ERIC PIKE with drawings

Figure 13.26 ERIC PIKE, Untitled, charcoal on paper, 36 × 48 in.

Figure 13.27 ERIC PIKE, Untitled, charcoal on paper, 38 × 42 in.

Figure 13.28 ERIC PIKE, Untitled, charcoal on paper, 36 × 30 in.

are, both artists were successful in finding a unique voice, as they pushed their drawings in clear, committed directions.

Maegan Fee

Maegan Fee majored in textile design and it makes sense that she had a strong interest in the textures of natural forms. Her subject matter was a collection of dried seedpods that she drew with mixed media: red and black conte, water, ink, charcoal, and wax as a resist on a rough surface paper. The combination of media and subject gave Fee an opportunity to explore the gesture, structure, shapes, and textures of the objects, while also investigating process and media (**Figures 13.29** to **13.34**). The natural objects inspired her to explore with an intuitive approach to line and tone. Bold, loose lines with strong value contrast emerged as consistent elements. The same objects were drawn numerous times: with rendered or abstracted form, widely or tightly framed. Closer views focus on abstract patterns of shape, mark, and gesture while greater distance allows for a consideration of the object as a

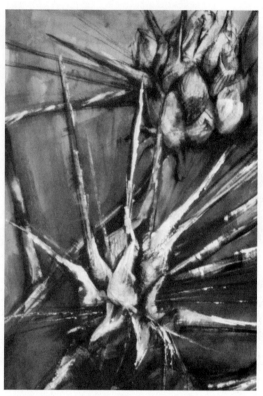

Figure 13.30 MAEGAN FEE, Untitled, charcoal, conte, ink, and wax on paper, 36 × 24 in.

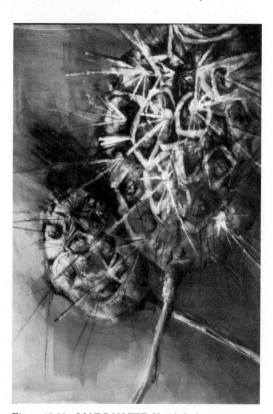

Figure 13.29 MAEGAN FEE, Untitled, charcoal, conte, ink, and wax on paper, 36 × 24 in.

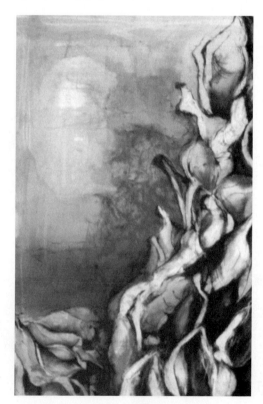

Figure 13.31 MAEGAN FEE, Untitled, charcoal, conte, ink, and wax on paper, 36 × 24 in.

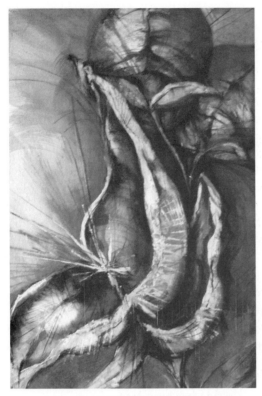

Figure 13.32 MAEGAN FEE, Untitled, charcoal, conte, ink, and wax on paper, 36 × 24 in.

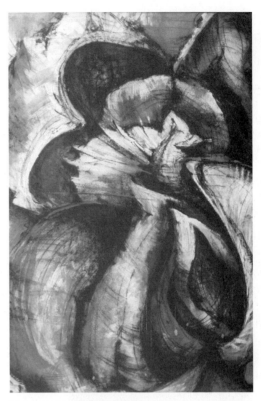

Figure 13.34 MAEGAN FEE, Untitled, charcoal, conte, ink, and wax on paper, 48 × 32 in.

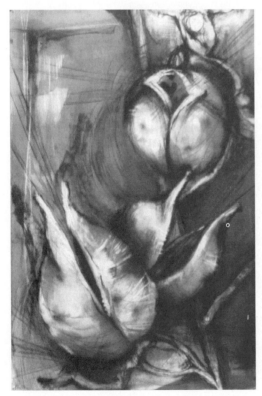

Figure 13.33 MAEGAN FEE, Untitled, charcoal, conte, ink, and wax on paper, 36 × 24 in.

discrete form in space. Fee explored the differences of form present in the seedpods as much as their similarities. Her wide-ranging marks parallel the diversity of organic texture and shape, and the marks became freer and freer as Fee got to know her subject matter. She was able to get beyond an initial response to a more involved mingling of media, structure, and gesture to give viewers a sense of the life and vitality these dried seed pods still hold.

Emily Gherard

Always interested in the figure, Emily Gherard transformed figure drawings done during class into complex, meaningful compositions (**Figure 13.35** to **13.38**). Narratives tie events of her own life to biblical stories and mythology such as Lott's Wife and the Pillar of Salt, Salome and the Dance of the Seven Veils, Leda and the Swan. Revealing the relationship of her own life to the myths collapses time and reminds us that though history has progressed, life issues remain similar. A present-day view intertwines Gherard's life

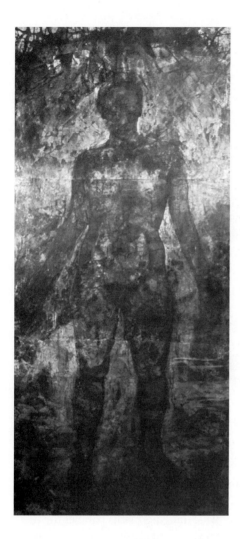

Figure 13.35 EMILY GHERARD, Untitled, charcoal, ink, and gesso on paper mounted on board, 80 × 30 in.

experience these drawings; contemplation is necessary as they reveal themselves slowly.

Gherard made these drawings by applying heavy layers of **encaustic,** charcoal, and other mixed media onto vellum that was mounted onto board. Supporting the paper in this way enabled her to work the media vigorously and achieve an encrusted surface through repeated layering and scraping. The drawings pull work together in well-considered compositions that show a simultaneous emphasis of sensual process, complex thinking, and emotional intensity.

The students whose work we have just considered found meaningful ways to express their ideas. Even when unsure or frustrated, they persisted, worked hard, and the rewards were huge. They loved doing the projects and looked forward each week to working on the drawings. Commitment pays off when you lose yourself in the drawings, and time passes unexpectedly because your level of concentration has been intense.

with the historical references in an edgy mood reminiscent of contemporary artist Marlene Dumas. As the drawings entered a territory of conceptual and emotional narrative, they also became larger in scale, allowing the viewer to participate in a more physical manner with the work. The initial lure for the viewer is the strength of drawing with its beautifully varied surfaces and enveloping tonalities. Then, interest is held in consideration of the narrative and the juxtaposed references. Finally, figure, narrative, and medium merge in an atmospheric environment that shifts from obscurity to sharp focus. It takes time to

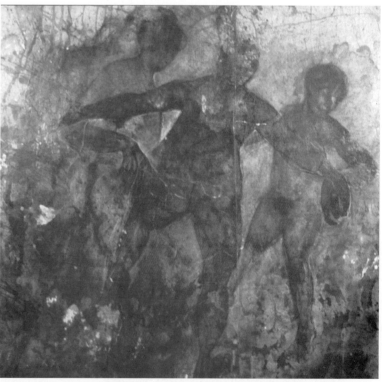

Figure 13.36 EMILY GHERARD, Untitled, charcoal, ink, and gesso on paper mounted on board, 48 × 48 in.

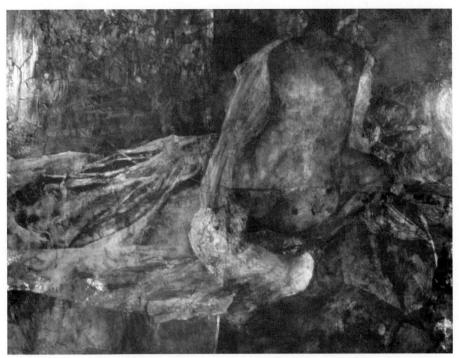

Figure 13.37 EMILY GHERARD, Untitled, charcoal, ink, and gesso on paper mounted on board, 48 × 60 in.

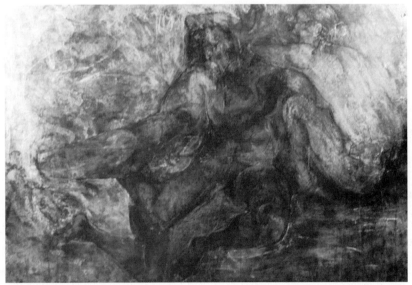

Figure 13.38 EMILY GHERARD, Untitled, charcoal, ink, and gesso on paper mounted on board, 48 × 70 in.

Notes

1. Joyce Maynard, "Writers on Writing," *The New York Times,* February 24, 2003.

2. Anna Claire Shapiro, *Artist's Statement.*

Critique Tips Chapter 13: Individual Series Development

Group critiques for the series drawings are very different than the ones for specified assignments. Because individuals work on unique ideas, each person will most likely present his or her work to the group. It is a good idea to be prepared to talk about your ideas, how your series has already progressed or changed, and what you think the next step may be. The following are some things to think about in preparation for discussions of your work or your classmates' work. The questions are organized to apply to different stages of your series, but many are interchangeable.

Critique Weeks 3 or 4

Are enough time and commitment being put into the work?

Is a clear direction emerging, or do you sense several different possible directions? *If several, what are they? Which one makes the most sense to you and why?*

Does the size of the work and the media being used seem to be working with the ideas?

Critique Weeks 6 or 7

Are there signs of a breakthrough or are surprising new directions emerging? *Are these good surprises (positive potential for development) or bad surprises (unforeseen problems or contradictions)?*

Is the work invigorating, that is, does it excite you? *Do you feel fully engaged with it? Would you rather be working on your series drawing than just about anything else? Does the work interest other people?*

From the response of others, are people seeing what was intended, or are you seeing one thing while everyone else sees another?

Can you resist pressure to be pushed in a direction you are not interested in, but remain open to other's ideas at the same time?

When you hear constructive criticism, can you listen without feeling defensive?

Critique Week 9 or 10

Do you see jumpy or gradual changes in the series?

Are you familiar with artists' work that you can connect with your or other people's work in the critique?

What have you learned about your way of working or your classmates' ways of working? *Does it seem planned, spontaneous, or somewhere between? Is the work generally loose and physical or neat and precise?*

How has a sketchbook helped with a series?

Are the compositions, use of media, and ideas working together in a way that makes sense to you?

Are there directions not taken that you think are worth pursuing?

Appendix A Materials and Processes

By now, you understand how important the choice of tools, medium, and paper are to each drawing that you make. As we have said throughout the book, the best way to learn about drawing media is to experiment with them in a free and open way. You will need to find the characteristics, limits and potentials of each tool, medium, and paper as well as the best way to use them with your sensibilities. Try to push the use of each medium in unexpected ways. But always keep in mind the safety issues discussed below and always work in safe, well-ventilated places.

DRY MEDIA

As you push, pull, drag, dot, skim, or in any way press and move a dry medium across a drawing surface, the friction between the drawing surface and the medium causes deposits of the medium to remain behind, creating a mark, line, or tone. Minute fragments of the charcoal, graphite or chalk create a record of the action you took as particles of your medium lodge themselves into the texture of the paper.

Most dry media, including graphite pencils, charcoal, conte crayons, lithography crayons, and so on are available in a range of density from soft to hard. Different manufacturers use different designations for this information. It should be easy to understand the system for each brand that you purchase, especially if the retailer has some samples out for trial. Some systems will be self explanatory such as Very Soft, Soft, Medium, Hard, Very Hard. Others will be 00, 1, 2, 3, 4, 5, 6 with 00 the hardest and 6 the softest. Graphite pencils are usually within the range of 9H, 8H, 7H, 6H, 5H, 4H,

3H, 2H, H, F, HB, B, 2B, 3B, 4B, 5B, 6B, 7B, 8B, with 9H the hardest, and 8B the softest. With most media, a range from hard to soft is good to have, but if you must choose opt for soft rather than hard.

Charcoal

Charcoal is available in stick, pencil and powdered form as seen in **Figure AA.1.** Both vine and compressed charcoal readily leave evidence or a history of the path they take across any paper surface, except perhaps the absolute smoothest or glossiest. Because of their flexibility and wide range of uses, vine and compressed charcoal are considered basic staples for drawing. Each artist finds his or her own way of using charcoal. This is evident in comparing its soft delicate use by Hans Poelzig

Figure AA.1 Top to bottom: powdered charcoal, charcoal pencil encased in paper, charcoal pencil encased in wood, vine charcoal, vine charcoal, and compressed charcoal

in Figure 6.23 to the sharp edges and clarity of form in Sangram Majumdar's drawing in Figure 6.29.

In the process of producing charcoal for drawing, vine, linden, willow, or other types of branches are slowly heated to a high temperature in an airtight kiln so that water and other compounds vaporize, and the wood carbonizes. Type of wood and length of heating time determine the softness or hardness of the charcoal: softer charcoal is heated longer than harder charcoal.

Vine Charcoal is straight from the kiln, without any binders added. It is therefore very delicate and breakable. Softer vine charcoal will crumble easily, and turn to powder therefore it is classified as friable.

Characteristics: Vine charcoal is fragile, and will break easily. It is also very smudgeable and highly erasable from most surfaces, although it will leave ghost lines on some papers. Flexible in the range of surfaces it allows you to create, experimentation is key to understanding its potential uses. Thin to bold lines can be made with the ends, and using the side creates wide tonal areas. Vine charcoal works well for quick sketches, preparatory drawings, and is great to use to get a drawing started. Highly developed drawings can be done with vine charcoal, but the surface will always be delicate. It can be pushed around with fingers, chamois or fabric cloths or built up gradually in an additive manner. Fixative should be used carefully to preserve the surface of a vine charcoal drawing.

Forms: Sticks, from thin to wide. Chunks.
Range: Very soft to very hard.
Special Techniques: Water can be sprayed onto a vine charcoal drawing as the drawing is being developed. This will create a different rate of drag on the charcoal as it moves across the surface of the paper, and more of the charcoal will adhere to the paper, making denser areas of line or tone. Vine charcoal can be soaked in linseed or olive oil to give the drawn line a bolder, darker color. This will also stabilize the surface so fixative will not be needed. Soaking in linseed oil will necessitate the use of the charcoal before it dries, or the charcoal will harden. Olive oil will not harden rapidly. The oil may cause a halo effect on the paper as it spreads beyond the charcoal line. Charcoal soaked in oil cannot be pushed around as the dry charcoal can.

Compressed Charcoal is made by crushing charcoal into powder, adding a gum binding agent, then compressing the mixture to form square or round sticks, and firing. The more binder added the harder the compressed charcoal will be.

Characteristics: Compressed charcoal will give richer, darker tones than vine charcoal, and is not as fragile to handle or to preserve. It can be used to create large tonal areas, but does not flow to cover surfaces as quickly or easily as vine. It erases well, but not as easily as vine. A combination of vine and compressed charcoal is very common for maximum flexibility in drawing. Compressed charcoal can be built up gradually, or spread with a cloth to create large tonal areas. It can be erased, put back down, erased over and over again. The erasing should be considered part of the drawing process, not just a means to be rid of part of the drawing. Compressed and vine charcoal drawings should be sprayed with a fixative to help to stabilize the surface.

Forms: Sticks; cylindrical or rectangular. Pencils; sticks encased in wood or paper. Pencil lengths allow for a different stroke than the shorter stick form, and are very useful for flowing linear work.
Range: very soft to very hard.
Special Techniques: Water sprayed on the surface of the paper of a charcoal drawing as it is being drawn will cause denser areas of compressed charcoal to adhere to the wet paper.

Powdered Charcoal is readily available and is another versatile form of charcoal. It can be used dry to lay down large areas of tone that can be erased into or drawn on top of, or water or solvent such as gamsol (in a well ventilated space) can be used with it to make washes. This is a good form of charcoal for large-scale work and lends itself to experimental mixed media drawings.

Special Techniques: Used on mylar or a heavy tracing paper with linseed oil, gamsol, or water, this is a very versatile medium. Using a brush, cloth or hands protected with gloves, the powdered charcoal can be pushed around as a wet medium and pulled off the paper, put back down, and so on.

Inhalation of charcoal dust should be avoided by wearing a mask.

Chalks and Crayons

Categories of chalks and crayons overlap, but range from dusty erasable chalk to waxy non-erasable crayons. In between these are charcoal, conte crayons, colored pencils, pastels and oil pastels to name a few. Mined chalk is made up of minute calcified salt water creatures from millions of years ago. Straight from the mine, chalk can have several colors such as white, ochre, brown, black, and sanguine (red). Manufactured artist's chalks were largely replaced in the 1800s with charcoal and conte crayons, but are still made from white clay and pigment. They can be very greasy and solid or dusty and breakable. Like charcoal, chalks leave behind particles that adhere to the paper to create lines, tones and marks. Chalks tend to be erasable, though not as cleanly as charcoal, but they can have color, whether naturally mined or added with pigments. Crayons are even less erasable than chalks because of their wax content. **Figures AA.2** and **AA.3** show several types of chalks and crayons.

Pastels are made from either clay or chalk along with powdered pigment, and gum tragacanth or resin as a binder. They vary from very soft to very hard depending on the pigment, and the amount of binder. Those with more binder are harder and less crumbly, but difficult to erase and blend. Some pastels have little or no chalk or clay and are pure pigment and binder. These are more expensive and can be extremely fragile and literally crumble in your hand.

It is important to understand each brand's system of information regarding color fastness because some pigments are fugitive and can change or fade in light. Tints and shades of colors are also indicated through a system. Many brands of pastels have hundreds of colors, tints and shades available. Quality and hardness or softness varies from manufacturer to manufacturer and experimentation is essential. Some artists make their own pastels so they can determine their own range of colors.

Characteristics: Pastels are opaque and colors underneath do not come through unless the coverage is incomplete. Therefore, mixing of colors often occurs with optical mixing or the placement of one stroke of color close to another. Very fine, resolved work can be accomplished with pastels, and blending can be done with a stump or tortillon, brush or a chamois. Alternatively they can be used loosely with erasing, and blending with fingers or cloth. The surface is matte, but dense and rich. Many black pastels give a deeper black than charcoal and are used with charcoal to extend the value range. Pastel drawings are delicate and should be sprayed with a fixative. Many artists fix their drawings as they work, layer by layer. Because of their fragile surface, it is unusual to see very large scale pastel drawings, but some artists like to push their media to the limit as Mark Milloff did in his pastel drawings of over twenty feet wide (Figure 12.15).

Forms: Sticks; cylindrical or rectangular and small to large. Pencils: sticks of hard pastel encased in wood.
Range: very soft to very hard, varying from brand to brand.

Care should be taken not to breathe in or ingest the dust from pastels as some of the pigments can be toxic. Gloves as seen in **Figure AA.2** should be worn to avoid absorption through the skin.

Conte Crayons as pictured in **Figure AA.3** were developed by Nicolas Conte in late 18th century France to replace the shortage of graphite due to the Napoleonic Wars. They were originally made from powdered graphite and clay, but now chalk, pigment and binders are used. They can be purchased in white, black, sanguine, and sepia.

Characteristics: Conte crayons are hard with a slight waxy or oily feel. They can be sharpened to a point with fine sandpaper or a knife blade to create fine lines, or used on their side to make tonal areas. The surface has a little sheen and is less dusty than charcoal or pastel. They are harder to erase than charcoal or pastel and are often used to build up areas, but erasers can be used to alter the surfaces and blend areas. Conte crayons can be used for quick gestural lines or full tonal drawings such as Seurat's drawing in Figure 6.34. He made characteristic use of the grainy, textured paper, building up the conte where he wanted darker values and

Figure AA.2 Various types of chalk pastels and latex gloves

Wax Crayons are made from paraffin and pigment. They are thought of as children's drawing tools, but there are professional brands made with colorfast pigments.
Characteristics: Wax crayons are not erasable or blendable. Optical color mixing can be achieved by putting strokes of different colors next to each other. Crayons are often used as **resist areas** with ink or watercolor washed over them, filling in where the crayon has not been used.

Forms: Sticks, cylindrical or rectangular

using the white of the paper to work with the conte to make light and middle tones. Because of the way the conte sits on the surface of the texture, Seurat's drawings are good examples of the importance of the interaction of the medium with the paper.

Forms: Sticks. Pencils.
Range: Hard, medium and soft

Colored Pencils are made with a mixture of pigment with a wax and gum binder that is molded into a stick and encased in a wood pencil form. There is also a watercolor pencil available. Colorfastness of pigments should be tested.
Charactericstics: Colored pencils can be used for loose, linear drawing, as well as for slowly layered and highly detailed or precise drawings. The surface is dust free with a sheen but erasing is not recommended. Optical blending by layering or juxtaposing colors is possible. Depending on the type of pencil, either water or organic solvent (with proper ventilation) can be used to blend colors. If both types of colored pencil are used together, water can be used to blend the water soluble colors while the other colors will remain intact. Hundreds of colors, tints and shades are available. In Figure 1.11, the colored pencil drawings of Julian Hatton are an example of a loose, open approach to the use of colored pencil. The medium allows him the fluidity and ease of gesture he is seeking. On the other hand, colored pencils also work well for Silke Schatz in Figure 5.26 where she needs a controlled, precise line. The effect of the layered lines in these two drawings is remarkably different considering that the same medium is used in both.

Form: Pencil

Figure AA.3 Left to right: colored pencil, China marker, wax crayon, oil pastel, oil pastel, lithographic crayon, black conte, and white conte

Lithographic Crayons are made from wax, lamp black, and resins for drawing on a print-maker's lithographic stone. Artists also use the litho crayon for drawing on paper.

Characteristics: Depending on the softness, they can be very greasy and can make areas of tone that are deep, velvety blacks. The litho crayon flows easily over a smooth paper. Erasing is not an option, but used with solvent (in a well ventilated area) on heavy tracing paper, the marks and tones can be moved around, or wiped away with a cloth. A brush can also be used with solvent and litho crayons as a wash.

Forms: Pencil. Sticks.
Range: hard to soft.

China Markers are a wax-based medium made for industrial use for writing on glass or plastic. Similar to lithographic crayons they have been adopted by artists for drawing.

Oil Pastels are made with pigment, oil and a wax binder; the more wax they have the greasier they are. The quality of oil pastels varies greatly depending on the manufacturer; experiment with several brands and test for light fastness. Like pastels they come in many different colors, some of which are light fast and some that are not.

Characteristics: Oil pastels are not dusty and delicate like pastels, nor are they erasable. They can be smudged together or used with solvent and a brush as a wash. They are opaque and cover a paper surface quickly in either flat colors or complexly modulated areas with many colors working together. Both can be seen in Mark Macrides's drawings Figures 13.9–13.13.

Forms: Cylindrical sticks.

Graphite

The "lead" in pencils is actually graphite, a chrystaline form of carbon that has been processed with clay and formed into pencils or sticks. The more clay in the mixture, the harder the graphite becomes. The range is from 9H, very hard to 9B, very soft. It is important to have

Figure AA.4 Top to bottom: powdered graphite, graphite stick, graphite stick, graphite lead holder, graphite pencil, graphite lead holder, and woodless pencil

several different hardnesses because the potential range of tones from each is remarkably different. Some of the varieties of form for graphite are in **Figure AA.4.**

Graphite pencils replaced silverpoint or metalpoint as a tool for making fine lines when graphite became available in the 17th century.

Characteristics: With a wide range of hardness graphite pencils are very versatile. They can be used to draw flowing elegant lines, as in Figure 6.21 in the drawing of jellyfish by scientist Ernst Haeckel, make expressive marks in a range of values as in Figure 5.4 in the drawing by Giacometti, create areas of subtly controlled tonalities as in Figure 4.38 by William Bailey, or to develop a full range of tones as in Figure 6.2 by Judith Murray. Large strokes can be built up to make tones, or smaller strokes can be used to form tone without any indication of their presence. Tonal areas often have a sheen that will catch the light. Graphite erases well, but hard graphite pencils with a sharp point may incise the paper, leaving its trace. Graphite can be blended, smudged or worked with a solvent in a properly ventilated area.

Form: Pencils with wood encasements. Woodless pencils which are actually larger graphite cylinders with a laquer paint applied to resemble a pencil.

Range: 9H to 9B; not all manufacturers make the entire range. H, 2B, 4B, 6B, and 8B would be a good range to start with.

Graphite sticks are the same medium as pencils, but in a stick form about 1/4 × 1/4 × 3 inches or 1/4 × 1/2 × 3 inches. Good for more general work, the side can be used to put down a quick large area of tone. They range from B to 6B, and they have the same sheen to the surface as pencils and are erasable as well.

Graphite leads are cylinders of graphite that come in many widths and are held by lead holders. The leads are available in the same range as graphite pencils.

Powdered graphite can be purchased in any art store, or ground from sticks of graphite. It is good for large areas of tone and can be rubbed onto the surface with a cloth. It is as erasable as graphite pencil and is a very flexible form of graphite for experimental purposes. It also has a sheen to the surface.

Figure AA.5 Left to right: chamois cloth, tortillon; **top to bottom:** kneaded eraser, plastic eraser, pink eraser, and gum eraser

TOOLS FOR DRY MEDIA

The erasers, tortillons, chamois, and soft cloths seen in **Figure AA.5** are useful tools to use with dry drawing media. They are often thought of as a means to correct or get rid of unwanted lines or marks, but they are more important when used as part of the drawing process to manipulate the medium in expressive ways.

Kneaded erasers are as soft and pliable as their name suggests. They can be made into any form and points can be used to dab at small areas of the drawing. Edges of shapes or lines drawn with most dry media can be softened and larger areas smudged. Kneading the erasers as you work will keep them clean. They work well to scumble areas of graphite or charcoal, but for very sharp, thorough erasing, a pink, plastic or gum eraser will work better.

Plastic erasers are useful to erase charcoal, graphite, and conte. They are good for full erasing as well as for drawing or manipulating the medium that is on the paper. Experimentation is key to getting the most out of this type of eraser. Clean hard edges as well as scumbled soft edges can be created. When the eraser gets worn down and the edges are round, you can cut a triangle off so that you still have a nice sharp edge to get into small areas.

Gum erasers are very soft and crumbly. They will not harm a paper's surface, but also will not remove media as well as plastic or pink erasers.

Pink erasers work well for most erasable media. If used aggressively they can damage the paper's surface. They tend to be stiffer than the plastic erasers, and less versatile.

Soft cloths are useful with charcoal and powdered graphite. They can move the medium around on the paper. Once they become saturated with charcoal they can be used to tone an area without applying any new charcoal.

Chamois is a soft animal skin that can be used in similar ways to the soft cloth mentioned above. When it is clean it can be used as an eraser to pick up dusty media such as charcoal tones. The chamois can be washed if desired, or left saturated with medium and used to put down tones.

Stumps or Tortillons are used to blend charcoal, graphite, pastel and so on. They are made with soft paper that is tightly rolled with points on each end of the cylinder. They can also be used to draw with if dipped into powdered charcoal for instance. Matisse used a stump to merge some areas of his charcoal drawing in Figure 4.25.

Spray bottles filled with water are handy to have to spritz your charcoal, conte, or pastel drawing. This will create different surfaces to draw back into and open up the process for further experimentation.

Fixative is necessary for large charcoal and pastel drawings. Be sure to do a test spray first as fixative can alter the surface of the drawing. Follow the directions on the can and be certain to use it in a very well ventilated space such as a spray booth or outdoors. Try to have the drawing on an easel or wall, stand back 3 feet and apply 2 to 3 light coats allowing it to dry in between applications. Workable fixative will allow you to draw over and even erase into the surface to a certain extent. Nonworkable fixative should only be used if you are absolutely sure that you will not want to rework the drawing in any way.

Sharpeners for graphite pencils come in various forms: electric, hand held and mechanical. They each give a standard sharp point to a pencil. An alternative is to use a matt knife to carve away the wood and then if needed, a sanding pad to sharpen the point exactly as you want it. This gives you the most control over the point of your pencils, and other drawing tools such as conte crayons and charcoal pencils and so on. Leads can be sharpened in a rotary lead pointer.

Drawing Boards are needed to stabilize your drawing pad or to fasten a sheet of paper onto. Pre-made masonite boards are available, or you can make your own with masonite or 1/2 inch thick foam core board. The foam core will be lighter to carry, but will not be nearly as long lasting as a masonite board. Be sure to have your drawing board a couple of inches wider and longer than your pad or paper.

WET MEDIA

Wet media in drawing range from watercolor to ink and are most often applied to the paper with either a brush or a pen. There are numerous variations of pens and brushes and a few examples are shown in **Figure AA.6** with ink and watercolor.

Ink

Inks were first used in China and Egypt 4,500 years ago. Ancient inks were made from ground pigment and glue that was dried into a block form. When used it was mixed with water. Today there are numerous types of inks and markers for many different uses. The most common drawing inks and markers will be discussed here. Ink is very flexible and drawings can be made with pen and ink, brush and ink or a combination of pen and brush and ink. It is interesting to look at two very different uses of brush and ink in Joseph Alber's drawing in Figure 2.1 and Hans Arp's drawing in Figure 3.18. Albers

Figure AA.6 Left, top to bottom: tubes of gouache and watercolor; **center, left to right:** synthetic round brush, synthetic flat brush, bristle brush, bristle brush, foam brush, bamboo brush, bamboo pen, crow quillpen; **right, top to bottom:** sumi ink, calligraphy ink, India ink

understood how to get the most out of the fully loaded brush as well as the drier brush. He was able to achieve an amazing range of value and texture in his lines. Arp chose to work in an opposite way and put down flat single values creating strong shapes rather than evocative lines.

Different approaches to the use of ink such as ink on dry paper versus ink on wet paper will give strikingly different effects. Experimentation is important to discover the possibilities of this medium.

Black Inks or carbon inks are widely used and the most common are india ink or the better quality sumi ink. They are made with carbon black and water and if waterproof, they have shellac and borax, or glue as binders and suspension agents. The pigment remains suspended in the water.

Characteristics: Black inks are used with pens or brushes for line and wash drawing. Wash mixtures can be made with varying proportions of water and ink to achieve different values of washes. Often three or more values of ink are prepared for application with a brush and used with full strength ink with a pen for line. Alternatively, one very light value of ink can be used and layered over an area to build up to a dark value, the number of layers determining the lightness or darkness of the area. Gwen Strahle used this method in her drawing in Figure 6.27. Waterproof ink cannot be erased or changed and once it dries it is permanent. Many types of line qualities are possible, and experimentation with different pens and brushes is important. Using line and wash with pen and brush, ink is a fluid medium that lends itself to incredible results ranging from bold and brash to subtle and detailed. Comparing Sandy Walker's straightforward black marks on white paper in Figure 7.23 to the subtle range of tonalities and delicacy of touch in Hiroshige's Figure 7.19 to the rich density of layered washes in Todd Moore's Figure 7.3 will give you an idea of the flexibility and range of possibilities of ink as a medium.

Forms: Liquid or stick forms of India and sumi inks are available. Sumi ink is more often found in solid form and is made into a liquid by rubbing it against a sumi stone with water until the ink is the desired density.

Colored Inks are available in many variations. Some are water resistant, others waterproof. Some are acrylic based and others are made with shellac. Check the lightfastness and degree of waterproof that you want to work with. You will need to balance your need to work back into the ink after it is dry with its durability over the long term. Most colored inks are mixable with other colors of the same type so that you can have a wide range of custom-mixed colors to use. Many old master drawings were done with brown inks called sepia or bistre. The sepia was made with ink from squid or cuttlefish as in Caspar David Friedrich's drawing in Figure 5.5 and bistre was made from chimney soot and wine. Today there are inks available in colors similar to sepia and bistre, but most are not made with the original ingredients.

Water-Based Paints

Watercolor is a wet medium that is often incorporated into drawings. The paint is made with pigment, the binder gum arabic, and water.

Characteristics: Watercolor washes are transparent unless white is added to them. The luminosity of watercolor is due to the light passing through the paint, hitting the white paper, and bouncing back to your eyes. Overlapping colors are mixed optically as the light comes back through them. Color can be built with overlap once the undercoat is dry, or wet-into-wet washes can be built giving a much different, more diffused effect. Comparing Jason Brockert's use of soft edges for an atmospheric effect in Figure 5.6 with Los Carpinteros straight, clear edges to make solid block forms in Figure 5.12 shows the versatility of watercolor as a medium. Choosing the right brush and paper to work with is critical to the drawing. Some artists make a line drawing with pen and ink and add color with watercolor washes. Most often the paint is applied directly to the paper with brushes, but experimentation with spattering can also be tried.

Forms: Watercolor is available in tubes or in cake form.

Gouache is made with pigment, gum arabic and water.

Characteristics: Gouache has some characteristics in common with watercolor but it is opaque and therefore lacks the transparency of watercolor. Unlike watercolor, a layer of gouache will cover a surface and completely hide the paper beneath it. Gouache is easily incorporated with other drawing media such as ink and watercolor. Modigliani used watercolor and gouache in Figure 3.28, playing off the transparent areas against the opaque areas of gouache. This medium also makes a good base for drawing on top of with graphite, charcoal or pastel. When dry, gouache has a matte finish.

Forms: Gouache is available in tubes, and it is sometimes referred to as designer colors.

TOOLS FOR WET MEDIA

Pens

Pens can be used with various types of ink to make lines and marks. It is important to read about the type of pen you choose to be certain that you use the right type of ink. Many types of ink such as India ink will clog in fountain pens or technical pens and should be used only with dipping pens. Most types of pens are available in a range of point sizes, and as many as possible should be experimented with.

Bamboo and Reed Pens are carved from reeds or branches of shrubs that are hollow. Points are rigid, but can be made in many widths and often several pens of varying widths are used in one drawing for variation in mark and line. When the points wear out they can be recut. The point is dipped into the ink, and must be replenished frequently. The dipping process becomes part of the rhythm of the drawing process. You will notice that the first strokes after dipping are bold and dark, but give way to a dryer, more nuanced mark. Reed and bamboo pens lend themselves to making bold lines or short repetitive marks as seen in Figure 11.1 by Van Gogh. Adding water to the ink in

different proportions will give you a range of ink values for the marks. Alternatives to dipping pens are sticks or small branches that have been sharpened with a blade.

Metal Pen Points or nibs are purchased separately from the holders. A very wide variety is available such as round, angular or straight and they all come in many widths. Before metal pens became widely used in the 1800s, quill or feather pens were used by artists such as Raphael in Figure 3.31. Metal crow quill pens generally tend to be stiff and make fine but abrasive or scratchy lines. These pens will draw in downward and side strokes, but not upward ones; a smooth paper is best for these pens. Lettering or calligraphy pens are also used for drawing. Lettering points allow only one line weight but calligraphy pens are shaped especially for the variations needed in calligraphy and are often used by artists because of the possibilities of linear variation. Metal point pens are often used to create value change through the massing of lines and marks.

Fountain Pens have the advantage of the metal point with an extended supply of ink. Some are made to hold India ink, but do not put India ink into fountain pens that are made for standard desk ink or it will clog.

Technical Pens are often called rapidographs and these give an even line weight and are filled with a cartridge or refillable reservoir. They come in numerous sizes, and a range of sizes can be useful to have. Lines can be drawn in any direction with these pens and the pen is held perpendicular to the paper.

Ballpoint Pens are useful for sketching because of the constant flow of ink. This is one of the types of red pens and pencils used by Tim Hawkinson in his large scale drawing in Figure 12.2.

Markers are available in fiber, metal, and plastic tips in endless colors, shapes, and sizes and a few are shown in **Figure AA.7**. Tips may be angled, flat, pointed, brush style, flexible or inflexible. Once you have decided on the type of pen you want to try, note the degree of permanence of the ink. Some are colorfast, others are not, and some are waterproof, others are not. As with all pens, it is important to try a range of types. In

Figure AA.7 Left to right: felt tipped permanent marker, metal tipped marker, three felt tipped permanent markers

some art supply stores trial pens and paper are available for you to experiment with so that you can have some idea of the range of marks before you purchase a pen. With many markers, you will be limited to one width for lines and marks and the density of the marks will determine the value of the area as in Figure 6.22 by Shuvinai Ashoona who worked with a felt-tip pen.

Brushes

There are several types of brushes for use with wet media such as ink, watercolor, and gouache. Brushes can give fluid lines with either full strength ink or a diluted ink. They are also used to put down ink washes. It is essential to experiment with different types of brushes as each different bristle type and shape holds different possibilities of linear or wash characteristics. A stiffer brush will produce dry brush effects while a brush that holds more ink such as a Japanese brush will give a flowing, wetter line. The combination of the brush, the medium, and the motion and pressure of your arm and hand will yield a range of results

that you will become sensitive to over time. Several brushes are shown in Figure AA.6.

Bristle Brushes are made with hog bristles and are stiff. They work with ink in a clumsy manner but are good for dry brush techniques.

Sable Brushes are made from sable hair, but the name may also include other animal hair such as camel or squirrel. They are softer and more flexible than bristle brushes and round versions will come to fine points for detailed work. These are a good choice for ink and watercolor.

Synthetic Brushes are less expensive than sable or bristle brushes but are still very good for ink and watercolor. They are made in different degrees of softness and stiffness so that they mimic bristle or sable brushes.

Japanese Brushes are round brushes of varying sizes set in bamboo handles and are excellent with ink washes. They are flexible, make good points and are often of goat hair.

House Paint Brushes can be found in bristle or foam rubber and inexpensive ones are excellent to use for very large areas of ink, watercolor or gouache. Gesso can also be incorporated into charcoal or ink drawings with house paintbrushes.

Brush Shapes and sizes are numerous and sable, bristle and synthetic brushes are made in many sizes of angular, flat, hake, liner, mop, oval, sash, square wash and other shapes suitable for liquid media. You will find brushes with just a few hairs or bristles to brushes that are eight inches wide. The best way to experience these is to go to a large art supply store and see the range of bristle type, shape type and sizes available. For extremely large-scale work household objects such as mops and brooms can be used as brushes with buckets of paint or ink.

Alternative Drawing Tools

Many found objects such as twigs, strings, ropes, sponges, rocks, toothbrushes, brooms, mops and so on can be used as drawing tools. Anything that can be dipped into ink or coated with powdered graphite or any other medium can be used to make a drawing.

ALTERNATIVE DRAWING MEDIA AND PROCESSES

Just as found objects can be used as drawing tools, found media can also be used to make drawings. Lipstick, spackle, coffee, tea, mud, juice, soot as seen in Bontecou's Figure 11.27 and so on can be used as alternative media for drawing. Painting media and printmaking inks and processes can also be used for drawings. Some alternatives to traditional media and processes are:

Beeswax as a medium dates back to 100 CE in Egypt. Many artists today use it as either a painting or drawing medium. Encaustic is a general term for different mixtures that include beeswax. This can be as easy as mixing pigment to melted wax, but adding damar varnish results in a harder medium. This type of encausitc cools quickly. Mixed with linseed oil encaustic becomes a slow drying medium that can be worked into over a period of time. Pigment is not needed if the natural color of the beeswax is desired. Encaustic is translucent so lower layers of color will come through. Of course if white pigment is added, it will become opaque. Brushed or spread with a knife onto a heavy paper or support, it can be scraped into or incised during or after the drying period to reveal layers underneath. In Figures 12.28 and 12.30 Cheryl Goldsleger used layers of beeswax mixed with oil and drew by incising and scraping into top layers to reveal the colors below. Elinore Hollinshead in Figures 12.11, 12.12, 12.13, and 12.14 adapted the medium by using India ink as pigment. Her surfaces are harder than Goldslegers's, and therefore chipping, and chiseling were necessary to scrape through top layers.

Collage gets its name from the French word *coller*, to stick. Even thought the technique is ancient, the term was first used by Georges Braque and Picasso in the early 1900s when they began to incorporate found images into their work by gluing them to the paper or canvas support. Since then artists have used collage in many ways with the common element of gluing something onto a surface. Magazine images, pieces of string, straw, part of one drawing glued into another drawing, are just a few of the limitless possibilities. Contemporary artist David Thorpe makes intricate collages (Figure 5.22) by cutting up many pieces of colored paper and adhering them to a support, creating an invented image. A good quality white glue is an appropriate choice as an adhesive. Rubber cement is easy to use, but is not permanent and gives off harmful fumes. Be certain to read the labels for safety and ventilation requirements.

Decalomania is a drawing or painting technique that some surrealist artists such as Max Ernst and Oscar Dominguez (Figure 10.24) used. On the surface of the paper, put a layer of a thick liquid media such as gouache, finger paint or oil paint. Before it dries, place a sheet of paper, cloth, aluminum foil or similar material on top of it. Press the two sheets together, and move the top sheet over the painted surface as you want. Remove the top sheet before the medium dries. The resulting effect will be strange and unexpected patterns that can be left, or worked into with other drawing media. If you wet the top sheet and or put glycerin on it, the effects will vary. This is a process that needs experimentation with different approaches and different media.

Frottage is another approach to drawing that Max Ernst began to incorporate into his work when he noticed that the grain from the wood floor planks he had placed his paper onto came through in his graphite drawing. After that, he began to look for textured surfaces that he could put paper over and rub with graphite, litho crayon, charcoal and so on to get the texture without actually drawing it. Frottage can be left as the finished drawing, or worked into with other media and approaches to drawing.

Gesso is a liquid ground that is brushed onto canvas and left to dry before oil or acrylic paints are applied, but it can also be a useful alternative drawing medium. For large scale, loose mixed media drawings it works well with charcoal, powdered charcoal or ink. Applied with a brush, the opaque gesso can cover areas, mix with the charcoal or wet ink to create a toned area, or it can be drawn into while it is still wet. Eve Aschheim used gesso as a wet medium with graphite and wax crayon in Figure 11.8.

Image transfer is a process that can be the basis for drawings. Often used by Robert Rauschenberg as in Figure 10.31 it gives the artist an image to draw into and develop further. A solvent such as wintergreen oil is applied to the back of a printed image from a magazine, newspaper, photocopy and so on. Once the oil has soaked into the paper, place the image face down onto your paper and rub it with a large spoon or a printmaker's burnisher. The image will transfer from the original source to your paper.

Mixed media can be the combination of any two or more media. In drawing a dry and wet media are often used together such as ink and chalk or charcoal. Leonardo began his drawing in Figure 4.5 as a chalk drawing, and then used pen and ink to develop it. In Figure 4.40, Diebenkorn used an ink wash and conte crayon together and Jasper Johns used charcoal, pastel and watercolor for Figure 7.6. Other artists use a wax resist by drawing with crayons and then putting a wet medium such as a wash of ink over it. The wax resists the wash. The use of mixed media can be subtle, or take over as the main point of the drawing. This begins to happen in Barry Ledoux's drawing in Figure 6.35 of cut paper, hair, glass beads, oil stick, and pigment. Judy Pfaff's Figure 12.41 includes watercolor, encaustic, oil stick, doilies and cast acrylic. The possibilities are endless and contemporary artists incorporate found objects, fingernails, skin, fabric and so on in their drawings.

Monotype is a unique, one-of-a-kind print and it can be considered the final form of the work of art, or serve as the beginning of a drawing. Working on a surface such as glass, plexiglass, a metal printmaking plate, or even yourself, one or more colors of paint or printmaking ink is applied with a roller, brush, rag and so on. Next the paper is placed on top of the surface and either run through a press, or rubbed with a spoon, hand, or burnisher. Figure 7.24 by Degas and Figure 10.29 by Antoinette Hocbo are examples of monotypes that were drawn into after the printing process.

PAPER AND DRAWING SUPPORTS

Paper is made from matted fibers that intertwine and adhere to each other. The paper you choose will have a definite impact on your drawing and you will want to carefully consider its texture, color, weight, degree of absorbency, and erasability. Paper with a texture may work well with charcoal because it will hold the particles, however, the same texture may trip up the stroke of an ink pen. Each stage of paper production from the choice of the fibers such as rice, cotton, linen, bamboo or mulberry to the water quality, temperature of processing and fillers that may be added affects the characteristics of the paper.

Categories of Paper Making

Hand-made paper is produced one sheet at a time. First the fiber is macerated or beaten with water to make pulp. Next the pulp is put into a vat with more water to form slurry. The proportion of water to pulp in the slurry will directly affect the thickness of the paper. Then sheets of paper are formed one by one with a screen mold that is submerged into the slurry and removed; as the water drains the pulp remains on the mold. Each sheet is placed on felt blankets and the remaining water is pressed out.

Mold-made paper combines the hand-made and machine-made processes, and the result is a paper that has many characteristics of hand-made paper. The fiber is beaten as in the hand-made paper. A cylindrical mold with a screen rotates in the slurry to gather pulp to form a long sheet or roll of paper. Next it is pressed between felted rollers to remove excess water, steam heated and rolled. Later it is cut into sheets or sold as a roll of paper.

Machine-made papers can be produced quickly with computer technology. This process chemically changes the fiber to pulp, adds water to make slurry, sends it onto rollers, presses out the

water with felt and dries the paper. It is made in the form of a roll and may be cut into sheets or sold as a roll.

Whether hand made, mold made or machine made variations of texture and lines on paper are from the different textures of the felts and or the placement of wires in the screen mold. Texture is an important aspect of paper choice as it significantly impacts how the medium works with the paper. This becomes clear when looking at Seurat's drawing in Figure 6.34 where the texture is such an important part of the luminosity of the image.

Paper Terms

Acid Free papers do not have any acid and have a neutral pH. They are either made with 100% rag fibers, or were treated to become neutral. It is important to use acid free paper for work that you want to keep over a long period of time because it will not yellow or deteriorate as will papers that are not acid free. Newsprint for instance contains acid and yellows quickly.

Cold pressed paper is pressed with cold rollers in the manufacturing process producing a texture between the smoother hot pressed papers and the more textured rough papers. (See hot pressed and rough.)

Deckle edge refers to the naturally occurring, irregular edges on all four sides of hand-made paper. Deckle edges are often artificially put into the manufacturing process of mold-made and machine-made papers. Because these papers are made in rolls, they have deckle edges on two sides.

Hot pressed paper is pressed with hot rollers in the manufacturing process giving the paper a smooth surface. (See cold pressed and rough.)

Laid paper has a pattern of parallel lines due to the wires making up the screen of the mold in hand-made paper. This pattern can be simulated in machine-made paper.

Ply refers to the number of sheets of paper put together to form some paperboards such as Bristol board.

Rag paper is made from cotton and or linen and is acid free.

Rough is a term that refers to a paper that is not pressed, or is just slightly pressed after the sheet is made. This gives it a rough or distinct texture. (See cold pressed and hot pressed.)

Tooth refers to the texture and surface qualities of a paper.

Watermarks on hand-made and mold-made papers are designs to identify the maker and are incorporated into the molds.

Weight reveals the thickness of a paper. This is measured in pounds per ream (500 sheets) or more commonly in grams per square meter (gsm). The range is from 12 gsm for some very light mulberry papers to 660 gsm for a heavy watercolor paper.

Wove paper has an unlined surface (in contrast to laid paper). It is made on a wire surface that is woven rather than on a mold with wires going in one direction.

Types of Paper and Drawing Supports

Bond paper is a general use, inexpensive paper that is often sold in pads. The quality varies, but it is most often not a permanent quality paper. It is fine for quick dry or wet media studies that will not be saved over a long period of time.

Bristol board is available in different plys and in a smooth or slightly textured finish. It works well with pencil, charcoal, watercolor, and ink. It can be found in an acid free or permanent quality.

Charcoal paper is made with a texture to hold the particles of charcoal. It erases well because the paper does not absorb the particles and it is available in a range of colors.

Illustration board is made by laminating watercolor or drawing paper to board, therefore it is stiff and works well for water based media. Permanency is good with a high quality illustration board.

Mylar is not a paper, but a transluscent polyester film that has a matte surface on one side.

Made for use by engineers, architects and designers, it has some unique properties that make it good for experimentation with ink, graphite, powdered graphite and grease-based media such as litho crayons and china markers. Used with a solvent, these drawing tools function as wet media and can be pushed around with a cloth or a bristle brush. Mylar is available in sheets or rolls.

Newsprint is the least expensive paper for drawing. It has a high acid content and therefore it is not permanent and will yellow and become brittle. It is most often available in pads up to 24 × 36 inches. It is good for students who use a lot of paper for quick drawings that they may not want to save over a long period of time. Charcoal, conte, graphite and pastel all work well on it and the erasability is good. Newsprint is available in smooth or rough.

Pastel paper is specially made for pastel, but can also be used with charcoal and other dry media. There are many different types of paper sold for pastel that range from velour surfaces to sandpaper surfaces.

Printmaking paper can be excellent for drawing. It varies widely as there are numerous types. Some erase well, but others are soft and absorbent and the erasability is low. But since many artists like to have erased lines show in their finished drawings, this is not necessarily a problem. It is generally good for any drawing media, but try to buy a few types and experiment with it. There are good quality printmaking papers available for reasonable prices, but you can also spend a fortune on one sheet. It comes in different sizes and weights and can be found on rolls.

Rice paper is especially suitable for brush and ink drawings. It is absorbent, does not hold up under erasing, and is very lightweight.

Watercolor paper is available in medium to very heavy weights in hot pressed, cold pressed and rough surfaces. Like printmaking paper, there are numerous types available in a great range of prices. A good, heavy paper will hold up to intense drawing and erasing and it is excellent for charcoal, ink, watercolor, pencil and most drawing media. It is available in large sizes. Experiment

with some modestly priced types to find some that work well for you.

Alternative drawing surfaces include anything from pottery, leaves, wood, building exteriors, interior walls, to temporary surfaces such as sand at the beach. Max Klink used architectural blueprints as a starting point for his drawing in Figure 5.25 and as we saw in chapter 12, Sol Lewitt designed many of his drawings for wall surfaces that may be painted over at some point after the drawing is completed (Figure 12.6). The first drawings we know of were done on cave walls and rocks; marble is a surface of choice for contemporary artist Glexis Novoa as we saw in his drawing of graphite on marble in Figure 12.5.

SAFETY ISSUES

There are a few basic safety issues to remember when working with any art or design media to avoid endangering your health and the health of others around you. The cautions listed here relate most specifically to drawing, but since drawing is an ever-expanding discipline, they are not inclusive of all media you may use or all situations you may encounter. Be sure to know the hazards of the media and processes you use, and the proper way to handle, ventilate, store and dispose of any residue.

Material Safety and Data Sheets: (MSDS) each product will have an information sheet that lists specific hazards such as toxicity, flammability, ventilation requirements and so on. These should be read for all art products you use. Manufacturers and retailers are required to have them available. If you are familiar with the specific hazards for the media you use, you can avoid using them in a careless manner. Get into the habit of reading these sheets each time you use an art product for the first time.

Labels: always read labels on art materials, and follow the directions. These are not substitutes for MSDS but can give you some basic information as to precautions that need to be taken.

Studio space: work areas should be used only for your drawing and artwork. Many media are toxic or dusty and working in a bedroom, kitchen or other shared space can lead to unintentional circumstances.

Inhalation: avoid inhaling any drawing media, glue or solvent. Any dry media will create dust, and even if, for instance, the charcoal you are using is not toxic, the dust can still irritate your respiratory tract and lead to allergies or asthma. Be aware that many pigments in pastels are very toxic and should never be inhaled. Do not blow on charcoal or pastel surfaces, and always damp mop any residue from the floor or table top. Appropriate masks should be worn when working with dusty media or products that give off vapors such as solvents and glues. Proper ventilation is also needed for these items. Sprays such as fixative must be used in spray booths that are properly ventilated. Never use these indoors without a spray booth. Be careful not to breathe in hot fumes from encaustic as the heating of the beeswax, damar varnish, and pigments can irritate the respiratory system. Also be careful with the powdered pigments used to color encaustic. These pigments can be extremely toxic.

Ingestion: avoid ingestion or intake of any art material. Eating, drinking and drawing do not mix, as you can accidentally ingest toxic pigments from pastels, watercolors, gouache, encaustic and so on. Smoking while working can also cause ingestion of toxic art materials.

Skin contact: or contact with a cut in the skin and any media should be avoided. Toxic pigments, solvents and so on can be absorbed through the skin and spread throughout the body. Some people have allergies to gum arabic that is used in watercolors and gouache paints. Gloves should be worn when using a medium that will come into direct contact with the skin such as pastels and oil pastels that can have toxic pigments. There are many types of medical gloves that fit tightly and will not prevent fine work or hinder your dexterity. However, even some gloves can cause allergies, so be sure to check the contents and watch for signs of a reaction.

Storage: be certain to properly store flammable and toxic products such as solvents and glues in special containers and cabinets. Again, always check MSDS and the product label for directions and cautions about storage as well as proper usage. Even items such as pastels, oil pastels, charcoal and so on should be stored out of the reach of children.

Allergies: if you have allergies or develop one while working with a particular medium or product, stop using it immediately. You can work for years with a product without any danger signs, and then suddenly develop a serious reaction.

Be as careful as you can and be certain to develop good safety habits staying informed with MSDS and label reading. If you do not understand something on a label or MSDS, ask your teacher, retailer, or manufacturer.

Appendix B Linear Perspective

Linear perspective is a geometric system developed by architects and artists during the Renaissance for projecting the illusion of objects in depth from a particular point of view. Originally developed for building imaginary scenes and most useful when drawing geometrically regular objects such as rectangles, linear perspective simulates the experience of real vision while existing as a system somewhat apart. Still, perspective can provide great insight into the nature of spatial relationships in depth, while giving powerful interest to drawings involving space and a convenient means to organize and build coherent compositions in relation to a specific position for the viewer.

ONE-POINT PERSPECTIVE

Figure AB.1 shows a basic one-point perspective system, so-called because all receding edges of parallel rectangular planes in the drawing converge at one **vanishing point**, located on the **horizon line**. Note that any two **vanishing lines**, such as the top and bottom edges of the building on the right, together define a certain *2-D* **measurement**, in this case, the height of the building, which appears to get smaller and smaller as it goes back into the distance. Perspective relies on the idea that

a fixed 2-D measurement visually diminishes with perfect regularity as it moves away from the viewer in space.

Elevation, Paraline, and Perspective Projections

Figure AB.2 shows a house in a schematic diagram called an **elevation projection**, which shows all visible sides without any adjustment for point of view: All rectangular sides are shown as actual rectangles; all equal dimensions are shown the same length. Architects use elevations as part of the plans for a house, to accurately document its dimensions.

Figure AB.3 shows the same house from a particular point of view high above the ground.

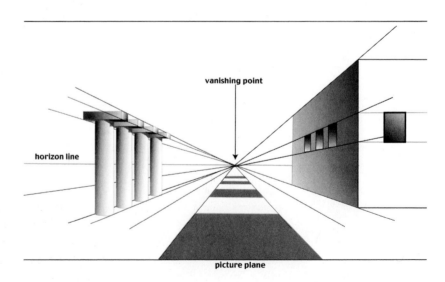

Figure AB.1

398

Now the three-dimensional arrangement of the forms is clearer, as is a sense of the viewer's relationship to the scene. Still, all equal dimensions are shown as equal lengths; there is no diminishment of scale with distance or foreshortening. This type of drawing is called **paraline projection** because all parallel edges in the object are drawn parallel. The viewer can understand the three-dimensionality of the house, without really feeling its existence in depth. Paraline projection is often used in engineer's diagrams.

Figure AB.4 shows the same viewpoint, but now a vanishing point has been identified on the **horizon line**, which is the projected line at which the ground plane disappears into infinite depth. It marks the point at which the viewer stops looking down on the ground plane and starts looking up at the sky. It therefore coincides exactly with the height of the viewer's eyes projected straight ahead. If the horizon is high above the drawn object, so is the viewer's position. In a drawing, the viewer is looking down on everything below the horizon line and looking up at everything above the horizon, and the line itself is straight ahead. Rectangular objects or planes seated on or parallel to the ground plane, like the house in Figure AB.4 and all the objects in Figure AB.1, have vanishing points located on the horizon. All horizontal edges, such as the top and bottom of the facades, the tops of the doors, windows, and so on recede along vanishing lines to a point on this line. The vertical lines that define the height of the house and the heights of the windows and doors diminish in length on the picture plane in a regular way as they move into depth, their endpoints defined by the vanishing lines. Note that only one side of the house is dealt with this way. The facing side remains perfectly rectangular. This is the characteristic of one-point perspective. It is a limited system to suggest depth with a single vanishing point and can work only with certain very regular and limited situations, usually when the point of view in the drawing is in front of the objects depicted and all the objects are facing the viewer. The use of one-point perspective was most prevalent in the fifteenth-century Italian Renaissance.

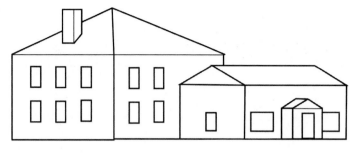

Figure AB.2

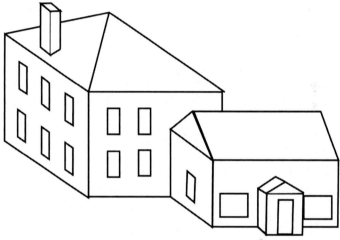

Figure AB.3

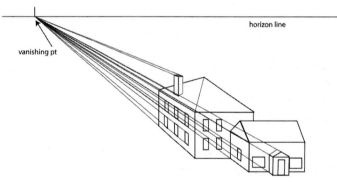

horizon line

vanishing pt

Figure AB.4

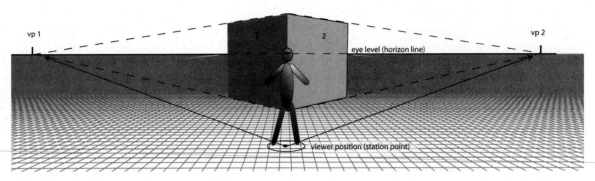

Figure AB.5

TWO-POINT PERSPECTIVE SYSTEMS

Greater versatility of viewpoint can be achieved using two-point perspective as shown in **Figure AB.5**, in which a box is shown on a gridded ground plane with an imaginary viewer. The box is turned so the viewer seems to be closest to one corner and each visible side recedes toward a vanishing point on the horizon line. (Note that the position of the horizon line indicates that the viewer's eye level is slightly above the midpoint of the height of the box.) The box is said to be in two-point perspective.

The practical and conceptual difficulty here is how to locate the two vanishing points for a two-point system. One-point perspective is comparatively simple: The vanishing point is more or less right in front of the viewer and needs only to be clearly located on the horizon line. The two vanishing points in Figure AB.5, however, must relate to each other in such a way that vanishing lines drawn to them define the properly foreshortened rectangular corners of the box when they meet. If the points are too close together or too far apart, the rectangular corners of the box will seem distorted.

Working with a Plan View

To properly understand two-point perspective, you must refer to an overhead view of the box, ground plane, and viewer known as a **plan view**. **Figure AB.6** shows a plan view of the scene in Figure AB.5. Note that you can accurately see the position of the viewer in relation to the box (indicated by the **station point**) as well as the orientation of the corners of the box to the viewer. What you cannot see is the horizon line because the horizon represents an infinite distance. The horizon is visible in perspective views because the foreshortened intervals on the ground plane become so tiny with great distance from the viewer that they are invisible and seem to merge into a line. Because a plan view shows ground plane dimensions without foreshortening, the ground plane extends infinitely in all directions, and there is no horizon. As a re-

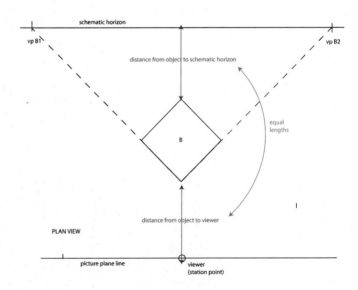

Figure AB.6

sult, it is necessary to introduce an artificial or **schematic horizon line**. In Figure AB.6, this line is located in the plan view behind the object being drawn at the same distance from the back corner of the box that the viewer is from the front corner. The location of this line is adjustble with the viewer's distance from the box, as you will see in a moment. Lines projected from the viewer's position to the schematic horizon parallel to the edges of the box effectively define vanishing points for the box on the schematic horizon line.

If you transfer the vanishing points from the schematic horizon to the actual horizon line in a perspective view, as seen in **Figure AB.7**, you can use them to draw the box in perspective as though it is seen from the viewer's position indicated in the plan view. A station point is also indicated in the perspective view, determined as the point at which lines drawn from the vanishing points in the perspective view meet to form a right angle. In other words, the **perspective station point** is the point at which the viewer is looking straight down at the ground plane under her or his feet, seeing rectangular corners as 90° angles as in a plan view. The usefulness of this perspective station point will be discussed shortly.

Changing the Viewer's Distance

Let's return for a minute to the plan view of the box with the station point (the viewer's position) and the schematic horizon. Because this is an invented scene, any aspect of position or dimension is changeable, including the distance of the viewer (and schematic horizon) from the box. **Figure AB.8** shows that the viewer has moved closer to the corner of the box than in Figure AB.6 (the schematic horizon moves closer too). Following the previous procedure, you can see that the vanishing points of the box move closer together on the schematic horizon, and the resulting change in the perspective structure becomes clear in **Figure AB.9**. The fact that the vanishing points are now closer to each other means that the edges of the box angle more sharply to the horizon, seemingly thrusting the corner of the box toward the viewer in space.

This increased sharpness of angle shows an aspect of real

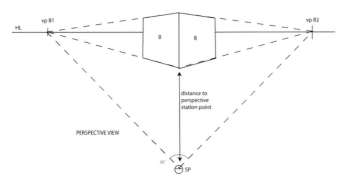

Figure AB.7

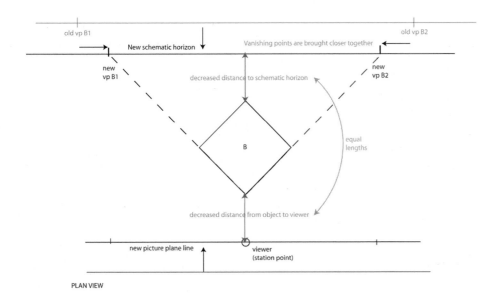

Figure AB.8

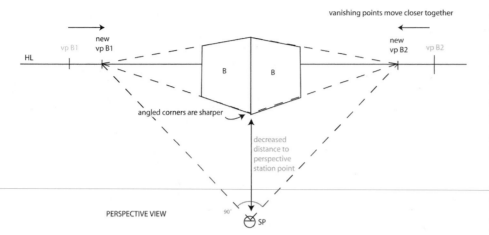

Figure AB.9

and rotate the box at the station point, **(Figure AB.10)** you can generate vanishing points that define an accurate change in the box's angle in a perspective view, as shown in **Figure AB.11**.

Once you have vanishing points for a box at a given angle, you can use them to draw other rectangular boxes and planes anywhere between the vanishing points in the perspective scene without further adjustment. In **Figure AB.12**, the box has in effect slid back and off to the left simply by choosing a point on the perspective ground plane and drawing lines to it from the same vanishing points you have been using. The easiest way to place the box is to define the front corner on the ground plane first, extend the vertical edge up to any desired height, and draw bottom and top edges to the line from each vanishing point. The locations of the back vertical edges are arbitrary as is the height of the box. Nothing in the system specifies the dimensions of the box; only its rectangularity, its angle to the viewer, and its distance from the viewer are specified.

vision that is easily discernible: The effect of visual diminishment of scale with distance becomes intensified the closer an object is to the viewer; the scale change between near and far edges of the object will be more dramatic. This is one of the lessons that perspective can teach that is applicable to drawing from observation. The closest parts of any scene have more intensely angled perspective edges than those areas nearer the horizon.

If you are working from imagination and using a plan view, the effect of closeness or distance can be adjusted simply by moving the viewer's position (and correspondingly the schematic horizon) closer to or further from the object being drawn.

Changing Object Angle

The other important aspect of the scene in Figures AB.5 through AB.9 is the angle of the box. So far you have been working with the a viewpoint exactly in front of the box's corner; the sides of the box are angled 45° to the viewer. If you return to the plan view

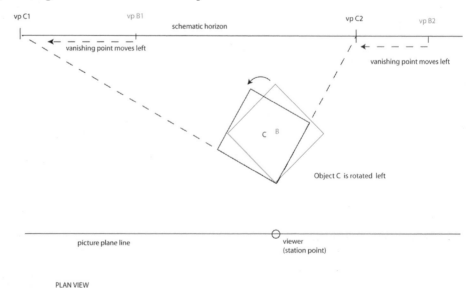

Figure AB.10

Ultimately, it is not necessary to go back to a plan view once you have a determined station point in a perspective view. **Figure AB.13** shows a new scene with two boxes at different angles to the viewer. Plan views of each box are drawn with the front corners on the perspective station point, and the edges are extended directly to the perspective horizon line to determine vanishing points for each box (or any boxes at similar angles). You might think of the perspective station point as the hub of a steering wheel for forms in the perspective drawing. Turning rectangles around this hub results in rotating boxes in the perspective view.

WORKING FROM SKETCHES

Finding Vanishing Points

Although linear perspective works most precisely as a closed system for creating imaginary scenes, it can be adapted to adjust or correct drawings from life and to combine elements from different drawings. This process has some

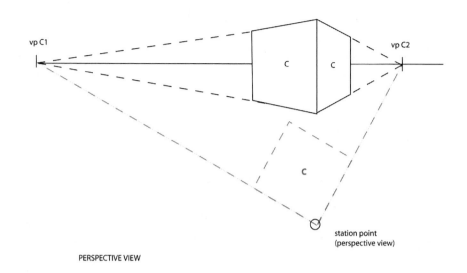

Figure AB.11

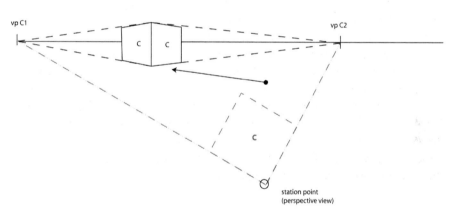

Figure AB.12

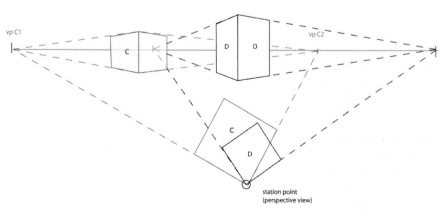

Figure AB.13

practical difficulties but they can be surmounted with certain techniques.

Let's say that you have a sketch from life of a simple house, represented by the slightly wobbly drawing in **Figure AB.14**. You want to use the sketch as the basis for a new drawing that which will be in clear perspective, adhering to the vanishing point system described earlier. To do this, you must know where the horizon line in the scene is. You must also be sure of the angle of two receding edges; possibly measured from life with an *L*-ruler as described in Chapter 5 on page 110. In this case, you are going to identify the top lines of the roof as these accurate receding edges, and use the following steps to find two vanishing points and the station point for the house.

1. Follow the measured angles of the roof to the horizon line to establish the vanishing points (VP1 and VP2).
2. Drop a vertical line from the house to the point at which lines from each vanishing point will converge at a 90° angle (you can use your *L*-ruler to determine this point as shown).

The vanishing points will allow the addition of other details with edges parallel to the edges of the house such as window bars and sidewalk squares. Also, now that you have a perspective station point for the scene, you can add differently angled elements to the image by using the station point technique described in Figure AB.13.

Vanishing Point Chalk Lines

If you have difficulty plotting and using the vanishing points because they are too far off to the right or left for a straightedge,

try putting the drawing on the wall and using threads tied to push-pins. If the push pin is put into the wall at the vanishing point, the thread can be pulled taut and lined up with edges in the drawing. It is even possible to "chalk" the thread with compressed charcoal, hold it in place and "snap" it to make an automatic line. If a portion of the thread is chalked directly over the desired location of a given detail in the drawing and snapped, it will create a short line segment at that point, in perspective.

Distant Vanishing Points

Sometimes vanishing points are so far off to the side of the drawing that even the thread method is not practical. This could be the case when one side of a rectangular form is almost directly frontal to the viewer. One option, of course, is to simply revert to one-point perspective, drawing the frontal side as a straight rectangle. You can begin this way and then bring the farthest corners together toward the horizon just a bit, and not be too far wrong, as described in Figure 5.15.

A more exact method for finding distant vanishing points is illustrated in **Figure AB.15**. This

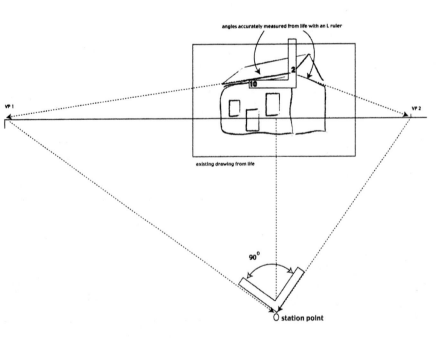

Figure AB.14

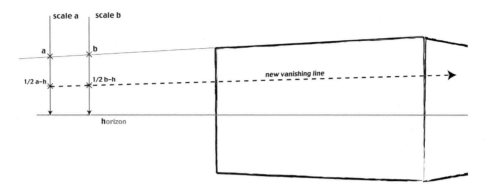

Figure AB.15

technique relies on the idea, already discussed, that fixed 2 D measurements vanish to a point on the horizon with perfect regularity. Two lines vanishing to any given point will divide any two verticals on the picture plane into segments with a proportional relationship that indicates a correct diminishment of scale in perspective and can be used to deduce other lines vanishing to that same point. If you have one line segment at a proper perspective angle, like the top edge of the house in Figure AB.14, you can use the horizon line as a second vanishing line, and find multiple new vanishing lines without having to plot the vanishing point.

In Figure AB.15, the top edge of a box and the horizon intersect two verticals to define two line segments: scale *a* and scale *b*. If you divide each of the vertical segments in half, a line connecting the halfway points is also a valid vanishing line parallel to the box's edge. All the segments of scale *a* are smaller in actual length than those of scale *b*, showing the diminishing effect of spatial distance. If you continue to divide scale *a* and scale *b* proportionally,

the corresponding divisions continue to define parallel perspective lines.

The easiest way to proportionally segment the lines is with folded paper as shown in **Figure AB.16** (inset). Cut two lengths of paper, one for scale *a* and one for scale *b*. Fold them in half, and again into quarters, and eighths. Then use the resulting creases to mark off the vertical scales in the drawing, as shown in **Figure AB.16**. Vanishing lines below the horizon can be drawn using the same paper; they will be mirror images of the lines above the horizon.

Obviously, this is time-consuming to do as a regular part of the drawing process. However, it can help you gain a foothold in connecting with the clarity and precision of spatial relationships. Ultimately, the goal is to internalize your knowledge

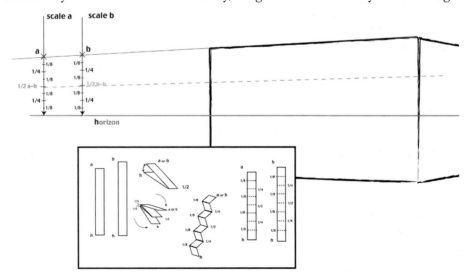

Figure AB.16

of these relationships so that can reliably estimate them as you work from life or from your imagination.

PERSPECTIVE OF CIRCLES

Circles Defined by Squares

Circles in perspective differ from rectangles in that circles have no straight edges to recede to vanishing points. They can be foreshortened, however, in relation to point of view.

The first step in accurately foreshortening a circle is to draw a square plane to contain it. Because squares have equal heights and widths, they are related to circles, which have equal diameters or axes in all directions through their center. These axes can be drawn through the midpoint of the squares sides, ensuring regularity of dimension. If the square is foreshortened in perspective, so are the midpoint divisions of its sides, and a circle drawn through them will be similarly foreshortened.

Begin by projecting a square in one-point perspective. The first step is simple; determine a central vanishing point with equally angled lines going to it (see **Figure AB.17**). The difficulty is to accurately foreshorten the length of the receding sides of the square that follow these lines so you will know you have a square, not a rectangle with unequal height and width. To do this, you can use a geometric property of squares: A line drawn through their corners is a 45° line. This is not true of any other kind of rectangle.

To find this 45° line in perspective and thereby the corner points of the foreshortened square, you need to

establish a 45° vanishing point. Determine a station point, and draw a 45° line from it to the horizon line (Figure AB.19) to establish your 45° vanishing point. Then draw a diagonal from the 45° vanishing point to intersect the

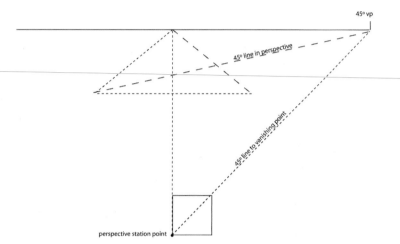

Figure AB.17

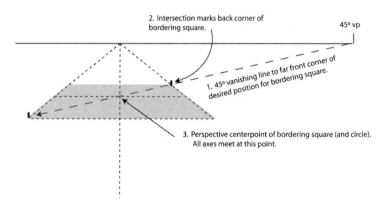

Figure AB.18

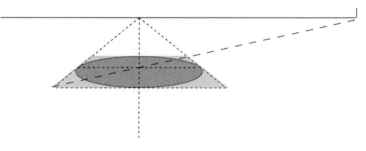

Figure AB.19

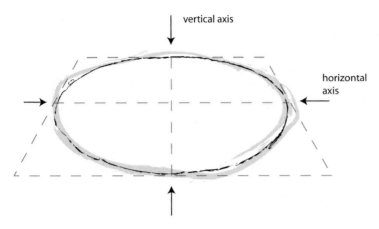

Figure AB.20

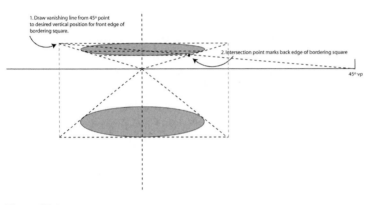

Figure AB.21

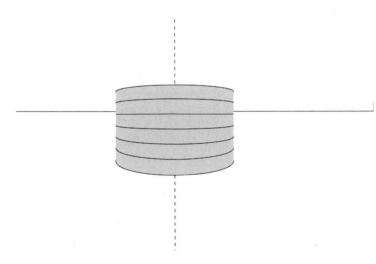

Figure AB.22

one-point vanishing lines in the perspective view. Drawing straight horizontal segments from the points of intersection of the 45° vanishing line with the one-point vanishing lines will form the front and back of a perfect square in perspective (**Figure AB.18**). A horizontal line drawn through the intersection of the 45° vanishing line and the vertical axis of the square intersects the edges of the perspective square at their midpoints. By connecting these midpoints with the midpoints of the front and back sides using smooth, even arcs (this part you must do freehand), you can describe a foreshortened circle (**Figure AB.19** and **AB.20**).

Cylinders

Figure AB.21 shows a similar circle drawn above the horizon line, closer to eye level but using the same vanishing points as for the first circle. Notice its flatter shape. Centering these two perspective circles or **ellipses** over each other and drawing straight lines between their outer points describes a cylinder (**Figure AB.22**) with the viewer's eye level at about two-thirds of its height. You are looking slightly up at the top and down at the bottom. Arcs made by the foreshortened ellipses occurring between top and bottom help project the illusion of rounded form as "cross-contours." (See Chapter 3, pp. 67).

Figure AB.23 shows multiple scaled and foreshortened circles drawn on and above the ground plane using the method just described. All circles are of equal diameter, seen from the

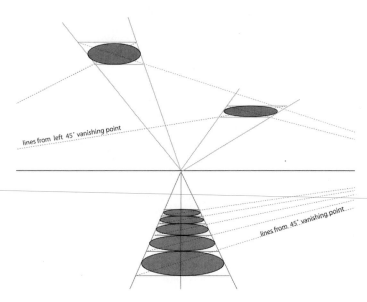

Figure AB.23

same point of view and are horizontal, or parallel to the ground plane.

TIPPED PLANES

So far you have been dealing only with planes parallel to the ground plane, but it is very simple to extend these methods to tipped or angled surfaces. **Figure AB.24** shows a plane with one edge raised from the ground. The vanishing point on that side moves directly up from its former position on the horizon line. The higher into the sky it goes, the more the plane will tip. Planes may be tipped down by moving the vanishing point directly below its original spot on the horizon. It is also possible to reposition the other vanishing point

at the same time, resulting in a plane that is tipped in two directions. The procedure for circles involves tipping a square in this manner and inscribing the circle within as described earlier.

SHADOWS IN PERSPECTIVE

The shapes of shadows cast on the ground plane by rectangular objects can be projected using variations on the vanishing point system with adjustments relating to the specifics of the action of light. All light radiates or spreads outward from its source, but the light of the sun is a special case because, being so far away, the spreading of its rays is often not apparent on the earth's surface. **Figure AB.25** shows parallel rays of sunlight casting the shadow of a box on the ground plane. The most important points of the shadow's shape to map are the corners; the shadow's edges will be found by connecting the corner points. The points of the box's visible shadow side are projected to the ground plane

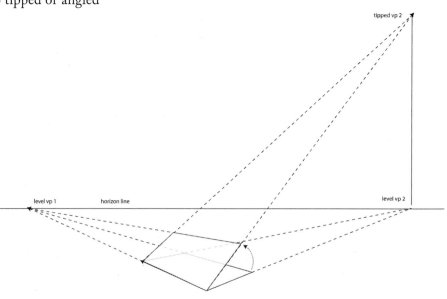

Figure AB.24

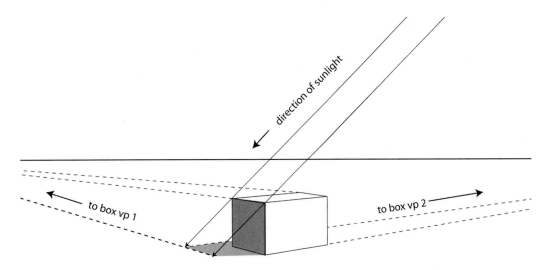

Figure AB.25

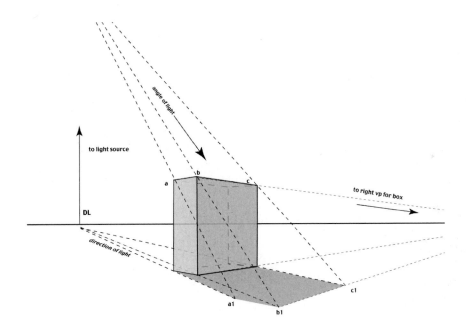

Figure AB.26

along the direction of the sunlight. The edges of the shadow are formed by connecting the shadow corners with the box's two vanishing points. The shadow lines formed by a box's horizontal edges are always parallel to the edges of the box and, therefore, vanish to the box's vanishing points on the horizon.

In the case of artificial light, the spreading of the rays is a more important factor. **Figure AB.26** shows a box, lighted by an artificial source from behind. In this case, the rays of light project outward from the source, spreading with distance. The closer the source is to the object, the greater is the spreading effect between object and shadow. Once again, the corners of the visible shadow side

are mapped to the ground plane by the light rays. In this case, however, another point must be determined to tie the spreading effect to the perspective of the ground plane. This point is called the DL vanishing point, for "direction of light"; it is located directly under the source on the horizon. The shadow lines of the box's vertical edges vanish to this point while the horizontal edges recede to the box's regular vanishing points. Each corner of the shadow is the intersection of all three lines: light rays, DL vanishing point lines, and regular vanishing point (VP) lines.

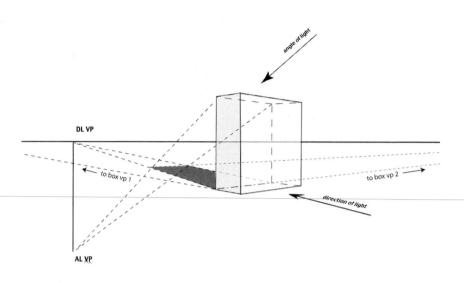

Figure AB.27

When the light source is in front of the object, the spreading effect of the light rays is countered by a diminishing effect as the shadow is cast toward the horizon (**Figure AB.27**). An artificial point for the angle of light (AL) is determined by following the direction of the light through one corner of the box to a point directly below the DL vanishing point line on the horizon. The shadow corners are formed on the intersection of vanishing lines to the DL vanishing point, the AL point, and the regular VP vanishing points for the box. Once again, all shadows of horizontal edges are parallel to the box's edges and vanish to the VP lines. The shadows of vertical edges vanish toward the DL vanishing point on the horizon. The length of the shadow is determined by the angle of the light: A lower source (AL closer to the horizon) creates a longer shadow; a higher source (AL farther from the horizon) creates a shorter shadow.

PERSPECTIVE AND IRREGULAR FORM

All the forms you have worked with in this Appendix are extremely simple geometric objects, whether circles or rectangles. Their simplicity and regularity make predicting their foreshortening by the geometry of perspective relatively simple. In addition, the situations in these diagrams are very regular and simple: objects on a flat ground plane, the viewer in front, at a medium distance. Introducing complexity or irregularity greatly complicates the use of these methods. Some objects without recognizable planes are just impossible to approach. A room full of clutter and furniture at odd angles can probably be analyzed perspectivally, but doing so is a complicated and time-consuming task, possibly involving hundreds of vanishing points.

Ideally, study of the methods described in this Appendix will give you a basic understanding of the way spatial illusion can be constructed in drawing. This phenomenon, which taps directly into the daily experience you have of the world, can be very exciting as was detailed in Chapter 5. Combine your study of the linear perspective methods with work from direct experience, and compare the results. "Breaking into" a world of depth in your drawings can be difficult for one simple reason: Drawings are flat, and space in drawing is an illusion that must be carefully nurtured. Perspective techniques can help you connect with this illusion and ultimately absorb it as a natural part of the way you see, allowing you to leapfrog the step-by-step techniques described here. Many complex,

intricate, and/or convoluted aspects of the world make good subjects for drawing, although they are difficult to deal with in a mechanical perspective system. Once you understand how to order space, you can include almost anything in the spatial matrix of your drawing, working freehand, conscious of the overall spatial effect you are trying to achieve. The study of perspective is a means to this end.

Appendix C Basic Human Anatomy

Studying the structure of the human body can give authority and expression to your drawings of the figure. The beginning of this study should be the skeleton, the body's armature. The volumes of the skull, rib cage, and pelvis are the essential components of the body as a form. The bones of the arms and legs, articulated at the joints, are linear axes for the limbs and are keys to understanding the configuration of a given gesture.

The skeleton is evident on the surface of the body in a number of places, as indicated in **Figure AC.1**, **Figure AC.2**, and **Figure AC.3**. Look for these landmarks on the model as a starting point for building a sense of the skeletal structure within the figure.

Of particular importance in the front view (Figure AC.1) is the centerline of the torso, connecting the *breastbone* (sternum) and the *center of the pelvis* (pubis of the pelvis), running through the navel. Careful observation of this line and its relationship to the outside contours of the figure can help you adjust the bilateral proportion of the form as the figure rotates in space, and its curve can help you establish the bending and twisting of the main volumes of rib cage and pelvis in relation to each other.

Also of great importance are the horizontal axes formed by the bilateral points of the skeletal torso: the *points of the shoulder* (acromion processes of the scapulae), the two halves of the *collarbone* (clavicle), the *borders of the rib cage*, and the *upper points of the hips* (anterior superior iliac crests). Comparison of the position of these points in a pose helps to orient the body in depth, foreshortening the form in rotation and clarifying the tipping of the shoulders and hips in response to gesture and weight distribution.

The back view of the figure is dominated by the *line of the spine*, probably the most important of all artistic landmarks of the skeleton. In addition to establishing the centerline of the figure from the back, the spine connects the rib cage and pelvis, and its curve accurately describes the orientation of these volumes in relation to each other, as well as the basic direction of a gesture.

The bilateral landmarks of the back (Figure AC.2) mostly correspond to the structures of the front view. The points of the shoulders are again visible, as are the borders of the rib cage. The pelvis is indicated by the *curve of the flank* (posterior iliac crest) and the *triangle of the sacrum*, which is centered over the crease of the buttocks.

The *shoulder blades* (scapulae), however, are more visually elusive than the collarbones, to which they are connected at the point of the shoulder. They lie partially below muscle layer and are capable of an astonishing variety of configurations in response to arm movements. Identifying shoulder blade position can be difficult in many models and is best achieved by beginning with the point of the shoulder (the acromion process) and following the ridge made by the *"spine" of the shoulder blade* as it crosses toward the center of the back. This ridge, usually a gentle diagonal, can tip to a nearly vertical position as the arm is raised over the head. Adding to the complexity, each shoulder blade (or scapula) is capable of moving independently of the other. The shoulder blades have an important relation to the rib cage, however, and should be thought of as sliding around on its surface. The *inner edge of the shoulder blade* (vertebral border of the scapula), usually lying next to the spine, is often visible and defines an important planar division of the back.

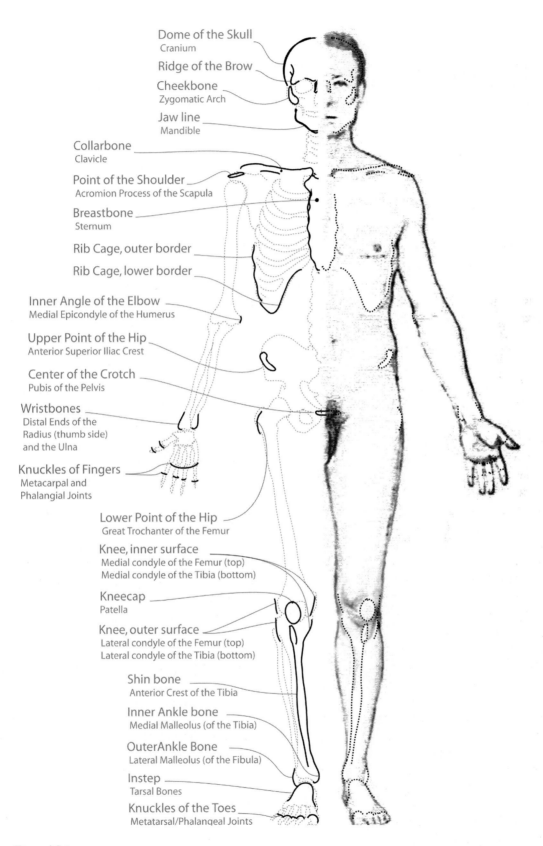

Dome of the Skull
Cranium

Ridge of the Brow

Cheekbone
Zygomatic Arch

Jaw line
Mandible

Collarbone
Clavicle

Point of the Shoulder
Acromion Process of the Scapula

Breastbone
Sternum

Rib Cage, outer border

Rib Cage, lower border

Inner Angle of the Elbow
Medial Epicondyle of the Humerus

Upper Point of the Hip
Anterior Superior Iliac Crest

Center of the Crotch
Pubis of the Pelvis

Wristbones
Distal Ends of the
Radius (thumb side)
and the Ulna

Knuckles of Fingers
Metacarpal and
Phalangial Joints

Lower Point of the Hip
Great Trochanter of the Femur

Knee, inner surface
Medial condyle of the Femur (top)
Medial condyle of the Tibia (bottom)

Kneecap
Patella

Knee, outer surface
Lateral condyle of the Femur (top)
Lateral condyle of the Tibia (bottom)

Shin bone
Anterior Crest of the Tibia

Inner Ankle bone
Medial Malleolus (of the Tibia)

OuterAnkle Bone
Lateral Malleolus (of the Fibula)

Instep
Tarsal Bones

Knuckles of the Toes
Metatarsal/Phalangeal Joints

Figure AC.1

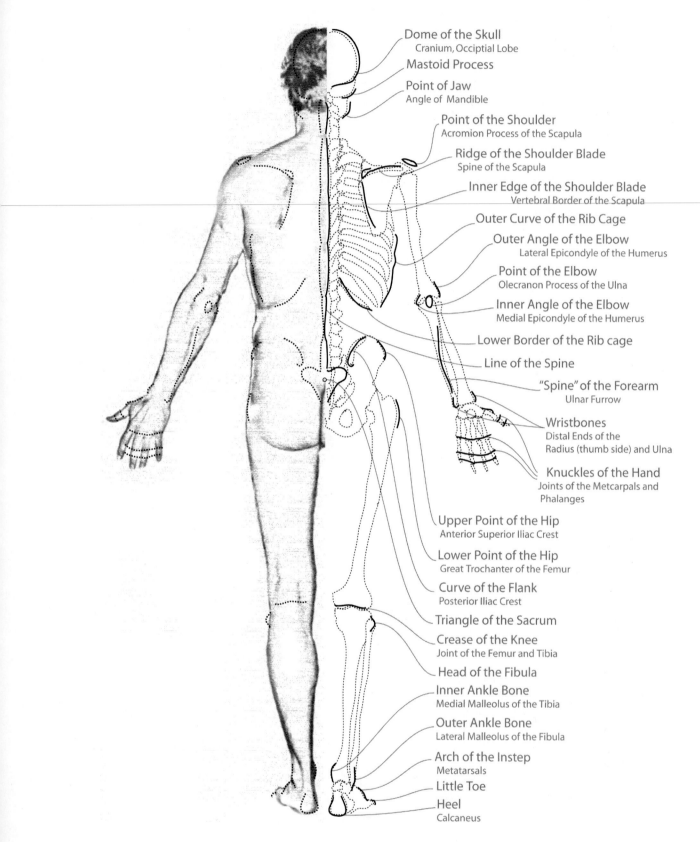

Dome of the Skull
Cranium, Occiptial Lobe

Mastoid Process

Point of Jaw
Angle of Mandible

Point of the Shoulder
Acromion Process of the Scapula

Ridge of the Shoulder Blade
Spine of the Scapula

Inner Edge of the Shoulder Blade
Vertebral Border of the Scapula

Outer Curve of the Rib Cage

Outer Angle of the Elbow
Lateral Epicondyle of the Humerus

Point of the Elbow
Olecranon Process of the Ulna

Inner Angle of the Elbow
Medial Epicondyle of the Humerus

Lower Border of the Rib cage

Line of the Spine

"Spine" of the Forearm
Ulnar Furrow

Wristbones
Distal Ends of the
Radius (thumb side) and Ulna

Knuckles of the Hand
Joints of the Metcarpals and
Phalanges

Upper Point of the Hip
Anterior Superior Iliac Crest

Lower Point of the Hip
Great Trochanter of the Femur

Curve of the Flank
Posterior Iliac Crest

Triangle of the Sacrum

Crease of the Knee
Joint of the Femur and Tibia

Head of the Fibula

Inner Ankle Bone
Medial Malleolus of the Tibia

Outer Ankle Bone
Lateral Malleolus of the Fibula

Arch of the Instep
Metatarsals

Little Toe

Heel
Calcaneus

Figure AC.2

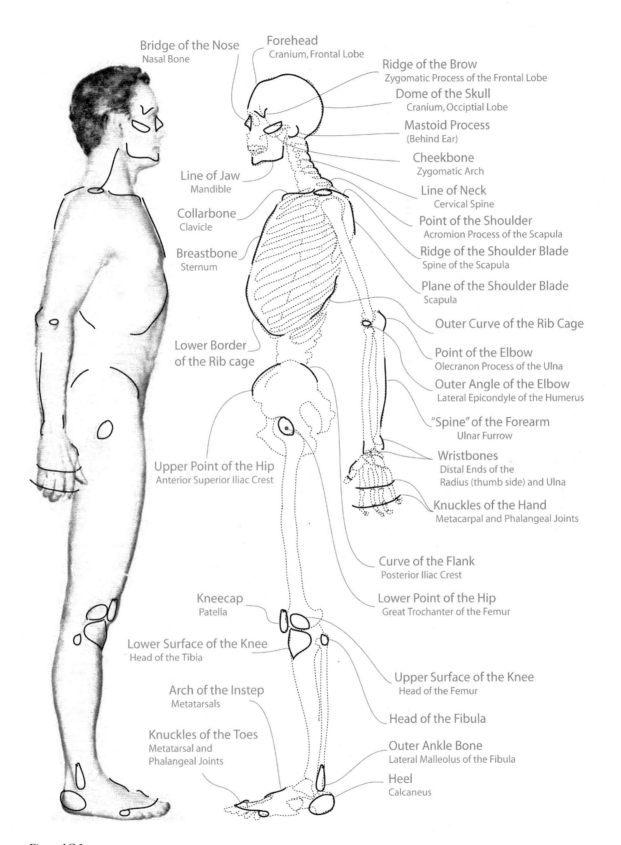

Bridge of the Nose
Nasal Bone

Forehead
Cranium, Frontal Lobe

Ridge of the Brow
Zygomatic Process of the Frontal Lobe

Dome of the Skull
Cranium, Occiptial Lobe

Mastoid Process
(Behind Ear)

Cheekbone
Zygomatic Arch

Line of Jaw
Mandible

Line of Neck
Cervical Spine

Collarbone
Clavicle

Point of the Shoulder
Acromion Process of the Scapula

Ridge of the Shoulder Blade
Spine of the Scapula

Breastbone
Sternum

Plane of the Shoulder Blade
Scapula

Outer Curve of the Rib Cage

Lower Border
of the Rib cage

Point of the Elbow
Olecranon Process of the Ulna

Outer Angle of the Elbow
Lateral Epicondyle of the Humerus

"Spine" of the Forearm
Ulnar Furrow

Wristbones
Distal Ends of the
Radius (thumb side) and Ulna

Knuckles of the Hand
Metacarpal and Phalangeal Joints

Upper Point of the Hip
Anterior Superior Iliac Crest

Curve of the Flank
Posterior Iliac Crest

Kneecap
Patella

Lower Point of the Hip
Great Trochanter of the Femur

Lower Surface of the Knee
Head of the Tibia

Arch of the Instep
Metatarsals

Upper Surface of the Knee
Head of the Femur

Head of the Fibula

Knuckles of the Toes
Metatarsal and
Phalangeal Joints

Outer Ankle Bone
Lateral Malleolus of the Fibula

Heel
Calcaneus

Figure AC.3

From the side (Figure AC.3), the egg-shaped volume of the rib cage appears in bold relief because the convex curving of the sternum and the spine are seen in profile. Also prominent from this angle is the *lower point of the hip* (great trochanter of the femur). This bony prominence can appear as a bulge or a dent, depending on the angle of the thigh to the pelvis. It functions visually as an axial hub for the movement of the *femur* (thighbone) where it connects with the pelvis, below and to the rear of the upper point of the hip. The great trochanter moves with the leg while the upper point of the hip, being part of the pelvis, remains stationary.

The joints of the arm and the leg at the elbow and knee, respectively, bend in opposite directions: the knee forward and the elbow backward. The *point of the elbow* (olecranon process) is part of the *ulna*, one of two forearm bones that also articulate at the wrist. The ulna lies closer to the surface throughout its length, creating the *ulnar furrow* between two muscle groups, running from the elbow to the wrist on the side of the little finger. The other forearm bone, the *radius*, forms the bulk of the wrist on the thumb side. More information about these bones is presented later in this Appendix (see Figure AC.7). The *outer and inner angles of the elbow* (lateral and medial epicondyles of the humerus) extend from the upper arm bone (humerus) at the elbow (see Figure AC.2). These angles or prominences are important attachment points for the forearm muscles together with the olecranon process, they give the elbow a triangular shape as seen from the rear.

The *surface of the knee* is the meeting point of the *head of the femur*, or thighbone, with the *head of the tibia*, which also forms the *shinbone* (see Figure AC.1). The tibia, lying near the surface of the skin throughout its length, is one of the most visible bones on the body. It ends at the ankle, where it forms the *inner ankle bone* (medial malleolus) (see Figure AC.2). The *fibula* is the smaller bone of the lower leg. Its "head" lies alongside the tibia at the knee, forming a bump on the surface behind and below the head of the tibia. The fibula's lower end shows on the surface of the figure as the *outer ankle bone (lateral malleolus)*.

The knee is most noticeably defined by the *kneecap* (patella), a free-floating bone that protects the open joint when the knee is bent. The knee is therefore composed of parts of four different bones as well as various muscular bulges and fatty pads. Sorting out these landmarks in different models can be a challenge; the patella is usually the best place to start.

MAJOR MUSCLE MASSES

The skeletal landmarks have another important role to play in building your understanding of the structure of the body: They are attachment points for the muscle groups that form the most important volumes in the shoulders, torso, arms, and legs and are involved in the support and movement of the body. Even with the rigid armature of the skeleton, the body would collapse if it were not held in perpetual tension by the muscles. This is due to the flexibility of the joints, which allow movement when necessary but can be held rigid by opposing muscular action. In addition, the muscles are responsible for the more dramatic actions of the body, such as lifting and running.

Every muscle can best be thought of as a mass or "body" stretched between two or more points of connection with the skeleton (or sometimes with ligamental sheaths). These points of connection are classified as *origins* and *insertions*. The origin of a muscle is its anchor, which usually is located closer to the center of the body. The *insertion* is the muscle's attachment to the bone or tendon that it is designed to move. Because their function is to move parts of the body in relation to each other, most muscles span a joint or gap between two or more bones. A good example of this principle can be found on the front of the body in the *pectoral* muscle as shown in **Figure AC.4**. This principal muscle of the chest is a very familiar muscle to most people. Its broad, fanlike origin is on the very center of the torso along the sternum but also attaches to the clavicle at the top and to the abdominal sheath of ligaments that cover the rib cage just under the chest. From these anchors, the pectoral muscle stretches out to insert along a

Skeletal Landmarks
A Mastoid Process
B Acromion Process of Scapula
C Clavicle
D Sternum

SternoCleido Mastoid
From sternum and clavicle
to mastoid process

Trapezius, shoulder portion
From cervical spine to scapula, acrromion process and clavicle

Deltoid, front and middle portions
From clavicle and acromion process to humerus

Pectoral
From sternum, clavicle and upper ribs
to humerus

Serratus
From ribs to scapula

Biceps
From scapula to radius (via tendon)
and to bicipital fascia around forearm flexors

Brachialis
From humerus to ulna

External Oblique
From abdominal sheath and pelvis crest to ribs

Abdominals
From center line of torso and pubis to upper ribs

Upper Crossover Group of Forearm
From the humerus to the wrist (thumb side) via tendons

Extensor Group of Forearm
From lateral epicondyle of humerus to fingers

Flexor Group of Forearm
From the medial epicondyle of the humerus
to wrist and fingers via tendons

Skeletal Landmarks
E Ribs (attachment of serratus and ext. oblique)
F Medial Epicondyle of the Humerus
G Anterior Superior Iliac Crest of the Pelvis
H Great Trochanter of the Femur
I Pubis of the Pelvis
J Distal End of the Radius

Tensor Fascia Lata
From Iliac crest to fascia lata

Gluteus Medius
From pelvic crest to great trochanter

Sartorius
From iliac crest of pelvis
to inner knee (head of the tibia)

Fascia Lata
From gluteus maximus and
tensor fascia lata
to outer knee (head of tibia)

Adductor Group
From ishium of pelvis to femur and knee

Vastus Lateralis
From femur

Quadriceps
to common tendon
over patella to tuberosity
of the tibia

Rectus Femoris
From pelvis

Vastus Medialis
From femur

Peroneus
From head of fibula
to sole of foot via tendons

Tibialis
From head of tibia
to inside arch of foot, via tendon

Calf Muscles
From end of femur, tibia and fibula
to calcaneus via achilles tendon

Skeletal Landmarks
K Patella
L Head of the Fibula
M Tuberosity of the Tibia
 (attachment for quadriceps tendon)
N Head of the Tibia
O Crest of the Tibia (Shin)

P Lateral Malleolus (Fibula)
Q Medial Malleolus (Tibia)
R Knuckles of Foot

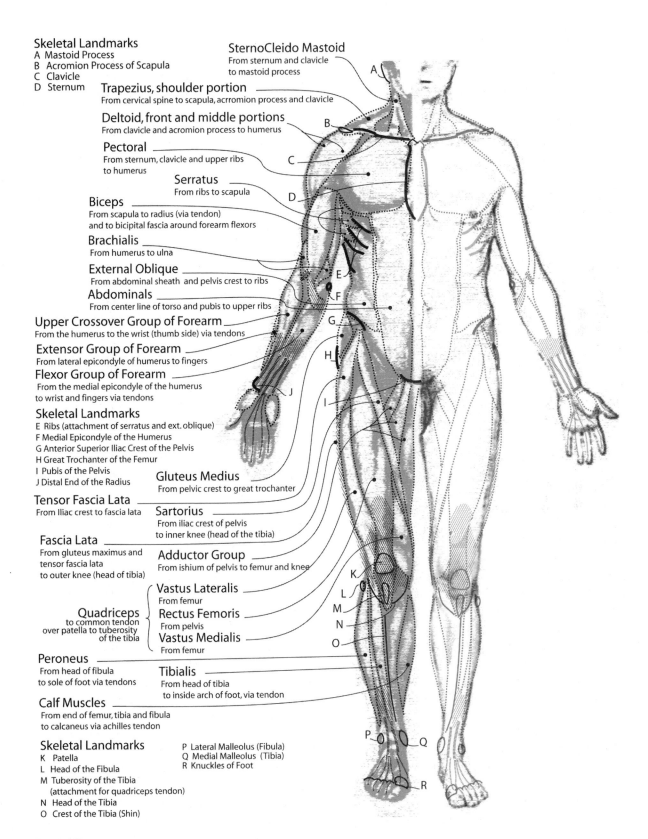

Figure AC.4

narrow line on the front of the humerus, or upper arm bone. Its function, easily imagined, is to pull the arm toward the chest. When you hug someone, for example, the pectoral is doing much of the work.

Two other muscles of importance to the action of the arm are the *deltoid* and the *trapezius*, which compose what people refer to as the *shoulder*. The principal skeletal landmark to remember in association with these muscles is the point of the shoulder (*acromion process of the scapula*). This flat disklike plate is very close to the surface of the skin and in slender models gives an angular sharpness to the profile of the shoulder. When the arm is raised, however, it becomes an abrupt dent as the deltoid bulges up on the humerus (upper arm bone). If the shoulder itself is raised, the trapezius bulges up on the other side of this dent, creating a very noticeable crevice between the angle of the arm and the mass of the shoulder next to the neck. The origin of the upper portion of the trapezius is in back along the spine at the neck (called the *cervical spine*). The insertion of the trapezius is into the acromion process as well as the clavicle or collarbone and into the ridge of the scapula or shoulder blade in the back. Through these three areas of insertion, the trapezius is designed to lift the entire shoulder girdle, extending the arc in which the arm can be raised to fully vertical. The trapezius and deltoid in relaxed position give the shoulder a softened, curved character; without them, the shoulder would be a series of hard geometric angles made by the skeletal joints.

Another important landmark of the shoulder area is the *sternocleidomastoid* muscle. This small, thin muscle is of great importance to the artist because it visually connects skull with the rest of the skeleton and is a key factor in determining the tilt or twist of the head.

The skeleton is still the dominant form in much of the torso, which is especially evident in the volume of the rib cage and the landmarks of the clavicle and sternum. The pelvis is less obvious from the front view, but it is very important to identify the landmarks of the iliac crest (the upper points of the hips) on either side as well as the pubis (the center of the pelvis). In addition to indicating the angle of the pelvis in a given pose, these are also important points of muscular attachment. The *external oblique*, or flank muscle, follows the top of the curve of the iliac crest, connecting with the broad central plate of the *abdominal* muscles by means of an enveloping sheath of ligament that extends across the front of the torso. The abdominal muscles bridge the distance between the sternum and the pubis of the pelvis; the furrow that runs down between the two halves of this muscle group through the navel defines the centerline of the front of the torso.

The iliac crest of the pelvis is also the origin of a number of hip and thigh muscles: the *gluteus medius*, which inserts into the great trochanter on the side of the hip; the *tensor fascia lata*, whose insertion is the *fascia lata*, a broad tendinous band connected to the outer knee, and the *sartorius*, which connects to the inner knee. Between these last two emerge the *quadriceps* muscles, which form the volume of the front of the thigh and have a common connection to the kneecap or patella through a broad tendon. In the center is *rectus femoris*, originating on the pelvis below the iliac crest. The side of the thigh is formed by *vastus lateralis*, which lies partly under the smooth contour of the fascia lata. *Vastus medialis* originates on the femur, under rectus femoris, and creates a prominent volume above the bony forms of the inner knee. In relaxation, it is crossed diagonally by a ligamental band that causes a shallow furrow in its form.

A more important furrow is made across the thigh as sartorius passes from the iliac crest to the inner knee. On one side of this division lie the quadriceps; and on the other is the *adductor group*, which originates at the pubis and mostly connects to the femur behind the sartorius. The adductors form the triangular shape of the inner thigh, which is pushed into greatest prominence when the figure is seated on a chair. One adductor goes to the knee where its fleshy tendon runs with that of sartorius to create a soft mass alongside the head of the tibia.

The lower leg is dominated by the flat plane of the shin (the shaft of the tibia), but a rounded surface created by the extensors of the foot, including *tibialis*, runs along its outer side to a series of

prominent tendons at the ankle. These can be seen in bold relief when the foot is raised.

The shoulder muscles are also visible from a rear view **(Figure AC.5)** and the deltoid looks much the same in shape as it did from the front. Now, however, its attachment is to the spine of the scapula where it butts up against the insertion of the trapezius. You can see, in addition, the origin of the trapezius on the cervical spine, as well as its extension down the length of the spine to the lower border of the rib cage. This configuration allows the trapezius to pull the scapula down as well as up, adding to the variety of arm movements.

The scapula itself is the origin of a group of *shoulder blade muscles* that lie against its surface or arc down from its lower corner to the humerus. These muscles have a function complementary to that of the pectoral muscle, helping to pull the arm backward. In this case, though, it is more of a chain effect: The trapezius and deeper muscles attached to the spine pull the scapula back as the shoulder blade muscles pull on the humerus. Another important muscle for this action is the *latissimus dorsi*, which connects directly to the spine and pelvis and has its insertion in the humerus near the armpit. The latissimus dorsi creates a visible fleshy angle on the profile of the rib cage just under the arm, which becomes more definite when the arm is pulled down and back against some resistance. Although it covers much of the back, the latissimus is quite thin over most of its area. This thinness allows for the *serratus* muscle, which attaches on the underside of the scapula and wraps around under it to the ribs in the front of the figure, to be visible as a diagonal bulge, shown as a hatched band in Figure AC.5.

The lower torso is organized around the curve of the flank formed by the posterior iliac crest and the triangle of the sacrum. Prominent muscles attaching to this ridge include the external oblique and gluteus medius, mentioned previously, and the *gluteus maximus*. This latter muscle is extremely prominent although its volume is almost always accentuated by a thick fatty layer. Its insertion is along the femur and the fascia lata and is responsible for moving the thigh backward, as in running or jumping, and for holding it in tension when squatting.

The back of the thigh is dominated by the *hamstrings,* two groups of muscles each with two separate bodies. Both groups originate principally beneath the gluteus maximus on the pelvis at the *ischium,* or "sit bone," which extends down from behind the socket of the femur. The hamstrings combine visually on the upper thigh and then separate to wrap around the knee on opposite sides, attaching to the head of the tibia on the inner knee and to the head of the fibula on the outer knee. Between these two tendinous attachments, the large bulge of the *calf muscles* (gastrocnemius and soleus) emerges from an origin deep in the knee joint on the femur and tibia, running vertically down to insert into the *heel bone* (calcaneus) via the broad *achilles tendon.* The calf is responsible for pulling on the calcaneus, which presses the toes downward, allowing the foot to spring off the ground in walking and running.

The side view of the body in **Figure AC.6** offers a clearer view of the overall configuration of the shoulder muscles: The deltoid is seen with all its points of origin (clavicle, acromion process, and spine of the scapula) with the trapezius inserting into same. Visible also are the muscles of the upper arm: the *biceps* facing front and the *triceps* in the back. Both muscles have a number of points of origin, principally on the parts of the scapula near the joint with the humerus, and their insertion is into the forearm bones. The triceps insertion point is the olecranon process of the ulna (the point of the elbow) by means of a broad tendon that seems to flatten out when the muscle is tensed while drawing the forearm backward. Actually, this "flattening" effect is caused by the bulging of three heads of the triceps, which surround the tendon in a horseshoe shape. The biceps, by comparison, seems to be a simple tube because its tendons of insertion do not intrude into the body of the muscle. One cordlike tendon goes to the radius, and the other fans out into a broad band that wraps around the *forearm flexor group.* These tendons pop up in bold relief when the biceps is curling the forearm.

The view of the torso from the side also reveals the intersection of the external oblique and the serratus muscles as they both emerge from their points of origin on the ribs, creating a distinctive zigzag pattern that suggests the forms of

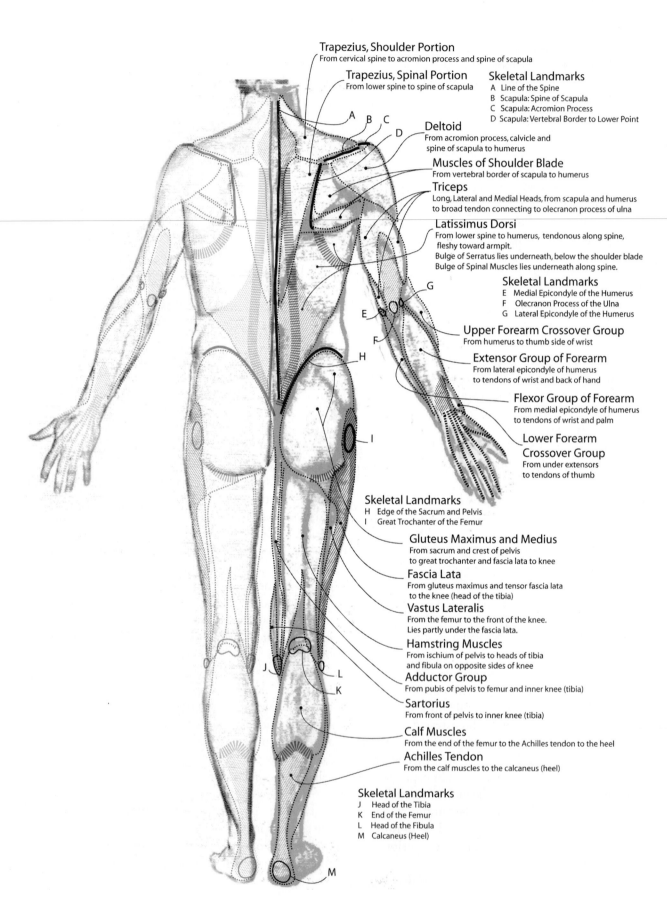

Trapezius, Shoulder Portion
From cervical spine to acromion process and spine of scapula

Trapezius, Spinal Portion
From lower spine to spine of scapula

Skeletal Landmarks
A Line of the Spine
B Scapula: Spine of Scapula
C Scapula: Acromion Process
D Scapula: Vertebral Border to Lower Point

Deltoid
From acromion process, calvicle and
spine of scapula to humerus

Muscles of Shoulder Blade
From vertebral border of scapula to humerus

Triceps
Long, Lateral and Medial Heads, from scapula and humerus
to broad tendon connecting to olecranon process of ulna

Latissimus Dorsi
From lower spine to humerus, tendonous along spine,
fleshy toward armpit.
Bulge of Serratus lies underneath, below the shoulder blade
Bulge of Spinal Muscles lies underneath along spine.

Skeletal Landmarks
E Medial Epicondyle of the Humerus
F Olecranon Process of the Ulna
G Lateral Epicondyle of the Humerus

Upper Forearm Crossover Group
From humerus to thumb side of wrist

Extensor Group of Forearm
From lateral epicondyle of humerus
to tendons of wrist and back of hand

Flexor Group of Forearm
From medial epicondyle of humerus
to tendons of wrist and palm

Lower Forearm
Crossover Group
From under extensors
to tendons of thumb

Skeletal Landmarks
H Edge of the Sacrum and Pelvis
I Great Trochanter of the Femur

Gluteus Maximus and Medius
From sacrum and crest of pelvis
to great trochanter and fascia lata to knee

Fascia Lata
From gluteus maximus and tensor fascia lata
to the knee (head of the tibia)

Vastus Lateralis
From the femur to the front of the knee.
Lies partly under the fascia lata.

Hamstring Muscles
From ischium of pelvis to heads of tibia
and fibula on opposite sides of knee

Adductor Group
From pubis of pelvis to femur and inner knee (tibia)

Sartorius
From front of pelvis to inner knee (tibia)

Calf Muscles
From the end of the femur to the Achilles tendon to the heel

Achilles Tendon
From the calf muscles to the calcaneus (heel)

Skeletal Landmarks
J Head of the Tibia
K End of the Femur
L Head of the Fibula
M Calcaneus (Heel)

Figure AC.5

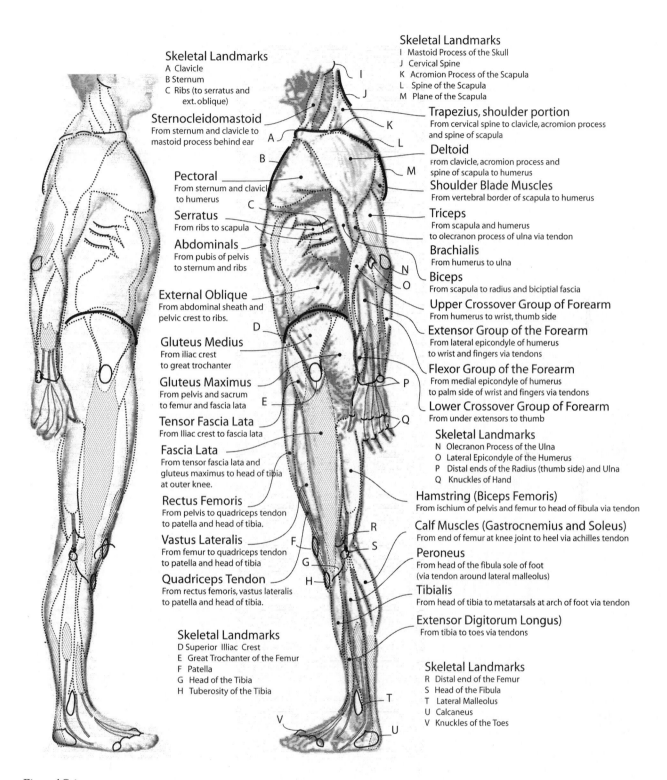

Skeletal Landmarks
A Clavicle
B Sternum
C Ribs (to serratus and
 ext. oblique)

Sternocleidomastoid
From sternum and clavicle to
mastoid process behind ear

Pectoral
From sternum and clavicl
to humerus

Serratus
From ribs to scapula

Abdominals
From pubis of pelvis
to sternum and ribs

External Oblique
From abdominal sheath and
pelvic crest to ribs.

Gluteus Medius
From iliac crest
to great trochanter

Gluteus Maximus
From pelvis and sacrum
to femur and fascia lata

Tensor Fascia Lata
From Iliac crest to fascia lata

Fascia Lata
From tensor fascia lata and
gluteus maximus to head of tibia
at outer knee.

Rectus Femoris
From pelvis to quadriceps tendon
to patella and head of tibia.

Vastus Lateralis
From femur to quadriceps tendon
to patella and head of tibia

Quadriceps Tendon
From rectus femoris, vastus lateralis
to patella and head of tibia.

Skeletal Landmarks
D Superior Illiac Crest
E Great Trochanter of the Femur
F Patella
G Head of the Tibia
H Tuberosity of the Tibia

Skeletal Landmarks
I Mastoid Process of the Skull
J Cervical Spine
K Acromion Process of the Scapula
L Spine of the Scapula
M Plane of the Scapula

Trapezius, shoulder portion
From cervical spine to clavicle, acromion process
and spine of scapula

Deltoid
From clavicle, acromion process and
spine of scapula to humerus

Shoulder Blade Muscles
From vertebral border of scapula to humerus

Triceps
From scapula and humerus
to olecranon process of ulna via tendon

Brachialis
From humerus to ulna

Biceps
From scapula to radius and biciptial fascia

Upper Crossover Group of Forearm
From humerus to wrist, thumb side

Extensor Group of the Forearm
From lateral epicondyle of humerus
to wrist and fingers via tendons

Flexor Group of the Forearm
From medial epicondyle of humerus
to palm side of wrist and fingers via tendons

Lower Crossover Group of Forearm
From under extensors to thumb

Skeletal Landmarks
N Olecranon Process of the Ulna
O Lateral Epicondyle of the Humerus
P Distal ends of the Radius (thumb side) and Ulna
Q Knuckles of Hand

Hamstring (Biceps Femoris)
From ischium of pelvis and femur to head of fibula via tendon

Calf Muscles (Gastrocnemius and Soleus)
From end of femur at knee joint to heel via achilles tendon

Peroneus
From head of the fibula sole of foot
(via tendon around lateral malleolus)

Tibialis
From head of tibia to metatarsals at arch of foot via tendon

Extensor Digitorum Longus)
From tibia to toes via tendons

Skeletal Landmarks
R Distal end of the Femur
S Head of the Fibula
T Lateral Malleolus
U Calcaneus
V Knuckles of the Toes

Figure AC.6

the ribs beneath. Further down, the hips are dominated by the curve of the flank (iliac crest of the pelvis) and the great trochanter below it. The semicircular arc of the gluteus muscles around this point is of particular geometric elegance. On a muscular level, the side of the thigh is smooth and sleek as a result of the sheath of the fascia lata although fat deposits occur frequently in this area. The higher the proportion of fat, the more likely the great trochanter is to appear as a depression rather than a bulge.

An important vertical axis for the leg is made by the connections of the thigh and leg muscles to the head of the fibula at the lower knee. The hamstrings from the thigh and the *peroneus* muscle rising from the outer calf seem to join at the knobby prominence of the fibula, forming a useful linear structure in both standing and bent leg poses. The peroneus articulates into a long tendon that then wraps down around the outer ankle at the lateral malleolus, thereby connecting the two visible points of the fibula. Another important tendinous connection follows from the *extensor digitorum* in the lower leg to the visible group of tendons that proceed to the individual toes. This tendon group forms the profile of the ankle in the front, the *achilles tendon* is the profile in the back.

ROTATION OF THE FOREARM

Because of the importance of hand movement to human activity, the forearm is a particularly complex part of the anatomy. Even at the skeletal level, the variety of its configurations is impressive, and it can be confusing for an artist trying to understand the structural connections. The two bones of the forearm, the radius and the ulna, can twist into a spiral between the elbow and the wrist, turning the palm of the hand 180°. The two extreme positions of this rotation are called *supination* and *pronation*. Supination is the default or beginning position of the hand. A *supinated* hand has the thumb pointing out to the side, away from the body. With the arms hanging

at the side of the figure, this means that the palms will be facing forward. With the hands extended forward, supination means that the palms will be up. With the arms over the head, the palms will face backward. *Pronation* means rotating the hand so that the thumbs point inward.

Much of this rotation is possible because of the nature of the joint at the elbow between the radius and the lateral epicondyle of the humerus (the bone of the upper arm). The lateral epicondyle has a spherical knob, the capitulum. The upper end (or head) of the radius is cup shaped and can spin freely on this knob, allowing the whole bone to rotate around its long axis. The lower end (distal end) of the radius is paddle shaped and forms the largest part of the wrist. Rotation of the radius at the capitulum flips the wrist, turning the hand.

The other wrist bone, the ulna, joins the humerus in a very different type of joint. The large knob of the elbow itself, the olecranon process of the ulna, surrounds a curved hook, which slides in a track (the trochlea) between the lateral and medial epicondyles of the humerus. This joint allows for the curling of the forearm against the upper arm but does not allow for the rotation of the ulna around its long axis. The lower end of the ulna fits against the side of the radius on the little finger side of the wrist, where it makes a very noticeable prominence. The broad blade of the radius swings around this pivot point as the hand flips.

Figure AC.7 shows a number of the positions of wrist rotation in a bent arm. Note the twisting configuration of the radius and ulna as the wrist turns. Position 1 shows full pronation: position 3 shows supination. Note that position 2 shows an even greater degree of pronation than 1; the rotation of the humerus, which requires the elbow to be lifted, allows this to happen.

ORIENTATION OF THE HEAD

Except for the jaw, the bones of the head do not move significantly in relation to each other, but the head as a whole is extremely flexible through its

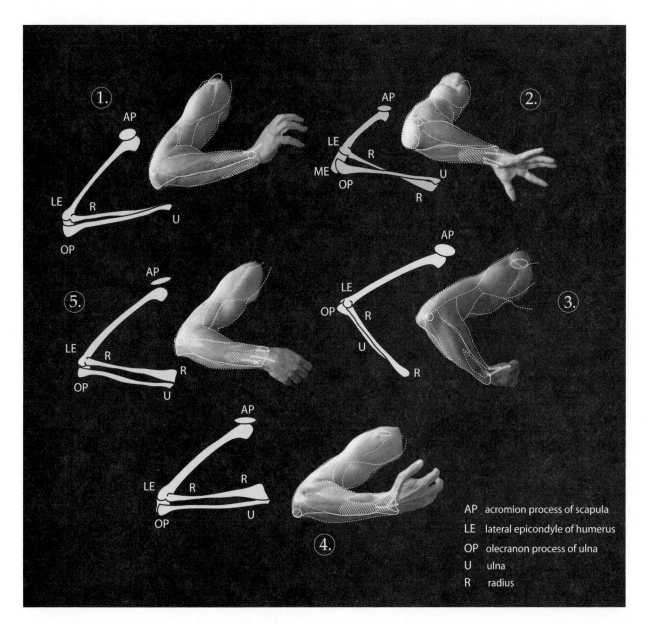

AP acromion process of scapula

LE lateral epicondyle of humerus

OP olecranon process of ulna

U ulna

R radius

Figure AC.7

connection to the neck. The most important skeletal issue for artists is therefore the overall orientation of the skull in relation to point of view or gesture. The foreshortening of the head by adjustment of its bilateral symmetry and horizontal axes was discussed in Chapter 9 and shown in Figures 9.13a–9.15. This geometric approach is the foundation for three-dimensional projection of the head in drawing but can be given greater specificity by incorporating important skeletal landmarks shown in **Figure AC.8**.

In addition to the domelike volume of the *cranium*, a number of bony ridges, angles, or protuberances form the head and face. Surrounding the eye is a ring of bone with several distinct components. A thin ridge, the *orbital rim*, runs along the bottom and outer edge of the eye socket. On top, the *outer brow ridge* is heavier and angled slightly up toward the center of the face, often bulging over the eye beneath the line of the eyebrow. The *inner brow ridge* is a smaller protuberance, angled down toward the bridge of the nose.

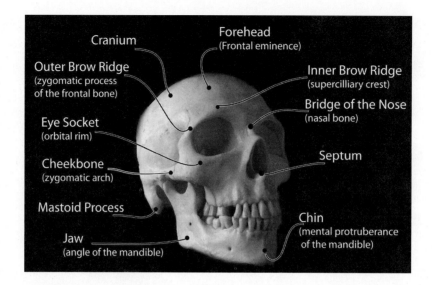

Figure AC.8

At its outer end, the brow ridge connects to the *cheekbone*. The shape of the cheekbone varies widely among individuals and races, but it is a prominent landmark in all cases. Arising from the ridges of the eye socket, the cheekbone articulates into the zygomatic arch, a thin curved flange of bone that connects the plane of the face with the back portion of the skull near the ear and above the *mastoid process*. The hinge of the *jaw* (mandible) fits in under this arch, extending down to a distinctive angle that protrudes from the neck, in front of and below the ear in the living figure. The bladelike edge of the mandible forms the line of the jaw, the lower border of the face, angling sharply at the chin.

All these landmarks can be organized visually with connecting axes as shown in Figure 9.13b. Awareness of bilaterally paired landmarks and attention to foreshortened axes and intervals between axes is the simplest way to orient the head as a three-dimensional entity in a drawing. From a simplified geometric configuration of an ovoid volume (the cranium) attached to a semicylindrical plane (the face), the form of the head can be divided and redivided into curved intersecting surfaces of ever greater subtlety. Side-to-side comparison of these bilaterally symmetrical planes, the skeletal landmarks, and the fleshy features allows you to "turn" the form of the head into depth.

Figure AC.9 shows the head with a model of the skull in 12 positions. Note the elliptical axis made by the visual connection of the left and right zygomatic arches from one ear to the other across the curve of the face. The centerline of the face is also a fundamental axis, running down the bridge of the nose, through the septum, the philtrum (the small vertical dent in the middle of the upper lip), and the midpoints of the lips to the center of the chin. All these surface features have subtle midpoint indications that can have special importance in a drawing because of their relation to the center line.

The face varies more than any other part of the body in relation to gender, race, body type, and age. It is also capable of a vast range of expressions, both subtle and drastically contorted. Despite all this potential variety, the principles of axial organization based on the skeletal landmarks usually provide a workable approach to drawing the head.

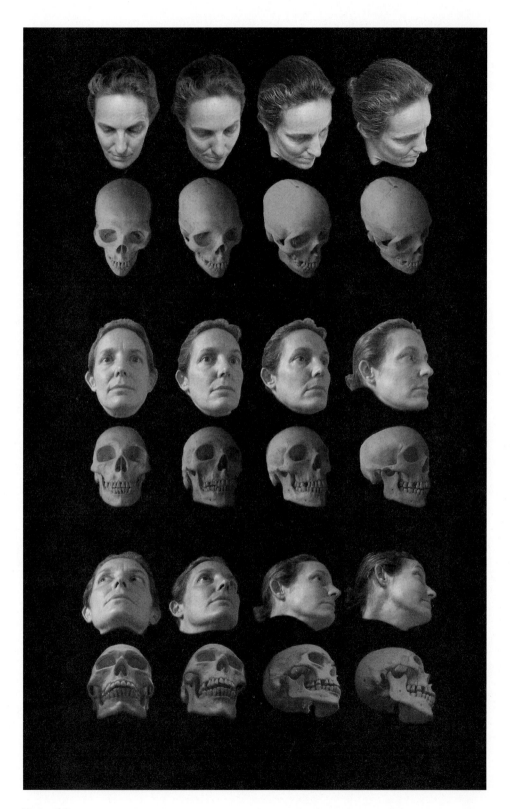

Figure AC.9

Glossary

2-D dimension or measurement
a measurement parallel to the picture plane: height, width, or 2-D diagonal; in a perspective drawing, an unforeshortened dimension.

2-D form
2-D (or *graphic*) form exists on the picture plane, having only dimensions of height, width, or diagonal measurement. Elements in this category are lines, shapes, graphic patterns and graphic textures.

2-D proportion
relationship between aspects of 2-D dimension.

3-D dimension or measurement
measurement in depth of form or space: height, width, depth, or diagonal measurement in depth.

3-D form
3-D (or *volumetric*) form exists in space, having height, width and depth. In addition to solid objects, there are 3-D lines, such as 3-D spirals, and 3-D configurations of non-volumetric objects such as planes. 3-D form in drawing is implied or illusionistic.

3-D projection
A method in a drawing or other 2-D image intended to represent an illusion of volume and depth.

3-D proportion
relationship between aspects of 3-D dimension.

abstract (abstract quality or character)
purified or extracted from reality; simplified to basic form: line, shape, color etc. Abstract art focuses on these qualities rather than on realistic description or anecdotal detail.

Abstract Expressionism
mid-20th century American movement in painting (and sculpture) stressing formal purity or *primacy of means* and instinctual choice in drawing, composition and color.

abstract form
(in drawing) line, shape or implied volumetric form that reads as a self-contained visual experience without outside reference or recognizable *motif.*

abstract thought
thought concerned with principles, theories or concepts.

abstraction of mark
intrinsic rhythms and qualities of mark separate from any representational function.

achromatic
without hue; in black and white; gray.

actual or local color
the innate color of an object or surface regardless of light source, i.e. the redness of a red shirt. In daily vision, actual color is always affected by the color of the light source.

aerial perspective
see *atmosphere perspective.*

allegory
a representation of an abstract or spiritual meaning through concrete or material forms; symbolic narrative.

ambient light
a general effect of illumination in a space; a lighting situation in which the shadows and light areas are soft or undefined.

ambiguous
having several possible meanings; indeterminate or indecisive.

ambiguous space, ambiguous sense of space
(*spatial ambiguity*) an effect of depth in a drawing in which spatial cues contradict each other, causing tension; a confusion of spatial indication.

Amerindian
Native North or South American peoples or cultures.

amoebic
(ah-MEE-bik, from Greek) blob-like, irregularly curvilinear (see *organic form*).

analyze
to investigate deeply for clear understanding.

angle of arrangement
the 2-D relationship between elements of a situation, described by a line of a given angle projected between them.

angle of recession
the orientation of a form in three dimensions, described by an axis or edge projected into depth (see *Appendix B*).

applied art
the practical application of artistic principles and skills, usually for commerce.

appropriation/appropriate (v.)
the selection and use of previously existing images or styles for use in art, inflecting their meaning through a new context.

arbitrary
determined by free choice, without constraint; also, without any particular motivation or purpose.

architectural renderer
a person who creates architectural drawings or illustrations of proposed designs.

armature
framework.

artificial light
see *natural light*.

associative
having an effect of significant connection in the subconscious or memory.

asymmetrical
imbalanced, or unequal in relation to a real or imagined axis.

asymmetry
formal inequality or imbalance, as in left/right asymmetry.

atmospheric
giving the feeling of atmosphere, air, climate, or mood.

atmospheric or aerial perspective
a systematic adjustment of values and contrast in a drawing to suggest distance or dense atmosphere such as fog. This effect can be observed in nature over large distances, but can be used artificially for spatial effect on any scale, and is also effective in hue relationships, as distant objects approach the color of the background (see Chapters 6 and 8).

attitude
way of thinking, clear point of view.

automatic
mechanical, involuntary.

automatic textures
textures created through the interaction of materials, with minimum intervention by the artist (also: automatic line; automatic composition).

axes
(pronounced AK-seez; singular is axis) the conceptual lines around which a plane or other form is organized (including possibly the picture plane itself), often vertical or horizontal in orientation.

axonometric projection
a form of *paraline* projection of 3-D geometry in drawing, which shows all dimensions in actual proportion, with *parallel* sides shown parallel, without *foreshortening* or *diminishment of scale with distance*.

backlit
illuminated from behind.

bilateral symmetry
similarity of form on both sides of a central axis, universal in vertebrate animals.

binocular/monocular vision
vision with two eyes (binocular), or one eye (monocular).

calligraphic mark
mark that suggests the act of writing; a form of abstract mark that calls attention to its discrete or coded character.

calligraphy
artful hand lettering with a brush or pen and ink.

camouflage
(verb) to hide or disguise; (noun) something that hides or disguises, usually through visual confusion or similarity of visual characteristic to surroundings.

cast shadow
area of darkness occurring when one form prevents light from reaching another form or surface.

chamois
soft textured cloth or leather used in drawing to disperse charcoal evenly (see *Appendix A*).

chaotic
without any sense of order; confused.

chiaroscuro
(KĒ-är-ō-SKOOŪ-rō fr. Italian) the systematic use of light (chiaro) and dark (scuro) to create the illusion of solid form in space.

chroma
see *saturation.*

classical
pertaining to Greek or Roman antiquity; stylistically traditional or enduring; concerned with sophistication or perfection of *formal structure.*

coalesce
come together, merging of several distinct entities.

Cold War
the international struggle between communist and capitalist countries, lasting from the end of the Second World War until the dissolution of the Soviet Union in the 1980's.

collage
(kô-LAZH fr. French) the art form of pasting or assembling diverse materials onto paper or other surface, also called papier collé (pa-PYEH kō-LĀY).

color atmosphere
an effect of tinted luminosity created by linked hue characteristics of colors in a composition.

color spectrum
see *spectrum.*

color temperature
an associative breakdown of the color wheel into two halves: warm (red, orange and yellow) and cool (blue, green and violet). Color temperature analysis can also be applied to complex or neutral tones.

comparative anatomy
study of anatomical similarities and differences among species. For example, human anatomy may be studied in comparison to other vertebrate mammals.

complement
(*noun*) color opposite. The complement of a color does not share any of its hue characteristics, and lies directly across the color wheel. Mixtures of a color and its complement will produce a neutral color. (*verb*) to enhance.

complementary
opposite, as in a complementary color; similar, as in complementary character of mark and form; "playing off of" or "in relationship to".

composition
an arrangement of forms on the field (2-D); an arrangement of illusionistic spatial relationships (3-D); the art of arranging form.

connection and contrast
relative characteristics of the qualities of hue, value and saturation in color relationships, or of relative value in value relationships. Connected tones are close in their relative qualities; contrasting tones are different in their relative qualities (see *contrast of value, hue or saturation).*

consumer culture
an aspect of society concerned with purchasing goods and services, and materialism in general.

Conte Crayon
a brand of drawing stick in a variety of colors (see Appendix A).

content
substance or meaning of a work beyond its *nominal subject matter.*

contextualize
to show or suggest the circumstances surrounding the creation of an idea or work of art.

contour
the outside edge or *profile* of a form. A line that shows either the outside edge of a form or the 3-D form of its interior surface (*cross contour).*

contour overlap
interruption of one contour by another, suggestive of *spatial overlap.*

contraposto
a shift in balance to one leg of the human figure that causes a tipped angle in the horizontal *axes* of pelvis and shoulders.

contrast (of value, hue or saturation)
the degree of difference between two or more tones or two or more colors. Highly contrasting tones are distant from each other on a value scale. Lower contrast tones are closer. Colors can differ in value, hue, and saturation. Highly contrasting hues are color *complements,* opposite each other on the color wheel. Hues of lower contrast

are neighbors on the color wheel. Colors with contrasting saturation will have differing degrees of purity or intensity. See *saturation (chroma)*.

contrast relationship
see *contrast of value, hue or saturation*.

converging
coming together. Converging lines begin from different points, and end at the same point. In linear perspective the term is often applied to the straight lines describing the opposite edges of a receding rectangular plane.

convex/concave
bulging outward (convex) or inward (concave). These terms can refer to the surfaces or edges of solid form or illusionistic solid form, or to the contours defining graphic form.

core of shadow
the darkest part of a shadow, with the least *direct* or *reflected light*.

cropping
the intersection of the edge of the *field* with a *form* or *composition*, usually implying that the form continues beyond the edge of the field.

cross contour/cross hatching
lines drawn following the implied surfaces of illusionistic forms, bridging the outside contours. Cross-contour is usually continuous across the form. Cross-hatching is discontinuous, and may be layered or used to apply shading.

Cubism
early 20th c. movement in painting and sculpture stressing *geometric abstraction*, with reference to Cezanne, "primitive" art, and industrial forms. The inventors of *collage*: Picasso, Gris and many others.

decalcomania
automatic textural transfer done by pressing an inked or painted surface against a sheet of paper.

deductively
through a process of reasoning in which a new conclusion is derived from a beginning premise or fact.

density of reflectance
strength of light reflected from an object (often based on the actual color of the object).

dichotomy
a split or division of ideas or methods into two opinions or approaches.

diffused light
light that is scattered or reflected in many directions, softening shadows; indirect or nondirectional light.

diminishment of scale with distance
the perceived shrinkage of a *2-D measurement* with increased distance from the viewer.

direct/indirect light source
direct light sources are generators of light, like the sun or light bulbs, or principal directional sources, like a window in an interior. Indirect light (general lighting or *ambient* light) is *reflected* or *diffused* from the original source.

directed looking
visual concentration on the communicative effects of a drawing (see Chapter 1).

directional light
undiffused light coming from a clear source and moving through a scene in a linear direction, causing *cast shadows*.

dislocated narrative/dislocated meaning
narrative or meaning (of an *appropriated* image) in which the original significance has been lost or changed.

double reading/double meaning
two coexisting or simultaneous interpretations. A *shape* in a drawing may have a double reading as a *cast shadow*, and also as an *abstract form* with *associative* overtones.

drama (of line or composition)
A sense of, emotional or physical event created by the configuration of a line or the composition in a drawing.

dry media
drawing materials that work through abrasion, rubbing off onto the *tooth* of the paper: charcoal, pencil, crayon etc.

dynamic balance
asymmetry of weight distribution in the figure (*contraposto*) conducive to a perception of flexibility and movement.

dynamic line
a line suggestive of directional movement in 2-D or in 3D through variable *line weight*.

dynamic tension
a balanced opposition between forces in a *composition*, often through a compositional relationship involving 2D or 3D *asymmetry*, *value contrast* or a positive/negative shape opposition suggesting *spatial ambiguity (push/pull)*.

earth tone
a brown pigment, often made from natural minerals including umber, sienna, ochre, and various iron oxides. An earth tone palette will also usually include black and white.

electromagnetic radiation
energy in the form of waves as a result of the interaction of electric and magnetic fields.

ellipse
a *foreshortened* circle.

elliptical contour
a line, usually a segment of a circle, suggesting the edge of a curvilinear form.

encaustic
painting or drawing medium that includes beeswax and pigment. It is heated to melting point and applied to a surface.

engraving
print made from a plate that has been incised.

evocative
poetically suggestive, *associative*.

experience of form
the expressive, *abstract* effect of *form*, in art or in life, on a viewer.

explicative
specifically stating; factually descriptive.

expressive subject/statement
The underlying motivation, point or message of a drawing.

eye level
the height of the artist's or viewer's eye; a horizontal *plane* extending straight forward from the eyes of the artist, expressed as the *horizon line* in a drawing.

eye/hand connection
the integrated response of the hand to the eye's perceptions, and the action of the eye in anticipation of the movement of the hand in drawing.

facture
the manner of making of an art work, either material or procedural; *touch* or use of materials in an artwork.

felt connection
instinctual linkage of artistic intent and *facture* in art making.

feminist
an advocate of women's rights.

field
the *graphic* surface on which a drawing is made, as defined by its borders (syn. *picture plane*, page).

figurative
representational; with recognizable subject matter or *motif*; non-abstract.

figure/ground
the *graphic* relationship between a 2-D object and a surrounding *field* on which it occurs.

film noir
(FEELM noo-WA, Fr. "black film") genre of film using strong light and shadow to create a sinister feeling. Usually associated with crime films.

final medium
a material suitable for making a resolved or fully realized artwork.

fine art
art considered primarily or exclusively in relation to aesthetic criteria or meaningfulness, without a priority for practical use.

foreshortening
in a *3-D projection*, the perceived shrinkage of one dimension of a *plane* or *form* along an *axis* angled away from the viewer into depth.

form
a volumetric object, whether in the real world (solid form) or as an implied three-dimensional entity in a drawing (illusionistic form); the qualities of a form. The word also refers to the qualities or properties of the elements of a work of art including *shape* or *line*.

formal
referring to the arrangement or configuration of elements in a work of art.

formal elements
the components of a composition such as shape, value, color, line.

formalist abstraction
art with a priority for simplification or purity of *form* (See *Abstract Expressionism, Minimalism*).

format
the basic physical characteristics of a work of art: in drawing especially the characteristics of the *field* in terms of dimension. Format may refer to a single issue such as proportion of the field, or to a combination of characteristics.

freshness or honesty of mark
a quality of discovery, instinct or spontaneity in mark-making or *facture*.

frottage
(frō-TAZH Fr. "rubbing") a method of texture transfer in which drawing material is rubbed over paper laid over another surface (see *Appendix A*).

fugitive
changing, not lasting.

geometry
a branch of mathematics dealing with the properties, measurements, and relationships of points, lines, angles and figures in space.

geometric
line that is based on the simple forms of geometry including straight lines and combinations of them (angles), and elliptical arcs or combinations of them.

gesso
a white water-based paint used for the preparation of surface for drawing or painting (see Appendix A).

gesture
the movement of the artist's arm in drawing; the movement expressed in a pose; the movement expressed by a line; the overall sense of movement in a drawing.

gesture drawing
an approach to drawing emphasizing the expression of movement, usually in the figure, through line as a record of the movement of the artist's hand.

ghost lines
traces of lines that remain after erasing.

glyph
a mark or simple figure, usually with symbolic character.

gouache
(gwäsh) opaque watercolor (see *Appendix A*).

gradient
a gradually changing quality of texture, value, or pattern, often indicating spatial recession, curving of a volumetric surface or a change in light striking a surface.

graphic
defined by 2-D qualities: line; shape; value or color; 2-D arrangement on the picture plane.

graphic form
graphic form is any 2-D visual element on the picture plane in a drawing, usually a line or a shape.

graphic integrity
a strength or integration of 2-D qualities or relationships.

graphic linkage
a connection between 2-D forms, or 2-D aspects of 3-D forms in a composition based on a shared graphic quality.

graphic novel
a genre of comic book aimed at an adult audience, of greater length and complexity of content than traditional comics.

graphic position
2-D placement on the *field*.

graphically active
visually strong or dynamic through 2-D qualities of *line*, *shape*, and *value* or color.

grid
a regular or semi-regular network of lines or points extending over the *picture plane* or *ground plane*.

ground plane
the illusionistic surface of the ground or floor in a 3-D projection, extending horizontally into depth.

hatching
short *parallel* lines in a texture or pattern used to create gradients or areas of tone.

hierarchy
an organization or ranking based on a system of significance or formal order.

highlight
an area in which light is most strongly reflected from an object's surface.

high saturation
see *saturation*.

history of a drawing
steps taken to create a drawing that may or may not be evident in the final piece.

homage
tribute.

homogenous mark
mark of a similar character or sameness.

horizon, horizon line
the horizontal line that represents infinite distance at the point of eye level. In landscape, the meeting of sky and the sea or the earth when the terrain is level.

horizontal
perpendicular to the direction of gravitational pull; perfectly flat; *parallel* to the horizon.

Hudson River School
a 19th century school of painting emphasizing the *sublime* spectacle of the American landscape.

hue
the character of a color in relation to the *spectrum* or the color wheel. Pure hues are the *primaries, secondaries* or colors in between (e.g. reddish orange), but a neutral tone may have a hue character (e.g. reddish brown); one of the three aspects of color determination along with *value* and *saturation*.

icon
a representation of a sacred personage, especially in medieval Greek and Russian art.

iconic emphasis
expression of a hierarchical, symbolic or sacred quality in an image.

iconic sign; icon
a symbol or sign, often with a formalized or symbolic *graphic* character.

idealize
to think of something as being fine or perfect regardless of problems that are present.

identity
the characteristics of an individual, as in ethnic or religious identity.

idiosyncratic
peculiar, of a highly individual nature.

illusion
something that seems to exist when it does not, such as deep space on a flat piece of paper.

illusionistic/ illusory
having an aspect of appearance that is convincing in contradiction of actual fact. A 2-D drawing can have illusionistic space, light, or movement, while in fact having none of these actual qualities.

Impressionism
a 19th century French movement in painting emphasizing direct observation of landscape and the evocation of daylight through *optical mixture* of color.

Inca
the dominant tribe of Andean peoples in Peru c. 1400.

indirect light source
see *direct light source.*

insertion
the outlying point of attachment for a muscle on the skeleton.

intensity of reflectance
the relative strength of a wave reflected from a surface.

interior form
the surface that exists inside the *outside contour* of a *volumetric form.*

interpretive
pertaining to the translation from one form to another, for example from reality to a drawing.

interval
distance between forms, in 2-D composition or 3-D arrangement (see also *spatial interval*).

intuitively
instinctually, based on subjective feeling, without methodical reasoning or *deduction.*

Inuit
indigenous people of NE Russia, Northern Canada, Alaska, and Greenland.

invented light
(in drawing) light source, shadow, and light that are imagined rather than observed.

irony
an arrangement of meaning expressive of a contradiction between what is stated and what is actually meant; a *juxtaposition* of two opposite or incompatible indications, from which a complex truth emerges.

isometric perspective
a technique for projecting 3-D rectangular forms and spaces in which all receding edges are shown at a constant angle (30°), with no diminishment due to foreshortening or distance (see *paraline* and *axonometric*).

juxtaposition
side-by-side placement.

labyrinth
pattern of interconnected passages, such as a maze.

light
illumination; planes facing the light source are illuminated by light.

light harmony
an illusion of *ambient light* of a particular *color temperature* or *hue* created by the use of related colors in a *composition.*

limited palette
a constrained set of colors used to create a very coherent or connected range of mixtures.

line quality/line weight
line quality is any characteristic of line including character of touch, thickness, texture, aspects of medium, color etc. Line weight refers more specifically to thickness, density or value (darkness).

line
a long thin mark. Also, the quality or use of lines (see also *mark; contour.*)

linear perspective
see *perspective.*

literal
limited, precise meaning; non-poetic.

local color
the *actual color* of an object, uninfluenced by light source or atmosphere.

low saturation
see *saturation.*

Mannerism
a 16th century school of painting and sculpture following and exaggerating the style of the high renaissance.

maps
(verb) carefully defines, or follows as a *form.*

mark
any trace of the artist's drawing tool on the page, including *lines.*

matte
non-reflective, non-glossy.

medium
(*pl. media*) the material used in making a drawing, for example charcoal or pen and ink. The paper is also part of the medium, but is sometimes referred to as the support.

metaphorical/metaphor
using an image to express an idea or thought the image does not literally denote.

milagro
(mi-LAH-gro; Sp.) small votive or healing charm.

Minimalism
a mid 20th century art movement based in New York emphasizing a reductive factuality of the art object, simplicity and/or repetition of form and mechanical process.

modeling
tonal modulation of surface; shading; the use of tonal gradient achieved by *cross-contour, cross-hatching,* smudging or another method to suggest the three-dimensionality of the surface of a *form* in a drawing.

modeling shadow
a soft edged or graded area of tone related to an implied directional light source used to suggest the rounded surface of a form in drawing (see *modeling*).

monochrome
a tonal range using only one color.

monocular
see *binocular.*

monotype
a simple printmaking technique in which ink or paint is applied to a metal or plastic plate, worked with various tools, and then printed onto paper using a press, roller or other pressure.

motif
nominal subject matter for a work of art: still life; landscape etc.

Mughal
a dynasty of Islamic rulers of northern India in the 16th-19th centuries, and the culture they sponsored.

natural /artificial light
natural light is daylight, whether direct sunlight or gray diffused light, while artificial light is from man-made sources. The distinction is usually important in considering of the color or mood of the light and configuration of the shadows.

naturalist
a person who studies nature and natural objects.

negative shape
a shape formed by the *outside contours* of two objects in the empty space between them.

neutrals
colors of *low saturation:* browns, grays, black and white.

nominal subject
The *motif* or subject matter of a drawing as distinct from its expressive subject. For example, the nominal subject of a drawing might be a pear, but the real subject or expressive statement might be "sensuality of form".

Nupastel
a brand of pastel (see *Appendix A*).

observational
concerned with direct observation of the visual world.

Op Art
art movement of the 1960's using geometric pattern and value or hue contrast to create illusions of vibration, three-dimensionality and movement.

opaque
not allowing light through, opposite of transparent.

optical mixture
blending of two separate color strokes to form a third color in the perception of the viewer, by means of

their close *juxtaposition* and/or the distance of the viewer.

organic form
lines, marks or *forms* that are non-geometric, or irregularly curvilinear. Elliptical arcs may appear more geometric or more organic, depending on the context.

origin
the anchor point for a muscle on the skeleton, beginning point for the action of the muscle.

outside contour
a line or edge representing the outer border of a *shape* or the *profile* of a *form* in a drawing.

overlap
the covering of one shape, line or form by another, suggesting a 3D relationship (see also *contour overlap, spatial overlap*).

ovoid
(noun) an egg-shaped form; (adjective) egg-shaped.

page of studies
multiple drawings of a subject on a single piece of paper; may be part of a sketchbook, or on individual sheets of paper.

page/rectangle
the plane or surface on which marks are made in drawing. Use of the word "rectangle" implies an awareness of the boundaries of the page.

panoramic view
a very wide view of a scene or landscape.

paraline projection
a method for showing rectilinear or geometric solids in a *3D projection* in which all receding parallel edges of the solid are drawn *parallel*.

parallel
non-*convergent;* equidistant along a length.

pattern of looking
a suggestion in composition of the movement of the artist's eye or interest.

pentimenti
(pĕń·tē·MĔN·tē It: "repentances") traces of lines in a drawing that have been erased, worked over or rubbed out.

perceptual screen
an imagined *plane, parallel* to the viewer's face, on which all aspects of a real scene are arrayed as 2-D shapes, analogous to the *picture plane* in drawing.

perfection of mark
refinement in drawing, either in relation to representation or in relation to abstract structure; lack of extraneous marks.

perimeter
the outer boundary of a 2-D shape, or of the field.

perpendicular
at a right angle (90°).

perspective
(*linear perspective; renaissance perspective*): a drawing system devised in the renaissance for showing *planes* in depth based on a fixed *point of view* and projection of receding *parallel* edges toward a *vanishing point* on the *horizon line*.

petroglyph
a drawing on a cliff or natural rock surface.

photogram
a print made by casting shadows on photographic paper from objects on or near its surface.

pictogram
a sign or drawn symbol with a descriptive or narrative significance.

picture plane
the conceptual 2-D field of drawing; the 2-D surface on which a drawing is made; the paper's surface (also *field, page*).

plan
that which has been determined before the work proceeds.

plan view
a conceptualized overhead view of a scene, used in perspective drawing.

plane
an area of 2-D surface, having a specific dimension (height and width) and a specific orientation, either on the picture plane (2-D), or in implied depth (3-D).

planar angle
the tipping of a plane in three dimensions.

planar solid
a 3D solid with sides composed of simple geometric *planes* (see *prismatic*).

planned process
method of working that has predetermined steps.

poetic connection/transformation
associative linkage of an image with a mood, memory, association, or symbol. Poetic transformation involves an unusual or *metaphorical* connection.

point of view
the position of the imagined viewer in reaction to a drawing *composition*, usually expressed through the location of *eye level* (*horizon line*), side to side placement and distance from the composition.

politically correct/incorrect
a bias or opinion that is acceptable/unacceptable by contemporary socio-cultural standards.

polygon
simple geometric plane with three or more sides made by straight lines.

polyhedron
a solid bounded by polygons.

Pop Art
an art movement of the 1960's using imagery from sources in popular and consumer culture: newspapers, TV, comics, advertising, and mass production.

positive/negative shape
2-D graphic form which represents an object or figure (positive shape) and the field or ground behind the object (*negative shape*) (see also *figure/ground*).

post-modern
a contemporary art-historical and critical category broadly concerned with "signification" or the means by which meaning is constructed in visual culture (semiotics), and covering diverse approaches to visual art including *appropriation, ironic* statement, concern with mass media, and social *identity*.

primacy of means
priority for essential *form,* medium and *facture* in a work of art.

primary colors/primaries
the three essential colors from which all others derive: in the mixing of paint (subtractive mixture) the primaries are red, blue, and yellow; in the mixing of colored light (additive mixture) the primaries are red, blue, and green.

prismatic
resembling a 3-D solid (a prism) that has a *polygonal* base and *rectilinear* sides.

process
actions that lead to an end or a product. In drawing, the accumulated steps, planned or unplanned, that are taken to make the drawing.

profile
the outer edge of a real *form,* seen against the background. Drawing this edge is expressed by an *outside contour.*

projection
linear description of 3-D geometric *form* in drawing, sometimes through a system such as *perspective* or *paraline projection* (see also *3-D projection*).

pronation
rotation of the palm so that the thumb points toward the body.

proportion
comparative dimensional relationship within a *form* or *composition.*

proportional balance
a *compositional* principle in which aspects of dimension or arrangement are weighed in terms of their *complementary* visual effect.

push and pull or push/pull
a compositional principle involving a shifting sense of *figure/ground* relationship in a *composition,* often suggesting *spatial ambiguity* (see also *dynamic tension*).

radial
proceeding from or towards a single central point or *axis,* as in circles, stars, spheres, or spirals.

Rajasthani
from a province in northwestern India.

Rajput
a Hindu dynasty and associated culture in northern India from the 8th through 19th centuries.

random mark
mark made without express intention, for the sole purpose of exploring the act of mark-making, or as a texture.

range of mark
(richness of mark) variety of touch in the marks in a drawing. One mark can be "rich" if it is varied in weight or texture.

range of values
the scale of the possible values used in a drawing. The widest range of values extends from black to white; tonal range.

rectangle
a four cornered *polygon* in which all corners are 90° angles and opposing sides are *parallel* (see also *page/rectangle*).

rectilinear
resembling a *rectangle;* angled at 90°; *vertical/horizontal.*

reed pen
pen made from the stalk of a tall marsh grass.

refer to/reference
connect to or suggest.

reflect
to cast or bounce back light.

reflected light
light which is reflected from one surface onto another, shadowed surface.

renaissance perspective
see *perspective.*

rendered textures
textures in drawing that are not real, but illusionistically portrayed, usually with passages of tone and mark.

representational
concerned with describing real world subjects in an understandable way.

research
(verb) investigate, study; (noun) the act of researching.

resist
a mark or area, often made with a wax-based material, that does not accept pigmenting with wet media.

rhythm of mark
a visual quality emphasizing movement or gesture and suggesting the *facture* or act of making marks. Fast rhythm suggests high energy and may involve a repeated pattern. Slow rhythm might involve a simple line suggesting movement, like an S-curve.

richness of mark
see *range of mark.*

romantic
characteristic of the 19th century style of art literature and music that subordinates formal considerations to expressive content and celebrates emotion and nature as well as experimentation, freedom, introspection and imagination.

S curve /serpentine line
line composed of one or more double curves, *referring* to a snake-like movement or the flow of water.

Sanskrit
an ancient literary and religious language of Hindu India.

saturation (chroma)
the relative purity or intensity of a color. The highest saturation colors are the purest and most intense: the primaries (red, blue and yellow) and secondaries (orange, green and violet). The lowest saturation colors are neutrals (grays and browns), which can be created by mixing all three primaries. They are the most complex or least pure colors.

scumble
to apply by rubbing, or smudging; to blur.

search
(noun) exploratory drawing process.

secondary colors/secondaries
the three colors made by simple mixtures of the primaries: orange, green, and violet.

sense of volume
the more or less *illusionistic* effect of three-dimensional *form* in drawing.

sensuous
experienced through one or more of the senses: sight, hearing, smell, taste, or touch.

series
a group of drawings united in theme or approach.

shading
see *shadow; modeling.*

shadow
areas where there is an absence of light because of blockage of the directional light (*cast shadow*), because the surface of a form is turning away from the light source (*shading, modeling shadow*), or because light is generally absent.

shape
non-linear or enclosed 2-D or *graphic form*. Shape is the *graphic* interpretation of *form*. A shape is an abstract perception, or an enclosed graphic form based on abstract perception (a dark shape; "the shape of things to come"). There is no such thing as *volumetric* shape.

shape association
associative connection between a shape in a drawing and some aspect of nature or life. For example, a rectangle might be associated with a brick, or with solidity in general.

signs
visual indicators or signifiers.

silhouette
a 2-D *shape*, based on the *profile* of a 3-D *form*, often filled in with black. Also, the art form, popular in the 18th and 19th centuries, employing silhouettes for portraiture and narrative.

simultaneous contrast
the effect that two or more colors will have on each other when closely juxtaposed. Each color emphasizes

the differing characteristics of the other: green makes red redder; blue makes green yellower; bright red makes brown duller or greener; white makes all colors darker.

solid form/volumetric form
the terms solid form and volumetric form are interchangeable and can be used to describe objects in the real world, or more or less illusionistic depiction of solid objects in drawing.

source of light/light source
an emitter of light, such as the sun or a lamp.

spatial ambiguity
a relationship between *graphic forms*, usually a *figure/ground* relationship, in which the forms shift in their visual prominence or implied spatial position.

spatial configuration
the arrangement of objects, planes and spaces within a scene or a drawing *composition* conceived three-dimensionally.

spatial intervals
quantities of 3-D space existing between objects in a *composition*. 3-D spatial intervals can be described in drawing by visually measuring 2-D intervals in a real scene, or by projecting measured lengths along *vanishing lines* in a *perspective* system.

spatial overlap
the blocking from view of a distant form by a closer one, clarifying their 3-D relationship. This can also occur between parts of the same form (see *overlap; contour overlap*).

spatial reference
indication or implication of three-dimensionality in the *motif*, construction or *facture* of a drawing.

spectrum triad
three colors, often approximating the primaries, mixed to build a palette of connected hues (see *Figure 8.17*).

spectrum/color spectrum
the array of colors produced by the separation of white light into its constituent rays. The spectrum contains the primary and secondary colors, and all colors in between them (e.g. yellowish green), but no black, white, gray or brown.

speed of mark
a characteristic of line which suggests the rapid or slow gesture of the artist's hand through the movement of the viewer's eye along the length of the line. Fast line tends to be sleek and very directional. Slow line meanders or is crumpled.

spontaneous process
method of working that is not pre-planned, decisions are made during the work's development.

staccato mark
(sta-KAH-toh, Fr. Italian, by way of musical notation) short, sharp rhythmic marks.

station point
the conceptual position of the viewer in a *linear perspective* system, either in *plan view* (plan station point) or in perspective view (perspective station point).

stereotypes
biases or opinions about societal groups based on ethnicity, religion gender, age or other distinction, ignoring individuality.

storyboard
a grouping of sequential drawings describing a time-based narrative, often used to plan the story line of a film.

stylized
not natural, depicted in a particular manner for an effect.

subject matter
in representational drawing, the objects that make up the image. In abstract drawing, the marks, shapes, and so on.

subjective
based on individual or personal understanding.

sublime
(noun, with "the") a concept of exaltation associated with 19th century romantic thought, based on the experience of the vastness of nature and the idea of God's presence there; (adjective) majestic.

sumi
Japanese term for ink painting with a high carbon ink. May have originated in China.

supination
rotation of the palm so that the thumb points away from the body.

Surrealism
a literary and artistic movement of the 20th century based on the liberation of the subconscious.

system of drawing
a formulated plan for the execution of a drawing.

tableau
(ta-BLOH, Fr. *plural tableaux*) scene that suggests a narrative or dramatic incident.

tactile
evoking the sense of touch. Mark may be tactile in its interaction with the texture of paper. A form may gain tactile qualities from the character of its contour or from surface modeling.

talisman
small object treasured for the magical powers it is believed to have.

tangential
laying next to or branching off from; divergent or marginally relevant.

texture
the feel of a surface, such as smooth, prickly, bumpy, rough.

tone
value.

tooth
texture of paper.

touch
sensitivity or character of *facture* or mark-making.

transcendental
rising above common thought or ideas.

transfer
bring directly to the page. A transferred dimension or *shape* will be based on a 2-D sighting of a *3-D form* or scene through a systematic approach as described in Figures 2.11–2.19. A transferred texture will be imprinted on the paper through *frottage, decalcomania* or other method.

transform poetically
see *poetic connection/transformation.*

transitional drawings
in a series, drawings that bridge the differences between those done before and after them, but that have common elements of both groups.

translucent
allowing the passage of light but not image; not as clear as transparent.

transparent
allowing the free passage of both light and image; completely clear.

triptych
a pictorial *format* of three separate but linked images, often arranged horizontally or vertically.

trompe l'oeil
(tromp-loy, Fr.: "fool the eye") a highly illusionistic 3-D pictorial effect.

two-dimensional/three-dimensional
see *2-D/3-D form.*

utopian
of an ideal state or idea that is not realistic.

value
the lightness or darkness of a color, white is the lightest value and black is the darkest value.

value range
the range of tone along a scale from dark to light. Black and white drawings have only value relationships, while color drawings may have a value range, but also hue and chroma ranges. A drawing may have a wide value range (including both very light and very dark tones) or a narrow range (including only certain shades of gray, a small part of the total range).

vanishing line
see *vanishing point.*

vanishing point
in *linear perspective,* the point of *convergence* of two or more *vanishing lines,* any two of which define the projection of a *2-D measurement* or *dimension* into infinite depth. All lines converging to a given vanishing point represent receding lines or edges that are parallel in the described scene.

verbal expression
something that is stated and understood through oral or written language.

vernacular
in art, a *visual language* peculiar to a particular culture or style.

vertical
parallel to the direction of gravitational pull, perpendicular to horizontal.

visceral
intensely emotional, intuitive.

visible spectrum
that part of the range of electromagnetic waves that the human eye can see (see also *color spectrum*).

visionary

idealistic; with imaginative foresight; unreal.

visual idea

a concept that is expressed and understood through vision rather than through words.

visual language

the expressive *form* and *facture* of a particular artwork or art tradition.

visual noise

the results of particular groupings of marks that lead the viewer to "hear" as well as see them.

visual system

an approach in drawing involving interrelated elements with a combined visual effect.

visual trajectory

the path of the viewer's eye in a composition, following a line or a form in space. A trajectory may be 2-D, across the picture plane, or 3-D into illusionistic depth.

visual weight

the relative effect of part of a composition on the eye of the viewer, through graphic presence or other means.

vocabulary of marks

range of marks and approaches to mark making in a given drawing or body of work.

volumetric form

see *solid form*.

wax crayons

drawing media made of pigment dispersed in wax. (see *Appendix A*).

wet media

liquid drawing materials including inks, watercolor, gouache paint, etc.

Credits

CHAPTER ONE
Page 4: Harmenszoon Van Rijn Rembrandt (1606–1669). *Woman ill in bed*, 1969, Musée des Beaux-Arts de la Ville de Paris, Petit Palais. Crédit photographique: © Petit Palais/Roger-Viollet. **Page 5:** Courtesy of Jan Uvelius Fotograf. **Page 6:** Marlene Dumas, *Artist Statement*, Courtesy of Galerie Paul Andriesse, Amsterdam. **Page 7:** Rhode Island School of Design. **Page 14:** Rhode Island School of Design. **Page 15:** Courtesy of Galerie Paul Andriesse, Amsterdam. **Page 16:** (top) Wayne Thiebaud, Café Flowers, Caged Condiments, Cupcakes Java and Sinkers and Other Food, ca. 1995/Wayne Thiebaud, artist, sketch: 1p.; 28 × 38 cm. Courtesy of the Wayne Thiebaud papers, 1944–2001, Archives of American Art, Smithsonian Institution, © 2009 Wayne Thiebaud/Licensed by VAGA NY; (bottom) Wayne Thiebaud, San Francisco Street Scene, Women's Shoes, Figure Studies, ca. 1990/Wayne Thiebaud, artist, sketch: 1 p.; 28 × 38 cm. Courtesy of the Wayne Thiebaud papers, 1944–2001, Archives of American Art, Smithsonian Institution Art 2009 Wayne Thiebaud/Licensed by VAGA NY. **Page 17:** *Alvar Aalto Theater*. Delphi, Greece. Sketch, 1929. Photo: The Alvar Aalto Museum, Finland. **Page 19:** (top and bottom) Courtesy of Julian Hatton.

CHAPTER TWO
Page 20: © 2007 The Josef and Anni Albers Foundation/Artists Rights Society, New York. **Page 22:** Printed by permission of Fritz Drury. **Page 23:** Courtesy Joanne Stryker. **Page 24:** Courtesy Joanne Stryker. **Page 25:** © Lebrecht/The Image Works. **Page 27:** (top) Marlene Dumas, *Love Hasn't Got Anything To Do With It*, 1977. Color pencil, collage on paper. Artist's collection © Marlene Dumas. Courtesy of Galerie Paul Andriesse, Amsterdam; (bottom) *Dogs Attacking a Man on a Mule* (watercolor on paper) by Goya y Lucientes, Francisco Jose de (1746–1828). © The Barnes Foundation, Merion, Pennsylvania, USA/The Bridgeman Art Library. **Page 28:** Michelangelo Buonarroti (1475–1564), *Sacrifice of Isaac*. Black chalk. Inv. n.70 F. Location: Casa Buonarroti, Florence, Italy. **Page 29:** Jean Arp (Hans) (1888–1966), *Danger of Death (Danger de mort)*, 1954. Pencil on paper, 322 × 257 mm. Presented by Mr. and Mrs. Robert Lewin through the Friends of the Tate Gallery 1987. Location: Tate Gallery, London, Great Britain. Photo: Tate, London/Art Resource, NY, © 2008 ARS, New York. **Page 31:** (top and bottom) Courtesy Joanne Stryker. **Page 32:** (top) Courtesy Joanne Stryker; (bottom) Printed by permission of Fritz Drury. **Pages 33–37:** Courtesy Joanne Stryker. **Page 39:** Printed by permission of Fritz Drury. **Page 40:** (right) Printed by permission of Fritz Drury. **Page 42:** Printed by permission of Fritz Drury.

CHAPTER THREE
Page 48: David Park, *Untitled (man)*, c. 1958. Ink on newsprint, 19 × 13 in. Coll. Michael Chadbourne Mills. Courtesy of Michael Chadbourne Mills. **Page 49:** (top) Bison from the Altamira Caves, Upper Paleolithic, c.15000–8000 BC (cave painting) by Prehistoric © Altamira, Spain/Giraudon/The Bridgeman Art Library Nationality. Copyright status: Out of copyright; (bottom) Printed by permission of Fritz Drury. **Page 50:** Courtesy of Mark Booth. **Page 51:** (left) © Karl Blossfeldt Archiv—Ann and Jurgen Wilde, Zulpich/ARS, New York, 2008; (top, right) Courtesy Kent Wood, Photo Researchers, Inc; (bottom, right) © 2002–2205 Omar I. Y.Pacheco, owner of www.almutamid.com/calligraphy/All rights reserved. **Page 52:** (top) Frank Auerbach, *Head of J.Y.M.* Pencil, 30 × 22 1/2 in. Marlborough Fine Art/© Frank Auerbach. **Page 53:**

Dreaming of That Sam Dog (John Serl at work), by Sam Messer. Reproduced by permission of the artist. **Page 54:** (top, left to right) © CORBIS All Rights Reserved; Printed by permission of Fritz Drury; © Arthur Noskowiak/Center for Creative Photography; © Andy Small/CORBIS All Rights Reserved; © Theo Allofs/CORBIS All Rights Reserved; © Martin Harvey/CORBIS All Rights Reserved; (bottom) . **Page 55:** (bottom) Victor Hugo (1802–1885), *Arbre couché par le vent*. Pen and brown ink wash, 8 9/16 × 11 7/16 in. Location: Paris, Maison de Victor Hugo. Crédit photographique: © Maisons de Victor Hugo/Roger–Viollet. **Page 56:** Digital image © 2008. The Metropolitan Museum of Art. **Page 57:** Georgia O'Keeffe (American, 1887–1986). *Red Canna, 1923*. Oil on canvas mounted on masonite, 36 × 29 7/8 in. (91.4 × 76.0 cm) Collection of The University of Arizona Museum of Art, Tucson, Gift of Oliver James Acc. No. 50.1.4. **Page 58:** (top) © The Trustees of the British Museum; (bottom) Vincent van Gogh (1853–1890) D0344V/1962 F1447, *The Rock of Montmajour with trees*. Pencil, pen, reed pen and China ink, on watercolor paper, 49 × 61 Arles, 1888/Amsterdam, Van Gogh Museum (Vincent van Gogh Foundation). **Page 60:** Printed by permission of Fritz Drury. **Page 61:** (top) © 2007, The Josef and Anni Albers Foundation/Artitst Rights Society, New York; (bottom) Printed by permission of Fritz Drury. **Page 62:** (top, left) *Caryatid*, c. 1913–14 (oil on cardboard) by Amedeo Modigliani (1884–1920) ©Musée National d'Art Moderne, Centre Pompidou, Paris, France/Lauros/Giraudon/The Bridgeman Art Library. Nationality/Copyright status: Italian/Out of copyright; (right, top and bottom) Printed by permission of Fritz Drury. **Page 63:** Rafael, *Studies of the Virgin and Child*. Pen and ink, 253 × 183 mm. Object reg: PD Ff, 1.36/© The Trustees of the British Museum. **Page 64:** (top) *Elefante caduto*. Pittura Rajput di Kotah (*Fallen Elephant*, Rajput Kota), ca.1700, brush drawing on paper, 22 × 25 cm. © Photoservice Electa; (bottom) **Page 65:** Printed by permission of Fritz Drury. **Page 67:** (left) Printed by permission of Fritz Drury; (right) Cheol Yu Kim, *Drawing for Sculpture*, 2002. Pencil on paper, 31 × 15 in. © Cheol Yu Kim/Courtesy CUE Art Foundation. **Page 68:** (left) *Arm of Lucretia*. Brush, heightened with white, on grey paper, 228 × 198 mm © Ambertina/Albrecht Durer. **Page 69:** (top and bottom) Printed by permission of Fritz Drury. **Page 70:** Courtesy of Cynthia Lahti. **Page 72:** (left) © Karl Blossfeldt Archiv—Ann and Jurgen Wilde, Zulpich/ARS, New York, 2008; (right) Courtesy of Cynthia Lahti. **Page 73:** (left) *Sunflowers*, 1911. Pencil and watercolor, 435 × 293 mm. © Albertina, Vienna/Egon Schiele; (right) Jan van Huysum, *Urn of Flowers*. Art Resource, New York. **Page**

74: (left) *Pinecones*, Fritz Drury; (right) © 2007, The Josef and Anni Albers Foundation/Artists Rights Society, New York. **Page 75:** (top) Christina Livesey, *Tag*, 1998, 24 × 16 in., student work; (bottom, left and right) Printed by permission of Fritz Drury. **Page 76:** (left) Aparna Mepani, Charcoal, 24 × 18 in., student work; (right) Nick Jaquith, Charcoal, 24 × 18 in., student work.

CHAPTER FOUR

Page 78: (left) Detlev van Ravenswaay/Photo Researchers, Inc; (right) Printed by permission of Fritz Drury. **Page 79:** (left, top) Karl Blossfeldt (1865-1932) (German), Eryngium maritimum (Sea Holly) (c) 2009 Karl Blossfeldt Archive-Ann u. Jurgen Wilde, Koln /Artists Rights Society (ARS) New York; (right) Leonardo da Vinci (1452–1519), *Star of Bethlehem and Anemonies*. Pen and ink over red chalk, 198 × 160 mm. The Royal Collection © 2007, Her Majesty Queen Elizabeth II. **Page 80:** Piet Mondrian (1872–1944), *Study II for Broadway Boogie Woogie*, 1942. Charcoal on paper, 9 × 9 1/2 in. © 2008 Mondrian Holtzman Trust c/o HCR International Warrenton, VA/Photograph © Christie's Images Ltd. 2005. **Page 81:** Mark Rothko (1903–1970), *Untitled*, 1959. Tempera on paper, 38 × 25 in. Location: Coll. Christopher Rothko, Art Resource, New York © Kate Rothko Prizel & Christopher Rothko/Artists Rights Society (ARS), NY. **Page 82:** Richard Diebenkorn, *Interior with Mirror*, 1967. Charcoal and gouache, 24 1/2 × 19 in. Private Collection, Courtesy Greenberg Van Doren Gallery. © Estate of Richard Diebenkorn, 2007. **Page 85:** (bottom, left) © Grand Tour/CORBIS All Rights Reserved; (top) Evan Hanne, *Untitled*, 1968. Brown ink with wash, 331 × 331 mm. Museum of Wiesbaden. © The Estate of Eva Hesse. Hauser & Wirth Zürich London; (bottom, right) Kuba cloth. Collection of Makari/Ogilvy. **Page 87:** Bridget Riley, *Untitled (Study for 19 Greys)*, 1966. Gouache and pencil on paper, 34.3 × 25.4 cm. Private collection © 2007 Bridget Riley. All rights reserved/Courtesy Karsten Schubert, London. **Page 88:** © by Leni Riefenstahl. **Page 89:** (top, right) Leni Riefenstahl–Produktion; (top, left) Kunstmuseum, Bern, Switzerland/The Bridgeman Art Library; (bottom) Printed by permission of Fritz Drury. **Page 90:** (top) Photograph © Justin Kerr, K521; (bottom) Keith Haring in the New York City Subway, 1981. Photography by Tseng Kwong Chi © 1981 Muna Tseng Dance Projects, Inc. New York. *Subway Drawing* by Keith Haring © 1981 Estate of Keith Haring, New York. **Page 91:** (left) Photograph © Justin Kerr; (right) Henri Matisse (1869–1954), *Self Portrait, 1937*. Charcoal and

estompe, 473 × 391 mm. The Baltimore Museum of Art: The Cone Collection, formed by Dr. Claribel Cone and Miss Etta Cone of Baltimore, Maryland, BMA 1951.12.61, © 2007 ARS, NY. **Page 92**: Richard Diebenkorn, *Seated Woman*, 1965. Conte crayon, 17 × 14 in. Private Collection, Courtesy Greenberg Van Doren Gallery. © Estate of Richard Diebenkorn, 2007. **Page 94:** Warner Forman/Art Resource, NY. **Page 95:** (left) Pablo Picasso (1881–1973), *Seated Nude*, early 1909. Charcoal on paper, 32.6 × 21.4 cm. MP 630. Photo: Le Mage/Location: Musée Picasso, Paris, France/Réunion des Musées Nationaux/Art Resource, NY © 2009 ARS, NY; (right) Picasso, Pablo (1881–1973), *Large Bather with a book*, 1937. Musee Picasso, Paris, France © ARS, NY/Scala/ Art Resource, NY. **Page 96:** Al Held, *Inversion XI*, 1977. Acrylic on canvas, 6 × 8 ft. (182 × 243 cm) Photo credit: Geoffrey Clements Photography, Staten Island, NY © 2008 VAGA, NY. **Page 97:** (top) Giorgio Morandi (1890–1964), *Metaphysical still life*. Location: Private Collection, Milan, Italy/Scala/Art Resource, NY/© 2009 ARS, NY, SIAE, Rome; (bottom) Giorgio Morandi (1890–1964), *Flagon and White Bowls*. Oil on canvas. Private Collection, © DACS/The Bridgeman Art Library © 2008 ARS, NY. **Page 98:** (left) Patrick Henry Bruce (1925–1928), *Still Life #12*. Oil with pencil underdrawing on canvas, 35 1/2 × 45 3/4 in. Hirshhorn Museum and Sculpture Garden, Smithsonian Institution, Gift of Joseph H. Hirshhorn 1972; (right) Wayne Thiebald, *Various Pastels*, 1972. Pastel on paper, 10 1/2 × 14 in. © Wayne Thiebaud/Licensed by VAGA, New York. **Page 99:** (top) Wayne Thiebald, *Desk Set*, 1971. Pastel on paper, 16 × 20 in. © Wayne Thiebald/Licensed VAGA, New York; (bottom) William Bailey, *Still Life with Natalie's Cup*, 1996. Pencil on paper 39 1/2 × 42 3/8 in. (100.33 × 107.63 cm), ©William Bailey/Coutesy Betty Cuningham Gallery. **Page 100:** (top) Printed by permission of Fritz Drury; (bottom) Richard Diebenkorn, *Untitled*, 1963. Wash and conte crayon, 12 1/2 × 17 in. Private Collection, Courtesy Greenberg Van Doren Gallery. © Estate of Richard Diebenkorn, 2007. **Page 101:** Printed by permission of Fritz Drury. **Page 102:** (left) Printed by permission of Fritz Drury. **Page 104:** (top) Sarah Wolf, *Self Portrait*. Compressed charcoal, 35 × 30 in., student work; (bottom) Edward Hopper, *Cold Storage Plant*, 1933. Watercolor over graphite on heavy white wove paper, 50.7 × 63.5 cm (19 15/16 × 25 in.) actual: 55.3 × 68.5 cm (21 3/4 × 26 15/16 in.) Harvard University Art Museums, Fogg Art Museun, Louise E. Bettens Fund, 1934–62. Photo: Imaging Department © President and Fellows of Harvard College.

Page 105: (all images) Printed by permission of Fritz Drury. **Page 106:** Danny Ruiz, *Geometric Objects Still Life*. Charcoal, 28 × 22 in., student work.

CHAPTER FIVE

Page 108: Geoffrey Mullen, 1987. Pencil 18 × 24 in., student work. **Page 110:** Printed by permission of Fritz Drury. **Page 112:** Bildarchiv Preussischer Kulturbesitz/Art Resource, NY. **Page 113:** Jason Brockert, *View of Providence*, 1990. Watercolor, 16 × 22 in., student work. **Page 114:** Printed by permission of Fritz Drury. **Page 115:** (bottom) Piero della Francesca (c. 1420–1492), *Virgin and Child with Saints John Baptist, Bernardine of Siena, Jerome, Francis of Assissi, Peter Martyr, John Evangelist; Federico da Montefeltro kneeling*. From the church of San Bernardino in Urbino. Location: Pinacoteca di Brera, Milan, Italy/Erich Lessing/Art Resource, NY. **Page 116:** (top) Caspar David Friedrich, *Blick aus dem Atelier des Kuenstlers in Dresden auf die Elbe (linkes Fenster)/View from the Artist's Studio in Dresden-on-the-Elbe (left window)*, 1805–1806. Pencil and sepia, 12 1/4 × 9 3/8 in. Oesterreichische Galerie Belve-dere, Vienna; (bottom) Printed by permission of Fritz Drury. **Page 117:** (top) *Los Carpinteros (20th c.)* © Copyright, Proyecto de Acumulacion de Materiales (Project of Accumulation of Materials). 1999. Watercolor and pencil on paper, 46 1/4 × 138 1/8 in. Purchased with funds provided by Sylvia de Cuevas, Leila and Melville Straus, and The Contemporary Arts Council. (1608.2000) Location: The Museum of Modern Art, New York, NY, U.S.A./Digital Image © The Museum of Modern Art/Licensed by SCALA/Art Resource, NY; (center and bottom) Printed by permission of Fritz Drury. **Page 118:** Printed by permission of Fritz Drury. **Page 119:** (top) Laura McCarthy, 2002. Charcoal and conte, 32 × 26 in., student work. **Page 120:** (bottom) Chris Murray, *3 point perspective mantelpiece*. Pencil 24 × 18 in., student work. **Page 121:** (top) Huma Bhabha, *Untitled*, 1983. Ink and charcoal on paper, 14 × 14 in.; (bottom) Kiefer, Anselm (1945–) © Copyright. *Innenraum (Interior)*, 1981. Oil, straw and paper on canvas, 287.5 × 311 cm. Stedelijk Museum, Amsterdam, The Netherlands. Photo Credit: Art Resource, NY. **Page 122:** David Thorpe, *Pilgrims*, 1999. Paper cut out, 117.5 × 173 cm, 46 1/4 × 68 1/8 in. Courtesy Maureen Paley, London. **Page 123:** (top) Printed by permission of Fritz Drury. **Page 124:** Max Klink, *Untitled*, from the Pittsburgh Series, 1997. Mix media on blueprint paper, 30 × 36 in. **Page 125:** Kristall II, *Hochzeitsbild (Kristall II, Marriage Picture)*, 2004. Pencil and colored pencil on paper, 140 × 110 cm (55 1/8 × 43 3/8 in.), © Silke Schatz, courtesy: Private Collection Munich, Photo:

Allister Overbruck, Cologne. **Page 127:** (bottom, left) © Victoria & Albert Museum/Art Resource, NY; (bottom, right) Cheryl Goldsleger, Plateau, 1994. Charcoal on paper, 50 × 85 in. **Page 128:** (top) Paul Noble, *Nobson Central,* © Paul Noble/Courtesy Maureen Paley, London; (bottom) Paul Noble, Nobson Central, © Paul Noble/Courtesy Maureen Paley, London. **Page 129:** Duccio (di Buoninsegna) (c. 1260–1319), *Christ and the Pilgrims on the Road to Emmaus.* Panel from the back of the Maesta altarpiece. Location: Museo dell'Opera Metropolitana, Siena, Italy/Scala/Art Resource, NY. **Page 130:** (top) Photo courtesy of Marlborough Fine Art (London) Ltd. © Jane Bown; (bottom) Paula Rego, *Crivelli's Garden IV.* Acrylic on canvas, 190 × 261 × 2 cm, after cleaning. Image © The National Gallery, London/© Paula Rego/The Marlborough Fine Art. **Page 131:** Stephanie Anderson, 1996, charcoal, 18 × 24 in., student work. **Page 132:** Timothy Liles, 2001, Conte, 14 × 28 in., student work. **Page 133:** Gavin Schmitt, 2002. Charcoal and conte, 16 × 20 in., student work. **Page 134:** (top, a) Charmaine O"Saerang, 2002. Pencil, 16 × 14 in., student work; (top, b) Chris Murray, *3 point perspective mantelpiece.* Pencil 24 × 18 in., student work; (top, c) Michael DeAgro, *Interior Studies,* 1983. Pencil and conte on paper 9 × 6 in., student work; (bottom) Juan Vera, 2002. Charcoal, 24 × 18 in., student work. **Page 135:** Melissa Rivera, *Airport,* 2000. Pencil and charcoal, 24 × 36 in., student work.

CHAPTER SIX

Page 138: (left) *Eleven Step Value Scale* illustrating a relatively consistent gradation of tones of gray, starting with white ending with black. Internet source: www.as.miami.edu/art/bc_bk_illus2d.html; (right, top) Judith Murray, *Am,* 1996. Graphite pencil on arches paper, 17 × 18 in. Courtesy of the artist. Private Collection, New York, NY; (right, bottom) Antonio López García, *Restos de Comida,* 1971. Pencil on paper, 42 × 54 cm. Artists Rights Society (ARS), NY, VEGAP, Madrid. **Page 140:** Courtesy Joanne Stryker. **Page 141:** (top, both) Courtesy Joanne Stryker; (bottom) David Tress, *Light Across (Loch Kishorn).* Charcoal on paper, 57 × 76 cm. © David Tress 2001. **Page 143:** (top) Courtesy Joanne Stryker; (bottom) Ramon Alejjandro (Cuban, b. 1943), *Fatum (Destiny),* 1990. Chalk 43 1/4 × 29 1/2 in. (109.86 × 74.93 cm), San Diego Museum of Art (Museum purchase). **Page 144:** Martin Kline, *Labyrinth,* 2001. Oilstick on paper, 38 × 27 1/2 in. Courtesy Martin Kline and Jason McCoy, Inc., New York. **Page 145:** (top, both) Claudio Bravo, *White Paper,* 2004. Pencil on paper, 28 3/8 × 39 in. (72.00 × 101.00 cm) © Claudio

Bravo/Courtesy Marlborough Gallery, New York, NY; (bottom, both) Claudio Bravo, *Babouches,* 2005. Pastel on paper 29 1/8 × 42 7/8 in. (74.00 × 109.00 cm) © Claudio Bravo/Courtesy Marlborough Gallery, New York, NY. **Page 146:** (bottom) James Valerio, *Doughnuts,* 1999. Pencil on paper, 28 11/16 × 40 in. © James Velerio/Courtesy George Adams Galley. **Page 148:** Leonardo da Vinci (1452–1519), *Drapery on a seated figure.* 26.5 × 25.3 cm. INV2255. Photo: J.G. Berizzi. Louvre, Paris, France Réunion des Musées Nationaux/Art Resource, NY. **Page 149:** (top) Roger de Piles, (French, 1635–1709) *Cours de Peinture par Principes, Paris, Esteve,* 1708, plate 2. Brown University Library; (bottom) Rubens, Peter Paul (1577–1640), *Youths, after 'Lo Spinario.'* Red chalk on paper. © British Museum, London, UK/The Bridgeman Art Library, Nationality/Copyright status: Flemish/Out of copyright. **Page 150:** Anonymous, 20th century, Portrait of Wassily Kandinsky. Black china ink, wash, 23.8 x 17.5 cm. Inv. AM81-65-1038. Musee National d'Art Moderne.Centre Georges Pompidou, Paris, France/CNAC/MNAN/Dist. Réunion des Musées Nationaux / Art Resource, NY. **Page 151:** Ernst Haeckel *Jellyfish, from 'Kunstformen der Natur',* 1874. Coloured engraving, by Ernst Haeckel (19th century) © Bibliothèque des Arts Decoratifs, Paris, France/Archives Charmet/The Bridgeman Art Library/Nationality/Copyright status: German/Out of copyright. **Page 152:** Shuvinai Ashoona (1961), *Cape Dorset, Rock Landscape with Stairs,* 1997/98. Felt–tip pen on paper, 25.9 × 33.5 cm. Collection of the West Baffin Eskimo, Cooperative Ltd., on loan to the McMichael Canadian Art Collection CD.148.225. Reproduced with the permission of Dorset Fine Arts. **Page 153:** (yop) Hans Poelzig, *Salzburg Festival Hall, first version: Auditorium.* Charcoal on tissue, 21 7/8 × 27 15/16 in. Architecture Museum of the Technical University of Berlin, University Library. Inv. No: 2763; (bottom) Fernand Leger, *Etude pour la lecture,* 1923. Crayon sur paper, 27 × 37 cm. Donation Genevieve et Jean Masurel en 1979, Musee d'Art Moderne deLille Metropole Villeneuve d'Ascq. Inv. No: 979.4.147. **Page 154:** Ted Weller, *Stocked Logs,* 1981. Burnt plywood. **Page 155:** (bottom) Gwen Strahle, *Untitled.* Ink on paper, 11 × 15 in. **Page 157:** (top) Sangram Majumdar, *Southern Hills,* 2005. Graphite on paper, 22 × 30 in. Courtesy of the Artist; (bottom) Roger Brown, *Misty Morning,* 1975. Oil on canvas, 72 × 72 in. Scottish National Gallery of Modern Art. **Page 158:** Tomás Sánchez, *El Norte y El Sur,* 2003. Charcoal and pastel on paper 19 × 25 in. (50.17 × 64.77 cm) © Tomás Sánchez/Courtesy Marlborough

Gallery, New York, NY. **Page 159:** (top) *Landschaft mit Herden und zwei rastenden Wanderern, im Hentergrund Ruine eines Schlosses*, 101 × 314 mm. Location: Albertina, Vienna. © Albertina/Jan Van de Velde II; (bottom) Kathe Schmidt Kollwitz (1867-1945), © Whitworth Art Gallery, The University of Manchester, UK/ The Bridgeman Art Library. Nationality / German (c) 2009 Artists Rights Society (ARS), New York, VG Bild-Kunst, Bonn. **Page 160:** (top) Seurat, Georges (1859–1891), *Seated Boy with Straw Hat*, study for Bathers at Asnières, 1883–1884. Black Conte crayon on Michallet paper. Sheet: 24.1 × 31.1 cm (9 1/2 × 12 1/4 in.) Framed: 47.784 × 54.134 × 2.223 cm (18 13/16 × 21 5/16 in.) Location: Yale University Art Gallery, New Haven, Connecticut, U.S.A., Yale University Art Gallery/Art Resource, NY; (bottom) Barry Ledoux, *Drawing of Self-Doubt, no 3*, 1989–1990. Cut paper, hair, glass beads, oilstick, pigment, 40 × 29 × 12 in. Courtesy of the artist and Lesley Heller Gallery. **Page 162:** Tessa Ferreyros, *Texture of a Dragonfly*. Courtesy of the artist. **Page 163:** Courtesy Joanne Stryker. **Page 164:** Erika Kim, *Untitled Still Life*. Charcoal on paper, 30 × 40 in. Courtesy of the artist. **Page 165:** Eleanor Sibley Denker, *Untitled Sill Life*. Charcoal on paper, 36 × 24 in. Courtesy of the artist.

CHAPTER SEVEN
Page 167: Richard Diebenkorn, *Fruit and Windows*, 1966. Gouache and ballpoint ink on paper, 17 × 14 in. Private Collection/Courtesy Greenberg Van Doren Gallery © Estate of Richard Diebenkorn, 2007. **Page 168:** Todd Moore, *03415, Little Compton*. Ink on paper, 31 × 21 in. **Page 169:** Todd Moore, *03155, Little Compton*. Ink on paper, 31 × 21 in. **Page 170:** (left) Don Bachardy (b. 1934), *Truman Capote (1924–1984)*, 1964. Pencil on Paper, 67 × 48.3 cm. National Portrait Gallery, Smithsonian Institution, Washington, DC, U.S.A./National Portrait Gallery, Smithsonian Institution/Art Resource, NY © Don Bachardy/Kenneth A. Maley; (right) Courtesy Scott Hyde. Cooper–Hewitt, National Design Museum, Smithsonian Institution. **Page 173:** (top) Jack Beal, *Oysters with White Wine*, 1974. Lithograph, 13 × 17 in. Arkansas Arts Foundation Collection: Memorial Acquisition Fund, 1975. 75.004.00e; (bottom) Courtesy of Samuel Freeman, Santa Monica. **Page 174:** (top and center) Cozens, Alexander (1717–86), *Italian Landscape with Domed Building*. Pencil and wash on paper. © Leeds Museums and Galleries (City Art Gallery) UK/The Bridgeman Art Library; (bottom) © Jake Berthot/Courtesy Betty Cuningham Gallery, New York. **Page 175:** (left) Dix,

Otto (1891–1969), *Grave (Dead Soldier)*, 1917. Drawing. Location: Graphische Sammlung, Kunstmuseum, Duesseldorf, Germany. Photo Credit: Foto Marburg/ Art Resource, NY, © 2009 ARS, NY, VG Bild-Kunst, Bonn; (right) Enrique Martinez Celaya, The Forest V, 1999, Watercolor on paper 15 X 32 inches, Private Collection, Los Angeles California © Enrique Martinez Celaya/Photo Courtesy Sara Meltzer Gallery. **Page 177:** (top) © Michèle Fenniak/Courtesy of Forum Gallery, New York; (bottom) Joseph Stella, *At the Base of the Blast Furnace* © Carnegie Library of Pittsburgh. **Page 179:** (top) Hans Otto Wendt, *Highway 301*, 1950. *Der Panther*, movie poster. Germany, Warner Brothers, image found in The Art of Noir by Eddie Muller, page 55. The Overlook Press, page 55, Woodstock and New York, 2002. Photo courtesy of Eddie Muller; (bottom) Courtesy of the Library of Congress. **Page 180:** Virgil Grotfeldt, *Growing Pains*, 2004. Coal dust and acrylic on linen, 60 × 54 in. (152.4 × 137.16 cm) © Virgil Grotfeldt, Image courtesy of Holly Johnson Gallery, Dallas, Texas. **Page 181:** Jaques Courtois (French, 1621–1676), *Horsemen in a Landsape*. Pen and wash, 8 3/4 × 13 11/16 in. Museum of Art, Rhode Island School of Design; Gift of Mr. Walter Lowry. **Page 182:** (bottom) Sandy Walker, *Cathedral/Water*. Ink on paper, 84 × 120 in. Courtesy of the artist. **Page 183:** (top) Edgar Degas (French, 1834–1917), Danseuse au Bouquet, pastel over monotype, 15 7/8 × 19 7/8 in. Museum of Art, Rhode Island School of Design; Gift of Mrs. Murray S. Danforth; (bottom) John Robert Cozens (1752–1799), *Padua, After 1782*. Watercolour on paper, 260 × 371 mm. Location: Tate Gallery, London, Great Britain/Tate Gallery, London/Art Resource, NY. **Page 184:** Courtesy Cheim & Read, New York/© Pat Steir. **Page 187:** Jaune Quick–to–See Smith (Enrolled Flathead Salish, member of the Confederated Salish and Kootenai Nation Montana) *Cowboy*, 1986. Acrylic, charcoal, pastel. © Jaune Quick–to–See Smith/Photo: Andrew Ambrose. **Page 189:** (top) Maria Garcia–Corretjer, *Untitled Still Life*. Charcoal on paper, 30 × 40 in., student work; (bottom) Josh Wood, *Untitled Self Portrait*. Charcoal on paper, 40 × 60 in., student work. **Page 190:** (left) Natalie Bluhm, *Untitled Self Portrait*. Charcoal on paper, 40 × 60 in., student work; (right) LaVare, *Self Portrait*. Charcoal on paper, 36 × 66 in., student work.

CHAPTER EIGHT
Page 196: Printed by permission of Fritz Drury. **Page 198:** (top) Printed by permission of Fritz Drury. **Page 199:** Printed by permission of Fritz Drury. **Page 201:**

(top) Yun–Fei Ji, *The Wedding Ballad [detail]*, 2002. Mineral pigments on rice paper 28 1/2 × 171 1/2 in. © Yun–Fei Ji/Image courtesy James Cohan Gallery, New York. **Page 203:** (left) Henri Matisse (1869–1954), *La Gitane–Gypsy*. Oil on canvas. © 2008 Succession H. Matisse, Paris/Artists Rights Society (ARS) New York . Location: Musée de l'Annonciade, St. Tropez, France Photo Credit: Erich Lessing/Art Resource, NY © 2009 Succession H. Matisse/Artists Rights Society (ARS), NY; (right) Peter Paul Rubens, *Portrait drawing*. Colored chalks with pale brown wash and white heightening, 381 × 294 mm. Object reg. no: PD 1893,0731.21. © The Trustees of the British Museum. **Page 204:** Lucian Freud (b 1922), *Lord Goodman*, 1986–87. Pastel and charcoal. Collection of Lord Goodman/The Bridgeman Art Library/© 2008 Derrick Goodman LLP Estate of Lucian Freud. **Page 205:** (top) *An English Landscape*, c. 1635–1641. Watercolor, gouache and pen & ink on paper, by Sir Anthony van Dyck (1599–1641) © The Barber Institute of Fine Arts, University of Birmingham/The Bridgeman Art Library. Nationality/Copyright status: Flemish/Out of copyright; (bottom) Joseph Mallord William Turner (1775–1851), *The Town and Chateau of Eu*, 1845. Pencil and watercolour on paper, 231 × 325 mm. From Eu and Treport Sketchbook [Finberg CCCLIX]. D35441. Finberg number: CCCLIX 6. Location: Tate Gallery, London, Great Britain/Tate Gallery, London/Art Resource, NY. **Page 208:** Henri de Toulouse–Lautree (1864–1901), *Portrait of Vincent van Gogh*. Coulored crayon on paper, on pasteboard, 57 × 46.5 in. Paris, Early 1887/Amsterdam, Van Gogh Museum/Vincent van Gogh Foundation. **Page 210:** David Hockney, *My Father*, Paris: Jan. 1974. Crayon on Paper 25 1/2 × 19 1/2 in., © 2008 David Hockney. **Page 211:** (top) Hal Forrstrom, *Machine*. Charcoal and pastel 24 1/2 × 36 1/2 in., student work; (bottom) Attributed to Ustad Murad, *Jyestha, the month of Heat* (from a *Baramasa* [Twelve Months] manuscript) c. 1725. Opaque and metallic gray watercolor on paper. 28.2 × 17.2 cm (11 1/8 × 6 3/4 in.) framed 48.58 × 38.42 × 2.22 cm (19 1/8 × 15 1/8 × 7/8 in.) Harvard University Art Museum, Arthur M. Sackler Museum, Gift in gratitude to John Coolidge, Gift of Leslie Cheek, Jr., Anonymous Fund in memory of Henry Berg, Louise Haskell Daly, Alpheus Hyatt, Richard Norton Memorial Funds and through the generosity of Albert H. Gordon and Emily Rauh Pulitzer; formerly in the collection of Stuart Cary Welch, Jr., 1995–124 Photo: Katya Kallsen © President and Fellows of Harvard College. **Page 212:** (top) Laura Owens, *Untitled*, 2001. Pencil and watercolor on paper, 30 × 22 1/2 in., Courtesy of the artist; (bottom) Geor-

ganne Deen, *Hope etc.*, 1995. Oil and collage on silk, 34 × 48 in. Collection of Neuburger Berman, New York, © Geroganne Deen. **Page 213:** (top) Portrait of Neo Rauch. Courtesy Galerie Eigen + Art Leipzign/Berlin & David Zwirner, New York. Photo: Gregor Hohenberg; (bottom) Neo Rauch, *Park*, 1999, oil on paper, 100 × 126 cm, Privatsammlung (Private Collection), Berlin. Courtesy Galerie Eigen + Art Leipzign/Berlin & David Zwirner, New York. Photo: Uwe Walter © 2008 ARS, NY. **Page 215:** (top, left) Kara Walker, from the series *Negress Notes*, 1966. Watercolor on paper 10 1/4 × 7 in., set #6, Drawing #4/Courtesy of Sikkema Jenkins & Co.; (bottom) Norman Paris, *Untitled*, etching and aquatint, 12 × 12in. **Page 218:** (top) Feather Sedam, *Atmospheric Color Study*. Mixed media on paper, 9 × 9 in., student work; (bottom) Grace Zong, *Self Portrait*, 2002. Conte and charcoal, 14 × 14 in., student work. **Page 219:** Jason Brockert, *Harbor*, 1992, watercolor, 14 × 12 in., student work. **Page 220:** Aaron Flynn, *Portrait with Drawing*, 2002. Pastel, 24 × 28 in., student work. **Page 221:** Snejina Latev, *Red Boy*, 2002. Monotype, 10 × 14 in., student work. **Page 222:** Julia Rothman, 2002. Gouache, 36 × 24 in., student work.

CHAPTER NINE

Page 225: (top) Erich Lessing/Art Resource, NY; (bottom) *The Archer*, rock painting from Santolea, c. 8,000 B.C. Print by Douglass Mazonowicz, from voices from the Stone Age. Thomas Crowell Co. NY/Courtesy of Nick Mazonowicz. **Page 226:** (left) *Dödsskogen/The Forest of Death*. Collage on paper, 129 × 98 cm. Courtesy Galleri Magnus Karlsson, Stockholm/David Zwirner, NY/Photo: Per–Erik Adamsson. **Page 227:** (top) Lotte Reiniger (6/2/1899–6/19/1981), *Scenes from Hansel & Gretel*, 1955. © 2008 Artists Rights Society (ARS), New York/VG BILD–KUNST, Bonn. **Page 230:** (left) Ground Plane Diagram, by Fritz Drury; (right) Paula Rego, *Study for the Family*. Pen and wash, 296 × 385 mm © Paula Rego/Photograph courtesy of Marlborough Fine Art (London) Ltd. **Page 232:** Odd Nerdrum, *Profile*, 1991. Oil on canvas, 33 1/2 × 34 1/2 in. © Odd Nerdrum/Courtesy of Forum Gallery, New York, NY. **Page 223:** (left) Duerer, Albrecht (1471–1528), *Studies of Heads*, 1506. Drawing. Location: Graphische Sammlung Albertina, Vienna, Austria. Erich Lessing/Art Resource, NY; (right) Joerg P. Anders/Art Resource/Bildarchi v Pressischer Kulturbesitz. **Page 234:** Leon Golub, *Fidel Castro I*, 48 × 48 cm. © Estate of Leon Golub/© 2008 VAGA, New York, NY. Courtesy Ronald Feldman Fine Arts, New York. **Page 235:** (left) Corbis/Bettmann; (right) Printed by permission of Fritz Drury. **Page 236:** (top) Antonio López García, *Mujer en*

la bañera, 1971. Pencil on paper, 42 × 54 cm © Antonio Lopez Garcia © 2009 ARS, NY/VEGAP; (bottom) Printed by permission of Fritz Drury. **Page 237:** *Young Boy,* from the Young Boy Series. Ink wash, watercolor on paper. Courtesy of Galerie Paul Andriesse, Amsterdam. **Page 238:** (left) Adam Fuss, *Untitled,* 1998. Unique cibachrome photogram, 40 × 30 in. (101.6 × 76.2 cm) Courtesy Cheim & Read, New York/© Adam Fuss; (right) Rory Keller, *Skeleton Study.* Charcoal on paper, 36 × 26 in., student work. **Page 239:** (left) Egon Schiele, Tulln (Vienna, 1890–1918), *Standing Male Nude,* Back View, 1910. Watercolor, gouache and charcoal, 17 5/8 × 12 1/8 in. Elizabeth Szancer Kujawski Art Advisors/Private Collection. Courtesy Neue Galerie New York; (right) © Réunion des Musées Nationaux/Art Resource, NY. **Page 240:** (top) *Caryatid,* 1911 (pastel on paper) by Amedeo Modigliani (1884–1920) © Musée d'Art Moderne de la Ville de Paris, Paris, France/Lauros/Giraudon/The Bridgeman Art Library: Nationality/Copyright status: Italian/Out of copyright; (bottom, right) Art Resource, NY; (bottom, left) Diagram by Fritz Drury. **Page 241:** (right) Antonio López García, *José Maria,* 1981. Pencil on paper (204 × 102 cm) © Antonio Lopez Garcia/VEGAP/© 2007 ARS, NY. **Page 242:** Diagrams by Fritz Drury. **Page 243:** Graham Little, *Untitled,* 2001. Colored pencil on paper, 16 7/16 × 11 13/16 in. Courtesy of the artist and Alison Jacques Gallery, London. **Page 244:** Barry McGee, *Untitled* (24 framed panel installation), 2005. Mixed media, variable dimensions (detail). Courtesy Deitch Projects. **Page 245:** (left) Lorbo-Porco, *Torso Study,* 24 × 18 in., student work; (center) Chris Evans, *Torso in Strong Light.* Nupastel, 18 × 24 in., student work; (right) Patrick Theaker, *Female Torso Study,* 18 × 24 in., student work. **Page 247:** (left) John Currin, *Blue Rachel,* 2001. Charcoal on paper, 18 × 14 in. (45.7 × 35.6 cm) © John Currin. Courtesy Gagosian Gallery. **Page 248:** Lucian Freud, *Portrait of David–Etching, 1998.* © Lucian Freud/License by Goodman Derrick LLP, London/Courtesy Acquavella Galleries, Inc. NY/Photograph courtesy John Riddy. **Page 250:** (top, left) Scala/Art Resource, NY; (bottom) Remy Toledo Gallery; (top, right) Clara Lieu, charcoal, 24 × 40 in., student work. **Page 251:** David Hockney, Yves-Marie and Mark. *Paris, Oct. 1975,* 1975. Red Conte on Paper. 25 1/2 × 19 1/2 in. © David Hockney. **Page 252:** (left) Edgar Degas (French, 1834–1917), *Seated Dancer Rubbing Her Leg,* c. 1878. Black charcoal with white and dark brown pastel on light brown paper, 17 5/8 × 12 1/4 in. (44.8 × 31.1 cm) Norton Simon Art Foundation. **Page 253:** (left) Ed Bray, *The Gas Station,* 1996, pencil, 20 × 24 in.; (right) Ed Bray, *Inside,* 1995, 20 × 24 in.

Page 254: *Rock Group,* F. Drury. **Page 255:** Nancy Diamond, 1983. Charcoal, 36 × 26 in., student work. **Page 256:** (top) Linda Wingerter, *Head Poses.* Pencil, 12 × 12 in. ea., student work; (bottom) Josh Tallman, *Head and Skull Studies,* 2001. Pencil, 18 × 12 in., student work. **Page 257:** Clara Lieu, 1999. Charcoal, 32 × 26 in., student work. **Page 258:** (top) Chris Livesey, 1998. Charcoal, 18 × 14 in., student work; (bottom, left) Angel Steger, 2000. Charcoal/conte, 2 sheet, 32 × 26 in. ea., student work; (bottom, right) Matt Bell, *Figure and Posong Skeleton.* Conte, 2 sheets 18 × 24 in. ea., student work. **Page 259:** (top) Tim Wilson, charcoal/conte, 24 × 18 in., student work; (bottom) Sue Williams, *Three in Blue.* Oil and acrylic on canvas, 15 × 18 in. Courtesy the artist and David Zwirner Gallery. **Page 260:** Edgar Degas 1834–1917, *Nude Dancer with Upraised,* ca. 1890. Location: Statens Museum for Kunst, Copenhagen/SMK Foto Den Kongelige Kobberstiksammling. **Page 261:** Joon Song, 1998, conte crayon on tone papepr, 34 × 28 in., student work. **Page 262:** (top) Matt Westervelt, *Tissue Samples,* 2000. Pen, 24 × 24 in., student work; (bottom) Gwen Cory, *Group Figure Study.* Charcoal on paper, 18 × 24 in., student work. **Page 236:** (top) Linda Wingerter, *Group Gesture,* 1995. Charcoal, 24 × 18 in., student work; (bottom) Doug Olson, 2001. Nupastel, 22 × 24 in., student work. **Page 264:** (top) Linda Wingerter, *Moving Figure.* Charcoal, 24 × 18 in., student work; (bottom) Gamaal Wilson, *Student Life,* 2002. Mixed media, multipanel, various sizes, student work.

CHAPTER TEN

Page 270: (right) Robert Longo, *Untitled,* 1981. Charcoal, graphite, ink on paper, 22 1/2 × 22 in. Courtesy of the Artist and Metro Pictures. **Page 271:** David Park, *Head with Hand,* 1960. Gouache on paper, 12.5 × 9.25 in. © David Park, Image courtesy Hackett–Freedman Gallery, San Francisco. **Page 272:** (top) Richard Diebenkorn, *Untitled, 1962.* Conte crayon, 11 × 17 in. Private Collection/Courtesy Greenberg Van Doren Gallery/© Estate of Richard Diebenkorn, 2007. **Page 274:** (top) Wes Mills, Courtesy of Private Collector; (bottom, left) Leach-Jones, *Cult Hook with Dark Flowers,* 1996–97. Pastel and charcoal on paper, 24 1/2 × 18 in. © Alun Leach-Jones/Photograph courtesy of Rex Irwin Art Dealer, Woollahra, Australia; (bottom, right) Eva Hesse, *Untitled,* 1969–70. Gouache, 30 3/4 × 22 1/2 in. © The Estate of Eva Hesse. Hauser & Wirth Zürich London. **Page 275:** (top) Philip Guston, *Untitled,* 1765. Ink on paper, 18 × 24 in. Courtesy Stephens Inc.; (bottom) *Abstract Composition,* 1937. Tempera on

board, 31 7/8 × 39 3/4 in. © J. Torres–Garcia. Alejandra, Aurelio, Claudio Torres Archives. **Page 276:** (left) School of Novgorod, *The Deposition*. Russian icon, 15th c. Location: Tretyakov Gallery, Moscow, Russia/Art Resource, NY. **Page 277:** Randy Twaddle (1957), *Evergreen*, 1990. Charcoal on paper, 60 1/2 × 43 1/2 in. (153.67 × 110.40 cm) 1991.36/Addison Gallery of American Art/Museum Purchase © Randy Twaddle. **Page 278:** Fan Kuan (Chinese), *Travelers among Mountains and Streams*, c.1000. Hanging scroll, ink and colors on silk, 81 1/4 in. Collection of the National Palace Museum, Taiwan, Republic of China. **Page 280:** (top) Richard Artschwager, *Door, Window, Table, Basket, Mirror #18*, 1974. Ink on paper 24 × 36 in. Courtesy of David Nolan Gallery, New York/© 2009 Richard Artschwager/ARS, NY; (bottom) Edgar Degas (1834–1917), *In Front of the Mirror*, ca. 1889. Pastel on paper, 49 × 64 cm. Inv. 1078. Photo: Elke Walford. Location: Hamburger Kunsthalle, Hamburg, Germany/© Bildarchiv Preussischer Kulturbesitz/Art Resource, NY. **Page 281:** (top) Image originally appeared online at http://www.ethicsofchoice.com/Galn.html. Used with permission of David Thomas; (bottom) *Capital Punishment* by Elizabeth Layton (1909–1993), 22 × 29 in., crayons and colored pencils. June 19, 1980. Courtesy of Don Lambert and the Lawrence Arts Center, Lawrence, Kansas. **Page 284:** (top, left) Joseph Mallord William Turner (1775–1851), *Goldau, with the Lake of Zug in the Distance: Sample Study*, ca. 1842–43. Pencil, watercolour and pen on paper, 228 × 290 mm. D36131. Finberg number: CCCLXIV a 281. Location: Tate Gallery, London, Great Britain/Tate Gallery, London/Art Resource, NY; (bottom) Wangechi Mutu, *Black Girl Thunder*, 2004. Paint , ink and collage, mixed media on mylar 81 × 42 in. Courtesy of Sikkema Jenkins & Co. **Page 286:** (left) Antionette Hocbo, *Imprint Self Portrait*, 2007. Mixed media, 60 × 25 in., student work; (right) Robert Rauschenberg and Susan Weil, *Untitled* [double Rauschenberg], c.1950. Monoprint: exposed blueprint paper, 82 1/2 × 36 1/4 in. Collection of the Cy Twombly, Rome, © 2008 Robert Rauschenberg/Licensed by VAGA, New York, NY. Used with permision of Susan Weil, collaborating artist. **Page 287:** (right) Sigmar Polke, *Untitled*, 2001–2006. Artificial resin on polyester fiber 54 × 46 in. (137 × 117 cm) POL 276 Credit line: Private Collection, Courtesy Michael Werner Gallery, New York and Cologne © The artist. **Page 288:** (top) Bada Shanren (Zhu Da), *Handscroll: Birds and Lotus Pond*, Cincinnati Art Museum, Museum Purchase. Accession #1950.79; (bottom) Judy Pfaff, *Deepwater*, 1980. Wire, plastic, paint, wood, mylar mirrors, and contact paper. Julius Kozlowski/©Judy Pfaff/Licensed by VAGA, NY. **Page 289:** (top) © Kara

Walker/Courtesy of Sikkema Jenkins & Co. **Page 290:** Elliott Gree, Three frames from the sketchmovie title: *Rumos of Swelling*, Made on September 3, 2000 © Elliott Green. **Page 291:** Courtesy of David Mazzucchelli. **Page 292:** Balthus, *Katia endormie (Katia Asleep)*, 1969–70. Pencil and charcoal on paper, 70x 50 cm, © 2009 Artists Rights Society (ARS) New York. **Page 293:** Julie Mehretu, *Transcending: The New International*, 2003. Ink and acrylic on canvas, 107 × 237 in. (271.8 × 602 cm) Collection Walker Art Center, Minneapolis; T.B. Walker Acquisition Fund, 2003. Photo: Cameron Wittig/Courtesy The Project, New York. **Page 294:** (top) *Black Tulip Feb 28 1983*, 1983. Charcoal and graphite on paper, 50 × 38 in. Private collection. © Donald Sultan; (bottom) Robyn O'Neil, Detail of *As darkness falls on this heartless land, my brother holds tight my feeble hand*, 2005. Graphite on paper 167 × 92 1/2 in. Collection of Bill and Charlotte Ford/Courtesy Clementine Gallery, NY. **Page 296:** Hugo, Victor (1802–1885), *The Dead City*. Ink, wash, and watercolor on paper. Private Collection/Archives Charmet/The Bridgeman Art Library Nationality/Copyright status: French/Out of copyright. **Page 297:** (top) Romare Bearden (1911–1988), *The Prevalence of Ritual: Baptism, 1964*. Paint and graphite on board, 9 1/8 × 12 in. Hirshhorn Museum and Sculpture Garden, Smithsonian Institution, Gift of Joseph H. Hirshhorn, 1966 © 2008 VAGA, NY.

CHAPTER ELEVEN
Page 304: (top) Vincent van Gogh (1853–1890), D0439V/1962F1522, *Trees with ivy in the garden of the asylum*. Pencil, reed pen and brown ink on paper, 62. 1/2 × 47 in. Saint Remy, 1889/Amsterdam, Van Gogh Museum (Vincent van Gogh Foundation) **Page 305:** David Bates, *Sunflowers I*, 2003. Charcoal and watercolor on paper, 41 × 26 in. Private Collection, Photo Courtesy DC Moore Gallery, New York. **Page 306:** Miriam Cahn, *L.I.S. das genaue hinsehen*, 5.1.1987. Series of 3 sheets, carbon on paper. Courtesy: STAMPA Basel. **Page 307:** (top) Bryan Hunt, American (1947), *Ode to The*, 1986. Wax, dry pigment, and graphite on paper, 29 3/4 × 22 1/4 in. (sheet), The Arkansas Arts Center Foundation Collection, 1987. 87.26; (bottom) William Kenttridge, *Untitled* (from Colonial Landscape series), 1995–1996. Charcoal and pastel on paper, 120 × 160 cm. **Page 308:** (bottom) Eve Aschheim, *Shell*, 1998. Gesso, black gesso, graphite, charcoal, Koh–I–noor wax crayon on duralene mylar, 12 × 9 in. Collection of Jack Shear. Photo: Farzad Owrang © Eve Aschheim. **Page 311:** (left) Leonardo da Vinci (1452–1519), *Plate 16, Myology of Trunk*, ca. 1510, The Royal Collection © 2007, Her Majesty Queen Elizabeth II; (right)

Leonardo da Vinci (1452–1519), *Plate 48, Myology of Shoulder Region*, ca. 1510, The Royal Collection © 2007, Her Majesty Queen Elizabeth II. **Page 312:** (left) © The Natural History Museum, London; (right) © The Natural History Museum, London. **Page 319–320:** Dawn Clements, *Kitchen and Bathroom*, (Installation: Miami), 2003. Sumi ink on paper, 81 × 312 in. Courtesy of the artist and Pierogi Gallery. **Page 322:** (left) Ellsworth Kelly, *Vault, Notre Dame, Paris (1)*, 1949. Pencil, 13 × 18 in. (33 × 45.7 cm) © Ellsworth Kelly; (right) Ellsworth Kelly, *Vaults/Flower*, 1949. Ink, 16 1/2 × 12 1/2 in. (41.9 × 31.8 cm) © Ellsworth Kelly. **Page 323:** (top, left) Ellsworth Kelly, *Five Sketches*, 1954–1955. Ink, 15 5/8 × 21 in. © Ellsworth Kelly; (top, right) Ellsworth Kelly, Study for Black and White Panel of *Painting in Three Panels*, 1955. Ink and pencil, 13 3/4 × 10 7/8 in. © Ellsworth Kelly. **Page 325:** (top) Federico Borocci, *Study of Hands; Gabinetto dei disegni e delle Stampe*, Uffizi Gallery, Florence, Italy. © Alinari/The Image Works; (bottom) Federico Barocci, *Study of Madonna del Popolo; Gabinetto dei disegni e delle Madonna*, Uffizi Gallery, Florence, Italy. © Alinari/The Image Works. **Page 329:** (bottom, left) Grace Park, *Untitled Studies*. Charoal, graphite, and conte on paper, 36 × 48 in., student work; (top) Sangram Majumdar, *Insect Studies*. Mixed media on paper, 36 × 48 in. Courtesy of the artist; (bottom, right) Sangram Majumdar, *Skeleton Studies*. Mixed media on paper, 36 × 48 in. Courtesy of the artist.

CHAPTER TWELVE

Page 334: Tim Hawkinson, *Wall Chart of World History from Earliest to the Present*, 1997. Pen and pencil on paper, 51 × 396 in. Photography courtesy the artist and PaceWildenstein, New York © Tim Hawkinson, PaceWildenstein, New York, NY. **Page 336:** Frank Auerback, *Head of E. O. W.*, 1960, © Marlborough Fine Art, London/The Whitworth Art Gallery, The University of Manchester, UK. **Page 337:** Richard Serra, *In Spite of the Other*, 2001. Paintstick on paper, 39 1/2 × 39 1/2 in. (100.3 c 100.3 cm) (#32) © Richard Serra/Courtesy Gagosian Gallery. **Page 339:** Sol LeWitt, *All Combinations of Arcs From Corners and Sides: Straight, Non–Straight, and Broken Lines* (wall drawing), 1972, blue chalk. Location, Kunsthalle, Bern. **Page 343:** John Currin, *Mrs. So–and–So*, 2000. Ink and gouache on prepared paper, 13 7/8 × 10 7/8 in. (35.2 × 27.6 cm) © John Currin/Courtesy Gagosian Gallery. **Page 344:** Elinore Hollinshead, *To the Altar*, 1986. India ink, beeswax, damar varnish on paper, 50 × 39 in. **Page 345:** (top, left) Elinore Hollishead, *Work in Progress: Letting Go*, 1986. India ink, beeswax, damar varnish on paper, 50 × 30 in.; (bottom) Elinore Hollinshead, *Letting Go*,

1986. India ink, beeswax varnish on paper, 50 × 39 in.; (top, right) Elinore Hollinshead, *Some Kinds of Love*, 1986. India ink, beeswax, damar varnish on paper, 30 × 50 in. **Page 346:** Mark Milloff, *The Dying Whale*, 1987. Pastel on paper 84 × 200 in. **Page 347:** (top) Mark Milloff, *Queequeg's Last Long Dive*, 2002; (bottom) Mark Milloff, *Stripping the Whale (preliminary drawing)*, 1987. Pastel on paper. **Page 348:** Mark Milloff, *Stripping the Whale*, 1987. Pastel on paper, 96 × 152 in. **Page 349:** (top) Stephen Talasnik, *Resurrection*, 1992–1993. Graphite on paper, 18 × 56 in. (45.72 × 142.24 cm) © Stephen Talasnik/Courtesy Marlborough Gallery, New York, NY; (center, above) Stephen Talasnik, *Floating World*, 2005–06. Graphite, 24 × 83 in. (60.96 × 210.82 cm) © Stephen Talasnik/Courtesy Marlborough Gallery, New York, NY; (center, below) Stephen Talasnik, *Parallel Observer*, 2005–06. Graphite on paper, 24 × 83 in. (60.96 × 210.82 cm) © Stephen Talasnik/Courtesy Marlborough Gallery, New York, NY; (bottom) Stephen Talasnik, *Laws of Unintended Consequences*, 2005–2006. Graphite on paper, 21 × 74 in. (53.34 × 187.96 cm) © Stephen Talasnik/Courtesy Marlborough Gallery, New York, NY. **Page 350:** (top) *Tired of Feeding this Body (John Serl Eating)*, by Sam Messer, reproduced by permission of the artist; (bottom) *John Serl at Work*, by Sam Messer, reproduced by permission of the artist. **Page 351:** (top) *Sadness*, by Sam Messer, reproduced by permission of the artist; (bottom) *John Serl in Bed with Patches*, by Sam Messer, reproduced by permission of the artist. **Page 354:** (top) Hilary Brace, *Untitled (#3–02)*, charcoal on mylar, 3 7/8 × 4 3/8 in. Courtesy of the artist; (bottom) Hilary Brace, *Untitled (#5–02)*, 2002, charcoal on mylar, 4 3/8 × 3 7/8 in. Courtesy of the artist. **Page 355:** (top) Hilary Brace, *Untitled (#14–02)*, 2002, charcoal on mylar, 3 5/8 × 8 7/8" Courtesy of the artist; (bottom) Hilary Brace, *Untitled (#8–03)*, 2002, charcoal on mylar, 8 7/8 × 3 5/8 in. Courtesy the artist. **Page 356:** (top, left) Russell Crotty, *Milky Way Northern Hemisphere*, 2000. Ink on paper mounted on lucite sphere, 36 in. diameter. Courtesy Shoshana Wayne Gallery/© Russell Crotty; (top, right) Russell Crotty, *The Universe From My Backyard* (Installation view). Art Center, College of Design, Pasadena, California. Courtesy Shoshana Wayne Gallery/© Russell Crotty; (bottom) Russell Crotty, *M11 Galactic Cluster in Scotum*, 1999. Ink and pencil on paper 48 × 48 in. Courtesy Shoshana Wayne Gallery/© Russell Crotty. **Page 357:** (top) Russell Crotty, *Ghosts in the Void/Planetary Nebular Drawings*, 1998. Ink on paper, bound in book, 37 × 37 in. Courtesy Shoshana Wayne Gallery/© Russell Crotty; (bottom, left) Judy Pfaff, *Untitled*, 2000. Mixed media on paper in artist's frame, 53 × 101 in. Courtesy of the artist/© 2007 VAGA, NY; (bottom,

right) Judy Pfaff, *Reverend M. J. Devine*, 2003. Watercolor, encaustic, oilstick, doilies, and cast acrylic on Japanese paper, 100.4 × 53.4 in. Courtesy of the Artist/© 2007 VAGA. **Page 358:** (top) Judy Pfaff, *Untitled, 2002 # 2002–2008*. Mixed media on paper in artist's frame, 53.5 × 101.5 in. Courtesy of the Artist/© 2007 VAGA, NY; (bottom, left) Jonathan Lasker, *Untitled*, 2003. Graphite and India ink on paper, 22 × 30 in. Courtesy Cheim & Read, New York/© Jonathan Lasker; (bottom, right) Jonathan Lasker, *Untitled*, 2002. Graphite and India ink on paper, 22 × 30 in. Courtesy Cheim & Read, New York/© Jonathan Lasker. **Page 359:** (top) Jonathan Lasker, *Untitled*, 2002. Graphite and India ink on paper, 22 × 30 in. Courtesy Cheim & Read, New York/© Jonathan Lasker; (bottom) Zak Smith, *Most Accurate Self–Portrait to Date*, 2004. Acrylic and Ink on paper, 38 1/2 × 27 in. Collection Ninah and Michael Lynne/Courtesy Fredericks & Freiser, New York. **Page 360:** (left) Zak Smith, *Varrick in the Kitchen*, 2003. Acrylic and Ink on paper, 40 × 28 in. Private Collection, New Jersey/Courtesy Fredericks & Freiser, New York; (right) Zak Smith, *Girls in the Naked Girl Business: Voltaire*, 2004. Acrylic and Ink on paper, 38 1/2 × 28 in. Collection Craig Robins, Miami/Courtesy

Fredericks & Freiser, New York. **Page 361:** (top) Julie Mehretu, *Untitled*, 2004. Ink and graphite on paper, DomEtch23, 25 3/4 × 40 in. (65.4 × 101.6 cm) unique JM–D–03.04, The Judith Rothschild Foundation Contemporary Drawings Collection Gift, The Museum of Modern Art, donated by Harvey Shipley Miller. Photo: Erma Estwick. Courtesy The Project, New York; (bottom, left) Julie Mehretu, *Transcending: The New International*, 2003. Ink and acrylic on canvas 107 × 237 in. (271.8 × 602 cm) Collection Walker Art Center, Minneapolis; T.B. Walker Acquisition Fund, 2003. Photo: Cameron Wittig. Courtesy The Project, New York; (bottom, right) Julie Mehretu, *Untitled*, 2000. Ink, colored pencil, and cut paper on mylar, 18 × 24 in. (45.7 × 61 cm) JM–D–28.00 Collection Mehretu–Rankin. Photo: Erma Estwick. Courtesy The Project, New York.

CHAPTER THIRTEEN
Pages 368–369: Courtesy of Anna Claire Shapiro. **Pages 370–371:** Courtesy of Mark Macrides. **Pages 372–373:** Courtesy of Ellen Gillespie. **Pages 374–375:** Courtesy of Preot Buxton. **Pages 376–377:** Courtesy of Eric Pike. **Pages 378–379:** Courtesy of Maegan Fee. **Pages 380–381:** Courtesy of Emily Gherard.

All images appearing in the appendices are courtesy of the authors.

Index

451